LUCAS.

APOCALYPSE

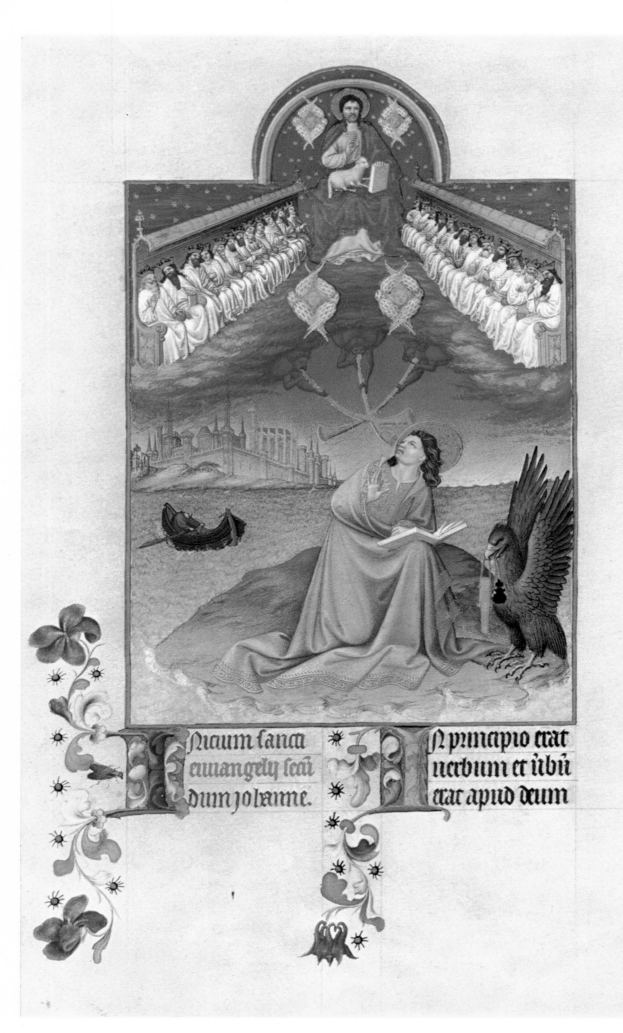

Sialum sanau
euuangeliy secu
dum johanne.

In principio erat
uerbum et ūbū
erat apud deum

FREDERICK VAN DER MEER

APOCALYPSE

Visions from
the Book of Revelation
in Western Art

with 228 illustrations, 82 in colour

Behold, a door was opened in heaven…

Rev. IV: I

THAMES AND HUDSON

First published in Great Britain in 1978
by Thames and Hudson Ltd, London

© 1978 by Mercatorfonds, Antwerp

Printed and bound in Belgium

Frontispiece
John, on Patmos, contemplating the Vision
of the Throne, with the Lamb, the four
Beings and the twenty-four Elders. Fron-
tispiece facing the beginning of the Gospel
of St John, in the *Très riches Heures* of
John, Duke of Berry. By the Limburg
Brothers, 1409-15. Chantilly, Musée
Condé. (1)

Apocalypse
The hands of John writing the Apoca-
lypse. Detail of Memling's panel (pl. 168)
of 1479. Bruges, St John's Hospital. (2)

Contents

Preface

All the same, what happened yesterday and what may happen tomorrow are in a curious way not unrelated to St John's narrative. What if we looked a little closer? Today people seem to be trying rather too hard to give the impression that they are enjoying themselves. What if something were brooding beneath their feet?

Paul Claudel

PHILOSOPHERS like Oswald Spengler and – less pessimistically – Arnold Toynbee have seen history as an endless process of rise and decline, each culture inevitably giving place to the next. Over our own Western civilization the shadow of death now lies darkly. Modern man, with his unbridled self-will, seems unable to live with his unprecedented wealth or to control the powers that he himself has released and which threaten to destroy him.

Slowly a sort of psychological terror appears to be overtaking us. We cannot escape from our consumer society where practically everybody is trying to get more and give less, regardless of the class, the country or the race to which he belongs. The causes of our malaise lie less in the lack of global prosperity than in the intellectual climate of our age and the social conditioning that we undergo. Yet we have probably still not reached the limits of our productive capacities, either material or mental. As Aldous Huxley remarked, more in sorrow than in anger, people will never be happy with little when they might be miserable with much. Even the new countries of the Third World, so confident and self-righteous in the intoxication of independence, are finding in the cold light of dwan that they have failed to construct a viable human society.

And over and above all the rest, there is the atomic threat. Nobody can define it. Nobody but a few top specialists can even understand it.

For all these reasons, the words 'Apocalypse' and 'Apocalyptic' are liable to crop up fairly frequently nowadays in serious conversation. In ordinary usage they mean simply 'the end of the world'. But there is a more strictly religious connotation. Though the word is Greek, the concept is Judeo-Christian. It means God's final message to mankind as revealed in certain parts of the Old Testament and the last book of the New – *The Revelation of St John the Divine*. This visionary text describes not only the end of all things but also the state of the blessed who will see God after the great cataclysm. It is a book of consolation for all the persecuted who have trusted in God's Word, and was central to European culture from Early Christian times until the Renaissance.

Frederick van der Meer, the author of the present book, is Emeritus Professor of the History of Art at the University of Nijmegen, where he has won a devoted following among both his own students and those from other universities. His publications, which have earned him a world-wide reputation, include works on St Augustine and on the Cistercians, as well as two books which have made him well known to the English-speaking public, the *Atlas of Western Civilization* and the *Atlas of the Early Christian World*. Equally distinguished as a historian, a theologian and an interpreter of art, he was awarded the P.C. Hooft Prize by the Dutch Government in 1956 for his contributions to the history of European civilization.

In this new book, he looks at the works of art which have drawn inspiration from the Apocalypse. He shows us the mosaics of Early Christian basilicas, pages from the Trier codex, manuscript illuminations from Flanders and England. With a keen eye and infectious enthusiasm he analyses a Roman fresco, the sculptural ensemble on the west front of a Gothic cathedral, or the glowing colours of a medieval tapestry. He makes us share his admiration for Dürer's great woodcuts and his sense of wonder before the Ghent altarpiece of Van Eyck.

Van der Meer is himself no mean stylist. If the Apocalypse has inspired artists and works of art, those works have inspired Van der Meer. The book begins with a moving account of his own personal reaction to the Apocalypse, in which he tries to come as close as he can to the profound basis of St John's vision and its mystical meaning. As a Catholic and a priest, he is especially fitted to understand its spiritual dimension – and that of the works of art to which it has given rise – and to see both in the context of human life.

It is essential for the reader to have the actual text of the Apocalypse ready to hand, and we have therefore printed the complete English Revised Version of it at the beginning of the book. It is not always easy to follow. The symbolism used to describe visions, the hermetic language and the ideas inherent in the conventions of Jewish apocalyptic writing present the layman with a series of problems in both the text and the iconography. The author supplies help on both these counts. He does not attempt a comprehensive analysis of the whole subject. He confines himself instead to some twenty key works, or complexes of works, that together sum up the achievements of apocalyptic art. Text and illustrations have been chosen to give the reader all he needs towards an understanding, as well as to provide a feast for the eye and the imagination. Some of the pictures, for instance the miniatures from the first Flemish Apocalypse, are published here for the first time.

Some readers will ask why the book ends with Correggio. Why not go right up to moderen times and include Goya's *Disasters of War*, etchings by Blake, lithographs by Odilon Redon, drawings by Frans Masereel in the *Apokalypse*

unserer Zeit or Picasso's *Guernica?* The reason is that after the Renaissance the term 'Apocalypse' has been shorn of its biblical overtones. Those who use it today are no longer referring to the vision of St John; they simply mean events leading to the destruction of mankind. Van der Meer, on the other hand, is concerned only with works that relate directly to the biblical sources. He excludes imagery that does not derive from that specific tradition and therefore does not try to go beyond Correggio.

Yet Apocalypse is not a remote myth; it is a terrifing reality. Every day brings us news of fresh tragedies: the exhaustion of the earth's natural resources, the pollution of air and sea, self-pollution, self-mutilation, self-destruction. Twice already our civilization has nearly been swept away by armed conflict. Now the shadow of atomic war falls upon us and upon the generations to come. We think again of Paul Claudel's ominous words, written before the Second World War: 'What if something were brooding beneath their feet?' Perhaps the greatest merit of Van der Meer's book is that after we have wondered at all the beauty, after we have understood the artistic processes and the theological implications, it can still make us realize that perhaps something *is* brooding beneath our feet. It can make us – humanists and Catholics alike – unite together to prevent the ultimate disaster and to humanize our world.

Did not a famous German once say: 'Even if the world were going to end tomorrow, I should plant my little apple-tree today'?

MAURITS NAESSENS

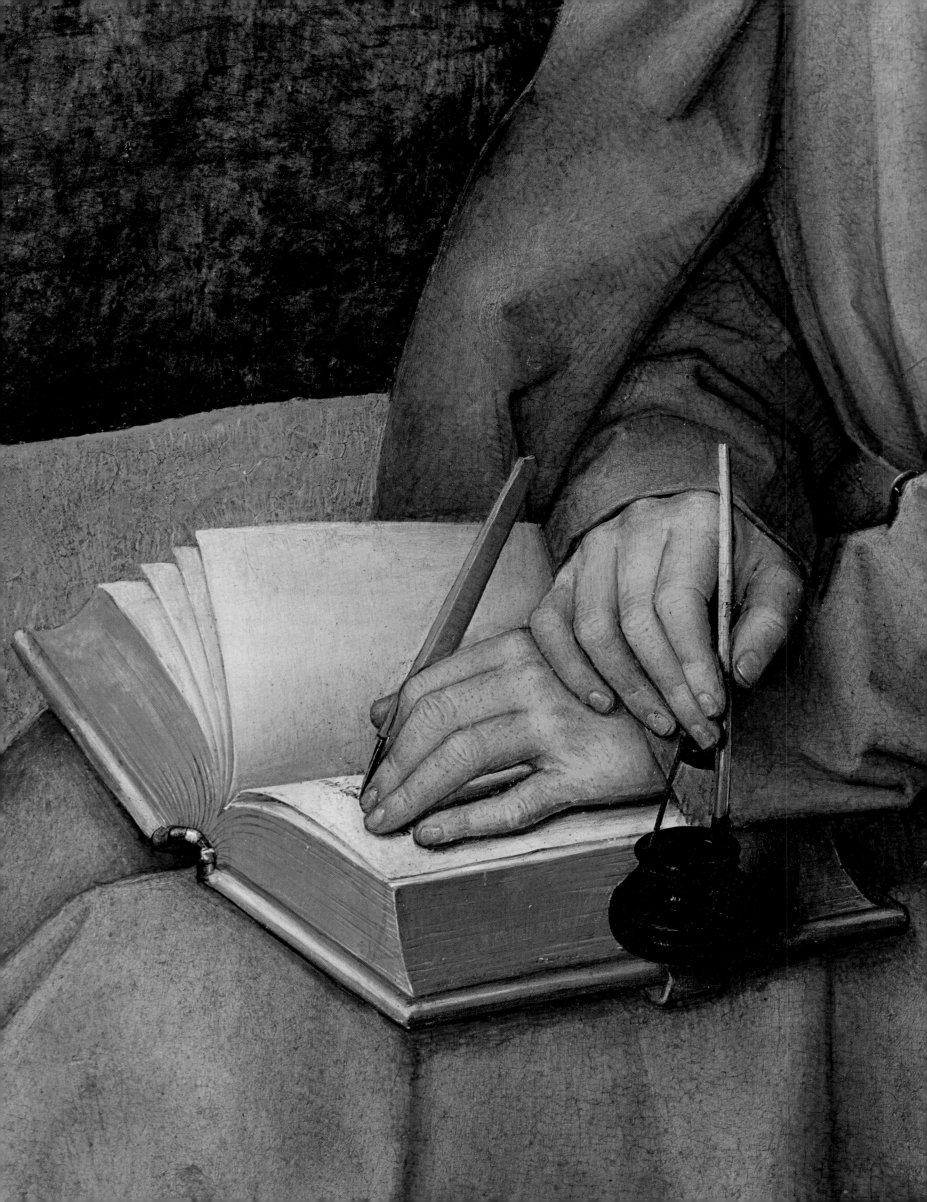

THE REVELATION

OF ST JOHN THE DIVINE

1 1 The Revelation of Jesus Christ, which God gave him to shew unto his servants, even the things which must shortly come to pass: and he sent and signified it by his angel unto his servant John; 2 who bare witness of the word of God, and of the testimony of Jesus Christ, even of all things that he saw. 3 Blessed is he that readeth, and they that hear the words of the prophecy, and keep the things which are written therein: for the time is at hand.

4 John to the seven churches which are in Asia: Grace to you and peace, from him which is and which was and which is to come; and from the seven Spirits which are before his throne; 5 and from Jesus Christ, who is the faithful witness, the firstborn of the dead, and the ruler of the kings of the earth. Unto him that loveth us, and loosed us from our sins by his blood; 6 and he made us to be a kingdom, to be priests unto his God and Father; to him be the glory and the dominion for ever and ever. Amen. 7 Behold, he cometh with the clouds; and every eye shall see him, and they which pierced him; and all the tribes of the earth shall mourn over him. Even so, Amen.

8 I am the Alpha and the Omega, saith the Lord God, which is and which was and which is to come, the Almighty.

9 I John, your brother and partaker with you in the tribulation and kingdom and patience which are in Jesus, was in the isle that is called Patmos, for the word of God and the testimony of Jesus. 10 I was in the Spirit on the Lord's day, and I heard behind me a great voice, as of a trumpet 11 saying, What thou seest, write in a book, and send it to the seven churches; unto Ephesus, and unto Smyrna, and unto Pergamum, and unto Thyatira, and unto Sardis, and unto Philadelphia, and unto Laodicea. 12 And I turned to see the voice which spake with me. And having turned I saw seven golden candlesticks; 13 and in the midst of the candlesticks one like unto a son of man, clothed with a garment down the foot, and girt about at the breasts with a golden girdle. 14 And his head and his hair were white as white wool, white as snow; and his eyes were as a flame of fire; 15 and his feet like unto burnished brass, as if it had been refined in a furnace; and his voice as the voice of many waters. 16 And he had in his right hand seven stars: and out of his mouth proceeded a sharp two-edged sword: and his countenance was as the sun shineth in his strength. 17 And when I saw him, I fell at his feet as one dead. And he laid his right hand upon me, saying, Fear not; I am the first and the last, 18 and the Living one; and I was dead, and behold, I am alive for evermore, and I have the keys of death and of Hades. 19 Write therefore the things which thou sawest, and the things which are, and the things which shall come to pass hereafter; 20 the mystery of the seven stars which thou sawest in my right hand, and the seven golden candlesticks. The seven stars are the angels of the seven churches: and the seven candlesticks are seven churches.

2 1 To the angel of the church in Ephesus write; These things saith he that holdeth the seven stars in his right hand, he that walketh in the midst of the seven golden candlesticks: 2 I know thy works, and thy toil and patience, and that thou canst not bear evil men, and didst try them which call themselves apostles, and they are not, and didst find them false; 3 and thou hast patience and didst bear for my name's sake, and hast not grown weary. 4 But I have this against thee, that thou didst leave thy first love. 5 Remember therefore from whence thou art fallen, and repent, and do the first works; or else I come to thee, and will move thy candlestick out of its place, except thou repent. 6 But this thou hast, that thou hatest the works of the Nicolaitans, which I also hate. 7 He that hath an ear, let him hear what the Spirit saith to the churches. To him that overcometh, to him will I give to eat of the tree of life, which is in the Paradise of God.

8 And to the angel of the church in Smyrna write; These things saith the first and the last, which was dead, and lived again: 9 I know thy tribulation, and thy poverty (but thou art rich), and the blasphemy of them which say they are Jews, and they are not, but are a synagogue of Satan. 10 Fear not the things which thou art about to suffer: behold, the devil is about to cast some of you into prison, that ye may be tried; and ye shall have tribulation ten days. Be thou faithful unto death, and I will give thee the crown of life. 11 He that hath an ear, let him hear what the Spirit saith to the churches. He that overcometh shall not be hurt of the second death.

12 And to the angel of the church in Pergamum write; These things saith he that hath the sharp two-edged sword: 13 I know where thou dwellest, even where Satan's throne is: and thou holdest fast my name, and didst not deny my faith, even in the days of Antipas my witness, my faithful one, who was killed among you, where Satan dwelleth. 14 But I have a few things against thee, because thou hast there some that hold the teaching of Balaam, who taught Balak to cast a stumblingblock before the children of Israel, to eat things sacrificed to idols, and to commit fornication. 15 So hast thou also some that hold the teaching of the Nicolaitans in like manner. 16 Repent therefore; or else I come to thee quickly, and I will make war against them with the sword of my mouth. 17 He that hath an ear, let him hear what the Spirit saith to the churches. To him that overcometh, to him will I give of the hidden manna, and I will give him a white stone, and upon the stone a new name written, which no one knoweth but he that receiveth it.

18 And to the angel of the church in Thyatira write; These things saith the Son of God, who hath his eyes like a flame of fire, and his feet are like unto burnished brass: 19 I know thy works, and thy love and faith and ministry and patience, and that thy last works are more than the first.

20 But I have this against thee, that thou sufferest the woman Jezebel, which calleth herself a prophetess; and she teacheth and seduceth my servants to commit fornication, and to eat things sacrificed to idols. 21 And I gave her time that she should repent; and she willeth not to repent of her fornication. 22 Behold, I do cast her into a bed, and them that commit adultery with her into great tribulation, except they repent of her works. 23 And I will kill her children with death; and all the churches shall know that I am he which searcheth the reins and hearts: and I will give unto each one of you according to your works. 24 But to you I say, to the rest that are in Thyatira, as many as have not this teaching, which know not the deep things of Satan, as they say; I cast upon you none other burden. 25 Howbeit that which ye have, hold fast till I come. 26 And he that overcometh, and he that keepeth my works unto the end, to him will I give authority over the nations: 27 and he shall rule them with a rod of iron, as the vessels of the potter are broken to shivers; as I also have received of my Father: 28 and I will give him the morning star. 29 He that hath an ear, let him hear what the Spirit saith to the churches.

3 1 And to the angel of the church in Sardis write;
These things saith he that hath the seven Spirits of God, and the seven stars: I know thy works, that thou hast a name that thou livest, and thou art dead. 2 Be thou watchful, and stablish the things that remain, which were ready to die: for I have found no works of thine fulfilled before my God. 3 Remember therefore how thou hast received and didst hear; and keep it, and repent. If therefore thou shalt not watch, I will come as a thief, and thou shalt not know what hour I will come upon thee. 4 But thou hast a few names in Sardis which did not defile their garments: and they shall walk with me in white; for they are worthy. 5 He that overcometh shall thus be arrayed in white garments; and I will in no wise blot his name out of the book of life, and I will confess his name before my Father, and before his angels. 6 He that hath an ear, let him hear what the Spirit saith to the churches.

7 And to the angel of the church in Philadelphia write;
These things saith he that is holy, he that is true, he that hath the key of David, he that openeth, and none shall shut, and that shutteth, and none openeth: 8 I know thy works (behold, I have set before thee a door opened, which none can shut), that thou hast a little power, and didst keep my word, and didst not deny my name. 9 Behold, I give of the synagogue of Satan, of them which say they are Jews, and they are not, but do lie; behold, I will make them to come and worship before thy feet, and to know that I have loved thee. 10 Because thou didst keep the word of my patience, I also will keep thee from the hour of trial, that hour which is to come upon the whole world, to try them that dwell upon the earth. 11 I come quickly: hold fast that which thou hast, that no one take thy crown. 12 He that overcometh, I will make him a pillar in the temple of my God, and he shall go out thence no more: and I will write upon him the name of my God, and the name of the city of my God, the new Jerusalem, which cometh down out of heaven from my God, and mine own new name. 13 He that hath an ear, let him hear what the Spirit saith to the churches.

14 And to the angel of the church in Laodicea write;
These things saith the Amen, the faithful and true witness, the beginning of the creation of God: 15 I know thy works, that thou art neither cold nor hot: I would thou wert cold or hot. 16 So because thou art lukewarm, and neither hot nor cold, I will spew thee out of my mouth. 17 Because thou sayest, I am rich, and have gotten riches, and have need of nothing; and knowest not that thou art the wretched one and miserable and poor and blind and naked: 18 I counsel thee to buy of me gold refined by fire, that thou mayest become rich; and white garments, that thou mayest clothe thyself, and that the shame of thy nakedness be not made manifest: and eyesalve to anoint thine eyes, that thou mayest see. 19 As many as I love, I reprove and chasten: be zealous therefore, and repent. 20 Behold, I stand at the door and knock: if any man hear my voice and open the door, I will come in to him, and will sup with him, and he with me. 21 He that overcometh, I will give to him to sit down with me in my throne, as I also overcame, and sat down with my Father in his throne. 22 He that hath an ear, let him hear what the Spirit saith to the churches.

4 1 After these things I saw, and behold, a door opened in heaven, and the first voice which I heard, a voice as of a trumpet speaking with me, one saying, Come up hither, and I will shew thee the things which must come to pass hereafter. 2 Straightway I was in the Spirit: and behold, there was a throne set in heaven, and one sitting upon the throne; 3 and he that sat was to look upon like a jasper stone and a sardius: and there was a rainbow round about the throne, like an emerald to look upon. 4 And round about the throne were four and twenty thrones: and upon the thrones I saw four and twenty elders sitting, arrayed in white garments; and on their heads crowns of gold. 5 And out of the throne proceed lightnings and voices and thunders. And there were seven lamps of fire burning before the throne, which are the seven Spirits of God; 6 and before the throne, as it were a glassy sea like unto crystal; and in the midst of the throne, and round about the throne, four living creatures full of eyes before and behind. 7 And the first creature was like a lion, and the second creature like a calf, and the third creature had a face as of a man, and the fourth creature was like a flying eagle. 8 And the four living creatures, having each one of them six wings, are full of eyes round about and within: and they have no rest day and night, saying, Holy, holy, holy, is the Lord God, the Almighty, which was and which is and which is to come. 9 And when the living creatures shall give glory and honour and thanks to him that sitteth on the throne, to him that liveth for ever and ever, 10 the four and twenty elders shall fall down before him that sitteth on the throne, and shall worship him that liveth for ever and ever, and shall cast their crowns before the throne, saying, 11 Worthy art thou, our Lord and our God, to receive the glory and the honour and the power: for thou didst create all things, and because of thy will they were, and were created.

5 1 And I saw in the right hand of him that sat on the throne a book written within and on the back, close sealed with seven seals. 2 And I saw a strong angel proclaiming with a great voice, Who is worthy to open the book, and to loose the seals thereof? 3 And no one in the heaven, or on the earth, or under the earth, was able to open the book, or to look thereon. 4 And I wept much, because no one was found worthy to open the book, or to look thereon: 5 and one of the elders saith unto me, Weep not: behold, the Lion that is of the tribe of Judah, the Root of David, hath overcome, to open the book and the seven seals thereof. 6 And I saw in the midst of the throne and of the four living creatures, and in the midst of the elders, a Lamb standing, as though it had been slain, having seven horns, and seven eyes, which are the seven Spirits of God, sent forth into all the earth. 7 And he came, and he taketh it out of the right

hand of him that sat on the throne. 8 And when he had taken the book, the four living creatures and the four and twenty elders fell down before the Lamb, having each one a harp, and golden bowls full of incense, which are the prayers of the saints. 9 And they sing a new song, saying, Worthy art thou to take the book, and to open the seals thereof: for thou wast slain, and didst purchase unto God with thy blood men of every tribe, and tongue, and people, and nation, 10 and madest them to be unto our God a kingdom and priests; and they reign upon the earth. 11 And I saw, and I heard a voice of many angels round about the throne and the living creatures and the elders; and the number of them was ten thousand times ten thousand, and thousands of thousands; 12 saying with a great voice. Worthy is the Lamb that hath been slain to receive the power, and riches, and wisdom, and might, and honour, and glory, and blessing. 13 And every created thing which is in the heaven, and on the earth, and under the earth, and on the sea, and all things that are in them, heard I saying, Unto him that sitteth on the throne, and unto the Lamb, be the blessing, and the honour, and the glory, and the dominion, for ever and ever. 14 And the four living creatures said, Amen. And the elders fell down and worshipped.

6 1 And I saw when the Lamb opened one of the seven seals, and I heard one of the four living creatures saying as with a voice of thunder, Come. 2 And I saw, and behold, a white horse, and he that sat thereon had a bow; and there was given unto him a crown: and he came forth conquering, and to conquer.

3 And when he opened the second seal, I heard the second living creature saying, Come. 4 And another horse came forth, a red horse: and to him that sat thereon it was given to take peace from the earth, and that they should slay one another: and there was given unto him a great sword.

5 And when he opened the third seal, I heard the third living creature saying, Come. And I saw, and behold, a black horse; and he that sat thereon had a balance in his hand. 6 And I heard as it were a voice in the midst of the four living creatures saying, A measure of wheat for a penny, and three measures of barley for a penny; and the oil and the wine hurt thou not.

7 And when he opened the fourth seal, I heard the voice of the fourth living creature saying, Come. 8 And I saw, and behold, a pale horse: and he that sat upon him, his name was Death; and Hades followed with him. And there was given unto them authority over the fourth part of the earth, to kill with sword, and with famine, and with death, and by the wild beasts of the earth.

9 And when he opened the fifth seal, I saw underneath the altar the souls of them that had been slain for the word of God, and for the testimony which they held: 10 and they cried with a great voice, saying, How long, O Master, the holy and true, dost thou not judge and avenge our blood on them that dwell on the earth? 11 And there was given them to each one a white robe; and it was said unto them, that they should rest yet for a little time, until their fellow-servants also and their brethren, which should be killed even as they were, should be fulfilled.

12 And I saw when he opened the sixth seal, and there was a great earthquake; and the sun became black as sackcloth of hair, and the whole moon became as blood; 13 and the stars of the heaven fell unto the earth, as a fig tree casteth her unripe figs, when she is shaken of a great wind. 14 And the heaven was removed as a scroll when it is rolled up; and every mountain and island were moved out of their

places. 15 And the kings of the earth, and the princes, and the chief captains, and the rich, and the strong, and every bondman and freeman, hid themselves in the caves and in the rocks of the mountains; 16 and they say to the mountains and to the rocks, Fall on us, and hide us from the face of him that sitteth on the throne, and from the wrath of the Lamb: 17 for the great day of their wrath is come; and who is able to stand?

7 1 After this I saw four angels standing at the four corners of the earth, holding the four winds of the earth, that no wind should blow on the earth, or on the sea, or upon any tree. 2 And I saw another angel ascend from the sunrising, having the seal of the living God: and he cried with a great voice to the four angels, to whom it was given to hurt the earth and the sea, 3 saying, Hurt not the earth, neither the sea, nor the trees, till we shall have sealed the servants of our God on their foreheads. 4 And I heard the number of them which were sealed, a hundred and forty and four thousand, sealed out of every tribe of the children of Israel.

5 Of the tribe of Judah were sealed twelve thousand:
Of the tribe of Reuben twelve thousand:
Of the tribe of Gad twelve thousand:
6 Of the tribe of Asher twelve thousand:
Of the tribe of Naphtali twelve thousand:
Of the tribe of Manasseh twelve thousand:
7 Of the tribe of Simeon twelve thousand:
Of the tribe of Levi twelve thousand:
Of the tribe of Issachar twelve thousand:
8 Of the tribe of Zebulun twelve thousand:
Of the tribe of Joseph twelve thousand:
Of the tribe of Benjamin were sealed twelve thousand.

9 After these things I saw, and behold, a great multitude, which no man could number, out of every nation, and of all tribes and peoples and tongues, standing before the throne and before the Lamb, arrayed in white robes, and palms in their hands; 10 and they cry with a great voice, saying, Salvation unto our God which sitteth on the throne, and unto the Lamb. 11 And all the angels were standing round about the throne, and about the elders and the four living creatures; and they fell before the throne on their faces, and worshipped God, 12 saying, Amen: Blessing, and glory, and wisdom, and thanksgiving, and honour, and power, and might, be unto our God for ever and ever. Amen. 13 And one of the elders answered, saying unto me, These which are arrayed in the white robes, who are they, and whence came they? 14 And I say unto him, My lord, thou knowest. And he said to me, These are they which come out of the great tribulation, and they washed their robes, and made them white in the blood of the Lamb. 15 Therefore are they before the throne of God; and they serve him day and night in his temple: and he that sitteth on the throne shall spread his tabernacle over them. 16 They shall hunger no more, neither thirst any more; neither shall the sun strike upon them, nor any heat: 17 for the Lamb which is in the midst of the throne shall be their shepherd, and shall guide them unto fountains of waters of life: and God shall wipe away every tear from their eyes.

8 1 And when he opened the seventh seal, there followed a silence in heaven about the space of half an hour. 2 And I saw the seven angels which stand before God; and there were given unto them seven trumpets.

3 And another angel came and stood over the altar, having a golden censer; and there was given unto him much incense, that he should add it unto the prayers of all the saints upon

the golden altar which was before the throne. 4 And the smoke of the incense, with the prayers of the saints, went up before God out of the angel's hand. 5 And the angel taketh the censer; and he filled it with the fire of the altar, and there followed thunders, and voices, and lightnings, and an earthquake.

6 And the seven angels which had the seven trumpets prepared themselves to sound.

7 And the first sounded, and there followed hail and fire, mingled with blood, and they were cast upon the earth: and the third part of the earth was burnt up, and the third part of the trees was burnt up, and all green grass was burnt up.

8 And the second angel sounded, and as it were a great mountain burning with fire was cast into the sea: and the third part of the sea became blood; 9 and there died the third part of the creatures which were in the sea, even they that had life; and the third part of the ships was destroyed.

10 And the third angel sounded, and there fell from heaven a great star, burning as a torch, and it fell upon the third part of the rivers, and upon the fountains of the waters; 11 and the name of the star is called Wormwood: and the third part of the waters became wormwood; and many men died of the waters, because they were made bitter.

12 And the fourth angel sounded, and the third part of the sun was smitten, and the third part of the moon, and the third part of the stars; that the third part of them should be darkened, and the day should not shine for the third part of it, and the night in like manner.

13 And I saw, and I heard an eagle, flying in mid heaven, saying with a great voice, Woe, woe, woe, for them that dwell on the earth, by reason of the other voices of the trumpet of the three angels, who are yet to sound.

9 1 And the fifth angel sounded, and I saw a star from heaven fallen unto the earth; and there was given to him the key of the pit of the abyss. 2 And he opened the pit of the abyss; and there went up a smoke out of the pit, as the smoke of a great furnace; and the sun and the air were darkened by reason of the smoke of the pit. 3 And out of the smoke came forth locusts upon the earth; and power was given them, as the scorpions of the earth have power. 4 And it was said unto them that they should not hurt the grass of the earth, neither any green thing, neither any tree, but only such men as have not the seal of God on their foreheads. 5 And it was given them that they should not kill them, but that they should be tormented five months: and their torment was as the torment of a scorpion, when it striketh a man. 6 And in those days men shall seek death, and shall in no wise find it; and they shall desire to die, and death fleeth from them. 7 And the shapes of the locusts were like unto horses prepared for war; and upon their heads as it were crowns like unto gold, and their faces were as men's faces. 8 And they had hair as the hair of women, and their teeth were as the teeth of lions. 9 And they had breastplates, as it were breastplates of iron; and the sound of their wings was as the sound of chariots, of many horses rushing to war. 10 And they have tails like unto scorpions, and stings; and in their tails is their power to hurt men five months. 11 They have over them as king the angel of the abyss: his name in Hebrew is Abaddon, and in the Greek tongue he hath the name Apollyon.

12 The first Woe is past: behold, there come yet two Woes hereafter.

13 And the sixth angel sounded, and I heard a voice from the horns of the golden altar which is before God, 14 one saying to the sixth angel, which had the trumpet, Loose the four angels which are bound at the great river Euphrates. 15 And the four angels were loosed, which had been prepared for the hour and day and month and year, that they should kill the third part of men. 16 And the number of the armies of the horsemen was twice ten thousand times ten thousand: I heard the number of them. 17 And thus I saw the horses in the vision, and them that sat on them, having breastplates as of fire and of hyacinth and of brimstone: and the heads of the horses are as the heads of lions; and out of their mouths proceedeth fire and smoke and brimstone. 18 By these three plagues was the third part of men killed, by the fire and the smoke and the brimstone, which proceeded out of their mouths. 19 For the power of the horses is in their mouth, and in their tails: for their tails are like unto serpents, and have heads; and with them they do hurt. 20 And the rest of mankind, which were not killed with these plagues, repented not of the works of their hands, that they should not worship devils, and the idols of gold, and of silver, and of brass, and of stone, and of wood; which can neither see, nor hear, nor walk: 21 and they repented not of their murders, nor of their sorceries, nor of their fornication, nor of their thefts.

10 1 And I saw another strong angel coming down out of heaven, arrayed with a cloud; and the rainbow was upon his head, and his face was at the sun, and his feet as pillars of fire; 2 and he had in his hand a little book open: and he set his right foot upon the sea, and his left upon the earth; 3 and he cried with a great voice, as a lion roareth: and when he cried, the seven thunders uttered their voices. 4 And when the seven thunders uttered their voices, I was about to write: and I heard a voice from heaven saying, Seal up the things which the seven thunders uttered, and write them not. 5 And the angel which I saw standing upon the sea and upon the earth lifted up his right hand to heaven, 6 and sware by him that liveth for ever and ever, who created the heaven and the things that are therein, and the earth and the things that are therein, and the sea and the things that are therein, that there shall be time no longer: 7 but in the days of the voice of the seventh angel, when he is about to sound, then is finished the mystery of God, according to the good tidings which he declared to his servants the prophets. 8 And the voice which I heard from heaven, I heard it again speaking with me, and saying, Go, take the book which is open in the hand of the angel that standeth upon the sea and upon the earth. 9 And I went unto the angel, saying unto him that he should give me the little book. And he saith unto me, Take it, and eat it up; and it shall make thy belly bitter, but in thy mouth it shall be sweet as honey. 10 And I took the little book out of the angel's hand, and ate it up; and it was in my mouth sweet as honey: and when I had eaten it, my belly was made bitter. 11 And they say unto me, Thou must prophesy again over many peoples and nations and tongues and kings.

11 1 And there was given me a reed like unto a rod: and one said, Rise, and measure the temple of God, and the altar, and them that worship therein. 2 And the court which is without the temple leave without, and measure it not; for it hath been given unto the nations: and the holy city shall they tread under foot forty and two months. 3 And I will give unto my two witnesses, and they shall prophesy a thousand two hundred and threescore days, clothed in sackcloth. 4 These are the two olive trees and the two candlesticks, standing before the Lord of the earth. 5 And if any man desireth to hurt them, fire proceedeth out of their mouth, and devoureth their enemies: and if any man shall

desire to hurt them, in this manner must he be killed. 6 These have the power to shut the heaven, that it rain not during the days of their prophecy: and they have power over the waters to turn them into blood, and to smite the earth with every plague, as often as they shall desire. 7 And when they shall have finished their testimony, the beast that cometh up out of the abyss shall make war with them, and overcome them, and kill them. 8 And their dead bodies lie in the street of the great city, which spiritually is called Sodom and Egypt, where also their Lord was crucified. 9 And from among the peoples and tribes and tongues and nations do men look upon their dead bodies three days and a half, and suffer not their dead bodies to be laid in a tomb. 10 And they that dwell on the earth rejoice over them, and make merry; and they shall send gifts one to another; because these two prophets tormented them that dwell on the earth. 11 And after the three days and a half the breath of life from God entered into them, and they stood upon their feet; and great fear fell upon them which beheld them. 12 And they heard a great voice from heaven saying unto them, Come up hither. And they went up into heaven in the cloud; and their enemies beheld them. 13 And in that hour there was a great earthquake, and the tenth part of the city fell; and there were killed in the earthquake seven thousand persons: and the rest were affrighted, and gave glory to the God of heaven.

14 The second Woe is past: behold, the third Woe cometh quickly.

15 And the seventh angel sounded; and there followed great voices in heaven, and they said, The kingdom of the world is become the kingdom of our Lord, and of his Christ: and he shall reign for ever and ever. 16 And the four and twenty elders, which sit before God on their thrones, fell upon their faces, and worshipped God, 17 saying, We give thee thanks, O Lord God, the Almighty, which art and which wast; because thou hast taken thy great power, and didst reign. 18 And the nations were wroth, and thy wrath came, and the time of the dead to be judged, and the time to give their reward to thy servants the prophets, and to the saints, and to them that fear thy name, the small and the great; and to destroy them that destroy the earth.

19 And there was opened the temple of God that is in heaven; and there was seen in his temple the ark of his covenant; and there followed lightnings, and voices, and thunders, and an earthquake, and great hail.

12 1 And a great sign was seen in heaven; a woman arrayed with the sun, and the moon under her feet, and upon her head a crown of twelve stars; 2 and she was with child: and she crieth out, travailing in birth, and in pain to be delivered. 3 And there was seen another sign in heaven; and behold, a great red dragon, having seven heads and ten horns, and upon his heads seven diadems. 4 And his tail draweth the third part of the stars of heaven, and did cast them to the earth: and the dragon stood before the woman which was about to be delivered, that when she was delivered, he might devour her child. 5 And she was delivered of a son, a man child, who is to rule all the nations with a rod of iron: and her child was caught up unto God, and unto his throne. 6 And the woman fled into the wilderness, where she hath a place prepared of God, that there they may nourish her a thousand two hundred and threescore days.

7 And there was war in heaven: Michael and his angels going forth to war with the dragon; and the dragon warred and his angels; 8 and they prevailed not, neither was their

place found any more in heaven. 9 And the great dragon was cast down, the old serpent, he that is called the Devil and Satan, the deceiver of the whole world; he was cast down to the earth, and his angels were cast down with him. 10 And I heard a great voice in heaven, saying, Now is come the salvation, and the power, and the kingdom of our God, and the authority of his Christ: for the accuser of our brethren is cast down, which accuseth them before our God day and night. 11 And they overcame him because of the blood of the Lamb, and because of the word of their testimony; and they loved not their life even unto death. 12 Therefore rejoice, O heavens, and ye that dwell in them. Woe for the earth and for the sea: because the devil is gone down unto you, having great wrath, knowing that he hath but a short time.

13 And when the dragon saw that he was cast down to the earth, he persecuted the woman which brought forth the man child. 14 And there were given to the woman the two wings of the great eagle, that she might fly into the wilderness unto her place, where she is nourished for a time, and times, and half a time, from the face of the serpent. 15 And the serpent cast out of his mouth after the woman water as a river, that he might cause her to be carried away by the stream. 16 And the earth helped the woman, and the earth opened her mouth, and swallowed up the river which the dragon cast out of his mouth. 17 And the dragon waxed wroth with the woman, and went away to make war with the rest of her seed, which keep the commandments of God, and hold the testimony of Jesus:

13 1 and he stood upon the sand of the sea.
And I saw a beast coming up out of the sea, having ten horns and seven heads, and on his horns ten diadems, and upon his heads names of blasphemy. 2 And the beast which I saw was like unto a leopard, and his feet were as the feet of a bear, and his mouth as the mouth of a lion: and the dragon gave him his power, and his throne, and great authority. 3 And I saw one of his heads as though it had been smitten unto death; and his death-stroke was healed: and the whole earth wondered after the beast; 4 and they worshipped the dragon, because he gave his authority unto the beast; and they worshipped the beast, saying, Who is like unto the beast? and who is able to war with him? 5 and there was given to him a mouth speaking great things and blasphemies; and there was given to him authority to continue forty and two months. 6 And he opened his mouth for blasphemies against God, to blaspheme his name, and his tabernacle, even them that dwell in the heaven. 7 And it was given unto him to make war with the saints, and to overcome them: and there was given to him authority over every tribe and people and tongue and nation. 8 And all that dwell on the earth shall worship him, every one whose name hath not been written in the book of life of the Lamb that hath been slain from the foundation of the world. 9 If any man hath an ear, let him hear. 10 If any man is for captivity, into captivity he goeth: if any man shall kill with the sword, with the sword must he be killed. Here is the patience and the faith of the saints.

11 And I saw another beast coming up out of the earth; and he had two horns like unto a lamb, and he spake as a dragon. 12 And he exerciseth all the authority of the first beast in his sight. And he maketh the earth and them that dwell therein to worship the first beast, whose death-stroke was healed. 13 And he doeth great signs, that he should even make fire to come down out of heaven upon the earth in the sight of men. 14 And he deceiveth them that dwell on the earth by reason of the signs which it was given him to do

in the sight of the beast; saying to them that dwell on the earth, that they should make an image to the beast, who hath the stroke of the sword, and lived. 15 And it was given unto him to give breath to it, even to the image of the beast, that the image of the beast should both speak, and cause that as many as should not worship the image of the beast should be killed. 16 And he causeth all, the small and the great, and the rich and the poor, and the free and the bond, that there be given them a mark on their right hand, or upon their forehead; 17 and that no man should be able to buy or to sell, save he that hath the mark, even the name of the beast or the number of his name. 18 Here is wisdom. He that hath understanding, let him count the number of the beast; for it is the number of a man: and his number is Six hundred and sixty and six.

14 1 And I saw, and behold, the Lamb standing on the mount Zion, and with him a hundred and forty and four thousand, having his name, and the name of his Father, written on their foreheads. 2 And I heard a voice from heaven, as the voice of many waters, and as the voice of a great thunder: and the voice which I heard was as the voice of harpers harping with their harps: 3 and they sing as it were a new song before the throne, and before the four living creatures and the elders: and no man could learn the song save the hundred and forty and four thousand, even they that had been purchased out of the earth. 4 These are they which were not defiled with women; for they are virgins. These are they which follow the Lamb whithersoever he goeth. These were purchased from among men, to be the firstfruits unto God and unto the Lamb. 5 And in their mouth was found no lie: they are without blemish.

6 And I saw another angel flying in mid heaven, having an eternal gospel to proclaim unto them that dwell on the earth, and unto every nation and tribe and tongue and people; 7 and he saith with a great voice, Fear God, and give him glory; for the hour of his judgement is come: and worship him that made the heaven and the earth and sea and fountains of waters.

8 And another, a second angel, followed, saying, Fallen, fallen is Babylon the great, which hath made all the nations to drink of the wine of the wrath of her fornication.

9 And another angel, a third, followed them, saying with a great voice, If any man worshippeth the beast and his image, and receiveth a mark on his forehead, or upon his hand, 10 he also shall drink of the wine of the wrath of God, which is prepared unmixed in the cup of his anger; and he shall be tormented with fire and brimstone in the presence of the holy angels, and in the presence of the Lamb: 11 and the smoke of their torment goeth up for ever and ever; and they have no rest day and night, they that worship the beast and his image, and whoso receiveth the mark of his name. 12 Here is the patience of the saints, they that keep the commandments of God, and the faith of Jesus.

13 And I heard a voice from heaven saying, Write, Blessed are the dead which die in the Lord from henceforth: yea, saith the Spirit, that they may rest from their labours; for their works follow with them.

14 And I saw, and behold, a white cloud; and on the cloud I saw one sitting like unto a son of man, having on his head a golden crown, and in his hand a sharp sickle. 15 And another angel came out from the temple, crying with a great voice to him that sat on the cloud, Send forth thy sickle, and reap: for the hour to reap is come; for the harvest of the earth is over-ripe. 16 And he that sat on the cloud cast his sickle upon the earth; and the earth was reaped.

17 And another angel came out from the temple which is in heaven, he also having a sharp sickle. 18 And another angel came out from the altar, he that hath power over fire; and he called with a great voice to him that had the sharp sickle, saying, Send forth thy sharp sickle, and gather the clusters of the vine of the earth; for her grapes are fully ripe. 19 And the angel cast his sickle into the earth, and gathered the vintage of the earth, and cast it into the winepress, the great winepress, of the wrath of God. 20 And the winepress was trodden without the city, and there came out blood from the winepress, even unto the bridles of the horses, as far as a thousand and six hundred furlongs.

15 1 And I saw another sign in heaven, great and marvellous, seven angels having seven plagues, which are the last, for in them is finished the wrath of God.

2 And I saw as it were a glassy sea mingled with fire; and them that come victorious from the beast, and from his image, and from the number of his name, standing by the glassy sea, having harps of God. 3 And they sing the song of Moses the servant of God, and the song of the Lamb, saying, Great and marvellous are thy works, O Lord God, the Almighty; righteous and true are thy ways, thou King of the ages. 4 Who shall not fear, O Lord, and glorify thy name? for thou only art holy; for all the nations shall come and worship before thee; for thy righteous acts have been made manifest.

5 And after these things I saw, and the temple of the tabernacle of the testimony in heaven was opened: 6 and there came out from the temple the seven angels that had the seven plagues, arrayed with precious stone, pure and bright, and girt about their breasts with golden girdles. 7 And one of the four living creatures gave unto the seven angels seven golden bowls full of the wrath of God, who liveth for ever and ever. 8 And the temple was filled with smoke from the glory of God, and from his power; and none was able to enter into the temple, till the seven plagues of the seven angels should be finished.

16 1 And I heard a great voice out of the temple, saying to the seven angels, Go ye, and pour out the seven bowls of the wrath of God into the earth.

2 And the first went, and poured out his bowl into the earth; and it became a noisome and grievous sore upon the men which had the mark of the beast, and which worshipped his image.

3 And the second poured out his bowl into the sea; and it became blood as of a dead man; and every living soul died, even the things that were in the sea.

4 And the third poured out his bowl into the rivers and the fountains of the waters; and it became blood. 5 And I heard the angel of the waters saying, Righteous art thou, which art and which wast, thou Holy One, because thou didst thus judge: 6 for they poured out the blood of saints and prophets, and blood hast thou given them to drink: they are worthy. 7 And I heard the altar saying, Yea, O Lord God, the Almighty, true and righteous are thy judgements.

8 And the fourth poured out his bowl upon the sun; and it was given unto it to scorch men with fire. 9 And men were scorched with great heat: and they blasphemed the name of the God which hath the power over these plagues; and they repented not to give him glory.

10 And the fifth poured out his bowl upon the throne of the beast; and his kingdom was darkened; and they gnawed their tongues for pain, 11 and they blasphemed the God of heaven because of their pains and their sores; and they repented not of their works.

12 And the sixth poured out his bowl upon the great river, the river Euphrates; and the water thereof was dried up, that the way might be made ready for the kings that come from the sunrising. 13 And I saw coming out of the mouth of the dragon, and out of the mouth of the beast, and out of the mouth of the false prophet, three unclean spirits, as it were frogs: 14 for they are spirits of devils, working signs; which go forth unto the kings of the whole world, to gather them together unto the war of the great day of God, the Almighty. 15 (Behold, I come as a thief. Blessed is he that watcheth, and keepeth his garments, lest he walk naked, and they see his shame.) 16 And they gathered them together into the place which is called in Hebrew Har Magedon.

17 And the seventh poured out his bowl upon the air; and there came forth a great voice out of the temple, from the throne, saying, It is done: 18 and there were lightnings, and voices, and thunders; and there was a great earthquake, such as was not since there were men upon the earth, so great an earthquake, so mighty. 19 And the great city was divided into three parts, and the cities of the nations fell: and Babylon the great was remembered in the sight of God, to give unto her the cup of the wine of the fierceness of his wrath. 20 And every island fled away, and the mountains were not found. 21 And great hail, every stone about the weight of a talent, cometh down out of heaven upon men: and men blasphemed God because of the plague of the hail; for the plague thereof is exceeding great.

17 1 And there came one of the seven angels that had the seven bowls, and spake with me, saying, Come hither, I will shew thee the judgement of the great harlot that sitteth upon many waters; 2 with whom the kings of the earth committed fornication, and they that dwell in the earth were made drunken with the wine of her fornication. 3 And he carried me away in the Spirit into a wilderness: and I saw a woman sitting upon a scarlet-coloured beast, full of names of blasphemy, having seven heads and ten horns. 4 And the woman was arrayed in purple and scarlet, and decked with gold and precious stone and pearls, having in her hand a golden cup full of abominations, even the unclean things of her fornication, 5 and upon her forehead a name written, MYSTERY, BABYLON THE GREAT, THE MOTHER OF THE HARLOTS AND OF THE ABOMINATIONS OF THE EARTH. 6 And I saw the woman drunken with the blood of the saints, and with the blood of the martyrs of Jesus. And when I saw her, I wondered with a great wonder. 7 And the angel said unto me, Wherefore didst thou wonder? I will tell thee the mystery of the woman, and of the beast that carrieth her, which hath the seven heads and the ten horns. 8 The beast that thou sawest was, and is not; and is about to come up out of the abyss, and to go into perdition. And they that dwell on the earth shall wonder, they whose name hath not been written in the book of life from the foundation of the world, when they behold the beast, how that he was, and is not, and shall come. 9 Here is the mind which hath wisdom. The seven heads are seven mountains, on which the woman sitteth: 10 and they are seven kings; the five are fallen, the one is, the other is not yet come; and when he cometh, he must continue a little while. 11 And the beast that was, and is not, is himself also an eighth, and is of the seven; and he goeth into perdition. 12 And the ten horns that thou sawest are ten kings, which have received no kingdom as yet; but they receive authority as kings, with the beast, for one hour. 13 These have one mind, and they give their power and authority unto the beast. 14 These shall war against the Lamb, and the Lamb shall overcome them, for he is Lord of lords, and King of kings; and they also shall overcome that are with him, called and chosen and faithful. 15 And he saith unto me, The waters which thou sawest, where the harlot sitteth, are peoples, and multitudes, and nations, and tongues. 16 And the ten horns which thou sawest, and the beast, these shall hate the harlot, and shall make her desolate and naked, and shall eat her flesh, and shall burn her utterly with fire. 17 For God did put in their hearts to do his mind, and to come to one mind, and to give their kingdom unto the beast, until the words of God should be accomplished. 18 And the woman whom thou sawest is the great city, which reigneth over the kings of the earth.

18 1 After these things I saw another angel coming down out of heaven, having great authority; and the earth was lightened with his glory. 2 And he cried with a mighty voice, saying, Fallen, fallen is Babylon the great, and is become a habitation of devils, and a hold of every unclean spirit, and a hold of every unclean and hateful bird. 3 For by the wine of the wrath of her fornication all the nations are fallen; and the kings of the earth committed fornication with her, and the merchants of the earth waxed rich by the power of her wantonness.

4 And I heard another voice from heaven, saying, Come forth, my people, out of her, that ye have no fellowship with her sins, and that ye receive not of her plagues: 5 for her sins have reached even unto heaven, and God hath remembered her iniquities. 6 Render unto her even as she rendered, and double unto her the double according to her works: in the cup which she mingled, mingle unto her double. 7 How much soever she glorified herself, and waxed wanton, so much give her of torment and mourning: for she saith in her heart, I sit a queen, and am no widow, and shall in no wise see mourning. 8 Therefore in one day shall her plagues come, death, and mourning, and famine; and she shall be utterly burned with fire; for strong is the Lord God which judged her. 9 And the kings of the earth, who committed fornication and lived wantonly with her, shall weep and wail over her, when they look upon the smoke of her burning, 10 standing afar off for the fear of her torment, saying, Woe, woe, the great city, Babylon, the strong city! for in one hour is thy judgement come. 11 And the merchants of the earth weep and mourn over her, for no man buyeth their merchandise any more; 12 merchandise of gold, and silver, and precious stone, and pearls, and fine linen, and purple, and silk, and scarlet; and all thyine wood, and every vessel of ivory, and every vessel made of most precious wood, and of brass, and iron, and marble; 13 and cinnamon, and spice, and incense, and ointment, and frankincense, and wine, and oil, and fine flour, and wheat, and cattle, and sheep; and merchandise of horses and chariots and slaves; and souls of men. 14 And the fruits which thy soul lusted after are gone from thee, and all things that were dainty and sumptuous are perished from thee, and men shall find them no more at all. 15 The merchants of these things, who where made rich by her, shall stand afar off for the fear of her torment, weeping and mourning; 16 saying, Woe, woe, the great city, she that was arrayed in fine linen and purple and scarlet, and decked with gold and precious stone and pearl! 17 for in one hour so great riches is made desolate. And every shipmaster, and every one that saileth any whither, and mariners, and as many as gain their living by sea, stood afar off, 18 and cried out as they looked upon the smoke of her burning, saying, What city is like the great city? 19 And they cast dust on their heads, and cried, weeping and mourning, saying, Woe, woe, the great city, wherein were made rich all that had their

ships in the sea by reason of her costliness! for in one hour is she made desolate. 20 Rejoice over her, thou heaven, and ye saints, and ye apostles, and ye prophets; for God hath judged your judgement on her.

21 And a strong angel took up a stone as it were a great millstone, and cast it into the sea, saying, Thus with a mighty fall shall Babylon, the great city, be cast down, and shall be found no more at all. 22 And the voice of harpers and minstrels and flute-players and trumpeters shall be heard no more at all in thee; and no craftsman, of whatsoever craft, shall be found any more at all in thee; and the voice of a millstone shall be heard no more at all in thee; 23 and the light of a lamp shall shine no more at all in thee; and the voice of the bridegroom and of the bride shall be heard no more at all in thee: for thy merchants were the princes of the earth; for with thy sorcery were all the nations deceived. 24 And in her was found the blood of prophets and of saints, and of all that have been slain upon the earth.

19 1 After these things I heard as it were a great voice of a great multitude in heaven, saying, Hallelujah; Salvation, and glory, and power, belong to our God: 2 for true and righteous are his judgements; for he hath judged the great harlot, which did corrupt the earth with her fornication, and he hath avenged the blood of his servants at her hand. 3 And a second time they say, Hallelujah. And her smoke goeth up for ever and ever. 4 And the four and twenty elders and the four living creatures fell down and worshipped God that sitteth on the throne, saying, Amen; Hallelujah. 5 And a voice came forth from the throne, saying, Give praise to our God, all ye his servants, ye that fear him, the small and the great. 6 And I heard as it were the voice of a great multitude, and as the voice of many waters, and as the voice of mighty thunders, saying, Hallelujah: for the Lord our God, the Almighty, reigneth. 7 Let us rejoice and be exceeding glad, and let us give the glory unto him: for the marriage of the Lamb is come, and his wife hath made herself ready. 8 And it was given unto her that she should array herself in fine linen, bright and pure: for the fine linen is the righteous acts of the saints. 9 And he saith unto me, Write, Blessed are they which are bidden to the marriage supper of the Lamb. And he saith unto me, These are true words of God. 10 And I fell down before his feet to worship him. And he saith unto me, See thou do it not: I am a fellow-servant with thee and with thy brethren that hold the testimony of Jesus: worship God: for the testimony of Jesus is the spirit of prophecy.

11 And I saw the heaven opened; and behold, a white horse, and he that sat thereon, called Faithful and True; and in righteousness he doth judge and make war. 12 And his eyes are a flame of fire, and upon his head are many diadems; and he hath a name written, which no one knoweth but he himself. 13 And he is arrayed in a garment sprinkled with blood: and his name is called The Word of God. 14 And the armies which are in heaven followed him upon white horses, clothed in fine linen, white and pure. 15 And out of his mouth proceedeth a sharp sword, that with it he should smite the nations: and he shall rule them with a rod of iron: and he treadeth the winepress of the fierceness of the wrath of Almighty God. 16 And he hath on his garment and on his thigh a name written, KING OF KINGS, AND LORD OF LORDS.

17 And I saw an angel standing in the sun; and he cried with a loud voice, saying to all the birds that fly in mid heaven. Come and be gathered together unto the great supper of God: 18 that ye may eat the flesh of kings, and the flesh of captains, and the flesh of mighty men, and the flesh of

horses and of them that sit thereon, and the flesh of all men, both free and bond, and small and great.

19 And I saw the beast, and the kings of the earth, and their armies, gathered together to make war against him that sat upon the horse, and against his army. 20 And the beast was taken, and with him the false prophet that wrought the signs in his sight, wherewith he deceived them that had received the mark of the beast, and them that worshipped his image: they twain were cast alive into the lake of fire that burneth with brimstone: 21 and the rest were killed with the sword of him that sat upon the horse, even the sword which came forth out of his mouth: and all the birds were filled with their flesh.

20 1 And I saw an angel coming down out of heaven, having the key of the abyss and a great chain in his hand. 2 And he laid hold on the dragon, the old serpent, which is the Devil and Satan, and bound him for a thousand years, 3 and cast him into the abyss, and shut it, and sealed it over him, that he should deceive the nations no more, until the thousand years should be finished: after this he must be loosed for a little time.

4 And I saw thrones, and they sat upon them, and judgement was given unto them: and I saw the souls of them that had been beheaded for the testimony of Jesus, and for the word of God, and such as worshipped not the beast, neither his image, and received not the mark upon their forehead and upon their hand; and they lived, and reigned with Christ a thousand years. 5 The rest of the dead lived not until the thousand years should be finished. This is the first resurrection. 6 Blessed and holy is he that hath part in the first resurrection: over these the second death hath no power; but they shall be priests of God and of Christ, and shall reign with him a thousand years.

7 And when the thousand years are finished, Satan shall be loosed out of his prison, 8 and shall come forth to deceive the nations which are in the four corners of the earth, Gog and Magog, to gather them together to the war: the number of whom is as the sand of the sea. 9 And they went up over the breadth of the earth, and compassed the camp of the saints about, and the beloved city: and fire came down out of heaven, and devoured them. 10 And the devil that deceived them was cast into the lake of fire and brimstone, where are also the beast and the false prophet; and they shall be tormented day and night for ever and ever.

11 And I saw a great white throne, and him that sat upon it, from whose face the earth and the heaven fled away; and there was found no place for them. 12 And I saw the dead, the great and the small, standing before the throne; and books were opened: and another book was opened, which is the book of life: and the dead were judged out of the things which were written in the books, according to their works. 13 And the sea gave up the dead which were in it; and death and Hades gave up the dead which were in them: and they were judged every man according to their works. 14 And death and Hades were cast into the lake of fire. This is the second death, even the lake of fire. 15 And if any was not found written in the book of life, he was cast into the lake of fire.

21 1 And I saw a new heaven and a new earth: for the first heaven and the first earth are passed away; and the sea is no more. 2 And I saw the holy city, new Jerusalem, coming down out of heaven from God, made ready as a bride adorned for her husband. 3 And I heard a great voice out of the throne saying, Behold, the tabernacle of God is with men, and he shall dwell with them, and they shall be

his peoples, and God himself shall be with them, and be their God: 4 and he shall wipe away every tear from their eyes; and death shall be no more; neither shall there be mourning, nor crying, nor pain, any more: the first things are passed away. 5 And he that sitteth on the throne said, Behold, I make all things new. And he saith, Write: for these words are faithful and true. 6 And he said unto me, They are come to pass. I am the Alpha and the Omega, the beginning and the end. I will give unto him that is athirst of the fountain of the water of life freely. 7 He that overcometh shall inherit these things; and I will be his God, and he shall be my son. 8 But for the fearful, and unbelieving, and abominable, and murderers, and fornicators, and sorcerers, and idolaters, and all liars, their part shall be in the lake that burneth with fire and brimstone; which is the second death.

9 And there came one of the seven angels who had the seven bowls, who were laden with the seven last plagues; and he spake with me, saying, Come hither, I will shew thee the bride, the wife of the Lamb. 10 And he carried me away in the Spirit to a mountain great and high, and shewed me the holy city Jerusalem, coming down out of heaven from God, 11 having the glory of God: her light was like unto a stone most precious, as it were a jasper stone, clear as crystal: 12 having a wall great and high; having twelve gates, and at the gates twelve angels; and names written thereon, which are the names of the twelve tribes of the children of Israel: 13 on the east were three gates; and on the north three gates; and on the south three gates; and on the west three gates. 14 And the wall of the city had twelve foundations, and on them twelve names of the twelve apostles of the Lamb. 15 And he that spake with me had for a measure a golden reed to measure the city, and the gates thereof, and the wall thereof. 16 And the city lieth foursquare, and the length thereof is as great as the breadth: and he measured the city with the reed, twelve thousand furlongs: the length and the breadth and the height thereof are equal. 17 And he measured the wall thereof, a hundred and forty and four cubits, according to the measure of a man, that is, of an angel. 18 And the building of the wall thereof was jasper: and the city was pure gold, like unto pure glass. 19 The foundations of the wall of the city were adorned with all manner of precious stones. The first foundation was jasper; the second, sapphire; the third, chalcedony; the fourth, emerald; 20 the fifth, sardonyx; the sixth, sardius; the seventh, chrysolite; the eighth, beryl; the ninth, topaz; the tenth, chrysoprase; the eleventh, jacinth; the twelfth, amethyst. 21 And the twelve gates were twelve pearls; each one of the several gates was of one pearl: and the street of the city was pure gold, as it were transparent glass. 22 And I saw no temple therein: for the Lord God the Almighty, and the Lamb, are the temple thereof. 23 And the city hath no need of the sun, neither of the moon, to shine upon it: for the glory of God did lighten it, and the lamp thereof is the Lamb. 24 And the nations shall walk amidst the light thereof: and the kings of the earth do bring their glory into it. 25 And the gates thereof shall in no wise be shut by day (for there shall be no night there): 26 and they shall bring the glory and the honour of the nations into it: 27 and there shall in no wise enter into it anything unclean, or he that maketh an abomination and a lie: but only they which are written in the Lamb's book of life.

22 1 And he shewed me a river of water of life, bright as crystal, proceeding out of the throne of God and of the Lamb, 2 in the midst of the street thereof. And on this side of the river and on that was the tree of life, bearing twelve manner of fruits, yielding its fruit every month: and the leaves of the tree were for the healing of the nations. 3 And there shall be no curse any more: and the throne of God and of the Lamb shall be therein: and his servants shall do him service; 4 and they shall see his face; and his name shall be on their foreheads. 5 And there shall be night no more; and they need no light of lamp, neither light of sun; for the Lord God shall give them light: and they shall reign for ever and ever.

6 And he said unto me, These words are faithful and true: and the Lord, the God of the spirits of the prophets, sent his angel to shew unto his servants the things which must shortly come to pass. 7 And behold, I come quickly. Blessed is he that keepeth the words of the prophecy of this book.

8 And I John am he that heard and saw these things. And when I heard and saw, I fell down to worship before the feet of the angel which shewed me these things. 9 And he saith unto me, See thou do it not: I am a fellow-servant with thee and with thy brethren the prophets, and with them which keep the words of this book: worship God.

10 And he saith unto me, Seal not up the words of the prophecy of this book; for the time is at hand. 11 He that is unrighteous, let him do unrighteousness still: and he that is filthy, let him be made filthy still: and he that is righteous, let him do righteousness still: and he that is holy, let him be made holy still. 12 Behold, I come quickly; and my reward is with me, to render to each man according as his work is. 13 I am the Alpha and the Omega, the first and the last, the beginning and the end. 14 Blessed are they that wash their robes, that they may have the right to come to the tree of life, and may enter in by the gates into the city. 15 Without are the dogs, and the sorcerers, and the fornicators, and the murderers, and the idolaters, and every one that loveth and maketh a lie:

16 I Jesus have sent mine angel to testify unto you these things for the churches. I am the root and the offspring of David, the bright, the morning star.

17 And the Spirit and the bride say, Come. And he that heareth, let him say, Come. And he that is athirst, let him come: he that will, let him take the water of life freely.

18 I testify unto every man that heareth the words of the prophecy of this book, If any man shall add unto them, God shall add unto him the plagues which are written in this book: 19 and if any man shall take away from the words of the book of this prophecy, God shall take away his part from the tree of life, and out of the holy city, which are written in this book.

20 He which testifieth these things saith, Yea: I come quickly. Amen: come, Lord Jesus.

21 The grace of the Lord Jesus be with the saints. Amen.

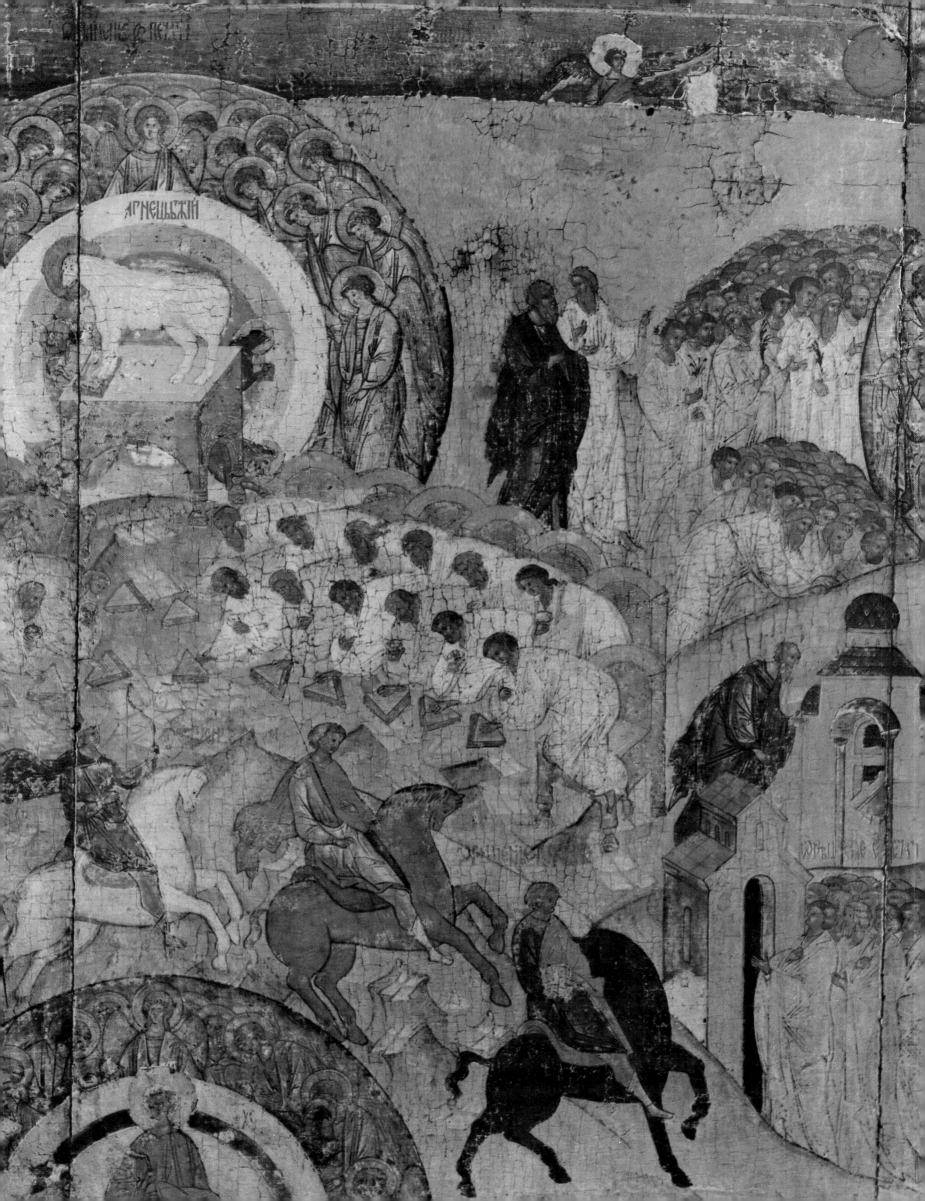

Introduction

Cosmic upheaval followed by dead silence. Cataclysm upon cataclysm. Yet, two-thirds of humanity are unhurt. The thundering fall of Babylon precedes the blossoming of trees on the banks of a peaceful river. The anger of this Lamb that has seven eyes and seven horns and 'rules the world' knows no frenzy. Hero of the drama, he, strangely, seems to ignore the catastrophes he unchains. The huge battles, the bold blows are the perquisite of his angels; it is the elements of Nature that are ordered to punish, to destroy, to purify.

The Lamb appears, takes the Book of divine decrees, opens it without any difficulty and afterwards does nothing whatsoever. He appears on the Throne and reigns. Although he is seen 'as slain', he rules everlastingly; in the end, we hear of his mystic wedding.

His antagonist, the strategist of evil, vainly exhausts his hideous power of destruction before being cast into the Bottomless Pit, under a lock never to be opened. The impassivity of the Lamb seems the hallmark of his sovereignty.

Neither bleating nor complaint can be imagined with the Lamb, only silence. His counterfeit, the Beast, has ten horns stupidly distributed on its seven heads; it has no seven eyes, however, and sees but little. It is loud and fierce, vomiting murderous waters against the Son of the Woman, the Messiah; and, finally, it spits out a grotesque frog. Roaring, flattering, insinuating, it works magic, hypnotizes crowds and organizes a diabolical cult. The Beast dispenses sceptres and calls fire from heaven. With the broom of its tail it sweeps some of the stars out of the Empyreum; they fall like rotten acorns in November, becoming its satellites. They are the rebellious angels, with their chief, the apostate Morning-star.

But the Lamb (who in the Apocalypse has the lion's share), announced as the Lion of Judah, is silent, and he remains silent, as foretold by Isaiah. In the end, we learn that he is a sun that neither rises nor sets. He operates as does the sunlight, opening the seven Seals by melting the wax. We hear no cracking, no tearing: the Book opens as if touched by an invisible ray. At once, the seven thunders start rumbling, the trumpets sounding; the mountains begin to burn, the stars to fall down, the Star Wormwood to change a third of the fountain-waters into Absinthe.

The Apocalypse. Icon preserved in the cathedral of the Dormition in the Kremlin, Moscow. Detail of a complete cycle. Top left: Adoration of the Lamb; centre left: the four Riders; centre right: the Great Multitude. The icon, 1.85 m by 1.52 m, unique of its kind, is attributed to Master Dionisii, Moscow, c. 1500. It is the Orthodox version of the apocalyptic tradition. (3)

Unattainable himself, the Lamb attains everyone and everything, though one does not see how. He is inaccessible to the blasphemies on earth, enthroned at the side of the Unnamed One; one does not even know whether he listens to the laments, or even to the hymns in his honour, resounding time and again during a ceaseless celestial Liturgy ordered on an astronomical calendar. A monstrance with all-powerful rays, he illuminates the landscape of the universe from the height of his Sion, the Altar, as in Van Eyck's altarpiece in Ghent.

What book could be more difficult to visualize than Revelations? Yet one cannot but imagine visible forms when trying to understand visions that at first seem incoherent and afterwards reveal exact details, including Hades, earth and the heavens. Even a war in heaven flashes by briefly, as lightning does; once the rebels have been cast into the Abyss, the great Hallelujah bursts forth in the inaccessible basilica where the Throne of the Lamb is surrounded by all the powers of Creation.

The reign of the Lamb confronts that of Satan from the beginning, and the Lamb wins, albeit after a sevenfold struggle that is fierce but limited in its duration. What perishes, in the end, is the world that has sold itself to Satan's satellites and myrmidons – the Beasts, the False Prophet, the Antichrist, Mammon, successive imperialisms, delusive techniques – formidable opponents, since poor mankind, both kings and beggars, love to throw themselves on their knees before all appearances of Power.

The 'Grotto of the Apocalypse' on Patmos, an island of the Dodecanese. Tradition suggests that this cavern was the place where St John wrote his book. It is situated below an annex of the Monastery of St John the Divine, Haghia Anna. On the iconostasis are scenes from the Apocalypse; bottom left: John dictating to his disciple, Prochorus. (4)

But the mighty of this world cannot get rid of the Lamb's last two Witnesses; murdered, and exposed in public squares, they revive and are taken away, and they will always return. Neither can the persecutors smother the cries of the martyrs growing impatient under the heavenly altar-hidden relics, as those of our own altars; bound to content themselves, for a time, with the beautiful baptismal robes, not reddened but made snow-white by illustrious Blood.

And far more powerful than the seven trumpets sounding the finale of this creation, more vitriolic than the mysterious contents of the seven vials of wrath, is a sword issuing from the mouth of the Rider on the white horse: a sword not of steel, but of thought, whose two-edged blade signifies the double sense of the Word of God. With it, the irresistible Cavalier cuts to pieces Gog and Magog and all their host, without any clash, without coming to blows, merely with 'the breath of his mouth', as a child blows on a feather to make it fly.

The Rider's name is True. Beware of Truth, worldlings! He is alarming, this mysterious Rider 'with many crowns on his head'. Divine Truth has nothing in common with human wisdom. Believers and unbelievers alike are prone to think like the three friends of Job, and imagine a divine justice subservient to human laws. Flying past with his celestial cavalry, the Rider Faithful and True sweeps away the law-makers and politicians as well as the merchants and the tyrants.

Who can subsist before the face of Uncreated Wisdom, whom the painters of icons imagined with a face of fire? Who can even see it? In his vision, Isaiah only distinguished the hem of its garment filling the Temple.

The Apocalypse, a phantasmagoria, also includes meaningful numbers, cosmic numbers as well as the 'three' of the divine Triad. Four and three make seven: the days of the week, and of perishable creation. But the City to come is built on the number twelve, symbol of perfection: the number of the tribes, of the Apostles, of the precious stones signifying spiritual perfection and, multiplied, the palm-bearing multitude surrounded by that even greater crowd, the Church of the Gentiles, 'that no man can number'. And, miraculously, that number is found again in the zodiac, the solar year, the compass-card. The Apocalypse teaches us that the entire cosmos is but a frame for the manifestation of the *raison d'être* of all things, the pre-existent Logos.

On earth as in heaven, the end is a symphony.

THE BOOK AND THE COMMENTARIES

The Apocalypse appeared shortly before 96 (when Domitian persecuted the Christians) and is truly one of the most baffling books of all literature.

Apokálupsis means 'uncovering, revelation', in this case the unveil-

ing of 'the things which must shortly come to pass' concerning the battle between good and evil and its issue. It is given, in the name of God, by Christ, and shown by an angel to his servant John, then in exile on the island of Patmos 'for the sake of the testimony of Jesus Christ'. The author sends his message to the seven churches of the Roman province of Asia, where he is evidently at home and about which he knows everything. He also testifies that he saw the visions he describes 'in the Spirit', that is, in ecstasy.

Since the second century, tradition has identified him with John, son of Zebedee, author of the fourth Gospel and the three Johannine Letters. His Apocalypse was the last book to be taken into the Canon of the New Testament. For centuries the Greek Church hesitated to use or to quote it; doubts were raised by the passage about the Thousand Years' Reign of the Saints (Rev. xx: 1-6), a prophecy taken too literally by some interpreters. This error, known as 'millenarism', was soon condemned by the universal Church. On the other hand, the Western Church has always accepted the book as canonical and used it extensively. It is a long, visonary letter of consolation for the persecuted.

A prophet believing in Christ, and an author of genius, writes down what he has seen in the Spirit using a stream of incomparable images in rapid succession. With incredible ease, he has borrowed some of them from his predecessors: Ezekiel, Zachariah, Isaiah, Joel and above all Daniel, whose prophecy has all the marks of an early Apocalypse. Other images are taken from the astronomical folklore of the Ancient East, such as the Dragon and the Woman, corresponding to the constellations of Virgo and Hydra with the Ancients. The author sees the risen Christ as the Word of God, the Lamb 'as it had been slain', and as the Son of Man, thus combining the names given to him in the Gospels.

Some of the visions are arranged according to cosmic numbers. Four is the number of the Living Beings supporting the Throne, and of the Winds. Seven the number of the churches, the stars in the right hand of the Son of Man, the candlesticks, the lamps and the eyes of the Lamb ('which are the seven Spirits of God sent forth on to all the earth'). There are seven Seals of the Book, trumpets, vials of wrath, plagues and thunders. Twelve and its multiples are the key to the number of the stars crowning the Woman; of the one hundred and forty-four thousand sealed with the seal of the Elect. There are halves of some numbers, indicating that a trial, however hard, will be limited in time; these numbers correspond to the seven days of the week and the duodecimal structure of the zodiac, the year and the universe.

In the struggle between good and evil, the saints – believers in Christ – will obtain the wreath of the martyrs. The powers of evil are depicted as monsters: symbolically attired Beasts. The outcome of the struggle is an overwhelming vision of peace, namely the celestial City, the New Jerusalem. In it time, death, sorrow and mortality

his commentators.
commentary on the
'85), in which the
in the picture are
iris, BN lat. 8878, f.
as illuminated about
model, at St-Sever,
). (6)

27

will be gone, replaced by a never-ending Liturgy, not so much an image as the very prototype of the oldest Eucharistic *synaxis*. This superterrestrial Liturgy is the source of Dante's *Paradiso*. The City walls of precious stones have certainly led to the idea of providing cathedrals with transparent tapestries in all the glowing colours of the twelve Gems: the stained glass windows. In fact, extracts of Rev. XXI and XXII have served from time immemorial as lessons for the office of Dedication.

89

6 **The earliest commentators** on this dense and mysterious text were looking not so much for the literal as for the spiritual meaning, which they found, it seems, firstly by sheer intuition, and, secondly, by associating the main motifs with related ones found elsewhere in Holy Scripture. Some of their interpretations, especially those of the post-apostolic Fathers, have become common property of the Church, at least in the Latin West; they are indispensable for the understanding of the illustrations.

Thus, for instance, we have the identification of the four Beings – in fact Ezekiel's tetramorph divided into four, the bearers of God's Throne – with the four canonical Gospels of Matthew (Man), Mark (Lion), Luke (Ox) and John (Eagle). From the end of the second century onwards, this idea occurs in the texts, though their order is not always the same; the idea itself goes back to Ireneus, 'bishop of the province of Gaul' about 170, who probably resided at Lyons. Another instance is the identification of the twenty-four Elders with the prophets of the Old and the Apostles of the New Testament. Furthermore, their names were connected with those of the twenty-four sacerdotal classes of I Chronicles XXIV: 7 ff; and sometimes with other, purely fantastic, names, as in Coptic Egypt, where there was even a liturgical cult of the Elders, as well as of the four Beings. Among later commentaries, Berengaudus's gloss appears to be the source of otherwise inexplicable motifs found, notably, in the Anglo-Norman cycle of illustrations flourishing on both sides of the Channel from 1230 until 1450.

88

36

A good example is the fourth Rider, Death, holding a bowl of fire in his right hand. Berengaudus, who interprets the Riders as symbols of the four ages of the history of Salvation, says: the pale horse signifies the prophetical era; the Rider is the Lord, for in a way he is 'Death' for the ungodly; he has power 'to destroy both body and soul in Gehenna' (Matt. X: 28). In the canticle of Deut. XXXII, the Lord says: 'A fire is kindled in mine anger, and shall burn until the lowest Hell.' Because both the canticle and the Apocalypse call up Death, Hades, Famine and monstrous Beasts (Deut. XXXII: 22-5 and Rev. VI: 6-8), the *rapprochement* is not as arbitrary as it seems, and it explains the bowl of fire. In earlier versions the fourth Rider does not hold anything; after 1200 he holds the bowl of fire (in the *Trinity Apocalypse* it is an empty bowl, clearly a survival), particularly in those codices where the Berengaudus gloss is used.

114,178

57,80
114,178

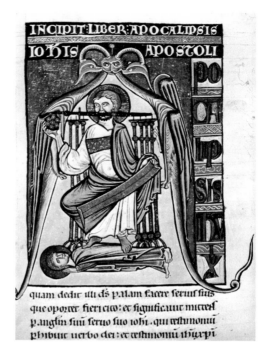

INCIPIT LIBER APOCALIPSIS IOHIS APOSTOLI

quam dedit illi ds palam facere seruis suis que oportet fieri cito: et significauit mittens p angtm sun seruo suo iohi . qui testimonin phibuit uerbo dei : et testimonin ihgxpi

John seeing the Son of Man among the candlesticks. Miniature facing the beginning of the Apocalypse, in the *Clermont Bible*, from the end of the twelfth century; on the banderole: 'Fear not; I am the first and the last' (Rev. I: 17). Clermont-Ferrand (Puy-de-Dôme), Bibliothèque communale et universitaire, ms. I, f. 423. (7)

The same is true for the identification of the Witnesses with Elijah and Henoch, which is found both with Beatus of Liébana and with Berengaudus. It goes back, for Henoch, to a Jewish Apocalypse and to the epistle of St Jude, XIV; and, for the greatest of prophets, to those passages in the New Testament that deal with the return of Elijah. Both names we continually see in miniatures illustrating chapter eleven of St John's Revelation, written above the heads of the two Witnesses.

Since the end of the Middle Ages several commentators felt inclined, rather foolishly, to interpret the visions as prophecies of events in Church history, especially of crucial stituations in their own time. The Franciscan *Spirituales*, followers of Joachim de Fiore, a Calabrian abbot, annexed for themselves the monopoly of the 'Everlasting Gospel' (Rev. XIV: 6), and identified themselves with the Church of the Holy Ghost. So did Luther, who outspokenly proclaimed the Whore sitting on the Beast to be not only the symbol of Roman Paganism in St John's time, but, furthermore, the symbol of its diabolical successor, Roman Papacy. This idea was immediately illustrated by Lucas Cranach, who crowned both his Beast and the Whore of Babylon with the papal tiara.

201,202

In reality, the only historical facts that can be identified with any certainty are: John's exile under Domitian, somewhat before 96; the number of the Beast, 666, to be read as an anagram meaning 'Kaisar Neron'; and the persecution of the faithful, launched by Babylon, that is, by the Rome of Domitian, with its obligatory cult of Divine Caesar, *Kyrios kai Sotèr*. These few but crucial historical references from the end of the first century, because of their symbolical presentation in a book of genius, have become eloquent symbols of any comparable situation, as has always been felt and expressed.

Applying them to particular periods of Church history has long become a thing of the past. As for the allegorical and purely associative interpretations, they can hardly explain anything, being too much an ingenious, albeit piously intended, game. On the other hand, an almost purely eschatological interpretation has lately found more and more adherents among both believers and positivists. According to this theory, the essential message of Revelations concerns the totality of the Final Era, the time between the death of the last Apostle, John, and the Second Coming of Christ, at the dawn of the New Creation.

As a literary genre, the Apocalypse is older than the Revelation of St John. The genre originated in Jewish circles after the disillusionment of the Captivity and the humiliating serfdom of Israel under foreign rulers, whose tyranny provoked the expectation of a spiritual reign. It is already found with Zachariah (where white, red and black horses also appear); the most important example is the prophecy of Daniel, which is set in the Babylon of the Captivity, but was written about 164 BC. Some of Daniel's motifs – The Son of Man coming with clouds, the Beasts as symbols of empires, the Judgment

29

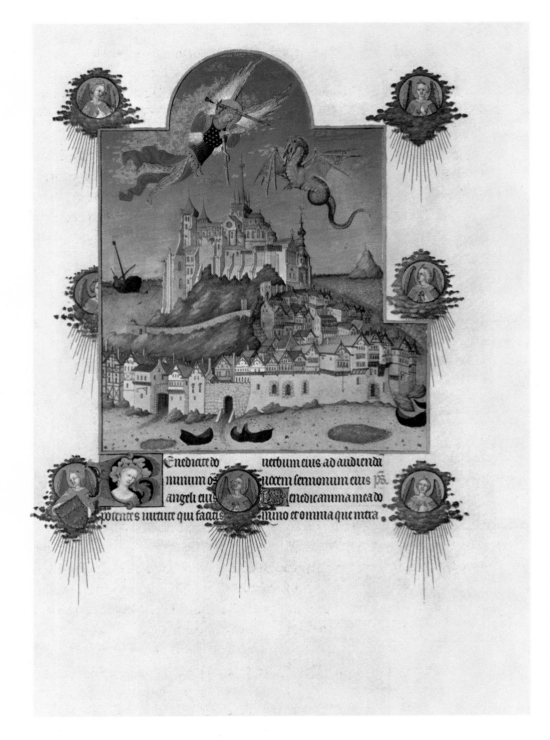

Michael fighting the Dragon i[s] above Mont-St-Michel, the rock off the coast of Brittany. Miniatu[re by the] Limburg Brothers, in the *Très riches Heures* of John, Duke of Berry, 1409-15. The text is in the Introit of the Mass in honour of the Angels. About 1415, towers and nave of the abbey church were still intact; the flamboyant chancel we see today had not yet replaced the old Romanesque east end. To the right: the little island of Tombelaine. Chantilly, Musée Condé. (8)

with its Throne and books and angelic hosts – are all found in the Apocalypse. Some of the latter, without the extravagant imagery, are used by Christ himself, in his eschatological discourse about the Last Things (Mk. XIII; Matt. XXV). Older Jewish apocalypses, Ezra III and IV, and that of Henoch, and a small series of Christian imitations, are important enough in themselves, but in the consciousness of mankind they have vanished as shadows before the glory and the beauty of St John's book.

In art history the allusions to contemporary events play only a minor role. The few exceptions are the illustrations of a commentary written by Alexander of Bremen, a man influenced by the *Spirituales*,

30

in the fourteenth century; a few satirical images of popes and clerics in the engravings of the good Catholic, Dürer; and, finally, the clearly *189,193* Protestant caricatures of Cranach, taken over by nearly all German and Dutch engravers of vignettes for the printed Apocalypses since the end of the sixteenth century, which merely served the religious *201,202* controversy of the age.

To understand the many, often great works of art inspired by the Apocalypse, an elementary knowledge of the chief visual motifs of the text is essential. Linked mainly in a rather surrealistic way, they are usually easy to recognize, if the text is studied alongside the relevant images.

THE ILLUSTRATIONS

The text of the Apocalypse defies visualization. Rightly, St Jerome wrote about it: *quot verba, tot mysteria*, 'as many mysteries as there are words'. Its images are alternately overwhelming and delicate, strident and still, terrifying and comforting, splendidly arranged in series, yet sometimes jostled together in an apparently confused and always dazzling succession. Divided between two scenes, heaven and earth, the images reach from the Bottomless Pit to the Throne of the Unnamed One, from the unchaining of the elements of Nature to the cries of the Seraphs.

Most of these metaphors, however, have a visual aspect; as with all effective symbols, they invest the invisible with visual features. They have both deterred and attracted the Fathers of the Church as well as the poor artists. Only the subtle but realistic Greek theologians silently took the book out of circulation. Consequently, Byzantine artists hardly had an opportunity to illustrate it. A few exceptions are found exclusively in the monastic hinterlands of the Greek Empire: Egypt, Syria, Cappadocia and especially in Coptic Egypt, where there even existed a cult of the four Beings and of the Elders (to whom names were given) and each of them had a feast-day in the calendar. The Greek Church itself admitted Ireneus's interpretation of the four Beings (borrowed from Ezekiel, of course) as symbols of the four Gospels, and their cries – 'shouting, roaring, shrieking and speaking' – found a place in post-iconoclastic liturgy, where they served as an introductory formula of the *Trisagion*, the thrice 'Holy' of Isaiah's Seraphs, our *Sanctus*. *36*

It was different in the Latin West, where a long series of very detailed commentaries originated, some of which are of consequence in art history. First is the commentary of the Asturian monk, Beatus of Liébana, who, about 786, compiled the main previous interpretations into a somewhat encyclopedic survey. An impressive array of illustrated manuscripts, of Beatus's work, from the tenth century onwards, proves that his original text was accompanied by a cycle of about ninety corresponding illustrations; specimens are found in Mozarabic Spain, and later in southern France. Another, very prolix *72-84*

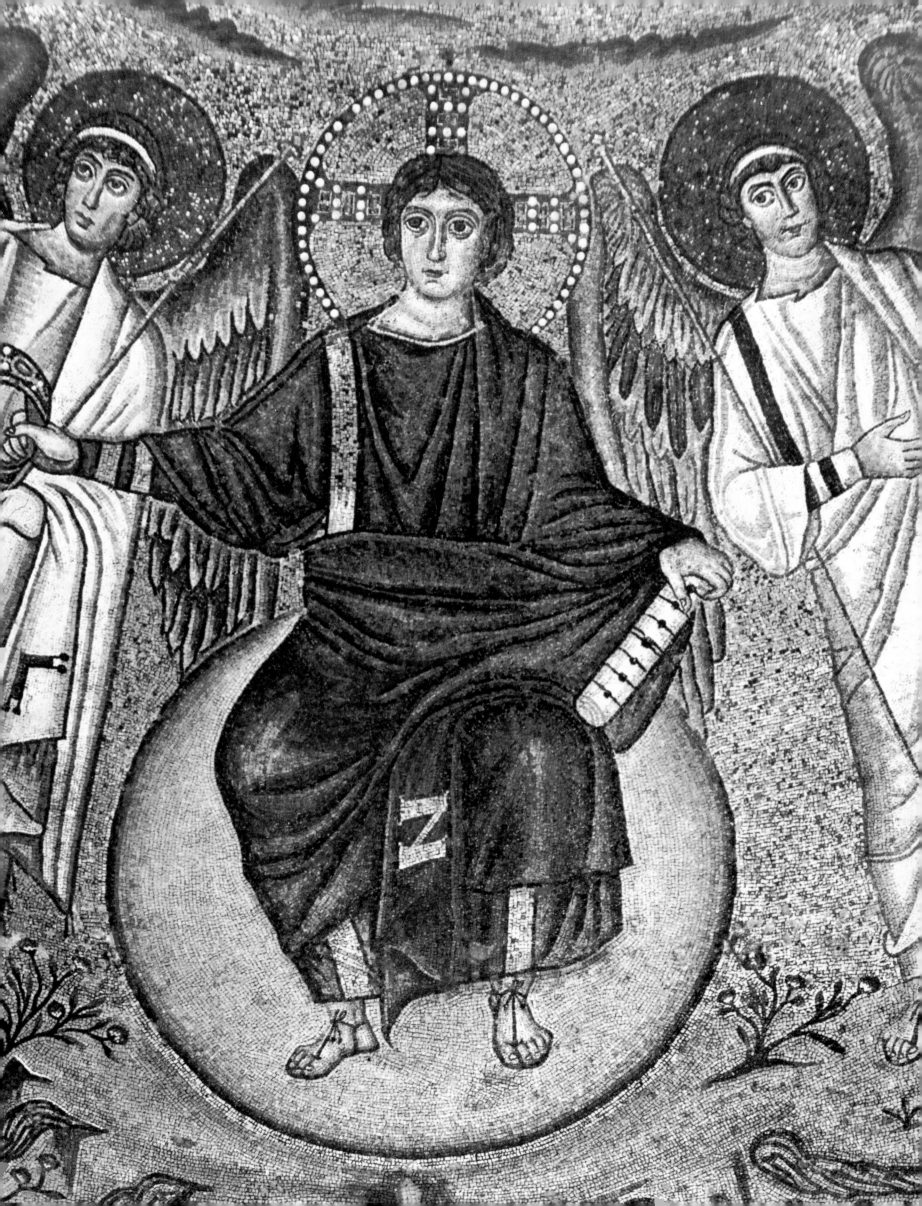

commentary is that of Berengaudus, a rather obscure author, assigned by some to the ninth century by others to the eleventh, and whose glosses have slightly influenced the illustrations of Anglo-Norman Apocalypses, from the thirteenth century onwards. The same is true *102-114* of Anselm, the founder of the school of Laon in the beginning of the twelfth century, whose interpretations became part of the *Glossa ordinaria*, the school commentary on the main books of Holy Scripture, including the Apocalypse. *91*

Isolated motifs were mainly used for the first illustrations. Rome seems to have played a decisive part in the elaboration of the oldest apocalyptic iconography. Soon after the Peace of the Church, shortly after 314 when the first great basilicas were built (the Lateran church of the Saviour, and the cemeterial churches of Peter and Paul), some elements taken from the Apocalypse were given a monumental form in the great Roman mosaics; a few of them, from about 400, can still be seen today.

These isolated motifs, were carefully selected, and are exclusively of the majestic, not to say triumphal, kind; discreetly veiled theophanies prevail. The Lamb on Mount Sion, surrounded by lambs; the Throne surrounded by the four Beings and the twenty-four Elders; the Book with the seven Seals; the seven candlesticks; the Sea of crystal mingled with fire.

Nearly all of the motifs can be summed up by the expression 'Heavenly Liturgy': they suggest the *gloria Christi* in a liturgical sense. Therefore, they could very aptly be used for mosaics decorating the huge apse behind the altar, and the spacious triumphal arch just above it – both axially placed in the basilical prospect.

It remains an open question whether this happened outside Rome as well, to what extent and whether everything originated in the *Urbs* and not, for instance, in the imperial residence of Milan. It may be accidental that the oldest, most numerous examples have survived inside Rome. Ravenna comes second, Milan third, Naples fourth. A now famous apsidal mosaic in the monastery of Hosios David, at Thessalonica, probably of the fifth century, shows the four Beings as part of the vision of Ezekiel, but single-headed, as in the Apocalypse. It illustrates the *Trisagion* of the liturgy, and by no means the apocalyptic vision. In Istanbul there is nothing relevant. Rome easily holds the palm.

Single motifs taken from these monumental compositions are found outside the architectonic framework in works of the minor arts: on sarcophagi, funeral paintings, small ivories, pyxes, book-covers, reliquaries and textiles. They are shown in an emblematical way, sometimes in combination with a brief inscription.

The Book with the seven Seals held by the Lord enthroned on the globe of the cosmos, between two lifeguards of the heavenly Host, the Powers Incorporeal. Central part of the mosaic in the apsidal conch of St Vitale, Ravenna, *c.* 549. (9)

Alpha and Omega is probably the oldest apocalyptic symbol in art: Aω, signifying the supratemporal trancendency of the Word Incarnate. Three times the Son of Man uses it to indicate himself *10,11*

33

as the beginning and the end of all things (Rev. I: 8, 17; XXI: 6; XXII: 13). Both letters are usually shown in connection with the *chrismon*, the Constantinian monogram of Christ, XP, which, shortly after Constantine's volte-face in religious politics, appeared on Roman standards and shields. It was a token of the now officially acknowledged status of the Christian Church, and it gradually became the sign of its victory over state paganism.

The letters, put on both sides of the monogram, often hang from the crossbeam of the tilted X, making the whole resemble the traditional Roman trophy, *trópaion*, and at the same time exhibiting the form of the Cross.

27 **The Lamb on Mount Sion** is a second symbol (Rev. XIV), frequently seen about 400 in the middle of a frieze running below an elaborate apsidal composition. A procession of six white lambs, on either side of the Lamb, represents the hundred and forty-four thousand (Rev. VII: 4); the four rivers of Paradise, flowing from the Mount, and mingling at its feet, form the River of Life (Rev. XXII), here expressly identified as IORDANES, and consequently meant as a baptismal symbol.

Elsewhere, the Lamb is seen alone; sometimes on the Mount with the four rivers; often standing near the Cross, or inside a medallion at the centre of a Cross. Frequently that Cross, studded with gems, clearly represents the then famous *staurotheca*, enclosing the relics of the true Cross – the Tree of Life – at Jerusalem on Mount Calvary, beside the Martyrion (the great basilica) and close to the Anastasis (the Constantinian rotunda built on the Holy Sepulchre). It evokes

Apotheosis of the Name of Christ, XP-AΩ. Lintel from the chapel of Mancioux (Hte-Garonne), eleventh century. An example of the survival of Early Christian symbolism. Toulouse, Musée des Augustins, no. 253. (10)

34

the 'trees yielding fruit every month' of the New Jerusalem, the Heavenly City.

Very often the Lamb is seen without the Mount, but in the same elegant foreshortening – *en trois quarts* – standing inside the wreath of the seasons: a wreath made of spring flowers, ears of summer corn, autumnal fruits and winter evergreens, time-honoured symbol of everlasting life and apotheosis. Elsewhere the same wreath surrounds the monogram of Christ, which shows the form of the Cross and is accompanied by the symbol Aω.

A splendid example of the Lamb in the wreath, on a golden ground, adorns the vault of the chapel of St John, which opens into the ambulatory of the Lateran baptistry, and was founded by Pope Hilary, 461-8. Another, more sumptuous mosaic, is found in the vault above the altar of S. Vitale at Ravenna, which dates from about 549: there, four angels (successors of the winged Victories, nobly arrayed, though with unbiblical wings) standing on globes are lifting up the Lamb, who is seen among the stars within the wreath of the seasons, in a graceful foreshortening.

Other mosaics show the Lamb lying or standing on a Throne supporting the Cross and a cushion of imperial purple, while the Scroll with the Seals is lying on the footstool. Here, the apocalyptic inspiration is unmistakable; together with the Sea of crystal it is seen, somewhat damaged and restored, on the triumphal arch of SS. Cosma e Damiano on the Forum Romanum, a *memoria* founded by Pope Felix IV, shortly after 529.

In some mosaics of the Heavenly Liturgy, on the triumphal arches of Roman basilicas, for instance in S. Paolo fuori le mura, the Lamb has been replaced by a head and shoulders of Christ, appearing within the shield-like medallion called *clipeus*. It is set centrally and is not

The oldest apocalyptic motif in the arts: Alpha and Omega, the first and the last letters of the Greek alphabet, here joined to the Constantinian monogram of Christ, XP, in which the X also indicates the Cross. The symbol of the eternal and pre-existent Logos, Aω is seen, thrice, inside the wreath of the four seasons, a symbol of the everlasting Return and also of Eternal Life; and, once, between peacocks and the mystic Vine. Sarcophagus of Theodore, archbishop of Ravenna (died, 688), buried in a reused fifth-century sarcophagus. S. Apollinare in Classe, outside Ravenna. (11)

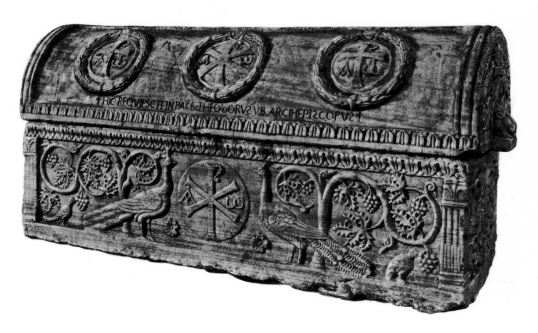

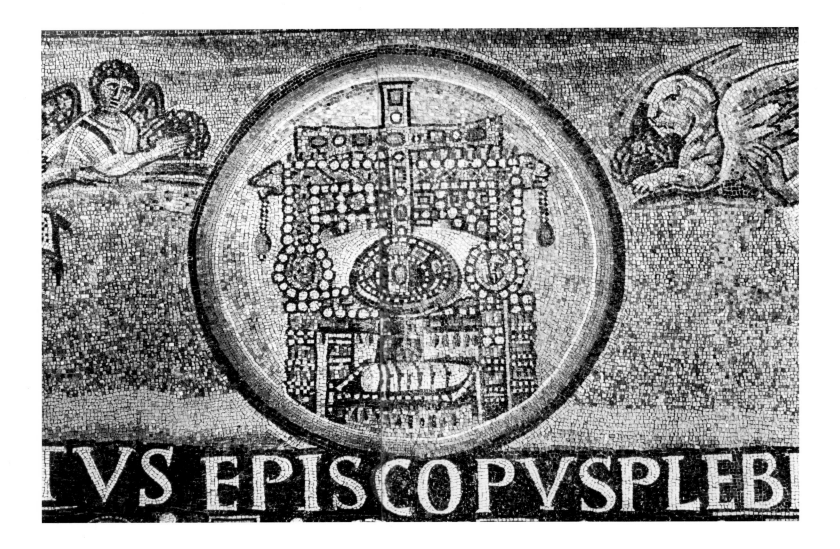

IVS EPISCOPVSPLEB

unlike a sort of sun; its border, shining with the iridescent colours of the rainbow, recalls the 'rainbow round the Throne'.

Throne and Lamb do not always go together. In the famous mosaic commemorating the dogma of Ephesus, 431, on the triumphal arch of S. Maria Maggiore, the church founded by Pope Xystus III, the central *clipeus* is surrounded by the rainbow. There, the Throne, while studded with gems, only supports the insignia of Christ: diadem and cross. The sevenfold-sealed Book – a scroll – lies on the footstool. These three purely biblical symbols of his presence are shown in a ceremonial setting derived from the imperial court, and recall the emperor's *epiphany*. On each side of the Throne, the four Beings, emerging from the Sea of crystal mingled with fire (here fiery clouds), are holding wreaths instead of Gospel-books, and, consequently, might represent the Elders, a detail until now unobserved.

The standing Lamb, drawn three-quarter-face and perfectly poised, belongs to an epoch in which good craftsmen could still cope with foreshortened figures; when found in later centuries, it is probably from an Antique model. After the fall of the Roman Empire and the barbarization of the West, the art of drawing degenerated

The Throne surrounded by the rainbow and the four Beings; on the cushion, a Cross studded with gems and a diadem, symbols of Christ's enthronement; on the footstool, the Book with the seven Seals. Central motif of the mosaics on the triumphal arch of S. Maria Maggiore, Rome, founded by Xystus III, 431-40, after the Council of Ephesus, in 431, where the unity of Christ's divine Person and the dignity of his Mother, the Theotókos, were solemnly proclaimed. Inscription: XYSTVS EPISCOPVS PLEBI DEI, 'Xystus the bishop to God's people'. (12)

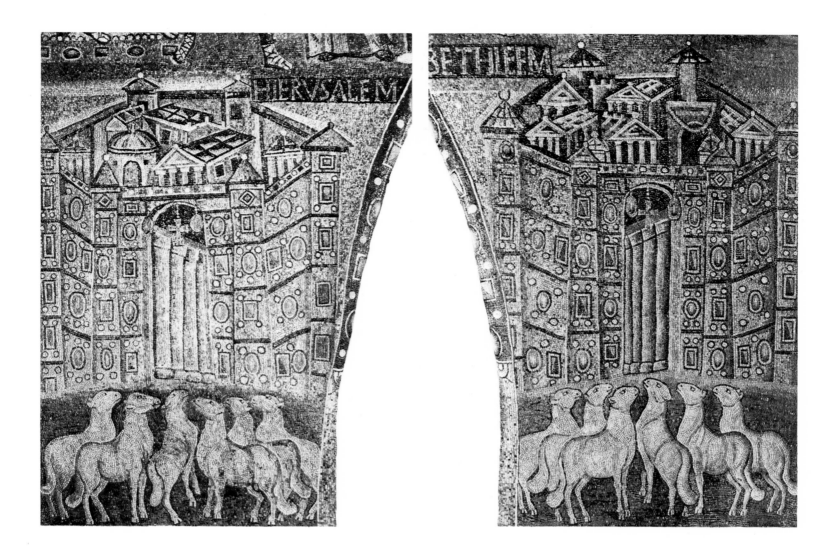

HIERVSALEM and BETHLEEM, here the symbols of the two Churches, that of the Circumcision and that of the Gentiles; the sheep-cotes have become celestial cities built of gems. Lower parts of the triumphal arch in S. Maria Maggiore, after 431. (13)

The Woman clothed with the sun (over-leaf), the moon under her feet. She represents the Church of all ages; the Child, the Messiah, is being carried off to the Throne; the Dragon is killing the saints (on the blade of his sword are the letters O N, probably 'Nero'); the Woman has already received wings. Bottom right: the Dragon vomits water against her; his tail sweeps a third of the stars from the sky, symbolizing the Fall of the angels. A seventeenth-century copy of a miniature in the *Hortus deliciarum* of Herrad, abbess of Landsperg, second half of the twelfth century; the manuscript was burned during the bombardment of Strasbourg, in 1870. (14)

quickly. Draughtsmen preferred simpler profiles and the Lamb is often standing, rather unsteadily, on the Scroll, or holding a triumphal Cross with one of its forelegs. A catalogue of the innumerable *45,47* medieval Lambs would clearly illustrate the history of a gracious Antique image becoming progressively hieratic. A thousand years later the emblematic figure again becomes naturalistic. After 1700, *160* woolly and huddled up, almost asleep, the Lamb of God, in a halo of golden rays, is mostly seen lying on a Baroque missal with seven sealed clasps. As a participant, the Lamb appears only in the manuscripts containing a cyclical illustration of the Apocalypse. Here, too, the Antique silhouette soon becomes hieratic or, when performing incongruous actions, primitive, or even clumsy.

Cyclical illustration of the cataclysms cannot be found in Early Christian art. They seem to have been illustrated for the first time when a text of the Apocalypse received a full set of illuminations, probably in Italy, in the Antique manner: a series of homogeneous rectangular pictures framed in red. We have no illustrated manu- *53-61* scripts earlier than the ninth century, but those early Carolingian

37

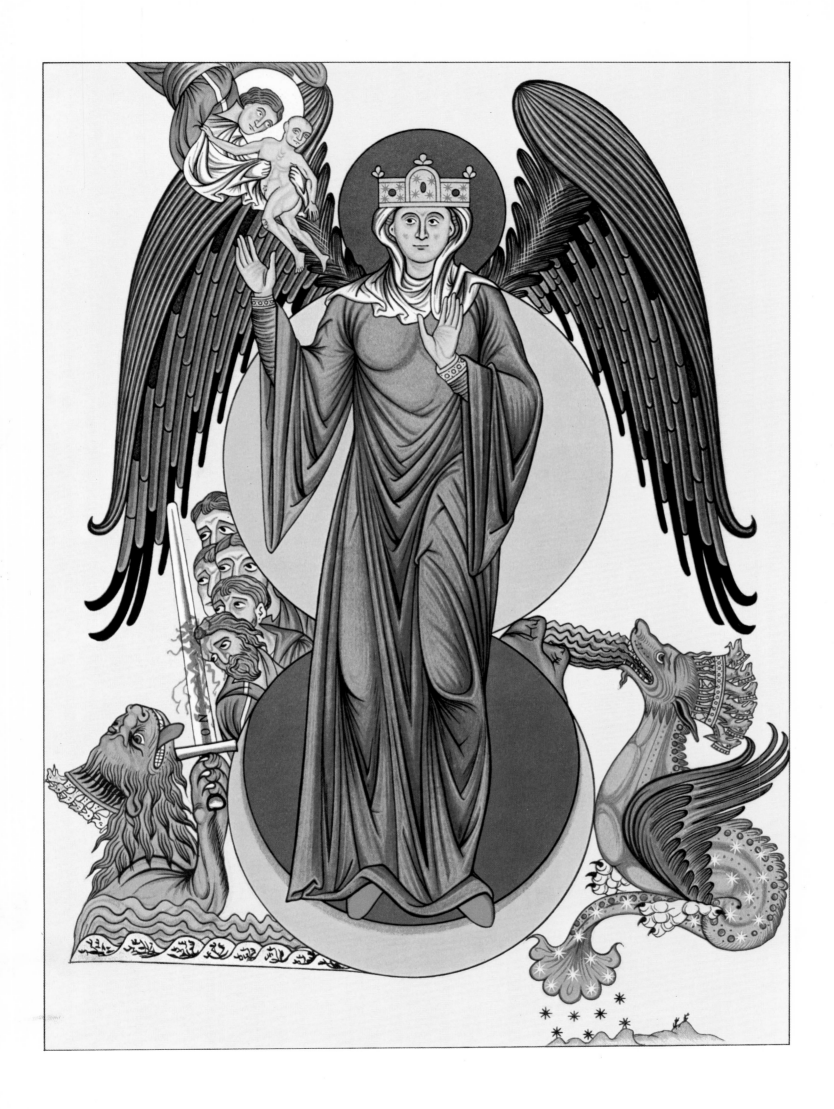

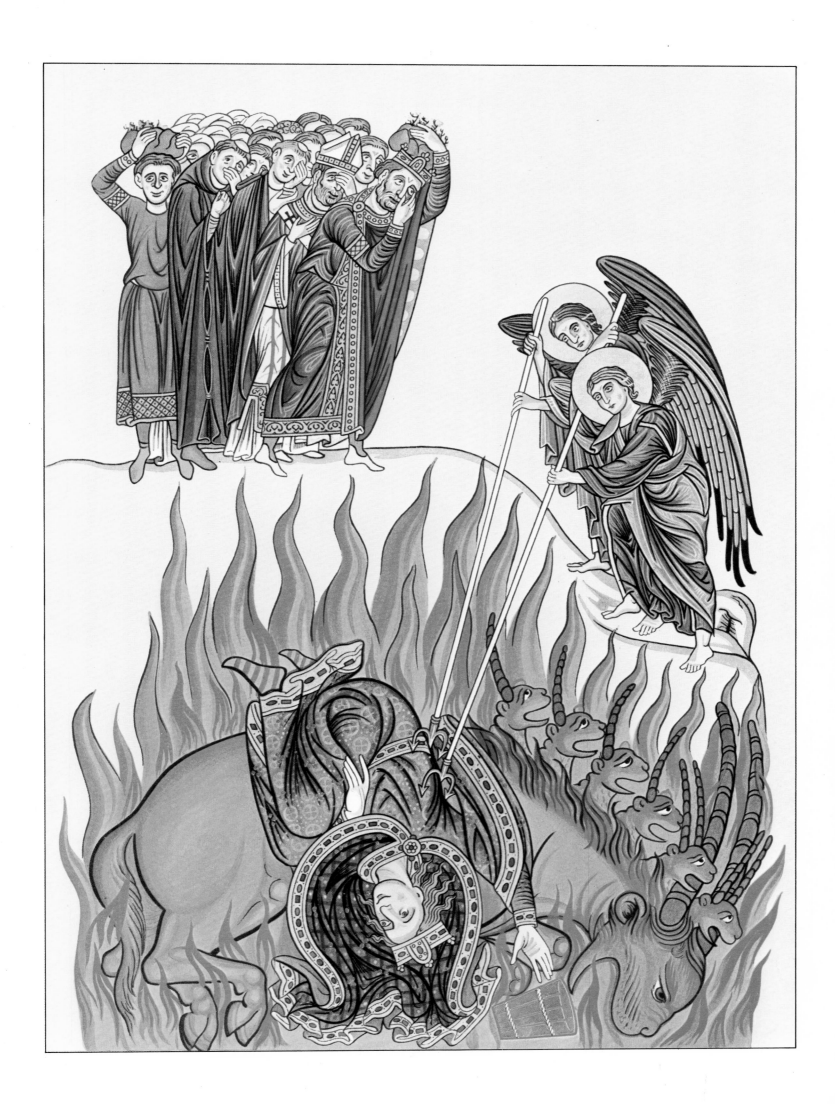

cycles clearly reproduce Antique prototypes, from about 500 or somewhat earlier, located in Italy. Nothing whatsoever is known about an apocalyptic iconography in Roman Africa, where the Book of Revelation has found some of its most eminent commentators. We do know, from Bede, that Benedict Biscop, abbot of Wearmouth, brought with him an apocalyptic cycle of images from Rome in about 685, as models for the decoration of a Northumbrian church (on the north wall; Bede, *Vitae abbatum* 5, PL 74, 718).

All fully illustrated manuscripts of the Apocalypse fall into three main groups: the Italo-Gallic, the Spanish, and the Anglo-Norman.

The Italo-Gallic group is the oldest cycle and includes six manuscripts. By far the most important, and the earliest – shortly after 800 – is the Trier codex, which will be discussed later. It is purely Antique in spirit, showing a series of motifs that resemble the mosaics (from about 400 to 600) of Rome, Ravenna, Naples and Poreč (formerly, Parenzo, Istria).

The second codex, that of Cambrai, is an incomplete copy of Trier. The third, the famous *Bamberg Apocalypse*, from about 1000, is a real work of art, and the earliest specimen of German expressionism (and will be dealt with in a special chapter). The remaining three, now in Paris and Valenciennes, are rather poor; some drawings in the *Catalan Bible* from S. Pere de Roda are worth examining.

A small number of isolated miniatures belong to the Carolingian era; in three Bibles, illuminated about 840-50 (two of them at Tours), a cryptic frontispiece is prefixed to the Apocalypse, which I have been able to decipher.

Remnants of wall- and roof-paintings from the eleventh, twelfth and thirteenth centuries betray evidences of the Italic tradition. The earliest are in Castel S. Elia, an abbey church in a ravine near Nepi. Later ones are in the little church of S. Pietro al Monte near Civate (on top of a steep mountain – the climb is worthwhile), where the New Jerusalem and a magnificent angels' battle against the Dragon threatening the Woman can be admired. A small cycle survives in the crypt of Anagni Cathedral. A fine French example is a set of somewhat faded frescoes adorning the gallery of the vestibule of the abbey church of St-Savin-sur-Gartempe. Isolated motifs can be traced on many Romanesque capitals, in the cloisters of Moissac, in churches of Poitou and Auvergne, and in the porch of St-Benoit-sur-Loire, where a painted cycle, now lost but known from its *tituli* (versified legends), adorned 'the front of the church', in the eleventh century.

The Beatus cycle, the second group, of manuscripts, originated in northern Spain, and is known from copies made on both sides of the Pyrenees, in the tenth, eleventh and twelfth centuries. The eleventh-century copy made at St-Sever, in Gascony, contains the finest Romanesque minatures of the time.

53-61
64-71
45-47
44-46
62,63
49
34,50
51
72-77
78-84

The Great Prostitue *(previous page)* and the Beast, representing pagan Rome, cast into the lake of fire and brimstone. Top left: the merchants lamenting the fall of Babylon (Rome). A seventeenth-century copy of a miniature in the *Hortus deliciarum.* (15)

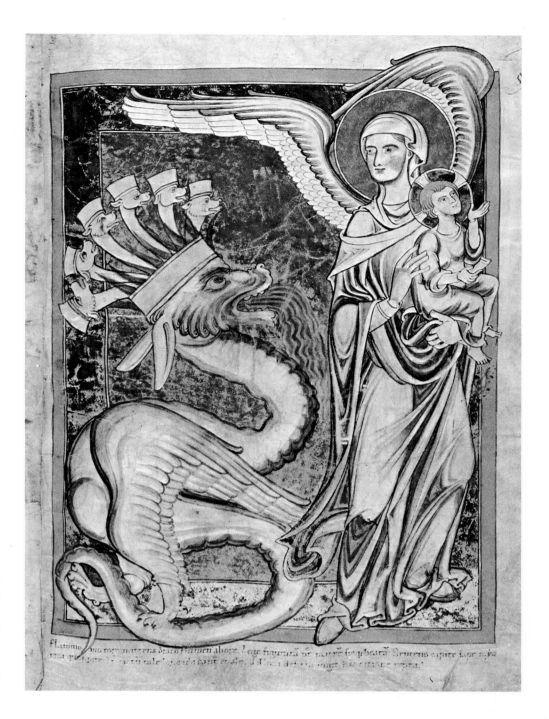

The Dragon vomiting water against the Woman; she is already winged and carries the Child, who is cross-nimbused and thus identified with Christ. Miniature in the *Liber matitudinalis* of Konrad von Scheyern, author and miniaturist, 1206-25. Munich, Bayrische Staatsbibliothek, CLm 17401. (16)

Smaller cycles are found in a commentary by Haimo of Auxerre, a ninth-century author, poorly illustrated in the twelfth, and in the encyclopedia compiled about 1120 by Lambert of St-Omer and called *Liber floridus*. These cycles nay be connected with the Italo-Gallic *85-88* tradition. The same applies to the splendid miniatures of the Woman clothed with the sun, the Whore of Babylon and the Lord 'wiping *14,15* away the tears from the eyes' of the redeemed, in the *Hortus deliciarum* of that learned and princely abbess, Herrad von Landsperg; and also to the well known leaf, with the Woman and the Dragon, *16* of Konrad von Scheyern, from about 1220.

In the great cathedrals, motifs clearly taken from the Apocalypse

41

occur only sporadically, often combined with scenes illustrating the legendary *Virtues of John*, an apocryphal Life of St John before and after his exile on Patmos. They can be seen, in early thirteenth-century windows, at Bourges, Auxerre, Troyes, Laon and Chartres. Original creations are rare; among them, the famous symbolic window *91,92* in the ambulatory of Bourges Cathedral shows a mystical summary of the whole Book of Revelation. Monumental sculpture also must be considered. About fifty groups, outside and inside the south-west *94,95,98* portal of Reims Cathedral form an exceptional ensemble that does not fit into any of the traditional schemes and has to be examined on its own.

The Anglo-Norman cycle constitutes the third group, and is made *102-114* up of more than seventy manuscripts, some of which form closely knit sub-groups. These often have an identical cycle, more or less following the Italic tradition but with a number of striking innovations, which points to a common source. It must have originated, not long after 1220 or 1230, either in the north of France or, more probably, in England: scholars have rightly called it the Anglo-Norman cycle. It accompanies a Latin, a French or an Anglo-French text, and is often enriched by glosses taken from the outspoken spiritualistic commentary of Berengaudus, which must have been fashionable in the milieu where the supposed, and duly influential, prototype appeared.

Apart from a series of some ninety apocalyptic subjects, some of the oldest and most refined manuscripts of this group contain a double set of pictures illustrating the Life and Death of St John, according to his apocryphal *Acta*. His preaching at Ephesus and the baptism *106* of Drusiana, his sailing to Rome, his martyrdom in the cauldron *137* of boiling oil at the Porta Latina and the voyage to Patmos usually precede the Apocalypse. The miracles he wrought on his return – among them the destruction of the Epesian Artemis and the drinking of the poisoned cup – his death, and his descent into his own tomb form a sort of epiloque.

In the better codices the illuminators often reach the summit of noble Gothic drawing and an extreme brightness of colour; or, in the opposite manner, miracles of delicacy in the slightly tinted and mainly slender nervous figures. Little wonder: some of these manu-*102-108* scripts were made for princes and queens. The *Trinity Apocalypse*, at Cambridge, one of the oldest and most likely the very first, was probably illuminated for Queen Eleanor, about 1230. Another (ms. *110-113* Douce 180) in the Bodleian, was made for Edward I, 1272-1307. These large books, obviously ordered for the sake of the pictures, and splendidly preserved, provoke unfeigned admiration. The quality of the drawing equals that of the best Paris Psalters, though in iconography, composition and background they are entirely different.

These two princely books have a number of almost equally aristocratic, and a multitude of more ordinary and often poor, relatives.

The second and the fourth trumpets. *Right:* the mountain cast into the sea (the two hands are borrowed from Dürer) among sinking ships. *Above:* sun and moon darkened, people hiding, the eagle crying 'Woe!' (VE VE VE). Lower parts of windows III and IV in the Royal Chapel of Vincennes Castle, near Paris. Ordered by King Henry II; by Nicholas Beaugrais, *c.* 1560-80, the angels freely after Michaelangelo. (17, 18)

The cycle of subjects, however, shows little variation and the whole family has been collected and divided into groups, first by Léopold Delisle and, more extensively, by Montague Rhodes James in 1931. Other scholars have proposed slightly different classifications since then, but it remains uncertain where the archetype came into being. I am inclined to suspect that this moderately traditional but very elaborate cycle, of which the rapid diffusion implies that an illustrated Apocalypse had suddenly become much in demand – almost a fashion – was compiled at the Royal Court. Everybody there spoke Anglo-French, and King Henry III, in view of his favourite project, Westminster Abbey, might have summoned many outstanding French as well as English artists.

A thirteenth-century manuscript (now in Paris, BN fr. 403), acquired by the king of France, was lent more than a century later by Charles V to his brother Louis I of Anjou, together with a more recent codex of the same kind, 'pour faire faire son beau tappis',

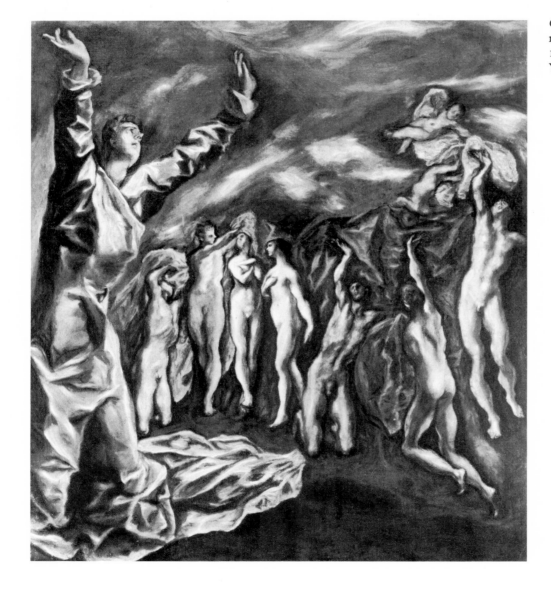

Opening of The Fifth Seal: the Souls receiving the white robes. By El Greco, *c.* 1608-14, canvas, 225 cm by 193 cm. New York, Metropolitan Museum. (19)

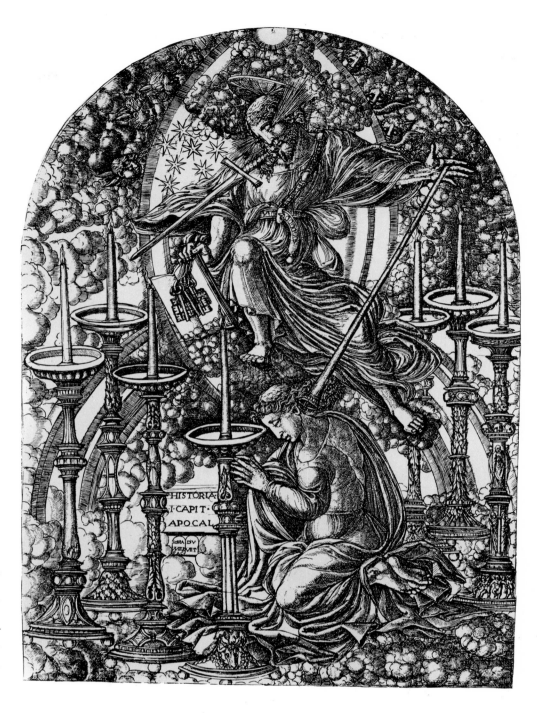

The Son of Man and the seven candlesticks. The trumpet behind John's ear is symbolic of the voice. Here, according to the Book, are the seven stars, the golden girdle, the sword coming out of the mouth, the keys of Hades, the eyes 'like flames of fire'. From the Apocalypse engraved by Jean Duvet of Langres, 1546-55, published at Lyons, in 1561. (20)

and is known today as the Angers tapestry, the cartoons of which, however, seem to have been modelled almost exclusively on the somewhat inferior later manuscript. Other monumental works of art reproducing the Anglo-Norman cycle belong to the fifteenth century, such as the splendid flamboyant west rose window of the St-Chapelle in Paris, and the Apocalypse inserted into the great East Window of York Minster, which is nearly its contemporary, less refined but more picturesque. The illustrated commentaries of Alexander, in which the idiosyncrasies of the Franciscan *Spirituales* emerge even in the pictures, belong to the fourteenth century; the best copy is now in Weimar.

120-124

101

99

Italy falls outside the sphere of influence of the Cisalpine cycle,
125,126 as can be seen in a fresco by Giotto, in S. Croce at Florence; a
127 cycle of wall-paintings in Padua, by Giusto de' Menabuoi; a double
panel, now in Stuttgart, certainly Neapolitan, and showing a great
130-135 many delicate scenes *en camaieu* on a dark background; and, finally,
118 part of a cycle preserved in the castle of Karlŝtejn, south of Prague:
rough but lively.

Shortly after 1400, an extraordinary *Apocalypse* appeared in the
137-159 Low Countries (Paris, BN néerl. 3), in which a western Flemish text
was accompanied by twenty-three colourful and dramatic full-page
miniatures. A few decades later Jan van Eyck created that unique
160-167 and mysterious masterpiece, the Ghent polyptych of the Lamb. In-
deed, the fifteenth century saw a rebirth of apocalyptic images.
Among the most popular are St John on Patmos, contemplating the
Woman clothed with the sun, the Heavenly Liturgy (as in the minia-
1 ture by one of the Limburg Brothers); or a synthesis of St John's
168-175 visions, cataclysms as well as glories (Memling's side-panel, in St
John's Hospital, at Bruges); Michael's battle against the Dragon;
and, finally, the favourite subject of the time, the Virgin, holding
her Child, adorned with the attributes of Rev. XII: the sun, the moon
and twelve stars. The motifs, and even texts, from the Alexander
commentary are again found on an altarpiece from Hamburg, now
in the Victoria and Albert Museum. Among the manuscripts repro-
ducing the old cycle in full, the Escorial Apocalypse is undoubtedly
the finest, the finale of the era of book illumination.

The creation of the block-book, and set of prints, marked the
beginning of a new epoch. The first book to be illustrated using
the xylographic technique was the Apocalypse. It appeared in the
176-180 northern Netherlands, probably at Haarlem: a series of fifty subjects,
faithfully copied from a purely Anglo-Norman manuscript of the
oldest type, in an unfailingly linear manner, with pieces of the text
182,183 inside the pictures. Then, in 1498, after the *Cologne Bible*, with its
handful of apocalyptic engravings and rather mediocre reprints,
185-200 Albrecht Dürer suddenly produced fourteen overwhelming large-size
woodcuts.

Dürer took hold of the Apocalypse as Dante did of Hell, says
Emile Mâle, and he shows that all sixteenth-century Apocalypses
go back to the composition invented by that young man from Nurem-
berg. They are numerous, not limited to the graphic arts, and can
be traced not only in sets of engravings, enriched by mostly inferior
additions and variations (Lucas Cranach's series for Luther's *Septem-
202 bertestament*, 1522), but also in a number of French church windows.
203,204 At La Ferté-Milon and in several churches in the Yonne and Aude
départements, are windows that look like enormous transparent *im-
ages d'Epinal à la mode de Dürer*.
205-220 Even the eight invaluable Brussels tapestries that Charles V took
with him to Spain (for which the cartoons were probably designed

The fourth Rider, Death. Detail from a
cycle of eight apocalyptic windows in the
parish church of Tubbergen (Overijsel,
the Netherlands). By Joep Nicolas, 1954-
72. (21)

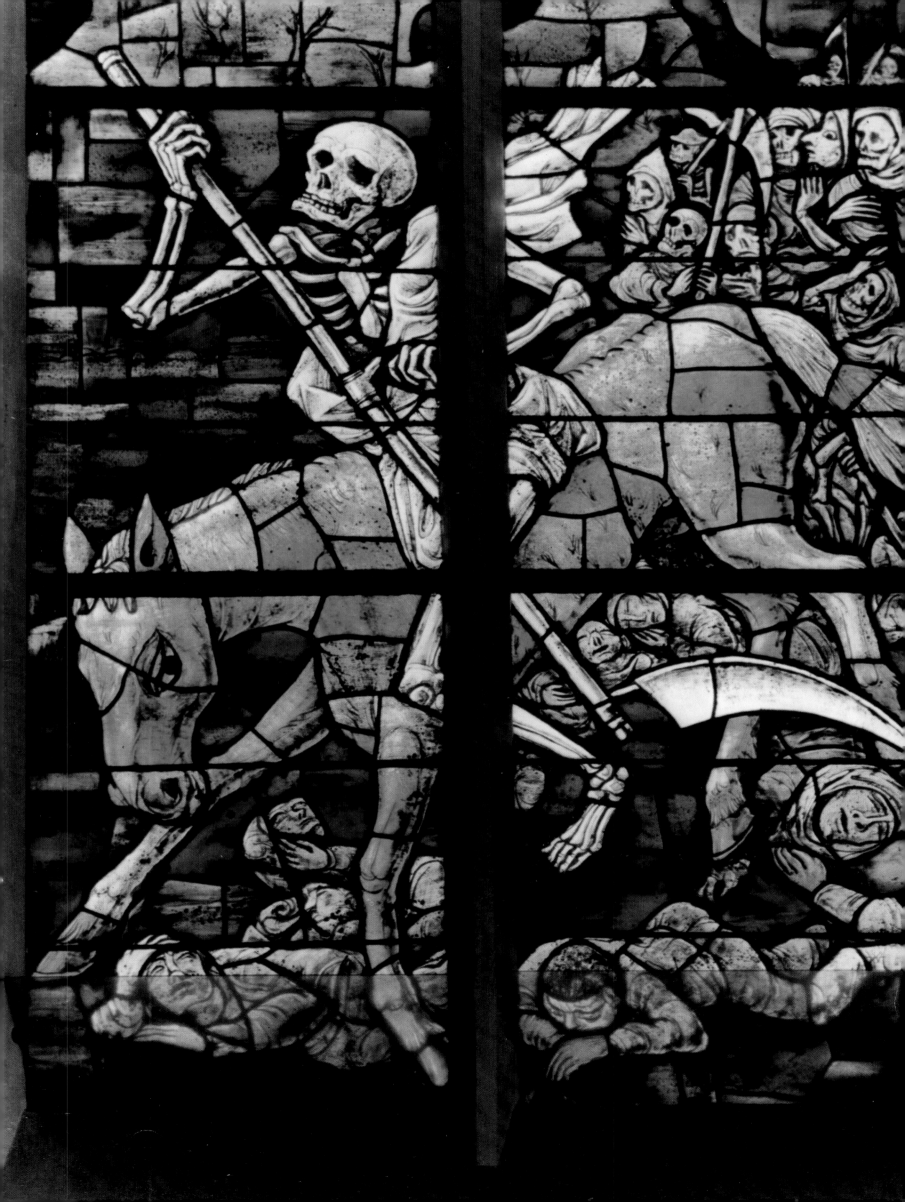

by Barend van Orley) are unimaginable without the Dürer prints. True, the imperial tapestries, as well as the many German and Dutch Bibles of later date, reintroduce subjects left out by Dürer for want of space (the episode of the two Witnesses, for example, was welcomed by the artists of the Reformation, who changed them into ministers of the new Gospel) and the Marriage of the Lamb.

Prints derived from the Dürer set found their way even to Mount Athos, where the typically Western subjects were aptly and delicately translated into the post-Byzantine idiom, as can be seen in wall-paintings at Dionysiou and elsewhere. They also reached pre-Petrine Muscovy; apart from a single, and by now famous, icon in Uspenskii Sobor (in the Kremlin) from about 1500, the new iconography was expressed in the wall-paintings of several churches in cities on the Volga, especially at Yaroslavl and Kostromá, and also at Vologda.

After 1500, all engravers charged with the illustration of the by now ceaselessly printed Bibles echoed Dürer and his first imitators, as far as the Apocalypse was concerned, consciously or not. The lengthy and childish cycles of the Anglo-Norman kind, now considered 'Gothic', seem to have been completely forgotten, as was the art of illumination itself.

In the chapel of Vincennes Castle, the anonymous glazier, who, by order of Henry II of France in about 1565, filled the chancel windows with apocalyptic visions, inevitably had an eye on Dürer's woodcuts, but he also had memories of Michelangelo at the back of his mind. His seven colossal windows for that lofty bare chapel, full of flying draperies, trumpet-sounding angels with bulging cheeks and streaming shocks of hair, shipwrecks in seas like whirlpools and flashes of lightning through packs of clouds, are not least among the great achievements of that age.

Another Mannerist, Jean Duvet, from Langres, engraved a set of twenty-five copper-plates, published in 1561 at Lyons: a complete Apocalypse. He knew the woodcuts of Dürer, as well as prints after Mantegna, Leonardo and Raphael; but his compositions, crowded with emotional tormented figures, are highly whimsical and original.

The great masters of the sixteenth and seventeenth centuries escaped the tyranny exercised on pictorial imagination by Dürer's work, when isolated motifs, and not serial illustrations, were at stake. In his mysterious *Opening of the Fifth Seal*, now in the Metropolitan Museum in New York, El Greco, as always, is completely individualistic: with uplifted arms his ecstatic John sees angels tumbling from tempest clouds, handing white robes to naked Souls. After the Council of Trent, the Catholic artists preferred three subjects: St John contemplating the Woman clothed with the sun; the Woman herself, always identified with the Blessed Virgin, and mostly without the Dragon; and Michael enchaining or casting down Satan (as in Guido Reni's famous altarpiece in the Cappuccini, in Rome). In Baroque

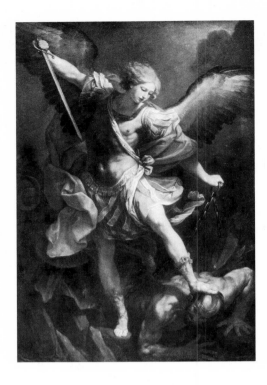

Michael thrusting down Satan, in chains. Altarpiece by Guido Reni, in S. Maria della Concezione (chiesa dei Cappuccini), first chapel to the right, Rome, after 1626. (22)

ceiling frescoes, a turbulent Liturgy round a Lamb lying on a Book with seven Seals occurs sporadically, as in the apse of the Gesù in Rome.

None of the great painters, however, has dealt more freely with a majestic apocalyptic subject than Correggio of Parma: by a stroke of genius he outshone them all. He was faced with the task of filling the cupola of S. Giovanni at Parma with the vision of the Throne, *221-227* described by the patron saint of the church in Rev. IV. His achievement will be described later. In the long history of apocalyptic iconography he is the antithesis of the craftsmen of the Early Christian era; compared with their symbolic abstractions, his work, concerned with material things, seems almost the exact opposite.

The nineteenth and twentieth centuries have seen the ebb of the Dürer tide. Conventional ideas as well as surprisingly new inventions, increasingly personal and disparate, have broken up an old tradition, and 'the thoughts of many hearts were revealed', far more than the texts of the holy Book, and often in an unbiblical sense. The hallucinatory drawings of Blake were followed by Peter Cornelius's *Four Riders* (now lost) and an endless series of romantic or naturalistic book illustrations. A remarkable ensemble can be seen in glass in the church of Tubbergen, in the Netherlands (1972), where the *21* venerable abstract schemes and remnants of Renaissance realism are perfectly balanced, in what is possibly the most suitable manner for the most exacting of all biblical Books.

49

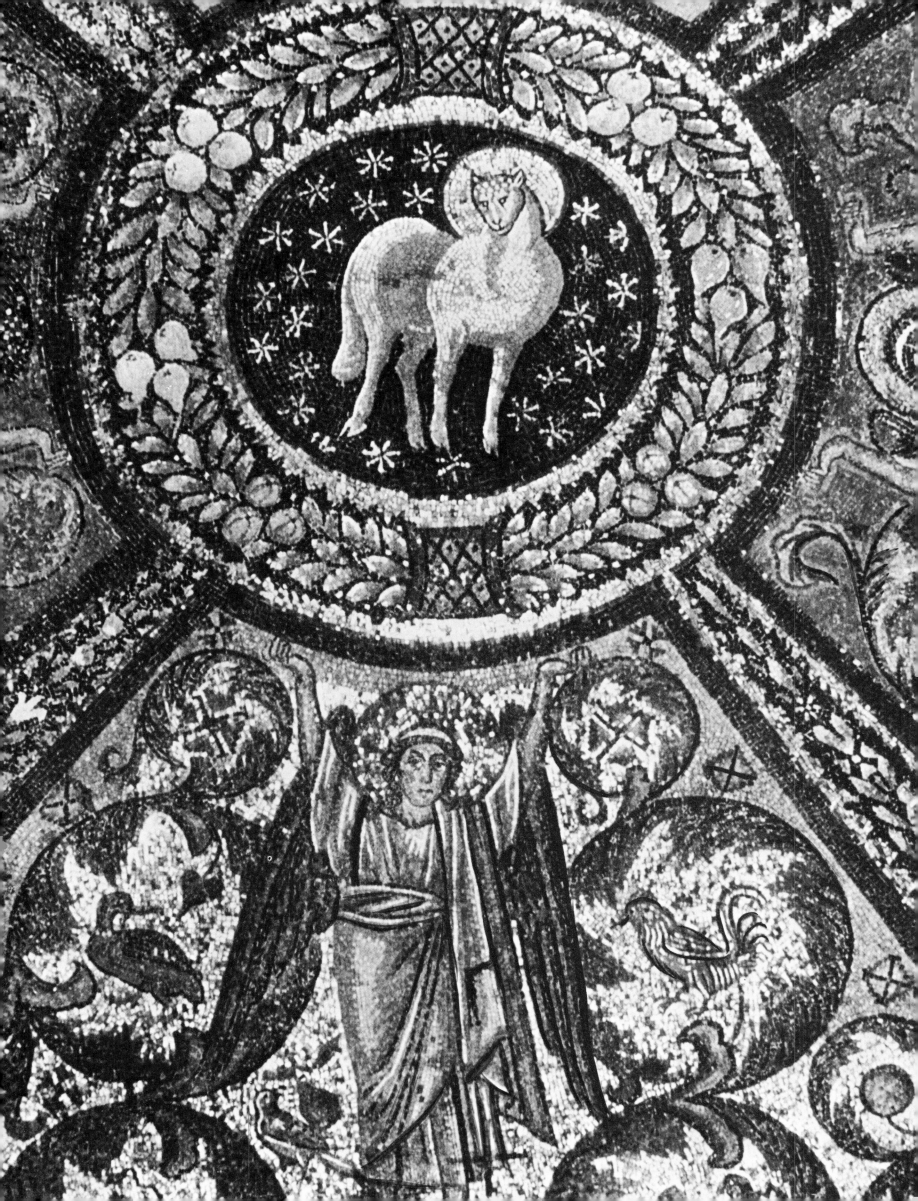

The Lamb and the Lambs

THE LAMBS FRIEZE

In many an ancient basilica in Rome, in the Campagna, and in the old cities of Latium, the mosaics or frescoes of the apsidal conch are bordered by a narrow frieze running below the composition proper. It is always the same: a double procession of white lambs, against a dark background often adorned with rhythmically disposed palm-trees, on both sides leading into a walled city. Sometimes the frieze is underlined by a metrical inscription.

In the middle, the Lamb of God is standing on Mount Sion (Rev. XIV: 1). The mountain also symbolizes the Paradise of the second chapter of Genesis, for the rivers Pison, Gihon, Tigris and Euphrates are seen gushing forth their waters; at the foot of the mountain these waters combine and form a horizontally flowing stream, sometimes – in huge apses – enlivened by the traditional Nilotic motifs, but often inscribed IORDANES, in letters of silver or gold mosaic. This is the mystical Jordan, not only the symbol of baptism, but also the River of Life 'proceeding out of the Throne of God and of the Lamb' (Rev. XXII: 1).

The snow-white lambs recall the white baptismal robes of the neophytes; from each side the lambs are hastening to the Fountain of Life, symbol of the baptismal font, as can be understood by the inscription accompanying the lambs frieze in the frescoed apse of the eleventh-century church of Castel S. Elia, near Nepi:

ISSTI SVNT AGNI NOVELLI QU(i) NVTIAVERVNT PACE ALLELVIA: (modo) VENERVNT AD FONTES REPLETI (sunt claritate)

These are the new lambs, who have announced the Peace (confessed their unity in the one Faith, by saying the Credo); now they have come to the font; they are filled with Light…

This ancient responsory was sung during the procession of the neophytes entering the basilica, to assist for the first time at the Easter Vigil Mass. The Benedictines of Castel S. Elia still knew it in the eleventh century, and, like St Augustine preaching at Hippo during Easter Night, they must have felt that all neophytes, children as well as adults, were eminently the 'new lambs of the Lamb'. Baptism

27,28

The Lamb raised to the stars, inside the wreath of the seasons, by four Powers Incorporeal. The 'angels', with unbiblical wings, are borrowed from the Antique Victories. Mosaic of the vaulting above the altar in S. Vitale, Ravenna, c. 549. (23)

51

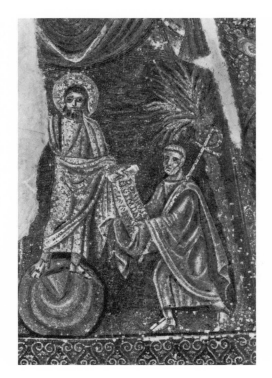

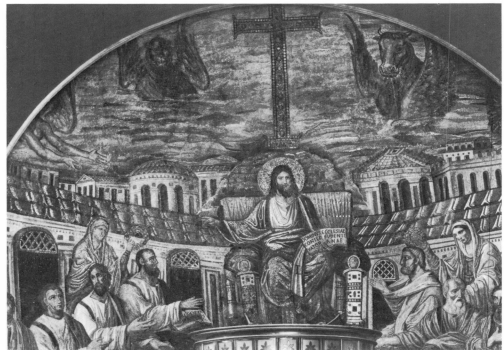

had given them enlightenment and was called 'illumination' in their liturgy (Greek: *phootismós*), and also 'seal' *(sphragis)*, that is, the mark of the Lamb.

The twelve lambs represent the procession going to the baptistry; after being baptized and receiving the unction in the *signatorium*, they proceed to the basilica, where they are welcomed by the jubilant hallelujahs of the faithful. Their number certainly recalls the Apostles, the first believers; but twelve, being the root of 144,000, also suggests the Great Multitude surrounding the Lamb on Mount Sion, the Elect, who were 'sealed' on the forehead with the mark of the Lamb, of which the mark of the Beast, the Antichrist, is the anti-sign. The palm-trees are reminiscent of the palms in the hands of the redeemed (Rev. VII: 9).

The lambs procession always emerges from the two cities at the ends of the frieze, of which one bears the name HIERVSALEM and the other BETHLEHEM. The rustic sheep-cotes of bucolic scenes have been replaced by cities with walls of precious stones, like the Heavenly City of the Apocalypse.

In Early-Christian Rome, after 314, Jerusalem and Bethlehem always symbolize the two churches founded by the Princes of the Apostles: Peter's Church of the Circumcision, and Paul's Church of the Gentiles. For Jerusalem was the city of the first community of converts from Judaism, and Bethlehem the town where the first-called of the Gentiles, the Magi from the East, had worshipped the Infant Logos.

13

The New Law given to Peter. On the banderole: DOMINVS LEGEM DAT (The Lord giving the Law). Underneath, out of the picture, are the harts, of Psalm XLI, XLII:2, at the Fountain of Life. In the squinch below is one of the four Beings, Man (symbol of the Gospel of St Matthew), with six wings. Mosaic in the cupola of the Soter baptistry near S. Restituta, to the left of the Duomo, Naples, *c.* 400. (24)

The Throne in the Heavenly City; here, the earthly Jerusalem of about AD 400, with the four Beings calling in the sky; the Churches of the Circumcision (right) and the Gentiles (left) are each holding a wreath above the heads of Peter and Paul, sitting among the twelve Apostles. Inside the City are seen Calvary with the Staurotheca (reliquary of the Cross), the rotunda of the Holy Sepulchre and the octagon with the open roof of the Ascension, on the Mount of Olives. Mosaic in the apse of S. Pudenziana, Rome, probably 401-17, the reign of Innocentius I. The outer parts and the frieze below, with the enthroned Lamb, were lost during the reconstruction of the church in 1589; three of the heads, on the right, are modern. The oldest apocalyptic mosaic, still entirely Antique, and purely Roman. (25)

52

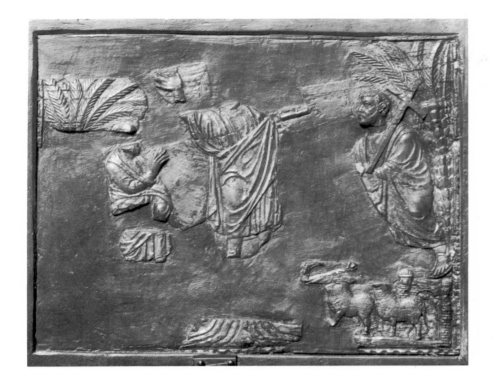

The New Law given to Peter. Bottom centre: the Mountain of Paradise with the four rivers; right: the City and the Lambs of the Church of the Circumcision. Lid of the ivory 'Pola Casket', c. 400, from Samagher, in Istria (Yugoslavia), formerly in the Museo Civico of Pula; location unknown (since 1945). (26)

The Law given to Peter. Top left: the Phoenix; bottom: the Lamb on Mount Sion, with the four rivers, the Jordan (IORDANES), and the lambs processions coming out of the two cities, IERVSALE and BECLE. Gold glass, about 400?; diameter 7.7 cm; in the Vatican, Museo Cristiano. (27)

THE APSIDAL COMPOSITION CORRESPONDING TO THE FRIEZE

In itself, this emphasizing of the two churches united by the Anointed Corner-stone, Christ, the Lamb of God, does not necessarily point to the city of Rome. The chief composition, however, dominating the frieze and filling the apsidal conch, always shows Peter on the side of Jerusalem, and Paul on that of Bethlehem.

In the mosaic of S. Pudenziana – the ancient *titulus Pudentis*, originally the house-church of Pudens – solemn purple-clad matrons, personifying both churches, are seen holding laurel wreaths above the heads of the Apostles, the *ecclesia ex circumcisione* standing behind Peter and the *ecclesia ex gentibus* behind Paul. Nothing could be more appropriate in Rome, for the city possessed the tombs of both Apostles and celebrated their joint memories on the same day, June 29th, as we know from the Roman calendar of 358.

In addition, the two-Apostle motif usually occurs in another composition, to which the lambs frieze evidently belongs and of which it forms an integral part. This composition, which not like that of the *titulus Pudentis*, is generally called DOMINVS LEGEM DAT, 'the Lord gives the Law', from an old inscription (e.g. in the cupola mosaic of the Soter baptistry at Naples).

Here, the Lord is standing on Mount Sion, in the attitude of the Roman emperor during the *adlocvtio*, the address to the senate, the people and the army. His right hand is raised in a gesture of speech, while with the left he unfolds a scroll, which is reverently received

53

by Peter on veiled hands. The Lord gives the Law of Grace to the new Moses, Peter.

Peter is clearly recognizable by his short fisherman's beard and white curled hair, his spontaneous attitude and the Cross of his martyrdom carried across his right shoulder, ending in the monogram of Christ. On the other side of Christ, Paul raises a hand in acclamation, recognizable by his high bald forehead, his thin lank hair and black pointed beard, his sharp profile and, one could say, his characteristically dyspeptic type.

Both Apostles are standing in a meadow full of flowers, between two golden palms bearing bunches of dates, like the Trees of Life 'fruiting every month' on the banks of the apocalyptic River of Life inside the Heavenly City. On a branch of the tree on the left (at the right hand of Christ) the Phoenix is sitting, haloed with sun-rays, the Christian symbol of Resurrection. The Lord's raised hand points to it. The Phoenix, though profane, was thought to be a natural prefiguration of a divine mystery; as such it had been celebrated

Mosaic on the triumphal arch of SS. Cosma e Damiano, Rome. The Throne with the Lamb, the candlesticks, four angels and two of the four Beings on the Sea of crystal mingled with fire; below: the wreaths held up on the veiled hands of four of the twenty-four Elders (the rest disappeared in 1632). Lamb and Book were restored in 1660. In the apse: the frieze with the Lamb and the lambs. During the reign of Felix IV, 526-30. (28)

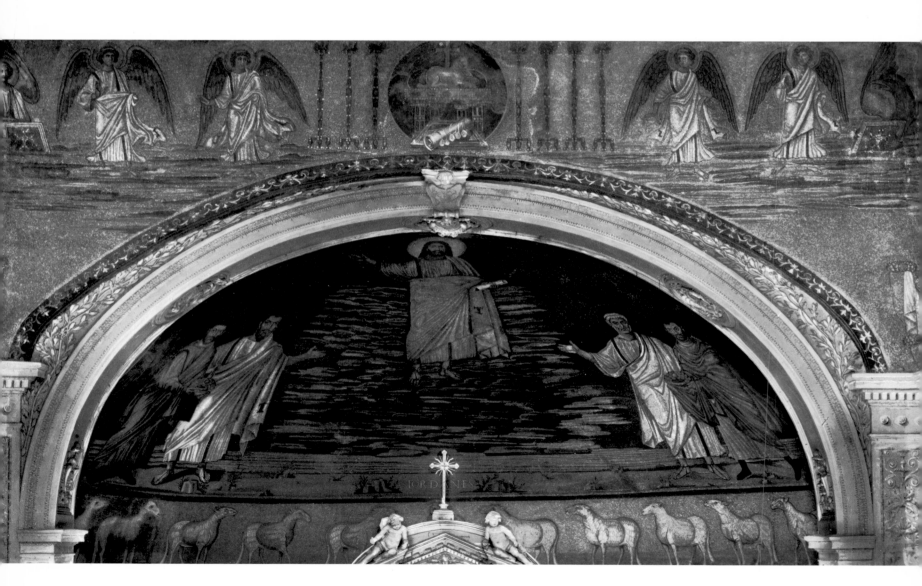

The Adoration of the Lamb by the Elders. Mosaic on the façade of Old St Peter's in Rome, restored by Sergius I, 687-701. In the forecourt: the burial of Gregory the Great (died, 604). Drawing from the abbey of Farfa (Lazio), eleventh century; Eton College, ms. 124. (29)

by Lactantius, a Christian poet and historian, in *de ave Phoenice*, 'The Phoenician Bird', a florid didactic poem of 170 hexameters dating from about AD 410, containing one rather cryptic allusion to the Lord's Resurrection, and well known at Rome and elsewhere. Finally, Christ appears on a background of fiery ethereal clouds – one cannot help thinking of the apocalyptic 'Behold, He cometh with clouds' (Rev. 1: 7) – and above his head the hand of the Father holds a wreath of golden leaves, closed by a gem and with fluttering ribbons.

It is clear that the frieze below is but an allegorical representation of the great scene above, and at the same time an explication of its theme: above, the *traditio* of the Law, below, the *redditio symboli*, the confession of adherence to that Law, before baptism; above, the founders, below, their churches; above, the Son of Man, below, the Lamb of God; both above and below, the mountain and the rivers of Paradise.

Regarding this formidable composition as a whole, one must conclude that it originated in Rome; and because the oldest derivations point to the era of Theodosius, it must be a creation of the so-called 'Theodosian Renaissance', a movement started before 400, and focused in Rome as well as in the residence of Milan.

Typically Roman, the composition is also apsidal and is perfectly adapted to the concavity of the apse. The relatively moderate size of the main characters, the presence of a frieze, and the celestial segment on top combine to prevent the figures from appearing out of proportion. There can be no doubt that this magnificently balanced ensemble was made for some imposing Roman apse. But in which of the many old Roman apses?

In some of them the scheme, frieze, background and all are recognizable; but nowhere is the archetype found, unaltered and entire. Intact mosaics – such as those in S. Prassede – are of much later date and show the main scheme, but are modified by contaminating accessories, and the main theme is left out. Some mosaics have disappeared; others have been heavily damaged, patched up and often totally remade. On the other hand, a number of more recent, provincial, derivative apsidal frescoes, such as those at Castel S. Elia and S. Silvestro in Tivoli, show the integral scheme, albeit somewhat simplified.

On a reduced scale the scheme can be seen in some products of the minor arts almost contemporary with the original masterpieces, from about 400 and afterwards; by then it had evidently become a cliché. One example is a gold glass in the Museo Cristiano of the Vatican, remarkable for its inscriptions; another, a graffitto on a funeral slab from Velletri; a third, a poor fresco in an arcosolium of the small catacomb at Grottaferrata.

Most important is an ivory reliquary from Samagher in Istria, known as the 'Pola Casket'; I saw it in the museum of that town, called Pula, but it disappeared after the Yugoslavian occupation. It

is a pilgrim's souvenir from the old basilica of St Peter, ordered or bought by a married couple of senatorial rank. On one side we see them offering their votive gifts at the tomb of the Apostle, or, rather, at the *aedicula* (marble pavilion) built above its deep shaft. It is easy to recognize the canopy, the *fenestella* (window-like opening) of the so-called confessio ('martyrdom', the whole, tomb, chapel, and pavilion together); the jewelled cross; the chancel-screen supporting the twisted columns and the architrave; the looped-up *vela* (curtains) between the columns; the apse behind the *memoria*. On the casket lid are the remnants of the complete *traditio legis*, with palms, Phoenix, lambs and cities.

The seven candlesticks. Mosaics (between the windows) on the façade of the basilica founded by Bishop Euphrasius of Parentium (Parenzo, today Poreč), sixth century. In the foreground: the baptistry and the porticos of the atrium; the gable mosaic has disappeared. (30)

THE ORIGIN OF THE THEME:
THE APSIDAL MOSAIC OF OLD ST PETER'S

The archtype, which already suggests a famous sanctuary, must have adorned the enormous, twenty-metre deep apse of the Constantinian basilica on the Vatican hill. The *memoria* with the *confessio* stood on its chord, exactly where it is today, hidden under Bernini's papal altar; the old altar must have stood twenty metres eastward, under the triumphal arch, just as in the Saviour's basilica in the Lateran.

During the thousand years between 400 and 1500 the mosaic was altered by the insertion of figures in the Byzantine manner; even the standing Christ was changed into an enthroned Pantocrator. Inside the frieze the Jordan – here filled with Nilotic genre-pieces – remained intact, but small figures of the Church and a medieval pope were added to the Lamb's Throne. Shortly before the demolition, a poor drawing was made of the remnants, our only remaining piece of information.

31 The Carolingian mosaic in S. Prassede is an unreliable copy: the setting is correct, but the *traditio* has been replaced by a group of saints. The same applies to the apsidal mosaic of 526, in honour *28* of the holy doctors, Cosmas and Damian, who are introduced to the Lord by the two Apostles. The palms, the fiery clouds, the Phoenix, the imperial figure of Christ are all recognizable and splendidly done; the frieze, although mutilated at both ends, is a perfect copy.

A composition that reveals such richness of thought betrays a master mind in the churchman who thought it out and a great skill in the mosaicists who executed it on such a colossal scale. One may wonder if there could be a better way to express the similarity and the diversity of the Princes of the Apostles than here, at the tomb of the second in genius and the first in rank; at any rate, no way could be more Roman, or, for that matter, more purely biblical.

The main theme summarizes the core of Paul's *Epistle to the Galatians*: 'For He that wrought effectually in Peter to the apostleship of the circumcision, the same was mighty in me towards the Gentiles' (Gal. II: 8). That both Apostles died martyrs in the capital of the

world and that both were buried outside the walls of Rome, makes the scene where they appear side by side even more impressive. The evocation of baptism, in connection with the promulgation of the Law of Grace, adds to its majesty and lifts it high above the level of mere veneration and gratitude.

It is also possible to list a series of delicate features borrowed from the Book of Revelation: the Lamb on Mount Sion; the Great White Multitude; the palms; the River of Life flowing out of the Throne of the Lamb; the fruiting Trees; the City built of precious stones, here symbolically doubled; the arrival of the Son of Man, with clouds. They are used in the Antique way, not too emphatically, in the offhand, laconic, truly Roman manner.

The two triumphal arches in S. Prassede, Rome; dated to Paschalis I, 817-24, by a monogram on the intrados of the foremost. The mosaics of the apsidal arch are a copy of those at SS. Cosma e Damiano, 527 (see pl. 28), and so is the frieze in the apse. On the front arch: the saints received into the Heavenly City, the walls of which are built of precious stones. (31)

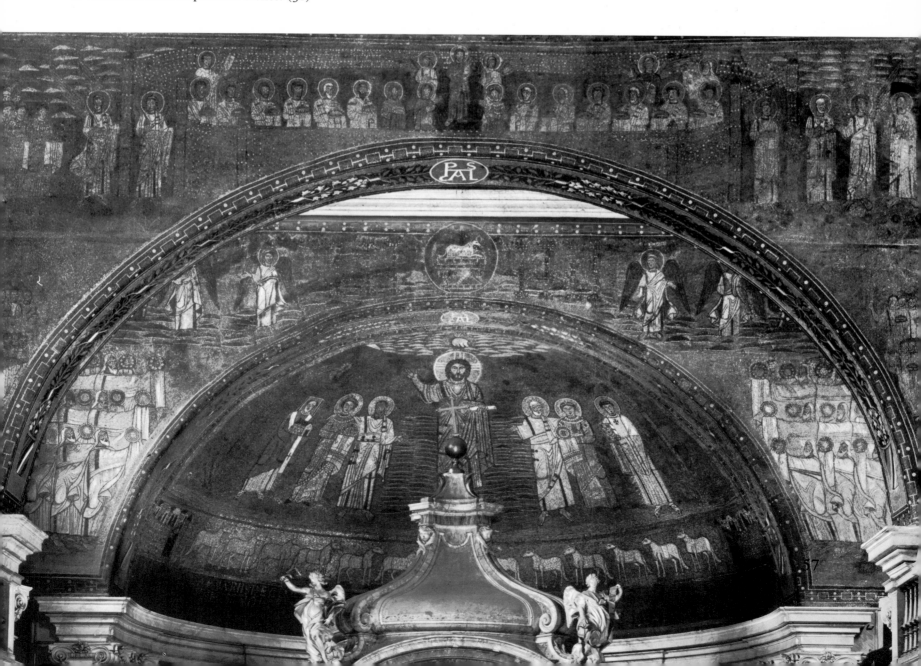

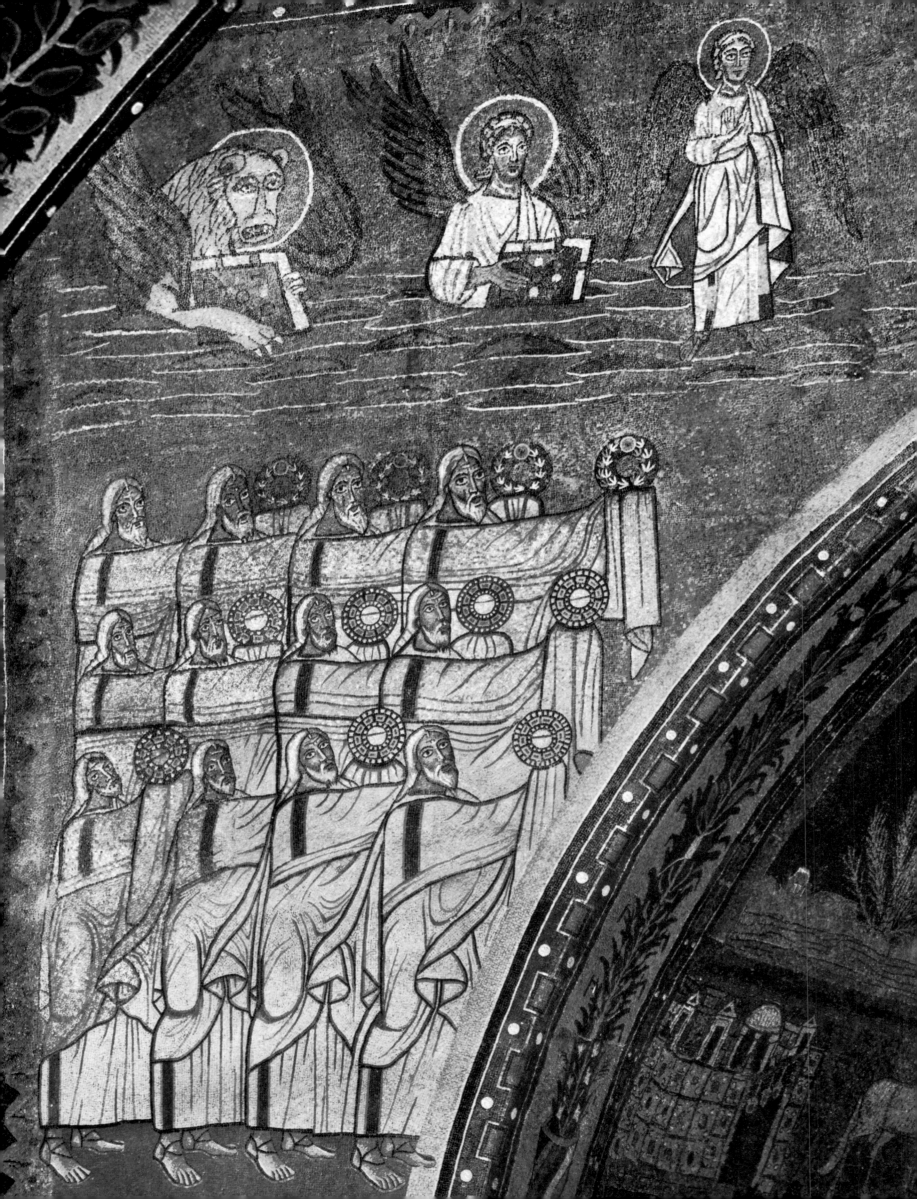

The four Livings Beings and the twenty-four Elders

In a Roman basilica, the wall into which the apsidal niche recedes corresponds to the conch of the apse as a sort of huge frame. Traditionally, the whole space between apsidal arch and coffered ceiling is called the 'triumphal arch', probably because it resembles the great arches erected by the emperors after a military triumph, and also because the arch spans the sanctuary, just above the altar.

Obviously, the mosaic adorning this frontal wall, which dominated the basilical interior, had to have some bearing on the mystery celebrated on the altar; it needed to be a subject that could fill a wide space of difficult shape, requiring a divison into zones. The choice fell on a representation of the Heavenly Liturgy, as described in the fourth chapter of the Apocalypse: a vision of the invisible prototype, evidently modelled on the Eucharistic *synaxis* of apostolic times. Framing the *traditio* and the baptismal frieze of the apse, the Liturgy of eternity thus appeared above the altar for the Liturgy of temporality.

When suddenly 'a door was opened in heaven', John saw the Throne of the Unnamed One, 'to look upon like a Jasper and a Sardine stone', and surrounded by a rainbow like an emerald, lightnings and thunderings proceeded out of it, seven lamps were burning before it; four and twenty Elders were enthroned round about it. Four Living Beings – *zôia*, or *animalia* in Latin – each with six wings and full of eyes, with faces like a Lion, a Calf, a Man and an Eagle, accompanied the Throne; clearly Ezekiel's tetramorph, but here split into four separate beings and thus quadrupled. They are carrying the Throne through the universe; their chant is the threefold 'Holy', the *Trisagion*; the wings and the eyes are those of Isaiah's seraphs. The four Beings are a blend of Ezekiel's cherubs and Isaiah's seraphs. Then, at once, the Lamb appears, 'as it had been slain', with seven horns and seven eyes. It takes the sevenfold-sealed Book out of the hand of the Unnamed One, and begins opening the Seals one by one, and the wrath of God breaks out in inconceivable cataclysms. Immediately, the praise of the Unnamed Lord changes into a 'new song' in honour of the Lamb: the Lamb, it seems, causes a radical reversal in the Liturgy of Heaven. A Sea of glass mingled with fire, pavement as well as firmament, separates heaven and earth.

How could a simple craftsman handle this unimaginable vision,

The Lion, the Man, the Sea of crystal. Below: twelve Elders hold up their wreaths to the Lamb on the Throne. Triumphal arch of S. Prassede, Rome (see pl. 31); the lower part on the left has been remade. (32)

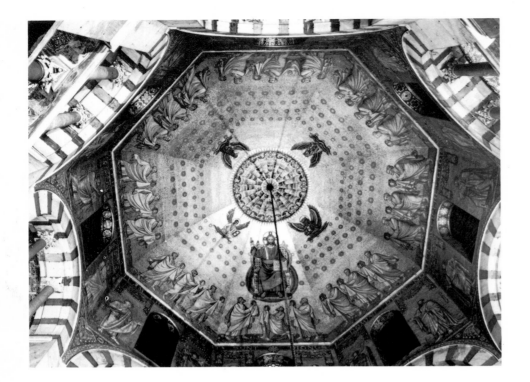

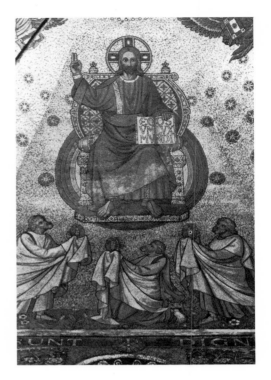

particularly an artist only familiar with the gentle clichés of late Antiquity, which were always moderate – never excessive, never too loud – and almost tamed into gracious insignificance?

THE HEAVENLY LITURGY ON THE TRIUMPHAL ARCHES

Their oldest creation (as far as we know) is the triumphal arch of St Paul's Outside the Walls. Alas, only miserably patched-up remnants of the mosaic are known, scorched by the great fire of 1823. Even before this catastrophe –which, according to Jakob Burckhardt, destroyed the most beautiful colonnaded interior in the world – little of the original seems to have been left. We can hardly rely on incomplete interior views before the fire (among them a Piranesi etching and a Pannini), nor on drawings of the ruin, where there is still less to see. What can be seen today provides the motifs and the composition; as for the rest, in spite of the excellent intentions of the restorers, this enormous piece of work is probably the ugliest mosaic in existence. One can hardly refrain from thinking that the head of Christ resembles a gorilla; the Elders look like marionettes, and the fiery clouds like floating sticks; the two figures below, probably prophets, have been restored as Peter and Paul, both in impossible attitudes.

Yet we can imagine how it must once have looked, belonging, as it does, to the golden era of Early Christian art. 'Theodosius founded, Honorius achieved' the basilica; and nobody less than Leo the Great, succoured by the pious Empress Galla Placidia, ordered

Mosaic in the Cupola of the Palatine Chapel (now the cathedral) at Aachen, Rhineland; tenth century. The twenty-four Elders, from a drawing by Ciampini, *c.* 1690-9; the actual mosaic, a reconstruction, by Salviati, from Venice, nineteenth century. The wreaths have become crowns (see pl. 32). (33)

The Elders, holding up the vials of perfume to the Lamb. Triumphal arch of the abbey church of Castel S. Elia, near Nepi (Lazio), eleventh century. (34)

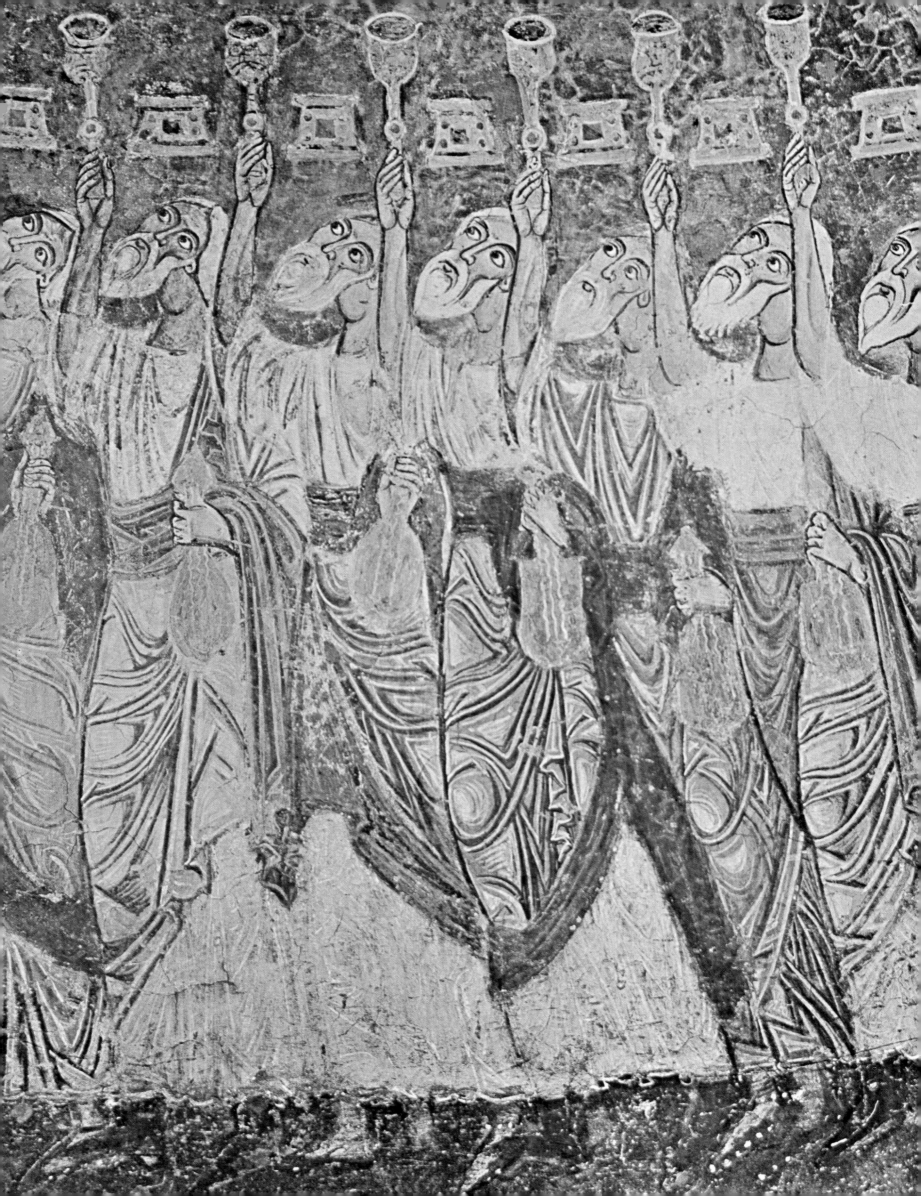

– and perhaps planned – the mosaic, shortly after 440. Its 'Throne' is a shield-like medallion, *clipeus*, bordered by a multicoloured rainbow, showing the head and shoulders of Christ: a grim, bearded face, surrounded by a blue cloud of empyreal ether. He holds a staff Cross obliquely, and his right hand is raised, as if he is speaking. He is the Lamb, but in the form of the Word Incarnate. The Sea of crystal mingled with fire is a zone filled with fiery clouds. From it emerge, on each side of the Throne, two of the four Beings.

25 In the mosaic of S. Pudenziana, thirty years earlier, instead of the vision of the Throne, the Lord appears sitting among his Apostles within the Heavenly City. This was represented as the earthly Jerusalem from about 400, the pilgrim's city seen by Etheria and Jerome. Here the mysterious Beings still appear powerful, in the Antique manner: a muscular naked Man, a roaring Lion, a mighty Bull and a fierce Eagle. They are even more beautiful and equally convincing

24 in the almost contemporary mosaics of the Soter baptistry at Naples, where the Man, in distinguished dress, has the intense face of an icon, and the six wings are open on a starred, dark background. (Monsignor Duchesne, who did not like the motif at all, would have had to swallow his sarcasms.)

In S. Paolo fuori le mura, the four Beings are, for the first time, somewhat precariously holding the Gospels: codices studded with gems. Evidently Ireneus's exegesis had reached Rome, for the lamps, the lightnings, and the gem-like Throne are missing.

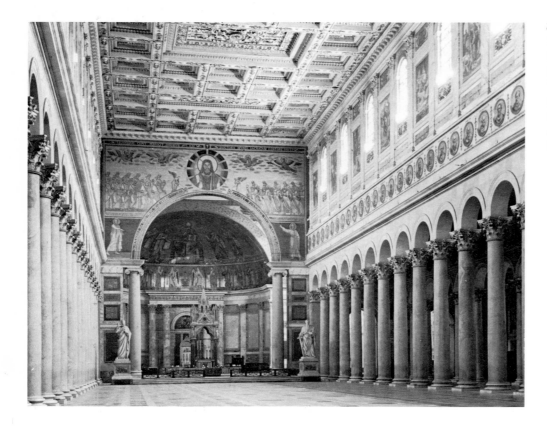

St Paul's Outside the Walls of Rome (S. Paolo fuori le mura), after the fire of 1823. On the triumphal arch: the remnants of the mosaic of the Heavenly Liturgy, the Throne (a head and shoulders of Christ), the four Beings and the Elders. During the pontificate of Leo I, the Great, 440-61; after a drawing by Bartolommeo Pinelli (died, 1835). (35)

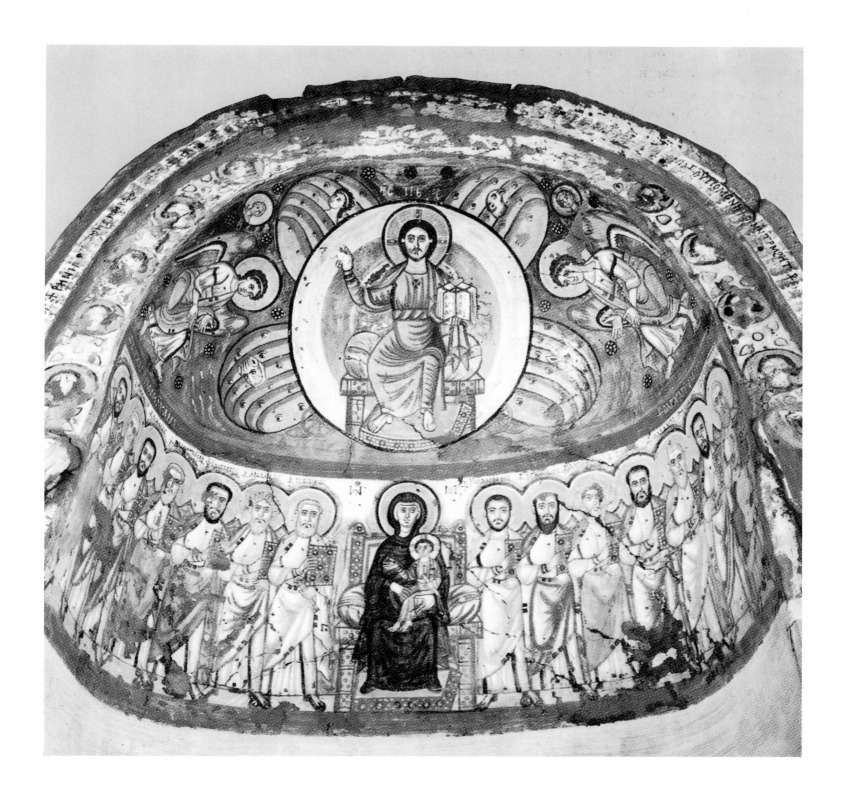

The theophany of the *Trisagion*, with the Throne and the four Beings. Frescoed apsidiole in a chapel at Bawît, in the Nile Valley, sixth century. Cairo, Coptic Museum, room six. (36)

THE TWENTY-FOUR ELDERS

The Elders, grouped together lower down, twelve to the left and twelve to the right, are bare-headed, white-haired old men wearing tunics with red *clavi* (vertical strips) and white palliums. With their right hands they lift up their laurel wreaths to the Throne above them, thus illustrating the text, 'they threw their crowns before the Throne'. This typically Antique gesture also occurs in the miniatures of the *Trier Apocalypse*, suggesting, moreover, that the model for the Trier manuscript could date back to fifth-century Italy. Strangely enough, the Trier Elders are beardless young men, raising their

56

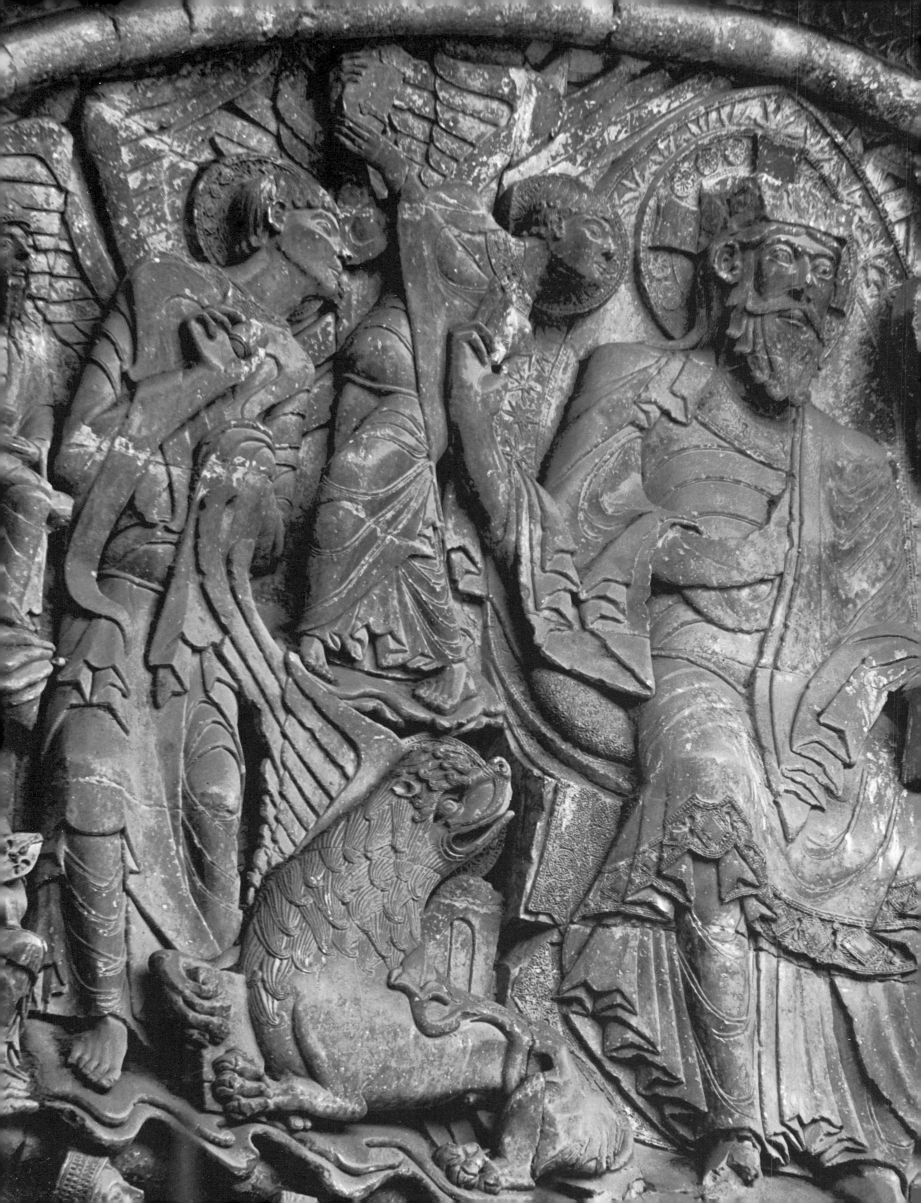

wreaths with bare hands, while the venerable presbyters of St Paul's reverently present theirs on hands veiled by a corner of their palliums.

The vials of perfume, the harps, and the citharas the Elders are holding in later chapters of the Apocalypse, are not seen in the mosaic, though they were probably shown elsewhere. Prudentius, the Spanish poet who shortly after 400 described a cycle of biblical images of both the Old and the New Testament, typologically arranged into antithetic sets, closes his forty-eight *tituli* (descriptive quatrains, one for each image) with a forty-ninth that is clearly the central theme:

> *Bis duodena senum sedes, pateris citharisque*
> *totque coronarum fulgens insignibus, agnum*
> *caede cruentatum laudat: oui euoluere librum*
> *et septem potuit signacula pandere solus.*

Twice twelve enthroned Elders with their bowls and harps, shining with as many crowns, praise the slaughtered Lamb, who alone was able to open the Book and loose the seven seals thereof.

Prudentius sees the twenty-four Elders, not on their feet, as in St Paul's, but sitting, and holding the vials and the harps, while the Lamb is opening the Book. Did he envisage it on the triumphal arch of a basilica in Spain or in Gaul or in northern Italy? We do not know; and it is possible that he only drew a programme for an imaginary decoration. Some centuries later, however, Elders of this type reappear, in monumental form, on the front of Romanesque abbey churches in France, and in Italian frescoes; the formula of St Paul's seems quite forgotten.

A curious drawing in an eleventh-century manuscript from Farfa in Latium, now at Eton, shows the funeral of Pope Gregory the Great in the portico of Old St Peter's; above its roof appears an accurate view of the façade and its mosaic. In a medallion in the gable, the Lamb, its seven eyes scattered over its body, opens the sealed Scroll; below are typically Roman busts of the four Beings. Placed between the windows and below the Beings, the Elders, in six groups of four, all crowned, lift up their vials.

Possibly the Lamb is due to a restoration, ordered by Sergius I (687-701), of an older mosaic founded by Leo the Great (440-61). Some scholars assume that the Leonine mosaic showed a bust of Christ, like Leo's mosaic in St Paul's, and that Sergius intentionally replaced it by the Lamb, as a protest against the 692 Synod 'in Trullo', in which the Greek Fathers had ordered that the representation of Christ 'after His human form' be substituted everywhere for the symbolic form of the Lamb – a prohibition as unacceptable to the Pope as the arrogance of a synod he had not recognized. The brief notice, however, that the *Liber pontificalis* devotes to the restoration does not mention it. What part is Leo's and what Sergius's remains uncertain.

Moissac (Tarn-et-Garonne): tympanum of the doorway on the south side of the abbey church, showing the Throne and the four Beings. By the first great master of the revival of monumental sculpture, c. 1110. (37)

29

With some variations the great composition of St Paul's has been copied several times in Rome itself. On the triumphal arch of SS. Cosma e Damiano, for example, where the beautiful mosaic of 526 has been truncated by a Baroque arcade, is a small remnant consisting of the wreaths, with gems, offered on the veiled hands of now vanished Elders. Four elegant angels are standing up to their ankles in the Sea of crystal mingled with fiery clouds, and above it hover the four Beings with their jewelled books. The three-legged jewelled candlesticks on either side of the Lamb's Throne may represent the seven lamps (instead of the candlesticks belonging to the Son of Man, Rev. 1: 12); they are identical with those in the façade mosaics of

30 the contemporary basilica of Poreč, where the chief scene has fallen from the gable, leaving only vague traces on the stuccoed wall.

28 In SS. Cosma e Damiano the Lamb is lying on the cushion of the Throne, and the sealed Scroll (once of painted plaster, now renovated) on the footstool. How the ensemble must have looked, we

31,32 can see in S. Prassede, where, in about 814, Paschalis I had it copied in the stiff linear style of the Carolingian age. The greater part of this mosaic is still intact, including twelve of the Elders, who lift up diadem-like wreaths. West of the arch with the Heavenly Liturgy a second triumphal arch, preceding the transept, displays a marvellous fantasy on the theme of the Heavenly City, Rev. XXI-XXII. A wall of gems encloses a crowd of saints surrounding their Lord; outside the circular wall, the Pope, the emperor, the empress and their respective flocks are approaching Peter and Paul, who welcome them, standing between the golden gates: those who have worshipped on earth are coming home for the everlasting Praise. When visiting S. Prassede, if the lights have been turned on, you will see one of the most primitive, but also one of the most delightful, tapestries of coloured marbles.

Curiously enough, the Elders again appear, standing, lifting up their round wreaths, in the mosaic Otto III had made, somewhat

33 later, in the cupola of the Palatine Chapel (today part of the cathedral) of Aachen (formerly, Aix-la-Chapelle). What we see today is an ornate nineteenth-century copy; but we possess a drawing of one of the Elders (now at Carpentras) and a seemingly unreliable engraving in Ciampini's *Vetera monumenta*, which show high-backed seats, and the enthroned Lord instead of the Lamb. The twenty-four Elders also occur in two famous Carolingian miniatures, one in the Gospels

45 from St-Médard of Soissons, and the other in the Golden Codex
47 from St Emmeran of Ratisbon: both will be discussed in the following chapter.

From the Carolingian Renaissance onwards we regularly come across Prudentius's crowned Elders, in manuscripts and elsewhere. Gradually, their wreaths of laurel leaves change into angular diadems studded with gems, and then into medieval crowns ending in a ring of pointed lilies. Their musical instruments begin to vary; the vials become flasks with long necks; the thrones high-backed chairs and,

Six Elders, in the lower zone of the tympanum at Moissac (see pl. 37). (38)

66

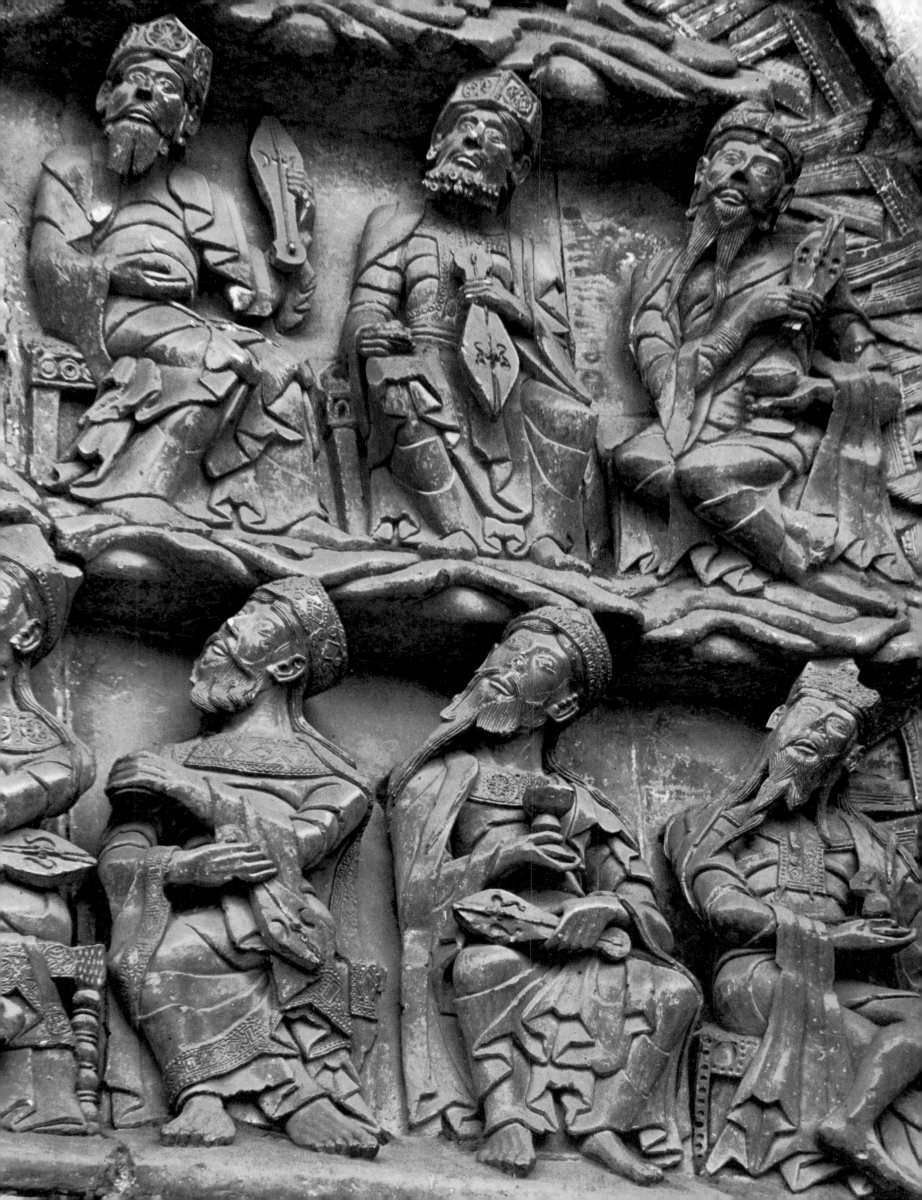

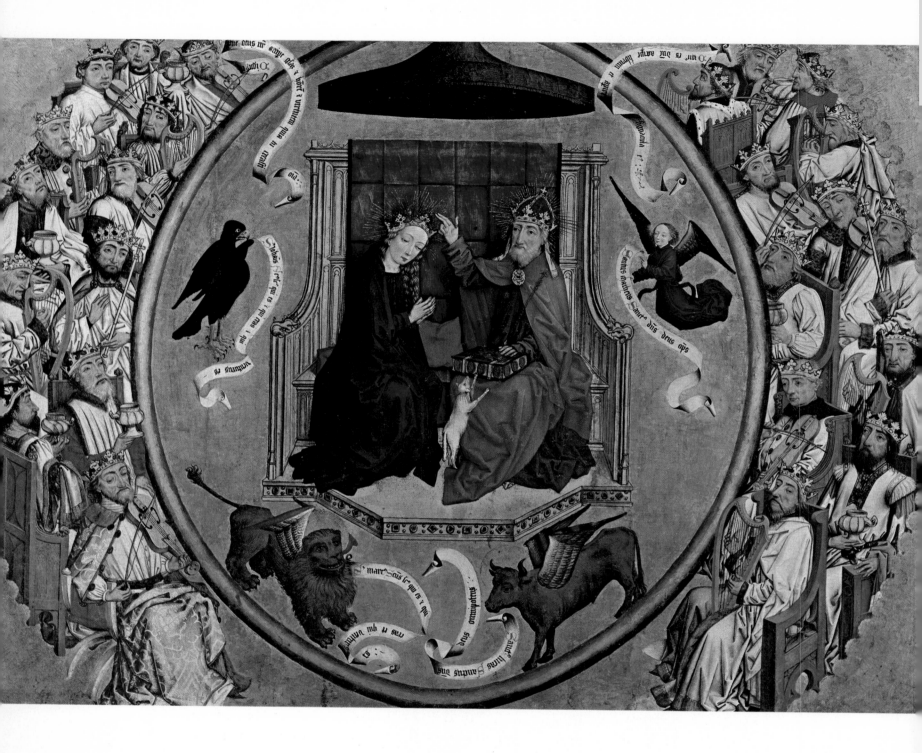

eventually, the joiner's masterpieces of the Romanesque era, wooden seats decorated with rows of arcades.

In Castel S. Elia the vials full of odours, 'which are the prayers of the saints', have become eucharistic chalices raised on veiled hands. 34 In Anagni the chalices float in the air. In the little church of Rignano Flaminia, north of Rome, jewelled cups are held up by tanned old men with magnificent white beards: only their stance and the absence of thrones recall their Roman origin.

Shortly after 1100, the Heavenly Liturgy occurs in the reborn technique of monumental sculpture, in that incomparable masterpiece, 37,38 the doorway of the Abbey church of Moissac. The crowned Elders,

The Vision of the Throne with the Elders, the candlesticks, John on Patmos and the donors, Lord Mayor Scherfgin (died, 1455) of Cologne and his wife. By the 'Master of St John's Vision', Cologne, *c.* 1450; panel 130 cm by 160 cm. Cologne, Wallraf-Richartz Museum, no. 113. (39)

holding their vials and instruments, sitting in rows above the lintel, crane their necks to see the vision above them, which fills the tympanum with an explosion of linear force.

Some decades later, on the Royal Doorway at Chartres, the vision *41,42* has been subdued somewhat, but the Living Beings are still vibrant, and turn their trembling heads to their peacefully enthroned and mildly gazing Lord, who looks like an honest *Beauceron* of the region. One above the other, the Elders, with their harps, violins and flasks, quietly sit on their thrones, in the inner row of voussoirs surrounding the tympanum. There, in the voussoirs, they are found again and again on many sculptured doorways. At Santiago de Compostela, *40* in the famous Portico de la Gloria, in a cordon fanning out at the top of the tympanum, they escort Christ in the scene of the Judgment; and Master Mateo's delicate Elders, I think, are the finest of them all.

In manuscripts the Elders appear mainly in compact groups, always seated, sometimes arranged in compartments on both sides of the Throne. After 1200 the diadems become the pointed lily-crowns, as in the *Trinity Apocalypse* at Cambridge. A little later (BN fr.403) *103* this crown has clearly become the *couronne fleurdelysée* worn by St Louis of France: it transforms the Elders into priestly kings. Such they remain: in the Angers tapestry, in the Karlštejn chapel, and *120* as late as in Memling's picture of 1479. Dürer, who delighted in *174* rendering chase-work, left the lilies untouched. Dante has seen them, *188* in that heavenly procession, between the seven golden trees and the triumphal chariot drawn by the four Beings, contemplated from the depths of Purgatory:

> *Sotto così bel ciel com'io diviso*
> *ventiquattro seniori a due e due*
> *coronati venìen da fiordaliso...*

> Under a sky as fair as I describe
> twenty-four Elders went on, two by two,
> with crowns of fleur-de-lis around their heads...

It is best to forget the prickly crowns disfiguring the heads of all kings and princes, and consequently of all Elders, in the Dutch and German Bible vignettes after 1550. Representations of the Elders become scarce; the last dignified formula can be seen on Mount Athos.

THE FOUR LIVING BEINGS

Soon after the fall of the western Roman Empire the four Living Creatures became detached from the Heavenly Liturgy and began to have a history of their own. In the illustrated Apocalypses they often play an active role, such as taking St John by the hand, with the words, 'come hither, and see!' One of them distributes the vials *80*

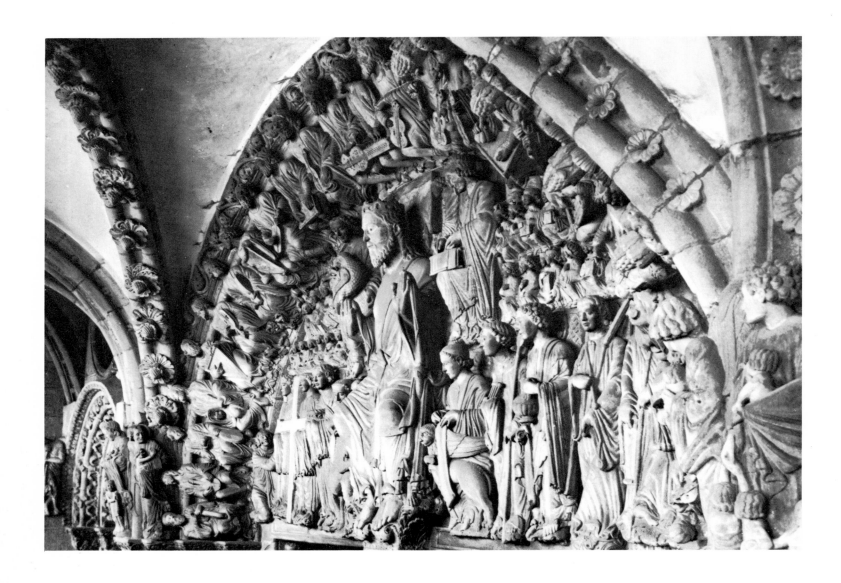

of wrath; in the Mozarabic *Beatus* they participate in collective worship by tumbling down on swastika-like fire-wheels.

Above all, they became the regular symbols of the fourfold Gospel, and, as such, the wheels of the chariot of the Word of God. Gradually, from Merovingian times onwards, they began to fill the four corners left free by the mandorla surrounding the cosmic Throne of Christ. Finally at Tours, using the same centrifugal arrangement, dramatically enlivened, and after much experimentation, the Beings, together with the Lord himself, were positioned in the unsurpassable formula known as the *Majestas Domini*, known among art historians simply as 'the Majesty'.

One cannot think of a more arresting motif for a frontispiece to an *evangeliarium*. The Majesty perfectly expresses the harmony of the four Gospels, far more eloquently than the ten Eusebian canons to which it is usually prefixed. Subsequently it led its own life on the front pages of innumerable Gospel-books, and from there passed into monumental sculpture. As the traditional symbol of the unity, the differentiation and the emotional power of the four holy Books, it ended by dominating doorways and also, painted in apses, the

Santiago de Compostela (Galicia): tympanum of the doorway inside the porch of the cathedral, called Portico de la Gloria. At the top: the Elders, with their instruments and the vials of perfume. The chief theme is the Second Coming and the Last Judgment. By Master Mateo, 1186. (40)

Chartres (Eure-et-Loir), Notre-Dame, Portail Royal, *c.* 1144-55. In the central tympanum are the Lord and the four Beings. In the surrounding voussoirs, the Elders; on the lintel, the Apostles; on the capitals, scenes from the Infancy of Christ, and on the jambs, his Ancestors (after Matt. I). (41)

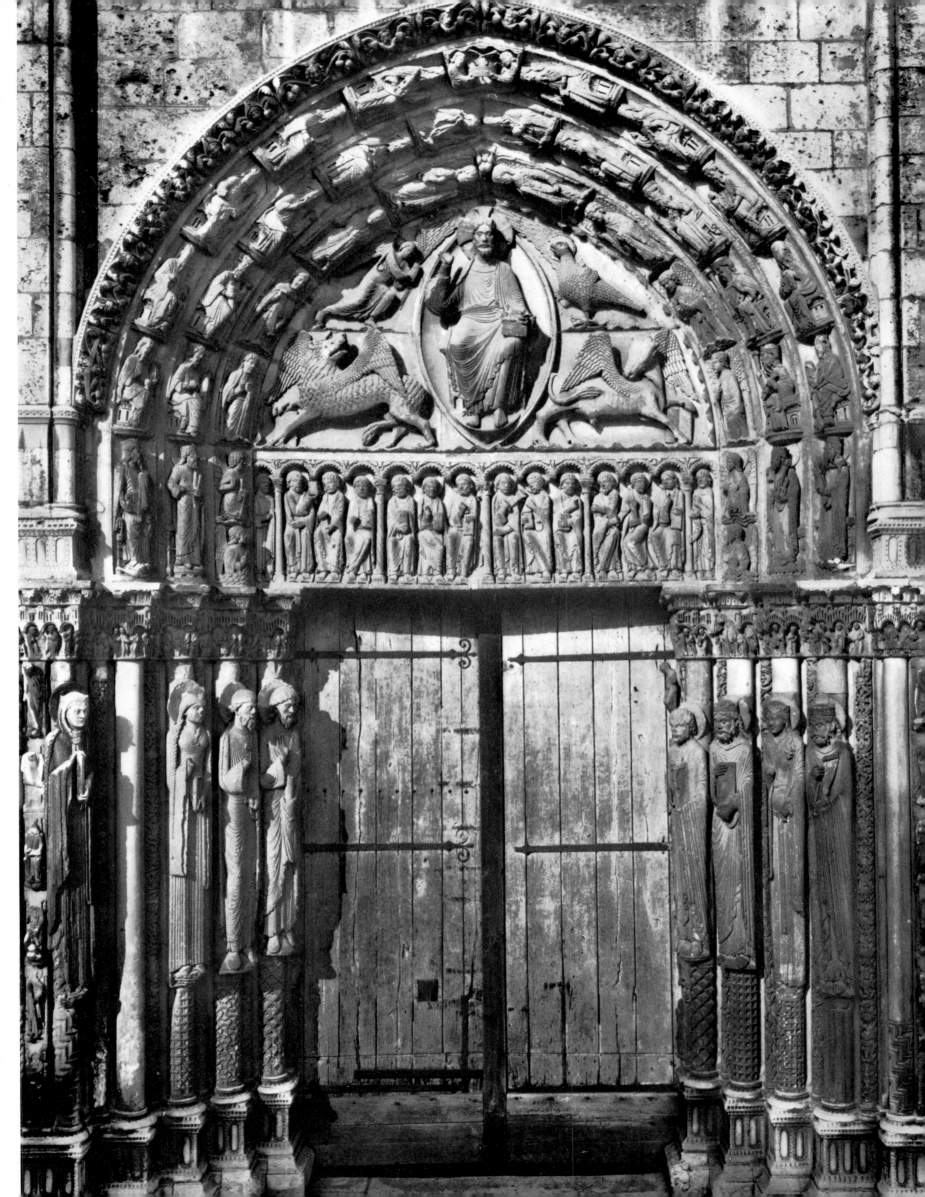

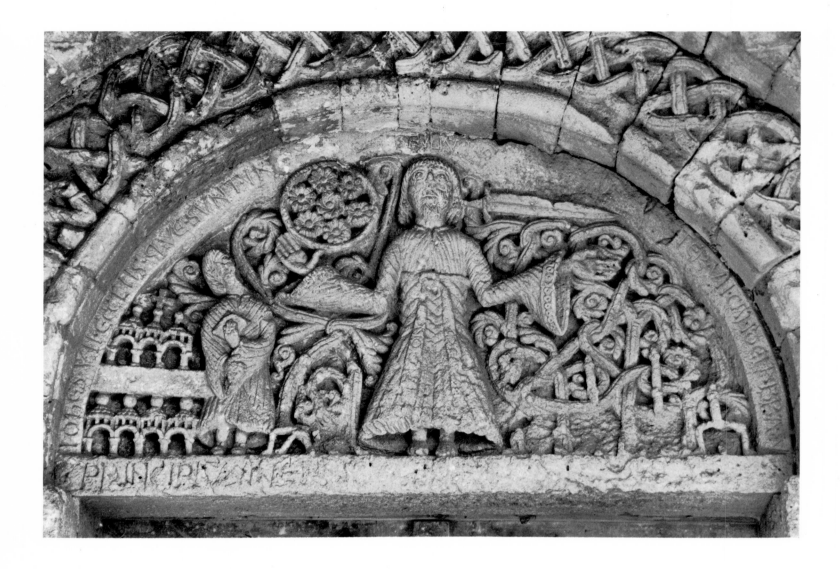

interiors of countless churches. That our occidental Majesty is ulti-
mately derived from the oriental 'theophany of the *Trisagion*', appear-
ing in sixth-century Egyptian chapels, can be neither proved nor
denied. This strictly liturgical motif illustrates a passage in the Alex-
andrian *anaphora* (canon of the Mass), where the Beasts are said
to 'roar, bellow, scream and speak' the threefold 'Holy', according
to their fourfold nature. But if their appearance evokes the Apoca-
lypse, the vision is Ezekiel's.

Their centrifugal disposition, at the corners of the mandorla, at
least seems a creation of Eastern and perhaps Egyptian monastic
piety. In Rome, the four Beings are always set in a row, holding
the books of the Gospels, which goes back to the idea of Ireneus
of Lyons, an image also acceptable to the Greeks. But the rarity
of the motif even in the East (Hosios David at Thessalonica, fifth
century; two miniatures of the Emmanuel, and apsidal frescoes in
the stone churches of Cappadocia, tenth century) remains unex-
plained; and we are in total ignorance of the route by which it
reached the West. After all, neither the centrifugal arrangement nor
the idea of the *Trisagion* are apocalyptic. The Heavenly Liturgy of

36 John seeing the Son of Man, with the sword
coming out of his mouth, holding the seven
stars (in a medallion) and wearing the
golden girdle. The seven arches represent
the seven churches. Tympanum of the
church at Lalande-de-Fronsac (Gironde),
twelfth century. (42)

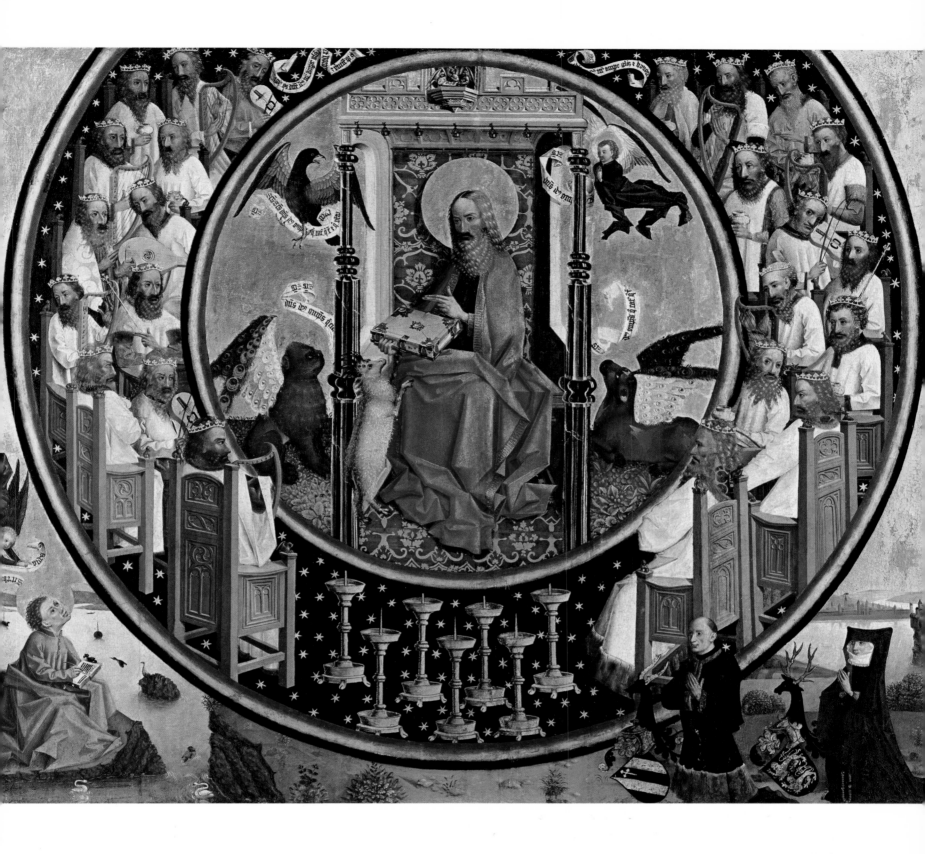

The four Beings and the Elders surrounding the Coronation of the Virgin; the Throne, with the Lamb taking the Book. By the 'Master of the Enthronement of the Virgin', Cologne, c. 1460, panel 105 cm by 147 cm (see pl. 39); Wallraf-Richartz Museum, no. 112. (43)

the Book of Revelation, however, unites Elders and four Beings in the unceasing worship of the Lamb. Lope de Vega expressed it in this way:

Llegò al Impireo divino
Solio del Cordero, dino
De abrir el libro sellado
Donde halló el fín deseado
Del inefable camino.

He came to God's empyreum,
throne of the Lamb, found worthy
to loose the seven signets:
there he could see the end of
the inexpressible Way.

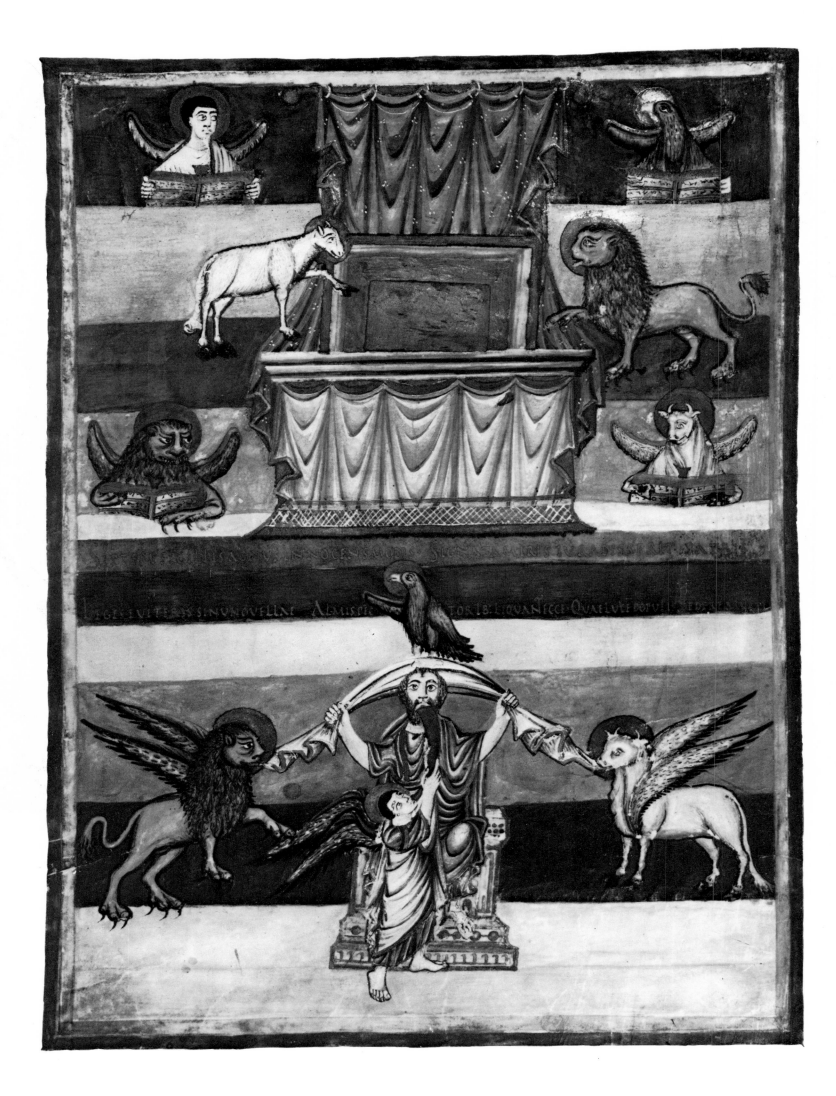

Carolingian Curiosities

The leaders of the Carolingian scriptoria, men such as Alcuin of York and his circle, to whom we owe the knowledge of so many Classical writers, were interested in texts first, in fine script second, and only after both of these in illumination.

As far as possible, they procured a critical text based on the best Ancient manuscripts. For the script, they adopted those magnificent and very un-Antique inventions of the Irish: the initial and the ornamental page. For their writing they devised those beautiful unjoined letters called uncial and semi-uncial, which, after the 'Gothic' interlude, became the starting-point for the printed character of the Italian Renaissance and for our own minuscule. Avoiding the Irish and Northumbrian intricacies, they created a more sober calligraphy in which even the initials were Roman capitals, and legibility and playful arabesques were perfectly balanced. Finally, they tried to copy the available Antique miniatures, especially when the pictures proved indispensable for the understanding of texts, such as Aratus's and Ptolemy's *Treatises on Astronomy*, or a poem evocative of strange allegorical hybridisms, such as Prudentius's 'Battle of the Virtues and the Vices', the *Psychomachia*. This also applied to sacred Books, including the Apocalypse.

They soon felt able to combine and vary styles, even to invent something on their own, and they learned to deal freely with all sorts of Ancient models. How quickly they established their independence, especially at the end of the Ottonian Era, will be shown in the chapter on the *Bamberg Apocalypse*.

64-71

Dealing with a dead language and painstakingly retracing models they did not always understand, as well as starting from scratch in the field of drawing, their admirable effort is rightly called a Renaissance – the very first of the many that were to follow. Their achievements have been admired as deceptively clever and more often decried as pedantic; and, of course, it has been easy for modern pedants to catch them out in small errors. They were more men of letters than artists; they could not refrain from inscriptions and didactic legends, *tituli*, which were far too ingenious and anything but epigrammatical. They were fond of allusive images and visual puzzles. In this respect the disparate imagery of Revelations offered rich possi-

Frontispiece to the Apocalypse, in the Bible from Moutiers-Grandval; Tours, *c.* 840. Top centre: the Lamb and the Lion of Judah on each side of the Throne with the four Beings; bottom: unveiling of the face of Moses by the symbols of the Gospels. This curious cryptogram, illustrating a passage from Victorinus of Poetovio, is explained on page 78. London, British Library, Add. 1054, f. 499r. (44)

75

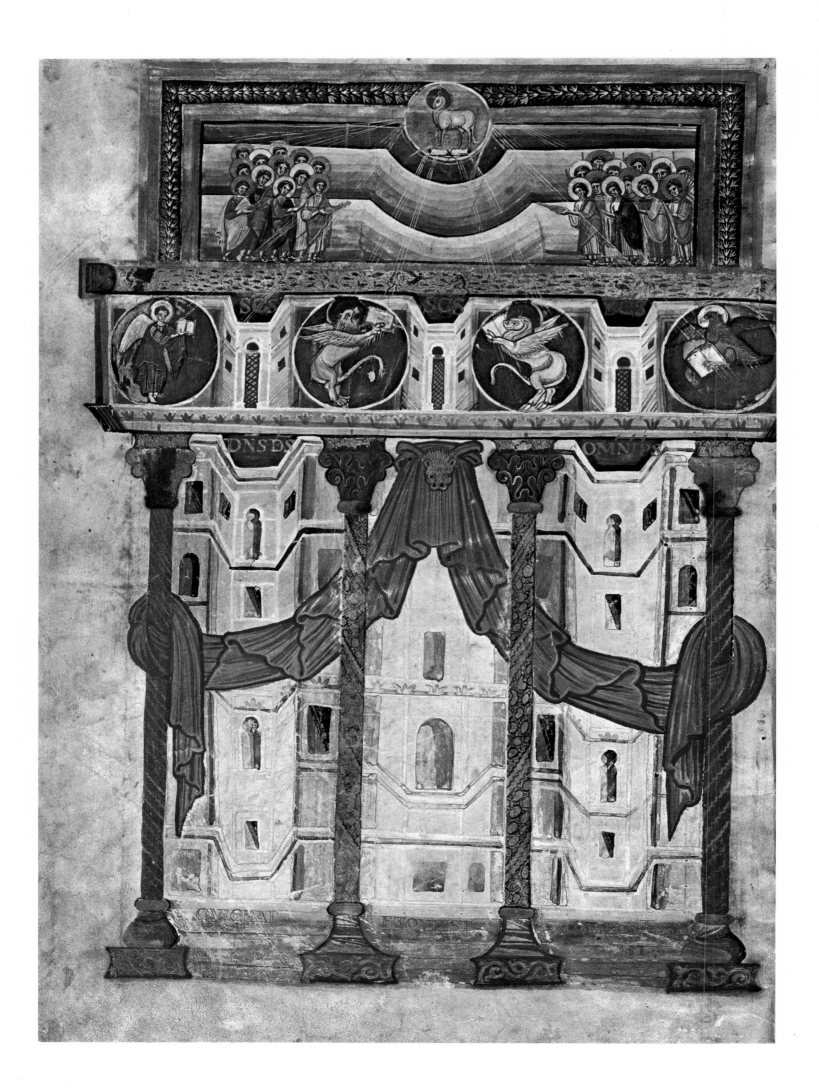

bilities. Consequently, the Carolingian weakness for subtlety produced some apocalyptic curiosities.

THREE FRONTISPIECES TO THE APOCALYPSE

In three of the great Bibles begun under Charles the Bald, a slightly baffling miniature, prefixed to the Apocalypse, summarizes the contents of the Book and at the same time illustrates the word 'Apocalypse' etymologically. Two of these were executed at Tours, about 840 and 844-51, respectively; the third, dated 869, seems to have originated at St-Denis, but offers a variation on the same motif. *44,46*

In all three, the Lamb loosens the first of the seven Seals, and the four Beings unveil the face of a seated old man. What they are doing – most impetuously, incidentally – is unveiling, revealing: *apokáluptein*. The old man, whose face is surrounded by a cloud of ethereal light (and in the most recent manuscript is clearly beaming) holds a long fringed scarf above his head with both hands. The Eagle tears the middle tip of the scarf from his forehead; the Lion and the Ox pull at the ends, with their mouths; the Man, with all his breath, blows a horn against the venerable face visible under the blown-away veil. In the Tours Bibles the legend hardly helps:

> *septem sigillis agnus innocend modis*
> *signata miris iura disserit patris*
> *leges e veteris sinu novellae*
> *almis pectoribus liquantur ecce*
> *quae lumen populis dedere multis*

> The guileless Lamb wonderfully opens
> his Father's Law, sevenfold sealed:
> a new Law, out of the womb of the ancient,
> behold, is made clear for enlightened hearts
> bringing light to a multitude of nations.

The hexameters in the third codex, the *S. Paolo furi le mura Bible*, at Rome, are more illuminating: *46*

> *insons pro nobis agnus qui victima factus*
> *detexit victor surgens volumina legis*
> *atque libri septem dignus signacula solvit*

> The guileless Lamb slain for our sake but triumphantly risen,
> has torn away the veil from the books of the Old Law:
> and been found worthy to loosen the seven Seals of that Book.

The Lamb adored by the Elders and the four Beings in the Heavenly City. Miniature illustrating Jerome's Prologue, *Plures fuisse*, in the Gospels from St-Médard de Soissons, probably illuminated in Rhineland before 827. Paris, BN lat. 8850, frontispiece facing the Prologue. (45)

The unveiling of divine decrees by the Lamb in the Apocalypse is here being identified with the unveiling of the Old Testament, and represented by the tearing away of the veil from the face of an old man. The old man is Moses, for St Paul says (II Cor. III: 7-16) that Moses covered the glory radiating from his face, and intolerable

for the eyes of his people, with an veil, and that this veil, covering the Law, was only 'done away with in Christ'. At the appearance of the Gospel of Grace, the veil lying on the Law vanished and its sense became suddenly apparent. Therefore, the four Beings, symbols of the Gospels since the days of Ireneus, eagerly snatch the veil from the face of Moses, who beams at us with a hitherto hidden glory.

Whose idea was it, to equate the unveiling of Moses with the unsealing of the Book by the Lamb? The answer is – Victorinus's. A bishop of Poetovio (Pettau, now Ptuj, Yugoslavia), he was the very first commentator of the Apocalypse, shortly after 300. When John is weeping, because nobody can unseal the Book, one of the Elders consoles him by announcing that 'the Lion from the tribe of Judah (Gen. IL: 9-10) has won the right to open it'. Immediately, the mysterious Being announced as a Lion appears in the surprising form of a Lamb 'as it has been slain', the Lamb of Isaiah and the Baptist, now seven-eyed and seven-horned. He occupies the Throne at once and, after inspiring a new liturgy in honour of himself, begins loosening the Seals one by one. About the Lion appearing as a Lamb Victorinus now says: 'He is the One who opens and unseals the Covenant He himself once sealed. Moses knew it, and therefore he veiled his face.' In this way Victorinus quietly identifies the unveiling with the unsealing. The Carolingian exegetes could have found Victorinus's idea in Jerome's expurgated edition; but I am afraid they failed to look up the passage, and simply copied an Early Christian miniature illustrating it. Indeed, in two of the Bibles, the earlier ones, the unveiled Moses appears side by side with both Lion and Lamb.

Although the three frontispieces are identical in their main theme, they differ in some details; these, too, betray an Antique and Italic model. In the first manuscript, the *Moutiers-Grandval Bible*, the Book stands upright on an Altar, before a curtain attached with rings to a pole. In the second, the *Vivien Bible*, it lies on a purple-covered Throne, recalling that of the Roman mosaics. The Altar is clearly a corruption of throne and altar.

Lamb, Lion, Book and the four Beings are identical in both of these codices. The artist working for Vivien, however, has added some strictly apocalyptic motifs. Above the Book, with one Seal loosened, the first Rider, in *chlamys* and with Phrygian bonnet, leaps forward – a perfect Parthian archer. Emerging from a cloud, the Elder shows the Lion and the Lamb to the weeping John. The Great Angel stands on the heads of *Tellus* and *Oceanus*, earth and sea, and sticks the little Book into the mouth of John, who is holding the rod for the measuring of the Temple: Book and little Book are thus brought together.

The third frontispiece, that of St Paul's, is by far the finest and the least equivocal. Within a frame of (slightly misunderstood) acanthus, the seven churches and a towered wall surround an open space

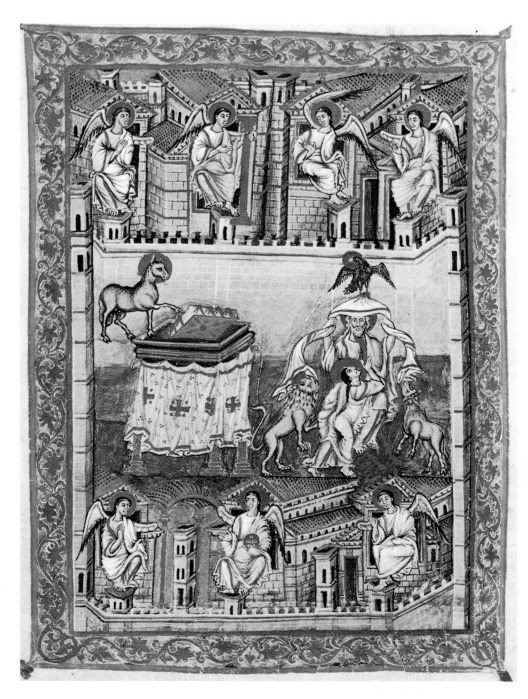

Frontispiece to the Apocalypse, in the Bible of S. Paolo fuori le mura; produced in St-Denis, 869. The seven churches with their angels; the Lamb and the Book; the same cryptogram as in pl. 44. Abbey of S. Paolo fuori le mura, near Rome, Bible, f. 328v. (46)

in which the Lamb loosens the first Seal, opposite the Moses group. The Book lies on an ordinary altar supported by four colonnettes and draped with a cloth embroidered with clovers and crosses in the Antique manner. The angels of the churches sit in the windows of the façades, their feet resting on the platform of small wall-towers. Robed in white tunics and pallia, *taenia* (an Antique headband, with fluttering ends) in their hair, each is elegantly and individually posed. They dominate the aisled basilicas, covered with red tiles, and the pink crenellated city walls, which possibly are meant to suggest the Heavenly City. The angel of Thyatira holds the iron rod (Rev. II: 27) and an imperial orb; the angel of Philadelphia, a column, alluding

to his message: 'Him that overcometh I will make a pillar in the temple of my God' (Rev. III: 12).

The unconstrained attitudes and the garments of the angels, the tympana at the top of the church façades, the long rows of windows in the clerestories, the bond of the masonry and the regular battlements all unmistakably point to an Italic model from about 500.

The main idea and the single motifs are derivative, but the mounting of the whole probably originated with the painter, for the Ancients did not use full-page miniatures but strips at the bottom and the top, or inserted pictures called *tabellae*. The *S. Paolo Bible* contains twenty-four of these full-page pictures, all of them crowded, and obviously composed of copies from Antique strips, cleverly put together one above the other, in different zones. Naturally these were copiously provided with explanatory verses, often ten lines to a page.

The very last picture is our frontispiece, the strangest and most sophisticated of them all. No other picture characterizes so exactly the genius of these gifted, recently converted Barbarians, who were fascinated by the majesty of the Early Christian past: these Frenchmen, Britons, Lombards, and Saxons living before France, England, Italy and Germany came into being. Charlemagne had been their leader, Latin Christianity was their fatherland, the Church their home. This would continue until the end of the Middle Ages.

THE FRONTISPIECE OF THE GOSPELS FROM
ST-MÉDARD DE SOISSONS

The supposedly Rhenish Gospel-book, given in 827 by Louis the Pious to the abbey of St-Médard at Soissons, opens with a full-page miniature illustrating Jerome's Prologue, which begins with the words *Plures fuisse*.

All contemporary Gospel-books contained a fixed set of prolegomena. First, Jerome's Letter to Pope Damasus, followed by his translation of Eusebius of Caesarea's Letter to Carpianus; then, the splendidly framed *canons*, or tables of concordance, by the same Eusebius, in parallel columns, under ornamental arcades; finally, Jerome's preface *Plures fuisse*. In this Prologue Jerome attacks the apocryphal gospels, those *naeniae*, and ditties rather to be sung by dead heretics than by living church people. He then begins his proof that there can be only four Gospels: 'The Church', he says, 'has only four corner-rings by which the Ark of the Covenant, the shrine containing the Lord's Law, is carried forward, as with separate sticks': namely, the four Beings bearing the Throne. Ezekiel had already said of them: 'four faces to One', that is, four aspects of the same thing, the four Gospels, no less and no more. John's Apocalypse, too, after mentioning the Sea of crystal and the twenty-four Elders holding citharas and vials, introduces four Living Creatures: 'They were full of eyes, and they have no rest day and night, saying, holy, holy, holy, is

The Lamb adored by the Elders. Miniature in the Golden Codex of St Emmeran, at Ratisbon, written for Charles the Bald, about 870. Munich, Bayrische Staatsbibliothek, Clm. 14.000 (Cim. 53), f. 6. (47)

45

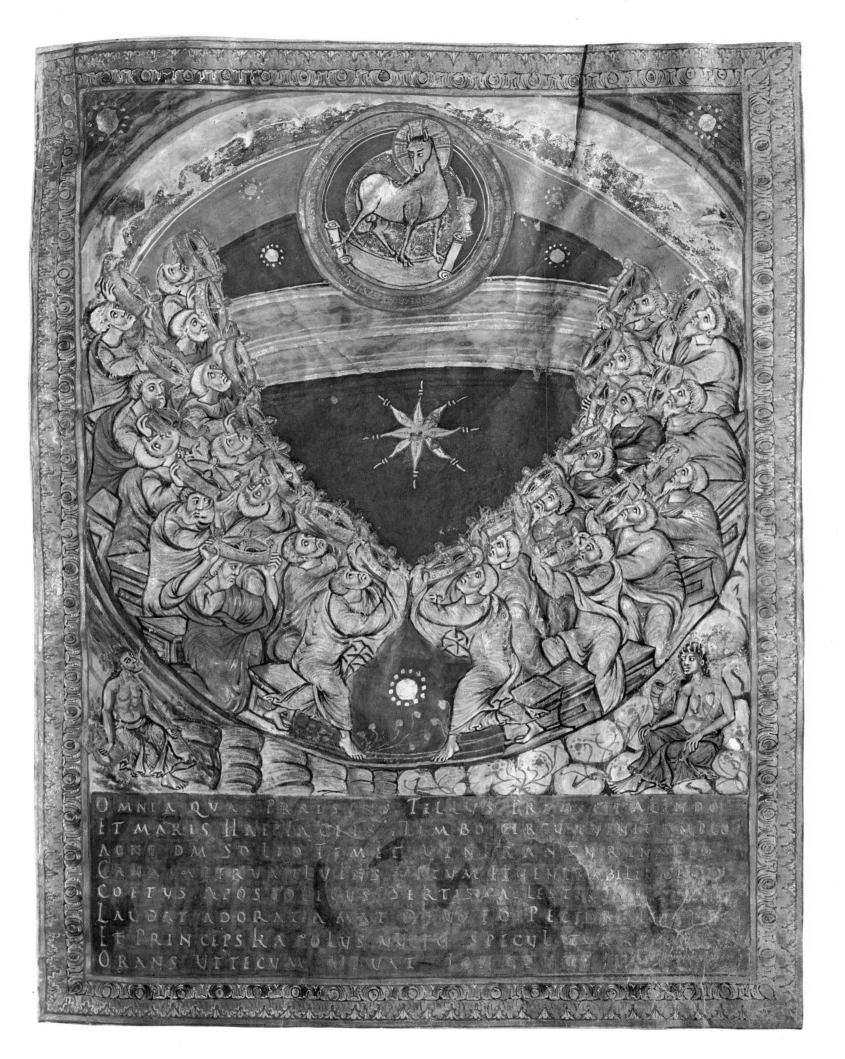

OMNIA QUAE PRAESENS TELLUS PRODUCIT AB INDO
ET MARIS HAEC CELLIS LIMBO CIRCUMVENIT AMBO
AGNI DM SOLIO TIMET VENERANTUR IN ILLO
CANA CATERVA LIVENS VARIUM ET VENERABILE CLARO
COETUS APOSTOLICUS SERTIS CAELESTIA
LAUDAT ADORAT AMAT DEVOTO PECTORE
ET PRINCEPS KAROLUS AUITO SPECULATUR
ORANS UT TECUM VIUAT LOTHARIUS

the Lord God Almighty, which was, and is, and is to come' (Rev. IV: 6 and 8).

All of this has been accurately illustrated in the frontispiece. The cry of the four Beasts is written below their images, in golden capitals. We see the Elders with their instruments, the Sea of glass, the adoration of the Lamb. The Beasts are very restless indeed, and are set in medallions which suggest four rings on the sides of a peculiar Ark. Such a meticulous rendering of a very abstruse text is almost unique.

In the truly imperial codex, the frontispiece is clearly the apogee: bright, subtle and slightly enigmatic. The Heavenly Liturgy, at the top, occupies less than a fifth of the composition. Like a sun, the golden medallion with the Lamb hangs in a blue sphere above two purple ones, sending down a fan of white rays; the Lamb proudly stands on the tightly bound Scroll. On each side, at a respectful distance, the twelve Elders are grouped: beardless young men, robed not in white but in blue, pink and pearl-grey, with white or golden haloes, and oblong citharas (only the Lamb has a silver halo). Faultlessly posed, they resemble a self-conscious orchestra. Instead of crowns they are wearing wreaths. They seem to pause, standing on the greenish Sea of glass in which tiny dark figures of naked fishermen are busy between water-birds and fishes, just as in the Nilotic idylls bordering Roman mosaics and figuring a playful Jordan.

The long beams sent forth by the Lamb, falling across the Sea, touch each of the four Beings, evidently the central characters. They are standing upright in azure medallions, raising their wings, roaring and bellowing and swishing their tails; between them, we read the text of their cries. Their medallions are mounted on the protruding parts of a sort of attic storey, adorned with trellised windows, and set on an architrave supported by four columns of variegated marble, the same kind as those seen in the Eusebian *canons*. From a lion's head, two curtains of red brocade fall open, their ends looped up around the shafts of the outer columns. The medallions with the four Beasts are reminiscent of Roman bas-reliefs, such as those on the arch of Constantine; the projecting parts of the attic storey recall the four sides of the Ark, and the *clipei* its four rings.

But the fantastic architecture goes even further; it fills the whole background. Behind the colonnade is a bluish white building of six storeys, again with four receding and projecting parts, empty as a deserted stage. In fact it evokes the *scaenae frons*, the mighty ornamental back wall of Roman theatres. Its arched doorways, horseshoe arcades over the windows, square openings and strong cornices between the storeys are pure Mediterranean, and exactly like those in Greek and Russian icons centuries later. Could it be the Heavenly City, where the Lamb is the sun?

It is the four columns, however, not the strange edifice, that support the architrave and the attic with the rings, and even that frivolous Sea of glass. Possibly the painter merely created a variant on

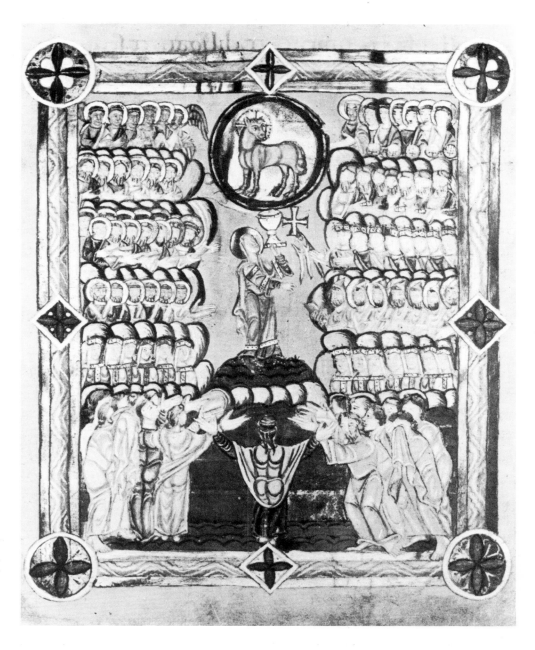

the layout of the pages with the canon tables. We should enjoy his
fine composition rather than speculate about his unknowable inten-
tion.

THE ADORATION OF THE LAMB
IN THE GOLDEN CODEX OF ST EMMERAN

The distinguished Elders of the Soissons concerto contrast violently
with their naïve equals in a famous miniature of the Golden Codex, *47*
which Arnulph of Carinthia gave to the monastery of St Emmeran
in Ratisbon, about 870, and now preserved in the State Library at
Munich.

Twenty-four robust old men are seen jumping to their feet from
little stools. Pulling gigantic diadems from their hoary heads with

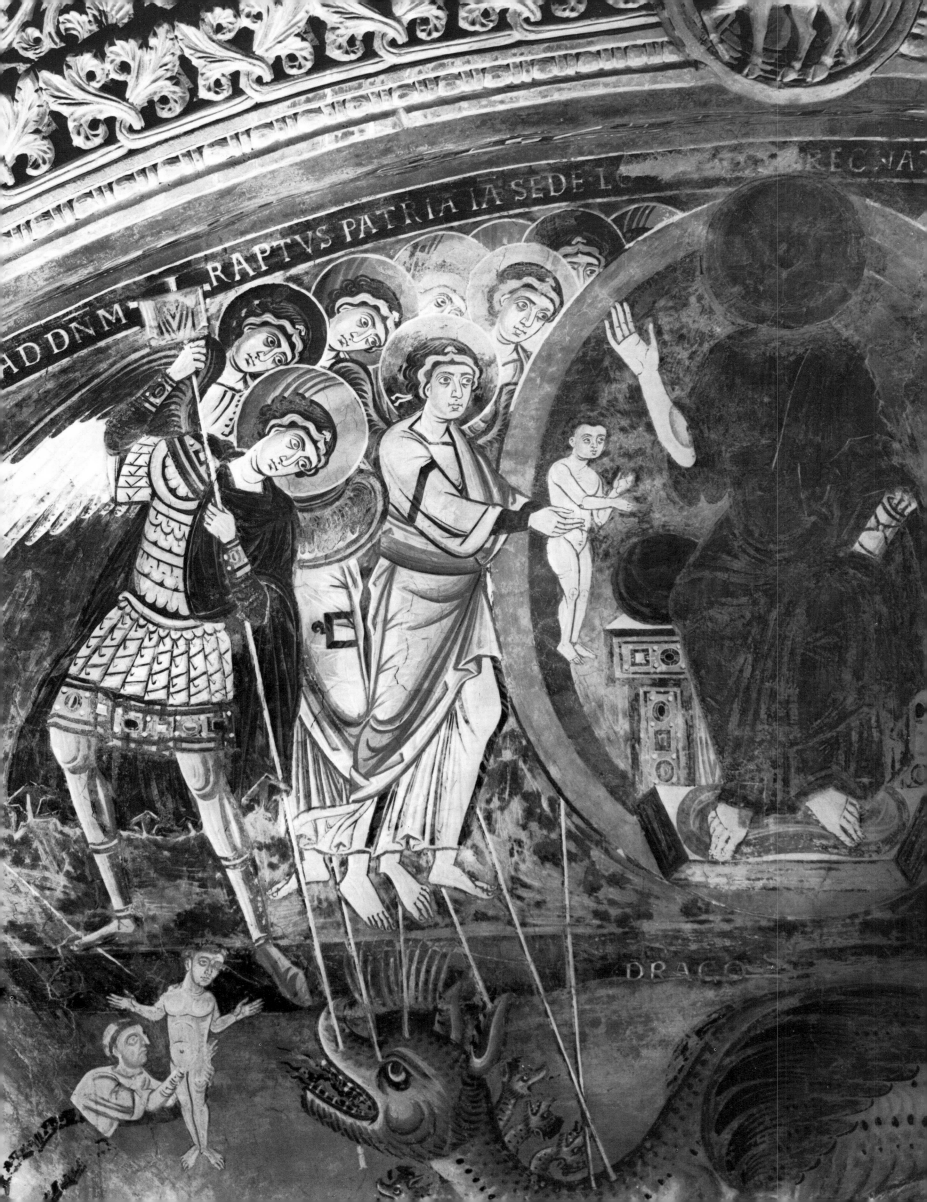

both hands, they rush forwards in a semicircle to look up at the Lamb, who stands quietly in the sun of his *clipeus* in the midst of the celestial spheres; his four feet hold an already unrolled Scroll. He looks down on the excited group below; blood trickles, one does not see exactly from where, into a chalice resembling the Tassilo cup at Kremsmünster. He is Prudentius's *agnum caede cruentatum*, the Lamb, bloodstained by murder. The chalice suggests the Eucharist and recalls the fact that long ago Pope Sergius I had introduced the chant of the *Agnus dei* at the moment of the Breaking of the Bread and the mixing of Bread and Wine in the chalice. The inscription surrounding the Lamb admonishes that it is the Church that holds the chalice, and the Synagogue that goes away empty-handed:

suscipit agne tuum populus venerande cruorem
et synagoga suo fuscata colore recessit

Your own Blood, venerable Lamb, your people now receives and the Synagogue, her colours darkened, has withdrawn.

The adoration of the Lamb in his tenderest mystery is represented with both utter naïvety and maximum dynamic expression.

The whole image is circular. The spheres, full of stars, seem to revolve, giving an impression of the slow rotation of the nocturnal sky, in which hangs the quiet sun of the Lamb. Suddenly a counter-movement begins below. Rising as one man, a crescent of surprised prophets, the Elders leap forwards: some with crowns torn halfway from their heads, others holding them out to the Lamb. The foremost ones have thrown back their heads, craning their necks, eyes dilated. And their huge diadems – worn easily around their waists – form a v of wrought gold just below the Lamb, on each side of an eight-pointed jewelled star (seen on mosaics in Rome and Ravenna) not unlike a stylized columbine.

In one of the spandrels below the orbicular main scene, a grey *Oceanus* looks up in amazement: a vigorous old man with a muscular torso, lobster-pincers in his hair. Holding a trident that ends in an oar, he sits on the waters gushing forth from an overturned pitcher. In the opposite spandrel, Mother Earth, *Tellus*, a woman with sagging breasts and holding two cornucopias, sits amidst creepers, looking askance at the celestial spectacle.

A lengthy metrical inscription, written in gold on purple, assures us that sea and earth and all they contain also adore the Unnamed and the Lamb. It also identifies the Elders:

cana caterva cluens et vatum venerabilis ordo
coetus apostolicus...

The 'white-haired' crowd: the group of the venerable prophets and the apostolic college...

Thus it proves that the painter knew very well that the Fathers of

The Woman threatened by the Dragon; the Child carried away to the Throne; Michael and his angels fighting the Monster, whose tail sweeps down the stars. Frescoed lunette on the inner west wall of the little mountain church of S. Pietro al Monte, 1400 m above Civate, near Lecco, on Lake Como (Lombardy); twelfth century. (49)

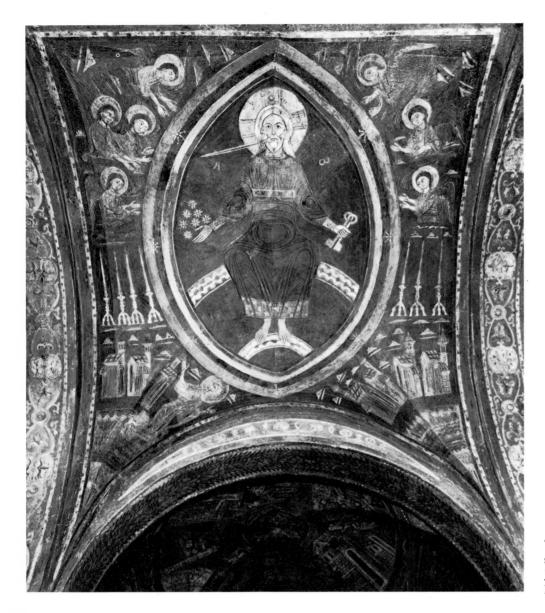

The Son of Man and the candlesticks, the seven churches and their angels; below: John. Frescoed vault in the crypt of the Duomo, Anagni (Lazio); 1231-50. (50)

the Church unanimously held the Elders to be the authors of the Old and the New Testaments.

Far more than by the poor clumsy verses, and the pagan allegories that have now become clichés, we are fascinated by the way a hitherto static motif has been powerfully brought to life. True, the attitude of the Lamb, the garments, the veiled hands, the spheres are still in the Antique manner. But the bare feet, the colossal crowns, the rotating spheres and, above all, the childish spontaneity and energy of the Elders are entirely new. More than a century ago Père Cahier, who deciphered the Bourges windows, a man always exquisitely prudent in his judgments, confessed that the Ratisbon Elders reminded him of a group of schoolboys rushing from the classroom at the first sound of the *Angelus*. I do not know a more convincing image of enraptured adoration, however, than this naïve and virtuosic minature.

86

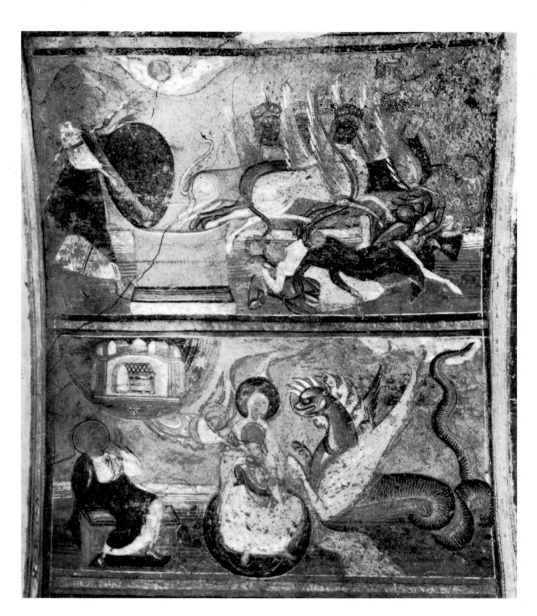

The Locusts swarming out of the Bottomless Pit; the Woman threatened by the Dragon, her Child being carried away; the Ark of the Covenant appearing in the Heavenly Temple. Frescoed vault of the gallery, in the porch of the abbey church of St-Savin-sur-Gartempe (Vienne); end of the eleventh century. (51)

SACRAMENTARIA FROM FULDA:
THE CHURCH AND THE BLOOD OF THE LAMB

Fulda, a centre famous in the ninth century for its learned men, for a humanist such as Hrabanus Maurus, for pupils such as Lupus, later abbot of Ferrières, and, above all, for its priceless editions of Classical writers, does not rank equally high in the field of art. It is not until after 970 that anything relevant to the iconography of the Lamb appears. A small number of miniatures, all of them found in liturgical manuscripts, are remarkable not for excellent drawing or bright colour but for the illustration of new ideas. A Lamb with seven eyes and seven horns, standing between the heads and shoulders of the four Beings, drawn across the verses of Hrabanus's *de laudibus sanctae crucis*, about 831-40, hardly deserves attention; 130 years pass before something really worthwhile occurs.

In a lectionary, now in Aschaffenburg, a full page is dedicated to the image of a slaughtered Lamb, surrounded by the four Beings and two angels. Below the medallion of the Lamb, its Bride, the Church – crowned and veiled, holding the banner of the Cross, and leaning back, open mouthed, to see the vision – receives the precious Blood, trickling from the Lamb's wounded side into a low golden chalice. Between the five crosswise linked medallions that contain Lamb and Beasts, on a leaden background, a legend reads:

MORTVVS AGNVS
DIGNVS HABETVR
SVMERE LIBRVM
ILLIVS ATQVE
SOLVERE SEPTEM
NEMPE SIGILLA

The Lamb who died
is found worthy
to take the Book
and loosen the seven
Seals thereof.

We do not see any Seals, in fact, only an open diptych. Near the angels it reads:

HIC SACER AGNVS
MILITE CAELI
VNDIQVE SAEPTVS
ENITET ALBVS

The holy Lamb
by the heavenly host
safely surrounded
shines in its whiteness.

The Lamb, however, is grey and pink; the angels hold neither orb nor lance. Near the Church the inscription proclaims:

AECCLESIA ECCE
CERNVA QVIPPE
SVSCIPIT AGNI
DIGNA CRVOREM

Behold the Church
bowing down deeply
receives, being worthy,
the Blood of the Lamb.

But the Church is not kneeling down, *cernua*, but leaning back. Text and images do not agree.

The presence of the Church is new, also her appearance: she is

The Rider with the iron rod, on the white horse. Fresco on the vault of the crypt of Auxerre Cathedral (Yonne); c. 1100. (52)

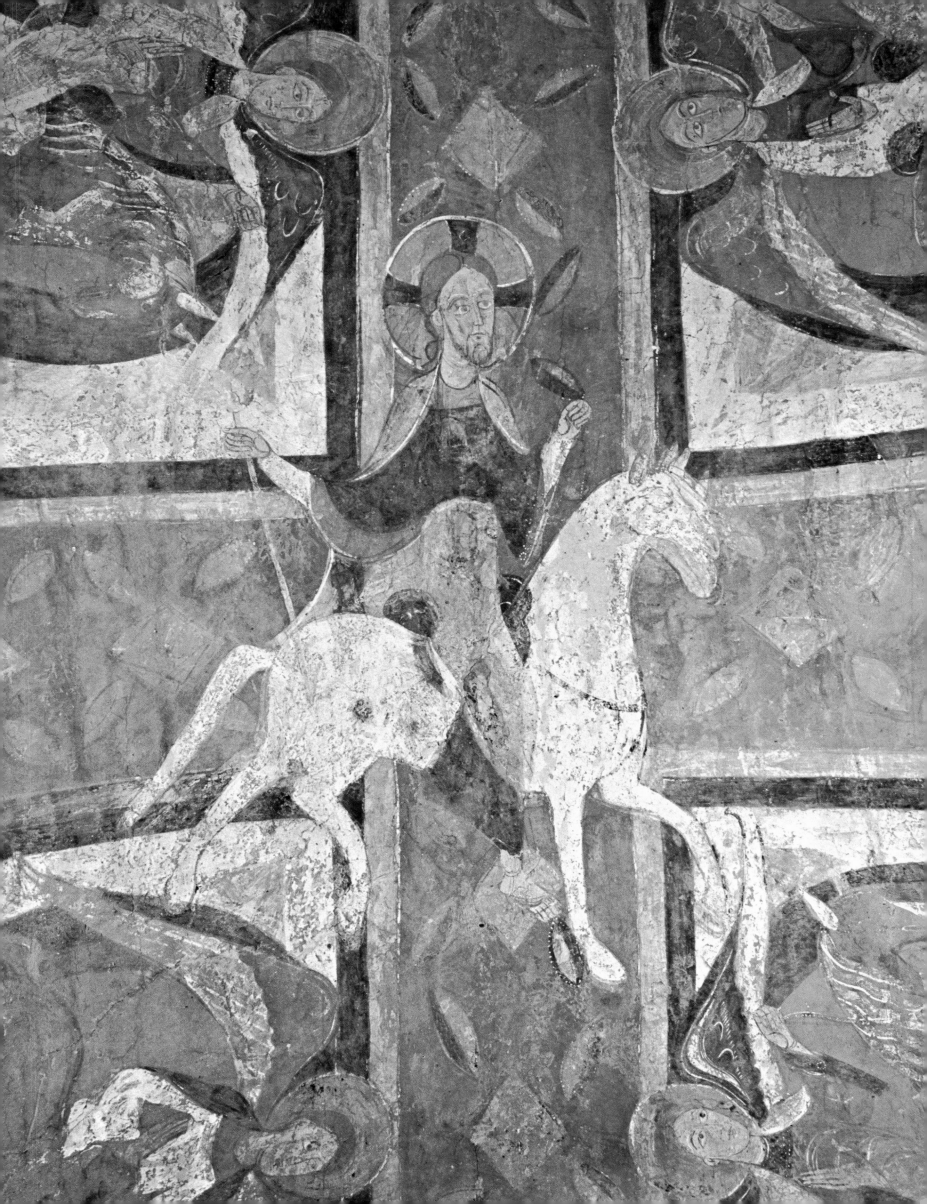

no longer the dark-veiled matronly Mother, *mater ecclesia*, of the mosaic in S. Sabina, but a crowned princess holding a triumphal banner, receiving the Blood of the Lamb in the chalice of the Eucharist. Presently she is to face the blindfolded Synagogue, whose crown falls down and whose banner is broken. The future grandiose figures of Reims and Strasbourg are already anticipated.

Sometimes, in Roman mosaics, the Lamb stands in front of the Cross. In the early Middle Ages its medallion forms the centre of the ivory or gold crosses carried in processions or adorning reliquaries and liturgical books. In this way it literally illustrates Venantius Fortunatus's famous stanza of the hymn, *Pange lingua*, sung on Good Friday:

> *Se volente, natus ad hoc,*
> *passioni deditus,*
> *agnus in crucis levatur*
> *immolandus stipite.*

> Voluntarily, born to suffer,
> to his passion He proceeds:
> to be slain the Lamb is raised
> on the wood-trunk of the Cross.

In the Apocalypse the Blood of the Lamb is mentioned, not the Cross on which it was slain. In the Fulda *sacramentaria* it is the Church who receives the Blood in the chalice from which it is mystically drunk. Later, the crucified Lord always takes the place of the Lamb, but the Church remains, standing at the wounded side – a new Eve born from the side of the new Adam, and personified by the Virgin Mary – and is seen receiving the mysteries of the 'blood and the water', baptism and the Eucharist.

In some other Fuldensian manuscripts the Lamb, the Blood, the chalice and the Church are brought together with the Great Multitude of the redeemed. In a *sacramentarium*, now at Göttingen, the whole community of the saints surrounds the Lamb and the Church receiving its Blood. In rows, one above the other, the Elect are seen half-length above the clouds: first, the Virgin and the Incorporeal Powers; then, the Apostles opposite the prophets (Elders? – one figure too many); the kings and queens, without clouds, follow; finally, bishops, pious laymen and, opposite, monks without haloes, in *cuculla*, with their abbot holding the Book of St Benedict, his *Rule*; the date is about 975.

48 In a second *sacramentarium* from the same time, now at Udine in Friuli, the Multitude is composed of angels, Apostles, prophets and old men holding crowns (Elders?), kings, monks and a double row of queens and princesses. The Church, standing on Mount Sion, below the Lamb, holds the banner of the Cross and the golden chalice. From below, the faithful of the Church Militant are looking up at the saints enthroned above the clouds; one of them wipes

his eyes with a tip of his mantle; a long-haired woman, seen from behind, stands in their midst and by her attitude recalls an *orante*, one of those figures praying with raised hands, seen in the catacombs.

These two humble miniatures are the oldest images of 'All Saints'. They can be compared to the mosaic in S. Prassede, mentioned before, and other images of the Heavenly City filled with the Great Multitude – such as the thirteenth-century roof-painting in the little church of Schwarzrheindorf opposite Bonn. There, the Multitude of All Saints'Day assists at the Marriage of the Lamb, and a profusion of texts quotes the Apocalypse, notably the passages about those 'who came out of great tribulation, and have washed their robes and made them white in the blood of the Lamb' (Rev. VII: 14), the martyrs.

It is in compositions like these, rich in thought and perfectly biblical, that the subject as well as the disposition of such a masterpiece as Jan van Eyck's polyptych of the Lamb are modestly announced *160* and almost prefigured, before they blossomed into perfection two centuries later.

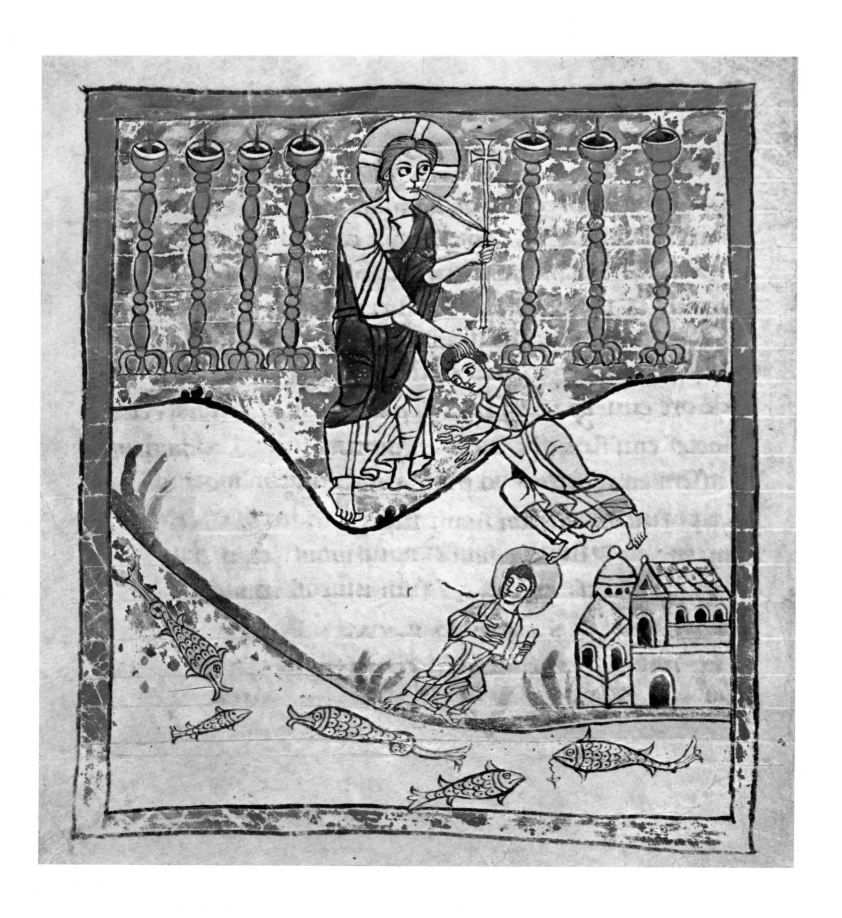

An Apocalypse 'en sourdine':
the Trier Manuscript

THE OLDEST ILLUSTRATED APOCALYPSE

At first glance this Apocalypse gives the impression of being childish copies of a full cycle of rather prosaic Antique miniatures, datable from about 500. The pictures of the original must have been drawn by a firm hand; those of the copy, which is apparently early Carolingian, seem very carefully reproduced, but the quality of the drawing deteriorates and is very poor towards the end.

There are seventy-four full-page pictures, each faced by the text, consisting of the Apocalypse, without commentary. The original Latin text, written in the beautiful semi-uncial peculiar to the scriptorium of Tours, was scratched out in the twelfth or thirteenth century, and replaced by the same Vulgate version, in a more modern script. As early as the tenth century the codex belonged to St Eucharius at Trier; today it is a treasure of the Trier Library and before long it will be published in full colour.

Experts unanimously place the original in Italy, about 500, and the copy in the first half of the ninth century, hypothetically, at Tours. True, the apocalyptic frontispieces of the Tours Bibles are better drawn and less purely linear than the miniatures done by the Trier copyist, who is a mere primitive bungler, but a certain affinity is unmistakable.

In itself, the very first illustrated Apocalypse is bound to intrigue. Here, however, we are fascinated by the purely Antique spirit permeating the whole, notwithstanding the poorly linear and sometimes clumsy procedure of the copyists. It is amusing to see, here and there, what these unimaginative clerics consciously modified. For instance, short tunics clothe formerly naked demons, and, twice, a pig's head and crooked horns appear, which belong to Tours, not to Italy. Alteration to the colour remains uncertain. Undoubtedly, the Ancient *tabellae* showed a differently coloured celestial and earthly zone, when required by the text; whether these zones were divided by hard lines, or still in the old illusionistic way, it is hard to tell. As a rule, the artists here simply filled their silhouettes with very thin colours, often no more than dull brownish, reddish and greenish touches. As far as I can see, they neither composed nor invented anything important of their own.

John on the island of Patmos; the Son of Man between the candlesticks. This miniature, and the eight that follow, are taken from the oldest cycle illustrating the whole of the Apocalypse, a Carolingian copy of an Early Christian prototype, dating from the end of the fifth or the beginning of the sixth century (see page 101, for the analysis of this cycle). Trier, Stadtbibliothek, ms. 31, f. 4v (Rev. I: 12-18). (53)

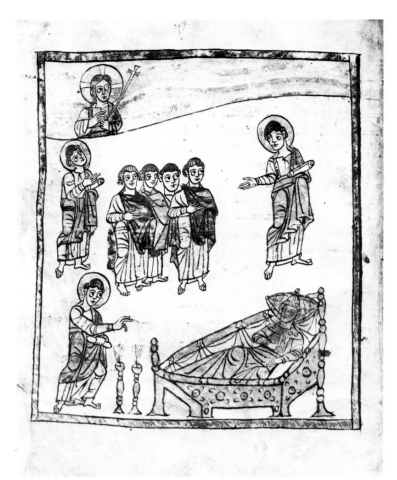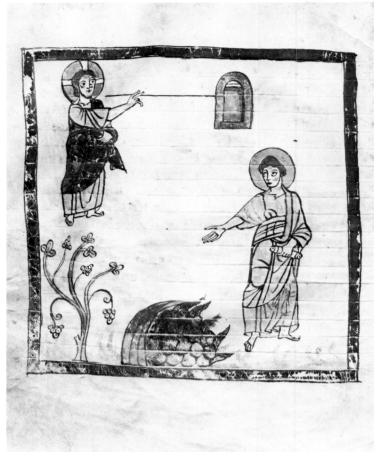

It is certainly worth enumerating all the evidently Antique features: everything that could not be of Carolingian origin. First, the very uniform composition. Each miniature is a rectangular *tabella*, framed in pale-red; the celestial zone is filled with one colour, the lower zone with another or left white. The gradual transitions, such as still seen in the Vatican *Virgil*, have vanished. Whether the whole of the abstract linear system is due to the copyists remains problematical. In itself, linearity has its advantages. It renders a picture surveyable and its details legible; figures and buildings are separate silhouettes that hardly ever overlap. Even compact groups – the Elders, spectators, worshippers, fugitives, victims – are always clearly contoured.

Figures and garments are purely Italic. Christ is a beardless young man, with a crossed nimbus, sometimes holding a staff-cross. He sits on the cosmic globe, exactly as in S. Vitale at Ravenna and S. Teodoro alle Terme in Rome, or sometimes, on the typically Tours globe that forms an 8 with the almond-shaped glory behind the Lord's seated figure. The four Beings closely resemble those on the Roman triumphal arches; their books are identical, but now and then we see only four heads, each set on six wings. The Lamb's *clipeus* is the Roman one; however, the Lamb wears a crest of seven horns,

Illustration of a passage in the Letter to Thyatira: 'I will cast her (Jezebel, the seductress) into a bed' (Rev. II: 20, 22). Trier, Stadtbibliothek, ms. 31, f. 9v. (54)

Illustration of a passage in the Letter to Laodicea: 'Behold, I stand at the door and knock' (Rev. III: 20); and: 'I counsel thee to buy of me gold tried in the fire' (Rev. III: 18). Trier, Stadtbibliothek, ms. 31, f. 13v. (55)

53-61

53,55

9

32,56

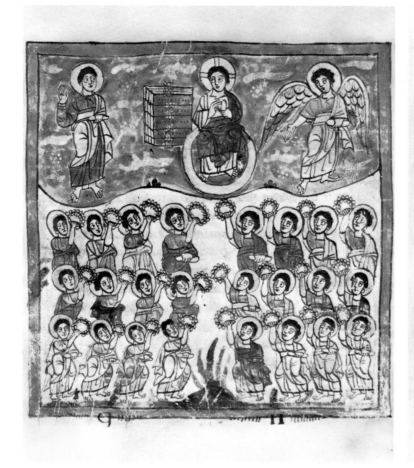

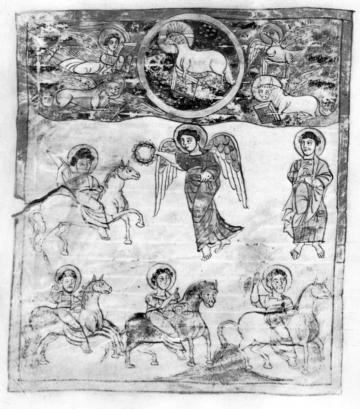

The Elders casting their crowns before the Throne; the Book with the seven Seals, admired by John (Rev. IV: 10 and V: 1-2). Trier, Stadtbibliothek, ms. 31, f. 16v. (56)

The Lamb opening the first four Seals; the four Riders (Rev. VI: 1-8). Trier, Stadtbibliothek, ms. 31, f. 19v. (57)

and five secondary eyes are set between eye and ear. These are crudities unacceptable to Classical artists and, therefore, never seen inside the basilicas.

The angels are the usual ones: decently dressed Victories, winged and haloed, almost always carrying a scroll, even when floating in the air or announcing cataclysms. John, too, invariably holds a scroll; his astonishment is indicated by a half-bared raised arm, his anxiety by a hand held against his cheek, traditionally the noble gesture expressing concern or affliction.

The central characters – the Lord, his angels, the Elders, Apostles, prophets, the Witnesses – all appear in the stately garments worn by people of rank: a white tunic adorned with *clavi*, bands indicating their rank; and that commodious upper garment called a pallium, which covers two thirds of the body, leaving one shoulder and arm free. They are not unlike senators marked by a Christian nimbus around their always clean-shaven faces; in the true Roman fashion, holding their scrolls, they are walking or standing quietly, looking at the cataclysms or the glories, with hardly a glance at the rabble. Even the Elders are beardless. Christ alone wears his hair somewhat longer than the others, who all have rather short hair: the angels wear a curly fringe, the common people a conical cap that falls down

56

60

95

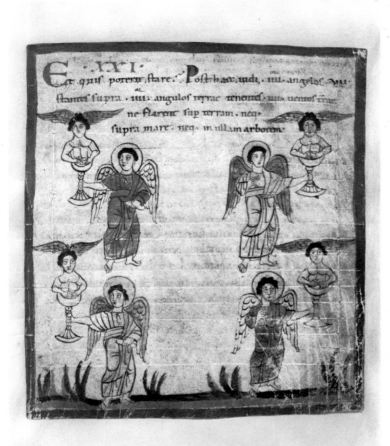

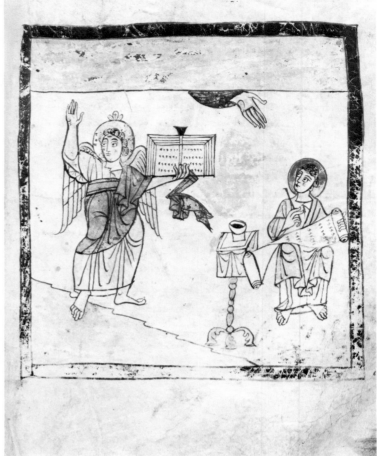

from the top of the head and is cut squarely over the eyes. Victims of the Locusts, stabbed to death by their scorpions' stings, are sprawled about, eyes closed, their hair sticking out in tufts, like Dickens's little schoolboys. On the demons, a dash of darkly flaming hair is just recognizable.

The common man wears a short tunic. The merchants of Babylon and the worshippers of the Beasts wear the split mantle called *chlamys*, attached to one shoulder with a brooch, and often breeches, puttees and boots. Soldiers are holding lances and round umbilicate shields, like those seen on consular diptychs and ivories representing the Massacre of the Innocents. Curiously enough, the four Riders, each in tunic and pallium, are sitting sideways on unbridled horses. The Rider Faithful and True, recognizable as the Lord by a crossed nimbus, holds the reins of the white horse. In the very first miniature – the most carefully drawn of all – we can see how the copyist wrestled with the *contrapposto* of a perfectly balanced Antique figure and the niceties of Classical drapery. Everyone is able to recognize, however, in the angel bringing the message to John, the traditional herald speaking to the hero, a group familiar from the Vatican *Virgil*, the *Joshua Roll* and the first images of the Annunciation. The protruding eyes, and the ugly proportions of all the minor figures, espe-

60

57

The four angels holding the four Winds (Rev. VII: 1-3). Trier, Stadtbibliothek, ms. 31, f. 21r. (58)

The Great Angel standing on sea and earth, with the little Book (Rev. X: 1 ff.). Trier, Stadtbibliothek, ms. 31, f. 31r. (59)

96

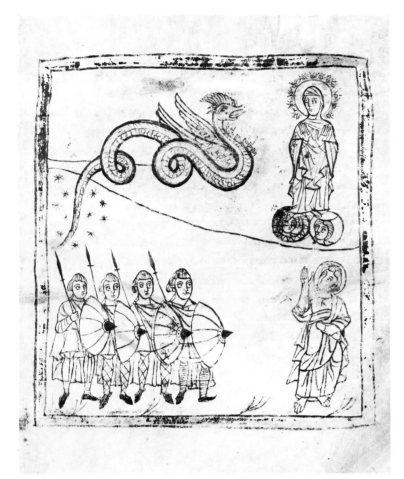

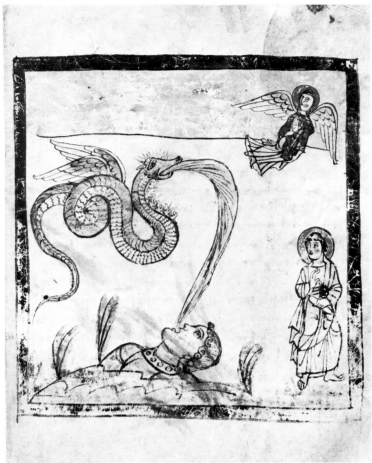

The Woman standing on sun and moon and crowned with twelve stars, facing the Dragon, which is sweeping down the stars. (Rev. XII: 1-6). Trier, Stadtbibliothek, ms. 31, f. 37r. (60)

The Woman flying away, Tellus (Earth) swallows up the water the Dragon is vomiting at the Woman (Rev. XII: 13-18). Trier, Stadtbibliothek, ms. 31, f. 39r. (61)

cially in the second half of the manuscript, where they are dwarfs with big heads, are attributable to the least gifted of the copyists.

The buildings – the seven churches, the walled cities, the Heavenly Jerusalem – faithfully reproduce the clichés we know from sixth-century mosaics and miniatures. The same towers with conical tops appear everywhere, as do the strange cupolas covered with tiles, crowned with a knob or a cross and resting on a drum pierced by rounded windows; the colonnades, with looped-up curtains between them, as seen inside the basilicas; and the endless tiled roofs. Patmos is a platform on which John sits writing, before a domed church, in the midst of a pond full of fishes.

Turning over the leaves, one soon discovers that a great many of the Classical features are typically Italic. The candlesticks, three-legged, with wild flames on top of a knobbed shaft, are exactly like those in the mosaics of Rome and Poreč. The four rivers in 'the Paradise of my God' have the shape of whelk-shells, just as in the earliest illustrations of Genesis. The lady Jezebel, with her tiara and jewelled *stola*, is lying in a Classical bedstead, on a suspended mattress. The seven lamps are the bowls that hung from the ceilings of all basilicas. The Hades following Rider Death is a hairy Gorgo. The wreaths of the Elders, and the wreath an angel brings to the

53,30

54

56

57

56 first Rider, are of laurel leaves. The altars are small tables, draped
59 with curtains on four sides. A *stylus* is stuck into the back of opened
codices. The four Winds are naked figures with winged heads, held
58 in goblets by angels. Sun and moon, darkened or not, are invariably
60 Apollo and Diana, heads set in a halo of rays, inside medallions.
59 The rainbow crowning the head of the Great Angel is a clover of
three little butterfly wings, such as worn by Psyche and Iris, set
on top of his nimbus. The censer is a covered pan full of charcoal,
swung on three chains, just as we know them from miniatures and
from real examples in Musea, both from about 500. All stars show
the eight points, with pearls at their ends and a gem in the middle,
familiar to us from Ravennatic and Roman mosaics. John's desk,
pen, ink-horn and scroll, and also his pose, are all from protraits
by Ancient authors. The Hand of God, thrust from the celestial
zone, is always seen in profile. Even the monsters look domesticated.
60 The Beast from the sea is an ordinary bear, which later on receives
horns and secondary heads. The Dragon is a conventional hydra,
scaled and winged, as in the Labours of Hercules; its horns form
a tidy crest, its minor heads a sort of jabot below his chin. The
Beast in the Temple is a bear squatting inside a small basilica.

The Woman seen in the sky, entirely covered by a dark *maphorion*,
60 and raising her hands in prayer, resembles the Virgin in the scene
of the Ascension. Here, she is standing on the medallions, with the
heads of Apollo and Diana, and around her nimbus are the twelve
stars. The fallen angels only differ from Michael's warrior angels
by the fact that they are falling down. Mother Earth, mercifully swal-
lowing the water spat at the Woman by the Dragon, is a colossal
61 *Tellus*, head and shoulders emerging from the ground. Her mouth
is wide-open, and she is now clothed; she has curled hair and a
necklace. The winged Woman, flying away above her, is again the
Virgin.

In the scene of the Harvest, the Lord and his angel are chopping
off several heads at a single stroke, with enormous sickles: very much
a medieval enormity. Medieval, too, is the square nimbus of the
Antichirst, who is vomiting his frog. It proves that he was regarded
as someone still alive. The Scarlet Woman mounted on the Beast
wears the embroidered *stola* and the exceptional head-dress worn
by the Virgin Mary in the mosaic on the triumphal arch of S. Maria
Maggiore. The cup 'full of her abominations' is a fluted glass; she
shows no sign of drunkenness. The demons in Babylon, naked little
men with bats' wings, are brandishing regular *ungulae*, torturers'
tongs; later, they are seen flapping their wings above the empty city,
and are decently dressed. A curious round wagon, its horses being
whipped up by the driver, and an ox gnawing at a tree illustrate
the 'beasts, horses and chariots' (Rev. XVIII: 13). A group of men
sitting together, hands held to cheeks, represents the Lament of the
Merchants. The 'Angel in the Sun' quietly stands on the head of
Apollo, holding his scroll. Inside the Heavenly City the Lamb holds

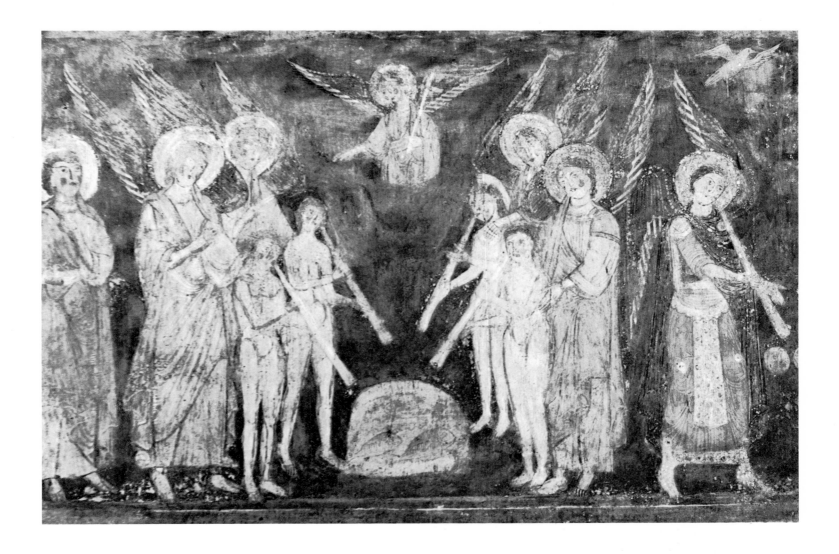

The four angels holding back the four Winds blowing down on the sea; the first trumpet (right), and the Eagle with the threefold 'Woe!'. Frescoes in the transept of the abbey church of Castel S. Elia, near Nepi (Lazio), eleventh century. (62)

his Cross, standing before the Tree of Life. The thirsty man stooping to the Fountain of Life drinks from an eight-foiled baptismal font guarded by an angel. A complete list of Classical motifs would be interminable; undeniably, the whole cycle has been copied from an Antique model.

A peculiarity of the Trier cycle is the attempt to illustrate the content of the letters to the seven churches. Thus, we see how 'the devil shall cast some of you into prison' – a whole group chained together, pushed into a barrel-vaulted gaol; how Jezebel 'is cast into a bed'; how 'those who overcome' will be made 'pillars in the temple' – here, columns in a basilica. The famous 'Behold, I stand at the door and knock' is visualized with an almost moving simplicity – holding a long rod horizontally between two delicate fingers, Christ taps at a small arched door hanging freely in the air – a remarkable anticipation of Holman Hunt's popular picture in Keble College, Oxford, *The Light of the World*. Below Christ, we see 'the gold tried in the fire' of a round smelting-furnace. The same motifs occur in the later and incomplete sister-manuscript at Cambrai.

The illustration is clear and dignified, apart from some odd, and possibly archaic, peculiarities: the beardless Elders and the nimbuses around the heads of not only the four angels at the Euphrates but

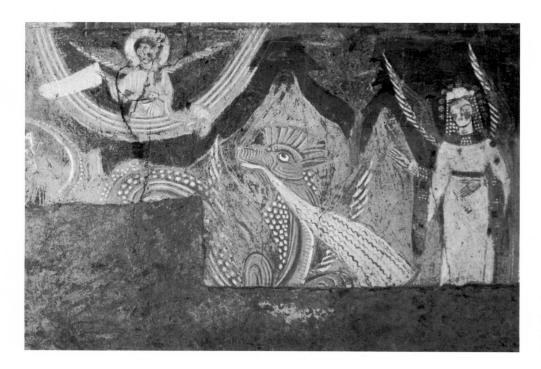

The Woman receiving the wings while
the Dragon is vomiting the water. Frescoes
in the transept of the abbey church of
Castel S. Elia, near Nepi. (63)

also the Locusts swarming out of the smoking Pit. There is no trace
of a particular exegesis: the two Witnesses, for instance, are quiet,
anonymous, young men holding scrolls, dressed not in sackcloth but
in tunic and mantle, as people of rank, interchangeable with John
and the other characters. Gestures are measured; many of the people
have dilated eyes, but show no signs of panic such as open mouths
and wringing of hands. These victims of the cataclysms fall like
wooden dolls, their hair standing on end, but otherwise unmoved.
Angels fly horizontally out of the heavenly Temple, and sometimes
fall perpendicularly from the celestial zone. One of them quietly
stands above the millstone 'cast into the sea', here lying on the bank
of a little pool. Their wings are tamely raised in pairs, never shaped
into a lively arabesque.

In essence, everything is calm and composed. Not one group
quivers with soaring lines, diagonal disposition or tormented faces.
The *Trier Apocalypse* is a story told in static hieroglyphs, which
in the better drawn figures retains something of the balance, clearness
and simplicity of Ancient art; others, however, anticipate the emble-
matic and didactic figures of medieval miniatures and painted glass.
I think it would be unfair to blame (or praise) only the Carolingian
copyists for giving in to this slightly dull and useful trend. The
Ancient model itself must have been something of a dignified panto-
mime; all Antique art is an instrument played *en sourdine*, with muted
strings. Here, we have the antithesis of Dürer's furious outbursts,
which were relieved by contrasting idylls. And everything between
Trier and Dürer instinctively held to the old lucidity and Antique
moderation.

We do not know to what extent the seven candlesticks and other apocalyptic subjects that Rubaeus, a Ravennate humanist, saw in S. Giovanni Evangelista at Ravenna (a church built about 430 by Galla Placidia) may have corresponded to the miniatures of the Trier prototype. We know even less about the apocalyptic cycle taken from Rome to Northumbria, about 685, to decorate the church of Wearmouth. The first monumental cycle, or what is left of it, goes back to the eleventh century, and can be seen in the transept of Castel S. Elia. On the south wall, seven scenes are recognizable, in three zones; on the north wall only one. Some of these recall the Trier pictures: the horses breathing fire and galloping over the heads of a prostrate crowd; a grey-haired and bearded Son of Man, on an Italic globe between small candlesticks with long white candles; the bearded Elders have no attributes, and seem to be on the point of kneeling down with empty outstretched hands. Others are quite different.

The four Winds are slender naked boys blowing horns above a little fishpond, while angels hold their shoulders – a unique scene. Sun and moon are coloured globes set within a celestial segment, but without any gods' heads. The Dragon is still the crested and winged hydra; but the Woman, standing on the globes of sun and moon, is a Byzantine princess arrayed in white, and crowned with a flat diadem from which jewelled pendants hang all around. The Pit, from which the Locusts swarm, narrows at the top, just as at Trier. The trumpets, somewhat longer in size, have the same curved shape. A little red dot is on each cheek; on all garments, the shadowless colour fills the neat but uniform silhouettes typical of the age.

62

63

Trier gives no key to later monumental cycles, but brings a catalogue of motifs that were destined to survive, with few variations, until the days of Dürer. It is rare to come across an illustration of the seven letters; one sees more often a newly introduced episode, such as the miracles of the Antichrist, the intervention of the four Beings at the appearance of the four Riders, and at the distribution of the vials of wrath.

Trier contains the average stock of images, which doggedly live on for centuries. From now on, the Apocalypse has a fixed visual repertoire, chosen by people limited by the taste and the prejudices of late Antiquity, where there is no place for forms too hybrid, too violent or too loud. Not until the *Cologne Bible* and Dürer do we find the 'legs like pillars' of the Great Angel, the slobbering, shouting mouths, the curling smoke, the surging seas – these still lie nine centuries ahead. The Ancients condescended to transform such things into poetry; they shrank from using them in the visual arts. Is this their reserve or, shall we say, aloofness? They themselves preferred 'moderation', which held most of medieval art, including the Apocalypse, within a temperate peaceful zone rarely shaken by a spasm of genius, as in the tympanum of Moissac.

183,195

37

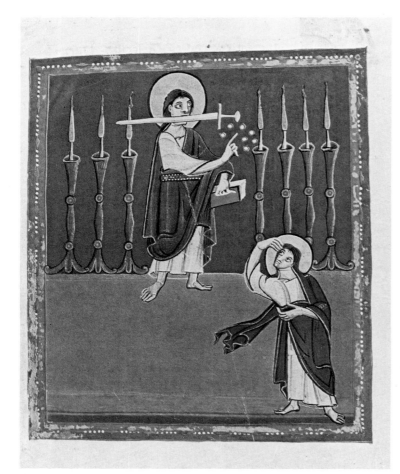

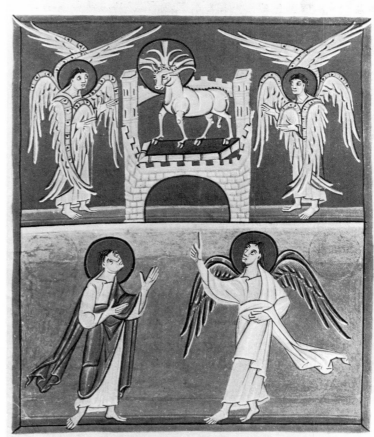

petris· cadite super nos· & abscondite nos
a facie sedentis super thronum· & ab ira
agni· quia uenit dies magnus ire ipsorum·
& quis poterit stare·

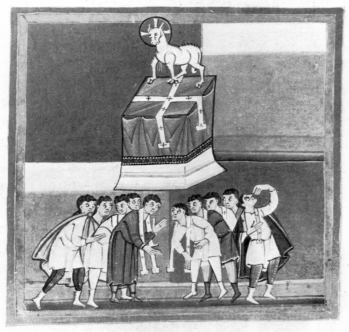

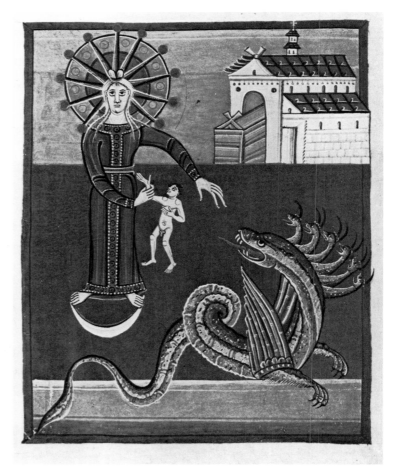

An Early Expressionist:
the Bamberg Master

The *Trier Apocalypse* is a document; that of Bamberg is a great work of art. The Trier cycle continually poses the question of what was the Early Christian model visible behind the primitive Carolingian drawings: it is like a palimpsest. At Bamberg we witness a first explosion of that typically German genius for violent expression.

The manuscript was made about 1000, by order of the saintly emperor, Henry II, for the cathedral of the bishopric of Bamberg which he had recently founded. Formerly it was thought to have been illuminated at Reichenau, an abbey on an island in the Lake of Constance. Today it seems more likely to have been some Rhineland atelier, Trier or Echternach. The question is far from being solved. However that may be, the codex is part of a homogeneous group belonging to one workshop; and, together with Henry II's *Book of Pericopes*, from the same painter's hand, the Apocalypse is the culmination of that atelier's production. It is known to innumerable Germans, children included, thanks to excellent reproductions, and it is no wonder, for its miniatures are the more powerful images of the times before Dürer.

The text is accompanied by fifty *tabellae* framed in pale-red (as at Trier), twenty-three of which are full-page. Figures and buildings are silhouetted against a background divided into three zones: gold for the sky, grey or pink for the atmosphere, light-green for the earth. This sounds calm and lovely, but what happens in the foreground is quite the opposite: the relatively empty scenes are filled with mute tension. We don't notice that no one shouts, nor throws his arms up, nor covers his eyes; nor that the trumpets are blown without bulging cheeks, and that Satan is driven into the Bottomless Pit without anger or panic. But all eyes are silently filled with horror, or, on the side of the just, with baffled adoration; only the angels show great resolution. Not a single pupil remains in the middle of the eye; every eye looks askance, sideways, up or down, and the whites of the eyes are much in evidence.

There is silence everywhere. The whole pantomime is played by the eyes, the hands, the feet, the wings and the ends of the draperies. We forget that grace and elegance are sacrificed to expression; that the feet are too large, the fingers too long, the forefingers overempha-

64-71

The Son of Man *(top left)* standing among the candlesticks. Miniature in the *Bamberg Apocalypse*, by an artist now famous for his dynamic compositions. From about 1000, probably at Trier or Echternach (and not at Reichenau). Bamberg, Staatsbibliothek 140 (olim A II 42), f. 3. (64)

The Lamb, *(top right)* with seven horns and seven eyes (symbols of its all-pervading power and penetrating intelligence), and the Book on the Throne, between two seraphs; John listening to the angel. Bamberg, Staatsbibliothek 140 (olim A II 42), f. 13v. (65)

The Souls *(bottom left)* under the Altar; the white baptismal robes they have received are represented as liturgical stoles (in the text *stolae*, or upper garments). Bamberg, Staatsbibliothek 140 (olim A II 42), f. 16v. (66)

The Woman *(bottom right)*, her Child, the Dragon, and the Ark of the Covenant in the heavenly Temple. Bamberg, Staatsbibliothek 140 (olim A II 42), f. 29v. (67)

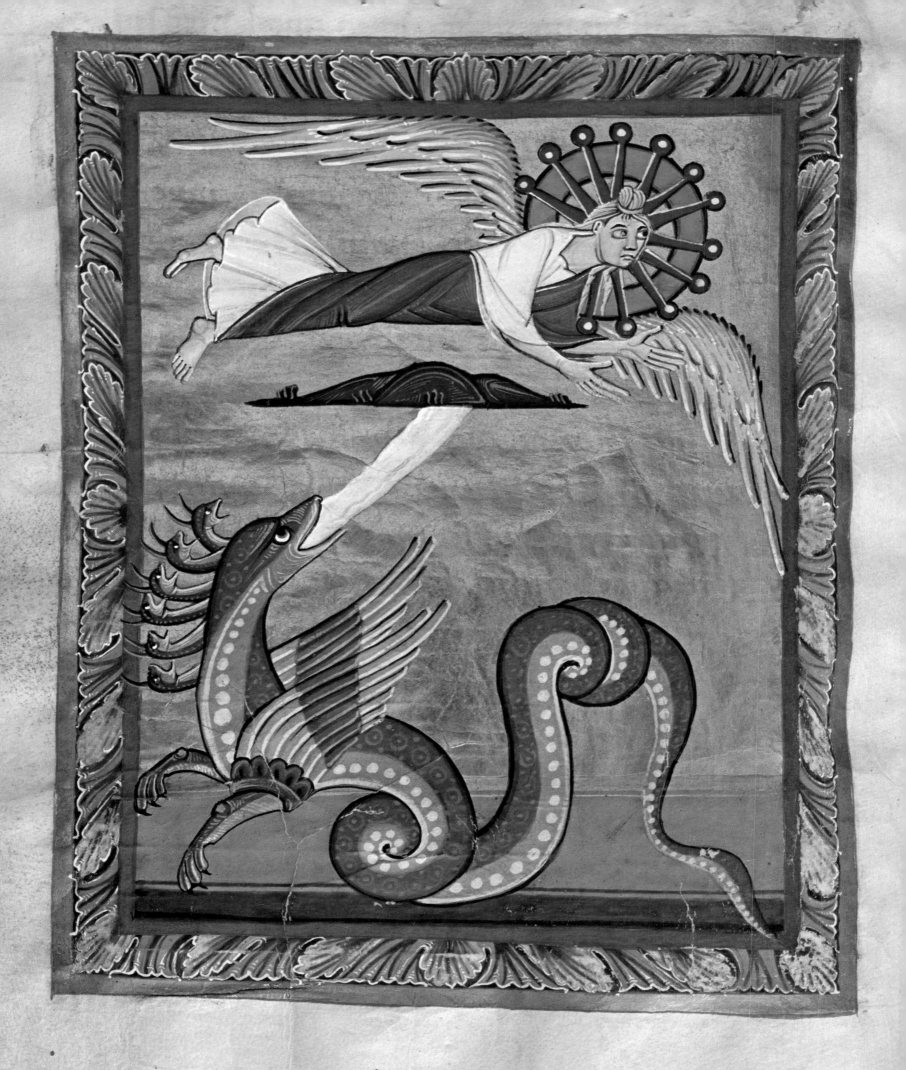

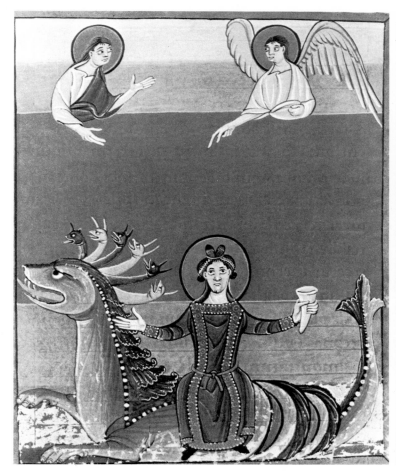

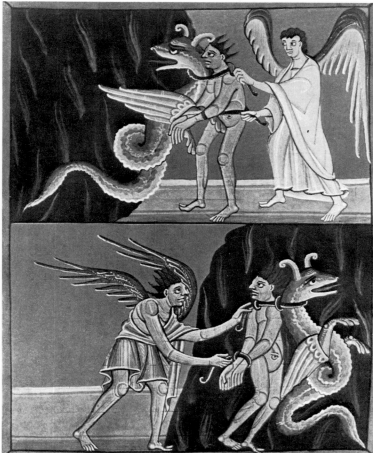

The Flight of the Woman *(opposite)*, while the Dragon spits out the water, which is swallowed up by the earth. Bamberg, Staatsbibliothek 140 (olim A II 42), f. 31v. (68)

The Great Prostitute riding on the Beast from the sea, 'holding the cup of her abominations', a drinking-horn. Bamberg, Staatsbibliothek 140 (olim A II 42), f. 43r. (69)

Satan and the Beast with ram's horns, chained and cast into the pool of fire and brimstone. Bamberg, Staatsbibliothek 140 (olim A II 42), f. 51v. (70)

sized, the backs of heads too small, the faces too thinly framed. All faults fade before such pure expression. What seems so dull at Trier, bursts with life at Bamberg.

The row of quills that represented the seven horns of the Lamb in Trier, has here become a twelve-tined antler, a *clivia* of bone springing from a set of five eyes; the two real ones are in their normal places, in the head of a grim Lamb trampling on a laced Scroll, representing the sealed Book, lying on a Throne not unlike a walled city – clearly the misinterpreted Throne we see on Roman mosaics. At the left and the right, two ecstatic seraphs, crossing four of their six wings, lift their hands. Below, the ends of John's dark mantle and the white garment of the angel play a counterpoint duet in the empty background. The little John, seeing the sword across the mouth of the Son of Man, between the red candlesticks with orange flames, is so frightened that he puts a hand to his brow and seems to be on the point of falling 'as dead', as the text says.

Satan, far from being a caricature, is a robust naked fellow, deeply tanned, his hair standing up like black flames; an 'evil genius', as the Fathers of the Desert saw him, a 'shameless Ethiopian'. Another demon, winged and girt with a white loin-cloth, cynically pushes

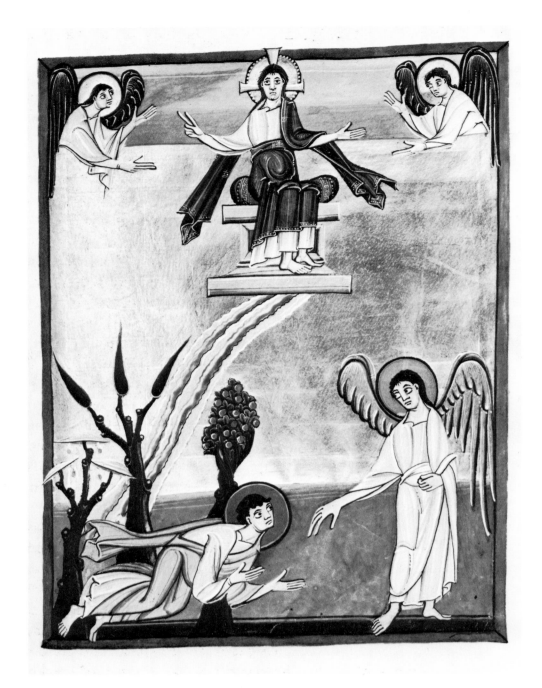

The River of Life flowing out of the Throne; John falling down before the angel who says: 'I am only your fellow-servant, worship God!' Bamberg, Staatsbibliothek 140 (olim A II 42), f. 57r. (71)

his master into the darkness of hell, together with the Beast from the sea showing the ram's horns. The Beasts are terrifying; there is nothing to laugh at here. They consist of heads, horns and coils, looming from scaly segments of clods or from rolling waves; the three frogs are thrown up from their gaping fish-mouths; their necks and tails make one think of some atrocious submarine organism.

A rectangular frame filled with leaves contains the image of the winged Woman flying away from the Dragon, which, turning one of its heads, spits the water at her, at once absorbed by a little mount of three clods, the merciful earth. The Woman, not unlike a gull, has a sun-wheel around her head; little white globes at the ends

68

of its spokes are the 'twelve stars'; below the knot of her hair we see her frightened protruding eyes. The painter has given her male attire: tunic and pallium; on the preceding page a less inventive *67* man has given her the classical *stola*, the long embroidered woman's dress we know from Rome and Trier. The coil of the hydra is so forceful, and the contrast with the horizontally suspended gull-wo- *68* man so striking, that its effect is incomparable: it is like an enamel. The harpers standing on the Sea of crystal, the angels with their flasks full of scent drawn as rising flames are all set in monotonous rows – but they tremble with excitement.

The chief miniaturist (who painted the winged Woman and the River of Life) handled the voids well. His trees, with their umbrella *71* leaves, scarlet berries and bare trunks, are completely surrealistic (we see them also in related manuscripts); the often recurring group of John and the angel has the aura of a ballet duo. This painter is certainly no primitive – he is an unconscious, and therefore better, surrealist.

Of course there are rather naïve traces of Antique detail. The 'wreaths' thrown before the Throne by the Elders are evidently mis-interpreted Antique laurel-wreaths, here drawn as crescents. The white garments, *stolae albae*, given to the Souls under the Altar, and which symbolize the baptismal robes, have become liturgical stoles with little embroidered crosses, worn round their necks over their *66* worldly dresses. The sacks worn by the two Witnesses are like long dresses of burlap. The Woman standing on the crescent is an ugly *Gretchen* with a bun and blonde pigtails, and the naked Child *67* at her side is all too visibly male. The angel piercing the Dragon is accompanied by his own image in reverse. But what does it matter?

It is difficult to find a more splendid miniature than this one, with the River of Life. The upper sky, the Throne and the garment *71* of the terrified John show three shades of tender pink; the Lord's garment is purple; pink apples fill a dwarf tree like a bunch of grapes. The River is a white stream falling obliquely behind strange trees. Three angels' dresses, in ochre, mark three corners of the image; in the fourth we see the flying end of John's pallium, against a back-ground of velvet-green, and the enormous hand of the angel, who admonishes him: 'I am only your fellow-servant, worship God!' With this rebuke, and this eternal Sunday afternoon, ends the Apocalypse.

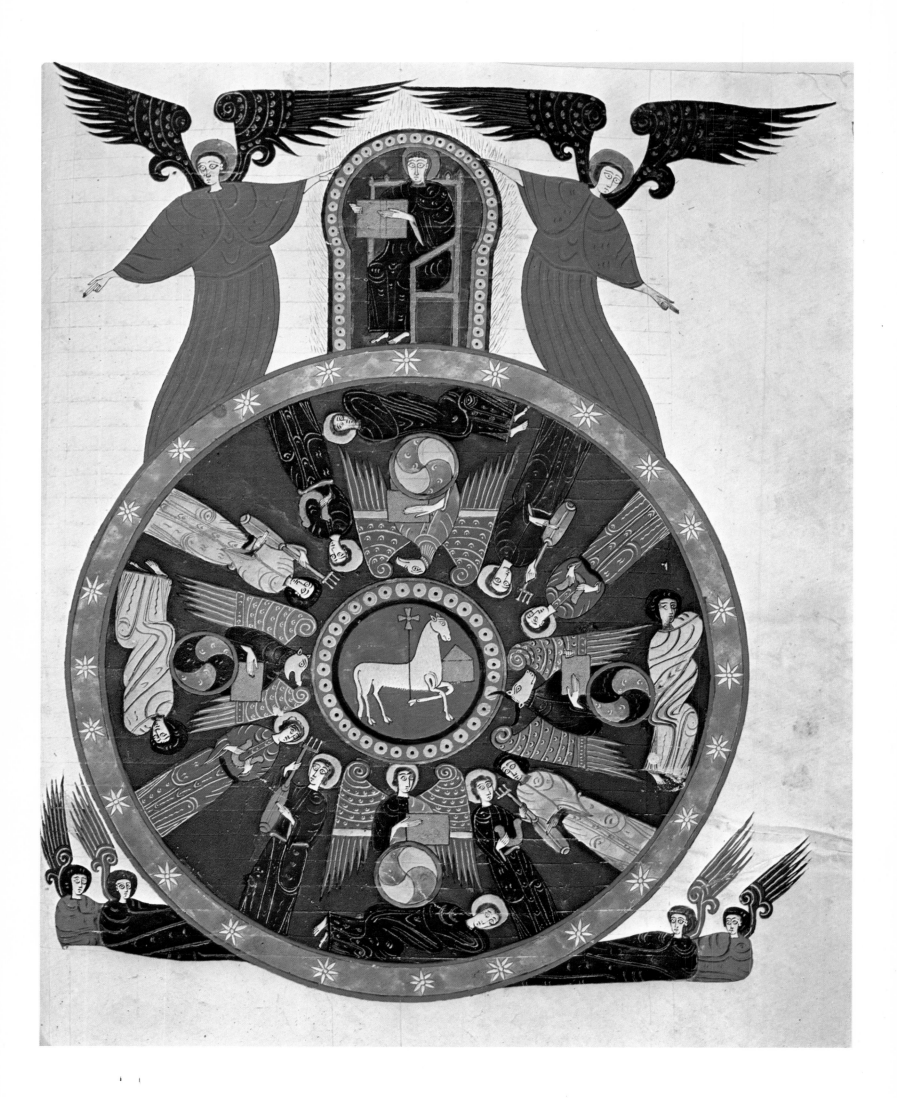

'Beatus in Apocalipsin':
Primitives of Genius

'Immediately I was in the Spirit: and, behold, a Throne was set in heaven.' At the bottom of the picture illustrating these words, *77* in the *Beatus* of Gerona, John lies prostrate, with tightly closed eyes. From his mouth a meandering white line stretches up to the Throne on high where the Lord sits with the sealed Book, and there ends in a dove: John's spirit. On either side of the Throne the seven lamps are burning: hanging vessels drawn in longitudinal section, showing the oil and the wick. Red arrows emanating from the Throne flash like meteoric discs to represent the 'lightnings and voices proceeding thereof'.

In the blue zone at the top, twelve Elders, arrayed in white and sitting on stools and folding-chairs, raise their hands; their faces are caught in a cap of light leaving a glimpse of dark hair, under a mushroom crown. One of them has horns on his forehead: Moses. The painter must have known that the Elders represent the prophets and the Apostles, and the latter are seen in a reddish zone at the bottom. In this way the opening verses of Rev. IV are illustrated.

The opening of the fifth Seal is illustrated in this way: below a horseshoe arch, such as can be seen today in a few small Mozarabic *73* country churches, an Altar is set up, its heavy stone table supported by a single column. Above it, project bright disks representing lamps, hung between votive crowns with rich hangings (not unlike those of King Recceswinthus, found at Guarrazar, near Toledo, in a treasure dating from the seventh century). Under the Altar, eighteen birds are seen waiting: the 'Souls of them that were slain for the word of God', souls, in Antiquity, always being symbolized by doves. In their midst, the Lord holds the unsealed Book and, below, the same Souls are seen again, this time clad in white robes (Rev. VI: 9-11).

In the *Beatus* from S. Isidoro of León is a splendid specimen *72* of the Vision of the Throne (Rev. IV). On top, two Beings in long red robes, with hooked wings full of eyes and a cap of red light, are holding the Open Door, under a horseshoe arcade. Inside, the Unnamed One sits on a stool, holding the golden Book: a spectre with dilated eyes and a cap of light, dressed in a black garment. The Door stands on top of a huge black disk bordered by white stars and surrounding a smaller red disk: this is the Throne of the

The Door opened in heaven (top); the Lamb and the Book (in a shrine) in the middle of the circular Throne, between the four Beings (with the heads of a Man, a Lion, an Ox and an Eagle), surrounded by twelve Elders, holding their instruments (here Spanish guitars). Miniature in the *Beatus* from S. Isidoro of León, *c.* 1047. Madrid Biblioteca Nacional, Vit. 14-2 (olim B 31), f. 116v. (72)

Lamb. With one leg the Lamb holds Pelayo's 'Cross of Covadonga', the palladium of the *Reconquista*. A golden shrine at its feet, not unlike an Irish bookcase, probably contains the sealed Book. Against the black background of the outer zone the half-figures of the Living Beings, appearing with the faces of Man, Lion, Ox and Eagle, hold the Gospels while they roll on fiery wheels – swastikas curved similarly to Yin and Yang – their wings full of eyes. Four Elders lie prostrate below them; four pairs are standing between, of whom four hold bowls drawn in section, to show the grains of incense, and four others Spanish guitars with four strings, screwed to a long handle. Winged and robed beings shoot out of the starred border. All this appears in glowing unbroken colours: scarlet, ochre, black, peacock-blue, mauve and flashes of white. The Throne seems like a disk of unreal enamel, and at the same time a slowly revolving supracosmic sphere.

In the *Beatus* all situations are suggested by a small set of unequivocal hieroglyphs. Invariably, dark massive figures, with a bright halo round an always identical face, stand out against the zones of heaven, air and earth. Small hands protrude from bundles of striped garments, resembling cocoons; miscroscopic pupils are set in the middle of wide-open white eyes. Angels' wings, huge open flaps of spiked feathers, shine in all colours, according to the hues of the background. The angels themselves sail in mid-air; fall from the sky with the Oviedo Cross in their hands; stand on their heads in circular compositions; brandish a big censer or a colossal sickle; emphatically point out to John what he must see. The shouting heads of the four Beasts are seen between the opened fan of their raised wings, above their *72* gambolling sun-wheels.

Gestures are exaggerated. To worship means: to lie flat. During the Adoration or the Great *Hallelujah* the Elders lie in rows, like dead insects, and the four Beings tumble down symmetrically on their wheels.

74 Cataclysms are indicated almost symbolically. Babylon on fire is an empty, schematic city, where precious vessels, seen in section, stand on window-sills under horseshoe arches, from which extinguished lamps are hanging on long rods. Thin flames, no more than red threads, tremble along the walls: that is all. Destruction means being turned upside down. Towers are not toppling over but stand on their heads; the burning mountain, speckled with clumps of fire, touches a motionless sea full of upturned ships, whose oars all stick out and sailors fall down. The Bottomless Pit is a rectangle inside which a Satan, looking like a wasp and black as soot, lies chained to a torture-rack, his red tongue sticking out.

The Powers of evil are fat wicked monsters, real nightmares: *75* hybrid bulls with the head of a billy-goat; impossible quadrupeds breathing fire; the heads of the Beast are mounted on his fat neck like the calyces of a snapdragon. The Great Dragon's scaled, coiling body is double-knotted, and six small secondary heads with pointed

110

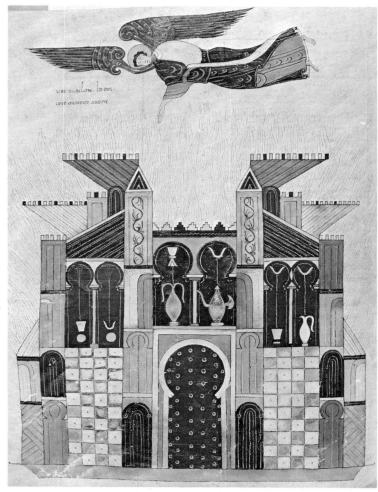

The message to the church of Philadelphia (Rev. III: 7-13). The church is a highly stylized Mozarabic church, with the characteristic horseshoe arches, the altars supported by one column, the curtains and the *azulejos* (coloured tiles) on the outer walls. *Beatus* of Gerona, 975; f. 94. (73)

Babylon burning: a doomed city full of treasures. *Beatus* of 1047. Madrid, BN Vit. 14-2, f. 233v. (74)

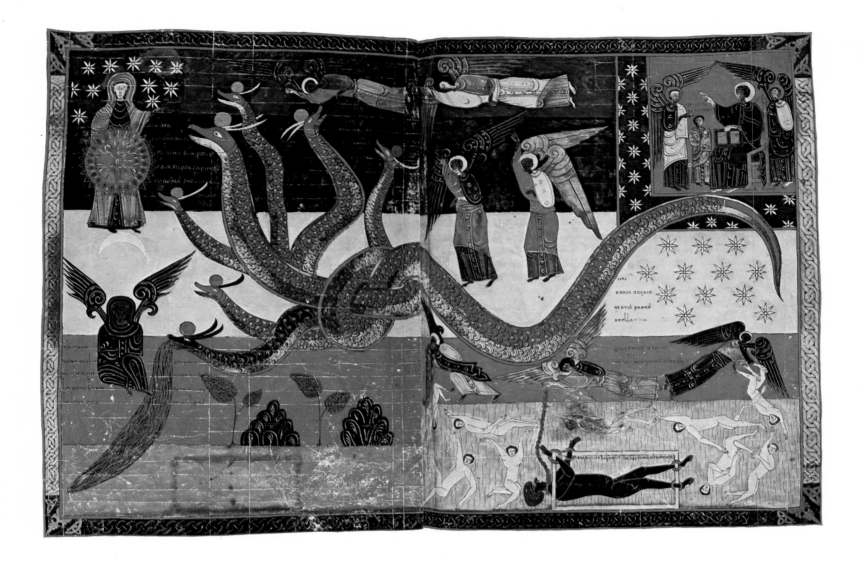

ears, on top of endless eel-like necks, stick out licking tongues. Thick red tongues project from the mouths of the chopped-off Beasts' heads, which are restored to their trunks two pages later, however, when they have been thrown into the Bottomless Pit, above which the angel swings a gigantic key (with a typical, old Spanish bit).

73 Architectually, few fanciful buildings match the cleverly simplified Mozarabic basilicas representing the seven churches. They are all different. Some of them have an upper storey, in which case there is an altar supported by a single column on each floor, standing under a votive crown or an oil-lamp, between looped-up curtains. Often a stocky chalice, like Tassilo's, is placed on the small table. Walls are crenellated, gables adorned with glazen tiles, roofs saddled, tops crowned with strange ornaments of ironwork. The whole rests on segments of rock or even on half-rosaces; sometimes an angel with a censer flies out of a tower to speak to John. There is no trace of depth or perspective.

All the people are alike, beardless, hatless, ageless. Only the few women are heavily veiled. There is only one child: the tightly swaddled little Prince born of the Woman, and solemnly presented by an angel to the Unnamed One on the Throne. Far below, the Dragon's tail sweeps the stars down from heaven – a Dragon so power-

The Woman attacked by the seven-headed Dragon. Bottom left: the flight of the (winged and darkened) Woman; one of the Dragon's heads is spitting out the water, swallowed up by the earth; Michael and his angels harassing the Dragon. Bottom right: Satan and his attendants inside the pool of fire (below the Dragon's tail stars are falling down). Top right: the Child presented to the Unamed One on the Throne. Double-leaf *Beatus* of 1047. Madrid, BN Vit. 14-2, ff. 186-187. (75)

fully conceived, so enormous (he fills two pages) and so frightening, that it is hard to imagine a more convincing image of the ubiquity of evil.

75

Finally, the alternation of bold and pale colours, standing out against a contrasting background of zones in turn yellow and pitch-black, holds the ghostly figures and groups both together and at the same time apart, within a solid frame of interlaced ribbons ending in small ivy-leaves.

THE BEATUS CYCLE

As reconstructed by Wilhelm Neuss, the original cycle contains 108 extremely disparate motifs, corresponding to the encyclopedic character of Beatus's commentary. Beatus lived in the Benedictine abbey of S. Turríbio at Liébana, in the Cantabrian Mountains (near the modern town of Santander), not far from the grotto of Covadonga, where the *Reconquista* was launched and Pelayo's Cross, the palladium of Christian Spain, was conserved and venerated.

We do not know if Beatus thought the end of this world imminent, but he brought together in his commentary everything relevant to it. Hence his work on the Apocalypse (the third edition of which was published about 785 – he died February 19th, 7798) is a *catena*, a cleverly arranged anthology of quotations from the Latin commentators of Antiquity: Ireneus, Ambrosius, Gregory of Elvira (i.e. Illiberris, Granada), the Donatist Tyconius, Augustine, Victorinus of Poetovio (Pettau, Ptuj), Jerome, Fulgentius of Ruspe, Apringius of Beja (now in Portugal), Primasius of Hadrumetum (Sousse, now in Tunisia), Gregory the Great and Isidore of Seville. There were, as well, the Europeans, four Africans and three Spaniards. Beatus was a well-read man; to his commentary on the Apocalypse he added a second one, on thhat earlier apocalypse, the prophecy of Daniel.

6

The illustrations correspond to his chapters, called *storiae*. They can be split up in three parts: introduction, Apoocalypse, Daniel. To the introductory cycle belongs a somewhat surprising set of images: a labyrinth; the Cross of Covadonga; a *Majestas Domini*; authors' portraits of the evangelists; genealogical tables of Christ's forefathers; a short series of scenes from his life; 'Bird and Serpent'; a page with John and the portraits of seven of his commentators; Alpha and Omega, in splendid calligraphical display on a full page; a map of heaven, showing the angelic orders. 'Bird and Serpent' is an allegory of Redemption: the Bird, divine Wisdom, hid his bright feathers under the mud of Man's earthly nature at the Incarnation, and thus he was able to approach and kill the Old Serpent, which did not recognize him. In the miniature, the Bird grips the reptile with its claws, a cloud of dirt hanging over its head. The next chapter, the Apocalypse, is illustrated by about eighty pictures, while thirteen pictures illustrate the prophecy of Daniel.

79

Among the ordinary apocalyptic scenes a number of inserted motifs

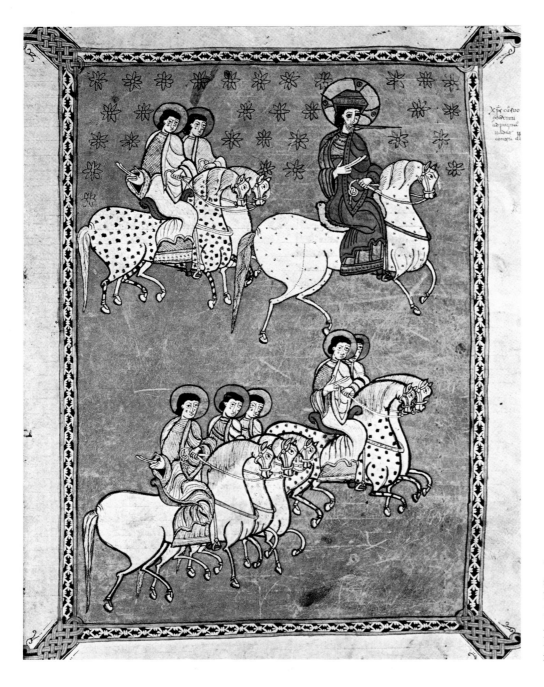

The Rider on the white horse, with the sword coming out of his mouth, followed by his horsemen; the 'many crowns' of the Lord are one huge crown. Miniature in the *Beatus* at Osma (Prov. Soria); *c.* 1086. Burgo de Osma, Archivo de la catedral 1, f. 151. (76)

deserve attention. The most remarkable is a map of the world, tracing the Mission of the Apostles and their dispersal 'unto the uttermost parts of the earth' (Acts 1: 8). The detailed map in the *Beatus* of St-Sever gives an excellent idea of the eighth-century view of the world. At the centre is Jerusalem; east lies Paradise, indicated by the Tree, Adam and Eve; both are in *Asia*; the other continents are *Europa* and *Libya* (Afrika); all three are surrounded by the Ocean. A good deal of knowledge, ranging from notes on the sources of the Nile to the peculiarities of the Hyperboreans and the situation of Ultima Thule, and including pictures of the chief Christian sanctuaries, has been arranged in a well drawn and fascinating ensemble.

Another motif that has been inserted is the Flood, with a multi-storeyed Ark full of animals. A third is the Palm-tree, symbol of the Way of Salvation: the soul, a naked man holding a hatchet, is

hoisted up to the fruits of life, by a pulley. A fourth motif is a table for computing the name of the Antichrist. A picture of the City of Babylon is a fifth: a fortress surrounded by two interlaced serpents; but inside, under an arcade of the church of the Christian town succeeding Babylon, Ctesiphon, we see the shrines of the Three Young Men, delivered out of the fiery furnace, with their names, ANANIE, AZARIE, MISAEL (this picture comes from Daniel III).

The *Beatus* of Gerona includes a Crucifixion, showing the two thieves, GESTAS and LIMAS (i.e. Dismas); the soldier with the spear, LONGINVS; the man with the sponge of hyssop, STEPHATON; and, finally, at the foot of the Cross, the mummy of ADAM in a carved sarcophagus. In the same manuscript, below the Flight into Egypt, Herod lies in agony, mortally wounded by a kick in the groin from his own horse, received during the pursuit (to be healed subsequently by an apple culled by the Child Jesus from a tree under which his parents rest): a legend Neuss spotted again in Ethiopia, and of course welcomed as corroborating his hypotheses of the African origin of the *Beatus* cycle.

THE MOZARABIC ILLUMINATORS: PRIMITIVES OF GENIUS

By far the most powerful pictures of the whole *Beatus* family are those of the Mozarabic group, both the earliest and the most primitive. Eight manuscripts belong to the tenth century. Begun some two centuries after the definitive edition of Beatus's text, they were illuminated in Oviedo, Távara, S. Miguel de Escalada (where one can still visit the exquisite Mozarabic basilica), S. Millán de la Cogolla, Gerona and Seo de Urgel or near by. The Gerona codex, *73,77* dated 975, is signed by a priest and a woman painter, *Ende pictrix*, probably a nun. Outstanding for the brightness of its colours is a *Beatus* dated 1047, from S. Isidoro of León, illuminated for Fernando I of León and Sancha of Castile (Madrid, BN Vit. 14-2). *72,74,75*

Among the *Beatus* manuscripts of the eleventh century, the masterpieces are the Apocalypse of St-Sever (to be discussed later) and *78,84* those of Burgo de Osma Cathedral and of the John Rylands Library *76* (about 1200). The Mozarabic group is not only the apogee of pre-Romanesque Spanish painting, but it is one of the peaks of apocalyptic imagery – not so much for intensity of colour or a few amusing primitivsms as for the powerful visualization of the most difficult book of the Scriptures.

Scrutinizing these bold innovations, which had suddenly become accessible, both experts and amateurs discovered that genuine primitivism is superior to mere technical perfection, above all when dealing with visions that transcend time and ordinary visual experience – abstract realms, where, with due respect to that exceptional genius, Dürer, even the most powerful realism will not do.

These nightmarish images that assail us from the Dark Ages reflect the solitary reveries of monastic life – a contemplation of the Judg-

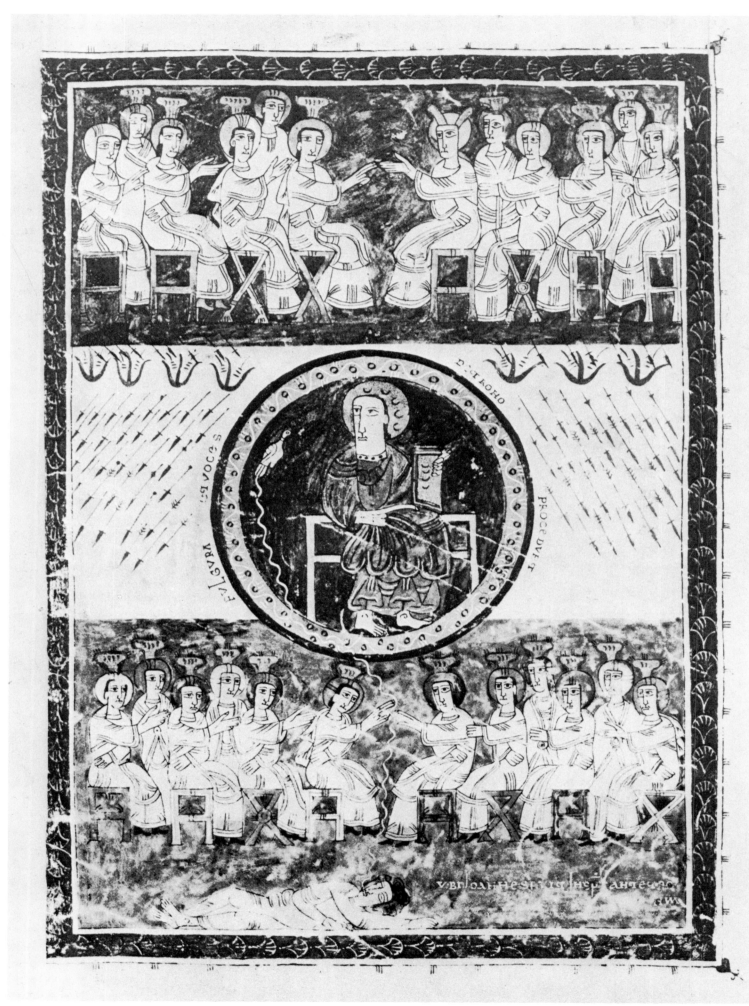

'And immediately I was in the spirit' (Rev. IV: 2): John lies prostrate; a white line coming out of his mouth ends in a dove, signifying his spirit, near the Throne. The seven lamps are seen in section; the red arrows represent the 'lightning'. The Elders (among them the horned Moses), wearing high mushroom-like golden crowns, are seated on folding-chairs. Miniature in the Gerona *Beatus*, about 975, a purely Mozarabic manuscript. Gerona, Archivo de la catedral I, f. 107. (77)

The Throne, the four Beings and the Elders (with their vials and guitars, all crowned and enthroned), a double-leaf. The composition, which was not part of the original *Beatus* cycle, is seen again somewhat later, in the monumental sculpture of the twelfth century, as at Moissac and Chartres. Paris, BN lat. 8878, ff. 121v-122r. (78)

ment, influenced at the time by the threat of Islam. They irresistably communicate both a horror and a delight almost equal to the Book of Revelation itself.

Rather like the drawings of gifted children, and at the same time like powerful abstract art, these small works, sprinkled with resounding inscriptions, are filled with subtle symbols, unshaded colours, insect-like people and buildings seen in section. Zoomorphic coumns support Visigothic arcades, showing everywhere the little snow-white fleshless Lamb holding the Covadonga Cross with its delicate black hoof. One should not forget that, for the people who created them, these throngs of sinners, saints, demons and angels, all these graceless puppets, were acting out the grim pantomime of the liquidation of evil – in the Last Days, when the wicked, under the Antichrist and the False Prophet, seemingly hold the damned world in their grip, and then suddenly liberate the world and themselves under the sun of the silent Lamb. These humble painters could vividly see the Judgment as a reality in their mind's eye, as only the believers in any epoch are able.

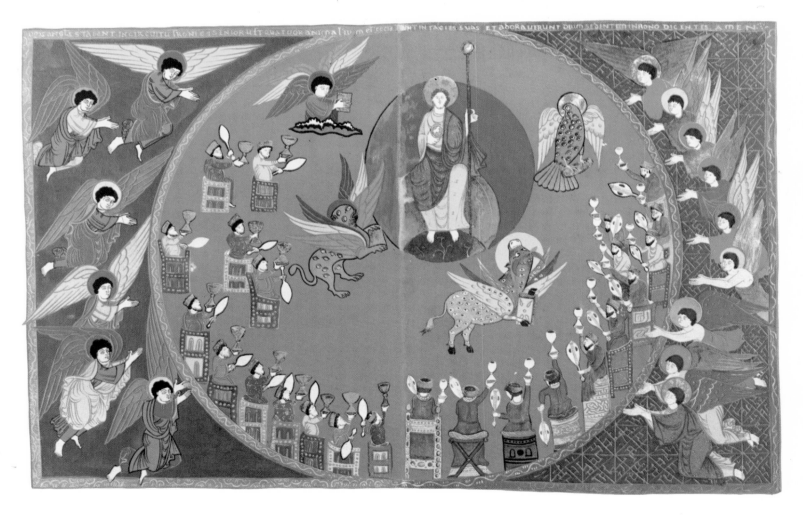

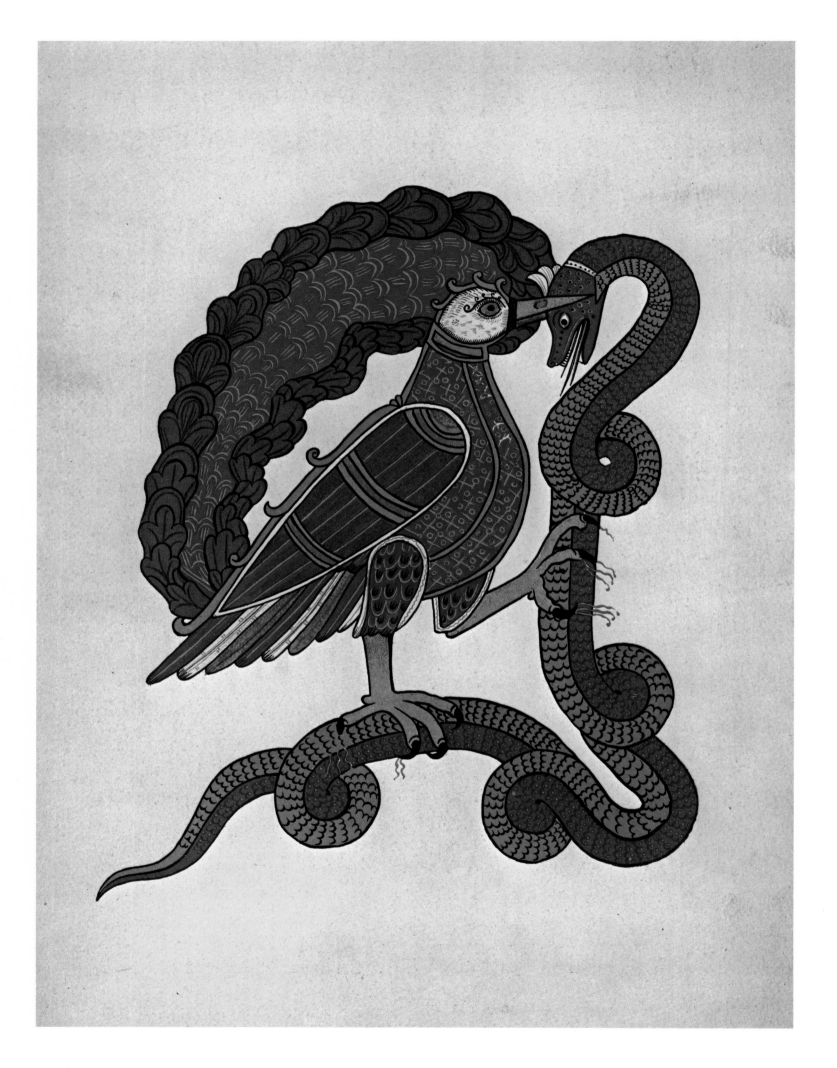

The Apocalypse of St-Sever

Against a background of fiery red representing the empyrean, the seven angels, wings raised, receive the trumpets: long Roland's horns. Five hold them upright, one across the chest and the foremost has just accepted it from the Lord, who sits in one of those stiff high-backed chairs that we shall see a century later on the Royal Doorway of Chartres. *81*

In the blue zone below, another angel stands on the *mensa* of a golden altar supported by three small columns. He holds up a huge golden censer: a pierced globe hanging on three chains, with a lily-shaped handle. Shoulder and right arm bared, the same angel darts into an even lower zone like a swallow with yellow wings. He tears the globe asunder with both hands, while red arrows flash across the brownish air, down to an empty field, the earth; and such is the furious dive of the flyer that handle and chains swing wildly about.

The slender angels and the Lord have small, round, identical faces, with a cap of black curly hair low on the forehead. They are wearing pallia reaching to just below the waist, a sort of cape that covers the arms to the wrists, sprinkled with white clovers. The parallel folds of their tunics taper towards delicate feet that stand on nothing; red folds on the dark garments recall the effect of cloisonné. Indeed, the whole composition, with its full-bodied colours and clear outlines, is like a large enamel. Twelve rosettes are set in a frame of interlaced ribbons, and in this way the first six verses of Rev. VIII are represented.

This description is of a picture that is typical of the better full-page miniatures in a famous *Beatus*, containing nearly the entire repertoire (fourteen folios are missing), known as the *St-Sever Apocalypse* – the best known, the most individual and the most complete specimen of the whole *Beatus* family, and, as Emile Mâle said, the most famous of all Romanesque manuscripts. Gregory, abbot of the Cluniac abbey of St-Sever on the Adour, in the Landees, who commissioned this early Romanesque cycle, reigned from 1028 to 1072. On the shaft of a column (f.6) appears STEPHANVS GARSIA PLACIDVS AD S [anctum Severum](?), possibly the discreet signature of an illuminator. The second name has a Spanish sound, and, Gascogne and Navarre belonging to the same kingdom, there is nothing strange about a

Bird and Serpent: a symbol of Satan beguiled and overcome by God's 'disguise' in the Incarnation of the Logos (see page 113). From the *Beatus* written at St-Sever, on the Adour (Landes), about 1076; one of the masterpieces of Romanesque book illumination. Paris, BN lat. 8878, f. 13. (79)

The Lamb *(overleaf)* opening the first four Seals; the apparition of the Riders; the four Beings taking John by the hand, crying: 'Come and see!' Paris, BN lat. 8878, ff. 108v-109r. (80)

119

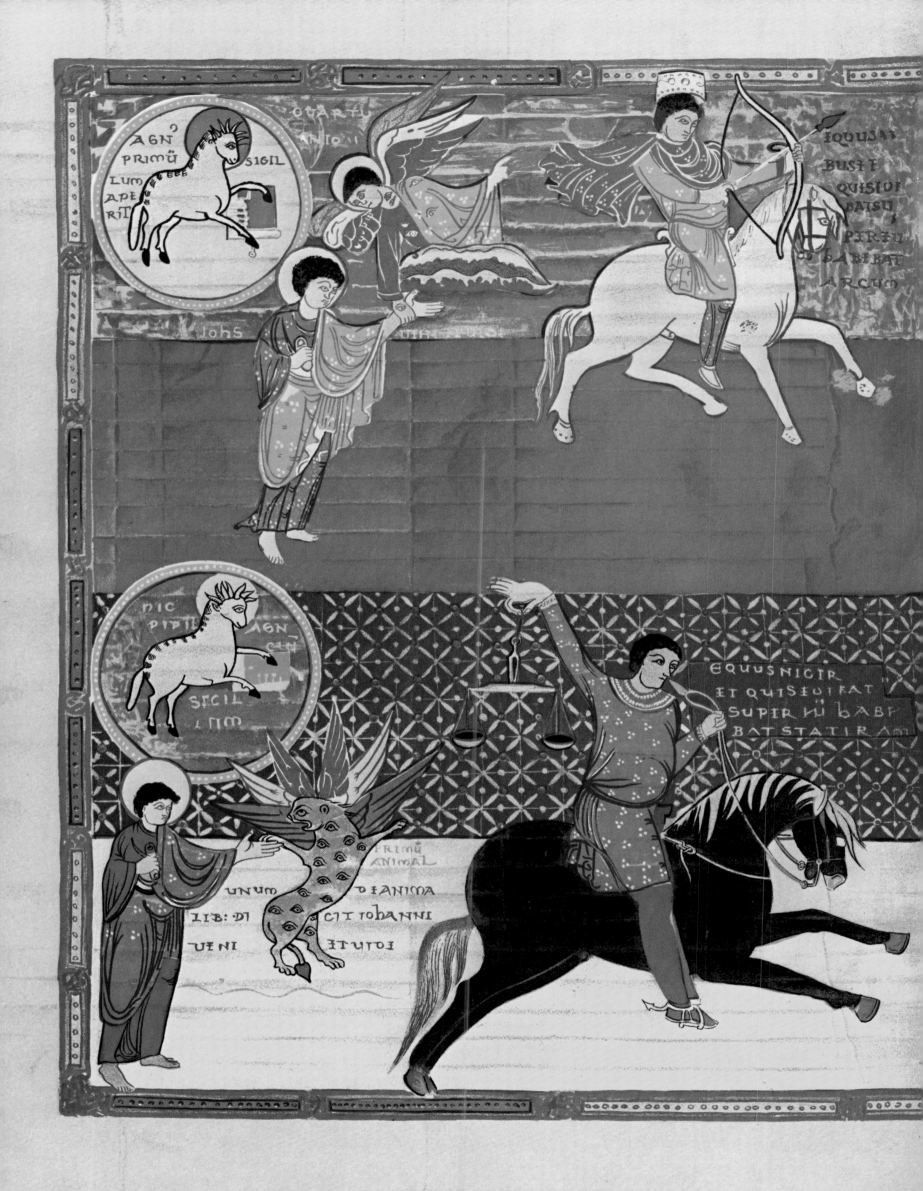

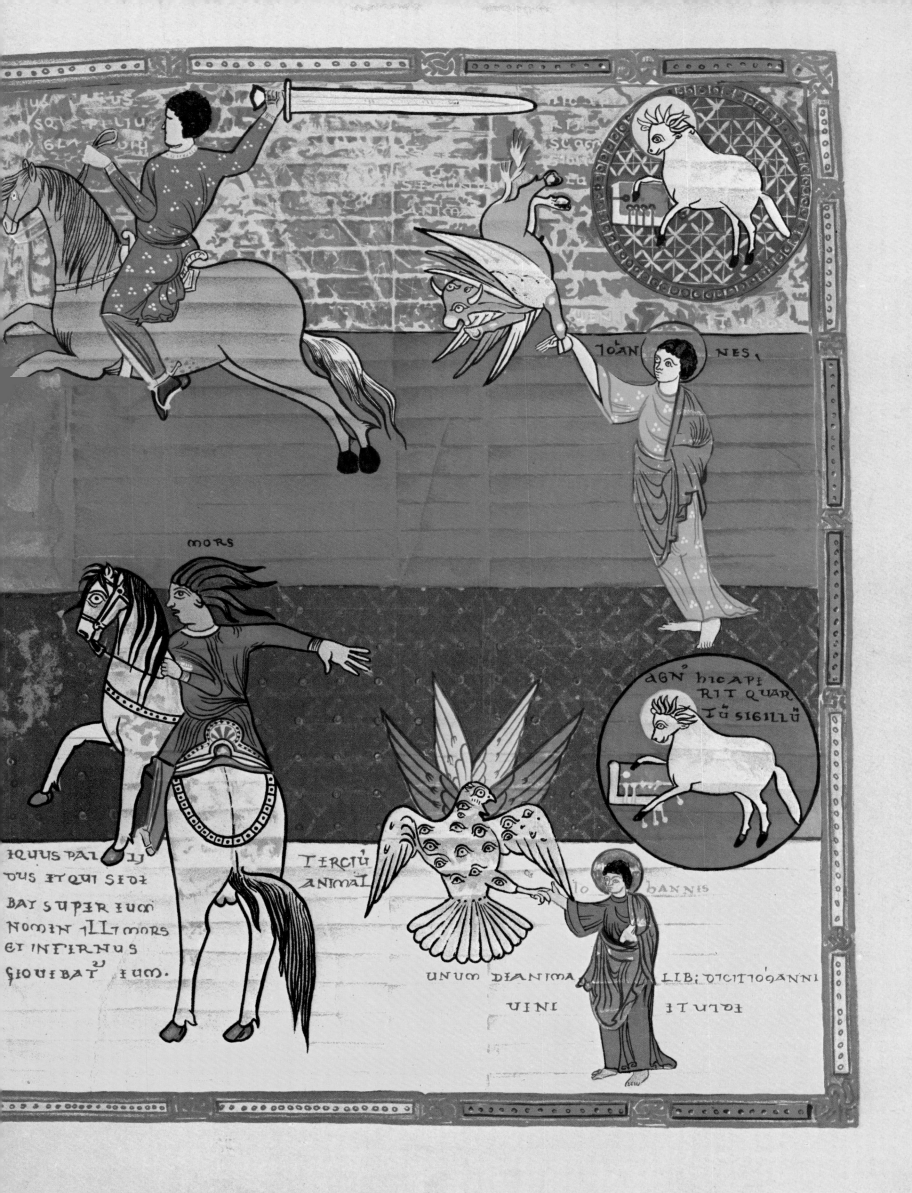

Beatus being copied this side of the Pyrenees. Far more than the fine colour, it is the incomparable drawing that distinguishes this isolated masterpiece from the purely Mozarabic as well as from the later *Beatus* manuscripts, which were executed in the usual late Romanesque or early Gothic manner.

Nowhere else – unless among real Gascons of today – do we see these dark, nimble, alert little figures, coldly or grimly executing terrible orders. The aristocrats among them, angels and saints, are tapering figures, tightly encased in dark material, precariously balanced, not unlike Japanese dancers tripping about in too-narrow robes. The more common people, soldiers, onlookers and victims, are smaller, undersized, and invariably clothed in a short tunic, wide breeches and a short cape floating from the right shoulder and fixed with a brooch on the left. Capes were often adorned with the three white clovers, obviously derived from the Antique *chlamys* of officers and high officials.

83 The Warrior giving the coup de grâce to the Beast and the False Prophet is a dashing little fellow in a white tunic, a white halo around his boyish head. He fights beneath the eyes of an angry Lamb, standing like a sun among white daisies representing the stars. Below his feet, the chopped-off heads of the Seducers roll away from their trunks, and the air is filled with the beautifully balanced white flashes of two enormous swords, bigger than the tiny toreadors who brandish them.

80 On the double page illustrating the four Riders, a more graceful Lamb, crowned with a tuft of seven thin horns, loosens the four Seals from the large golden Book with a tap of his hoof, one by one. Each time, a screaming six-winged Being, one of the four Creatures, grips John's hand saying: 'Come and see!' One after the other the Riders leap forward on small-headed Moorish horses with black hoofs. The last Rider, Death, his prickly hair standing up like black flames, rides a wildly prancing pale horse, seen from behind, its black mane flying about its neck – a little figure drawn well enough to be a credit to Dürer. The *Infernus*, mentioned in the inscription, has been forgotten. The Riders, shown together on one page in other *Beatus* manuscripts, here are divided into four episdes filling two pages.

There is an abundance of stimulating and astonishing detail. The Kings of the Earth wear strange trilobed crowns; a phalanx of them appears with lances and umbilicate shields, wearing pointed caps sticking out of flat diadems. Satan, a bristling demon, is vaguely reminiscent of an Antique evil genius; the Beast is a bull with a dog's head – at the end, this livid monster lies in a sewer, encased by a strait-jacket of red-hot iron bars. It is very satisfying to see the Antichrist and his Beasts suffocating as they vomit the frogs. It is portrayed so vividly one can almost hear them retch. The Scarlet Woman, sitting sideways in her saddle, wears a wrinkled red bonnet over a hooded pelerine fastened with a large brooch; she holds her

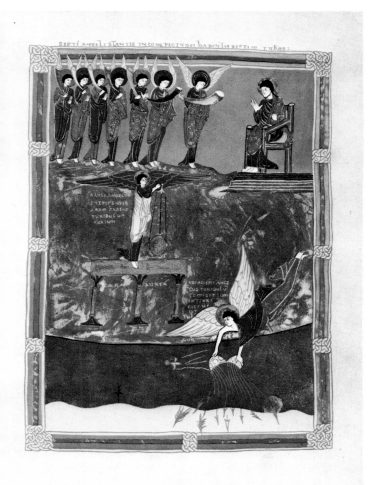

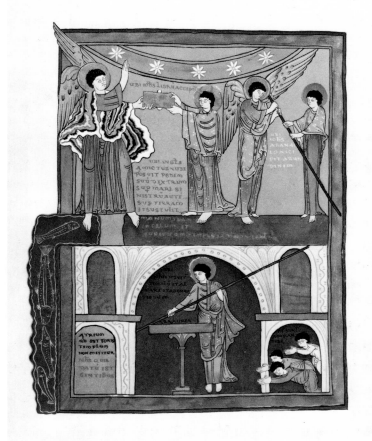

The seven angels receiving the seven trumpets before the Throne; the angel with the censer standing on the heavenly Altar, throwing the fire of the censer down to the earth. Miniature from the *Beatus*. Paris, BN lat. 8878, f. 133v. (81)

The Great Angel, standing on sea and earth, swearing his oath, and giving the little Book to John; John receiving the measuring-rod; bottom: John measuring the Temple, with a group of worshippers on the right. Paris, BN lat. 8878, f. 150v. (82)

cup with thumb and forefinger of a fat hand, staring stupidly at us, above a double chin. Elsewhere, too, even among respectable people, we see a lot of strikingly large chins and very low foreheads. The screaming Locusts, thick tufts of hair flopping out of their diadems, display open mouths full of triangular teeth. The poor little trousered wretches, stung in the head by their scorpions' tails, squirm and wriggle, touching their tormented skulls in spasms like the throes of tetanus. Abaddon, who commands the vermin, is a grimacing red-haired, wasp-waisted, carbuncle-eyed demon, with a loin-cloth as sinister as his dirty yellow skin.

On the other hand, the Great Angel, his legs apart on earth and sea, is nobly draped with a cloud resembling a chinchilla stole. The angels holding the four Winds delicately put a hand on each of the blowing mouths of winged heads. John, balancing an immense measuring-rod in the Temple, looks like a tightrope-walker. Doomed Babylon is a schematic city with three open gates and not a living soul inside, the millstone hangs in the sky, above the sea.

Cruel pictures – such as the atrocious Flood: floating carrion, drowned cattle, black heads with eyes picked out by birds – are followed by scenes of serene beauty. The assumption of the two Witnesses, HELIAS and HENOC, looks like heads and shoulders appear-

82

ing on an evening cloud. The River of Life falls obliquely from a Throne surrounded by saints seated in rows of arcaded boxes, admired by an ecstatic John, who stands on a heap of clods.

Almost every page brings a surprise, sometimes a very unexpected one. In a vignette we see a genre-piece: two bald dwarfs with big heads are plucking out each other's beards, before the eyes of a chuckling little lady, who crosses her hands over her apron. An inscription explains: *frontibus attritis barbas conscindere fas est* – if foreheads are bald, you may tear at the beards. A similar scene was discovered by Mâle on a contemporary capital at Poitiers, once in St Hilary-the-Great, now in the Town Museum. Such playful extras do not occur in the purely Spanish *Beatus*, and this brings us to the question of the provenance and the degree of originality of the St-Sever manuscript. How far is it archaic, and how far typically Romanesque, in the meridional manner?

THE QUESTION OF INSPIRATION

After the pictures devoted to the opening of the Seals a splendid double-page miniature introduces the Heavenly Liturgy in a formula unknown in the ordinary *Beatus* cycle. Not a single detail of this famous and often reproduced composition recalls the corresponding picture in the Mozarabic scene of the Adoration, described above; instead, it agrees perfectly with those in the tympana and voussoirs of a century later, at Moissac and at Chartres. The whole also recalls many motifs of the *Majestas*, painted in the apses of country churches in Catalonia and in the Roussillon, which was part of it in the eleventh century.

The Unnamed One is enthroned on the cosmic globe. His feet repose on a segment of green earth; in one hand he holds a medallion with the Lamb, in the other a long staff ending in a knob containing a Dove: clearly a succinct image of the Trinity. The Throne is set in a circular blue zone. The four Beings, all with six wings full of eyes, are turned towards it. Three of them hold Gospel-books; the Eagle holds a Scroll with his claws, exactly as in Carolingian *evangeliaria* in Tours, two centuries earlier, and as in the tympanum of Chartres a century later. Evidently we are not in Spain, but in Romanesque France. Inside a scarlet orbicular outer zone, the Elders form a loosely grouped circle surrounding the Throne. Seated on lavishly decorated wooden chairs, broad diadems on their heads, they hold up their golden chalices and instruments, in a burst of enraptured acclamation. Outside their red area, fifteen undersized but graceful angels are flying towards the vision with outstretched hands.

Of course Emile Mâle was right to link this grandiose ensemble with the *Majestas*, which appeared in monumental sculpture some sixty years later at Moissac, and afterwards at Chartres. At Moissac the four Beings are whirling round the Lord as if caught by a cyclone and the Elders, sitting below, are staring upwards in complete bewil-

The Wrath of the Lamb: death of the False Prophet, the Beast (sticking out a red tongue), Satan and the Dragon (a scaled serpent). Paris, BN lat. 8878, f. 193v. (83)

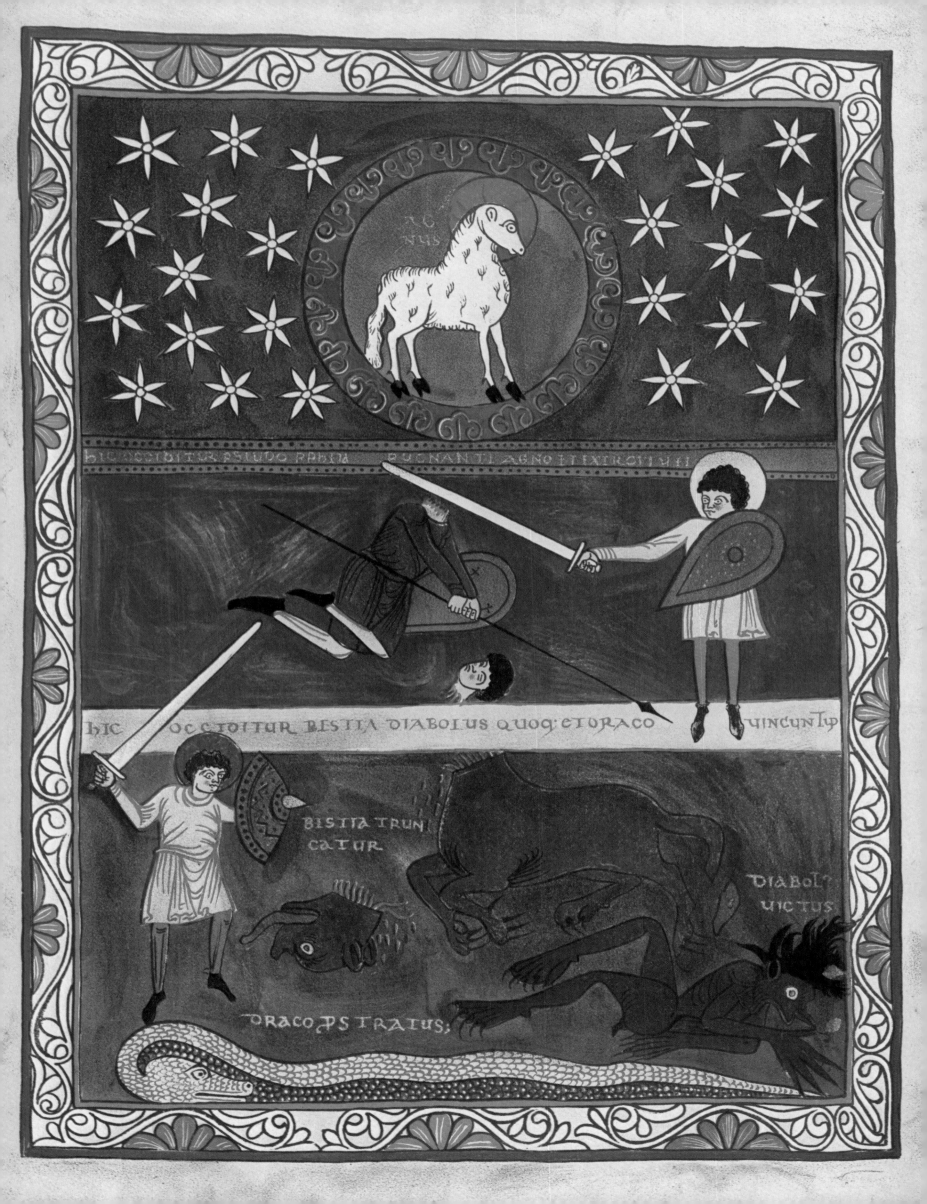

40 derment; at Chartres, and on tympana derived from it, they sit quietly in the voussoirs surrounding the tympanum, but invariably they are holding the same cups and the same instruments, and are sitting on the same ornamented chairs, thus perpetuating Prudentius's model.

Mâle believed the St-Sever Heavenly Liturgy to be part of the *Beatus* cycle. Consequently he connected the chief theme of the suddenly reborn monumental sculpture, the *Majestas* – that miracle of the twelfth century – with the *Beatus* family. He put forward this theory in 1924. But seven years later Wilhelm Neuss, who had collated both text and illustrations of the entire *Beatus* group, definitely proved that the famous St-Sever composition did not belong to the archetype, thus refuting Mâle's theory about the chief theme of Romanesque sculpture being dependent on the old Spanish Apocalypse.

THE PROVENANCE OF THE BEATUS CYCLE

For his part, Neuss firmly held that no other manuscript rreproduced the archetype as closely as this relatively late and isolated masterpiece made in Gascony. Many of his arguments were impressive, especially the linguistic ones. He stressed the archaic character of the legends, some of which he roundly called 'Visigothic'. He pointed out several visual details of a remarkably Antique flavour, not found in the oldest Spanish manuscripts. Stephan Garsia's model, he concluded, might have been very near to the archetype and thus to the Early Christian tradition. But to which part of it?

Somewhat hesitantly, and in view of the many African authors used by Beatus – Fulgentius, Augustine and the never mentioned but most important of all, the Donatist Tyconius – he proposed Roman Africa from before the Arab Conquest, and, of course, because he was badly in need of visual parallels, Coptic Egypt. With some good will, one might discover the low foreheads with the round caps of black hair, the three-leaf clovers decorating short mantles, 36 in the early sixth-century frescoed chapels of Bawît. Figures standing below arcades can be seen on any Coptic funeral slab. The Riders of St-Sever are likely to recall Coptic Cavalier Saints. There, however, the similarities end. Nearly all Coptic figures are stiffly frontal, and the famous cap of curly hair is seen on the heads of innumerable saints, Byzantine or not, in ivories, mosaics and icons, from the tenth to the twelfth centuries, and even long afterwards.

Apart from a handful of products of the minor arts – scraps of silk and wool, ivory pyxes, remnants of a few late funereal frescoes, and perhaps some of the oldest Sinai icons – the Christian art of Alexandria has perished. There is neither trace nor record of any illustrated Bible book in Roman Africa, and, after all, it was an intensely Christianized country with five hundred Latin bishoprics. That the nineteen remarkable and crammed pre-Carolingian minia-

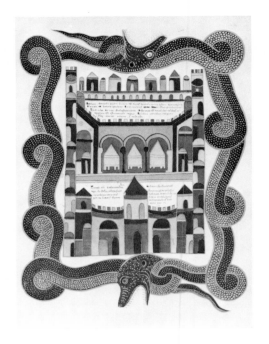

Babylon. Miniature illustrating the commentary on Daniel, following that on the Apocalypse. Two serpents frame the city. Exposed under the arches of a temple are the shrines of Ananias, Azaria and Misael, the three Children saved from the Furnace, and honoured in the cathedral of Christian Babylon (Ctesiphon, in Sasanian Persia). Paris, BN lat. 8878, f. 217. (84)

tures of the *Ashburnham Pentateuch* have anything to do with Spain or Africa, is a gratuitous supposition; as I see it, there is very little obviously comparable to archaic details of the St-Sever pictures.

Instead of wasting time on an insoluble question, we should bear in mind that such a skillful craftsman as the copyist of St-Sever might have drawn arrows from his own quiver. The sure, strong Romanesque manner is not older than the twelfth century. In the eleventh century, the master of St-Sever stands alone; the scriptorium of St-Martial at Limoges was not yet in full swing, and even much later the Limousins cannot equal Stephan Garsia. Would it be wise to exclude, a priori, a modest man of genius, and always suppose dependence instead of originality?

The man who drew the double leaf with the Woman and the Dragon (of which the left part is lost); who painted the flock of flying angels pointing their lances against the heptacephalic hydra; who copied the group of the Lord, the angel and the little Prince – all three with lifted eyebrows, in garments sprinkled with white clovers – must have been more than a pedantic and helpless copyist. Examine the naked reprobates tumbling down into the pool of fire and brimstone, where Satan lies roaring in his chains: you will recognize a hand as sure as that of the young Picasso, also a Catalan, incidentally.

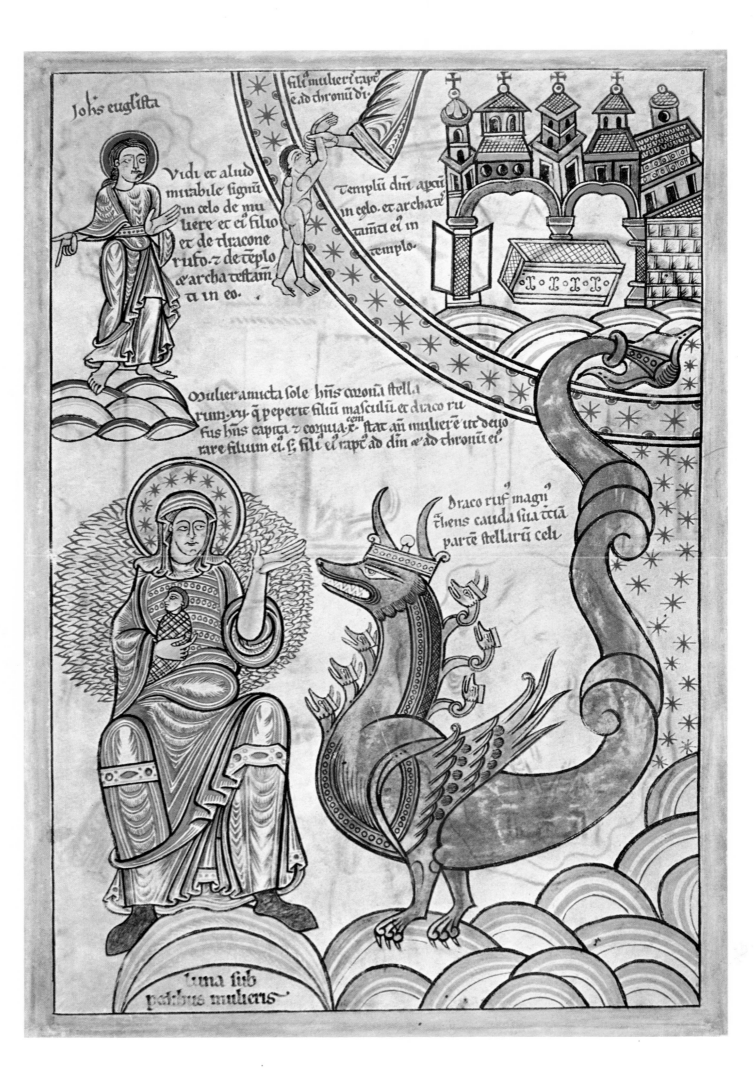

Joħs euglista

Vidi et aliud
mirabile signū
in cœlo de mu
liere et ei filio
et de dracone
rufo. ⁊ de tēplo
et archa testam
ti in eo.

fili mulieri rape
e ad thronū di

templū dñi apū
in cœlo. et archat
tamti ei in
templo.

Mulier amicta sole hñs cōronā stella
rum .xij. q̄ peperit filiū masculū. et draco ru
fus hñs capita ⁊ cornua. ⁊ stat an̄ mulierē ut dev̄o
rare filiū ei. ſ. fili ei rapē ad dñ̄ ⁊ ad thronū ei

Draco ruf magn̄
łbens cauda sua tciā
partē stellarū celi

luna sub
pedibus mulieris

The 'Liber floridus'
at Wolfenbüttel

An illustrated Apocalypse formed part of the curious encyclopedia called *Liber floridus*, compiled by Lambert, canon at St Omer, shortly before 1120. It was torn out of the original manuscript, which is preserved at Ghent; fortunately at least part of it survives in a very early German copy, now kept at the Library of Wolfenbüttel. The *85-88* Ghent codex still contains a number of kindred motifs, such as the Antichrist riding Behemoth and Leviathan; the Heavenly City, the twelve precious stones of which are connected with the Apostles; the Lamb, the four elements, and ten *modi* of the solar year.

The *Wolfenbüttel Apocalypse* contains twenty-five scenes, and breaks off at the appearance of the two Beasts. Some fill a page, others are set in strips one above the other. The pictures are clearly drawn in the usual manner of that age, a kind of German Romanesque permeated by the inevitable Byzantinisms and moderately expressive. Its main interest, however, lies in the fact that this laconic cycle precedes the Anglo-Norman one by a century, and its iconography still follows the old Italic tradition.

We again find the Woman clothed in the *maphorion*, set against *85* a piece of red lace representing the sun; the twelve stars fill her nimbus. Sitting with the swaddled Child on her lap, she recalls the oldest statues of the *Majestas Virginis*, and also the Trier Woman. The Dragon, the usual Antique hydra, has horns sticking out of a low diadem. There is even the large head of the Earth, *Tellus*, *86* swallowing the water vomited by the Dragon, exactly as in the Trier miniature. The churches, the cities, the angels, the demons, the four Wind-heads, the Phrygian bonnet of the third Rider, the censer, the heads peeping from a frieze of clouds and representing seven thunders, Elijah and Henoch – everything recalls the Early Christian past.

Novelties are not entirely lacking, however. The Souls under the Altar (here the footstool of the Unnamed One) are naked little fellows transfixed by swords and lances indicating their martyrdom. Two *87* angels hold the Wind-heads on veiled hands. Rider Death – a bearded, hairy, bat-winged demon inscribed *mors improba* – is followed by Famine, *fames*, leaping out of the Mouth of Hell, a finger thrust into his hungry mouth. And, last, though not least, the twenty-four Elders – surrounding first the Lord and, on the following page, the Lamb. Sitting or standing in as many compartments, they are *88*

John contemplating the Woman and the Dragon; the Child carried away to the heavenly Temple, where the Ark of the Covenant appears behind the Open Door, under the arches of the nave; the Dragon's tail sweeps down a third of the stars. Miniature in an early German copy of the *Liber floridus*, by Lambert of St-Omer, twelfth century. Example of the survival of the early Italic tradition. Wolfenbüttel, Herzog August Bibliothek, cod. Guelf. Gud. lat. 2, f. 14v. (85)

129

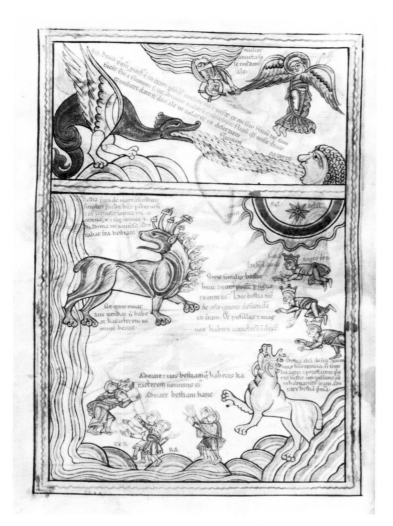

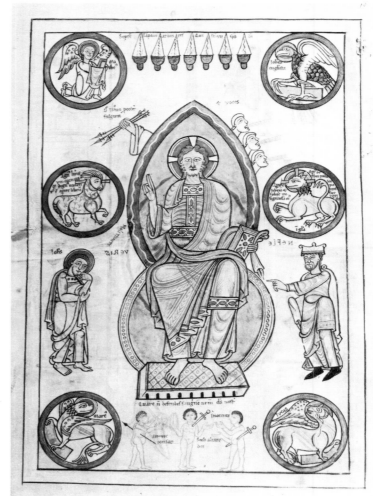

named after the twenty-four orders of the sons of Aaron enumerated in I Chronicles XXIV: 7-18. Eighteen names correspond with those of the biblical list, one is Ezekiel and five cannot be identified. To each name is added another, this time of a biblical person. The names of twelve patriarchs and prophets accompany the Elders disposed round the Unnamed One, those of the Apostles go with the Lamb.

The idea of giving names to the Elders originated in Coptic Egypt, where they had their own feast (the 24th Hatour: November 20th), as did the four Beings (the 8th Hatour: November 4th). The fanciful names we find again, in Graecized form and afterwards in hardly recognizable Latin deformation. At the end of the Middle Ages the devotion to the Elders had a curious second blooming in such a hinterland as Carinthia, expecially at Judenburg; but Lambert only emphasizes the classic interpretation: the Elders represent the prophets and the Apostles, and as such they symbolize the perfect harmony of the two Testaments.

Now that we are on the point of entering the great French cathedrals, we might well bear in mind the archaisms of the *Liber floridus*. For the very sporadic apocalyptic motifs we shall discover in the immense cathedral repertoire have much in common with this latest witness of the past.

The Woman receiving wings (from her Son, the Lord himself); the Earth (still the Antique *Tellus*) is swallowing up the water spit out by the Dragon. Bottom: the Beasts from the sea and the earth being worshipped. Wolfenbüttel, Herzog August Bibliothek, cod. Guelf. Gud. lat. 2, f. 15v. (86)

The Unnamed One on the Throne, holding the 'lightnings'; the heads are the 'voices'; in the corners, the four Beings; on each side, the Lamb and the Lion of Judah; under the footstool, the transfixed 'Souls under the Altar'. One of the Elders consoles the weeping John, Wolfenbüttel, Herzog August Bibliothek, cod. Guelf. Gud. lat. 2, f. 10r. (87)

The Lamb with the Book *(opposite)*, surrounded by twelve Elders, all identified by their names. Wolfenbüttel, Herzog August Bibliothek, cod. Guelf. Gud. lat. 2, f. 11r. (88)

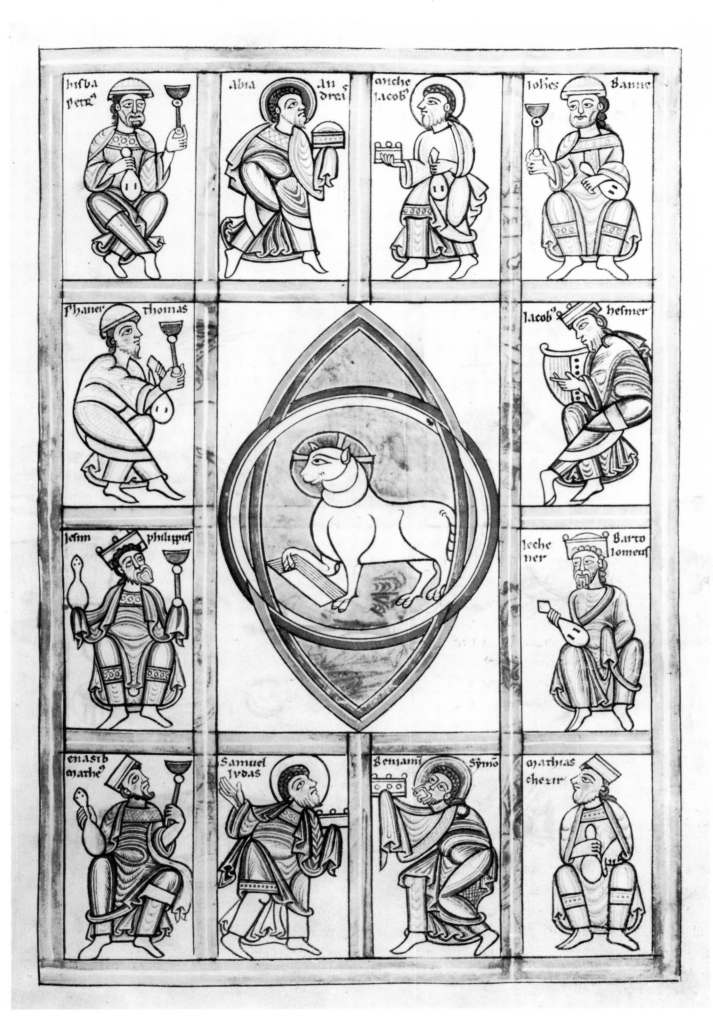

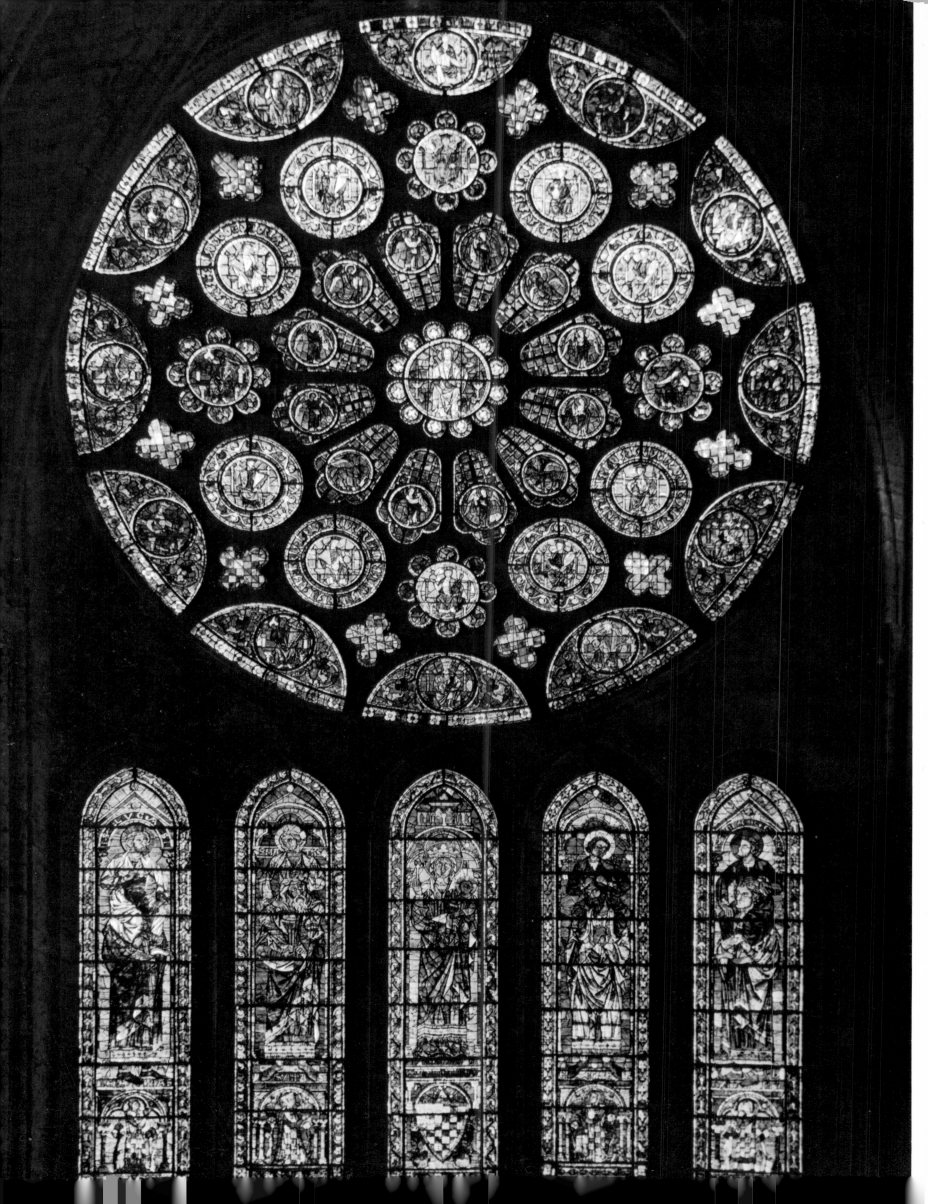

The Cathedrals

The great cathedrals, where so much is portrayed, reveal little from the Book of Revelation, and even this disappears soon after 1230. But the cathedral itself, the moving spirit behind this synthesis of French Universalism, this acme of medieval Christianity, which rapidly arose between 1137 and 1230 – did it not stem from the last chapters of the Apocalypse?

'Cathedrals: organs for light', Paul Valéry wrote in his *Cahiers*. By day, the sun's dazzling spots of light contrast against deep shadows, playing symphonies on the keyboard of the bizarre yet austerely ordered mass of mellow-coloured stone; sometimes the entire clerestory appears transparent, striated rather alarmingly with oblique shadows cast by those half-bridges, the flying buttresses. At night, the full moon, far above the trees, shines on the roofs, the balustrades, the galleries of truncated towers, the spires and the needle-like pinnacles of the crossing. By day and night, the nave, with its oars of white stone, like an aisled shrine mysteriously come to anchor, rises far above the once narrowly walled, tightly packed little town.

Inside, below the high vaults of juxtaposed corridors, the daylight plays its fugues on the architectural themes, especially by means of stained glass windows. Open and yet closed, bright and yet glowing dark, a myriad of coloured sieves catches the light and sifts it into an infinity of variations. Every day, the sun goes round the church: in the morning filling the east end with fresh sparkling gems; at noon glaring on the long stretch of the south side; in the evening, the façade – a cliff with grotto-like open porches – catches, in its rose window, the red-gold of the sunset sky. In all keys, the light unceasingly plays the organ of colours held within glass, grisaille and lead, between delicately profiled frames, arches, mullions and colonnettes.

This symphony of stained glass is the overwhelming achievement of the French cathedral: even more, its very essence. Here, too, 'all the beauty of the King's Daughter is inside', she is 'glorious within' (Ps. XLIV: 14, Vulg.). One sees from inside that the church has been built for the sake of the windows. Certainly, one recognizes the Apostles in the unshakable columns rooted in foundations whose Cornerstone is Christ. The walls are not built of dead stones, but of living ones, played upon by the light: precious stones, gems – exactly like the Heavenly City, which appears at the end of the Apocalypse.

89

The cathedral, a symbol of the Heavenly City: 'the walls of Jerusalem being built with precious stones.' South rose window in Notre-Dame, Chartres. In the centre, the Lord holding the Book, on his Throne, between two candlesticks, surrounded by the Elders, disposed in two concentric circles of twelve medallions. Chartres (Eure-et-Loir), cathedral of Notre-Dame, *c.* 1230. (89)

133

Detail of a chandelier with twelve lamps, each with a gate, symbol of the Heavenly City. Given by Bishop Hezilo of Hildesheim, 1054-79, it is one of the oldest in Europe. In 1962 it was reinstated in its original place, in the badly damaged (1944) but now restored cathedral; other famous examples are at the cathedral of Aachen and in the church of Grosz-Komburg, near Schwäbisch-Hall. (90)

THE HEAVENLY CITY

This was something no one ignored, and which everyone took for granted. If it was not a glimpse of heaven, what else was? Everybody who knew some Latin understood the Vesper hymn, sung at the Dedication of any church, praising the most wonderful Church of all:

Vrbs beata Hierusálem	Town of Salem, blessed City,
dicta pacis visio	thou art named 'vision of peace'
quae construitur in caelis	thou art built on high in heaven
vivis ex lapidibus	solely of living stones
et angelis coornata	and adorned with the angels
ut sponsata comite.	as a bride with her escort.

134

At Reims Cathedral, those guardian angels, statues with spread wings, stand under the canopies on top of the buttresses. They surround the entire clerestory with the celestial guard requested in the immemorial supplication: 'This City surround, Thou, Lord: and let your angels guard it.' Outside Reims, curiously enough, that visible bodyguard, around the huge roofs of grey slate or green copper, is found nowhere; nor are the Invisible Powers, to guard the twelve Gates, or to welcome those who enter. In fact, the resemblance of the cathedral to the apocalyptical City is only discreetly suggested by a few, but decisive, features.

The 'Lamp' that renders the sun superfluous is here also the Lamb of God, but hidden under the veil of the Eucharist. It shines on the Altar: there is the Lamb's Throne; there lies its Paradise, and there the Waters of Life are flowing; there the trees are blossoming that 'bring forth their fruit every month'. It is there that incorporeal Presences surround the Altar, celestial Powers as well as saints of the Church Triumphant.

It was this vision that Jan van Eyck evoked two centuries later, with the magic of his light and the prestige of a new technique, on the central panel of the Ghent altarpiece, where the faithful imme- *161* diately recognized the image of their own dreams of Paradise. Since 1230, that inner image of the Celestial City remained unchanged, in Flanders as well as in the north of France.

THE THRONE AND THE ELDERS

In the tympana of the first Gothic cathedrals the Lord in Majesty, *Majestas Domini*, dominates the chief entrance, where it still appears *41* in the traditional way. The Lord is enthroned on the globe of the cosmos, within a mandorla and surrounded by the contorted figures of the four Living Beings; in the voussoirs framing the tympanum, the twenty-four Elders sit on their elaborately made wooden thrones, one above the other. Thus they appeared at the apogee of the Romanesque era, 1110-37, which leads from Moissac to Chartres in *37,38,41* the space of forty years.

The Elders belong to the Apocalypse, but we look in vain for the Lamb or the Book with the seven Seals. The essential motif of the Majesty – the Lord and the Living Beings – expresses a very different idea, namely the harmony of the four Gospels. Already in the Carolingian ateliers of Tours and Corbie, about 840, the *Majestas Domini* had received its perfect, dynamic formula: a motionless Christ amidst the centrifugal turmoil of the four throne-bearers. Whether in the last resort this magnificent formula goes back to the already mentioned theophany of the *Trisagion*, which originated in the *36* monasteries of the East, is a question best left undecided; the important thing is that the Western illuminators invariably adopted it for the frontispiece of their Gospel-books.

At the moment of the sudden rebirth of monumental sculpture

in France, shortly after 1100, the *Majestas* passed from the manu-
scripts to the tympana of the Romanesque abbey churches: it was
translated in stone, on a huge scale, and adapted to the segment
of the tympanum. Until then, it had opened the Gospels; now, it
dominated the chief entrance of the façade and one could see it
repeated in the great fresco of the main apse, behind the high altar.
It was impossible to fill a huge portal with the five figures of the
Majesty. The sculptors, therefore, extended the Lord's escort: on
the lintel they arranged the Apostles, in the voussoirs the Elders,
in the remaining space hosts of angels. The Elders were represented
as celebrating the Heavenly Liturgy, and holding their citharas and
vials of perfume. The faithful entering their church in order to
participate in the terrestrial liturgy, saw above their heads the image
of the everlasting Liturgy in heaven.

In this way the Majesty appeared in the porches of the Midi,
at Cluny, and at Suger's St-Denis. From there it reached the front
of the first Gothic cathedrals. How it was in Sens, we do not know:
the chief tympanum was damaged and replaced by a composition
in honour of the patron saint, St Stephen. At Chartres the Majesty
still holds the place of honour, as at Angers, and Arles; elsewhere
the Chartres composition is imitated not in the central doorway, but
in a side-porch, as at Bourges and Le Mans, and, much later, in
a transept doorway at Burgos. The painting in the apse, until now
the visual focus of the interior, was forced to disappear, beacause
in the new style the calotte of the apse was sectioned into five or
seven rib-vaults, crowning the east end of the church with a lofty
scalloped shell, adorning a range of clerestory windows.

Before long the apocalyptic *Majestas* disappeared even from the
façades; in the sanctuary it vanished because there was no apsidal
conch where it could be put; in the sculptured tympanum, because
it was superseded by another motif, the Last Judgment.

THE LAST JUDGMENT

Doomsday, as our ancestors called it, or the Last Judgment, that
eschatological opera called up by St Matthew (Mat. XXIV and XXV),
showed a drama much more human than the theophany described
by St John. John's vision, essentially supratemporal, defies repre-
sentation: what sculptor would seriously venture to show the Un-
named One in the likeness of 'a jasper and a sardine stone', sur-
rounded by 'lightnings and thunderings and voices', above a Sea
of crystal?

In fact, nobody ever did. In the old Carolingian *Majestas*, the
Lord was seen in the guise of the Son of Man, and everybody recog-
nized him immediately, though he was sitting on the spheres and
holding the tiny globe of the cosmos between thumb and forefinger.
Alpha and Omega shone on each side of his face and, though escorted
by those strange creatures, the four Beings, the seraphs and the

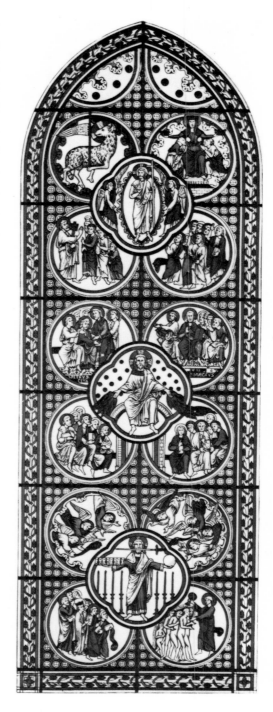

The symbolic 'window of the Apocalypse',
in the ambulatory of Bourges Cathedral
(on the south side); first part of the
thirteenth century (see page 144). Bourges
(Cher), St-Etienne. (91)

The Son of Man holding the Book with
the seven Seals, the candlesticks on each
side. Detail of pl. 91 (bottom quatrefoil).
(92)

41

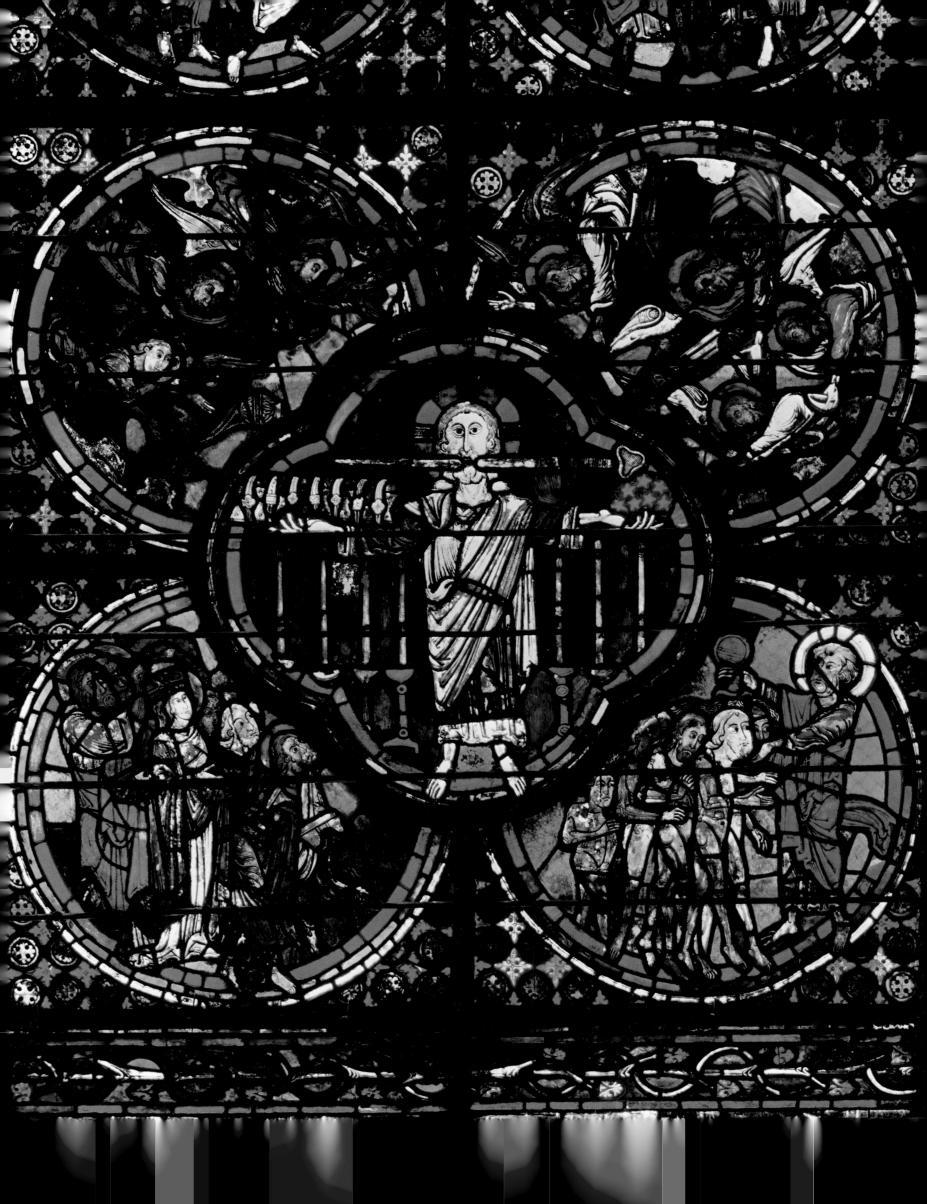

cherubs, he was readily known. At Doomsday, however, the Son of Man appears as himself, and what he says affects every man; a child can understand it, especially those words of welcome to all who had practised the Works of Mercy so eminently cherished by medieval Christians. So it came about, that immediately after the masterpiece of Moissac, in the same region, on the doorways of other important Cluniac abbey churches, at Beaulieu, at Conques and elsewhere, another composition made its appearance in which the central figure was not the inaccessible Majesty, but the Judge.

The Lord, his tunic open at the side, or naked below his pallium, silently showed his wounds, sitting on the Seat of Judgment, hands outstretched. Behind him, in deep silence, angels held the 'sign of the Son of Man appearing on the clouds', the Cross, and the other instruments of the Passion. Silently, the Twelve were enthroned at his side. Angels blew the last trumpets; the dead rose from their sarcophagi, all of them aged thirty-three, as 'perfect men', in the fulness of Christ's stature (Eph. IV: 13). In the middle of the scene, Michael weighed the Souls; sheep and goats had already been divided. The Elect went smiling past Peter holding the keys of the Kingdom, the cursed were driven by hideous demons into the gaping mouth of hell. Finally, one even saw 'Abraham's bosom' (Luke XVI: 22), the old patriarch holding up an apron full of jubilant little heads. Instead of the four Beings, the two last intercessors, the Virgin and the beloved disciple John, were seen kneeling as suppliants at the Lord's feet (and aptly filling the lower edges of the tympanum). All this was striking and extremely moving, and, on the west side of the church, where the last rays of the setting sun fell, an eloquent warning, a silent reminder of the tremendous Last Things to come.

No wonder the Judgment appears on the front of nearly all the great cathedrals of the second Gothic period: at Laon, Paris, Bourges, Amiens, Reims, Poitiers, Strasbourg; at Bamberg on a side-portal, as at Bordeaux (where, incidentally, angels are taking away the sun and the moon) and at Compostela. Nobody knew that this incomparable composition was a gift from the East, and that, in travelling West, it had lost several motifs and the logic of that richest of ensembles, the 'Terrifying Judgment' invented by the Greeks.

Yet, the Apocalypse was not entirely forgotten. Sometimes the Elders were chosen in order to fill the voussoirs around the tympanum; later on, however, they had to make way for the Wise and the Foolish Virgins of the parable preceding the Judgment chapters. On a voussoir of Notre-Dame in Paris, we unexpectedly meet Rider Death, blindfolded, riding a prancing horse and dragging a naked corpse behind: a poignant motif, but chosen as one of the portents of the End, and thus part of the paraphernalia of the Last Judgment.

A surprising feature of the Gothic Judgment is the presence of John the Evangelist, who replaces the Baptist. In the Greek Judgment, the *Deisis*, or 'Great Intercession', the group of Lord, Virgin and Prodrome (John the Precursor) is the heart of the composition:

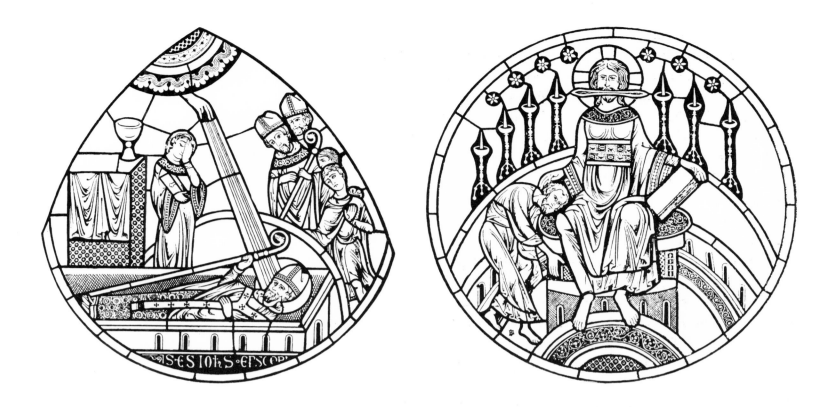

John lying in his tomb at Ephesus after his last Mass; the Son of Man among the candlesticks. Details of a window in the apse of St John's Cathedral, at Lyons (Rhône), thirteenth century. (93)

only the Mother and the Friend, the only two that were born entirely pure, the snowy summits of the two Testaments, dare ask that justice be tempered with mercy. The idea, not unknown in the Latin West and frequently illustrated in Italian churches, did not enter the typical Gothic version of the Last Judgment. Its authors, whether clerics or artists, when introducing the beloved Disciple facing the Virgin, might have had in mind the familiar figures standing by the Cross: John facing Mary, the Faithful facing his Mother, the Church (John XIX: 26-7); here they are both on their knees, for a last Intercession.

THE LEGEND OF JOHN

Though seldom found in scenes borrowed from the Apocalypse, throughout the world of the cathedrals John himself is fairly conspicuous, even apart from his presence in every Crucifixion group dominating the choir-screen or the rood-loft until the time of the Reformation.

Most cathedrals are dedicated to the Virgin, several to Stephen, the Baptist or a local saint (Tours: Gatien); as for John, in France one can only mention Besançon. Yet, among the most venerated saints he comes immediately after Peter and Paul. In thirteenth-century windows illustrating his life, a medallion with the exile on Patmos is never left out. It is not so much an introduction to the visions of Revelations, as an integral part of a series dedicated to his, by then, extremely popular legend, the *Acta*, or *Virtutes Johannis*, in which, with the exception of the sojourn at Patmos, nothing whatsoever is borrowed from the Scriptures. The legend, summarized

in a lesson read during Matins on St John's Day (December 29th), comes from a very dubious source, from second-century Gnostics infected by Docetism. They denied the human nature of Christ and taught that he only appeared to die; Encratites, who loathed corporality as a delusion, condemned marriage and extolled virginity. In so far the Acts of John were mere propaganda and far from orthodox: a fanciful fiction repudiated with indignation by the Orthodox Church.

As it happens, once the tendency had become a thing of the remote past, the old tale survived. Three centuries later it appeared in a somewhat expurgated adaptation made in Syria. By now, the narrator was the deacon Prochorus (Acts VI: 5), the young man always seen on the Greek and Russian icons as St John's secretary, in the grotto of Patmos as well as in Ephesus, where the white-haired, almost centenarian John dictates the forth Gospel; it is interesting to note that neither Prochorus nor the bearded old John occurs in the Latin West.

The French clerics of the thirteenth century knew no Greek; they read the story in a Latin version under the name of a legendary bishop, Abdias, or a certain Mellitus (probably a deformation of Melito, the second-century bishop of Sardis). In the third quarter

of the thirteenth century, the essential parts of the story, now venerated as a harmless post-apostolic document and known as *Virtutes Johannis* or *Passio Johannis*, were briefly summed up and inserted in the *Golden Legend* of James of Voragine, archbishop of Genoa. By then, the legend of John had become a familiar tale, and its episodes could be seen in many a cathedral window, such as those preserved at Chartres and Auxerre, put up fifty years earlier.

Because the legendary scenes partly precede and partly follow – and, consequently, frame – the strictly apocalyptic series in some manuscripts of the Anglo-Norman family, it is as well to know their contents. It is an adventurous story, slightly extravagant and full of disguised Gnostic themes, but not entirely unfounded: a legend cleverly adapted to history. At the start we find John preaching at *137* Ephesus. He then baptizes a noble virgin, Drusiana. Denounced by spying Jews, he is brought before the proconsul of Asia and sent off to Domitian. In Rome, the emperor assists at his martyrdom in the cauldron of boiling oil from which he rises unhurt (the scene *137,186* is at the Latin Gate, where his church and *memoria* now are; Tertullian mentions, and Eusebius of Caesarea tells us, that Domitian had Christ's kinsfolk brought to the capital, and, seeing they were simple people, dismissed them).

Exiled to Patmos, John writes the Apocalypse. Back in Ephesus, after Domitian had been murdered, he resuscitates Drusiana as she *109* is carried out to be buried. Meeting two young men taught by the Cynic, Craton, who, out of contempt for the material world, had smashed their jewels, he condemns their pride and restores the splinters to gems, and thus brings them to the faith. Two others, Eutychius and Atticus, out of false idealism, had sold their estates. John, meeting them on the beach, changes sticks into gold, and pebbles into gems and says: 'buy back your land and look after the poor'. The youths, seeing the futility of their endeavours as well as the vanity of all material things, repent and do penance, and the treasures become again what they were before.

As according to John's prayer, the statue of the 'Diana of the Ephesians' falls down and her temple collapses. Aristodemus, 'bishop of the idols' takes up arms against him, and proposes the ordeal of the poisoned cup. Two criminals sentenced to death drink it and drop dead; John throws his mantle on their corpses and they come back to life. He himself drinks and comes to no harm: and this explains why for centuries the poisoned cup became his attribute. Even when represented alone, he carries the cup and makes the sign of the Cross over it, and little black serpents are seen running out of it. Both Aristodemus and the city's governor are baptized, and *109* found the first cathedral of Ephesus.

John, by then ninety-nine years old, is taken home by his beloved Master who had said: 'If I will that he tarry till I come...' (John XXI: 22). He has his tomb dug before the Altar and, having sung his last Mass, he lies down in his tomb and immediately vanishes *93,179*

Details of the Apocalypse in the voussoirs of the south-west doorway of Reims Cathedral. *Left :* an angel holding a Wind-head; the nude Souls under the Altar (the angel, bottom left, is an eighteenth-century restoration). *Right :* a well preserved series, which includes: the Great Angel with the rainbow round his head; the Lord facing the Church (the Marriage of the Lamb, see pl. 98); the angel pouring out the vial on the throne of the Beast; the Rider on the white horse with two swords issuing from his mouth; the angel in the sun summoning the birds of prey; the millstone thrown into the sea; the birds of prey picking out the eyes of the dead kings; the two angels holding a book, probably recalling the passage about the 'Everlasting Gospel'. First part of the thirteenth century. (94)

in a dazzling light. In the empty tomb the Disciples find only a constant stream of manna, a miracle, word of which reached Augustine at Hippo, about 400. No wonder this blessed end enjoyed great popularity. We often find it in the cathedrals, together with some other rarer episodes, and chiefly in stained glass.

93 A thirteenth-century window in the apse of Lyons Cathedral shows the Son of Man enthroned amidst the candlesticks; below the seven stars, with a two-edged sword-blade across his mouth, and 'girt about the paps with a golden girdle'. He lays his hand on the head of the aged John, prostrate at his feet. Near by, John lies in his sarcophagus, before the Altar, with mitre, chasuble, archiepiscopal pallium and crozier; a shaft of light issuing from the Hand of God touches his face and blinds his deacon, who covers his eyes, while two bishops and two young gravediggers look on.

97 At Auxerre Cathedral in a window of the ambulatory are nine preserved panels dedicated to the author of the Apocalypse and its visions. A servant crushes the gems in a mortar with an enormous pestle; John drinks the cup and resuscitates the (three) poisoned criminals. With outstretched hands, the Lord, in the attitude of a Judge, sits enthroned above the celestial Altar; the seven angels blow the trumpets, one of them also holds the golden censer. A hand

96 on her womb, the pregnant Woman sits against a bed of flames — the sun — her feet on the crescent; the twelve stars, in a globe, upon her veil; an angel points out the 'great sign' to John. From the border of a medallion John is watching the seven-horned Lamb loosing a Seal of the Book, at the side of the Unnamed One. He sees fire and hailstones falling down and frightened men 'hiding in the dens and rocks of the mountains'. The Son of Man appears with the sickle, on the white cloud, and the angel of the Harvest flies out of the heavenly Temple. An angel puts a crown on the head of the first Rider: a bowman galloping on his white horse, watched by John. The panel with Rider Death and Hades has been relegated to another window.

In a clerestory window of Troyes Cathedral John, rising from his tomb, is a tonsured young man. Together with other episodes of his life the same scene appears in a number of thirteenth-century windows entirely dedicated to his legend: at Bourges, in the Ste-Chapelle of Paris, in a clerestory rose window at Reims, in the chancel of Tours, in St-Julien-du-Sault and, finally, in Chartres Cathedral.

The Chartres window (the first, from the west, in the southern aisle) is the earliest and the most complete. John sails to Patmos; writes the Apocalypse; raises Drusiana from the dead; restores the gems under the eyes of Craton (again we see the mortar and pestle); Eutychius offers the gems to a money-changer; a certain Stacteus is carried out to be buried (his resurrection is left out); executioners pound reptiles in a mortar, to prepare the poison; the Lord takes home his beloved Disciple, who stands upright in his sarcophagus under a flash of light and then is met by angels, according to the

The Souls under the Altar; the four Riders (here naked, a unique feature); John, the angel, and the Lamb with the Book (see page 146). Front side of the south-west buttress, cathedral of Notre-Dame, Reims (Marne). First part of the thirteenth century. (95)

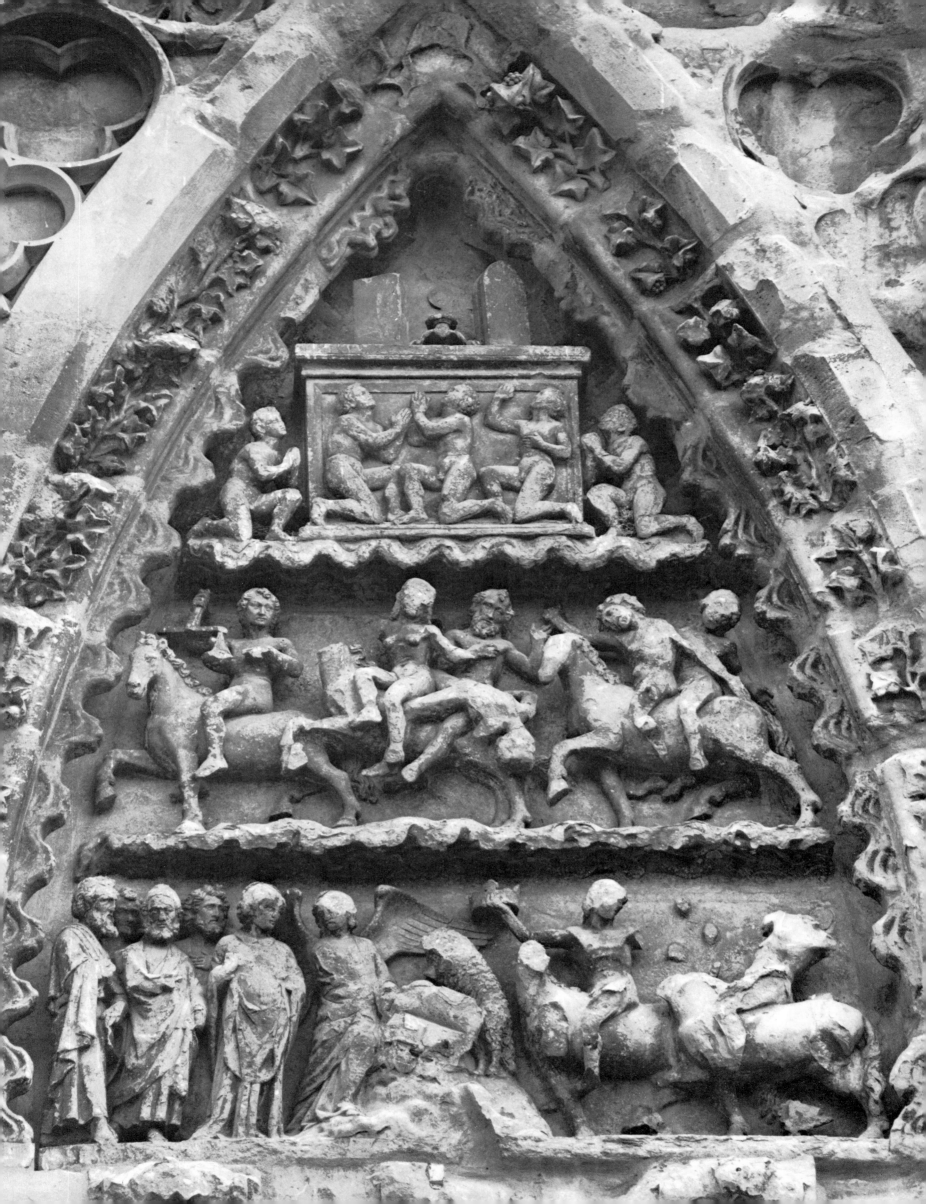

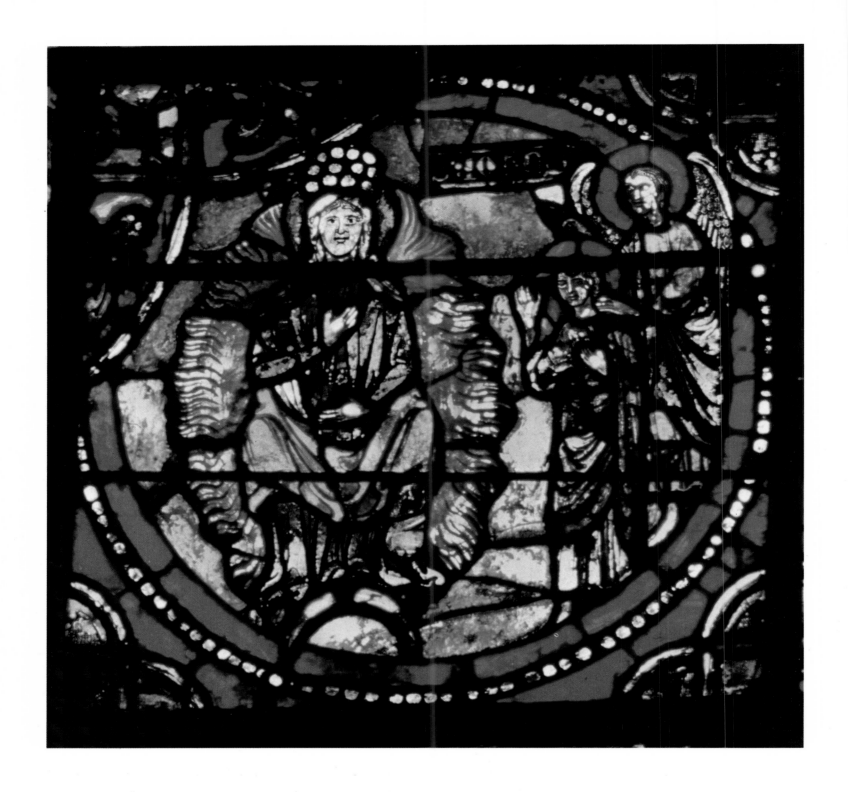

old responsory sung at every funeral: *occurrite, angeli dei!* 'rush to meet him, ye angels of God!' The angels, again, swing censers or hold the cushion at the heads of the glorified dead, the recumbent effigies of all thirteenth-century tombs.

The Woman clothed with the sun. Detail of pl. 97. St-Etienne, Auxerre. (96)

THE SYMBOLIC WINDOW OF BOURGES

91,92 The famous window of Bourges, on the other hand, is purely apocalyptical, but in an exceptional way. Though a number of visions

144

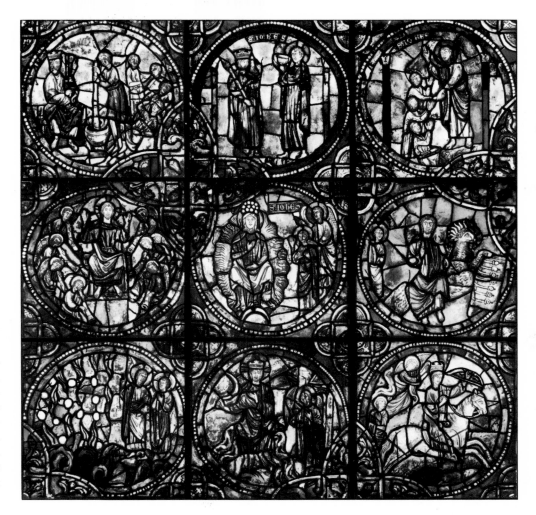

Nine panels of a window representing the *Life of John*, and the Apocalypse. Top (from left to right): a servant crushing the gems with a huge pestle in a mortar; John drinking from the cup; John resuscitates the three poisoned criminals. Centre: the angels with the seven trumpets; John beholding the Woman; the Lamb, with seven horns, opening a Seal. Bottom: the rain of fire and hailstones; the Lord on a white cloud, holding the sickle of the Harvest; the first Rider. (97)

are recognizable, the whole is symbolical and illustrates a text of Anselm of Laon, whose commentary has been mentioned in the Introduction. The profound theme is enhanced by an incomparable symphony of deep colours – crimson, blue, yellow, bottle-green, black – which, in this thick glass, have a stereoscopic effect not found elsewhere.

In the lower quatrefoil, the Son of Man stands amidst the seven candlesticks, a sword across his mouth, a huge sealed Scroll in one hand and a cluster of red stars in the other; the angels of the seven churches swing censers at him. At his feet, Peter, pouring water from a red ampulla, baptizes a group of naked catechumens; facing them, a group of saints, with John and a queen, who is probably the Church, look up at the vision. The baptism represents the Sea of crystal, for 'crystal', says Anselm, 'is hardened water, and baptism changes a wavering man into a firm Christian'.

The middle quatrefoil contains the Vision of the Throne. Flames issue from the hands of the Unnamed One, whose nimbus contains the Cross of Christ and who is surrounded by four groups of six Elders. Among them we recognize the evangelists (the four Beings),

Apostles, Moses and other prophets: the great figures of the Church of all ages.

The Marriage of the Lamb fills the third quatrefoil. The Lamb holds the triumphal banner of the Resurrection; his Bride, the Church, a royal woman on a throne, holds up the cup and the paten of the Eucharist and nourishes the faithful at her breasts. Above her, at the top of the window, seven fiery globes are set below a frieze of seven clouds, perhaps to suggest the seven lamps or the seven gifts of the Holy Ghost. The entire composition, so well conceived and so original, is unique. It eminently typifies, however, a spirituality entirely given to mystical interpretations – a tendency only gradually weakened and finally eliminated by the rationalistic trend of early Scholasticism.

THE ROSE WINDOWS

The great rose windows, with their concentric openings, are admirably suited to a display of worshippers around a Throne. In the
89 southern rose window of Chartres the four Beings and the twenty-four Elders escort the Majesty of the Lord. In the eastern rose window of Laon they encircle the 'Seat of Wisdom', the Virgin holding the little Logos on her lap. These are both splendid examples of the adaptation of a traditional theme to a difficult architectonic frame. The Heavenly Liturgy has been transposed into an entirely new setting, anticipating the mysterious *rosa sempiterna* of Dante's Paradise (*Par.* XXX: 124).

THE REIMS CYCLE

94,95,98 The only extensive Apocalypse found in a great cathedral is at Reims, where a disparate ensemble of small sculptured scenes fills the voussoirs of the south-west doorway, the inner side of the same portal, and the lower parts of the south-west buttress.

The inner doorway survived the catastrophes of 1914 and 1944; part of the outside doorway suffered from eighteenth-century innovations; the sculptures of the west side of the buttress can be recognized; those on the south side are too weather-beaten to be convingly deciphered. Best preserved are the voussoirs that curve behind the projecting gable: thirty-six blocks are fairly intact, each showing an arrangement of two figures or a single figure with its attributes. At first sight this awkwardly scattered cycle is embarrassing; it looks like a filling up of empty space. It is Reims at its best, but on a small scale. What is far more serious is that it has more sweetness than force: with all its smiling grace, says Mâle, it is a failure. There is too much of it for an Apocalypse.

Yet able hands have been at work – artists well versed in the grand manner, which prevailed at Reims about 1250. The slender figures, always showing a fine *galbe*, wear long garments without too

The Woman holding her Child and shrinking back from the Dragon; below: the Lord and the Church (Marriage of the Lamb). Two groups at the top of the arches framing the south-west inner doorway of Reims Cathedral, first part of the thirteenth century. (98)

146

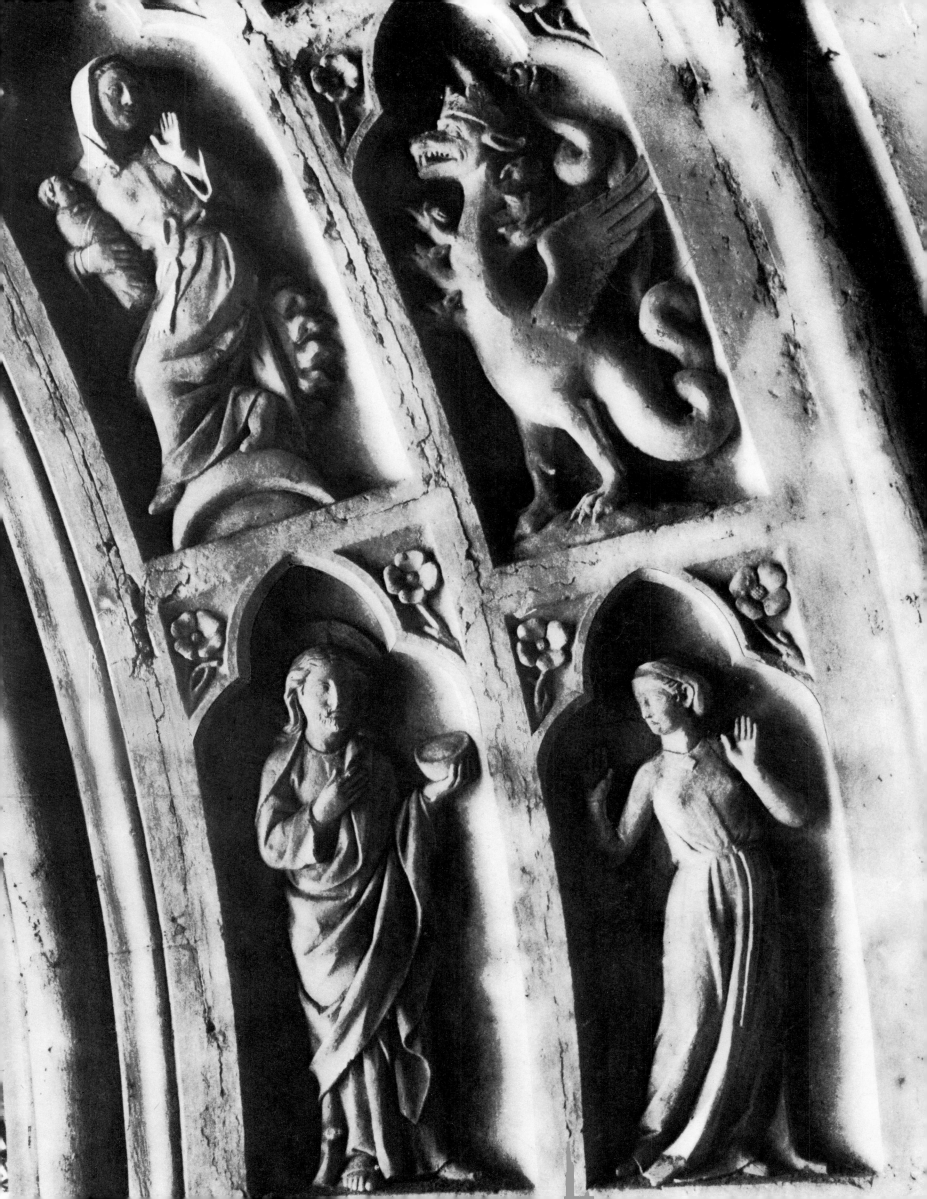

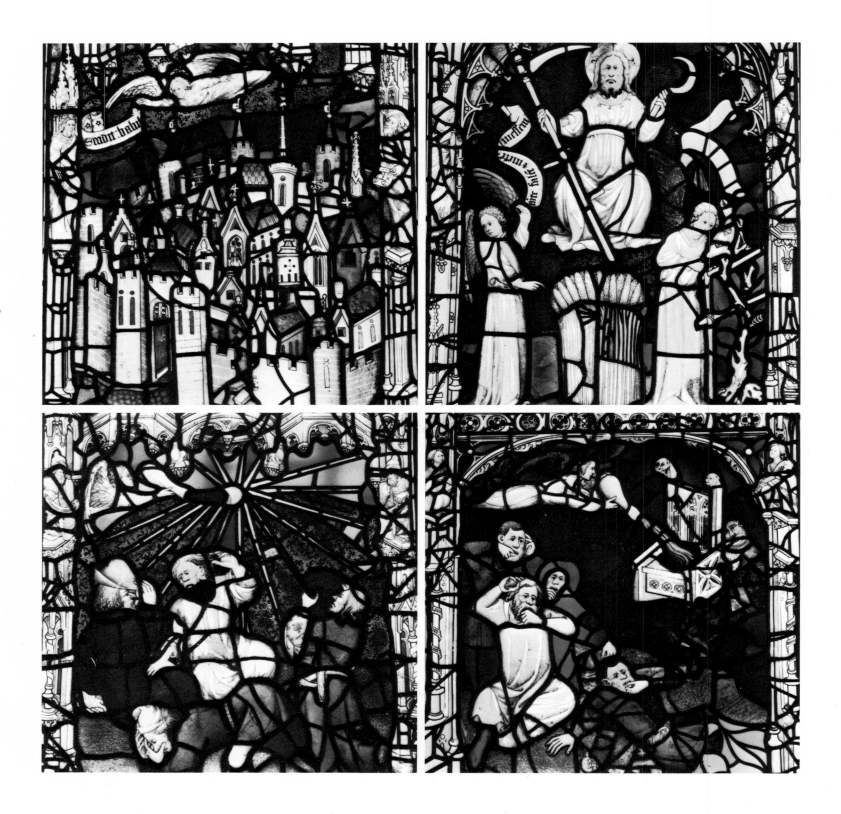

many folds, nobly moulding the body and strangely, but inevitably, recalling the drapery of the Ancient Greeks. Remarkably enough, just after 1200 the immemorial attire of late Antiquity began to lose its monopoly. For the angels, the old robes were no longer obligatory and the new, strictly liturgical vestments, were not yet universally adopted. Here in Reims, as in Bourges, instead of the pallium we find a thin cope, and instead of the alb – the ancient tunic – those long loose robes recalling children's nightdresses. All angels have short curly hair, and their small feet rest on a narrow pedestal serving as a canopy for the group below.

Four panels of the great East Window of York Minster, containing a complete cycle. Top, from left to right: the fall of Babylon; the Harvest with the Lord holding sickle and scythe above the cornfield and the vineyard. Bottom: the fourth vial of wrath poured out into the sun, and the people tormented by the heat; the fifth vial, poured out on the throne of the Antichrist, whose attendants are 'biting their tongues with pain' and blaspheming (Rev. XVI; 10-11). By master glazier John Thornton, 1405-8; nos. IX 7, 8; X 6, 7. (99)

The Lamb, the four Beings, and the angels guarding the gates of the Heavenly City. Frescoed vault in the west gallery of the cathedral at Gurk, in Carinthia, *c.* 1260. (100)

Most of the work is done by the angels. One of them dictates the letter to John, sitting in the door of one of the seven churches: a tiny chapel with a lamp, and a chalice on the altar. Another takes the moon away; a third opens the Bottomless Pit; a fourth pours out the vials of wrath on a squatting man who protects his head; a fifth, standing inside a spider of sun-rays and waving his arms, summons the birds of prey which (on the next voussoir) are pecking ferociously at the eyes of dead kings, their wings still flapping; a sixth throws the millstone into a quietly rippling sea. The Great Angel, a cloud around the waist and the little Book opened in his hand, stands on land and sea. Two angels, wings raised, both in copes, hold an open book together, like precentors before a lectern.

The Marriage of the Lamb is rendered with a noble simplicity: a youthful Christ, holding a chalice, faces the Church, who is veiled and draped like a Demeter. The Rider Faithful and True clutches the rod of iron, and two swords set at an acute angle protrude from his mouth, while his horse tramples demons' heads. The four angels of Euphrates, elsewhere rather dreadful, stand in the water with joined hands, two long chains falling from their wrists like garlands: smiling acolytes, rather than executioners, soon to be released for the tasks of divine Wrath. A man puts his scapular over his anxious face; a king has a harp at his feet, another holds a palm. The meaning is ambiguous, for the sequence of the scenes near the top is far from clear. The concentric rows of voussoirs are separated by magnificent friezes of leaves copied from the most simple herbs of the flora of Champagne.

The Lord and his Bride are again found on the inner side of *98* the doorway. Here the Church has no veil, and she looks like a great lady in a house-dress. Above this group, the Woman, a star of sun-rays flaming behind her, hurries away with her swaddled Child, anxiously looking back at the thick-set Dragon, which, with its flat diadem, its short legs and coiled tail, bears a striking resemblance to the Ancient Italic hydra. In the niches of the door-jambs are twenty-four bearded men, one above the other: doubtless the Elders, and, at the same time, the Apostles and the prophets.

On the outside, the opening of the Seals is visible on the front *95* of the buttress, and here a very remarkable sculptor has been at work. In the lower register an angel leads a child (one of the Elect?) by the hand. The next groups are too worn to be deciphered. In the middle zone, John, an angel and one of the Elders are talking together, while the Lamb, standing on its hind-legs, touches the Seals of the Book The Riders follow, all of them young, muscular and completely naked: an absolutely unique feature. The first Rider holds up his crown of fleur-de-lis; the second his (vanished) sword, the third his pair of scales. The fourth, a bearded Death, has a naked woman in front of his saddle and a dead man trailing behind (as in Paris); he is followed by a fifth Rider, with another man at the back (Hades, perhaps?). In the top register, three naked Souls kneel

before the heavenly Altar on which survives the foot of a vanished chalice; two others have already received their (very short) robes.

The south face of the buttress is so weather-beaten that we can only identify some of the fifteen groups illustrating the *Life of John*: his martyrdom in the boiling oil, the drinking of the poisoned cup, his descent into his own tomb, and his assumption amidst a crowd of angels.

A survey of the harvest of *apocalyptica* in the cathedrals yields two outstanding facts. The first, is that the legend of John is emphasized at the cost of scriptural data. John is seen lying on his Master's breast in images of the Last Supper; lying prostrate on Mount Tabor in images of the Transfiguration; regularly, of course, under the Cross; and amidst the Apostles in scenes of the apparitions and at the Ascension. Episodes not explictly commemorated in the lessons of a feast – such as his vocation – are very rarely illustrated in narrative cycles, and then always in an inconspicuous way. There is nothing astonishing in the fact that the artists relied on the legend: extracts of Pseudo-Abdias were read during Matins on St John's Day. We can read them in the twelfth- and thirteenth-century lectionaries of Chartres Cathedral.

The second fact is one of internal evidence. Mâle assumed that the strictly apocalyptic motifs in the cathedrals went back to those of the Anglo-Norman cycle. Even the incidental analyses given above clearly indicate that the sporadic monumental themes correspond more closely to the earlier, Romanesque, and even Italic and Early Christian traditions. Certain details are never seen in Anglo-Norman manuscripts: the pounding of the jewels and the preparation of the poison. Evidently the artists working in the great cathedral workshops of the Isle de France did not know of the new cycle, in as late as 1250.

95 As for the wilful master of the naked Riders at Reims – he did not need models, he knew his capabilities. What he thought of the sweet avenging angels his colleagues hewed out of their limestone blocks, we can only suspect; but we look at his work with the pleasure reserved for a talented nonconformist who dares to be different where others are highly conventional.

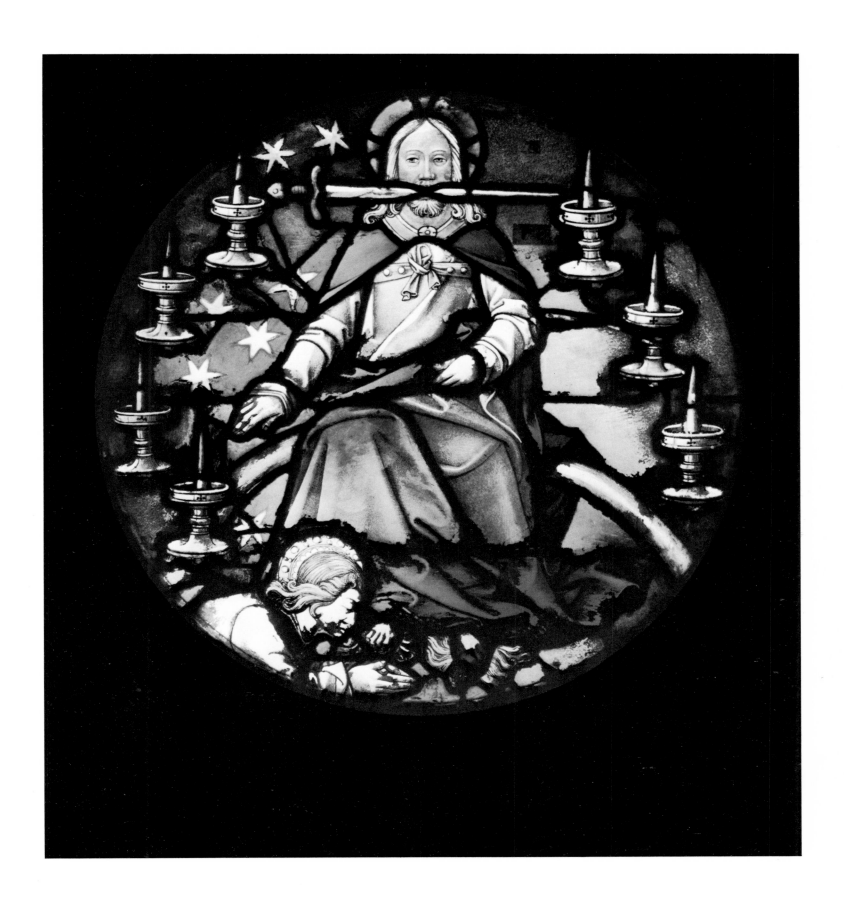

The Son of Man amidst the candlesticks
and the churches, holding the seven stars.
Central part of the rose window that
Charles VIII had made in the west wall
of the Ste-Chapelle, Paris. Diameter of the
medallion: 75 cm; G I-7. (101)

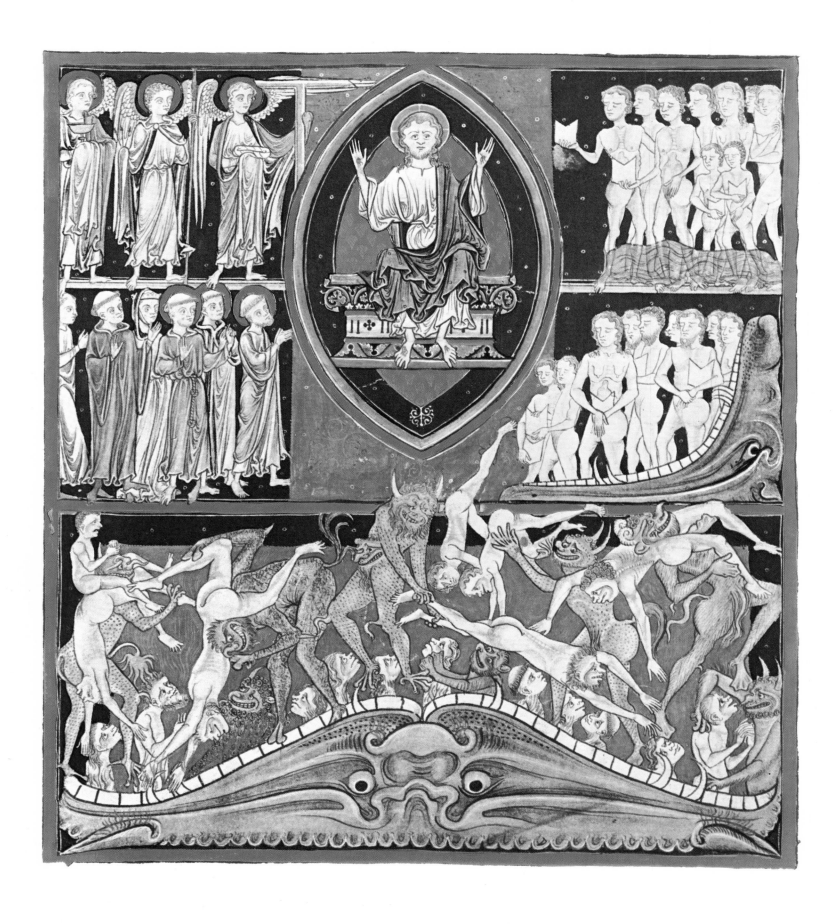

Queen Eleanor's Apocalypse

Medieval queens were seldom illiterate; some were women of letters, among them Eleanor, wife of Henry III. Her husband was that extravagant Plantagenet upon whom the learned chronicler of St Albans, Matthew Paris, reported so unfavourably and whom Dante portrayed as sitting miserably alone in Purgatory (VII: 131), but to whom we owe Westminster Abbey. Eleanor was her husband's equal in knowledge as well as in good taste; both were exemplary spouses and devout Christians.

Eleanor was a Provençal princess, daughter of Raymond Berengar, a learned and poetical Savoyard. She worshipped the Muses herself; before she married she had sent a novel to her future brother-in-law, the poet, Richard of Cornwall. She admired those angels of her age, St Francis and St Dominic. Her father was keenly interested in the reveries on the 'everlasting Gospel' (mentioned in Rev. XIV: 6) of Joachim de Fiore, the *abate calavrese* held in great veneration by the Franciscan Spirituals and by Dante, 'for his prophetic mind' (*Par.* XII: 140-1). Joachim dreamed of a third era that would come before long, the era of the Holy Ghost, after that of the Father and the Son, and, as the Spirituals thought, of their own kindred. Although Raymond Berengar appears to have recognized the precariousness of this vision, he must have been fascinated by the Book that contained the *evangelium aeternum*, the Apocalypse.

It is not too bold to assume that his daughter knew about it. Now that experts have put forward good arguments to connect a splendid, truly royal codex, now at Trinity College, Cambridge, with Eleanor *102-109* (particularly because the founders of both Mendicant Orders and several royal persons and noble ladies appear more often in the miniatures than the text warrants), I gladly give in and, hypothetically, see the book in her hands. It is clearly not a monastic show-piece; it could be compared to a chandelier in a royal court rather than to a monk's cell-lamp.

The visitor to the partly Norman, partly early English abbey church of Amesbury, north of Salisbury, on the Avon – a double monastery of the order of Fontevrault, mostly governed by princesses of the blood (there were other houses at Nuneaton and Westwood, Worcestershire) – will remember that in this typically Plantagenet foundation Eleanor took the veil, after her husband's death; in 1292 she died at Harby, Lincolnshire, while on her way to the south.

The Judgment. To the right of the Judge are the angels with the instruments of the Passion; and (below) Peter, Dominic, Francis, a queen and Benedict, the founders of the great Orders in their different frocks. To his left the sea is giving back the dead drowned in it, and the earth those that were buried in its soil, some of them holding the 'opened books'. At the bottom are the reprobates. From an Apocalypse probably made for Queen Eleanor, about 1242-50. Cambridge, Trinity College, R 16 2, f. 28. (102)

153

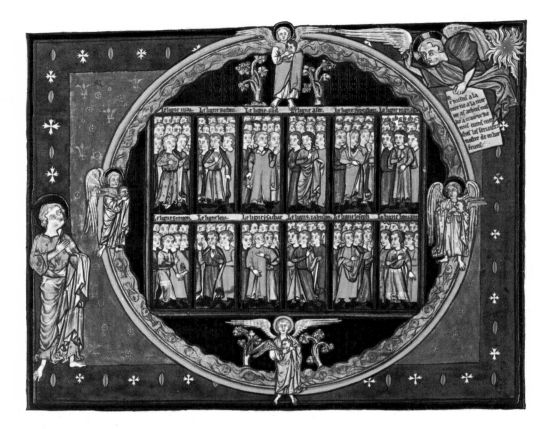

The four angels covering the mouths of the four Winds; a sea full of fishes encircling the earth and the trees, which the Winds are forbidden to hurt; and the one hundred and forty-four thousand Elect, here named after the twelve tribes of Israel. Top right: the angel ascending from the east, identified as the Lord by a crossed nimbus. Bottom left: John. Miniature in the *Cambridge Apocalypse*. Trinity College, R 16 2, f. 7. (103)

A manuscript written for the queen of England towards 1230-40 rouses great expectations; only the Apocalypse which may be admired at Cambridge can exceed them: not so much for the shining gold-leaf covering crowns, vases, sceptres, vials, the censer and the background of the Heavenly City; not only for the fine handwriting; least of all for the sake of the Berengaudus gloss, shortened and translated into the Anglo-French of the court, in which the text is heavily spiritualized and made to bear upon the Church and its Old Testament prototypes. The gloss, bits of which have been put, not too obtrusively, within the miniatures, on oblong straps or banderoles, has only slightly influenced the illustration.

Montague Rhodes James considered the *Cambridge Apocalypse* the finest of all. In any case, it has no rival; firstly because it is complete: it contains eighty-nine miniatures (some of which cover more than half a page) and the most extensive version known of the legend of John's life before and after his exile, shown in thirty scenes. Secondly, its execution is magnificent, its colour intense and its drawing lively, varying from the very dignified to the picturesque. As far as drawing is concerned, greater refinement can be found else*110-113* where, as in the *Douce 180 Apocalypse*, at Oxford, illuminated some decades later for Eleanor's gifted and art-loving son, Edward I. Though incomplete and containing some unfinished line drawings, it is a major work of both mannered courtliness and confident in*114* genuity. Of similar status is the nearly contemporary (BN fr. 403) Apocalypse, with its fine, firm homogeneous technique. The faces

The Great Multitude standing before the Throne; on the footstool the names of the three Continents, the Elders are holding harps and vials; one of them is talking to John. Among the palm-bearers are seen the queen, the king, a bishop, monks of different Orders and clerics. Cambridge, Trinity College, R 16 2, f. 7v. (104)

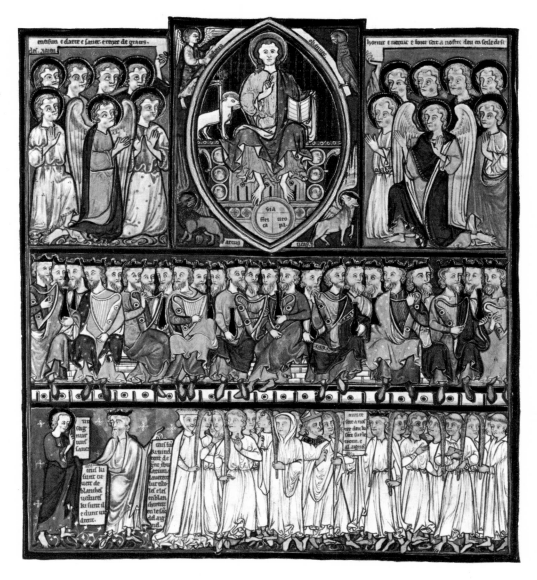

do not reach the high French standard as seen in the better sculptures of Reims Cathedral, where, incidentally, in the inner and outer porch at the south-west corner, is another minor Apocalypse in sculptured groups – unique and already mentioned and analyzed. A miniature is less monumental than a work of sculpture, and towards 1240 the fashionable and conventional are paramount in all techniques. But in the Trinity manuscript, in which several hands can be recognized, two things stand out in spite of the variation in execution: the triviality of the faces, and the naïve contrast between the 'good' and the 'wicked'; only afterwards do we discover the Baroque liveliness of the secondary figures.

All faces are chubby, mostly with a spot of pink on each cheek, below a curly crop of hair, and they are very much alike; especially in the case of the 'good', this early Gothic drawing syle already has something of the doll-like sweetness that makes much of the period after 1290 so dull and sometimes unpalatable. Here, however, it is a kind of continuous rapture and surprise that makes the 'good' so

94,95

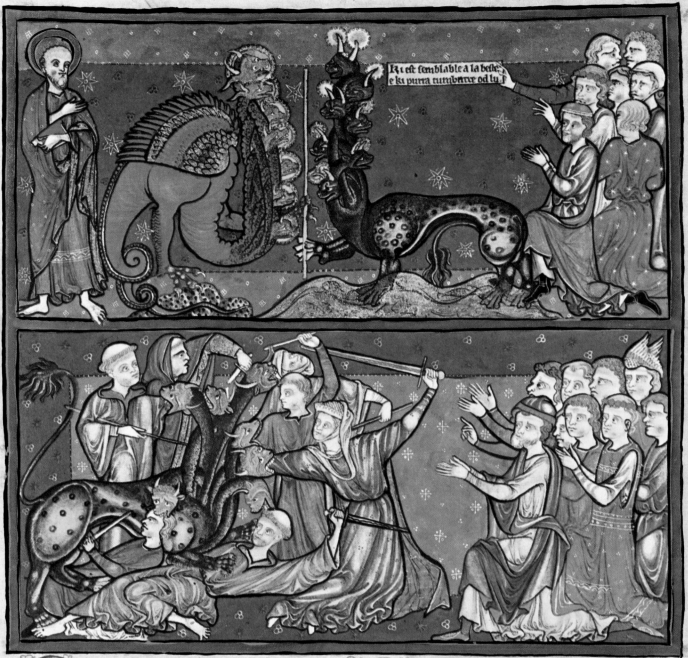

E li dragun estut sur la gravele de la mer.
E io vi une beste muntaunt de la mer
avaunt set restes e dis corns. e sur les corns: dis dia
demes. e sur sas chefs: les nuns de blasfemie. E la bes
te ke io vi ester semblable a une beste ke lem apele
parde. e sas pes aussi cum pes de urs. e sa buche cum
buche de leun. e li dragun li duna sa uertue e graunt
pouste. E io vi un de sas restes aussi cum ostis de mort
e la plaie de samort est garie. e tute la tere sa esmerui
la apres la beste. e il aorerent le dragun pur coke il
dona pouste a la beste. e il aorerent la beste disaunz.
Ki est semblable a la beste. e ki purra cumbatre od lui.
E li est dune buche parlaunt graunt choses. e blasfe
mies. e li est dune pouste a fere quaraunte deus meis.
e il oueri sa buche en blasphemies. e a mesdire deu
e le nun de lui. e le tabernacle de lui. e ceus ki habi
terent en le ciel. E li est done fere bataile od les seinz.
e a uentre ceus. E li est done pouste en tuz lignes e en
poeple. e langages. e paens. e il le aorerent tuz icels
ki habiterent en tere. les nuns des quels ne sunt

Car la guele de la mer. sunt entendus la multitu
dne des repruues. ki sunt aueir en tel tens. Ceste
beste signefie auntcrist. E pla mer ensemblement sunt en
tendus. les repruues. La beste est ne muntter de la mer.
pur co ke auntcrist leuera de la cumpainie as repruues.
La gent ke auntcrist fra suret a sai sut signefie ples dis
cors. Les set restes signefient les set uices pncipauls. les quels
io uoil numbrer solu co ke prudence les oedine. Il mist
le premerein uice idolatrie. co est honur des ydeles. le secid:
libidine. le terz ire. le qart orgul. le quint lecherie. uiffe
rence est entre libidine e lecherie: mes ke il serreient mis pur
un. kar libidne signefie en mens ke lecherie. le sitte aua
rice. le setime blasfemie. u descord. La blasfemie auntrist
est auera plusurs nuns. kar il durra blasfemies en plu
surs maneres. P le parde ki est dit auer duierse colurs
la ypochie auntcrist est entendu. P le urs ki est queonte
beste: por estre entendu sa ueiesse dunt il deceiuera la
gent. P le leun sa cruelte: dut il destruira le poeple deu.
Li diable li durra sa uertue ke est tute male. pur co ke
il maundra en lui. e kautike il por penser il fra de mal.

much alike, and sometimes attractive. Above a tiny pursed mouth and a small nose, the cod-like eyes, with a dot for a pupil, stare ahead below high arched eyebrows; the gold of the halo encircles the head, or the cloak drawn over it, like a lofty gold helmet. All the figures are nervously tense: toes and fingers are wide apart, as are the eyes; all wings are spread horizontally.

The 'wicked' are, without exception, grotesque. They have grinning slit-like mouths, turned-up or hooked noses below small workmen's caps; in one instance wings are used as a cap. The Monsters – the Riders of the fire-breathing horses and the Locusts, hideous Negresses with turbans and long auburn hair – are shown with the same satanic faces as the demons in the Mouth of Hell, behind the Rider called Death. Dead victims lie wretchedly prostrate. Most natural are the scenes of battle, especially the small archers who attack the powers of evil and, surprisingly, are assisted by a fearless noble lady and a very young and very English-looking Franciscan. Other figures in the battle scenes, done by the best hand, recall ballet dancers; even though they are shown in the fashionable pleated dresses with white higlights, hands and feet are always visible, and each finger, each toe, white as of courtiers, can be made out separately.

The altars, thrones, gateways, the Temple, everything architectural continues to be represented emblematically; they are still full of Romanesque arches and old-fashioned cornices. Only occasionally, as in the projection of the Heavenly City, do pointed arches appear, as do the arcades and small quatrefoils and mullioned lancet windows of early English style. Trees and plants are rare and purely hieroglyphic, as in Romanesque initials and in the medallions of thirteenth-century windows of the Chartres type.

But why concentrate on the stereotyped mannerisms that are the hallmark of the rising Gothic, when on most folios composition, colour and rhythm are such a delight to the eye and, in the more lofty scenes, make one think of an All Saints' Paradise? The horrors of the final struggle are put into the background, the cataclysms are second to the glories. Everywhere the triumph of the Lamb and his Bride, the Church, is emphasized; and it must be admitted, that within the Church royalty is discreetly stressed, especially the ladies. Perhaps this partiality for the brighter side of the Apocalypse is the reason why the Berengaudus gloss has been chosen. Glorious theophanies dominate, as one can tell even from the size of the corresponding pictures.

The first theophany is a poor composition: the sleeping John, the vision of the Son of Man between the candlesticks and the seven churches, with their angels, fill three compartments within a square. The Vision of the Throne displays more pomp. While John cranes his neck at the call of the angel standing in the Open Door, the celestial Court shines in full splendour. Lions' heads on the posts of the Throne represent the voices and thunders; the assembly itself

The faithful fighting the Beast: among them the queen, a nun, a Benedictine, a lay brother and, lying prostrate, a young Franciscan. Cambridge, Trinity College, R 16 2, f. 14v. (105)

105

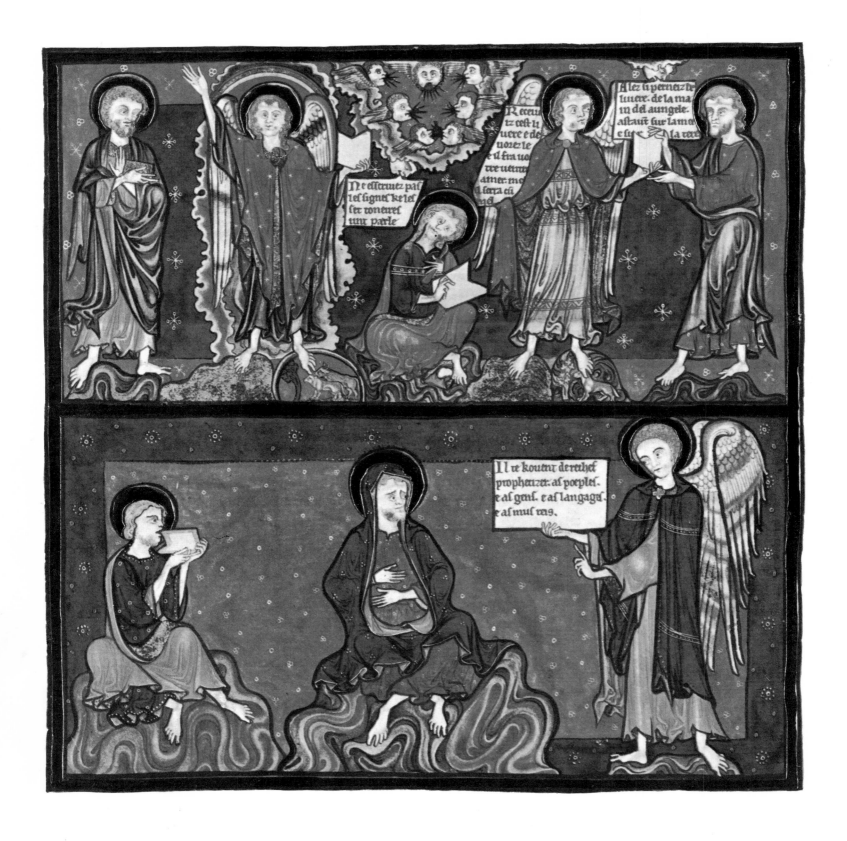

is sitting motionless and in silence. The Elders take off their crowns in a body. On a golden background the Lamb leaps to the knee of the Unnamed One. Below, the Lamb is seen again, holding his banner, and a lance-head next to his side-wound; in his book are the words *le novel testament et le veil*; on each side, the Elders lower their harps and raise the thin-necked scent-bottles with the perfume of the prayers. Even animals, birds, herbs and flowers take part in the Heavenly Liturgy.

The Great Angel, the seven thunders and John, who is forbidden to write down what they are saying, and who receives the little Book. Below: John eating the Book and sitting down with stomach-ache: 'it shall make thy belly bitter' (Rev. X: 9). Cambridge, Trinity College, R 16 2, f. 10v. (106)

158

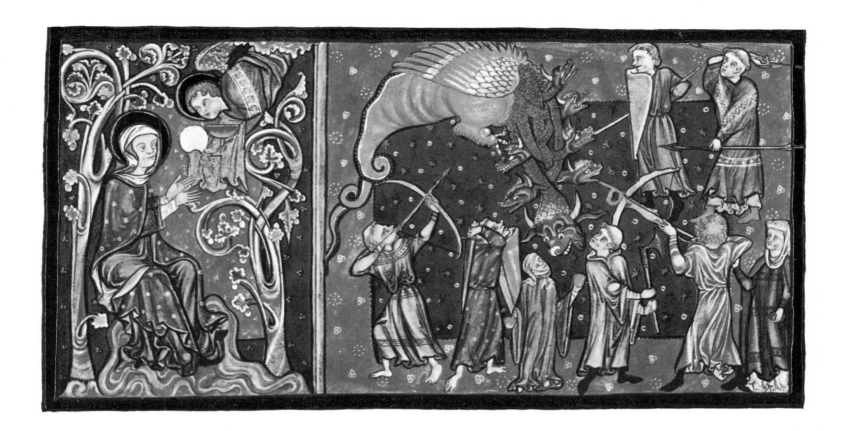

During the happy interval caused by the retaining of the four Winds, the twelve groups of the Sealed Elect from Israel, bearing *103* the names of the twelve tribes, as enumerated in the epistle of All Saints' Day, stand together inside a disk full of trees, surrounded by a sea full of fish. At the four points of the compass the angels are holding the heads of the Winds exactly as in the *Beatus* manuscripts.

A large picture, divided into three zones, is dedicated to the Great Multitude singing their canticle before the Throne. But no one opens his lips; no Elder touches a string. The palm-bearers, however, are happily engaged in conversation, a very earthly prattle, strangely contrasting with the dead silence hanging over the celestial group on high. No doubt a sort of courtly reception is meant, for we see the king talking to an archbishop, and a cleric entertaining the queen, whose figure is the foremost and the most conspiciuous; all are robed in white, so that we cannot make out whether the monks are Benedictines or Cistercians.

The Judgment, by far the most grandiose of the theophany pictures, recalls the chapter of St Matthew and the composition of the *102* cathedral tympana rather than the short passage of the Apocalypse, of which we are only reminded by the seven 'open books' held by the naked dead rising from their tombs. As in the French tympana, we see the instruments of the Passion; the Judge silently and sorrowfully showing his wounds. But instead of his assessors, the Apostles, and the Intercessors, Mary and John, an unusual procession

159

approaches the Throne: Peter, followed by Dominic in his white frock and black mantle; Francis of Assisi, his brown habit girt with a knotted cord; and, finally, without nimbus, the queen, a Benedictine (of Westminster?) and a young lady.

The final theophany is shown in a purely abstract way. The Heavenly City is seen in projection; three by three the twelve Gems face each others. The layers of stone, in the walls, indicate the twelve Gems with as many colours. On the golden empty space inside the walls the Lamb and the Lord occupy the Throne; an angel handles the measuring rod; the River of Life, full of fishes, falls down through a flowering arabesque symbolizing the Tree of Life but covering also, as far as I can see, the monogram of Queen Eleanor. The idea of showing the City not as an Antique fortress but in projection is a feature this manuscript has in common with the *Beatus* family; another corresponding feature is the picture of the 'earth, sea and trees' set within a world map between the four Winds; a third is the Animal, one of the four, who, at the appearance of each Rider, grasps John's hand and exclaims, 'Come hither and see!' Yet these similarities can hardly make clear the origin of the new cycle; apparently the painters, carefully plundering the traditional and predominantly Italic stock, often let their imagination run away with them.

Not only among the palm-bearers of the Great Multitude are Royalty and Court meant to be prominent, for among the cithara-players standing upon the Sea of crystal are a nun of noble birth and a great lady arrayed in a purple cloak – seen with a group of monks. At the warning: 'Leave here!', the king, the queen and some courtiers are seen flying hurriedly from the doomed city of Babylon, together with a few monks. In the splendid picture showing the battle of the saint against the Beast risen from the earth – a heptacephalic leopard – a young monk lies prostrate under the paws of the monster; a cleric seizes one of its heads; a Benedictine stabs another head with a poniard; and, most conspicuously of all, a very great lady, wearing the fashionable flat cap and chin-strap that distinguishes the queens on the side-doorway at Chartres, fearlessly brandishes a colossal sword high above her head. In the picture above the former, the Dragon pompously hands over the sceptre of power to the Beast. But here, as elsewhere, the monsters are brought into prominence only when absolutely necessary, and the same applies to the cataclysms. All of them are relegated to narrow, secondary pictures.

Even Michael fighting the rebel angels, always a favourite subject, is not particularly emphasized. The plagues following the opening of the Seals, the blowing of the trumpets and the pouring out of the vials of wrath are soberly illustrated and given a setting within a narrow strip. The four angels of Euphrates, seen at first standing in the water and chained, then released, though alarming and slightly demoniacal, are far from monstrous. The Woman facing the Dragon appears three times in a magnificent composition. This is clearly done in honour of the Virgin, with the whole episode symbolizing the

107,108

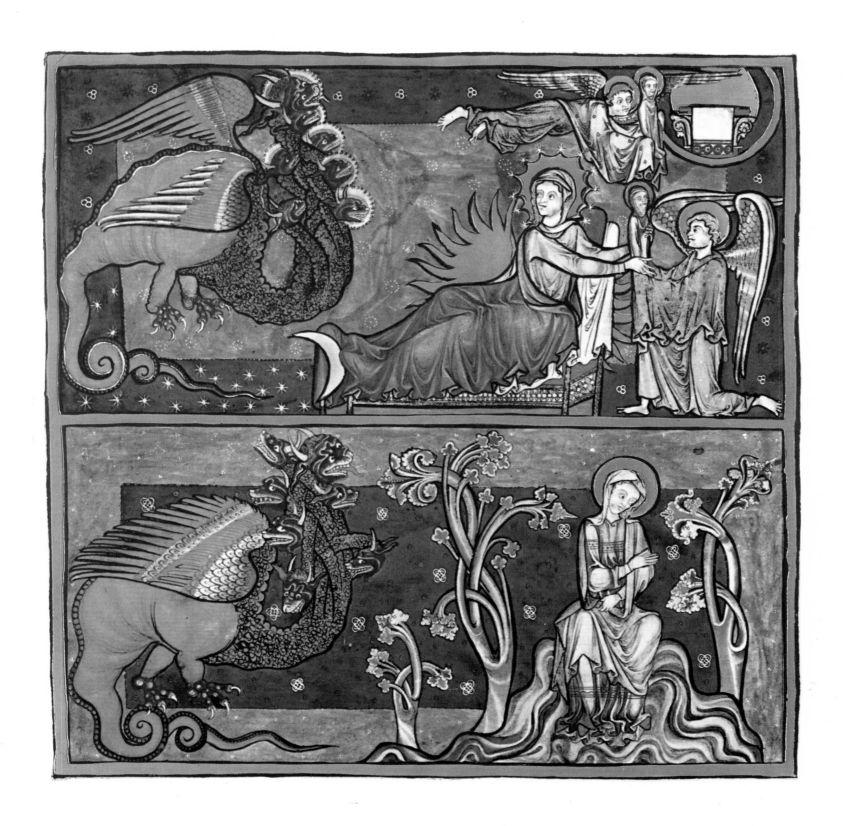

The Woman threatened by the Dragon; her Child carried away to the Throne by an angel. Bottom: the Woman safely in the wilderness. Cambridge, Trinity College, R 16 2, f. 13. (108)

first salvation and the eternally guaranteed security of the persecuted Church, of which the Virgin is the icon and archetype.

Though kept in the background, the episodes of disaster and evil are equal in glory and triumph in one respect – in the unparalleled intensity of the colours. Regardless of the subject, an unbroken brightness unifies the whole sequence of pictures. No other manuscript of the large Anglo-Norman family – where the typically English tradition of linear drawing technique and slightly tinted figures pre-

112,116 dominates, as one can see in Morgan 524 and Douce 180 – attains these harmonies of deep scarlet, indigo, bottle-green, white and gold; and where else are angels' wings found looking like *millefiori* of feathers?

The whole story is told with a sort of naïve and graceful courtliness, in spite of the childish faces of the virtuous and the grimaces of the wicked; for really powerful figures are nonexistent, they are either too nervous or too stiff. The one hundred and forty-four thou-*103* sand are packed into small compartments; the Elders, sitting in a long row below the Throne, do not know where to put their royal feet: there is no space on the footrest, which strikingly recalls that of the Westminster Chapter House. Nothing is rude or coarse. The Great Prostitute, an impeccable Amazon in a flowered and extremely demure gown, quietly raises the 'cup of her abominations'; elsewhere, holding a round mirror, she arranges her head-shawl; she is neither drunk nor merry, but rather absent-minded and insignificant.

This all-pervading decency largely makes up for the ingenuity of a narrative style recalling that of contemporary French tympana, such as the superimposed friezes of Rouen or Strasbourg. Compared with the slim, pliant and extremely affected figures of, for instance, the *110-113* *Douce 180 Apocalypse*, made for Eleanor's son Edward I, those of the queen's great book seem almost artless, especially the minor actors arranged in groups. Big heads, set on short bodies, stare vacantly at the performances of angels. The crowd of undersized, bare-headed saints gaping at the Lamb on Mount Sion (one, viewed from the back, displays a shock of neatly combed red hair) looks like a class of stupid children.

Of course, these bright little pictures cannot be compared to super-

ior graphic work, such as Dürer's, too powerful to need colour; they have nothing in common with products of a master mind who knew how to oppose a tender landscape to a terrifying throng of fighters. However, though incapable of achieving a single one of Dürer's major effects, these pictures succeed in making us happily forget them temporarily. They are not entirely lacking in force, as can be seen in the battle scenes, nor in the grand manner, as we can see in the chief actors who, with their accomplished air, are as noble as any Gothic statue. But the composition, being essentially static, is based on juxtaposition, and avoids subordination, intertwining and overlapping. The presentation, still emblematical, is neither flashy nor loud: there is no trace of the thundering sweep, the brazen brutality of Dürer's avenging Powers. There are no paunchy merchants, no moustached rogues, no roaring angels, with streaming hair, hitting out at popes, kings and rabble alike, raging in albs that look like sheets of crumpled metal – these things were unthinkable in the thirteenth century.

Yet, the still primitive and less crude manner of our manuscript has the advantage of being both rich and distinguished. Subservient to the text, the illustration is also more complete, more instructive, and consequently more appropriate – nothing is left out. Besides, it shares the great style of the liturgy: in its monotony it reminds one of sacred texts sung in noble recitative, with slight modulations, during Mass and Office.

Certainly there are a few comic features. After eating the little Book, John, sitting uneasily on an agate-coloured rock, has drawn a corner of his mantle over his head, while he holds his stomach with both hands and makes a face, for the Book has 'made his belly *106*

Two scenes from the *Life of John. Opposite :* John resusciting Drusiana, surrounded by the people she had looked after in charity. *Below :* John baptizing the governor of Ephesus and the philosopher Aristodemus. Cambridge, Trinity College, R 16 2, f. 28; f. 29, central zone. (109)

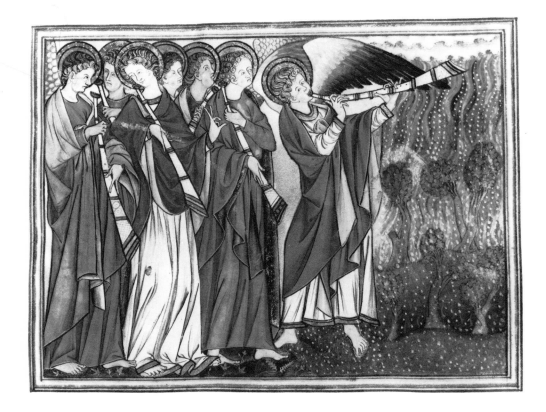

The first trumpet; a rain of fire and hailstones. Miniature in an Apocalypse made for Edward I, end of the thirteenth century. Oxford, Bodleian Library, Douce 180, no. 23, f. 12. (110)

bitter' (Rev. x: 9). The moment a page-like angel hits the scarlet Beast, a frog's head, darting out of its puffy salamander-like body, grimaces at the assailant.

107,108 But clearly the painter has concentrated on the scenes of quiet, solemn, somewhat ceremonial joy, and he is delighted by the contrast of the peace of the saints and the vain onslaughts of the wicked. Perhaps his masterpiece is the series dedicated to the Woman menaced by the Dragon. The Woman is no longer the darkly veiled *orante*, recalling the Theotókos of the Blachernae, standing on the heads of Apollo and Diana. As in the pictures of the Nativity, she is lying in childbed. The sickle of the moon touches her covered feet, the flames of the sun blaze behind her, the stars are stuck on her nimbus. Sitting half upright, using her blue mantle as a coverlet, her hair just visible under the veil, she hands her swaddled Child to a kneeling angel, while she glances sideways at the fuming Monster. Above her, the angel with the baby is hurrying to the Throne. Further on, she is hiding between stylized trees, lost in thought; an angel ties wings on her shoulders, and, suddenly, like a bird, she flies away, headlong, with robes billowing, above some trees (in which a finch is sitting), to the secret place in the Desert.

After a picture of the angels harassing the fallen Dragon (and, again, two great ladies are seen throwing stones at him) we see the Woman again, peacefully resting under a tree, her little hands held up to receive the white Host and the blue chalice brought by an angel. This angel is wearing an embroidered stole and his shoulders are covered by the humeral; he darts out of a scarlet cloud. She does not look up, she smiles: she is safe.

164

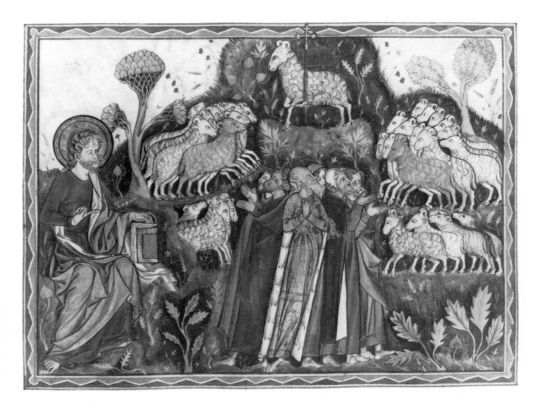

The Lamb on Mount Sion surrounded by the Elect marked with its name; some of them are lambs. A curious and, in this century, very rare relic of an Early Christian motif. Oxford, Bodleian Library, Douce 180, no. 53, f. 26v. (III)

Such lovely details abound; even in scenes of catastrophe the atmosphere is one of undisturbed friendliness. All godly heads, especially those of the administering Spirits, are slightly inclined: here too 'the meek inherit the earth'. Smiling angels draw the white robes over the heads of the naked martyrs under the heavenly Altar. Bare feet stick out from under a long undershirt adorned with red clovers; a tonsured monk reaches with both hands for his shirt, a tunic embroidered in cross-stitch like a Balkan blouse, looking exactly like an urchin changed by a friendly uncle. John kisses the wrist of the young robber who went wrong but repented; after baptism, the aged Apostle himself leads him through the door of the church. Among the onlookers at Drusiana's resurrection is a poor tramp in a wrap, *109* carrying his child on his back; the little boy, who wears a cap, is sucking a lollipop. A flask hangs from the man's wrist and two, black, child's shoes are dangling from his girdle. Elsewhere we see the same wretch and child hurrying to a place where a satellite of the Beast with the ram's horns pencils the mark of the Beast on the forehead of its dupes, mimicking a bishop at Confirmation.

The picturesque and genre are everywhere. Standing near the font, *109* the stately, mitred Aristodemus, 'bishop of the idols', is wearing nicely creased trousers that are tied around his waist by a ribbon laced through the band, its ends dangling against his thigh. His hands are still stuck in the sleeves of the shirt he has just stripped off his poor thin body. The Diana of the Ephesians, crumbling on her pedestal at John's exorcism, is black (all demons are black or walnut-brown); on her long robe she makes the gesture of the *Venus pudica*. She wears a bun at the nape of her neck, below a crown. The servants

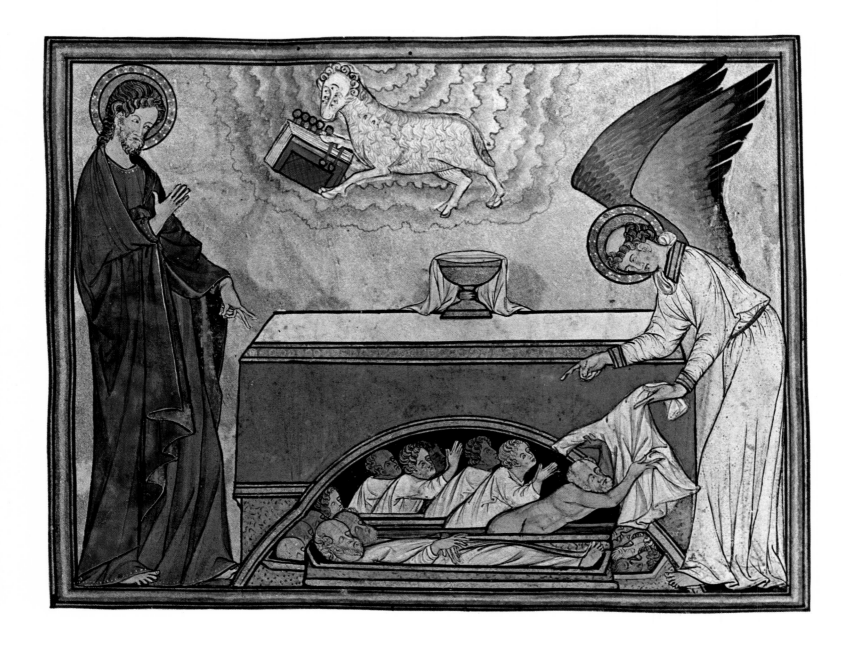

of the Beast also have a curious chignon at the napes of their necks. Rightly famous is the scene of the young robber sitting disconsolately on the ground, a red cap on his head, lost in thought, while John pleads his cause with a bishop, and the youth's comrades shoot birds in a forest of gaudy dwarf trees.

The Lamb opening the fifth Seal, the Souls under the heavenly Altar receiving the white robes. Oxford, Bodleian Library, Douce 180, no. 17, f. 9. (112)

DATE AND ORIGIN

We do not know in which year the manuscript was ordered or finished (the last leaf, showing the last four scenes of the *Life of John*, is by an incompetent painter, incapable of copying the style of his predecessors). Yet there might be a slight clue to a particular date. The four angels leaning back on the waters of the Euphrates and released by four ordinary angels, are winged and nobly arrayed, but their faces, although not demoniacal, look dark and rather exotic.

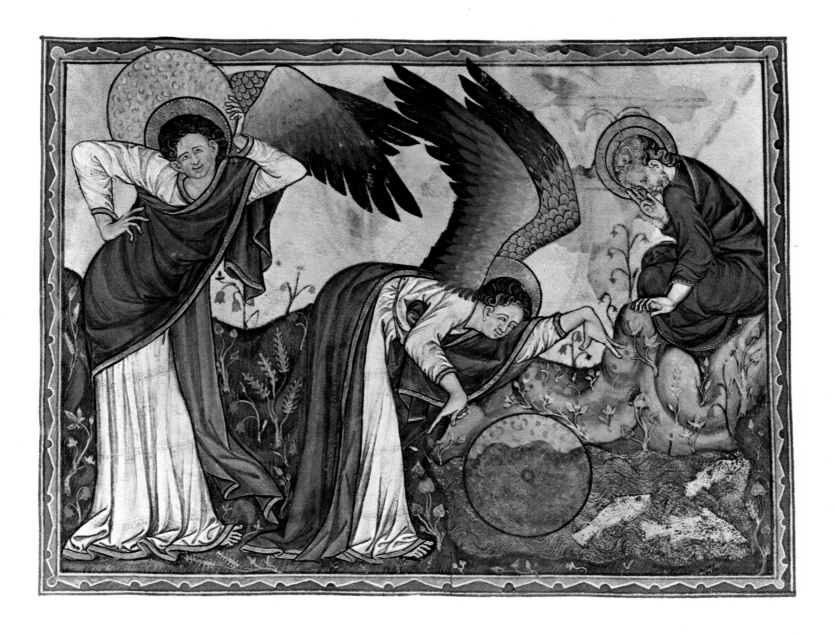

An angel brings the millstone and throws it into the sea, while John looks on. Oxford, Bodleian Library, Douce 180, no. 78, f. 37v. (113)

In a lower zone they have risen and stand upright, their feet in the water, swords drawn, lances and javelins ready, apparently symbolizing a dangerous people menacing Christianity from outside.

It seems improbable that in England of about 1240 anybody knew that St John had in mind the Parthians from Iran, threatening the Euphrates *limes*, the Eastern frontier of the then Roman Empire. Peter Brieger, commenting on the facsimile of our manuscript, suggests the Mongols of the Golden Horde, who, about 1230-40, brought the Russia of Kiev under the Tartar yoke and before whom the Greek principalities (their capital, Constantinople, being occupied by the Latins) trembled with fear. In the eyes of all Christians they, and no others, were Gog and Magog.

According to another theory, our Apocalypse shows symptoms of anti-Joachimism; consequently it might have been planned after the condemnation of Gherardo di Borgo San Donnino, in 1245/46; a

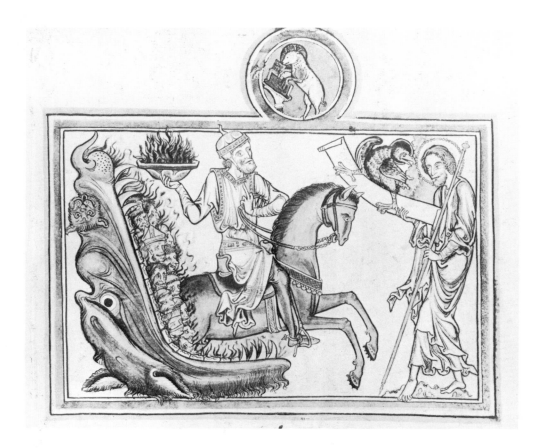

The Lamb opening the fourth Seal; the Eagle crying to John: 'Come and see!'; and the fourth Rider, Death, holding a bowl of fire, followed by Hades, here the mouth of Hell. The fire, according to Berengaudus, is divine Wrath (Deut. XXXIII: 22-5 and Rev. VI: 8). Miniature in an Apocalypse illuminated in France or in England about 1240-50; the text is in French. Paris, BN fr. 403, f. 9. (114)

gratuitous supposition, for nothing forces us to put the manuscript after that date. True, the angel preaching the 'everlasting Gospel' does not even hold a book, but this is a current feature. Nowhere is the episode particularly emphasized; on the other hand, the Franciscans and their founder clearly occupy a place of honour. As for the style – always a precarious criterion – notable archaisms in presentation, drawing technique and architectural details (which are partly late Norman and partly recall early English in its prime) point more to a date before 1250.

Its place of origin is indicated by the massive colour and the still very plain style of drawing, which hardly favour the attribution of the manuscript to the scriptorium of St Albans, the products of which are marked by clear backgrounds, extremely thin outlines and light colours, delicately gradated, and by tinting rather than filling up the always very slender, 'Gothic' figures. This great manuscript is a thing apart. It does not reproduce an archetype; it brings a homogeneous cycle, one of the first of the type called Anglo-Norman. Ordered by a great lady, admired in the upper circles of a polished court, it is likely to be the first Apocalypse of its kind and to have inaugurated the undeniable vogue for its genre.

There does not appear to be any conspicuous Apocalypse in England to fill the gap of the five centuries between the end of the seventh, when Benedict Biscop brought a series of pictures from

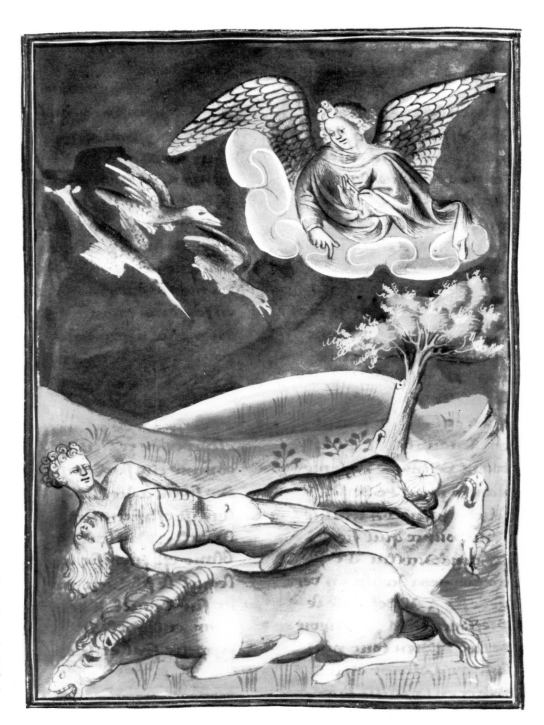

The angel, standing in the sun, summons the birds of prey. In the foreground: the bodies of the slain kings. Miniature in the so-called *Berry Apocalypse*, illuminated, about 1400, by a master who equalled the powerful pictures of the *Rohan Hours*, in a more rough but highly original form; French. New York, Pierpont Morgan Library, ms. 133, f. 73v. (115)

Rome to Northumbria, and the middle of the thirteenth, when a flow of illustrated Apocalypses appears, all displaying a cycle of about ninety pictures, almost identical with those of the Trinity manuscript except for some minor variations and the occasional addition of the three episodes of the Antichrist. The isolated paintings on the barrel-vault of the nave of Kempley Church (Gloucestershire), with the Son of Man and the candlesticks and some other motifs, of uncertain date, do not fill the gap. It appears that the Anglo-Norman cycle was created for our manuscript, and in the years 1220-30.

The flow of illustrated Apocalypses of the new type must have begun somewhere, and instead of a monastic atelier, it might have been artists working for the court, within or outside the workshops of Westminster. In the field of art, the great achievement of Henry III's reign was the reconstruction of Westminster Abbey and the renovation of the shrine of Edward the Confessor, canonized in 1163 (nearly a century after his death in 1066) and whose relics had been solemnly transferred to the old abbey church of St Thomas à Becket, shortly before the Murder in the Cathedral. In 1269, three years before his death, Henry III and the Queen assisted at the dedication of the colossal new abbey church and the transference of St Edward's relics to the new shrine.

The new church was built in the new style, and up to this day remains the most purely French church of the kingdom. And it was the Queen who had the new *Life of St Edward* written by the chronicler of St Alban's, Matthew Paris. We know the shrine as it appeared in 1270, in its finished state, from a miniature illustrating the new *Life*, a manuscript now preserved in the University Library of Cambridge (Ee 3. 59). A group of pilgrims kneel at the tomb of one of their most venerated national saints. The reliquary itself is exposed on a high feretory (a substructure behind the high altar) and has a *Majestas* of chased gold within its gable. It is flanked by two statues standing on columns of gilt metal: St Edward holding a ring and, facing him, a pilgrim who is St John.

A legend tells how King Edward, because he had no money with him, once gave his ring to a poor wretch who said he was a pilgrim. Afterwards, two pilgrims brought it back, and one of them was St John the Evangelist. So the Apostle was honoured in the Coronation Church, together with the Confessor. One wonders whether the surprising popularity of the Anglo-Norman Apocalypse, and its origin, might have had something to do with the devotion to its author, St John.

We already have intimations that the *Life of John* displayed in our manuscript is the most complete of all, far more extensive, for instance, than his story told in glass in the window of the south aisle at Chartres. The image of John occurs thirty-five times; before Patmos he is a young man, after the exile an old man, nearly a hundred years old. In the Apocalypse he appears five times, but this is nothing to wonder at, for in the earliest cycle, that of Trier, he has already appeared ninety times. He accompanies every episode where the text says that he saw or heard something, or was ordered to do something. Being the protector of the Blessed Virgin, John was particularly honoured at Fontevrault. Queen Eleanor, who after her husband's death took the veil at Amesbury, a monastery of that Order for monks and nuns, may have shared this devotion, thus providing a possible link with the Johannine Prophecy.

The second trumpet: the burning mountain cast into the sea. One third of the sea turns to blood (shown here as red), one third of the vessels perish. Apocalypse probably illuminated in Normandy, about 1320-30. New York, the Cloisters, f. 13. (116)

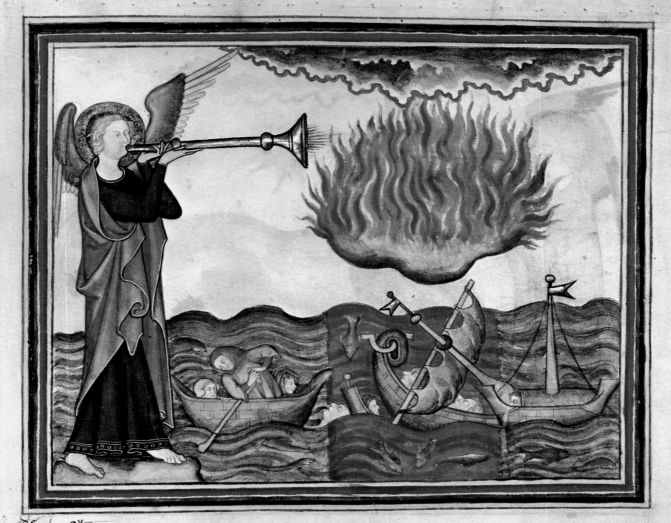

Et secundus angelus tuba cecinit. et
tanquam mons magnus igne ardens
missus est in mare. et facta est tertia

pars maris sanguis. et mortua e
tertia pars creature. que habent a
nimas in mari, et tcia ps navui tenita

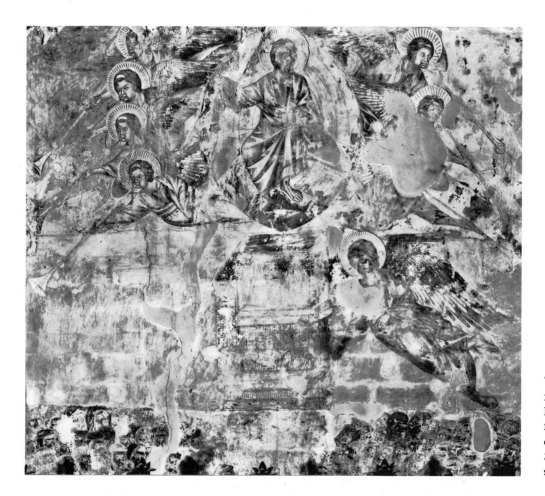

The seven trumpets, blown by the angels from behind the Throne, above the heavenly Altar, the angel casting the fire from the censer on the earth. Remnants of a fresco by Cimabue, *c.* 1280-3. Assisi, San Francesco, Upper Church, above the stalls in the north transept. (117)

THE ANGLO-NORMAN CYCLE, AND ITS DERIVATIONS

Undoubtedly our manuscript is one of the earliest, if not the very first, of the many that contain the complete Anglo-Norman cycle. As far as we know, it has never been copied as such; it remains unique and unparalleled. Would it not be plausible to assume that it was precisely this splendid work, made for the court, and used as a fascinating illustration of a somewhat subordinate text in Latin or Anglo-French, that literally brought the Apocalypse into fashion?

110-113 Edward I, ordered a similar Apocalypse (Douce 180) done in the purely French manner, more mature, finer and if possible even more courtly. Its cycle is almost the same; only the *Life of John* is missing. It contains a number of features seen nowhere else: 'two olives and candlesticks' shown together with the two Witnesses (Rev. XI: 4);

111 a flock of lambs among the Elect surrounding the Lamb on Mount Sion – a motif curiously reminiscent of Roman mosaics; the Kings of the East; a visibly drunken Whore; merchants of Babylon scratching their heads in despair at the fall of their opulent City; finally, in the last episode, naked saints washing their clothes in a basin and putting them on clean ('Blessed are they that wash their robes', Rev. XXII: 14); and, next, an idol falling down from a column, while

172

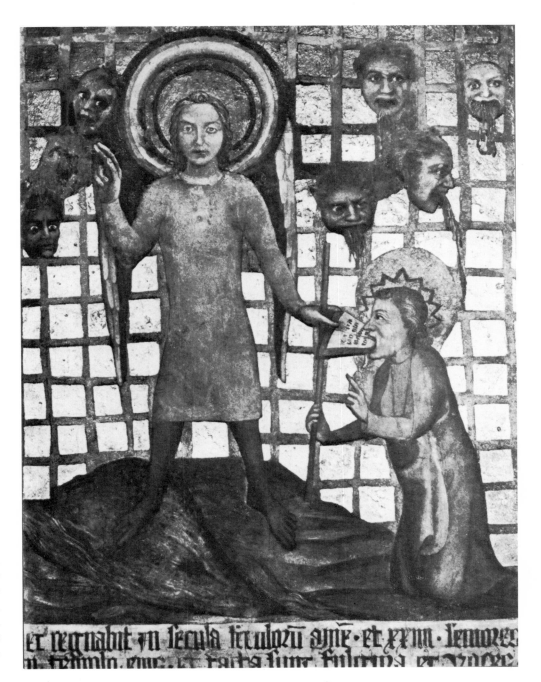

ET REGNABIT IN SECULA SECULORUM AMEN · ET XXIIII · SENIORES
IN TEMPLO · EIUS · ET FACTA SUNT FULGURA ET VOCES

The Great Angel, in a short tunic, his legs a fiery red, standing under a rainbow on sea and earth, orders John to devour the little Book. At the top: the seven thunders (heads). Detail of a frieze painted on the walls of St Mary's Chapel, in the Castle of Karlstejn, south of Prague, *c.* 1357. (118)

six dogs run away ('Without the dogs... and the idolaters', Rev. XXII: 15). The rest of the cycle is identical with that of Eleanor's book, and this is also true of the large number of kindred manuscripts that rapidly succeed each other, in England as well as in France, until the end of the fourteenth century. After a pause, its vogue reached a second peak in the fifteenth century.

Princes took the lead, while abbeys, convents, gentry and clergy followed. We possess, for instance, an Apocalypse from Nuneaton, another Fontevrault monastery; others were written in Cistercian Abbeys. The new Apocalypse conquered England, northern France, and Flanders; it was less known in fourteenth-century Germany, and completely unknown in Italy. The first block-book, made in Holland, *176-179*

173

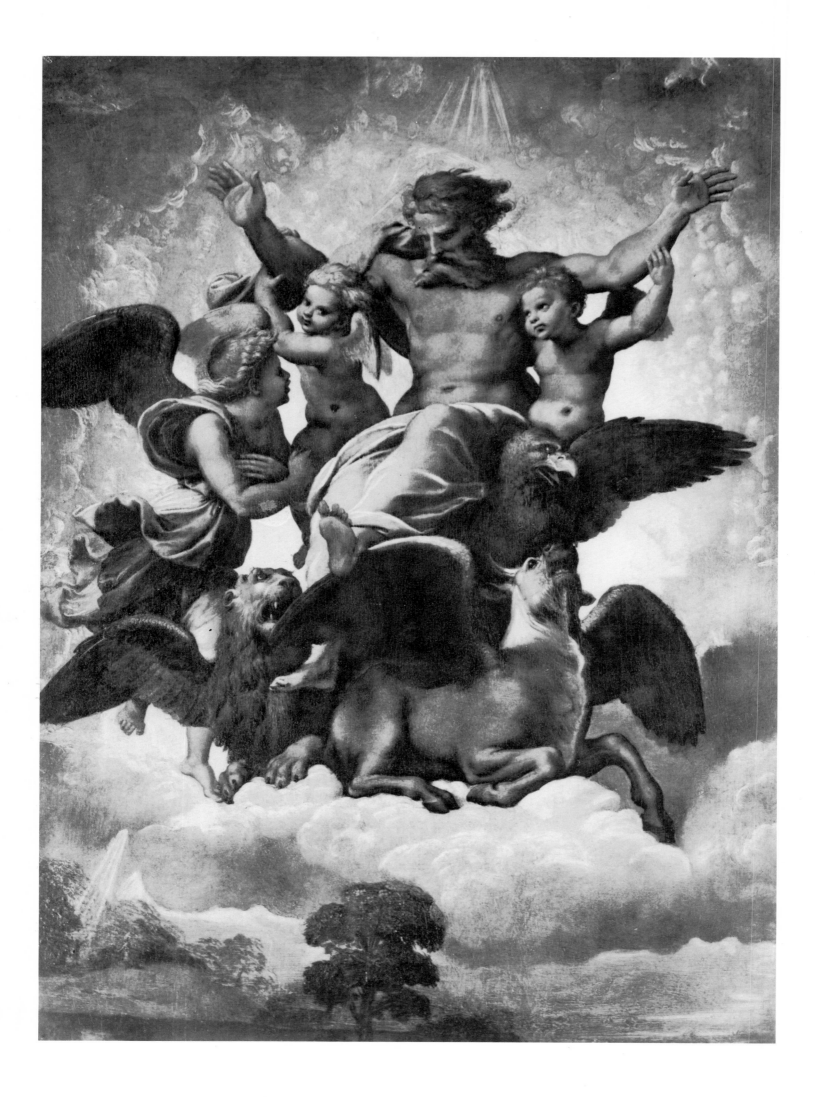

faithfully copied the entire Anglo-Norman cycle, and its model must have been a manuscript of the first period, for it contains the *Life of John* and the miracles and the death of the Antichrist. Compared with the court manuscripts, the average Apocalypses are mediocre and sometimes very poor. Splendid works, however, appear again after 1400, such as the Flemish Apocalypse preserved in Paris (BN néerl. see Chapter XIII) and the much later one of the Escorial. In *137-159* the third quarter of the fourteenth century, two manuscripts of an earlier date were chosen as models for the Angers tapestry, which *120-124* will be discussed in the next chapter.

A considerable harvest of monumental apocalyptica belongs to the fifteenth century. The extensive cycle, painted above the seats of the Chapter House of Westminster Abbey, has vanished for the greater part and what remains is in poor condition. Another can be seen, or rather guessed at, in a series of sculptured bosses, high up in the vaults of the Cloisters of Norwich Cathedral. An altarpiece from Hamburg, now preserved in the Victoria and Albert Museum, shows a remarkable cycle inspired by the commentary of Alexander of Bremen: the traditional scenes, done in the manner of Master Bertram, are all interpreted in terms of Church history by means of inscriptions. Some of the scenes are extremely curious: the angels of the seven churches are represented as mitred and winged bishops, appearing in seven chapels, all of them historical figures. Timothy of Ephesus, Polycarpus of Smyrna, Carpus of Pergamum, Irenaeus of Thyatira, Melito of Sardis, Quadroctus of Philadelphia, Sagares of Laodicea. All these names can be found in the *Ecclesiastical History* of Eusebius of Caesarea, written in the first half of the fourth century. In the Ste-Chapelle in Paris the west wall received a magnificent *101* Apocalypse, arranged within the petals of the new flamboyant rose window. The eighty apocalyptic panels filling part of the great East Window in York Minster are justifiably famous for their excellent *99* visibility (after a laborious restoration); yet they seem almost popular when compared with the exquisitely drawn, laconic, and brightly coloured glass panels of the Paris rose window.

If our somewhat tenuous suppositions stand the test and cover the facts, it was ultimately the initiatives of Henry III, Queen Eleanor and Edward I that induced the apocalyptic tidal wave that reached the Continent and, before slowly ebbing, determined the illustration of the Apocalypse outside Italy until the time of Dürer. The great lady who, in the *Trinity Apocalypse*, attacks the Leopard Beast with *105* a man's sword, might after all stand for Queen Eleanor. She is rightly made conspicuous in such a bold way. Nevertheless, in the militia of Christ, she fought the good fight quite alone, hidden by the veil of the austere Fontevrault.

The Vision of Ezekiel, by Raphael, 1518. In this small, famous picture only the clouds, the brightness of the Apparition and its likeness 'as of a man' are represented; the four tetramorphs (each of them with four faces and four wings) have been changed into the four Beings of the Apocalypse. The prophet himself is a tiny, hardly visible figure standing on the bank of the river Chobar (Ez. 1: 1-2), raising his arms and staring into the sky. The formidable vision, which occupies nearly the whole of the picture, has become a naturalistic but exquisitely composed group, done in the grand manner of the cinquecento (see page 182). Florence, Palazzo Pitti. (119)

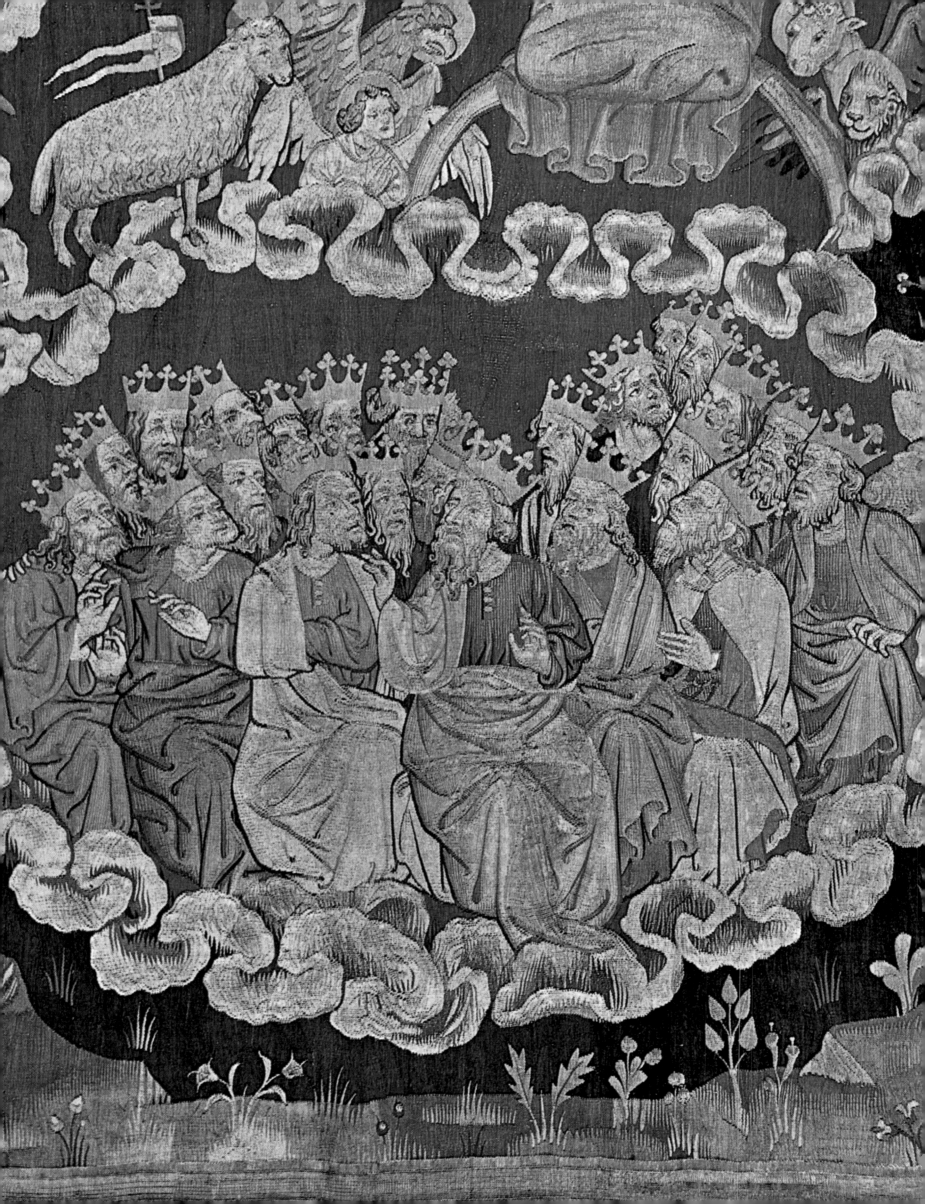

The 'fair tapestry of my Lord of Anjou'

One summer day, in 1843, the bishop of Angers, Mgr Montault, was reading his breviary while pacing up and down his garden, next to the cathedral of St-Maurice, when suddenly something caught his eye. On a piece of faded tapestry covering a greenhouse he saw something that looked like a pair of wings, just visible through the caked dirt. Examining it more closely, he recognized the outlines of an angel vested in alb and mantle, blowing a crooked trumpet; behind the angel a saint looked on, a corner of his garment against his cheek; above them, pale red arrows rained down from a ribbon of twilled clouds. *121*

When he pulled down the whole piece he discovered, successively, a bunch of flames, not unlike the tentacles of an octopus, burning on a rock; and two little boats in a puddle of rippling bluish water, one wrecked, with a broken mast and two sailors tumbling out upside down, and in the other, a manikin with a desparate face wringing his hands, against a background of dirty red. 'Something medieval', the bishop thought, 'a Gothic fabric – could it not be some scene from the Book of Revelation?'

Whether he could immediately locate the second trumpet, the shipwreck and the burning mountain thrown into the sea is not known. The bishop was a well-bred man, however, and loved Antique lore, the romantic taste for Antiquities from the feudal age and its primitive works of art being as strong in the beautiful country of the Loire as it was in Paris. He made inquiries among the nuns and gardeners in charge of the hothouses, and was told that the heavy carpets came from a dump of national property; that since the Revolution nobody had wanted to purchase them and that, as far as they knew, they were still for sale.

After consulting an antiquarian, the bishop had the whole lot collected, large and small pieces alike. He examined them closely and thought them remarkable; apparently they were all part of a set of tapestries, and though they were soiled and tattered they formed an impressive ensemble. An extensive search brought to light a number of scattered pieces; finally ninety scenes could be identified. The uncut pieces showed fourteen episodes each, in two rows of seven; the mutilated ones four or two. Five oblong ones, about 5 m

The Elders before the Throne of the Lamb. Detail from the tapestry woven in he Paris workshop of Nicholas Bataille, after the cartoons of the Bruges painter, Jon Bondol, for Louis I of Anjou. Angers (Maine-et-Loire), Castle, New Gallery. (120)

177

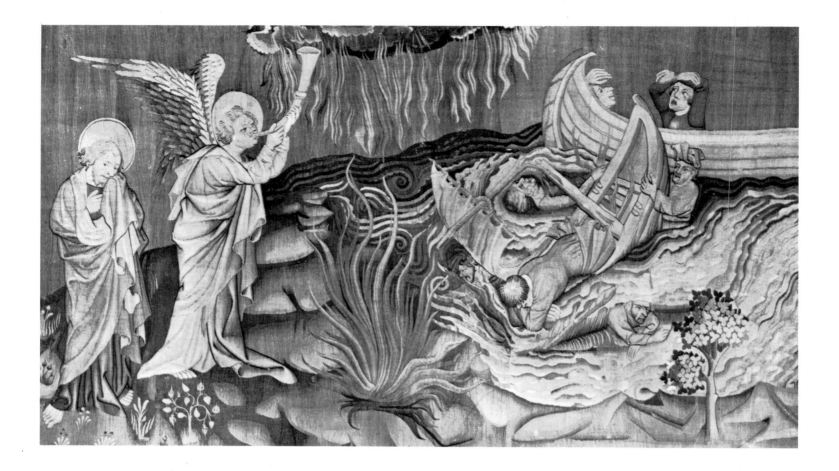

high (corresponding to two rows of the average episodes), each contained an image of St John, a lank and ugly figure, writing at a desk set within an open, vaulted pavilion, between the cusped gables where tiny angels waved fleur-de-lis banners.

The Domanial Administration confirmed that the fabric, whole or fragmentary, could be sold – by auction if necessary. The bishop bought the whole lot for three hundred francs, had it sorted out, and immediately ordered a thorough restoration in the old technique. We do not know exactly what he admired, but the operation was carried on energetically, and, before long, on high festivals the greater part of the enormous cycle was hung on the walls of the broad, single nave of St-Maurice, on the same spot where it had been exposed for almost three centuries, from 1480 until 1750, when the Chapter decided to get rid of the 'Gothic rubbish' and offered it for sale, in vain, as was to be expected.

Meanwhile, archivists had discovered the origin and provenance of this colossal and completely forgotten tapestry. 'Good King René' – a great Maecenas, the author of the *Livre du cuer d'amour espris* and the famous *Treatise on Tournaments* – bequeathed it to the cathedral, before his death in 1480. He had inherited it from his ancestors, the Dukes of Anjou, Louis I, II and III, and from 1380 it decorated the walls of a hall within the castle of Angers. The first Louis, brother

178

of the art-loving princes, John Duke of Berry and Philip of Burgundy, had it made, in 1373, by the best *lissier* (tapestry weaver) of Paris, Nicolas Bataille. The cartoons were drawn by 'Hennequin de Bruges', the nickname of Jan Bondol, a court painter of King Charles V, and one of the most refined illuminators of his time (at least one luxurious codex decorated in his own hand is known). The weaver received six thousand pounds in gold, a fortune even for that time; the designer's wages are unknown, but we know that he was given a thirteenth-century manuscript as a model, a codex belonging to King Charles's library. An inventory, dated 1373, shows that it 'was lent by the king to my Lord of Anjou, in order to have his fair tapestry made,' *pour faire faire son beau tappis*. This manuscript, an Apocalypse with a French text and seventy-six large miniatures, set between two series of pictures illustrating the *Life of John* in fourteen scenes, is preserved in the Bibliothèque Nationale, Paris (BN fr.403). Whether it was made in France or in England remains undecided. Recently, scholars discovered that, though 'Little John from Bruges' might have consulted this splendid but somewhat out of date work, he closely followed the almost identical cycle of another Apocalypse, illuminated shortly after 1300 and, consequently, in the eyes of an artist living in the 1370s, more up to date. Indeed, this second manuscript, coming from the abbey of St Victor in Paris, and today in the Bibliothèque Nationale (BN lat. 14410), seems to have been his chief model.

114

Now, more than a century after Mgr Montault's discovery, all that remains of this astonishing masterpiece – more than three quarters – can be seen inside the Castle of Angers, in an L-shaped gallery built in 1952, consisting of two wings each nearly 200 m long, perfectly adapted to the surrounding buildings inside the walls, and built in the same stone.

The original seven tapestries, reconstructed as far as possible, hang on walls painted pale brick-red where they receive quiet even light from the high mullioned windows opposite. Modest cartoons, put up against the jambs above the sills, give the text of the Apocalypse as well as the corresponding miniature, from BN lat. 14410, for each of the scenes on the opposite wall. It is amusing to contemplate the millions required to insure this largest and one of the earliest of all large medieval tapestries, and then recall Mgr Montault's three hundred francs.

With its mighty round towers, its chapel, its high halls and fine inner garden, the Castle is in itself impressive enough; but the innumerable visitors, after admiring the twelfth-century windows and the gilt Berninesque high altar of the cathedral, enter the Castle mainly for the sake of the Apocalypse tapestry, now one of the marvels of France. The honest people who used these pieces of carpet to cover their hothouses, would stare their eyes out if they could see this unexpected Pilgrimage of Grace, and would be astonished at the extent, within 150 years, that tastes and public opinion would

change. Whether for better or worse, neither they nor I could be certain.

Most visitors take for granted that they can read the single episodes of the tapestry cycle without any difficulty. Yet this stupendous legibility is perhaps the most striking feature of this exceptional work of art. Everyone acquainted with the chief motifs of the Apocalypse *124* recognizes everything at first sight: the Son of Man amidst the candlesticks, the Throne with the crowned Elders, the four Riders, the Rider 'on whose head were many crowns' (here an aureole filled with overlapping haloes); the pale little Souls crying under the Altar; *122* the 'blessed dead who died in the Lord' (Rev. XIV: 13) sleeping in a large bed, under one coverlet; the Eagle flying down with the threefold 'Woe' written on a curling banderole; the angels blowing the trumpets and pouring out the vials; the Scarlet Woman doing her hair before a hand-mirror; and, everywhere, pale red fire – flaring down from the clouds, up from the Pit, out of the censer; the toy towns falling down; the frightened people crawling away in chasms and being drowned alongside upturned boats; finally the River of Life, a ribbon of rippling water, between emblematical dwarf trees.

This superb legibility is achieved by the very simple method of making all outlines of people and things stand out against a dark background, alternately brick-red and indigo-blue. Even compact groups – the Elders, the worshippers of the Beasts, the Great Multitude, the Elect risen from the dead – form collective silhouetts, and so do the walled-in cities and the open-air chapel representing the heavenly Temple. Some of these silhouettes are naturally eloquent: flapping wings, galloping horses, scrolls curling out of hands, mouths and muzzles, against the dark, neutral background. The theophanies are set within a quatrefoil or a mandorla filled with a colour complementary to the background colour outside; some of them recall a midnight sun hanging above a landscape filled with stalk-like trees, with tops of stiffly erect leaves. The quietly rippling or turbulent water of springs, pools, rivers and sea are likewise enclosed within nicely drawn banks. Invariably, heaven is shown as a frieze of scalloped clouds, out of which heads, voices, angels, lightning, fire and thunders are shooting down, sharply outlined against the red or the blue of the setting.

Of course, anyone remembering furiously dynamic compositions, such as Dürer's, cannot help finding the Angers rendering of violent episodes static and tame. The whole show is reminiscent of a liturgical pantomime, with its meekly trotting horses, uniformly leaping Locusts and Beasts, and woodenly clashing armies – simply two clusters of impassive pikemen facing each other, sometimes on a background that is sweetly filled with hundreds of scattered blossoms. And yet, all those flapping gulls representing angels, that confetti of scrolls, those birds diving from the sky, the fiery stripes flashing horizontally beside the seven parallel giraffe-necks of the Beast, and all those collapsing towns of toy bricks suggest the apocalyptic cata-

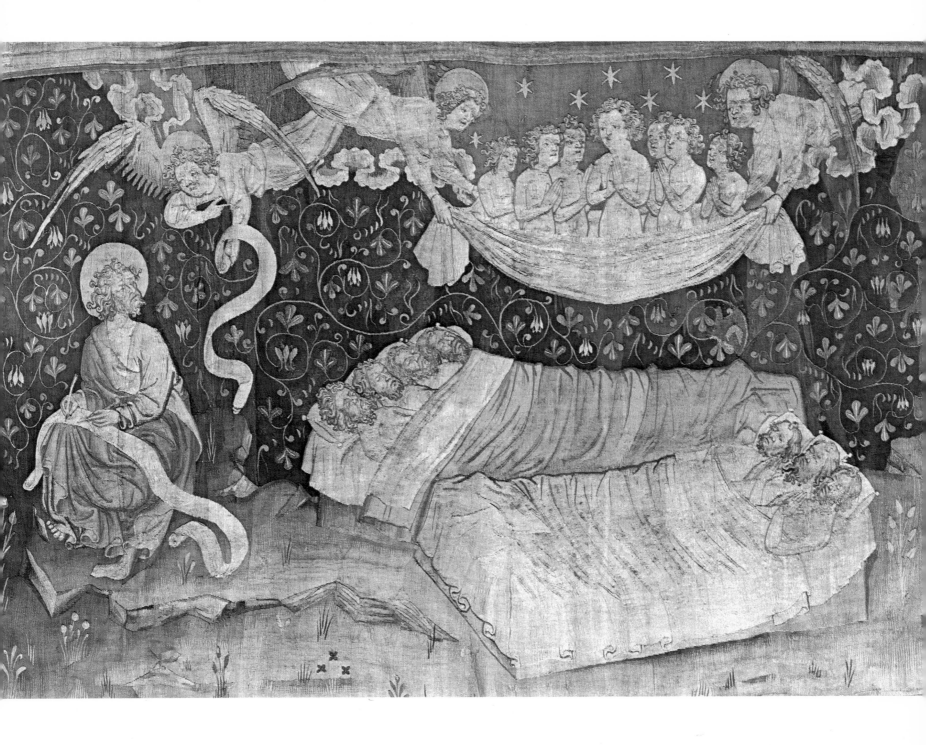

The angel calling: 'Blessed, those who die in the Lord'; John listening and looking up. Top right: the souls of the deceased, lying naked in a single bed after the fashion of the age, received by angels, after the responsory: 'Ye angels, come to meet them, and bring their souls before the face of the Almighty' (*Occurrite – angeli domini, suscipientes –*). Angers (Maine-et-Loire), Castle, New Gallery. (122)

clasms with greater power than any ghostly Brueghelesque landscape full of burning horizons.

As for the visions proper – the Ark appearing in the open Temple, the Woman set off against a spider of red sun-rays and isolated by a ruffle of plissé clouds, the Great Angel under his rainbow – they, too, strike us convincingly, for their degree of abstraction is still sufficient to evoke the absolutely uncommon. It is true that figures emerge from or disappear between the stripes of land, but a third dimension is never intended. The artists only use silhouettes set off against an isolating background. In miniatures, the background is often empty, mostly bleak and whitish, and always insignificant; here,

123

it is essential. Smooth or speckled with flowers, its dark surfaces always match the invariably beige silhouettes enlivened only by light touches of pink, red and blue.

These partly unreal compositions, neither totally unearthly nor entirely abstract but without a trace of *chiaroscuro*, are the perfection of visionary art: perhaps the only convincing images of biblical visions.

A CONTRAST

Strangely enough, works done in the naturalistic way are never intended to be visionary, and are handled in an ideal manner. They always remain unconvincing. Take such a masterpiece as Raphael's *Vision of Ezekiel*, in the Pitti, beautiful beyond words; or Guido Reni's *Michael trampling upon Satan*, in the Cappuccini in Rome.

The Lord appearing on Ezekiel's tetramorph is a handsome middle-aged man with a muscular torso, outstretched arms and streaming hair and beard. Flying across a golden sky, he rides on a knot of four Beings rushing forward on a thunder-cloud and calling out. Hardly touching his living throne, his elbows supported by jubilant children, He looks down mildly on an insignificant empty landscape (where everybody overlooks the tiny figure of Ezekiel). A perfect group of beautiful beings: the Lord, a Man, a Lion, an Ox, an Eagle and angelic children, it is an incomparable *deus ex pictoris machina*, but no vision. Guido's Michael, a proud youth showing off his armour, his purple cloak, his strong body and his unrivalled grace, has rightly been called a Catholic Apollo. Satan is a bald elderly ruffian, sprawling under the triangle of his chains disdainfully held up by the fair archangel.

And now, in contrast, look at the Angers tapestry's Great Angel holding the little Book. With rainbow round his fair head, he has come down from a ruffled cloud out of which the seven thunders vomit their rumble from lion's mouths. His garment has borrowed the whole spectrum of the rainbow: pink, red, blue, green, yellow. He stands on earth and sea, with feet hardly visible below the undulating seam of his tunic and raises his hand for the oath, his head touching the sky. Here, the visionary image holds its own with the sacred text; in its half abstract form it almost entirely lacks a third dimension, but any more would spoil the vision.

Its trumpet blown, the tapestry calls for closer inspection. This shows the other side of the coin, especially the mannerism of late fourteenth-century Gothic. Even in the supreme works of this century everything looks thin, dry, affected and shrunken, the architecture as well as the images. It is as if the full-blown vitality of the foregoing era deteriorated continually in this century of less distinguished works. To put it bluntly, at a distance most of its works of art are still canonically 'Gothic' and, consequently, vaguely elevating. Viewed too closely, they are often ugly.

182

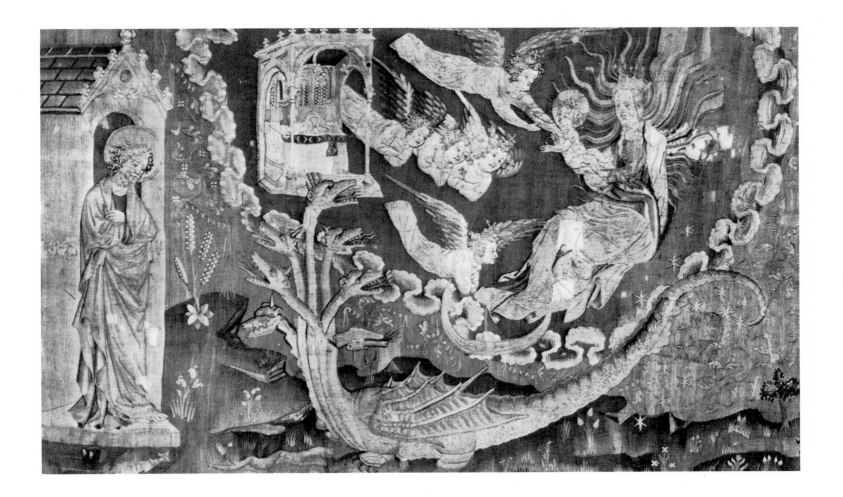

The Ark of the Covenant (here an altar with a chalice) appearing in the heavenly Temple; John watching the Woman, and the Child being carried away; the Dragon sweeps down the stars from heaven. Angers (Maine-et-Loire), Castle, New Gallery. (123)

Overleaf: The Son of Man and the seven candlesticks. Detail of the first tapestry of the Apocalypse, after 1373. Angers (Maine-et-Loire), Castle, New Gallery. (124)

Whether it is the fault of the weavers, or of the craftsmen who enlarged the cartoons (it certainly was not the designer), one cannot decide; but the ugliness of many details of this grandiose and costly work is truly staggering: the sullen faces of the Elders, staring vacantly below their pointed crowns; the unexpressive faces of the Riders; the manikins and puppets representing crowds, dressed up in the often grotesque attire of the age; the stiff toy soldiers; the curly crops of hair and baby faces of the secondary angels; the ever-present countenance of John, no longer ideal and not yet expressive; not to speak of the toy fortresses and towns turned upside down or falling to pieces. Often it seems so needlessly childish that one can guess why *le bon roi René*, who lived in the days of Jean Fouquet and the Master of Moulins, had enough of it and decided to bequeath the venerable tapestry to his cathedral. In his own house he wanted something different. One has only to look at the miniatures illustrating his *Book of the Heart kindled by Love*: enchanting fairy scenes full of light and shadow, a rising sun above a bedewed meadow; secret timbered little cabins; tender and fervent people people whispering in a bedroom. The Gothic abstraction had been turned into a dead mannerism.

About 1370, the international but essentially French mannerism

120

183

was still supreme; about 1480 it had been vanquished by the new manner of the Flemish masters, Van Eyck and Rogier. Today, at a distance of six centuries, no one is likely to take sides, but one realizes the symbolic power of the first manner as well as the higher degree of visual reality of the second, and one might well remember that, even in court art, mediocrity is the rule and excellence the exception. About 1370-80 even the major works betray the diluted style of the age. The personages of the *Crucifixion* and the famous portraits of Charles V and Jeanne de Bourbon on the *Parement de Narbonne* (a silken frontal, now in the Louvre) show the same linear brittleness and unsteady poise that slightly irritate even the admiring modern eye in the Angevin tapestry, far more than the court dress of the queen or the pointed nose of that enlightened monarch. In the *Wilton Diptych* of the National Gallery – in my eyes the most delightful picture of the age – we can see this *fin-de-siècle* preciosity at its best; yet the kneeling Richard II (who reigned from 1377 until 1400), the Virgin majestically arrayed in deep-blue, and the ethereal angels with their downy raised wings have mouse-like faces. They are refined, somewhat bloodless late-comers, portrayed without a single vigorous contour, in a style one is tempted to describe as Rococo without frivolity.

Its colour has, of course, faded; but I cannot imagine it was ever exuberant, even when the tapestry was brand new. Faces, hands and feet have grown pale and almost colourless; today nearly all the lighter parts are the colour of bulrushes or old hay, pleasantly contrasting with the far less faded blue and red of the background. It is this even, dark background that distinguishes this great work from the contemporary stained glass and miniatures. In them, the background is nearly always filled with a dirty white, in the windows tempered by grisaille, and flakes of violent yellow *(jaune d'argent)*; in the miniatures, by delicate patterns of variegated colour. In the windows, the white tends to darken the figures, which are often enlivened however, by hues of moiré and nacre.

Inside the silhouettes of the tapestry, the colour is confined to light touches, ranging from pink to brick-red (and sometimes scarlet), from copper-green to ultramarine, from a not too bold yellow to that all-pervading neutral yellowish grey that reminds one of jute and is restful to the eye. The figures are enlivened by the ordinary crumpled folds and seams of Gothic drapery, the attributes furnished by the text, and the often clumsy and astonishingly empty faces and mostly far too big hands and feet. But, invariably, they are lighter than the massive background, and so are the accesories: the bluish water, the tiny buildings, the emblematical treees, the ruffled cloud-friezes.

When compared with the crammed, often unreadable tapestries of the fifteenth century and those of the first half of the sixteenth (such as the admirable *Life of the Virgin* of Reims Cathedral), which, notwithstanding an astonishing display of fascinating details, give the

impression of faded Primitives translated into wool, the *Angers Apocalypse* forms a category apart, and a very superior one. It is unique, not so much for its enormous size or its early date but for the richness of its iconography and the unparalleled legibility of its episodes. Between the rare hieratic tapestries of the two preceding centuries and the more naturalistic works of the next age, it is a lonely peak, perhaps with an invisible angel standing on top of it and holding a balance. It is also a true mystery play, acted by faded shades gesticulating on a timeless background. Its actors may be slightly childish, and their acting pure pantomime, yet we are contemplating scenes that are never disloyal to the greatness of the sacred text.

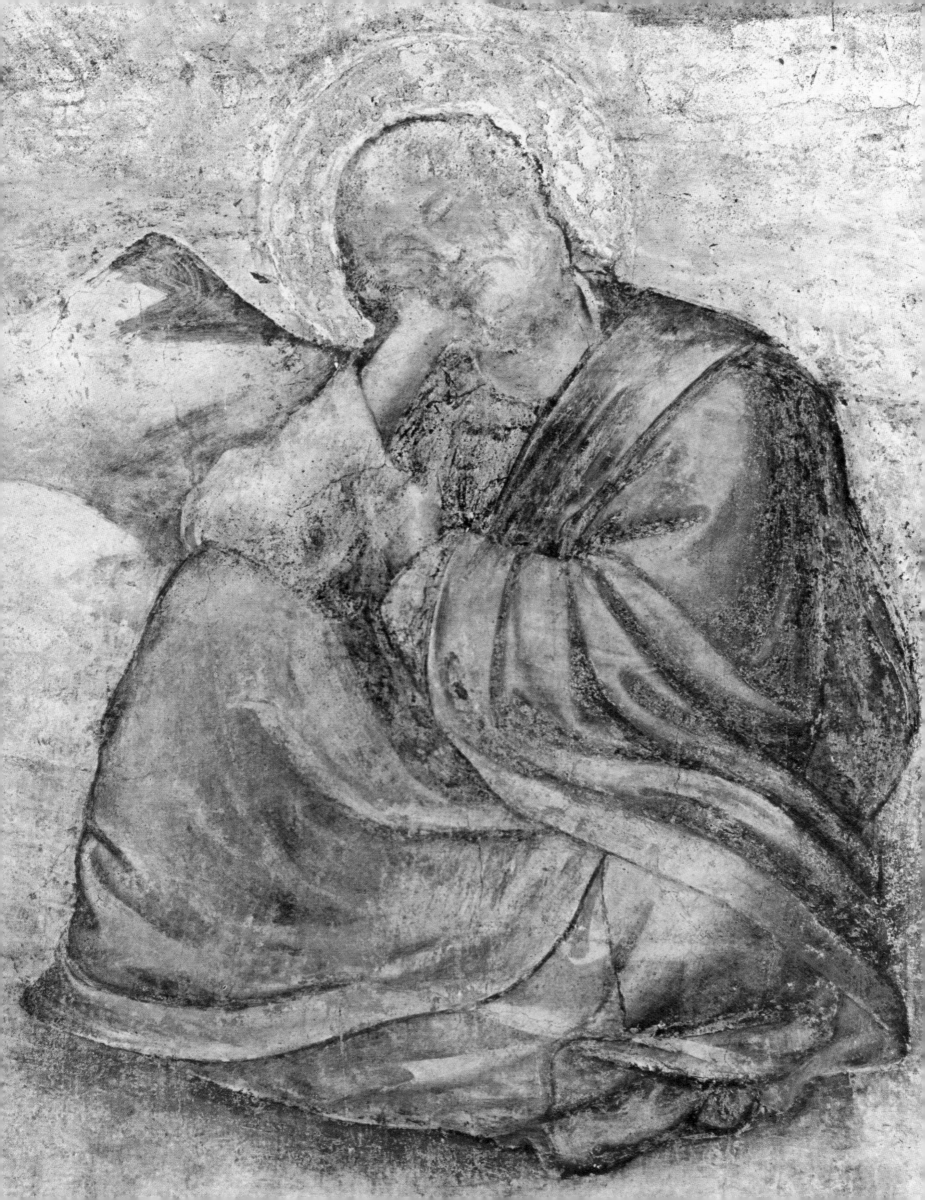

Giotto:
the Baptistry of Padua
and the Panels at Stuttgart

GIOTTO, THE MASTER

Vasari writes in his *Life of Giotto*: 'Giotto having returned to Florence, Robert, King of Naples, wrote to his eldest son Charles, King of Calabria, to do his utmost to get Giotto to Naples, because the convent and the royal church of S. Chiara, founded by him, had just been finished and he wished the church to be adorned with noble frescoes. Giotto, very much aware that a king who was praised and famed had sent for him, eagerly put himself into his service. After his arrival he painted many scenes from the Old and New Testaments in different chapels of that (Poor Clares') convent. It is rumoured that the episodes of the Apocalypse he painted in one of these chapels were invented by Dante, as, by chance, were those much boasted frescoes at Assisi of which enough has been said earlier; although Dante had died by then, they might have talked about them as friends are wont to do.'

In 1322, Giotto was in Lucca; only in 1326 was Charles elected Lord of Florence, and a year later he left that city. S. Chiara, begun in 1310, was finished in 1328; in 1329 Giotto went to Naples, and a year later became 'the king's housemate'. Until at least 1332 he stayed in the capital of Robert of Anjou, called the Wise. Actually, the frescoes in the Lower Church of St Francis at Assisi, ascribed by Vasari to Giotto, are due to the 'Master of the Veils', and there is nothing that could have been borrowed from Dante. The rumour of Dante playing a part in the elaboration of the Apocalypse painted in a chapel of S. Chiara – the enormous burial church of the Anjous, the St-Denis of Naples, badly wrecked in 1944 but restored to its grandiose pristine barreness – seems utterly unfounded. Dante, whom Vasari calls *amicissimo del Giotto*, died in 1321, an exile at Ravenna.

In S. Chiara there is no trace of Giotto's work, alas; what we wouldn't give for seeing what Giotto, of all people, made of the Book of Revelation. We do know something, albeit little, but no more than a secondary fragment. In the Peruzzi chapel of S. Croce

John in ecstasy on Patmos. Detail of a lunette painted by Giotto, on the right wall of the Cappella Peruzzi (second on the right of the high altar), in S. Croce, Florence, 1335. Restored after 1958 (see page 190). (125)

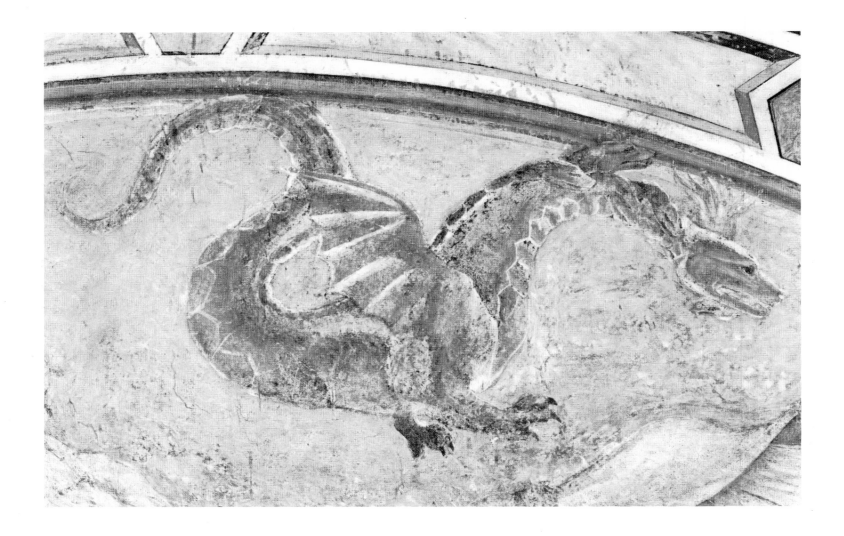

in Florence – the second chapel on the right of the high altar –
some of the frescoes Giotto painted after his return from Naples
are preserved; they were finished in 1335. Whitewashed in 1714,
rediscovered and badly repainted in 1852, they have recently been
very carefully cleaned by Luigi Tintori.

Vasari, who saw them, extols the two scenes from the *Life of John*:
the resurrection of Drusiana (a domed church in the background,
recalling *Il Santo* of Padua) and the Apostle's Death and Assumption.
He does not mention the lunette above them, which shows an ex-
tremely laconic summary of the apocalyptic visions. Freed from
several coats of paint, the fresco, though damaged and faded, unmis-
takably betrays the hand of the master, and his iconography is undis-
guisedly different from anything found elsewhere.

The chapel is dedicated to both Johns, the Baptist and the Evan-
gelist; each of the side walls refers to one of them. In the top lunette
125 at the right, the main concern is St John the Apostle himself, not
his vision. He is shown sitting asleep on a tiny island, washed on
all sides by a turbulent Aegean Sea. He is not lying down, but has
suddenly fallen asleep, his cheek resting on the palm of his hand,

his hoary head slightly inclined, his eyes and lips tightly closed. In this way, Giotto interprets 'I was in the Spirit on the Lord's Day'. The 'Son of Thunder', in quiet ecstasy on the bare rock of Patmos, is surrounded by several images of his inner visions. At the four corners of the sea encircling the island, just as in the manuscripts, the four angels retain the blowing heads of the Winds who are forbidden to disturb the sea. Clearly, the painter intends to suggest the breathing space ordained for the Elect, and here John is preeminently the Sealed one. Two visions appear above his head: the Woman threatened by the Dragon, and the Harvest.

In the vision of the Woman, one immediately recognizes the familiar figure of the Virgin as she appears in the scenes of the Childhood of Christ, in the Scrovegni Chapel at Padua. Bare-headed, dressed as a simple housewife, she lies in childbed, and lifts up a hand, in astonishment at the appearance of the snorting Dragon that is curling one of his heads out at her. But she is not frightened. As a simple halo, the sun crowns her head, the crescent of the moon lies against the seam of the robe covering her feet, and she already

126

The Woman, the Child in a cradle. *Opposite :* the Dragon. S. Croce, Florence. (126)

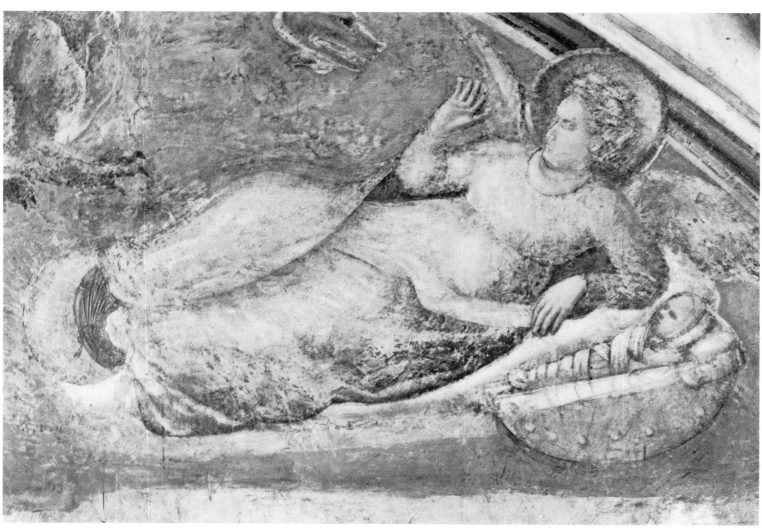

191

has the wings that will bring her to safety. The swaddled Child sleeps quietly in a rocking-cradle decorated with knobs, a unique motif. The Dragon is the familiar Italic hydra, with short legs and bat's wings, and its ten horns stick out of a low diadem placed on its chief head, while the secondary heads look like a frill in front of its neck, exactly as in the Trier manuscript, the fresco at Castel S. Elia and the miniature by Konrad von Scheyern.

Facing his Nativity, the Son of Man is seen again as the Harvester appearing on the white cloud (Rev. XIV: 14): the Child of former days has become the Judge. Across his chest he holds the *falx* of

Part of the Apocalypse painted by Giusto de' Menabuoi and his workshop, in the baptistry of Padua, and finished about 1378. In the lunette: the Son of Man and the candlesticks; in the spandrel: the fourth Rider, Death, followed by Hades. In six compartments: the second trumpet (the mountain cast into the sea); the third trumpet (the Star Wormwood falling upon the waters); the Woman and the Dragon; the flight of the Woman and the battle of the angels against the Dragon; the Scarlet Woman riding on the Beast; the defeat of the kings. Padua, baptistry (near the Duomo), left wall of the altar-niche. (127)

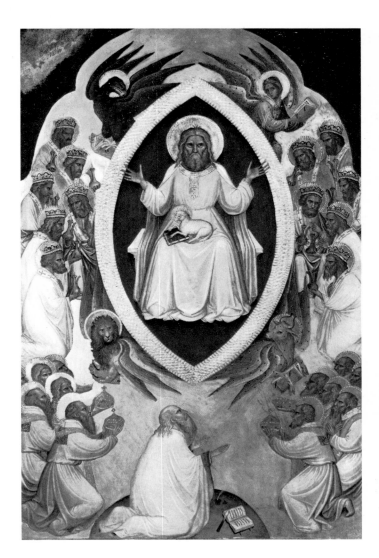

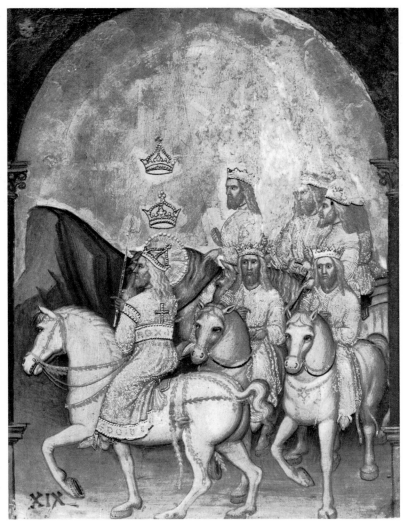

The Throne, the four Beings and the Elders holding their crowns and vials and wearing curious stoles. The twelve below are the Apostles, clothed in liturgical vestments; those at the top are the prophets and patriarchs. (128)

The Rider with the 'many crowns' (here one above the other) and his crowned horsemen. Two panels of a polyptych dedicated to the Apocalypse and attributed to Jacobello Alberegno. Formerly at Torcello, now in the Museo Correr at Venice, nos. 25 and 26, end fourteenth century. (129)

the text, and here this is not the sickle one sees elsewhere but, as far as I can see, for the first time it is a scythe. Even today Italian has one word for both sickle and scythe, as has Latin. Giotto's large scythe is continually seen throughout Italy, and suddenly it appears in the *Cologne Bible* of 1479, where the Judge's scythe is also seen in the hands of the carcass representing Rider Death. Ever since, the Scytheman has inseparably been linked with the allegory of Death mowing down all that lives, immortalized in Brueghel's picture in the Prado. Near the enthroned Son of Man, an angel holding a pruning-knife comes out of the Heavenly Temple: as the scythe to the harvest of corn, the knife refers to the vintage of the earth.

THE BAPTISTRY OF PADUA

More than forty years after the unknown cycle of S. Chiara an apocalyptic ensemble of more than fifty scenes of different sizes was painted on the walls and the spandrels of the domed altar-niche of *127* the baptistry at Padua, executed by Giusto de' Menabuoi, a Floren-

193

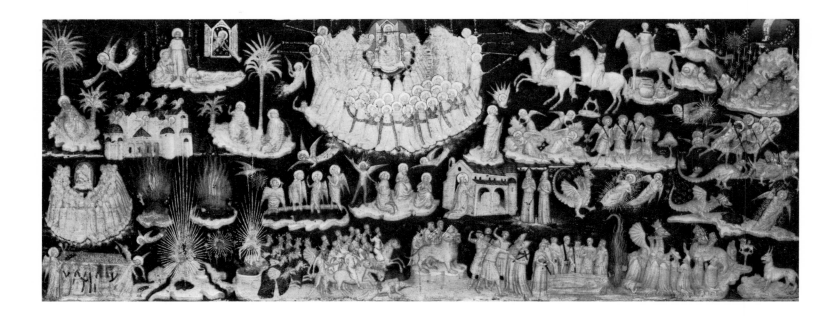

First part of a double panel, with a complete cycle of the Apocalypse, of Italian origin, possibly from Naples, 1330-40. Stuttgart, Staatsgalerie. (130)

tine who had become a citizen of Padua. There are remnants of a series of medallions, with subjects from the Apocalypse, by the same painter and his staff, in the small church of S. Benedetto. A number of altar panels, ascribed to Jacobello Alberegno, with kindred subjects, which came from Torcello (in the Venetian lagoon), are preserved in the Museo Correr at Venice.

In the baptistry, the choice and order of the subjects fairly coincide with those of an average cycle north of the Alps. But Giusto's iconography is purely Italian and his style is the average *giottesco* of about 1378. He is a late comer. True, his Son of Man, his angels and women still wear the ample and clearly modelled robes of the great master; but his figures are heavy and his manner is provincial *Trecento*, in which no trace is left of the striking firmness of touch that is Giotto's hallmark.

The Woman, a fat housewife with scanty hair gathered up, lies down wearing an ungainly house-dress, a sun-head on her bosom and the naked Child in her lap. A dark moon-face supports her un-shod feet. She stretches out her short arms, frightened by the hydra's seven heads set on parallel necks, not unlike prickly eels, that nearly touch her. Next to it, she flies away, in the same attitude and adorned with the same luminaries, while the Dragon spits out a huge jet of water bent like a hairpin, below a host of armoured angels harassing a crowd of hideously caricatured demons.

The Throne, set within an oval glory, together with the four Beings, and surrounded by the Elders (clearly respresented as the heroes of both Testaments) and the angel talking to the awe-struck John, fills the lunette above the altar, and recalls Giotto's *Last Judgment* in the Paduan Arena Chapel. The Riders'leaping horses fill the

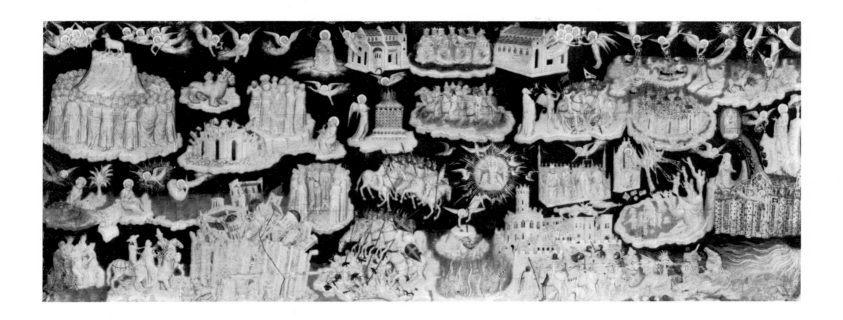

Second part of a double panel represent-
ing the Apocalypse (see pl. 130). Stuttgart,
Staatsgalerie. (131)

spandrels, the angels with the trumpets and the vials the arcades.
Curiously enough, the calotte of the cupola is dedicated to the circu-
lar, almost Byzantine composition of Pentecost, with the fiery tongues
falling on to the heads of the seated Apostles. Seen from the floor,
the ensemble is legible, lively and rather impressive. The compart-
ments of the side walls, disposed in rows, recall the pictures of a
manuscript, but we do not know the model.

More graceful are the Torcello panels. The little Lamb rests on
the lap of the Unnamed One, who raises his arms in the attitude
of an *orante*. As in a Carolingian miniature, the four Beings appear
from behind the four corners of his mandorla, holding their books
and turning their heads to the Lord. Twelve of the Elders, all
crowned, are holding up the vials of perfume; below, twelve others,
on their knees, are offering their precious crowns. The foremost are
Peter and Paul. All are arrayed in white albs adorned with an
embroidered *parura*, and have stoles with small crosses round their
necks: they are the priestly kings of both Testaments. A white-haired
John sits on a rock, hands raised, with an open book and ribbon
book-mark, lost in contemplation of the vision.

The Great Prostitute, a plump woman fashionably dressed and
holding the cup of her abominations, rides on a sort of leopard cran-
ing the same eel-like necks as the seven-headed Dragon; a curved
jet (of luxury?) issuing from her face falls down on the earth. The
angel of the Harvest, coming out of the Temple, and wearing a dea-
con's dalmatic, holds both handles of a huge scythe, the blade of
which, however, is a sickle.

The most remarkable of the panels is the one representing the
Rider Faithful and True, commonly called *la cavalcata dei re*. It *129*

shows a cortège of six royal cavaliers, magnificently arrayed in gold brocade, all crowned, and riding splendidly harnessed horses. The foremost horseman, the Lord himself, has a golden halo round his locks and holds the sword (of which the text says that it goes out from his mouth). On his broad girdle the words REX R[egum] are embroidered in pearls; there are three large crowns with high bows, one above the other, two floating in the air, one on his head: the 'many crowns' of the text (Rev. XIX: 12). In all the manuscripts of the Anglo-Norman family these many crowns fill the Lord's aureole with seven overlapping golden disks; his garment is spattered with blood and the sword lies across his mouth or goes out of it. These details clearly prove that the Transalpine cycle was not known in Italy.

THE STUTTGART PANELS

The same Giusto de' Menabuoi has wrongly been put forward as the author of two narrow panels, 85 by 35 cm, on which a complete

130,131

John on Patmos hears the trumpet; the vision of the candlesticks and the seven churches; the Open Door; the Throne; and John consoled by an Elder. Detail of the first panel, upper left. Stuttgart, Staatsgalerie. (*132*)

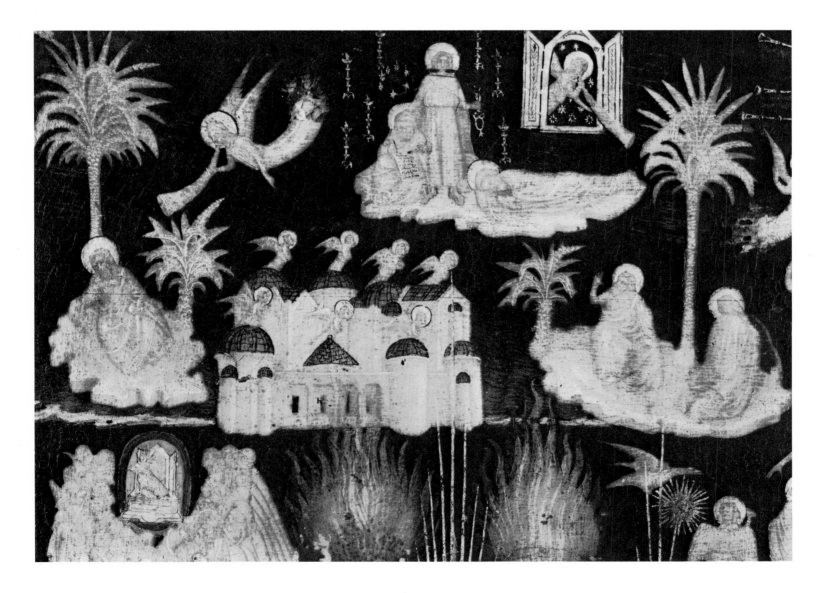

Apocalypse is displayed by means of grisaille groups and figures standing out against a smooth dark-blue, background. Formerly part of the collection of Count Erbach of Fürstenau, they can now be seen in the Stuttgart Staatsgalerie.

Their provenance is uncertain; their iconography has been connected with that of contemporary Neapolitan Bibles, and even with the lost cycle Giotto painted in the church of the Poor Clares, S. Chiara, in Naples, in the year 1330 and afterwards. Other scholars have pointed out similarities with the Apocalypse of the Paduan baptistry. The very high quality indicates a gifted man, but no one knows where to look for him.

The first striking feature is the Mediterranean setting. John sits under a high, accurately detailed palm-tree. The seven churches, all 132 domed, form a compact group conspicuous by its many high, narrow apses, recalling those of Apulian churches such as Trani or Bari. A fortress dominating the Beloved City reminds one of Frederic II's Castel del Monte. The angels receiving the vials of wrath swarm out of the door of a purely meridional three-aisled basilica. The

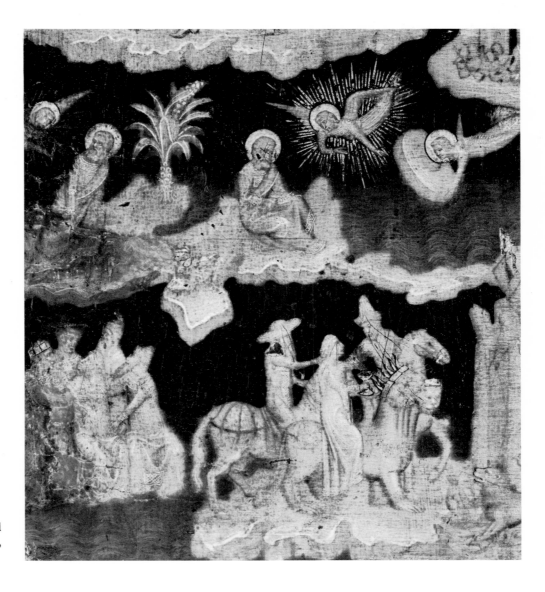

The millstone thrown into the sea. Detail of the second panel, lower left. Stuttgart, Staatsgalerie. (133)

197

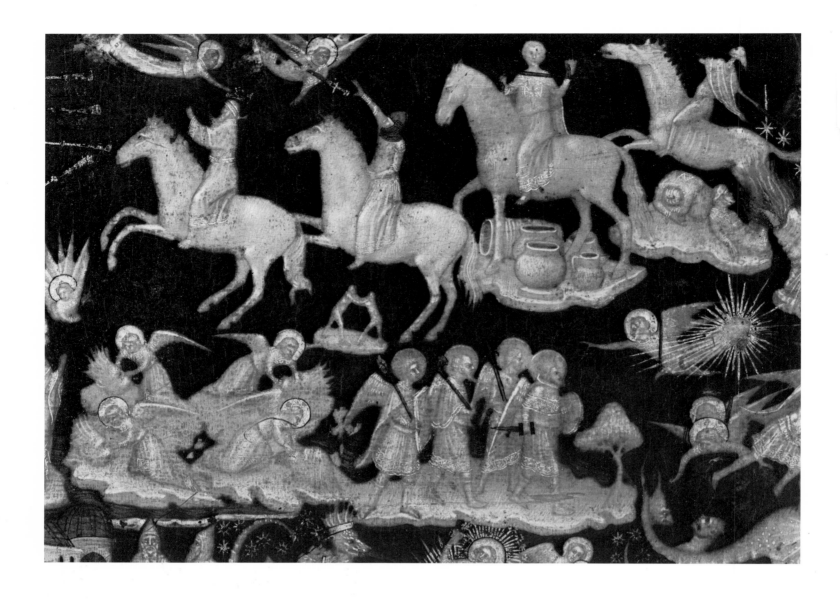

Thrones, however, and the bench of the Judging Just, show the crotchets, pinnacles and triangular gables of average trecento furniture. The Open Door is an opened triptych; the Ark in the Temple, a reliquary seen behind the columns of a Romanesque basilica. The Bottomless Pit is the cistern, narrowed at the top, of the Italic tradition.

Many other features point towards Italy: the ten horns of the Dragon emerging from a flat diadem; the armour of the warriors; the *133* quaint flat sugar-loaf hats of the merchants cajoling the Great Prostitute; the big scythe held by the Lord on the white cloud, and brandished by the Rider Death – a grinning carcass riding on the pale horse. Burning Babylon is a mountain fortress full of domes, all its gates are round-arched. Finally, the Rider on the white horse is wearing a pointed tiara made of three narrowing crowns, one upon *135* the other, the same tiara seen in a miniature of the rather primitive Apocalypse of the Hamburg Library, which never occurs in the

The four Horsemen of the Apocalypse. Detail of the first panel, upper right. Stuttgart, Staatsgalerie. (134)

198

Anglo-Norman manuscripts. A unique feature is the two-handled vial of wrath.

The story is told with utter vivacity: a profusion of rushing, flying, clamouring silhouettes. Multitudes are grouped together, big fires leap to the sky. The Eagle and the carrion vultures stand out splendidly against the black sky; in the midst of growing flames the Star Wormwood falls down into the Pit, from which the oddest Locusts are escaping. The Riders on the fire-breathing horses wear the high turbans of the Janissaries; the Leopard-Beast, worshipped by misled wordlings, stands on the capital of a column, like the Lion of St Mark at Venice. The hair of the four Winds (whose mouths are squeezed by nimble angels) flares up like fire. We are still in an Antique country, and in the right Italic tradition.

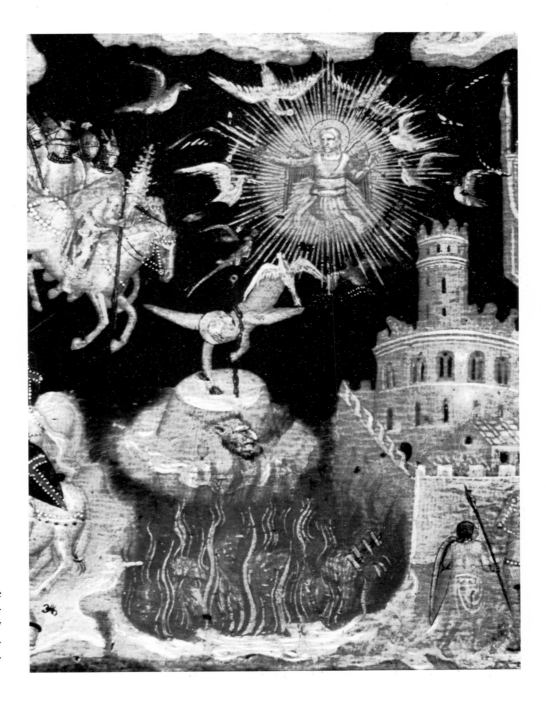

The Rider with the many crowns; the angel in the sun; Satan chained and imprisoned in the Pit; the beloved City beseiged by the armies of Gog and Magog. Detail of the second panel, middle part. Stuttgart, Staatsgalerie. (135)

134
Flying along, an angel drops a crown on the head of the first Rider; the second seizes the hilt of a sword handed over by another angel; below the third Rider's horse, an empty barrel and three empty jars symbolize Famine; and a dead tonsured cleric and a sprawling soldier lie under the belly of the fourth horse, the Rider of which is Death. During the 'rain of the stars' a cavern shelters a huddled crowd; the 'heaven rolled together as a scroll' shows the signs of the zodiac, the sun has 'become black as sackcloth of hair'. The two Witnesses recall Basilian monks; the Great Angel, clothed in the short tunic also seen in the baptistry of Padua and the chapel 118 of Karlštejn (in Bohemia), has red fiery legs, but not yet the 'pillars of fire' mentioned in the text and later drawn as real columns by Dürer.

Four horns shout from the corners of the Heavenly Altar; the Souls underneath wear dark stoles on their robes, the same liturgical stoles that appeared in Bamberg and Anagni. Three of the four angels at the Euphrates are bearded, again a unique feature.

In the scene of the Heavenly Liturgy, the compact crowd of the Elders adoring the Majesty is encircled by a second crowd of haloed personages, all wearing costly, gold-embroidered stoles slung over one shoulder, or both, and round the waist. This very exceptional, and not strictly liturgical, garment is identical with the *stola* worn by King Robert on Simone Martini's famous *pala* (now preserved in the Capodimonte Museum at Naples). This picture shows the

The Throne, the rainbow, the seven lamps, the Book, and the Elders; the Lamb taking the Book and standing inside the Throne (a medallion flanked by the four Beings). Part of the cycle painted above the arches of the nave, in the abbey church of Pomposa, *c.* 1350, near Codigoro, in the Romagna (Prov. Emilia, north of Ravenna). (136)

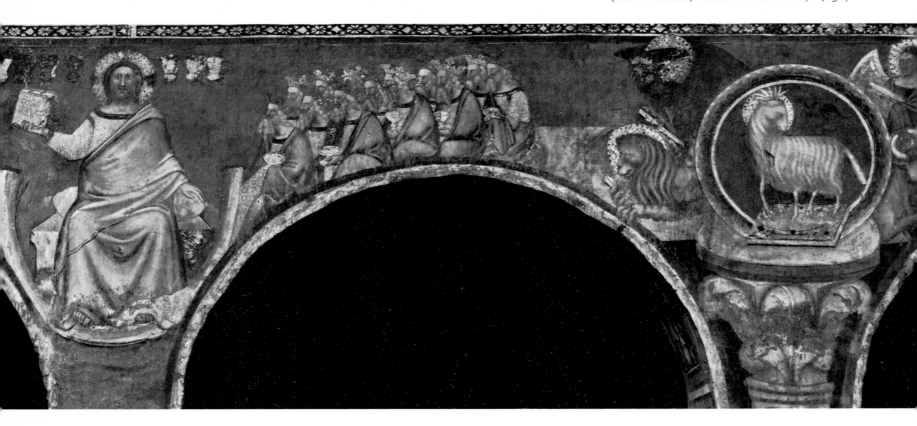

coronation of Robert, king of Naples, by his brother Louis, archbishop of Toulouse – a Franciscan, afterwards canonized – at Avignon, in 1317. The similarity of the lily-embroidered strip of brocade, which hangs over his shoulders, falls over his arms and is tied round his waist, to the strange *stolae* on the Stuttgart panel is so perfect that a mere coincidence must be excluded. Of course, the saints adorned with this scapular-like ornament are 'those who washed their *stolae* (again the misunderstood, robes, *stolas suas*) in the Blood of the Lamb'. Whether their scarves, and that of the king, are connected with the Court of Naples or simply represent the badge of affiliation to a pious brotherhood or an ecclesiastical order, we do not know. At any rate, the Stuttgart cycle has some connection with Naples, and little or nothing in common with the Anglo-Norman tradition.

A few details, such as the Great Angel, may recall the mediocre series of the Paduan baptistry, but the Woman, the Dragon, the rebel angels, Michael and his warriors are so strikingly different, and so much better drawn, that a common origin seems highly improbable. One cannot help thinking of another model: the unknown cycle of Giotto in S. Chiara.

I think that anybody who has seen the Paduan series and immediately forgotten it, and afterwards finds himself looking at the Stuttgart panels – a play of silhouettes *en camaïeu* set against a background of dark lacquer – will remember this anonymous Apocalypse as one of the jewels inspired by that Book full of precious stones, the Revelation of St John.

Here and there the ochres of the grisaille are enlivened by the deep red of flames, flaring up into yellow points; by the red of the water changed into blood – piquant, well distributed accents. The ensemble makes one think of a sky crammed with unreal constellations, punctuated by red blow-pipe flames. A real Apocalypse, and a delightful one, notwithstanding a style of drawing that sometimes mars the high quality of the composition. Maybe the cycle has nothing to do with Giotto's frescoes at S. Chiara, but I can hardly believe it. The *Stuttgart Apocalypse* might be a second-hand work, and a copy on a small scale, but a great model must have stood behind it. A work of such strength can be copied or reduced, it cannot be improvised by a mediocre craftsman.

135

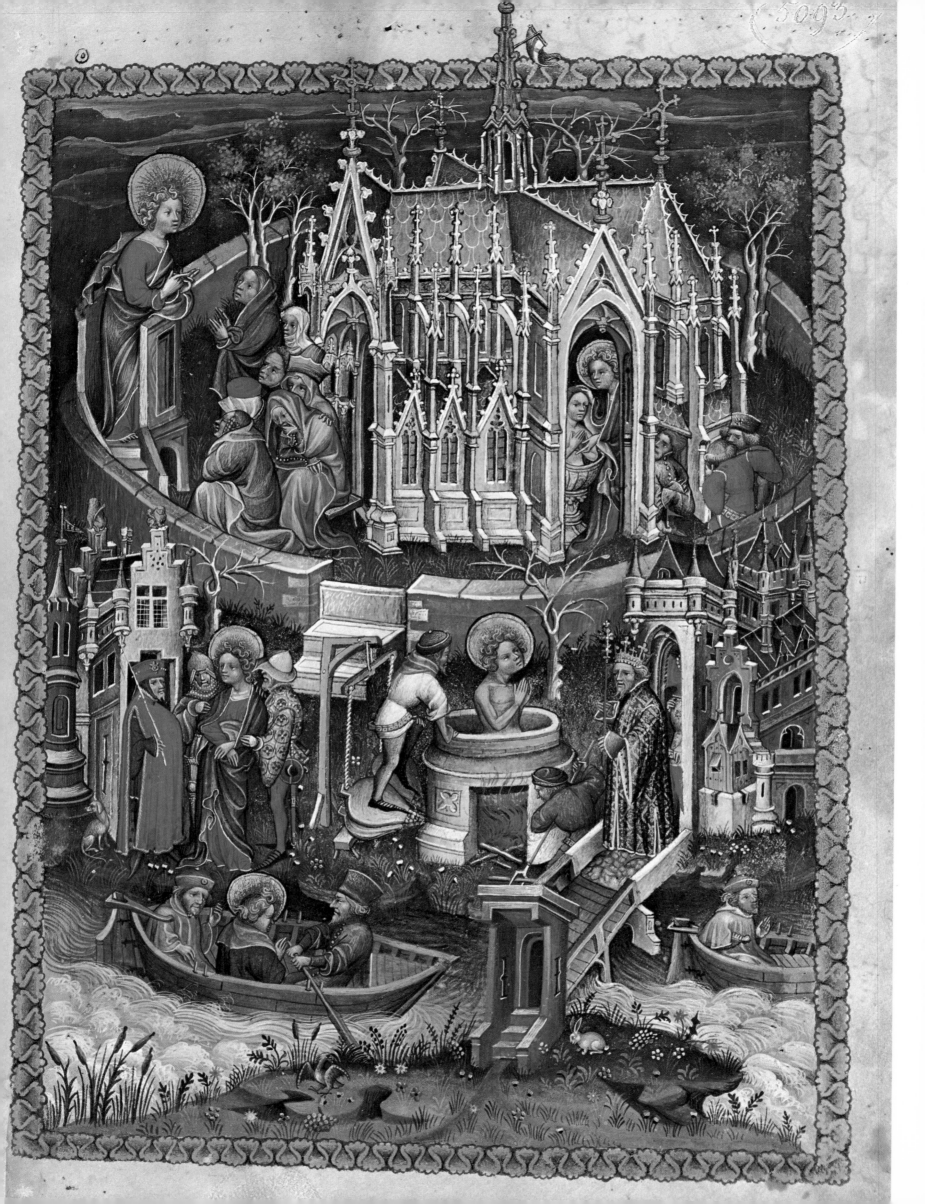

The First Apocalypse in the Low Countries

An exceptionally planned and splendidly executed Apocalypse is owned by the Bibliothèque Nationale in Paris. Registered as BN néerl. 3, it is the first one written and illuminated in the Low Countries. Its creator planned it with one full-page miniature devoted to each of the twenty-two chapters, and one introductory page to the customary scenes taken from the legend of St John, just before his exile.

The twenty-three miniatures, nearly 20 cm by 25 cm, are positioned opposite the text, which is in West-Flemish, and accompanied by the Berengaudus gloss. The pictures are full to the brim: on a third of the folios they bring together nearly all the motifs of the eighty half-page images we know from the Anglo-Norman cycle. Chapter and image fit perfectly; only the subjects taken from the long chapter, nineteen, and the very short, twenty, are freely disposed on two pages. *137-159*

Sometimes the result is a single concentrated vision with small accessories, as in the case of the Throne, the Great Angel, and the Heavenly City; but it is mostly a series of groups cleverly put together, to be read from above, preferably with a finger on the text. In order to fill the two folios devoted to the seven letters addressed to the churches, the painters tried to illustrate something of their content: an idea not seen, or if so only sporadically, since the *Trier Apocalypse* four hundred years before. *141,147* *139,140*

An ingenious process is used for combining several scenes: they are all set off against a velvety, very dark background, one above or beside the other. The background isolates the groups as well as the single figures, and holds them together within a frame of pleated clouds, to remind us of their visionary nature. That background consists of a massive dark-blue, alternating with zones of fiery red; only f.2 shows a morning sky, with streaks of real clouds. Elsewhere, we see only thin twisted clouds, yellow stars and bits of gold. *138*

At the bottom of the pages the sky changes into an earthly zone, consisting of curiously split rocks, meadows full of flowers and bushes of darnel, and small trees with tufts of brownish foliage. Hues of pale-grey and brown dominate, made up of many shades. When necessary, the earthly zone is interrupted by masses of fast running and sometimes whirling water full of white foamy crests. This repre-

The twenty-three full-page miniatures of a Flemish Apocalypse, written about 1400, preserved in the Bibliothèque Nationale in Paris, here published in full, and in colour, are commented upon and explained in the text. The first picture is dedicated to the *Life of John* before his exile; the others to the Apocalypse, each miniature corresponding to one of the twenty-two chapters. Dimensions, including the border: 19 cm by 25.8/26 cm. Paris, BN neerl. 3.

John preaching at Ephesus; his martyrdom in the cauldron of boiling oil; his departure for Patmos. (137)

sents the sea, the Euphrates, the 'many waters' upon which the Great
159 Prostitute is sitting, and finally the River of Life, similar to a moun-
tain torrent. It falls between twelve dwarf trees, the trees 'yielding
their fruit every month' (Rev. XXII: 2).

The few scholars who have studied the manuscript – Waagen,
Frimmel, Vogelsang in 1899, Montague Rhodes James about 1930,
later Panofsky and Mlle Hontoy – have all been struck by the splen-
dour of the colours. Only bright-green is lacking; scarlet, deep-blue,
ochre, and a crude white dominate. White is used for modelling,
mostly by means of highlights; it lightens the metal of the bluish
armour; rows of white ornament mark the ridges of the roofs, white
balustrades run along the gutters; hailstones are enormous and snow-
white; St John's mantle has a graceful white hem.

The skilfully distributed red brings out the Beasts, the tiled roofs,
and, of course, all the fire. Finally, the gold-leaf flashes round the
heads of the Lord, his angels and St John, sharply set off against
the blue or red of the sky. Several small angels are seen with a
halo of needle-thin golden rays, the same as are found later on in
the altarpieces of Rogier van der Weyden. The gold of violins, harps,
citharas and crowns speckles the blue around the Throne. It takes
some time to realize that the instruments belong to the twenty-four
Elders, vaguely drawn whitish shades of naked old men with bits
141 of drapery hiding their loins. One has his crown on his forearm,
also something unique. The wings of the four Beings and most of
the angels consist of white pieces of fluff changing the outer side
of their feathers into a kind of fern.

As striking as the colour, is the emphatically popular and vigorous
way in which the story is told. After the courtly puppet-show of
the fourteenth century, this sudden display of authenticity is so
refreshing that we, of the Low Countries, cannot help thinking: there
it is at last, our national genius, the real rich manner – Brueghel
a hundred years *avant la lettre*. The Utrecht professor, Willem Vogel-
sang, was the first to stress the quality of this manuscript. In a little-
noticed essay of 1899, he wrote: 'Here an extraordinary man has
been at work; it is high time to publish this splendid piece.' He
himself did not manage to achieve this, probably because it was then
hardly possible to reproduce the colours; the specimens given in black
are very poor indeed.

THE DATE

The specialists are all agreed about the date: the first decade of the
fifteenth century. But they had to admit that neither in the Low
Countries nor in northern France could they find anything compar-
able. The situation is slightly different today. The, by now famous,
pathetic *Heures de Rohan* have furnished some points of comparison:
those strange phantom-like figures drawn in a kind of chiaroscuro
against a dark sky, also the tilted-up nose of John, and his wild

locks. But the John of our manuscript is far more level-headed (and more rustic) than the Apostle maddened by grief in the famous *Lament* of the *Rohan Hours*.

We have met the alternately red and blue backgrounds in the Angers tapestry of 1380. The armour, the weapons, and most of the costumes are those of the end of the fourteenth century. These are the strangely folded head-dresses, the wide *houppelandes*, the princely ermines and the liturgical vestments of the years around 1400; and there are even the slightly later bobbed hair and shorn neck of the 'page' fashion, the spindle-legged dandies with the idiotically pointed shoes called *poulaines*, all much in vogue at the courts of Dijon and Bourges. The Great Prostitute wears, under her crown, *155* the velvet cap with side-flaps. Her low-cut, low-girdled training dress is the style worn by Queen Jeanne de Bourbon, wife of Charles V, on the *Parement de Narbonne* and on her statue from the church of the Parisian *Célestins*, now in the Louvre. Jeanne died in 1377 and the fashion may have lingered on; provincial miniaturists certainly did not worry about details.

The Throne on page five, with its large seat and high pinnacles, *141* and the silky round folds of the Lord's mantle, recalls those of André de Beauneveu, in the *Psalter* made for the Duke of Berry in 1386. Several figures resemble those of Jacquemart de Hesdin, in the *Très belles Heures* of the same prince, from about 1390-5. The *Rohan Hours* are somewhat later, 1418-25, but this masterpiece is anything but precocious when judged by naturalistic standards and compared with the revolutionary landscapes of the Limburg Brothers or the anony- *1,8* mous artists of the *Turin Hours,* both nearly contemporary works. Of landscape, there is very little in our Apocalypse: no horizon, no aerial perspective. The bluish distances, the clear skies, the daylight of Jan van Eyck and his immediate predecessors are still in the distant future. The atmosphere remains surrealistic, even partly emblematical; the whole is conventionally fourteenth-century. Only the gorgeous colour and the vigorous style of the narrative are new.

THE PROVENANCE

The exact provenance of the manuscript being as uncertain as its date, we are even more at a loss when asked to locate its author. Its pictures clearly betray different hands; it appears that a gifted artist, to whom at least the first leaf is due, has set up a compositional *137* scheme and a scheme of colours faithfully continued by one or more fellow craftsmen.

Figures and faces are increasingly rustic. From the second pictures onwards, round heads appear, with shining bulging foreheads under an untidy tuft of hair, which are the rule in the later part of the manuscript; the more popular characters, however, are strikingly authentic and extremely picturesque. The composition itself varies between haphazard, sometimes jostled, juxtaposition and powerful

I *Overleaf:* The Son of Man among the candlesticks and the churches, f. 2 (Rev. I). (138)

II *Overleaf:* The Son of Man; illustrations of the messages to Ephesus, Smyrna, Pergamum and Thyatira (Rev. II). (139)

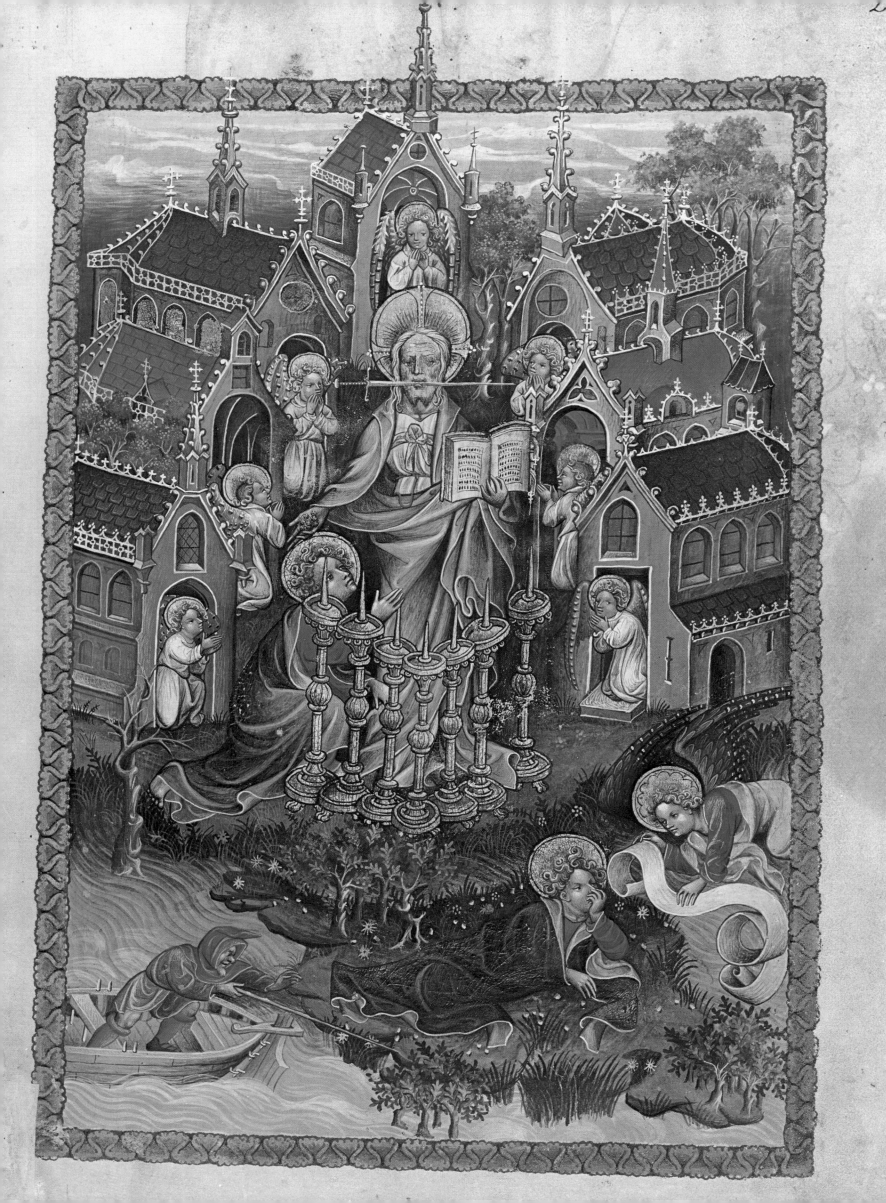

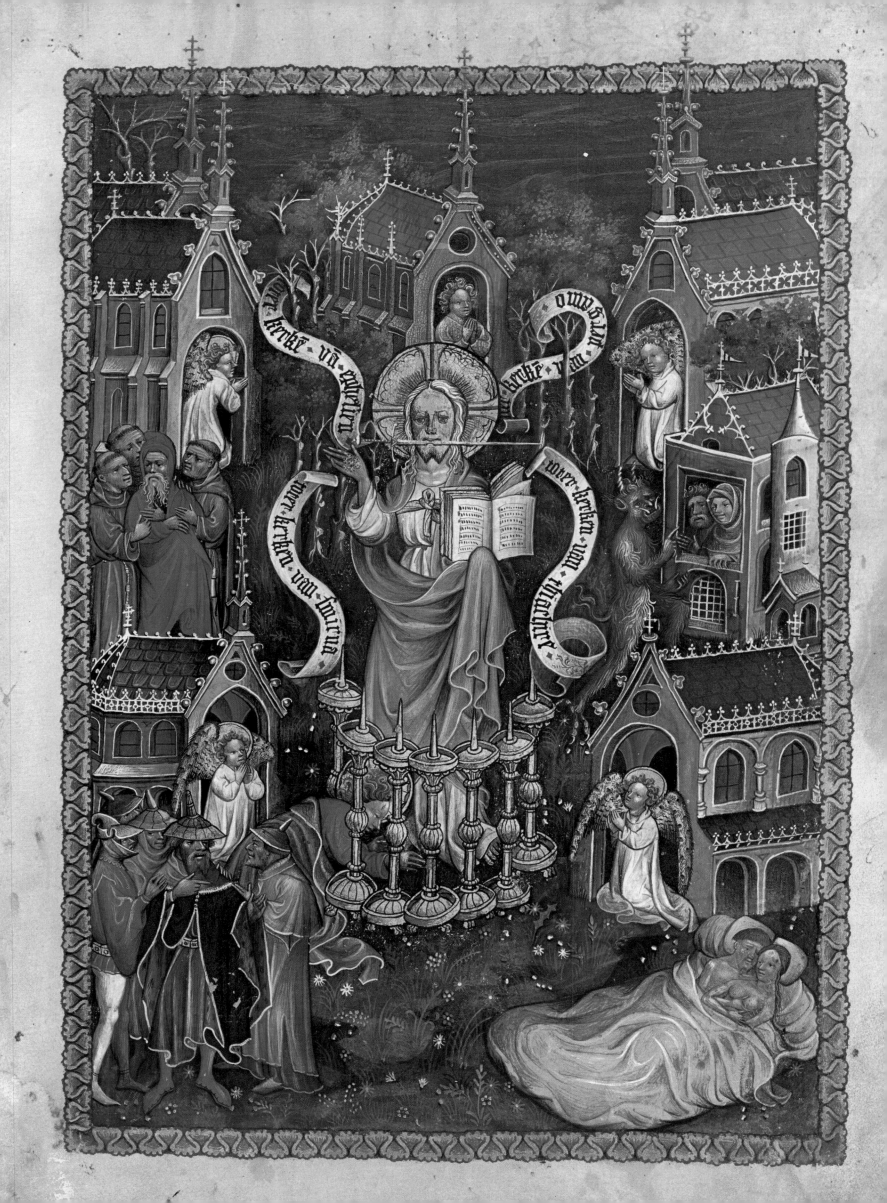

concentration. The most striking scenes are those of the Vision of
141 the Throne, leaf five, and of the Woman assailed by the Dragon,
149 leaf thirteen, though neither of them can be attributed to the painter
of the opening picture. Instead of guessing at imaginary authorships
it would be better simply to examine and enjoy this first display
of Netherlandish visionary realism.

SCENES FROM THE LIFE OF JOHN

137 Admiring the opening picture, I readily forget even the calendar
leaves of the *Très riches Heures* of the Duke of Berry, those master-
pieces of the Limburg Brothers (who, by the way, probably came
from Nijmegen), for something entirely different but equally fascinat-
ing.

Within a wall of red brick, between bare trees, a white cruciform
church, not unlike a silver shrine, reveals the chapels, the ambulatory
and the thin spire on its crossing; inside, pink light fills the vaulting,
and through the door of the transept one has a glimpse of John
baptizing Drusiana in a golden font. The slates of the roof have
a white border; a banner hangs from the spire. From a pulpit in
the open John preaches to a congregation of six women; he is count-
ing the arguments on his fingers.

Below, we see him again, naked, in the cauldron of boiling oil;
a torturer is treading the pulley-block of the pair of bellows while
his companion rakes dead wood into the furnace. Domitian, in bro-
cade, and with a two-pointed goatee, stands on the cobbles of a little
yard before the Latin Gate, close to a bridge across the Tiber and
a bit of sea on which John is being rowed away to Patmos. Rome
and Ostia are miniature Flemish towns, with pinnacled belfries and
lions on top of stepped gables.

The faces are exquisite; those of the listening women show every
degree of attention; those of the executioners are hidden behind the
caps and helmets. St John's face is so noble that one easily misses
four changes of expression: from persuasiveness during the sermon,
and ritual correctness during baptism, to joyous resignation, when
carried off to death between two gaolers and a traitor, and quiet
prayer during the torturing. In the boat only his cheek is visible.
In the grass at the sea-side a hare twitches its nose and a bird flaps
its wings.

THE APOCALYPSE

138 **I In the first picture** of the Apocalypse proper, showing the Son
of Man and the seven churches, the same delicate faces appear, this
time on the angels, children in white albs, kneeling on the doorsteps
of pinnacled chapels set in a circle behind the Apparition.

The Son of Man, however, has a wrinkled sad face of yellow-gold,
that shines from between long, lank locks, reminiscent of the broad

III John writing; illustrations of the mes-
sages to Sardis, Philadelphia and Laodicea
(Rev. III). (140)

IV *Overleaf:* The Vision of the Throne;
the angel calling John: 'Come up hither!'
(Rev. IV). (141)

V *Overleaf:* The Lamb receiving and
opening the Book (Rev. V). (142)

208

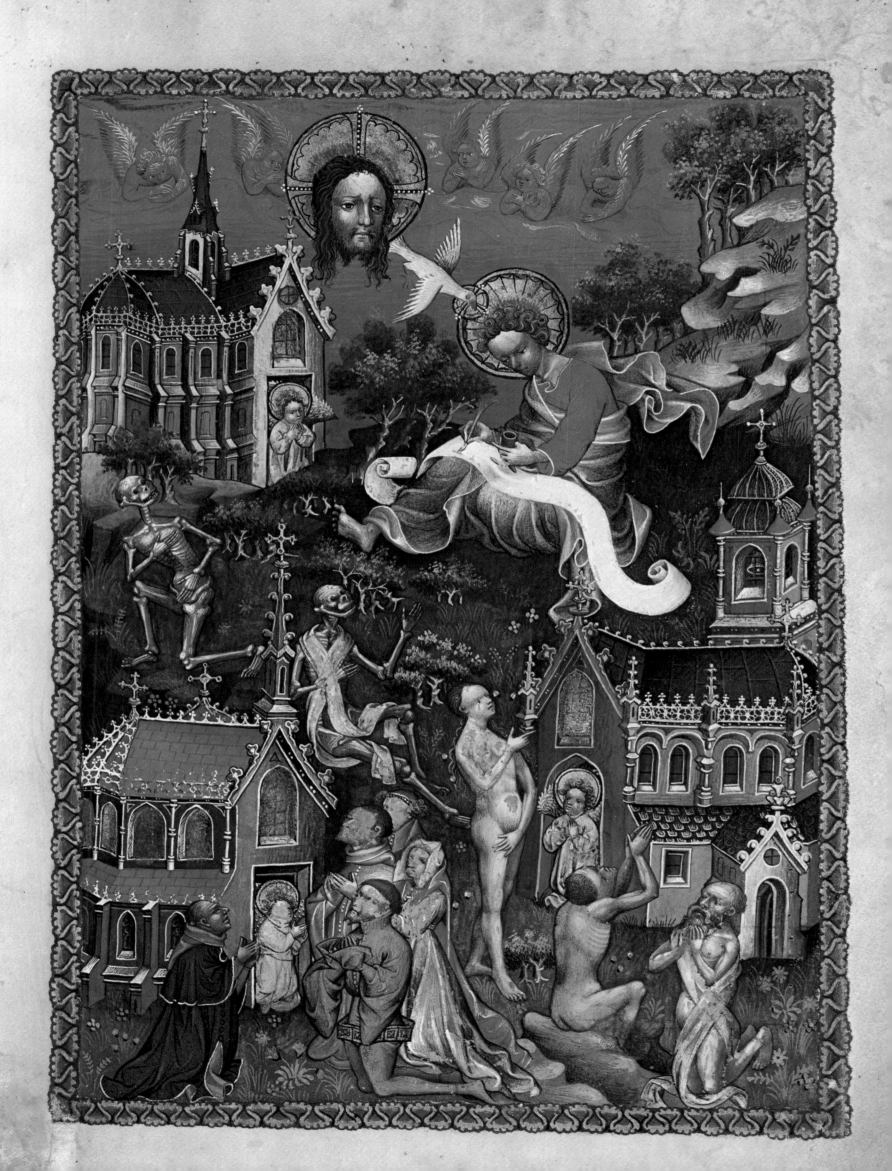

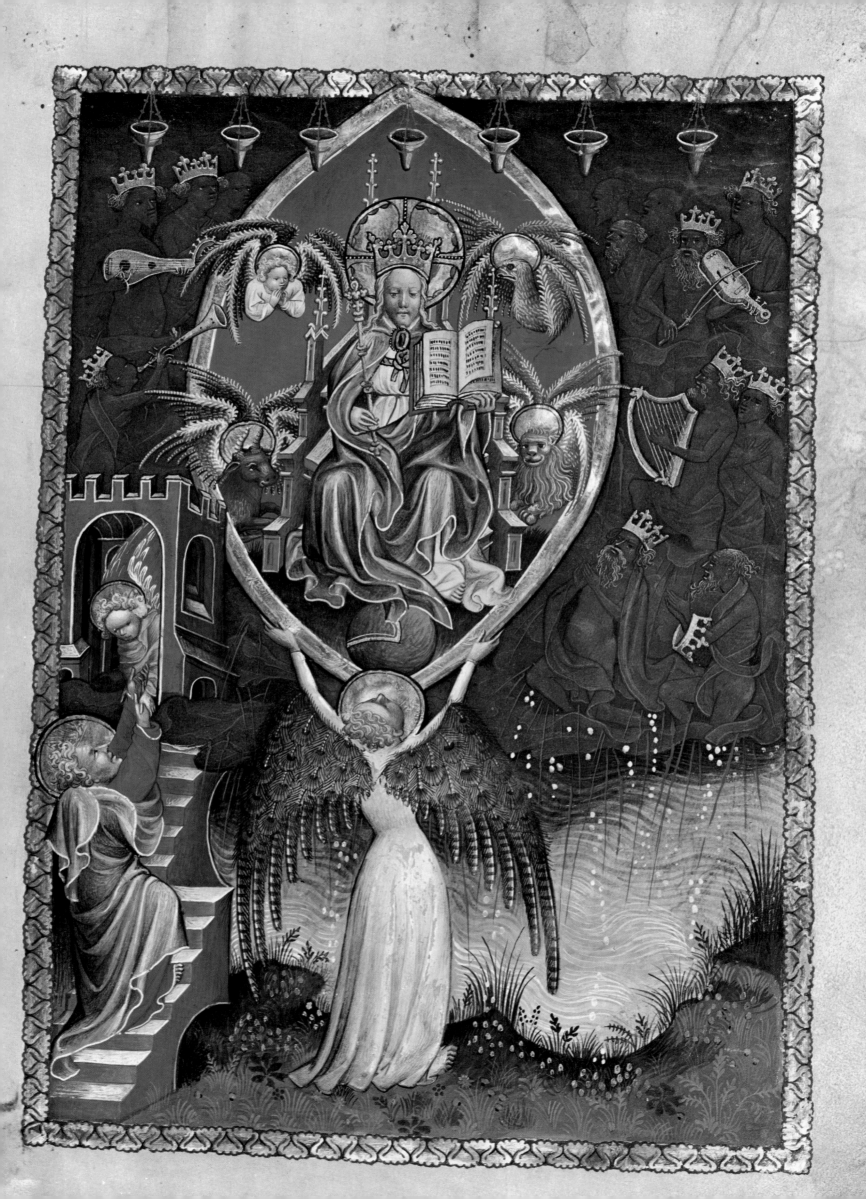

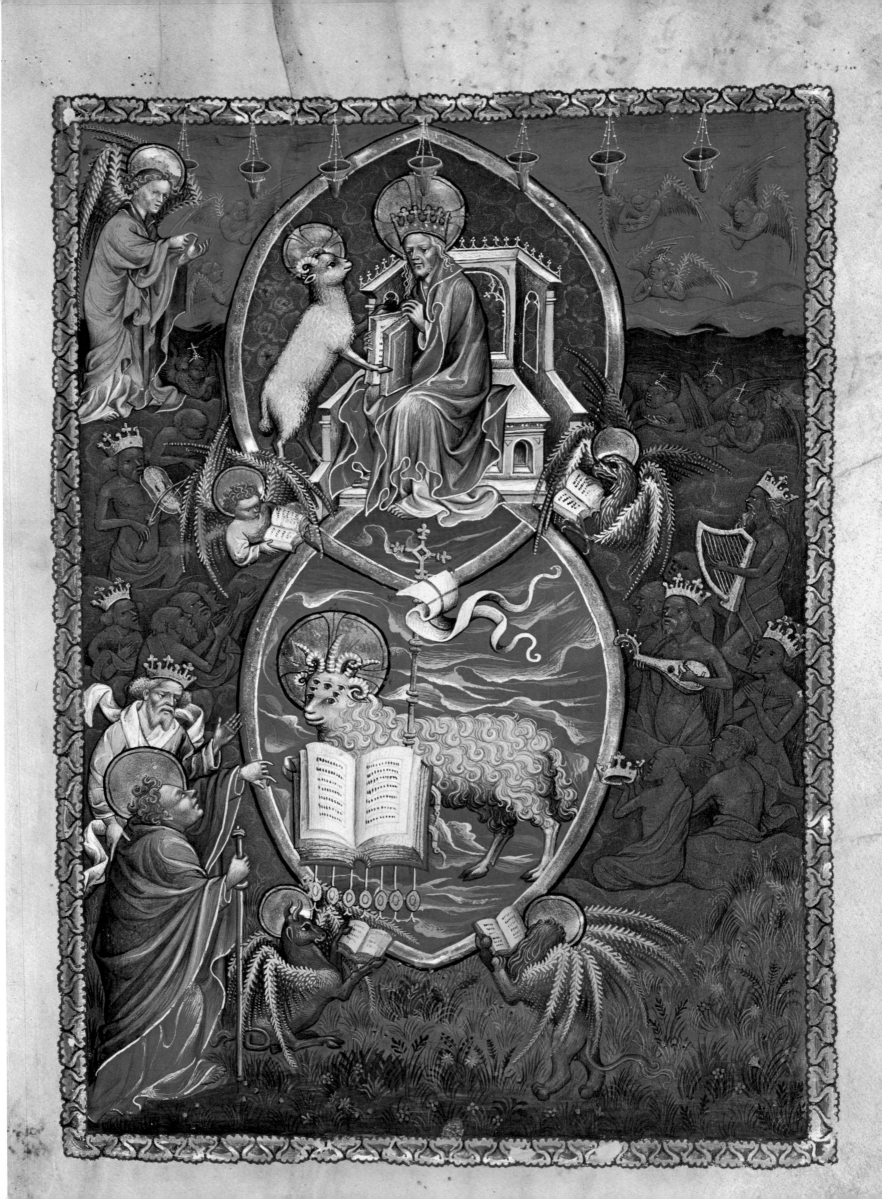

face of the *Volto Santo* at Lucca. The sword flashes across his mouth, the stars are crumbs of gold in the palm of his hand, the Book is open, the golden girdle literally touches 'his paps', and a second girdle encircles his waist. One sees also a tip of his glowing feet. The keys and the flames flaring up from his eyes are omitted. The candlesticks, set in the grass at his feet, have no candles, a baffling case of carelessness, occurring again in the block-book. At the bottom of the scene, John, a young handsome lout with wild corkscrew locks, lies on his stomach in the grass, lost in thought. He covers his mouth and nostrils with his fingers, half unconsciously, and slowly turns to a peacock- feathered angel, who has already begun to whisper in his ear what he has to jot down on his empty scroll. Small pollard-willows and a bare birch stand sadly in the water; the ferry-man, in pointed cap, cape and jack-boots, a true villain, pushes his little boat away from the crumbling bank with a pole. He is going back, the exile has disembarked. These two pieces of genre make up for the whole page.

139 **II Four scrolls,** going out from the Son of Man to the first four churches, show the words *toter kercke van ephesien-smirna-pergamo-thiachire.*

In front of the Ephesus chapel three well-fed Franciscan friars are leading away a bearded man in a red hooded cloak, probably a Nicolaitan (Rev. II: 6); the scene is meant as a compliment to the Minorites. Before the Smyrna church a sinister-looking soldier, his visor opened, is going to scatter a group of disputing Jews, identifiable by their pointed conical caps: they are the blaspheming people 'who say they are Jews, and are not, but rather a synagogue of Satan' (Rev. II: 9). A hairy horned and clawed demon, standing before a window from which a man with a moustache and a monk look out, illustrates the words: 'Behold, the devil shall cast some of you into prison' (Rev. II: 10). Below, in front of the Thyatira chapel, a naked couple is seen lying in bed, their cushions resting on a broad pillow, under a neatly folded coverlet; the man is fondling the breasts of the woman, the false prophetess Jezabel, who is seducing God's servants 'to commit fornication' – the usual biblical metaphor for idolatry (Rev. II: 20-2, where the bed is also mentioned).

140 **III In the third picture,** the grave face of Christ appears above a Dove flying down to John, who is writing and holding his ink-horn: 'He that hath an ear, let him hear what the Spirit saith unto the churches' (Rev. II: 17 and III: 6). To the church of Sardis the Spirit says: 'Thou hast a name that thou livest, and art dead' (Rev. III: 1). Two carcasses, like those seen in the *dance macabre,* are squatting in the grass, one of them with his shroud crosswise on his split-up belly. In front of the Philadelphia church, a group of pious burghers kneels before the 'open door' (Rev. III: 8). Near the Laodicea chapel, a naked woman, making the gesture of the *Venus pudica* and recalling

VI The Opening of the first six Seals: the Riders and the Souls under the Altar (Rev. VI). (143)

212

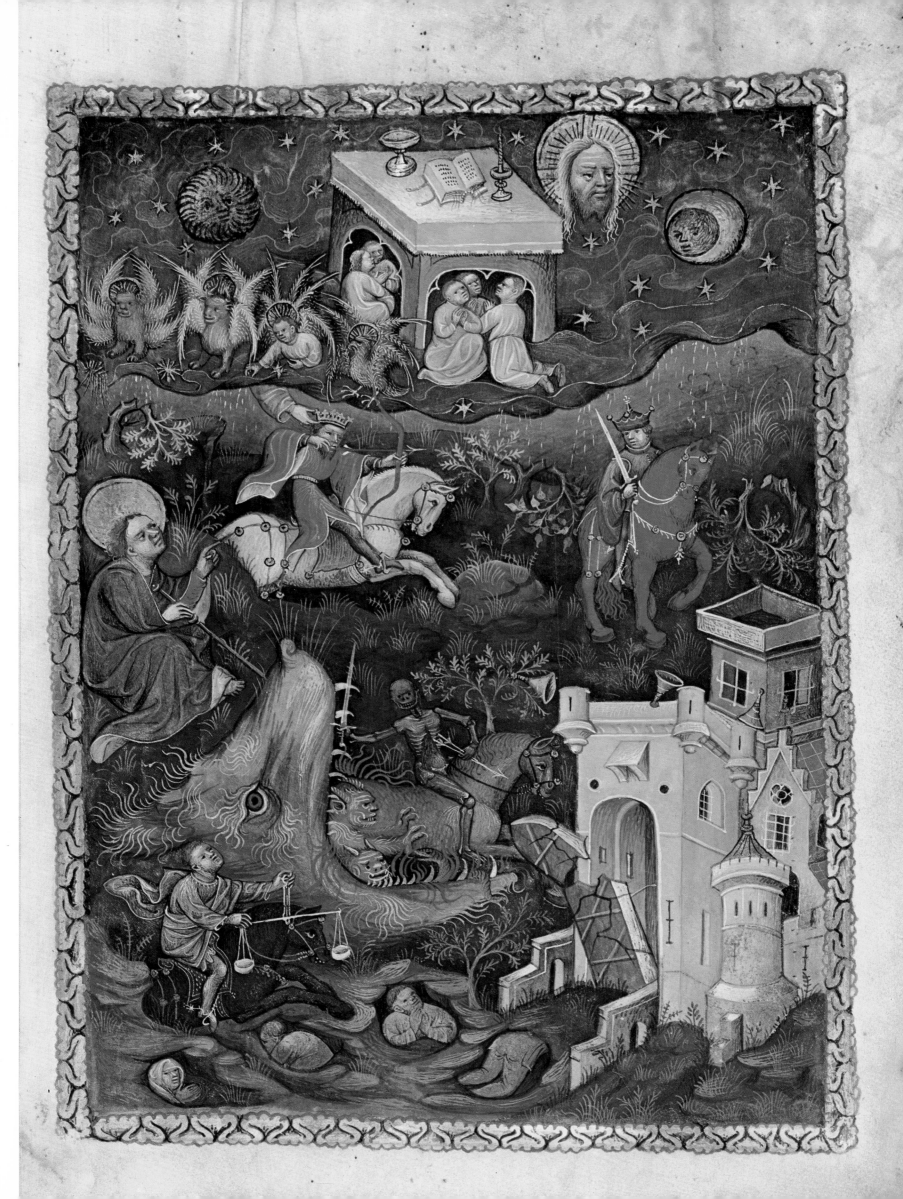

the usual Eve, looks down ashamed. An old wretch, sitting on a stone, pitifully raises his joined hands; a blind man in rags kneels at the side of another poor devil, so skinny that one can count his ribs. The four of them recall the words: 'Thou sayest, I am rich, and have need of nothing; and knowest not that thou art wretched and miserable and poor and blind and naked' (Rev. III: 17).

IV The Vision of the Throne, the fourth picture is an unforgettable composition and undoubtedly the acme of the cycle.

Already, in earlier manuscripts, such as BN fr.403, a seated angel is seen supporting the glory of the Throne, with raised arms, more or less like an Antique Atlante. Here, a slender angel, seen from behind, clothed in a white tight-fitting robe and flapping mighty peacock-feathered wings, holds the shining mandorla high above his curly head, almost like a weight-lifter. So violently does he throw back his head that one sees his cheeks and nose upside down, in the middle of his golden halo. He stands on a grass plot full of flowers, before the undulating Sea of crystal, into which arrows of fire and hailstones fall. Inside the golden mandorla, the Son of Man, wearing a high chiselled crown, is enthroned against a scarlet background. He holds the opened Book, and is surrounded by the four heads and the twenty-four fern-wings of the four Beings, and, outside the golden vesica, by a row of seven lamps and the flashing crowns, violins and harps of the Elders, who sit in nocturnal darkness like shades, almost invisible.

'Come up hither!' says the angel, rushing out of the 'door opened in heaven' and dragging the bewildered John by both hands up the twelve narrow steps leading to the doorway. Nobody ever illustrated this vision more convincingly.

V The Lamb appears twice: first standing on its hind legs to receive the Book; a second time holding the opened Book, from which the Seals hang down as book-marks, and a staff with a cross-banner that flutters against a background of morning clouds. This time he has the many eyes and horns, and a thick woolly fleece. John, comforted by one of the Elders, forgets his tears and rapturously touches the Lamb's mandorla.

VI Rider Death, in the crammed and disorderly picture with the four Riders, brandishes two darts and a sword while leaping out of the mouth of hell. He is a carcass, taken from the *danse macabre*. People crawl into chasms; spires tumble down from turrets like lids. The white-robed little Souls lie below a covered Altar with a missal, a candlestick and a chalice. Christ's morose face absently hangs among the stars, between the darkened heads of sun and moon. On the border of heaven the four Beings, quietly installed and sitting in a row, do not pay the slightest attention to the four galloping and, indeed, not very striking horses.

VII The Great Multitude holding palms; the Winds being held; bottom: a series of unexplained motifs (Rev. VII). (144)

Overleaf:

VIII The trumpets distributed; the angel with the censer; the rain of fire and hailstones; the Eagle crying 'Woe! Woe! Woe!' (Rev. VIII). (145)

IX The fifth and the sixth trumpets: tne Star Wormwood, the Locusts and the fire-breathing leopard-horses (Rev. IX). (146)

X The Great Angel giving the little Book to John (Rev. X). (147)

XI The Temple measured; the Witnesses; the Antichrist enthroned in the Temple (Rev. XI). (148)

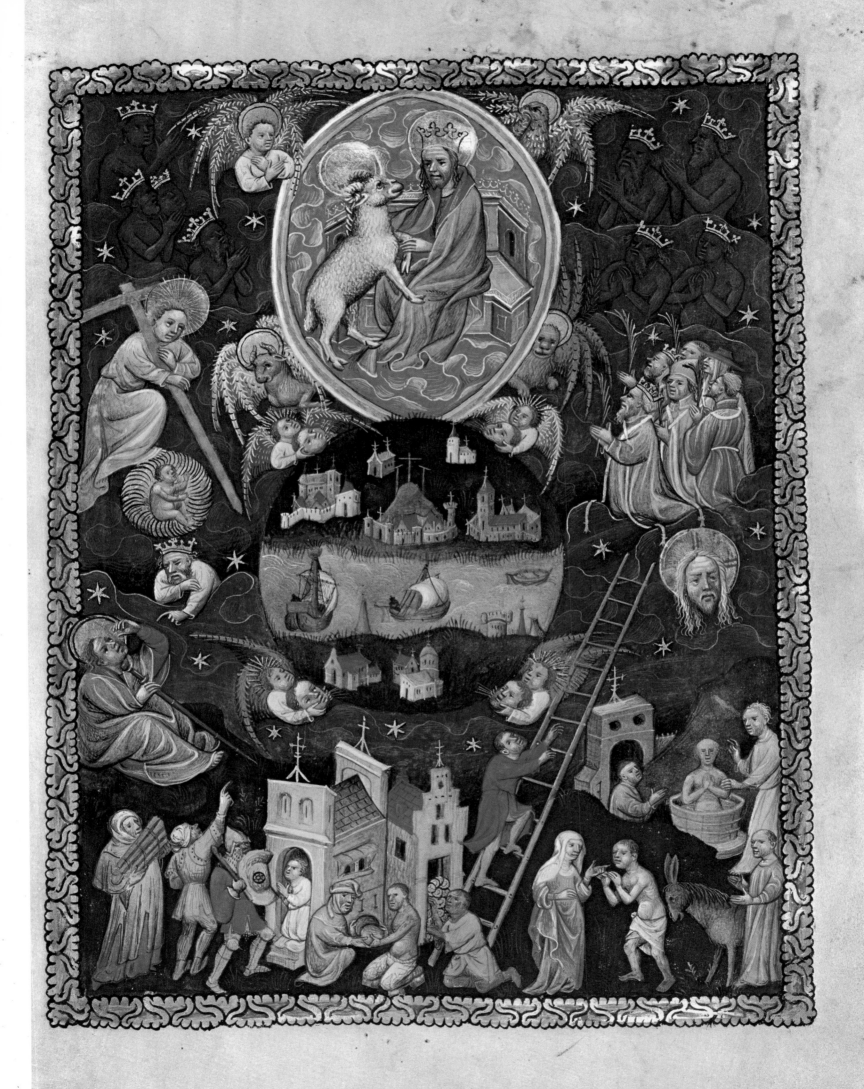

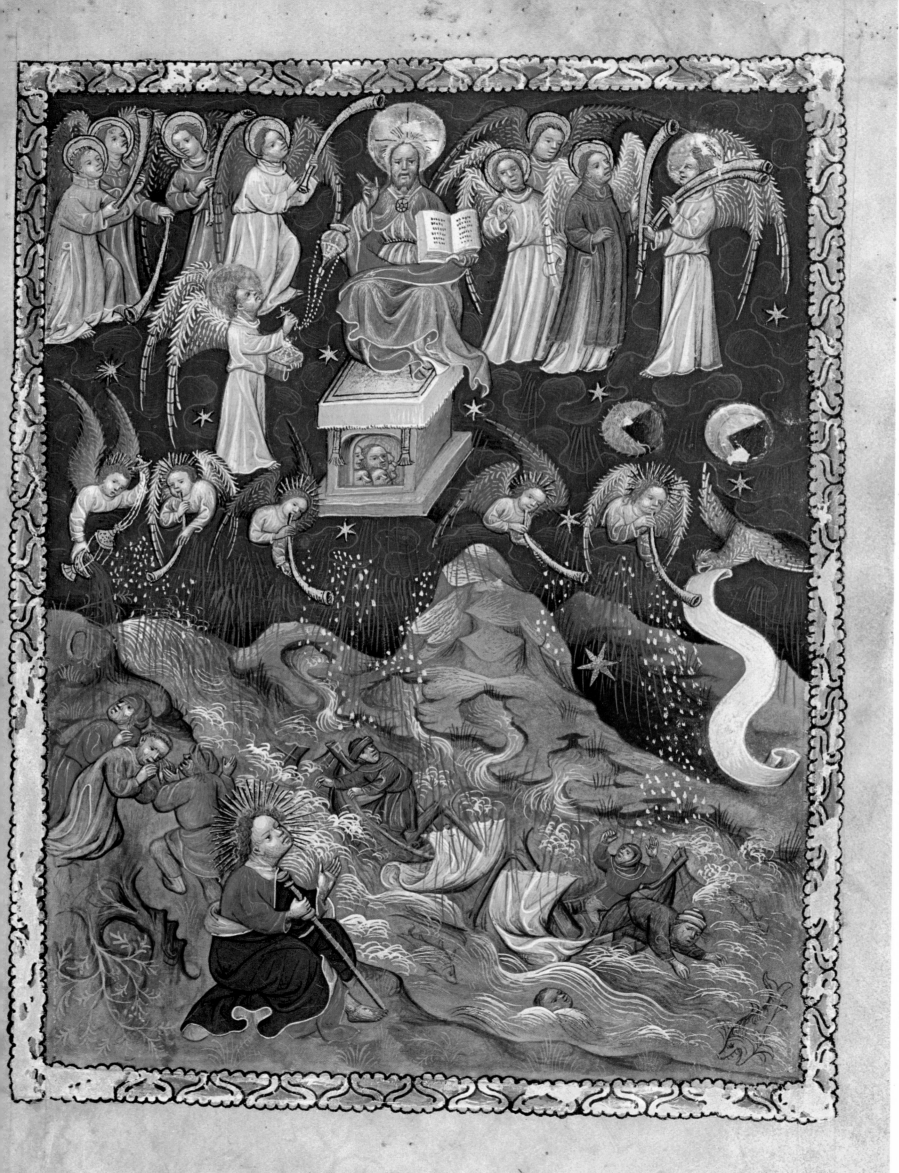

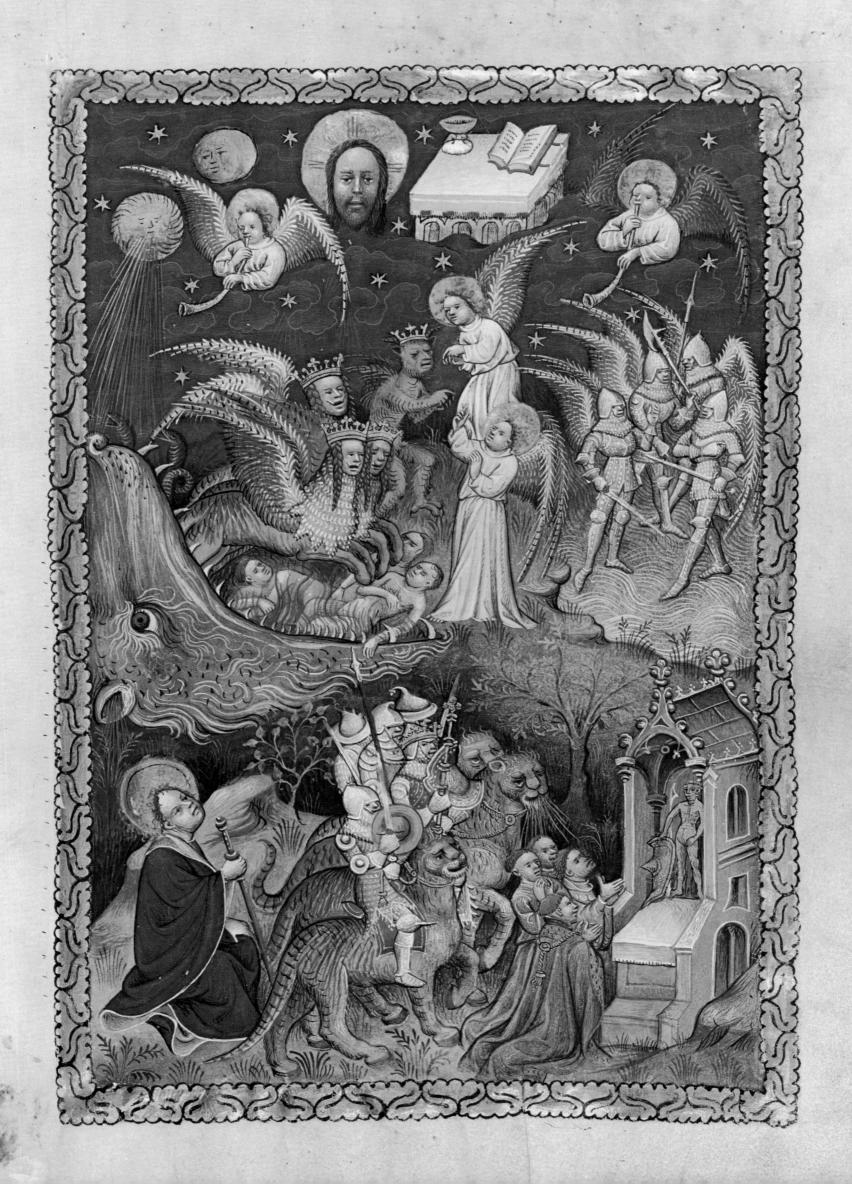

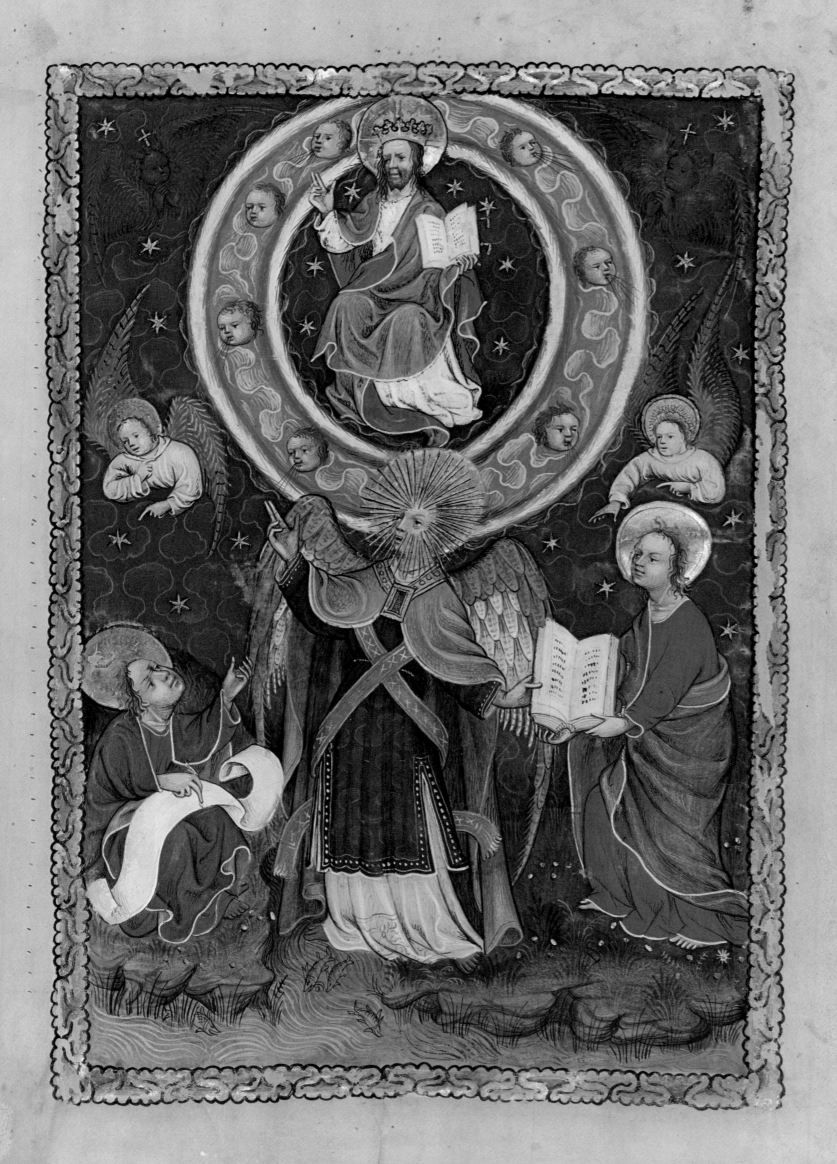

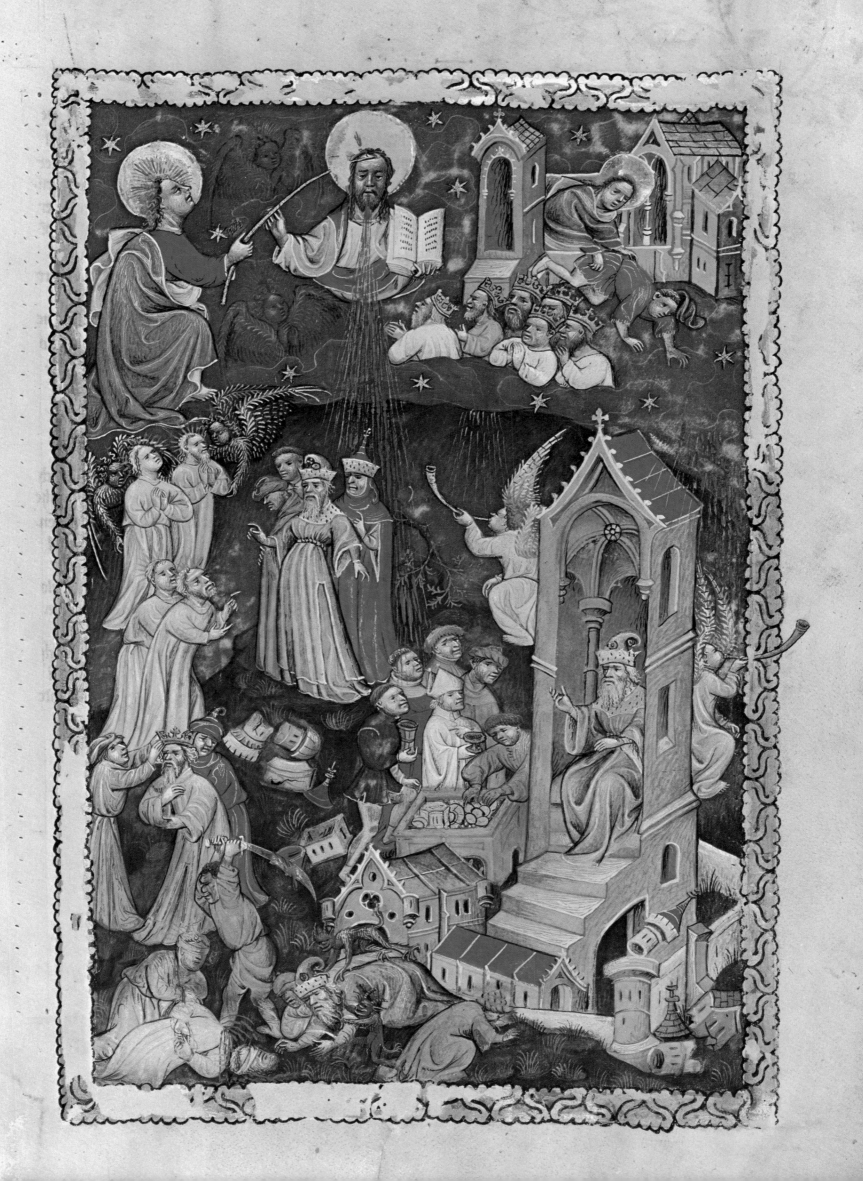

144 **VII The earth,** as in older manuscripts, 'not to be hurt' by the four Winds, held back by the angels, is a round disk, divided into two parts by the sea, and filled with trees and buildings. Its centre, where the three crosses of Calvary rise above walls, is Jerusalem. The 'seal of the living God' held by the angel 'ascending from the rising sun' is the Cross; a naked Child sitting in a sun-wheel is the Sun of Justice, the Lord Incarnate himself. A cardinal, a bishop, two kings and two others rather poorly represent the Great Multitude, identified by the palms and the stoles. I could not find the key to the enigmatical scenes filling the lower part of the picture; neither in Berengaudus nor elsewhere. One sees an old wood-picker holding dry sticks in her arms, a soldier pointing to the sky and another threatening a small cleric standing in a church doorway. A poor devil is climbing a ladder ('They go from strength to strength, every one of them in Sion appeareth before God', Ps. LXXXV: 8? Indeed, the face of Christ appears at the top). A man is giving a loaf to a beggar; pieces of gold are being heaped up behind a door in a step-gabled house; a man and a wife are talking to a traveller robbed of all he has and standing beside a mule. The Works of mercy? A baptism may recall Rev. VII: 14-15.

145 **VIII The Trumpets are distributed** in the following picture, and the angels put them to their mouths, while another angel empties the censer on the earth. Among the cataclysms, one is suddenly fascinated by the foundering ships, 'one of the most convincing shipwrecks in art history' (Erwin Panofsky).

146 **IX The angels of the Euphrates** are winged, armoured knights. The Locusts, stupid monsters, with fangs, crowns, pigtails and feathered collarettes, are not jumping out of a Pit, but out of the mouth of hell.

147 **X The Great Angel** is dressed up in a most unusual way. Over a dalmatic and a crossed stole he wears a cope; he is swearing loudly, his open mouth set in a face composed of converging rays, the 'sun'. John has no occiput and hardly any hair; the thunders are children's heads, with red needles coming out of their baby-mouths. But the colour is splendid.

148 **XI The picture with the Antichrist** shows an amusing detail. At the moment John receives the rod for measuring the Temple, the angel says: 'The court which is without the temple, leave out, *atrium... eice*' ('throw out', according to the Vulgate, Rev. XI: 2). So the painter shows John throwing a young pagan across the wall of the forecourt. The Antichrist is a turbaned old man; his satellites are distributing pieces of gold from a chest to a crowd, among whom are a dandy (dressed up in the Burgundian way), a bishop and a councillor. Next to them, one sees the drama of the two Witnesses,

XII Apparition and flight of the Woman; the Child carried away; Michael fighting the Dragon and the earth absorbing the vomited water (Rev. XII). (149)

XIII *Overleaf:* The Beast and the False Prophet worshipped (Rev. XIII). (150)

XIV *Overleaf:* The Lamb on Mount Sion and the Harvest (Rev. XIV). (151)

220

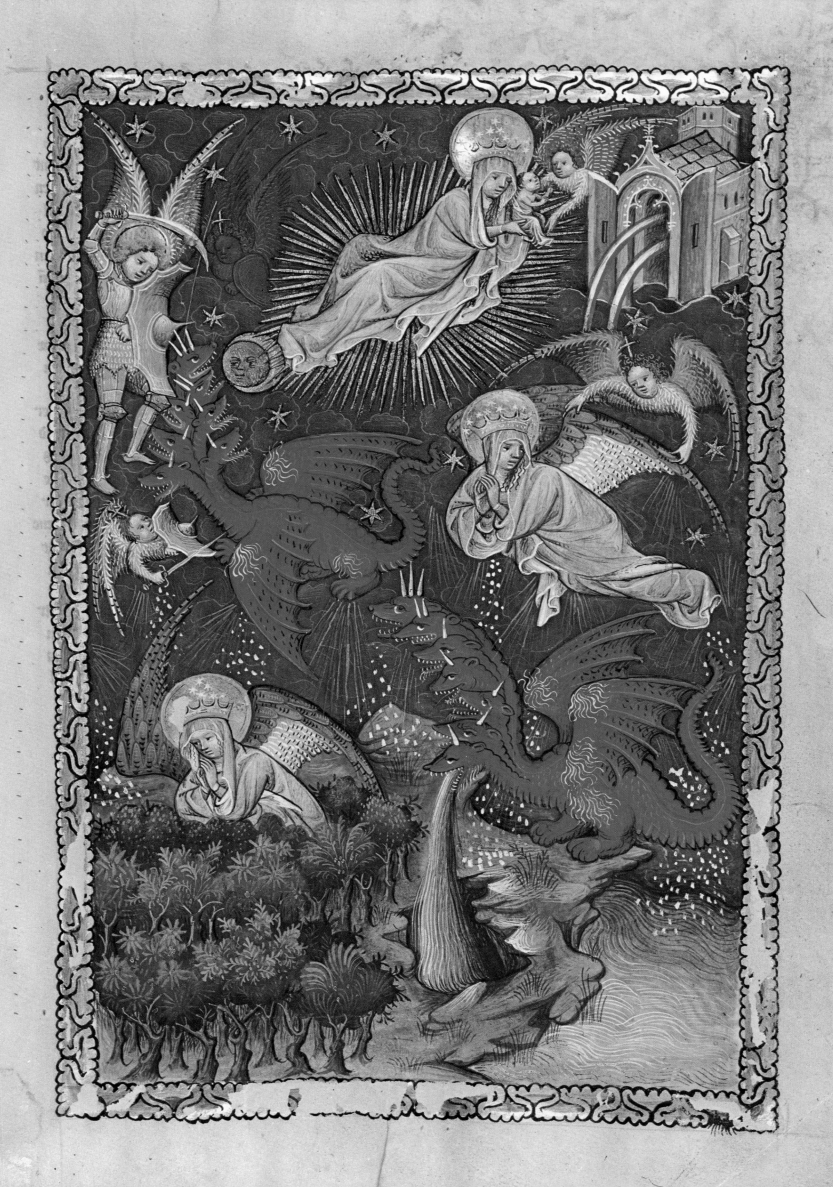

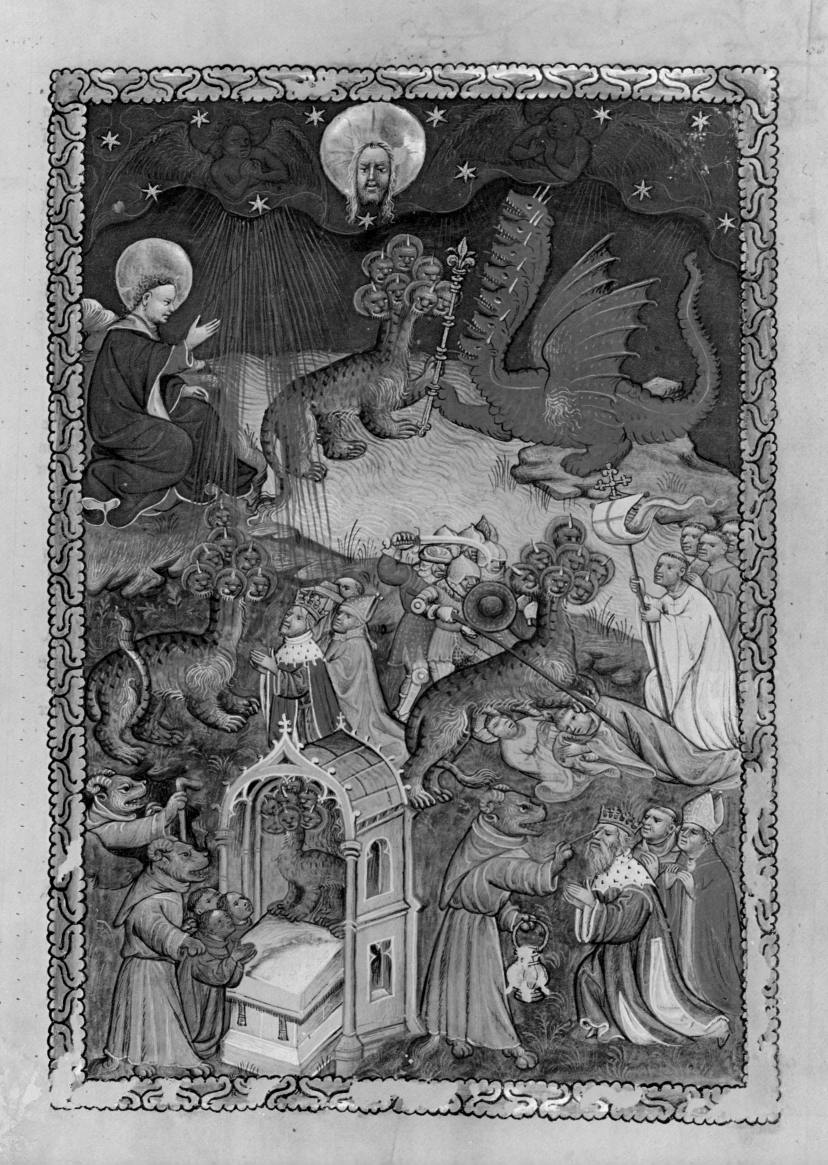

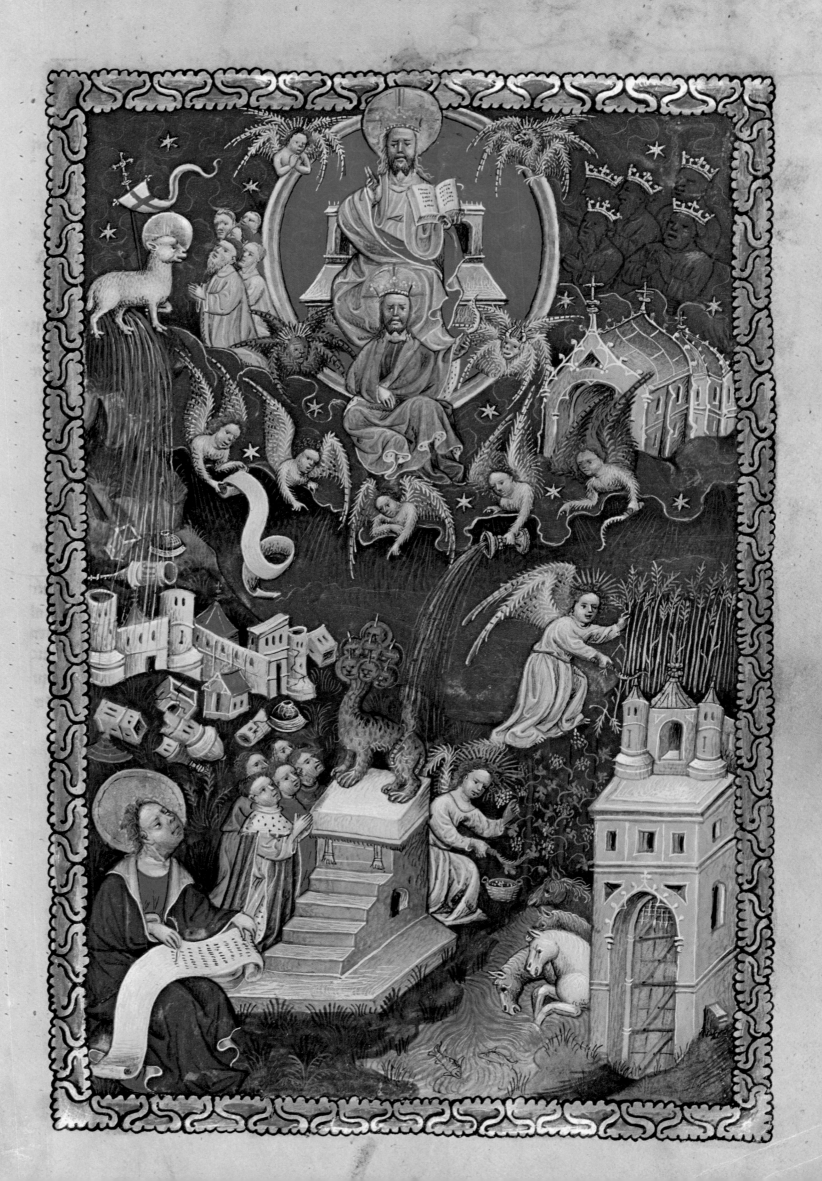

but nothing indicates that they are meant to be Elijah and Enoch. From the mouth of Christ, a head and shoulders high up in the sky, fire falls upon the Antichrist, a man attired as a cardinal but with a conical turban – a Jew's hat – on his head; not a particularly happy rendering of 'He shall consume him with the spirit of his mouth' (Thess. II: 2,8).

XII The Woman assailed by the Dragon is a splendid page. The Woman, in delicately shaded white robes, the twelve stars attached to the points of her crown, sits up in childbed and hands her Child to an angel; another angel is fitting a wing to her shoulder. Below, she is seen again, diving into a grove of dwarf trees, while the Dragon vomits its water, and Michael is harassing the heads of the top-heavy scarlet monster that flashes its teeth and has tufts of hair on its wings.

XIII The seven-headed Leopard-Beast (below the head of a slightly squinting Christ, hanging among the stars) has emerged from the sea and receives the sceptre from the scarlet Dragon 'standing upon the sand of the sea': a handsome diabolical duet. A king, a cardinal, a bishop and a layman adore the Leopard, which, enthroned on the Altar inside a gabled chapel (the Temple), is worshipped by commoner people led by the Beast from the earth. In older manuscripts this second Beast – which is the anti-Lamb, the False Prophet – used to be a bear with ram's horns. Here it wears a Franciscan frock, but without a cord. With a long staff he pencils the mark of the Beast on the foreheads of a bishop, a Mendicant, and an emperor recalling Sigismund (of the Council of Constance).

While the Beast tramples upon the saints, a procession of monks intrepidly defies it; the standard-bearer looks like a Cistercian, and so does one of the prostrate victims. We recall, involuntarily, the abbeys of Ter Duinen and Ter Doest in West Flanders. Fire falls from the sky: one of the bold feats of the Antichrist (Rev. XVIII: 13).

XIV The 'Lamb on Sion' seems to be what follows. Here, it is standing on a fiery stream threatening Babylon; a paltry group of only five people represent the one hundred and forty-four thousand. The 'everlasting Gospel' and the always very touching motif of the 'Blessed Dead who die in the Lord' are omitted. Instead, the Harvest is emphasized. While an angel pours out the 'wine of the wrath of God' on the Leopard and its worshippers, the Lord, holding the sickle and sitting at the feet of the Unnamed One in majesty, presides over the double Harvest of sickled corn and gathered grapes. But the painter has forgotten the white cloud, the blood flowing from the wine-press 'unto the horse bridles' and the bridles themselves.

XV A somewhat schematic orderly Liturgy occurs in the fol-

XV The vials of wrath distributed, and the cithara players standing on the Sea of crystal (Rev. XV). (152)

XVI *Overleaf:* The vials poured out, and the ensuing cataclusms (Rev. XVI). (153)

XVII *Overleaf:* The Judgment; Satan enchained; the Beloved City attacked, after a thousand years. (154)

224

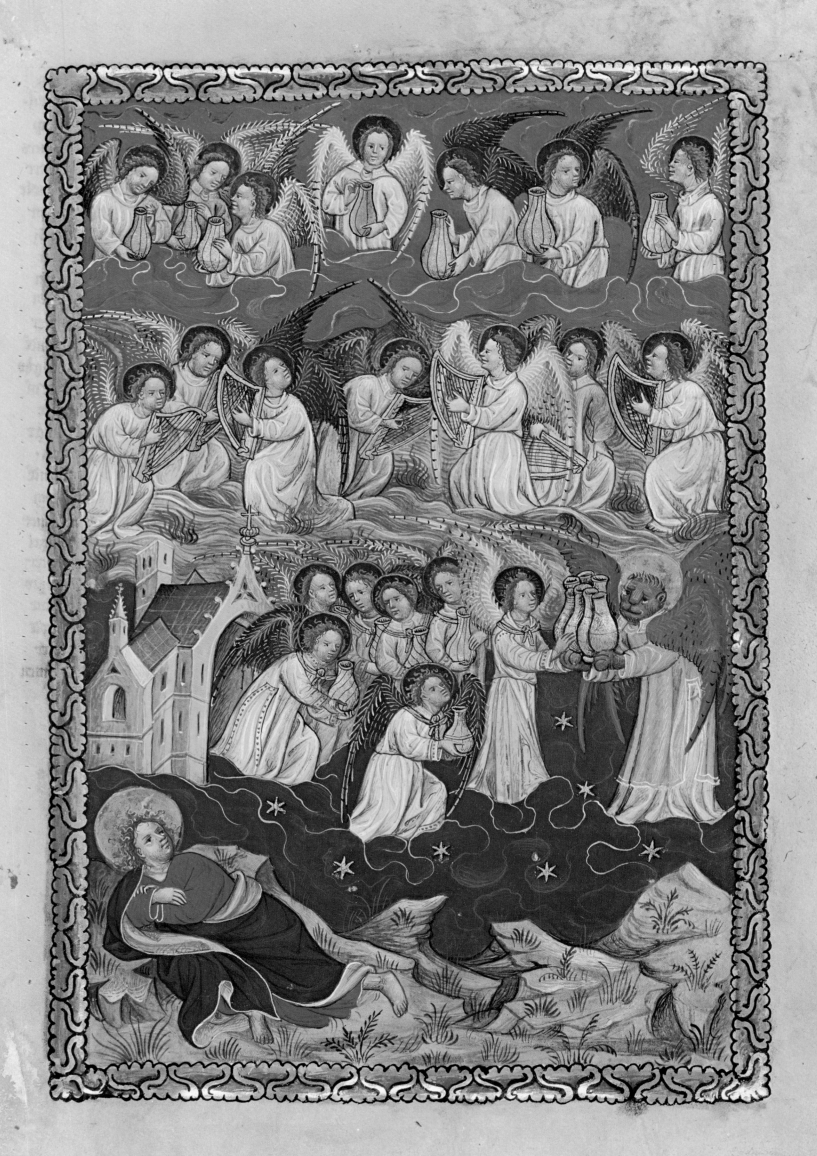

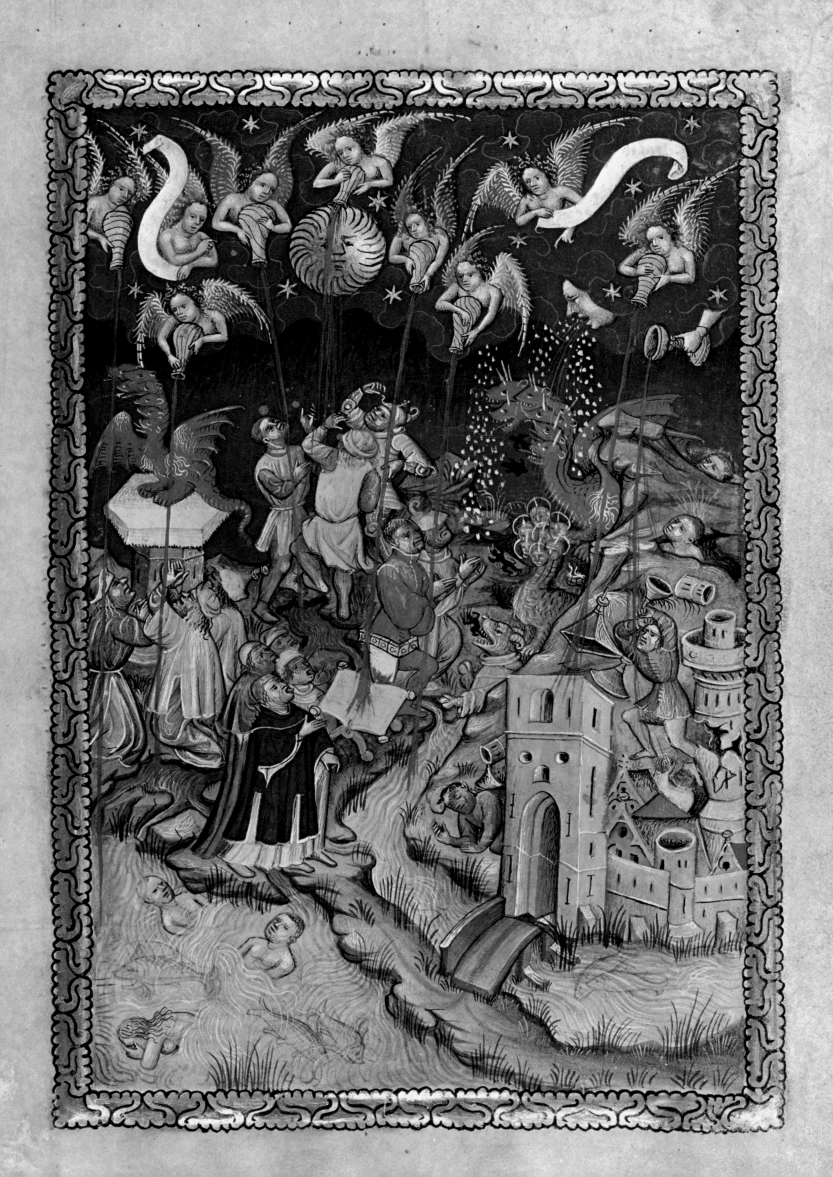

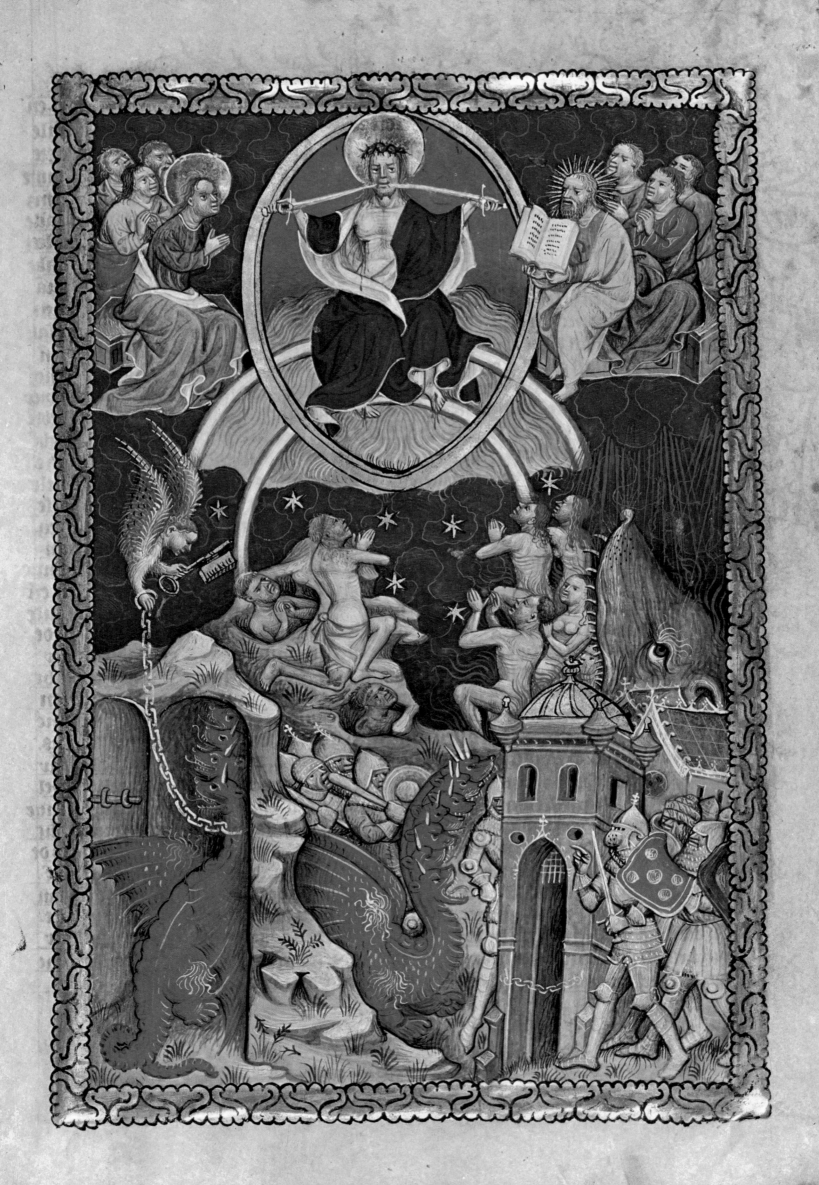

lowing picture. From a frieze of clouds, the seven angels emerge with their vials; in the zone below, seven harpers stand on the crystal Sea, interspersed with tufts of fire, and sing the great *Hallelujah;* in a third zone, the six-winged Lion wearing a deacon's dalmatic, distributes the vials to the seven angels; at the bottom, John, lying flat on the rocks, stares straight ahead.

153 **XVI The seven angels,** now suddenly naked, are pouring out the seven plagues. From the vials, long red jets hit the rivers, the sea, the earth, the sun and the Throne of the Beast, but very inaccurately. A strange head hanging in the sky is vomiting fire on the Dragon, among a shower of hailstones. The three monsters spit up their frogs; the worshippers of the Beast, who 'gnaw their tongues for pain', are grouped before a lectern with a gradual, and desperately stick out their swollen tongues (that's what comes from forging Beastly liturgies).

154 **XVII The Judgment,** the siege of the Beloved City and the locking up of the Dragon, seen together on one page, continue the story. The Judge holds two swords coming out of his mouth: one of them evidently the misunderstood lily of contemporary Last Judgments. Another corruption is the crown of thorns round the head of Christ. That John the Evangelist takes the place of the Virgin and faces the Baptist, is far from normal and probably an error.

155 **XVIII The Heavenly City comes too early,** for it belongs to chapter twenty-one, again a proof of negligence. The Lord, holding the globe, appears with an angel holding the measuring-rod and a vial; the four Beings – merely heads between six flaky wings – crown the corner-turrets of the City; twelve angels, standing in doorways adorned with flamboyant tracery, surround a Lamb set on an Altar and turning its head under a cross-banner – not a very prepossessing ensemble. An emperor and three kings, dressed after the fashion of 1400, are bringing gifts: a chalice, a ciborium and a tower-reliquary (Rev. XXI: 24).

156 **XIX An angel, with a jewelled cross** on his diadem, shows John the Great Prostitute on the Beast. The monster puts its paws 'on the many waters'; little black serpents are crawling out of the woman's 'cup of abominations'; instead of being scarlet, her robe is of white silk embroidered with twigs, double-girdled and low-necked; her depilated forehead and crown-cap (with cheek-flaps) are exactly those of queen Jeanne, after the fashion of the years 1370-80.

One remarkable detail deserves attention. The heavily horned Lamb hands a Crusader's banner to two armoured princes: they are two of the 'ten horns', that is, 'kings', who in the end turn against the Seductress (Rev. XVII: 12 and 16). Below, one sees how the other eight princes are driving the now stripped and screaming courtesan

XVIII The angel with the rod showing John the Heavenly City, to which the kings are carrying gifts (Rev. XXI). (155)

XIX *Overleaf:* the angel showing the Scarlet Woman seated on the Beast, and the 'many waters'; the kings are driving her into the pool of fire (Rev. XXIII). (156)

XX *Overleaf:* the millstone thrown into the sea; the angel summoning the birds of prey; the downfall of Babylon (Rev. XIX and XX). (157)

228

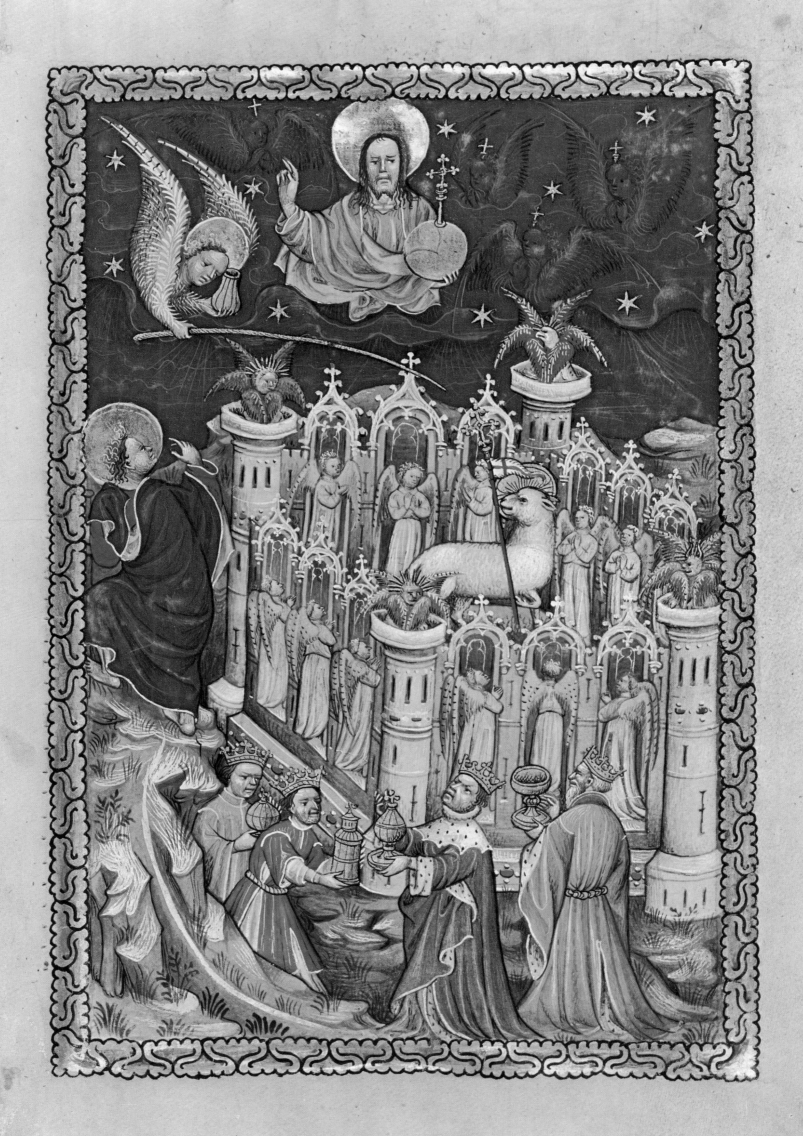

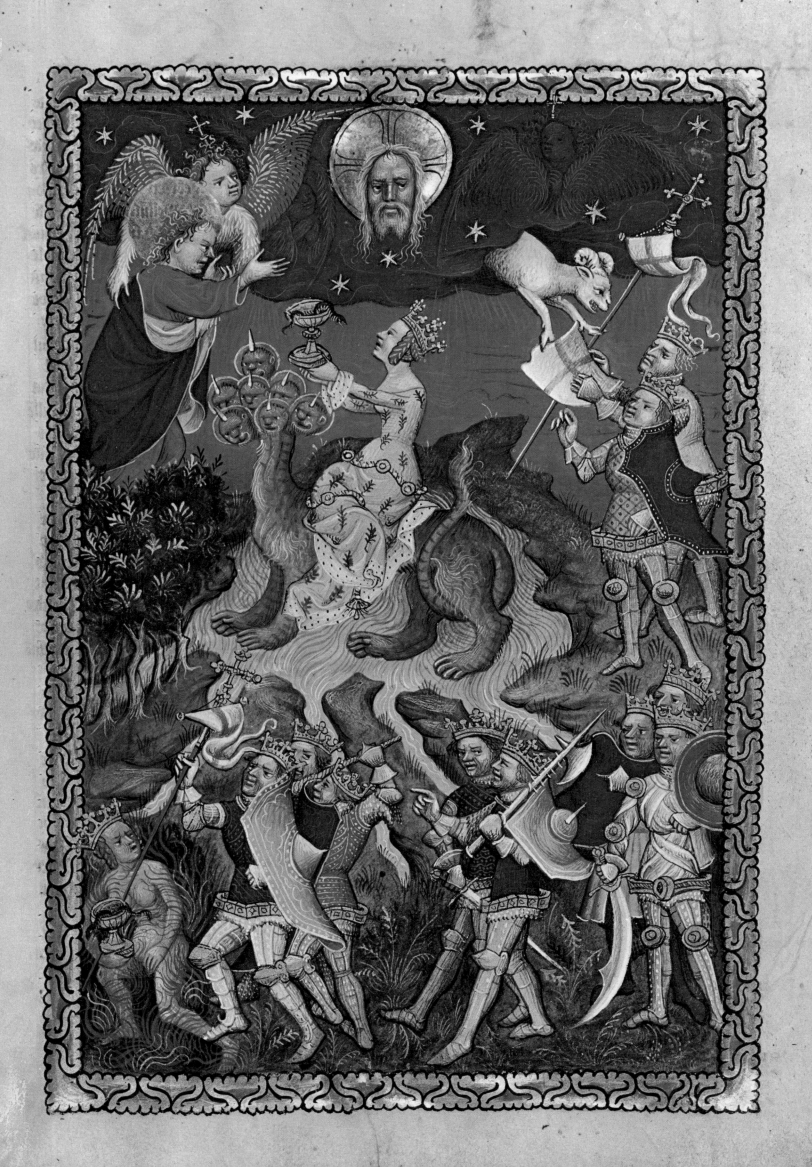

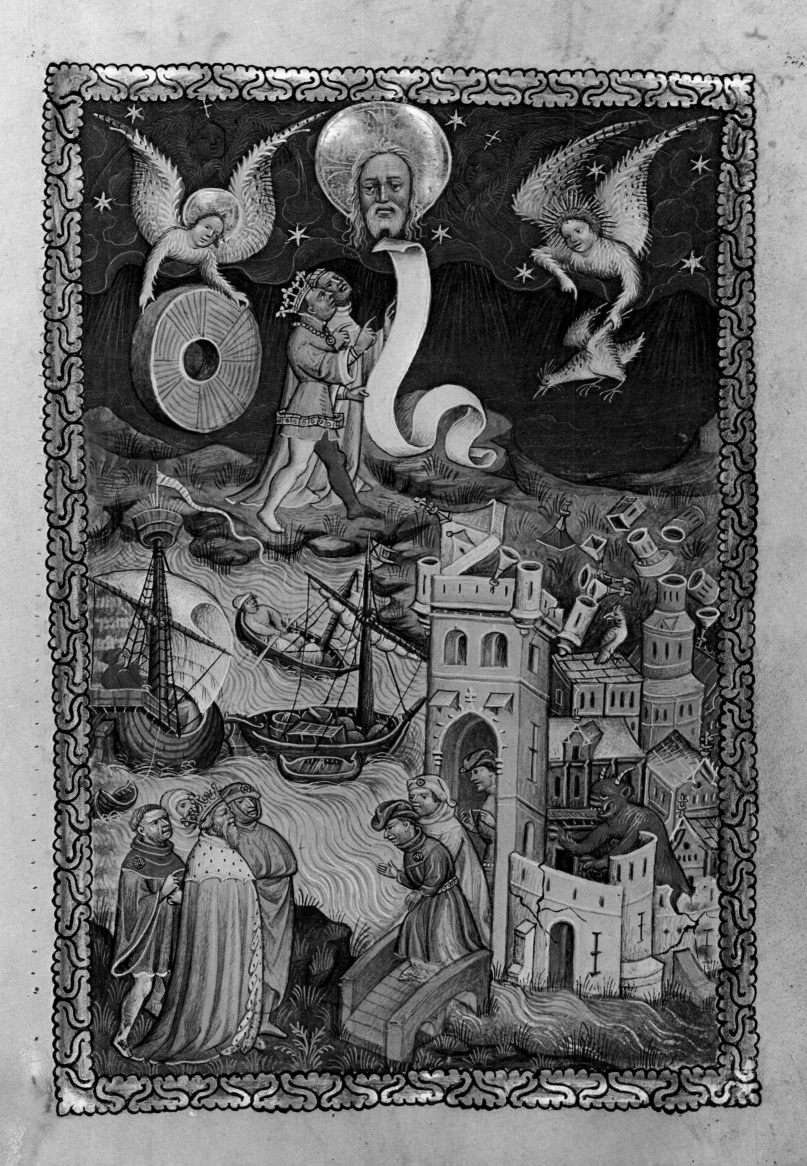

with their Cross-banner into the pool of brimstone and fire. (In the Flemish version the *decem cornua* (Rev. XVII: 16) have become 'ten kings.') This looks like a tribute paid to the Christian princes of the day, and no wonder: their battle against the Great Turk, pathetically appropriate after the disaster of the Crusaders' Army at Nicopolis (Bulgaria) in 1396, was still on everybody's mind.

157 **XX** **The good people,** on the next page, who escape in good time from the doomed city of Babylon, are great lords, courteously received by a German emperor. Near the sea into which the millstone is thrown, a king (in tight trousers with one red and one white leg) and a duke (dressed in white satin) are looking up at Christ's lonely face in the sky. An angel holds a bird of prey by its wing, but we do not see any vultures pecking at the eyes of fallen kings. In this manuscript princes play the fair part.

158 **XXI** **In the scene of the Marriage,** a dull Lamb stands on the table-cloth, in front of an impassive Bride sitting behind the table. No trace is left of the idyll seen in earlier manuscripts. The other motifs – the angel in the sun summoning the birds; the flaming eyes and the blood-spattered robe of the Rider on the white horse; the Beasts swallowed up by an enormous mouth of hell – are mere variations of the standard types.

159 **XXII** **The Lamb joyfully leaps** onto the throne of a very youthful Lord, in the final picture, before the eyes of John looking on from a mountain. Below, as John is about to fall down before the guiding angel, the angel says: 'See thou do it not, I am only the fellow servant! Worship God!', while the River of Life rushes down from the Throne, along a double row of fruit-trees.

Clearly the painters' chief interest was not iconographical; too many familiar details have been handled carelessly. There are striking omissions; and splendid motifs, such as the Great Multitude, are poorly handled. After all, the traditional ninety episodes had to be compressed into twenty-two compositions, and the result, although not entirely satisfactory, signifies a definitive break with the monotonous succession of episodes peculiar to former *Apocalypses,* and is a step in the direction of Dürer.

We are no longer in the south of England, nor in Paris, Angers, Moulins or even Mehun-sur-Yèvre: we are in Flanders (or, as others think, near the Meuse Valley). You can tell by the churches, the stepped gables and the belfries; by the rustic faces and the pleasant coarseness of the narrative. There is no real evidence that the chief painter knew the work of that strange genius, the master of the *Rohan Hours,* or an early work of the three Limburg Brothers. He followed his own devices, and his aides, unable to cope with his more refined tricks, at least faithfully copied his colour schemes.

XXI The Marriage of the Lamb; the Rider Faithful and True and his heavenly host; the downfall of the Beasts (Rev. XX). (158)

232

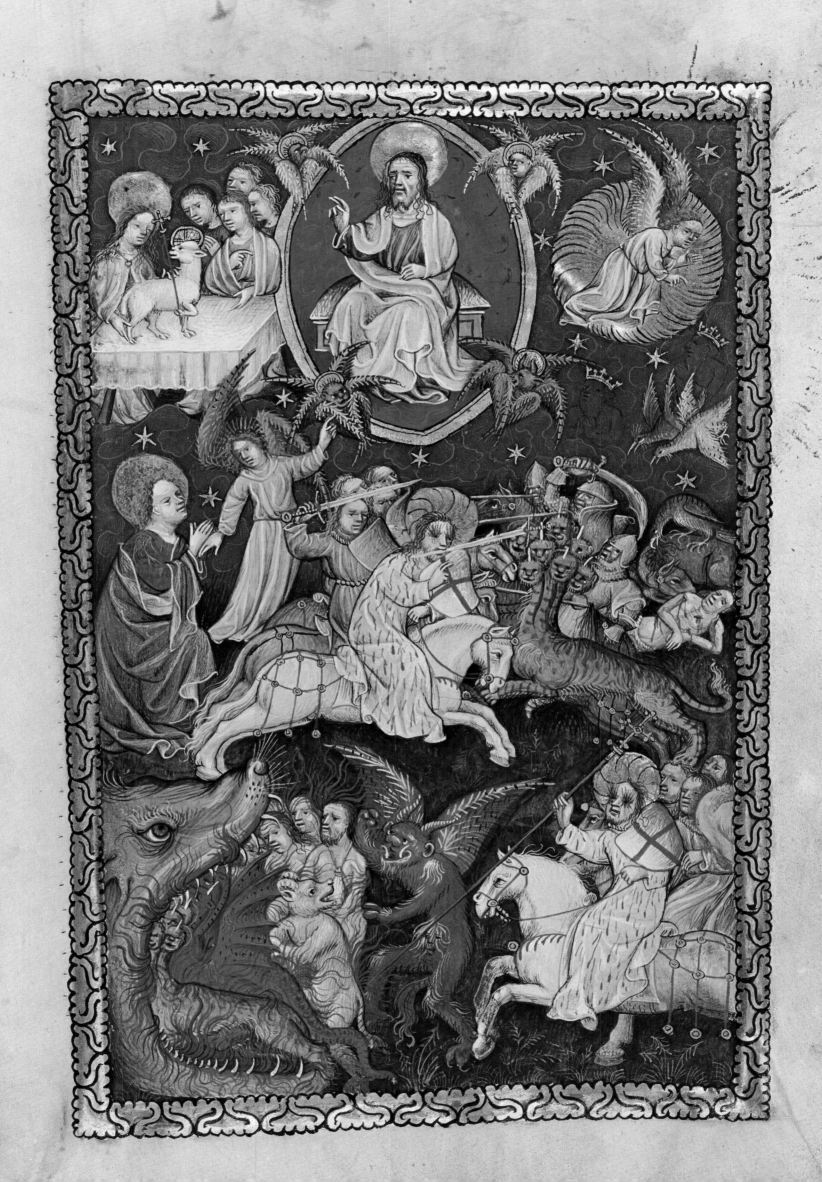

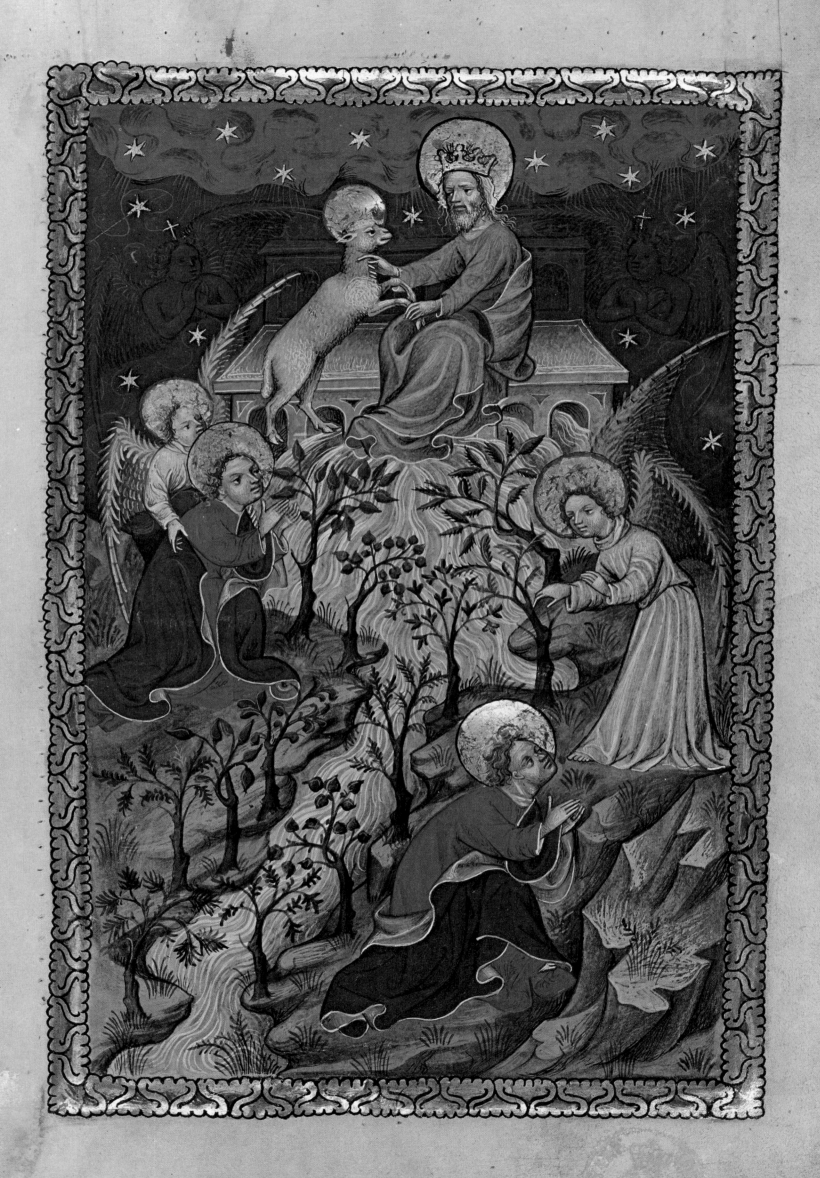

No other miniaturist has so strikingly rearranged the standard episodes of the past into collective pictures, using such bright colours, as has the creator of this first Netherlandish Apocalypse, which is in many respects incomparable. For the first time the macabre carcasses, the pitiful nudes, the flamboyant buildings, the still small but real trees and lawns, and the gaudy attire of the later Middle Ages enter the scene of that least trivial of books, the Revelation of St John.

Apart from the first picture, the faces very seldom show any intensity of feeling, and nowhere do they show the affected courtliness or the haughty expressions one notices in the miniatures made for the great lords, by artists like Jacquemart de Hesdin, or the Bruges master Jan Bondol, court painter of Charles V of France. Here and there one might catch a glimpse of the quiet devotion and pious attention revealed in the contemporary writings of those inconvertibly Netherlandish contemplatives, the creators of the *Devotio moderna*.

The *Paris Apocalypse* is also the first Netherlandish picture-book. The painters aimed at a gorgeous display of colour and gold, and as many picturesque trivialities as possible, under the pretext of literal illustration, far more than at the transmission of the deadly serious apocalyptic message.

It seems almost symbolic that they forgot the lighted candles on *138* the seven candlesticks. They are splendidly chased altar-candlesticks of shining gold; but they are unlit, they are on parade. Here, as shortly afterwards in the great pictures of Van Eyck, ordinary and even humdrum things are used for the staging of very sacrosanct realities.

In this Apocalypse, the pleasure of making the most of a brilliant and exciting story has nearly eliminated the wonder and awe inevitably instilled into the mind of any reader by the text of the Prophecy.

XXII The River of Life; John rebuked
by the angel (Rev. XXII). (159)

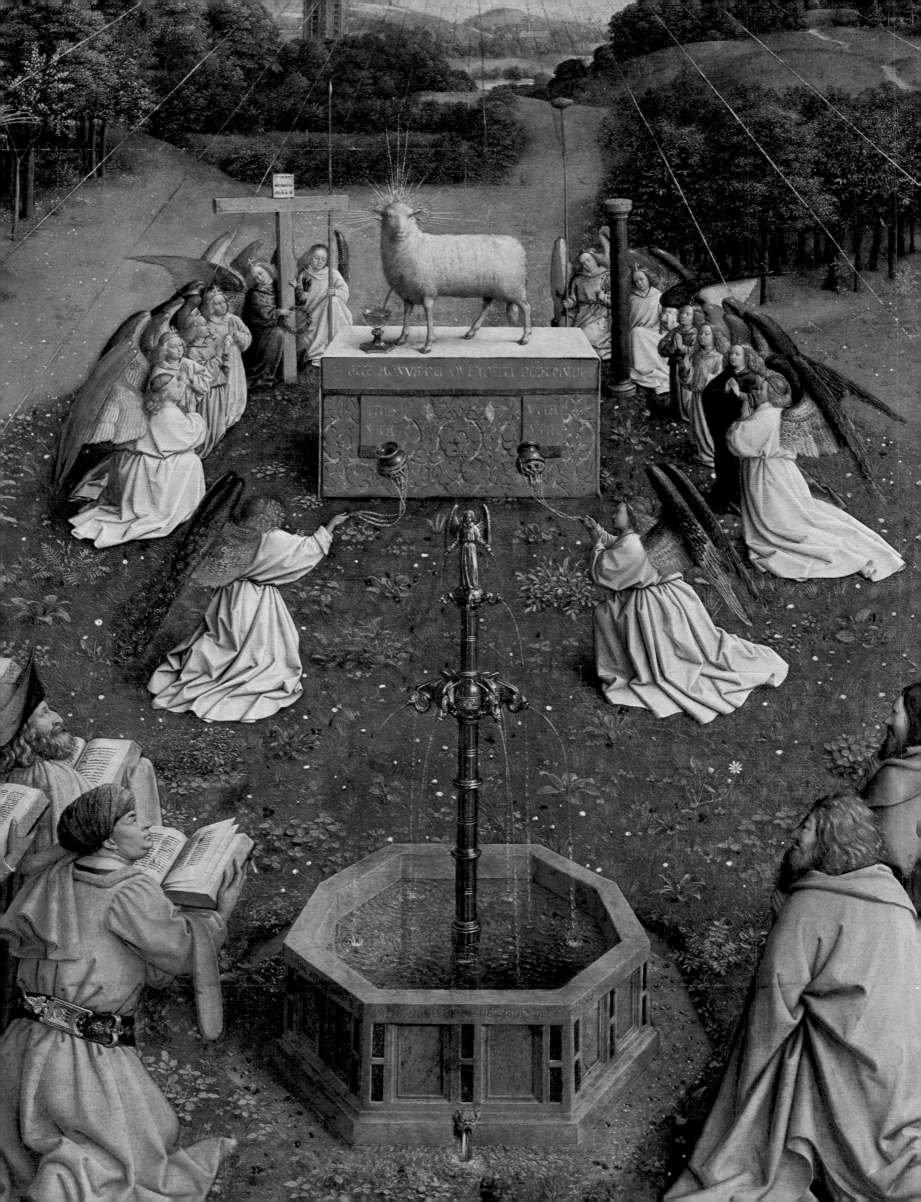

Jan van Eyck

THE POLYPTYCH OF THE LAMB

The magnificence of the *Adoration of the Lamb* in St Bavo's at Ghent invariably renders every visitor speechless. As the huge wings on the polyptych are slowly opened, the natural human reaction to this masterpiece is awed silence. Indescribable beauty is completely over-powering; one cannot stand it for long, but it rouses an unquenchable thirst to repeat this almost intolerable experience of helpless joy and inexplicable rapture. It is like the elevation felt at the acme of a solemn Mass sung in a high, packed church, a feeling that makes one breathless with unearthly and unspeakable delight.

The thoughts evoked by the spectacle can hardly be defined, neither by a peasant from a Flemish village nor by an expert like Albrecht Dürer himself, whose trained eyes saw a hundredfold more, but who is said to have remained completely silent and finally kissed the frame.

In a way, the iconography seems secondary, it only rouses side reflections, second thoughts. The masterpiece edifies without requir-ing any intellectual effort: we are profoundly happy that it exists, and there it ends.

It is also unthinkable that anything might be changed. It is un-touchable, not only because there is no trace of the making, of a trick explaining the amazing effect in which the maker has chastely covered the strokes of his brushes; but because the ensemble is so smooth and perfect that one thinks: this was not made by an ordinary man, this is a miracle.

It does not matter that the groups are stiff, the attitudes wooden; the horizon unnaturally high; the faces of the kneeling Apostles almost grotesque; the prelates well-fed, often ugly, dignified but absent-minded; that the slouch-hats, hoods, pointed caps and turbans of the exotic personages are as absurd as fashionable dress and fancy clothes always are. If hardly matters that here and there the embroi-dered *parurae* of amices and albs, the orphreys of the copes, dalmatics and episcopal chasubles are so tightly studded with pearls and gems that one suspects the master of having availed himself of every oppor-tunity of displaying deceivingly true imitations of all this glitter. The same applies to the amethysts of the processional crosses, the exces-sively chased croziers, the cabbalistic signs on head-dresses.

Detail of the central panel of the Ghent altarpiece. The Adoration of the Lamb. By Jan van Eyck; before 1432, St Bavo's Cathedral, Ghent. (160)

237

It is not to its detriment that when looking at the linen albs of the angels one immediately thinks how well starched they are and how nicely ironed; that the Lamb of God looks like a plump sheep standing sullenly on a wayside altar, while Blood is still trickling from his scarlet side-wound into a prosaic chalice.

Everything in this glorious show is rendered soberly and precisely, after having been observed by a cool, pitiless eye that neither distorts nor beautifies – an eye like that of Hans Holbein the younger, a century later. To the enchanted eyes of the Flemish peasants who are packed between the wall and the entrance screen of the narrow chapel (where the retable cannot even be opened properly in a straight line) there appears, in the faces of the Great Multitude filling the lower panels, an expression that is far less intense: rather one of repressed boredom; something like the perfunctory respect mingled with a slight impatience, felt by almost anyone attending a prolonged liturgical service.

THE CHIEF PANEL

165 Indeed, the landscape filling the lower central panel can best be described as a botanical garden situated in Fairyland, in the midst of which an open space, occupied by a lush meadow full of daisies, ranunculi and lilies of the valley, serves as a liturgical processional park.

From four sides, out of flowering groves, four cortèges enter the close and stop at a certain distance from an Altar set up in the midst of it, one of those open-air Altars that always look make-shift and bare. On it, instead of a monstrance or a reliquary, stands the Lamb of God: a vacant-looking, full-grown sheep, mechanically in-
160 censed by two kneeling and highly-trained acolytes (swinging a censer in a graceful upbeat demands great skill from a boy kneeling in a starched alb). The acolytes, ordinary boy servers with shocks of thick frizzed hair, are angels, one of whom has wings of peacock feathers. Eight others kneel round the Altar with their hands stiffly joined, as drilled acolytes will do when they are very young and a bit afraid – those delicate hands that are one of the distinctive marks of Van Eyck's figures. Four adolescent angels hold the crown of thorns, the lance, the reed with the sponge and the flagellation column, clearly copied from the ordinary stage properties of a Passion Play.

The processions have just come to a standstill, the foremost is already on its knees, on either side of a fountain: the apocalyptic
160 Fountain of Life. It is an octogonal marble basin into which eight little dragons, mounted on a copper pillar, spout tiny jets of water – a fountain similar to those in contemporary abbey quadrangles, complete with a sandy pebbled path across the lawn.

No word is spoken, no whisper heard, the singing has not yet begun; there is no sound but the tinkling of the censer chains; it is the strange moment of silence before the *Tantum ergo*. Only a

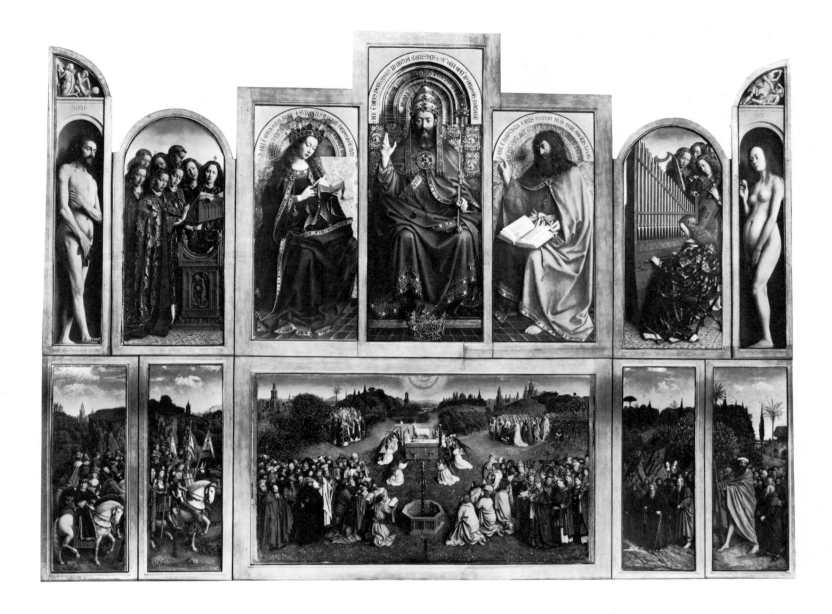

The Ghent altarpiece opened. Below: the Militia of Christ, the Great Multitude, the Anchorites and the Pilgrims. Above: the Anonymous One on the Throne, the Virgin, the Baptist, Adam and Eve, angels playing, singing and listening. On top: Cain and Abel. (161)

few of the assembled saints are looking at the Lamb; one of them, a tense, curly-haired youth with a pointed nose, is John. The others each look down into a book of Hours, or over it, or sideways, or at the grass at their feet, or nowhere; some stare ahead or peep through the rows of mitres and hats. In a fat prelate's face one bored eye vaguely fixes a possible onlooker. Most are lost in thought and, I think, waiting for things to come, peacefully and decently but not too attentively. They know everything by heart, they have been through so many celestial liturgies. The most devout are the Virgins, a group of fair maidens, all bowing coquettish heads under diadems or wreaths and a weight of neatly combed and fluffed hair: a group of local beauties in state.

In short, what we see is exactly what the eagle-eyed Jan van Eyck could observe about him during a brilliantly conducted open-air ceremony, although never at one time would he have seen six popes, two cardinals, nineteen bishops and at least two throne-deacons — not in Flanders nor at the courts of Dijon or Lisbon.

And yet nobody is scandalized when looking at this ostentatious ceremony, this prosaic and coldly recorded ritual, perhaps the crudest evocation of late medieval ecclesiastical pomp in the history of art. On the contrary, everybody is deeply edified. What we see is a cruelly authentic but at the same time mysteriously enhanced reality, such as had never been seen before. Because, all this flaming vermilion, all this dark-blue, all this brocade and clean white linen standing out against the soft green of the grass and the brown of the thick wood, where silhouettes of palm-trees, cypresses and even parasol-pines are outlined against a bright sky turning to azure, and this infinitely distant horizon beset with improbable, towering ornate buildings – all this is bathed in an invisible and yet perceptible after-noon light, symbolized by the halo at the top, a sort of unearthly sun, from which long thin golden rays shoot down on to the silent groups in the park. We are no longer in an earthly but in a new, heavenly Paradise: a *Paradise regained*.

THE FOUR SIDE-PANELS

163,164 On the side-panels four groups are seen riding and walking towards the processional park; those on horseback from the left, those on foot from the right. The mounted cavaliers are great lords, perhaps princes, one has only to look at the caparisons and the jewelled harnesses of the horses; foremost are three young armoured knights holding banners. The pedestrians are anchorites and hermits, coming out of a ravine and followed by two holy women. The last group is one of simple pilgrims, walking on a Flemish country road.

Three of the groups are riding and marching along fantastically overgrown rocks, on a hollow road strewn with boulders and stones. There can be no doubt that the late-comers belong to the multitude already assembled on the celestial lawn, for the same landscape fills the background of all the five panels, with the same bluish horizon, the same trees and the same bizarre buildings; only at the extreme right does it give way to a view of ordinary hilly country. Evidently the five panels are meant as one composition, and its centre is the Lamb, after whom the whole polyptych is traditionally and rightly named.

THE SEVEN UPPER PANELS

As for the seven upper panels, until now nobody has been able to explain their connection with the scene below in a satisfactory way. *166,167* In the middle panel the Lord is enthroned between the seated Virgin and the Baptist, but this famous group is no traditional *deisis*, for neither saint kneels nor stands in the attitude of the 'last Interces-sion', but the Virgin is quietly reading her Hours and St John seems to be arguing from a book held on his lap. Why the still more famous groups of the singing and playing angels and the pathetic nudes of

The two wings of the Ghent altarpiece closed. Above: two prophets and two Sibyls; centre: the Annunciation; below: the two Johns and the donors. (162)

Adam and Eve accompany the Adoration of the Lamb, is a riddle; and, as everyone knows, the iconographical context of the whole remains an enigma after a century of controversy and, sometimes, plain quarrelling.

The argument involves a double question. First: who is the author of the whole? One master, or two? Conjointly or in succession? What is Jan van Eyck's and what is Hubert's? Second: is there any intrinsic connection between the upper and lower row, and any connection at all between this two-storeyed front side and the outside, where an Annunciation surmounts the portraits of the donors, burgomaster Josse Vyd and his wife Isabel Borluut, and the two Johns, painted in grisaille? 162

There is no use in summing up the various hypothetical solutions, for not one is convincing. Besides, the Hubert affair goes back to a quatrain discovered on the lower part of the frame, already known in 1621 but which vanished subsequently, in which Hubert is called the chief master and Jan his subordinate; an obscure stanza, where the date of May 6th, 1432, is also mentioned (the feast of St John before the Latin Gate). It might be a local forgery, meant to advance the Ghent Hubert at the expense of the Bruges Jan. It is true that even a moderately skilled eye sees at once that the enormous work is not entirely homogeneous. There may have been phases and interruptions, but even the contrast of somewhat archaic parts with more advanced and accomplished ones does not necessarily imply the existence of two masters. Hubert is no more than a name, Jan an overwhelming and well-known master. I think we might leave the dark to itself and forget Hubert, if he ever existed. For nobody can be equal to Jan van Eyck.

THE SUBJECT: ALL SAINTS, IN THE LAMB'S PARADISE

Because this book deals with the Apocalypse we can, apart from a few allusions in the central Triad, ignore the disparate personages of the upper row and confine ourselves to the analysis of that most august of miniatures, the quinquepartite *Adoration of the Lamb;* a miniature that is gigantic in scope, the central panel of which alone measures 1.38 by 2.43 m, a width never found in contemporary altarpieces.

What is the subject of the five panels taken together? Iconographical significance, although it does not affect the formal beauties of a masterpiece, enhances, rather than impairs, their splendour by revealing the invisible realities to which they owe their existence. 'The art of making people see what they do not see and yet is visible and even impossible not to see... as soon as it is shown in a visible form, that art is the best part played by human intelligence' (Valéry, 1915).

Thus Van Eyck revealed a thousand realities hitherto unobserved, or at least never perceived by such a penetrating eye and visualized

in such an accomplished way. The universe he evokes contains the grandiose as well as the minute. He dwells on the capricious shape of a block of stone, on a creeping dwarf palm he must have seen in Portugal (the *chamaerops humilis,* the only wild palm in Europe), but at the same time he puts the whole of this terrestrial magnificence into the service of the Unseen One and of the Powers Incorporeal. His mirror is so large that it reflects a landscape from the blades of grass at our feet up to an immense horizon; so perfect, that we need a magnifying glass in order to verify what is mirrored in the eye of a horse or in the buckle of a cope; so subtle, that we fancy we see the quiet light of a Sunday afternoon in summer. When asked to paint a mystery of the Faith, he did it in his own way, not by imagining anything abstract but by clothing an almost indefinitely multiplied wealth of phenomena in a light that has nothing magical but that seems supernatural, and has remained his painter's secret.

The subject of the five panels has been taken from the liturgy of All Saints' Day, well established as a major feast long before the fifteenth century. Its main theme is strikingly summed up by the words of the first Vesper anthem, sung to a tune not unlike a blast of trumpets: *vidi turbam magnam,* 'I beheld, and lo, a great multitude, which no man could number, of all nations, and kindreds, and tongues, stood before the Throne and before the Lamb, clothed with white robes, and palms in their hands' (Rev. VII: 9). The anthem gives only the first words, but the text is quoted in full in the epistle of the Mass (Rev. VII: 2-12).

We see the palm branches in the hands of the Confessors and the Virgins, the two groups in the background. The Altar is the Throne; the Lamb is standing on it 'as it had been slain' and 'in the midst of the Throne' (Rev. V: 6). The Blood of the Lamb flowing into the chalice not only recalls the prophecy of Isaiah and the sacrifice of the Eucharist but also another apocalyptic vision: 'And I looked, and lo, a Lamb stood on the mount Sion, and with him a hundred forty and four thousand, having his name and his Father's name written on their foreheads' (Rev. XIV: 1); and 'These are they which came out of the great tribulation and have washed their robes, and made them white in the blood of the Lamb. Therefore are they before the throne of God, and serve him day and night in his temple… they shall hunger no more, neither thirst any more, neither shall the sun light on them nor any heat, for the Lamb which is in the midst of the throne shall feed them and shall lead them unto living fountains of waters…' (Rev. VII: 14-17).

In the last chapter of the Apocalypse the Water of Life is 'proceeding out of the throne of God and of the Lamb' (Rev. XXII: 1); it is a river flowing between the trees of life 'yielding fruit every month', and of which the leaves are 'for the healing of the nations (Rev. XXII: 2); in that Heavenly City no sun is needed, for 'the Lamb is the light thereof' (Rev. XXI: 23).

Much of all this, subtly combined, or at least hinted at, can be

seen in the central panel. What was meant, clearly appears from the inscription carved in thin Gothic minuscules on the outer border of the fountain in the foreground:

hic est fons aqve vite procedens de sede dei et agni

This is the Fountain of the Water of Life proceeding out of the throne of God and of the Lamb (Rev. XXII: 1; VII: 14-17).

The ever-blossoming trees appear behind the Great Multitude – the whole scene is a Paradise. It is not by accident that twice four jets of water flow down from the Fountain's mouths. They evidently allude to the four rivers of Eden mentioned in Genesis (II: 10-14), those rivers that sprang from the mountain of Paradise, that is, Mount Sion, which had already been represented in the mosaics of ancient Rome a thousand years before, and which were still visible in 1430. We recognize immediately the 'Great Multitude, standing before the Throne of the Lamb' (a motif in those days familiar to almost everyone through the epistle of All Saints' Day), and the Fountain of Life standing in the middle of Paradise.

The fact that Jan van Eyck embellished his Paradise with all the shrubs and trees of his native country and those he had seen in Portugal, and did not forget the everlasting blossoms and fruits, proves that he had in mind the Garden of Eden as well as the celestial landscape described in the last chapters of the Apocalypse. In imagining all those walls, roofs, towers, keeps and temples standing out against a distant horizon, he might have in mind the vision of the Heavenly Jerusalem. Of course, local patriots could not help seeing real monuments in those fancy buildings: such as the steeple of Our Lady at Bruges (above the crisp groves to the left of the Virgins) and, next to it, the high chancel of the unfinished cathedral of Cologne, and even, to the right, the cathedral of Mayence. The massive towers of the side-panels made others dream of Ely and Durham, places the painter had never seen. At the most, the huge domed rotunda looming behind the Confessors might be a fantasy on the theme of the Holy Sepulchre in Jerusalem (always mistaken for the silhouette of the Omar Mosque). As for the tower of Utrecht, immediately above the Lamb, an x-ray examination has shown it to be an addition, probably due to Jan van Scorel, a Utrecht canon, who in 1550, together with Lancelot Blondeel, was commissioned to restore the famous retable. As a whole, this architectonic display is meant as an allusion, by means of terrestrial monuments, to the towered celestial City described by St John.

All Saints' Day, November 1st, had been a solemn feast-day since at least the ninth century. From Carolingian times onwards, as we have see above, the Great Multitude surrounding the Lamb was pictured in miniatures accompanying the lessons of the day in the lectionaries; we regularly see the wounded Lamb, its Blood flowing into a chalice and the saints assembled in well ordered groups. So far

Overleaf: the two left wings of the Ghent altarpiece: the Militia of Christ. (163)

Overleaf: the two right wings of the Ghent altarpiece: the Anchorites and the Pilgrims. (164)

48

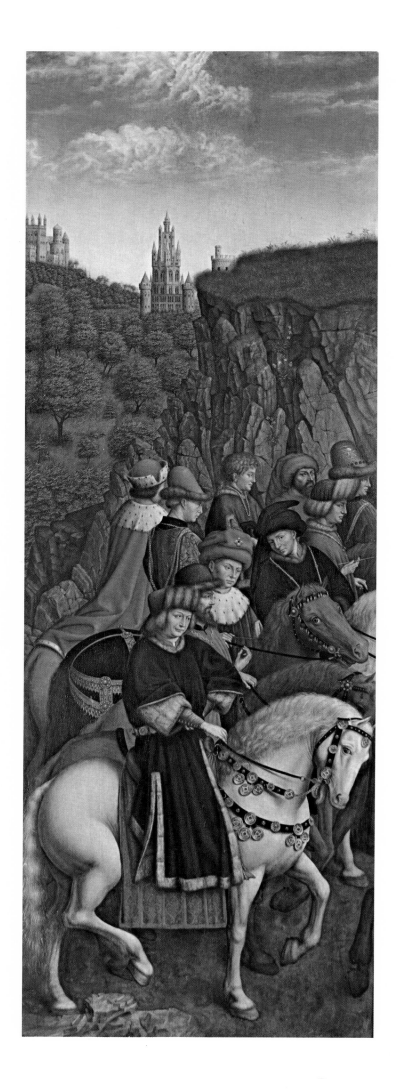
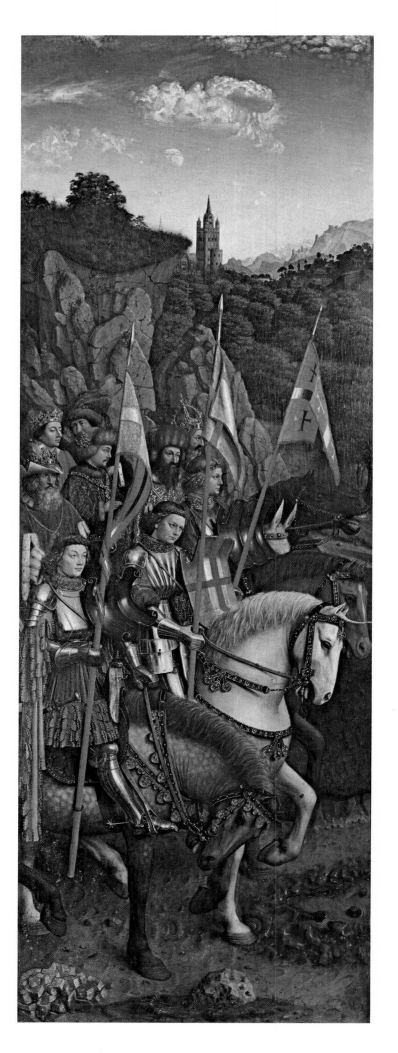

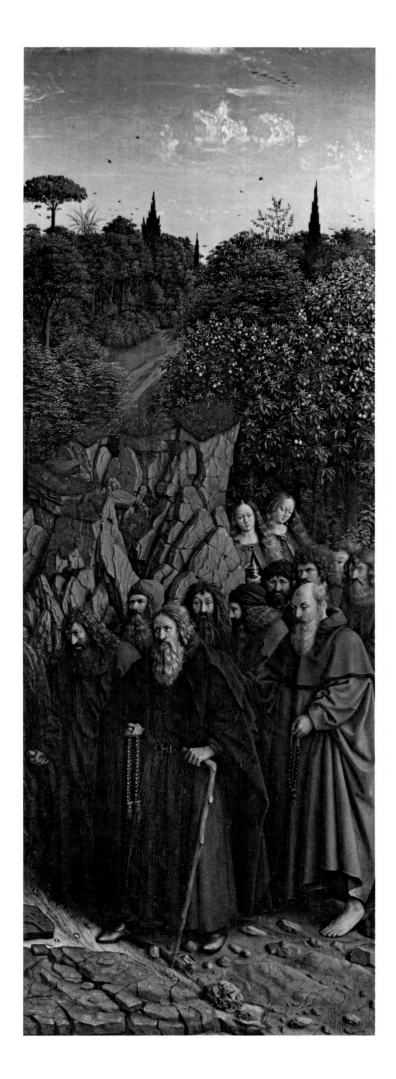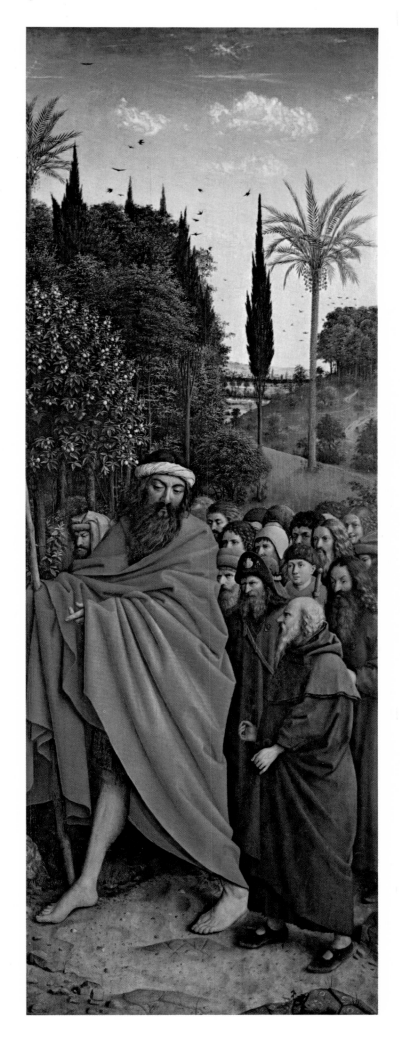

Jan van Eyck's composition can be said to be wholly traditional.

In his grouping of the saints, the number of twelve, root of the 'one hundred and forty-four thousand sealed Elect', seems to play no part; we look in vain for the crowned Elders and the four Beings – always the central characters of the Heavenly Liturgy, but not mentioned in the office of All Saints' Day; and search for the white robes. Only the Confessors and the Virgins are holding palms, here the usual long branches still distributed in Mediterranean countries on Palm Sunday. The saints are disposed according to the pattern established in all the anthems, hymns and sequences of All Saints' Day, in which the Virgin comes first, and this might be the reason why, afterwards, she was represented on one of the upper panels.

The angels follow, grouped into the Nine Orders, all of them mentioned in the anthem at the *Magnificat*. A playful mind might seize upon this for an explanation of the angels on two upper panels, who are seen singing a motet and listening to an organ recital, occupations well becoming heavenly worshippers.

Of the saints, the martyrs always come first. The veneration of saints originated from the cult of the martyrs, the most ancient and strongest special cult of Early Christianity. In the hymn of All Saints' Day they are called *purpurati martyres*. Consequently, we see them (below, on the right) all arrayed in scarlet copes, chasubles and dalmatics (we cannot see what the lay martyrs, who stand at the rear, are wearing).

Then follow the Confessors (on the central panel, top left); the Anchorites and Hermits, the Fathers of the Desert (on the first side-panel, on the right); finally, the Virgins, here standing near a bed of lilies (upper right). 'Among the flowers of the Church neither the roses nor the lilies are lacking', says the Venerable Bede in a homily read during Matins of All Saints' Day; and by the roses he meant the 'purpled martyrs' and the lilies the Confessors and Virgins, the heroes of continence.

In the same homily, anticipating John Bunyan, Bede also mentions the 'Soldiers of Christ'. In the Heavenly City, he says, both Peace and Phalanx are furnishing flowers for the Soldiers of Christ! This might have led to the presence of the cavalcade of the *militia Christi*, on the first panel on the left.

In the Heavenly Liturgy John the Baptist usually leads the chorus of the patriarchs and the prophets; the Apostles are at the head of the martyrs. On the retable, the Apostles are seen on the right of the Fountain, the heroes of the Old Covenant (and some others) on the left. Whether John's name explains his presence at the side of the Lord in the upper row, is hard to decide.

The Pilgrims and the great lords of the outer wings are not named in the office of the day; neither is the Lamp, seen at the top, a segment of gold from which golden rays are falling down on the Great Multitude; the halo was changed and narrowed, and the Dove is a later addition.

246

It is far from easy to identify the individual saints. Among the Apostles, only John, who is standing and looking at the Lamb, can be easily pointed out. From the seven who are on their knees, the foremost, Peter and Andrew, can be seen, both astonishingly ugly and drawn in an archaic manner sharply contrasting with the noble simplicity of the 'purpled martyrs' behind them. Two others accompany the Apostles. The man with the large and, as it seems, tonsured head, some have identified as Barnabas. His neighbour shows the traditional features of Paul, a sharp profile and a high bald forehead with a little tuft of black hair. Both are mentioned with the Apostles in the Litany of All Saints.

As for the martyrs, Stephan, the first deacon and the first martyr, has a place of honour, in the first row; his round tonsured head meekly inclined, he looks down on the stones of his Lapidation held up on a slip of his scarlet dalmatic. The bishop behind him is Livinus or Lieven; he is holding his tongue with the pair of pincers by which it was torn out. We do not know who the three popes are, as nearly all Roman bishops of the first three centuries are martyrs, but Fabian, Cornelius and Xystus II come first to mind. The deacon with the full face, who stands behind the last-named and holds the precious Gospel-book, could be Xystus's famous deacon, Lawrence. The strong head with the ermine-bordered doctor's cap might be Cosmas or Damian or another deacon, Vincent of Saragossa.

Seven of the prophets facing the Apostles are also kneeling, four of them holding the books of their prophecies: solid fifteenth-century codices with a text written in two columns; two of them are looking together at one book. One is wearing a *houppelande* (a long upper garment, with side-slits and wide sleeves, of heavy wool, often lined with fur); all have large mantles, and those strange turbans, hoods and slouch-hats, which they wear in the pictures and stained glass of the later Middle Ages, and which were also worn on the stage in the mystery plays.

Yet stranger headgear is seen in the packed crowd standing behind the kneeling prophets. Who are they? Their attire points to the heroes of classical Antiquity, and one of them certainly belongs to the prophets. They must be the innumerable crowd 'from all nations and tongues'. In the white-robed man with the full broad beard and the strong features, who is wearing a wreath of green leaves and holding up a lily of the valley, some have seen Virgil, the Poet of the Fourth Eclogue: *Iam nova progenies caelo demittitur alto*, 'Now a new offspring comes, alighting from on high' – the seer, who, in his famous line,

Vltima Cumaei venit iam carminis aetas,

'The last of Times has come the Cuman song foretold,'

clearly indicated the days of Augustus as the final era. This was prophecied by the Sibyl of Cumae, whose mysterious sister, the

247

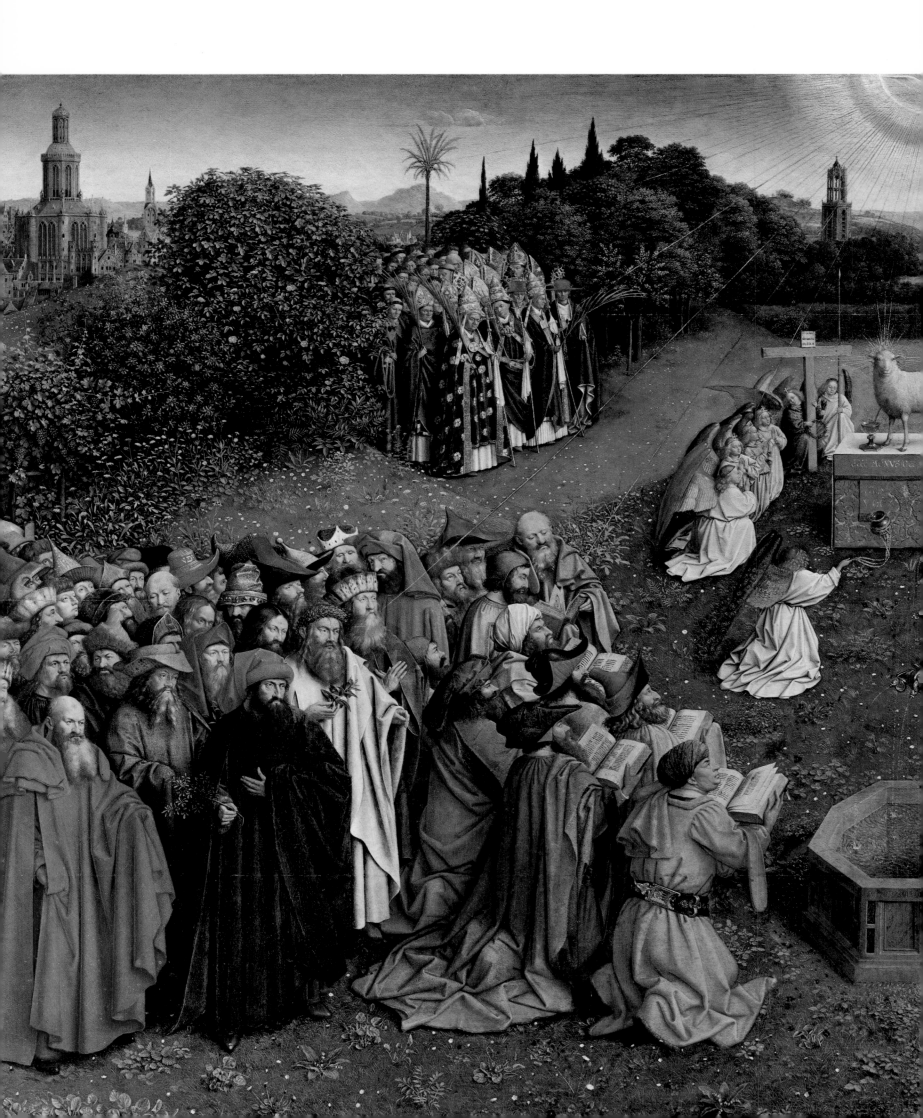

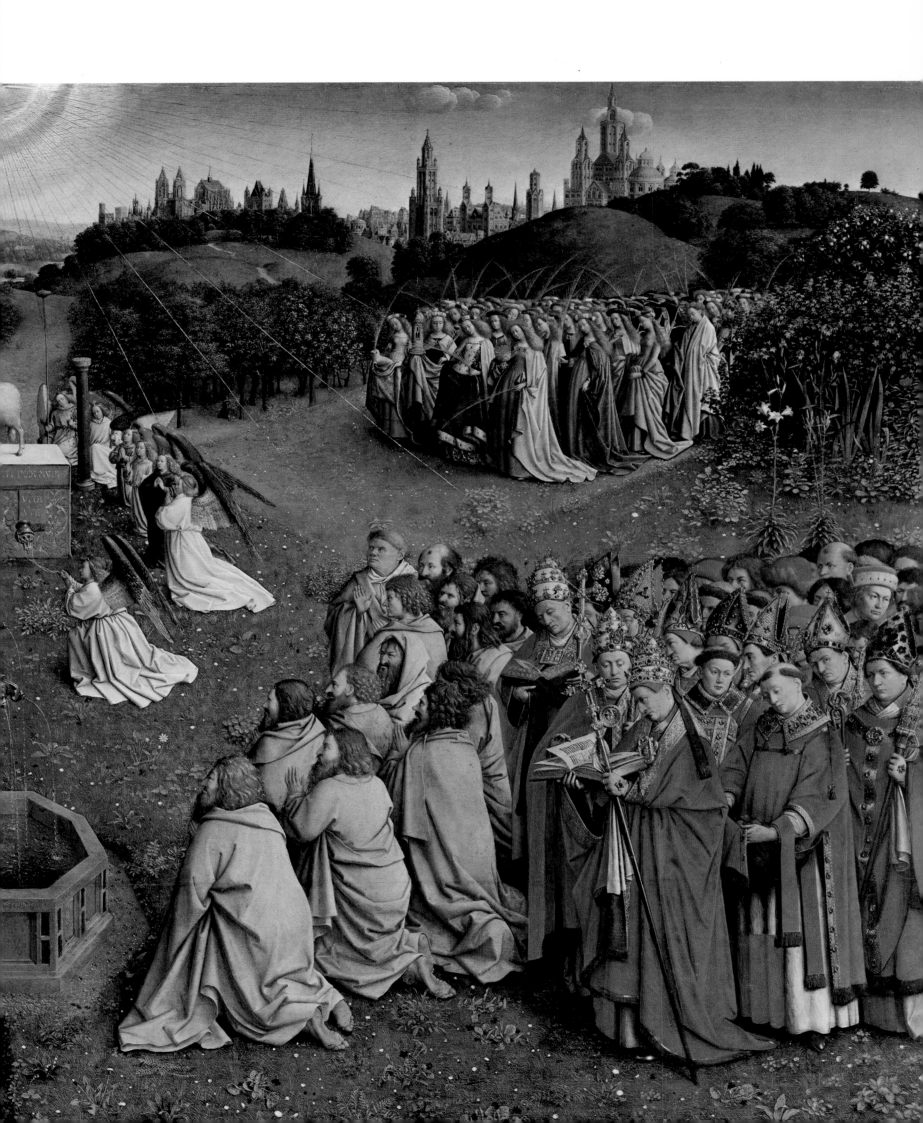

Tiburtine Sibyl, at a place next to the Capitol called *Ara coeli,* had shown the Son of a Virgin to the emperor. Virgil was the only great man of Antiquity who was thought to have caught a glimpse of the Incarnation and recognized the Fullness of Time, and consequently occupied a certain rank in the history of Salvation and a place of honour in Limbo, where Dante met him as his predestined guide through Hell and Purgatory, until reaching the very threshold of Paradise.

The stately man with the furrowed face standing before Virgil, dressed in a split blue mantle reaching down to his shining brown boots, and in a red hood, is lost in thought and, covering his heart with one hand, he holds a twig of myrtle in the other. Remembering Isaiah LV: 13, 'Instead of the brier shall come up the myrtle-tree; I will set in the desert the fir-tree, and the pine and the box-tree together', one is inclined to see, in this majestic figure, the fifth Evangelist, Isaiah, who saw the Saviour 'brought as a Lamb to the slaughter' (LIII: 7), and at the same time, with greater poetical force than any of the prophets, announced his Messianic glory. One might even recognize some of the trees and plants quoted by the prophet, in the exotic flora of Van Eyck's Paradise.

Whether we might still go further and, looking at the bearded prince with the gold-worked hat and the delicate Eyckian hands, for instance, think of the emperor Augustus, is an open question. But surely this heterogeneous crowd, so exotically arrayed, represents the multitude 'of all nations, and kindreds and people and tongues' standing before the Lamb, together with the tribes of Israel, as enumerated in the third anthem of the Vespers of All Saints' Day.

Contrasting pleasantly with the bright red of the martyrs, the main figures of the Confessors are clothed in blue. The foremost, a pope, perhaps Gregory the Great, is wearing a velvet cope, embroidered with heraldic flowers in gold, over a dalmatic. Even the two cardinals, with their scarlet tasselled hats, are in a blue *cappa magna;* with one exception the episcopal mitres are blue, and so are the *cucullae,* the wide frocks, of the three Benedictines on the left. The bishops and mitred abbots hold their processional crosses (with a white *mappula*) as well as a palm branch; together with the Virgins, they represent the 'palm-bearers' on Mount Sion. Laymen and monks are bareheaded; of a mitred abbot we only see the crozier and the *infula;* the prelates are daintily shod in red; a bishop wears a blue chasuble, one of the popes grey gloves, his neighbour red ones.

The lovely group emerging from the oleanders and the other flowering shrubs in the background, and standing among lilies, the long silhouettes of their palms crossed above their bowed heads, is the *chorus sanctarum virginum* of the Vesper hymn: the chorus of Virgins. They are a somewhat timid group. A few of them stare ahead, the others stand with downcast eyes. All are wearing a wreath of flowers or twigs; the one who holds a little basket dreamily lowers her long thin palm. A long mantle, which here and there is sliding

off, covers the fashionable tight-laced, low-cut bodice. The one with the orange blossom in her hair is wrapped from top to toe in a blue mantle; the other cloaks are fastened with a clasp, or a little chain between two buckles, precious *fibulae*. All heads are slightly bowed, the carefully curled hair standing out above sloping shoulders. The mysterious lady in blue has her hair done up under her orange toque; below her thin waist the protruding abdomen, from which long folds fall to the grass, is enhanced by a fold of the mantle held transversely before it. This is only the usual courtly carriage of a great lady of the time.

First comes Ursula of Cologne (and Bruges), in an ermine-trimmed princely dress; then Margaret, carrying flowers in a basket; at the extreme left is Agnes, holding the lamb *(agnus)* on a slip of her mantle, and Barbara, a shy beauty, with her tower. We do not see the attributes of Catherine or Dorothy. There is an abbess with a crozier, dark mantle, and white-bordered black veil, probably a Cistercian nun; other nuns are wearing a wreath over their veils.

THE SIDE-PANELS:
ANCHORITES, PILGRIMS AND THE MILITIA OF CHRIST

On the four side-panels only a few saints can be identified. Among *164* the Anchorites, the world-renouncing ascetics succeeding the martyrs by retiring from their all too superficially Christianized cities, those 'whom the Desert sent up to the stars', the two old men, with T-shaped crutch and rosary, might be Paul, who is said to have been the first hermit and the founder of eremitical monastic life in the Egyptian Thebaïs, and Anthony, the founder of coenobitical monasticism and 'father of all monks'. Paul has bare feet, Anthony has shoes. The others, with their untrimmed beards and uncut hair, recall the Fathers of the Desert, the famous heroes of the Natron Valley and the Thebaïs, who had already become legendary by the end of the fourth century.

They are followed by two women, appearing in a bend of the ravine behind them: Mary Magdalen with the box of ointment, and Mary of Egypt, the Alexandrian courtesan who, after a life of penance (covered only with her long white hair and hidden among the bulrushes of the Jordan) was discovered and given the Viaticum by the priest Zosimus. Here, both are without any trace of their austerities, young and beautiful, with shining chestnut hair. It is not to be wondered at that Mary Magdalen accompanies the hermits: everybody then believed she had done penance in the grotto of Ste-Baume, in Provence, after Martha had gone to Tarascon and Lazarus became bishop of Autun. After an x-ray examination, it is held that the two figures – which indeed do interrupt the sloping line of the groups on the two panels on the right – are later additions, but how much later? No one will regret them, for they are worthy of the master.

The good-natured giant, who, on the outer panel, leads the way

talking, is Christophorus. The Pilgrims, who are not mentioned in the liturgy, are very simple people, of every age (the boy with the bobbed hair and the staff is not yet twenty). One of them, an introvert man of forty, wears the long dark frock, the shoulder-belt with travelling-bag, and the scallop of Santiago de Compostela fixed on the upturned brim of the hat, which St James himself is always seen wearing in the fifteenth century. I do not know why the man with the pointed nose is supposed to be Cucuphas, the martyr of Barcelona.

163 The Good Soldiers of Christ, of old the most admired panel, make one think of many things, but do not evoke any name – perhaps with the exception of George: but where else is George wearing a wreath? They are more than noble, they are princes, proudly riding on their splendid horses alternately white and brown: a dappled sorrel, a dapple-grey, a bay, again a dapple-grey, and a black stallion, all pricking up their ears like little horns. Their saddles, caparisons and harnesses are as priceless as the spurs, stirrups and suits of armour of the cavaliers.

The three ensigns riding in front with flying banners wear an extremely thin wreath of green leaves; another cavalier wears the high crown of the German emperors; a third the fleur-de-lis crown of France; a fourth, a bearded elderly man, his crown set around the top of a slouch hat slightly (but not exactly) recalling the headgear of the Paleologues. On the red-crossed shield of the middle ensign – the noblest face of the retable – inside the arms of the cross, one reads, as a device, the mysterious words: D FORTIS ADONAI SABAOT V EM IHC XP AGLA, rendered as 'God of strength, my Lord of Hosts, True Emmanuel, Jesus Christ, AGLA'. The last word is a cabbalistic siglum in Hebrew, used elsewhere by Van Eyck. On the floor-tiles, in the scenes of the Singing and Playing Angels. It is a *sefirah*, a Hebrew anagram: *Ata Gibor Leolam Adonaï* ('Thou strong for ever my Lord'); it has even been interpreted as Jan van Eyck's cryptic signature. An excellent device for a Christian warrior, but hardly characteristic of saints on horseback, as Martin of Tours or George of Lydda-Diospolis. Looking at this princely cavalcade, one feels tempted to remember the heavenly cavalry mounted on white horses and headed by the Rider called Faithful and True, of the nineteenth chapter of Revelations. But the horses are not white, the riders not clothed in white byssus, and their Leader, wearing the 'many crowns', is nowhere to be seen. One had better simply think of the Christian princes fighting the good fight and thus serving the cause of the Lamb of God.

The rearguard of the cortège – which continues on the outer panel, as one can see by the hind legs of the bay horse – is known as the 'Just Judges'. This panel, stolen in 1934 and untraced, has been replaced by the corresponding panel of the copy executed in 1557-9 by Michael Coxcie, for Philip II. Who are the ten not less princely cavaliers following the nine? I cannot help remembering the 'then

The Anonymous One on the Throne. Central panel, upper row, Ghent altarpiece. (166)

252

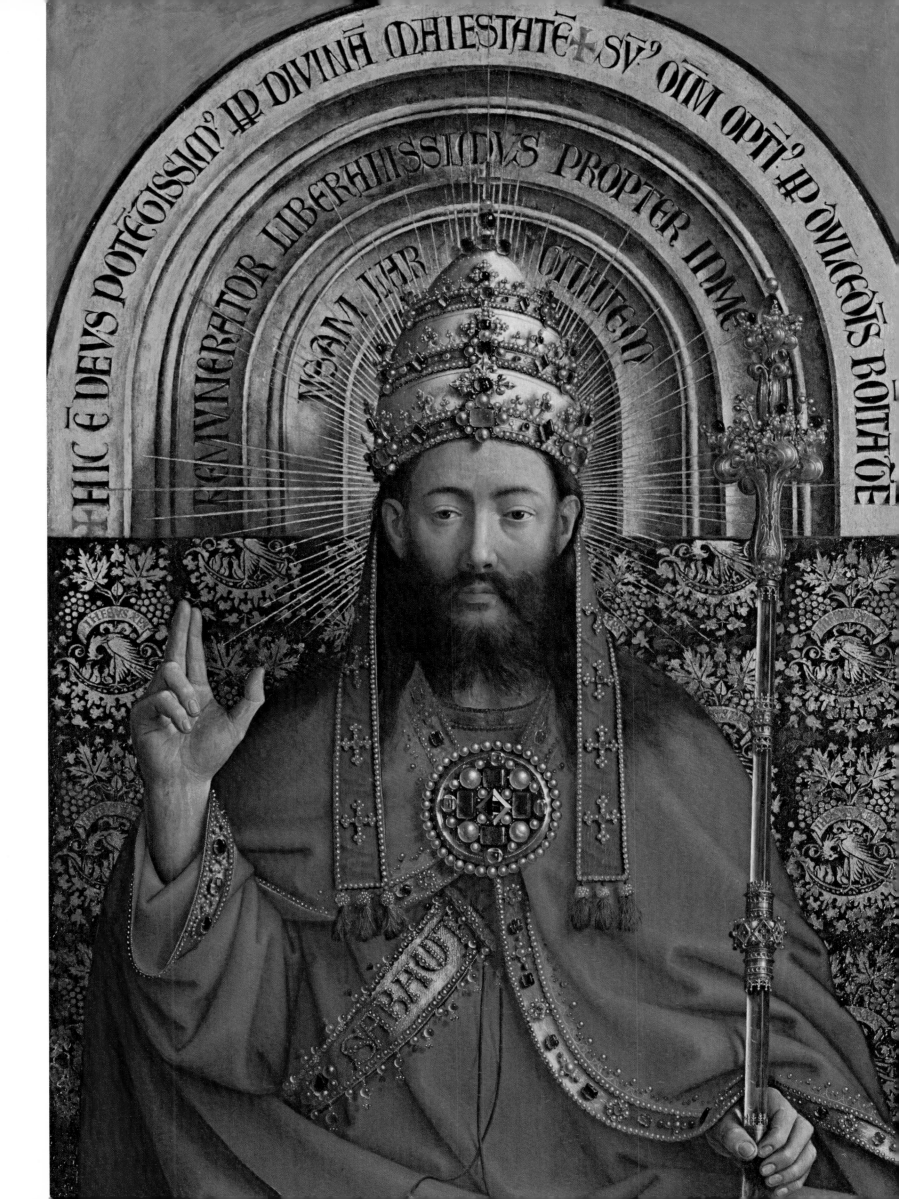

kings' (Rev. XVII: 17), not for the sake of the context (for they are rather equivocal personages) but for the number of ten. It has been noticed that the dapple-grey horses, on both panels, strikingly resemble the steed of William VI Count of Holland, in the miniature with the *Prayer on the Beach* in the lost *Turin Hours,* a picture always attributed to Jan van Eyck. Others believed the four lords in front to be four counts of Flanders: Philip the Bold, Louis of Male, John the Fearless and Philip of Burgundy, Van Eyck's patron and godfather of his first-born son. For a critic with some good will, and a great deal of scepticism about the relative likenesses (known from excellent and very individual portraits elsewhere) this might not seem totally unacceptable; yet this part of the cavalry of Christ, too, remains enigmatical.

THE SEVEN UPPER PANELS

As for the dominating but disparate upper row of panels, which until now nobody has been able to connect convincingly with the 'All Saints' theme of the lower row, it contains at least some motifs borrowed from the Apocalypse, which in a way attest to the intention, original or *post factum*, to establish a not too far-fetched iconographical connection between the seven upper and the five lower panels.

166 Undoubtedly, the central figure, the enthroned Lord, represents the Unnamed One of the Vision of the Throne (Rev. IV), though we do not see either the four Beings or the rainbow or the seven lamps. After 1400, the tiara, the sceptre and the cope became the regular attributes of Divine Majesty. On the part of the stole that is visible just below the clasp of the pluvial, can be read, in letters of pearls: SABAΩT, 'of hosts', with a Greek omega between the Roman capitals. The inscription on top of the Throne is a eulogy of the almighty;

> This is God, mightiest for his divine majesty
> highest and best of all for his sweet generosity
> most open-handed remunerator for his immeasurable liberality.

And, on the step in front of the throne appears:

> Life without death in the body, youth without age
> on the forehead,
> joy without sorrow on the right, security without fear
> on the left.

All of which partly applies to the Father and partly to the Word Incarnate. Their Consubstantiality has not been forgotten: on the hem of a slip of the cope covering the Lord's knees, a hybrid Greco-Roman inscription, embroidered in pearls, says: PEX + PEI V, *Rex regum;* NC + NANXIM, *dominus dominatium.* This is 'King of kings and Lord of lords', a quotation from Rev. XIX: 16, where it is said of

254

the Rider on the white horse, crowned with the many diadems, that 'he hath on his *vesture* and on his *thigh* a name written, King of kings and Lord of lords'. This name is given elsewhere (I Tim. VI: 15) to 'the blessed and only Potentate, the King of kings and Lord of lords', whom 'our Lord Jesus Christ in his times shall show', that is, at his Second Coming.

In the Rider on the white horse tradition has always recognized the powerful Word of God as well as the head of the Church militant. Consequently, on Van Eyck's panel, the Unnamed One on the Throne shows the features of the Word Incarnate, the only features becoming the invisible deity, for he alone 'is the icon of the invisible God' (Col. I: 15). We do not see a fatherly old man, but an image in the likeness of an ageless, perfect man, the Second Adam, and the Son of God. Once again, the Saviour is symbolized by a motif woven into the brocade hanging on the back of the Throne, the motif of the Pelican that feeds its young with the blood from its breast; a discreet allusion to the sacrifice of the Lamb, connecting the Throne on high with the Lamb below.

There is still another, very delicate, allusion to an apocalyptic vision. At the right hand of the Lord, the Virgin is seated; she is quietly reading her Hours, her lips moving in prayer – one has a glimpse of two rows of small white teeth. She looks very young, and is not wearing a veil. She is crowned with a high diadem out of which seven white lilies emerge, a symbol of her seven Joys. But between them twelve filigree disks are trembling on the long pistils of other flowers, not unlike lilies of the valley. These little sun-wheels are the twelve stars crowning the Woman clothed with the sun (Rev. XII: 2). And so, this enchanting young queen, lost in her prosaic devotion, whom one rather imagines in a lady's bower, nevertheless recalls the timeless, cosmic Woman representing the Church Universal in the most visionary Book of the Scriptures.

How the polyptych, in its present state, finally came about, we do not know. Was it Josse Vyd who had the upper row superimposed on an existing retable consisting of five panels, and the reverse of this heterogeneous ensemble adorned with the donors' portraits, the two Johns, and that surprising Annunciation, in which the Virgin and Gabriel are set widely apart and the middle space is precariously filled with elaborate still-lifes?

From 1432 until 1587 this epoch-making masterpiece is said to have been exposed in the family chapel, in the crypt below the chancel. But even today, now that it can be seen in a chapel of the ambulatory, the retable is too large, and too high for its final abode. In 1566 it escaped the iconoclastic rabble; it was mutilated, dismembered and partly sold; neglected, here and there repainted, restored, cleaned, put together and reinstated in 1918; it lost its left outer panel in 1934. It is high time it also escaped the controversies kept alive by its iconographical iconcruities as well as by its uniqueness – and even more by the uncertainty of an authorship hypothetically

255

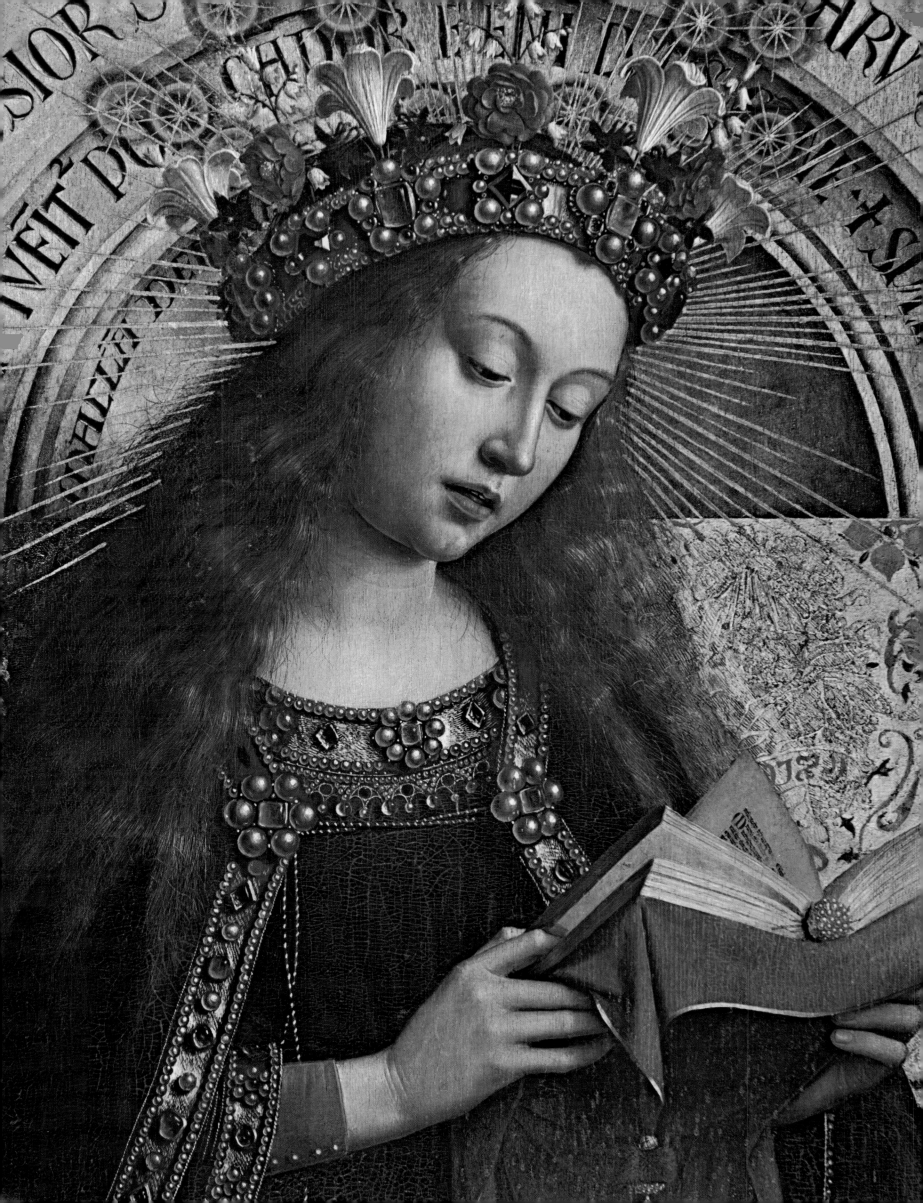

(and perhaps arbitrarily) divided between two 'brothers', of whom one is a shadowy name and the other the greatest painter of his age north of the Alps, and the keenest eye before Holbein. The mystery remains: but the enigmatic, far from disturbing, beauty always enhances it.

Later on, the Great Multitude assembles before the Throne of the Trinity, as on Dürer's *Allerheiligenbild*. There, the divine Persons are seen in a group called 'the Throne of Grace', the *Gnadenstuhl* (Hebr. IV: 16). The Father, in the likeness of Daniel's Ancient of Days, wears the tiara and a sumptuous cope, and holds the Cross with his crucified Son, while the Dove of the Holy Ghost – *proceeding from both,* as the Latin Credo says – hovers between them. *184*

So far, Van Eyck's polyptych belongs to the past, and to the Apocalypse. But nearly all he shows was then brand new, and so it remains to the present day. Looking at these processions pausing, in dead silence, on the celestial meadow, while the cavaliers and the hermits approach from the side-ravines, who thinks of the childish symbols of the past?

What Jan van Eyck renders visible round that prosaic open-air Altar adorned with a red frontal erected among grass and weeds, and on which the least gracious of all lambs stands obtusely looking at nothing, what he shows in that quiet afternoon-light, he has shown once and for all to generations of Netherlandish painters. And it has never been equalled by any subsequent artist. This enormous display of all there was to fascinate a painter's eye has proved of more avail for perpetuating the visionary Paradise of All Saints than the ecstatic, bustling crowds seen in Baroque cupolas, or the grim throng of palm-bearers standing together, on the threshold of the Reformation, in the *zwelfft Figur* of Albrecht Dürer. *198*

The Woman crowned with the twelve stars. Detail of the panel with the Virgin; Ghent altarpiece. (167)

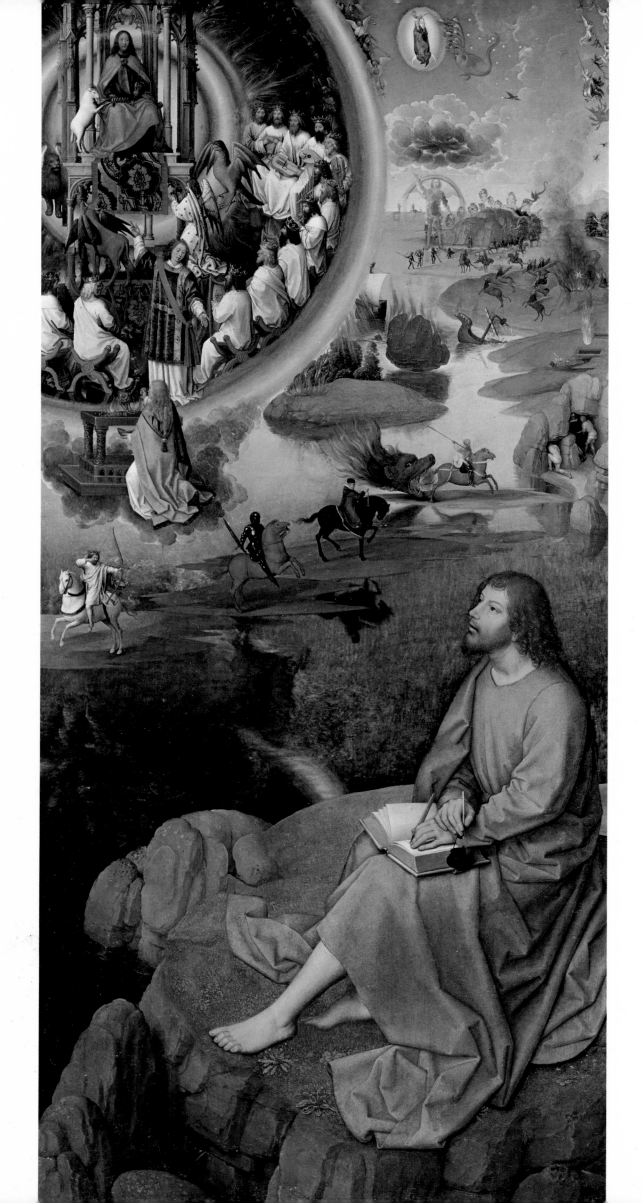

Hans Memling

Memling is the very last person one would expect to have painted an Apocalypse. Who would associate an Apocalypse with that sweet man from the Maingau, born at Seligenstadt, near the Carolingian abbey church of master Einhard? He seems to have preserved the benedictine peacefulness of his native land in the workshops of Rogier van der Weyden and Dirc Bouts, and finally at Bruges, as both a good citizen and an even better painter. Memling is the creator of the quietest of groups, of the most peaceful assemblages of silent, pious people, in sacred places – groups that have nothing of the unnatural deadness of a *tableau vivant*. He is the Perugino of Bruges. A Perugino without eyes raised to heaven, mannered attitudes and easy Umbrian grace.

His figures are always slender, frail, quiet, static – people without grit. Yet, an invisible sanctuary lamp seems to shine behind their faces, to light up the delicate never gesticulating hands, and even the folds of their always impeccably arranged and mostly rather simple garments. They hardly do anything; their gestures are unemphatic; they lower their eyes, they sit and read; if standing, they are dreaming. His holy women have faces seen only in very strict contemplative convents. His male saints, though always healthy and often tanned, never show more than a thin moustache and a short beard; at the most a slightly curled but never tousled mop of hair; hardly any shoulders, slender limbs. They are all of the asthenic type, more modest and dry than fiercely ascetic. They are introverts, never looking up, never confronting the onlooker eye to eye. They are the most gently contemplative figures of the waning of the Middle Ages, and maybe of all sacred art.

Feelings can only be guessed; there is no trace of that clearly visible, infectious tenderness, the open hilarity of so many figures by Beato Angelico; only the small angel with the hand-organ is smiling. Even the portraits – not those of the donors kneeling in prayer, who feel the hand of their patron saint on their shoulders, but the simple portrait heads and shoulders (that sometimes do look at us) – even they betray, without exception, the same profound sentiments: preoccupation about the salvation of their soul, and yet an imperturbable peace of mind.

Eugène Fromentin, who came to know Memling at Bruges, in 1875, and could not have known very much about his life, yet dis-

St John on Patmos experiencing, in the Spirit, the vision of the Apocalypse. A detail from the right wing of the altarpiece by Memling of the *Mystic Marriage of St Catherine*. Bruges, St John's Hospital. (168)

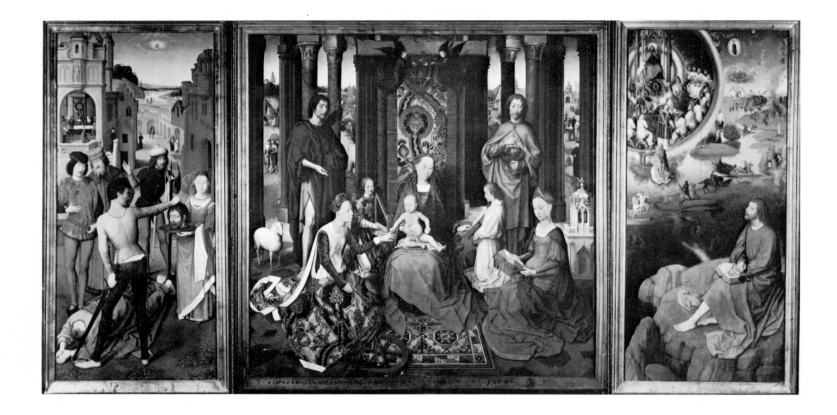

believed the legend that made of him an old soldier come to rest as a permanent guest in the Hospital of St John, puts him, in a way, above Jan van Eyck. Jan van Eyck, he says, paints with the eye, Memling with the mind. There is something in this. Jan van Eyck makes people look neither more handsome nor better than they are; he never idealizes them. So his maidens are simply sweet and his men simply shrewd, brutal, or dignified; perhaps distinguished, but not sublime; his saints are solid and authentic, not handsome; the Lord and his Mother hardly so. What he shows, splendidly, is chased work, armour, copes of brocade, a tassel of a case; he never has enough of gems, flowers, grasses and jewels; but neither of double chins, furrows, warts, crow's-feet, and frizzled girl's hair.

Hans Memling, who, of course, forty years later, knew all the tricks of the great master's métier, is not so much interested in luxuries. He knows how to paint a Persian carpet (you can easily recognize its brand) or sunlight sparkling in the metal of a hanging-lamp. But what he really wants is to make visible the celestial peace and gentleness that saintly people radiate. A wordless peace, often manifest in a kind of imperturbability which, rather than foolishness, I prefer to call guileless simplicity. In his paintings only the wicked are stupid.

He is fond of telling stories and he likes juxtaposing a lot of small scenes. He has filled big altarpieces with dozens of episodes from Our Lord's Passion. And there he cannot avoid depicting the hypocrites and the wicked. But his hangmen are puppets, his judges ummoved officials, the spectators imbeciles. Salome, receiving the head of the Baptist on a golden dish, is a clumsy girl, an overdressed

The *Mystic Marriage of St Catherine*, in the presence of St Barbara and the two St Johns. Left wing: the decollation of St John the Baptist, and scenes taken from his life; central panel: the *Mystic Marriage of St Catherine*; behind the colonnade are scenes from the lives of the two St Johns; right wing: St John on Patmos gazing at the Apocalypse. The altarpiece measures 172 cm by 79 cm, and dates from 1475-9. Bruges, St John's Hospital. (169)

doll with a diadem and an expensive necklace. But his saints, who are all somewhat alike, literally do not belong to this world; they are too good for it. You don't meet them anywhere, they are too peaceful, too gentle, too perfect – they are all sitting in a divine oasis.

Yet Memling has painted an elaborate Apocalypse. True, it is a make-weight, an accessory. It complements a greater whole, and it shows an incredibly silent main motif: a soundless Liturgy before the heavenly Throne. It fills the right wing of a triptych representing the *Mystic Marriage of St Catherine of Alexandria,* ordered by the superior and manager of St John's Hospital at Bruges, in 1475, and completed in 1479, fifteen years before the painter's death. Everything said above about his appearance and mannerisms, can be substantiated by what you see on this mature and most famous of Memling's works.

THE CENTRAL PANEL, WITH THE TWO ST JOHNS

In the warm-coloured central panel the little Jesus, holding an apple *169* in his left hand, with his right slips a ring on St Catherine's finger. The Blessed Virgin turns a leaf in the *Pontificale,* held open before her by a kneeling angel in amice and alb; the smiling angel on the other side is the one with the small organ. In front of her metre-high tower, St Barbara, sitting up stiffly, is reading her Hours. The Virgin's seat is placed on a Persian carpet, under a red canopy, against a piece of brocade with an amaranth pattern. The ceremony takes place in a kind of chancel surrounded by dark columns with gilt Romanesque (and therefore sculptured) capitals. The ambulatory has pillars but no walls, so that we can admire the view behind the colonnade in its entirety: a delicately painted, lovely landscape unobtrusively filled with an infinity of far-away episodes. And there we must begin.

To the left and the right of the Virgin, both St Johns are seen standing, the Baptist and the Evangelist. They are the Witnesses at the Marriage. And everything we can decipher in the landscape behind the columns, and see on the side-wings of the triptych, is related to those two saints. The very youthful Baptist, not more than thirty, has with him the Lamb of God he once so emphatically designated, a fine graceful animal. Far behind the columns we see John's preaching in the desert, his captivity and the burning of his relics at Nablus (Samaria), by order of Julian the Apostate.

THE LEFT WING: THE LIFE OF ST JOHN THE BAPTIST

On the side-wing, on a far greater scale, we see the Decollation, the banquet of Herod, and Salome receiving the saint's head on a dish; in the background, his disciples Andrew and John in the court of the fortress Macheronte and, far away, in a lovely view of the

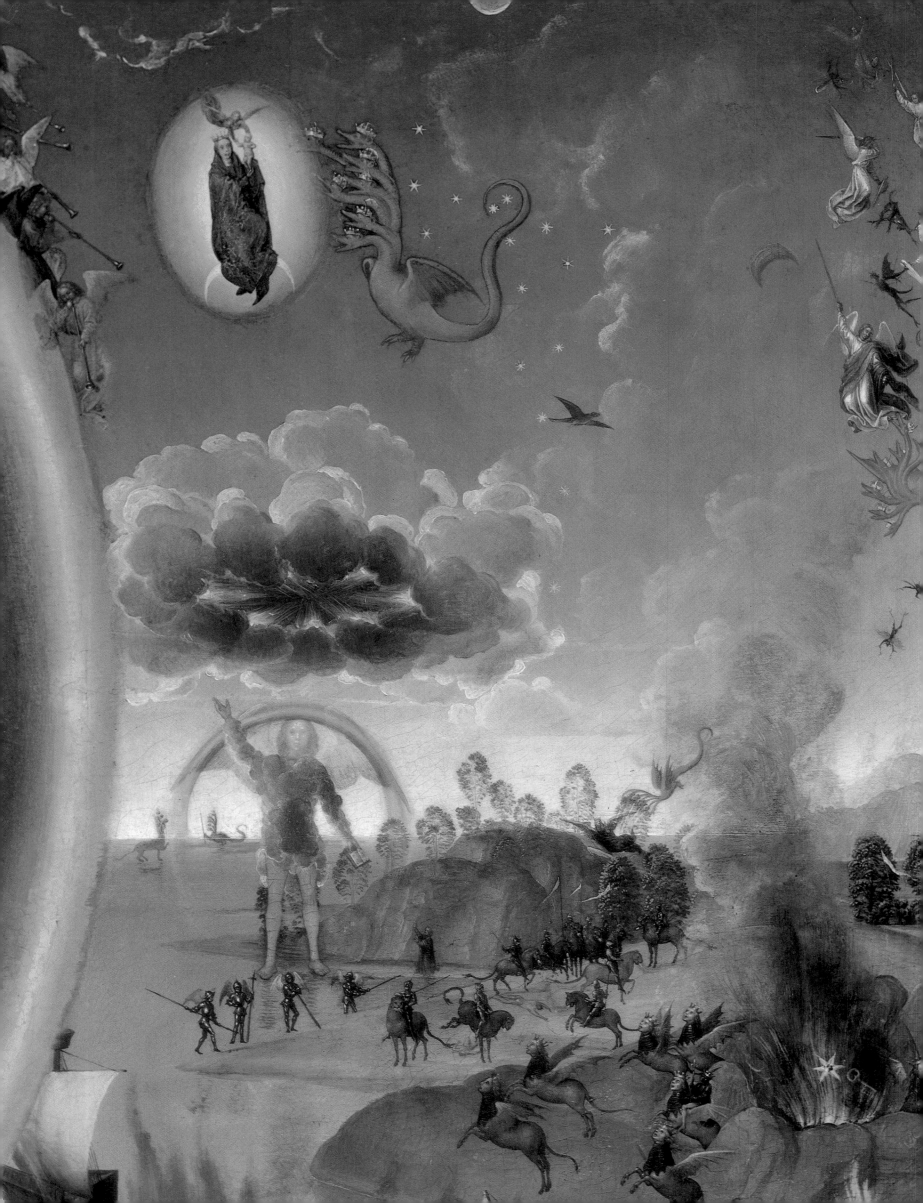

Jordan, the baptism of our Lord, the Theophany in the air, and, on one of the banks of the river, the 'first-called' Apostles following a lonely Jesus.

On the right side of the central panel as well as on the right wing of the retable, we see a series of corresponding scenes devoted to the Evangelist; these lead up to Patmos, and the illustration of the Apocalypse.

JOHN THE EVANGELIST

In front of the marble columns John, clothed in dull-red, his mantle buttoned at the neck, stands motionless, with downcast eyes. He pays no attention to the ceremony; mechanically, he makes the sign of the cross over the poisoned cup he holds in his left hand, a chased golden chalice out of which two little snakes are lifting up their black heads. It is the hemlock of Aristodemus, a long while the Apostle's attribute. The secondary actors have been omitted.

The story continues behind the columns, told in tiny scenes staged inside the townscape of the background. One sees the white body of the saint in the cauldron of boiling oil put on an oven, the torturer stirring the oil, his helper pouring it on John's head, Domitian looking on, talking to some gentlemen, and a lancer on guard. Behind them, people are crowding below the Latin Gate and a corner of the Colosseum looms above the Aurelian Wall. A blue pond represents the harbour of Ostia, where a soldier leads John to the boat that will bring him to Patmos. To the left, in what seems an out-of-the-way corner of Bruges, the great wooden derrick dominates the Zwin. More in the foreground, one of the donors, James de Keunic, in his black hospitaller's frock and little cap, is staring, motionless, at the back of the patron saint of his house, through the columns of the chancel.

THE RIGHT WING: JOHN SEES THE APOCALYPSE

On the side-wing the *Life of John* continues, but now on a far larger scale; the panel measures 172 cm by 79 cm, and, by its colour and composition, is the exact counterpart of the left wing, but far more impressive. It shows one motif: John seeing the Revelation.

The Apostle occupies the lower half; the upper shows what he is seeing. Both parts are linked together by the Aegean Sea, in which the visions, floating round the Throne on grey-green clouds, are reflected. The horizon is so high that the sky fills only a sixth of the height. The mere idea of a perfectly quiet sea mirroring cataclysms is a splendid invention.

John, dressed in the same dull-red tunic and mantle as before, sits' on the scanty grass covering the rock of Patmos, a steep cliff rising between creviced boulders from a tideless sea. Hands crossed upon his open book, stylus, penknife and the strap of the ink-well

168

2

Detail of the background showing, at the top, the Woman, the Dragon and Michael's battle; the Great Angel; the angels of the Euphrates; and, lower down, the Locusts. Bruges, St John's Hospital. (170)

263

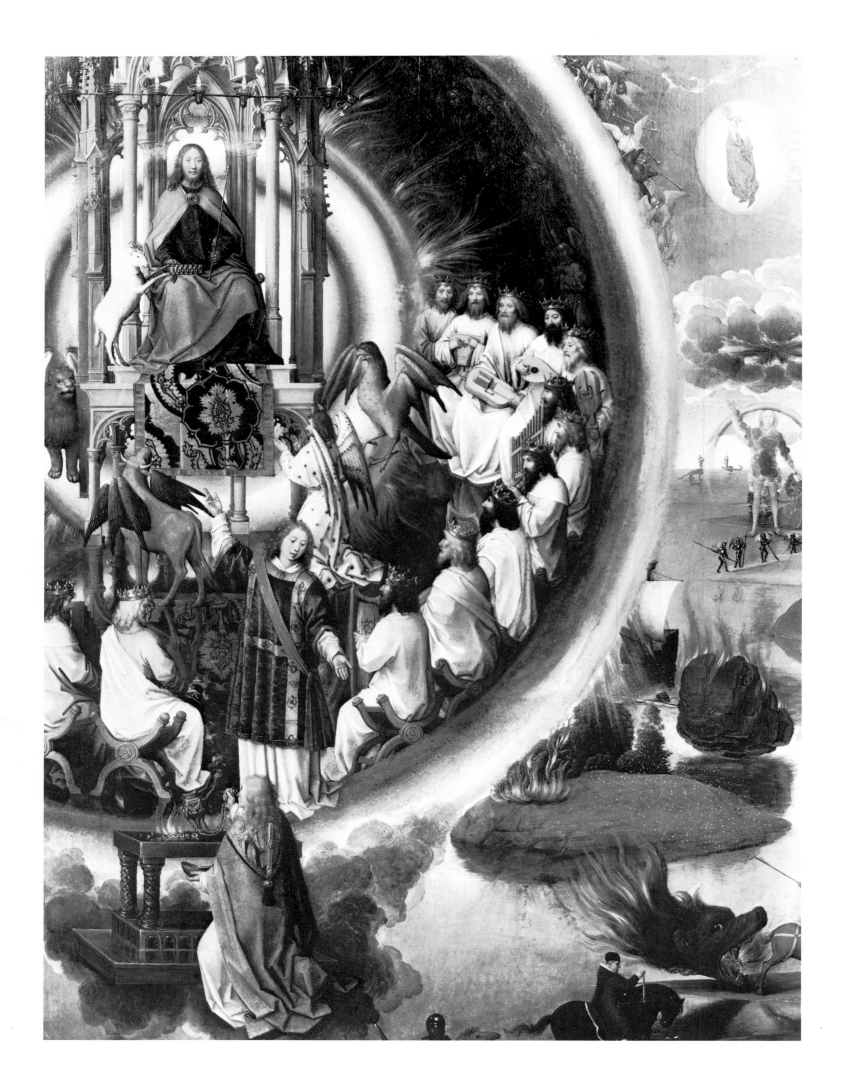

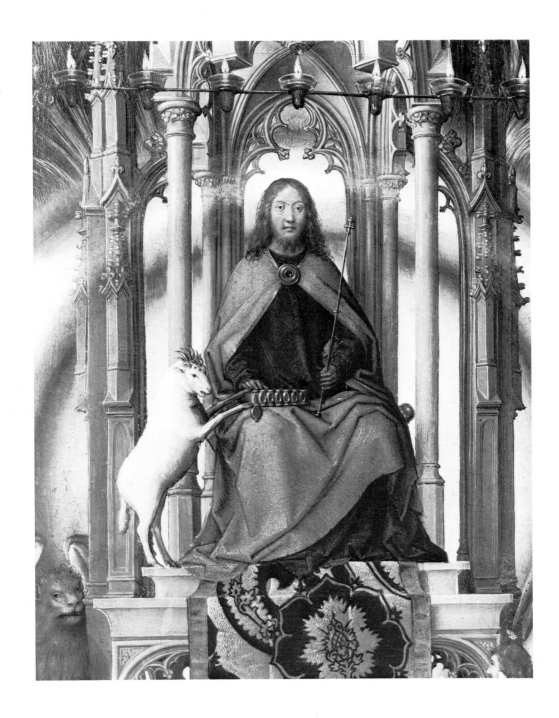

between his fingers, a thin bare calf protruding from the hem of *228*
his mantle, he sits very upright with lifted head, staring before him
with quiet brown eyes. He sees, but 'in the Spirit'; he does not
look at the visions above the sea seen behind him, he sees the better
and authentic vision.

He is not in the least excited. We can tell that there is not a
breath of wind by the hair loosely falling over his low forehead along
his ears and thinly bearded cheeks. He is lost in the quietest of
ecstasies, has nothing to do but to hear the words 'faithful and true'
which he is listening for in order to write down. He does not see
the angel looking down on him from the Throne and beckoning to
him and calling from afar: 'Climb hither!' I think he looks very
much like his namesake, Hans Memling himself. In the whole history
of art no seer is as calm as Memling's John.

Opposite: the Throne, the angel calling
'Come up hither!', the angel with the
censer and the heavenly Altar. Bruges,
St John's Hospital. (171)

A detail of the Unnamed One on the
Throne, the seven lamps, the Lamb taking
the Book. Bruges, St John's Hospital. (172)

Exactly half of the panel is filled with the visions. Taken together, these well chosen scenes give one of the rare summaries of all that is essential in the apocalyptic message. Memling did what until then no one had tried to do: join one dominant vision and a number of secondary ones and put them above a wide panorama of coastland and sea, perfectly linked to the Patmos rock in the foreground. The red and white of John and the pale grass stand out against the dark sea; in the distance, tempest clouds are gathering and throwing alarming shadows on the brighter parts of the sea, and above it the sky slowly turns to Elysian azure. From the darkness of his solitary island, John sees the visions we see behind his back, in a landscape lit up by the theophany of the Unnamed One and the Lamb.

171 The Throne is a dimly shining disk, hanging above a sea that has turned into light-blue. Part of the rainbow surrounding the vision is reflected in the quiet waters darkened by the clouds below. A smaller rainbow encircles the seat of the Lord, set inside a colonnaded pavilion, built on top of a crypt, in pure *rayonnant*: in 1470, an old-fashioned variety of traditional Gothic. A tapestry of brocade flowered with an amaranth pattern hangs down from the platform. Between the columns supporting the gabled and pinnacled canopy *172* the seven lamps – hanging lamps of glass, fastened in a row to a rod – burn high above the Throne.

The Unnamed One has no nimbus but shows the features of Christ; he is holding the sceptre and the sealed Book. Standing on its hind legs, the Lamb gracefully leaps from the step to the knee of the Lord, and, already, with a delicate hoof touches the first Seal A crest of seven tiny black horns crowns its head, above a row of secondary eyes. The Lord does not move and stares ahead. Hair-like red flames shoot from the inner rainbow. In the dark zone outside, shades of angels join their hands in prayer.

On the lower border of the rainbow the four six-winged Creatures are guarding the Throne: a tame cat-like Lion, a slender Ox, an Eagle, and a moustached Man in a white alb; the bodies and even the alb are studded with tiny eyes.

174 Screened off by a low rail covered with a tapestry the Elders are sitting in a kind of semicircular chancel, on the then usual liturgical folding-chairs. They are bearded men of all ages, with black, fair or grey hair, who wear golden crowns of fleur-de-lis. Only thirteen of them are visible (one sees but four fifths of the disk). Each holds an instrument: harp, hand-organ, violin, lyre, hurdy-gurdy, dulcimer; one still holds his flute to his lips but does not play. There is a solemn pause. One thinks of the 'silence there was in heaven about the space of half an hour' (Rev. VIII: 1). Far away, behind the Throne, the seven angels, too, are holding their trumpets in readiness, and some of them have already put them to their lips, but still they do not blow them.

The first Rider. (173)

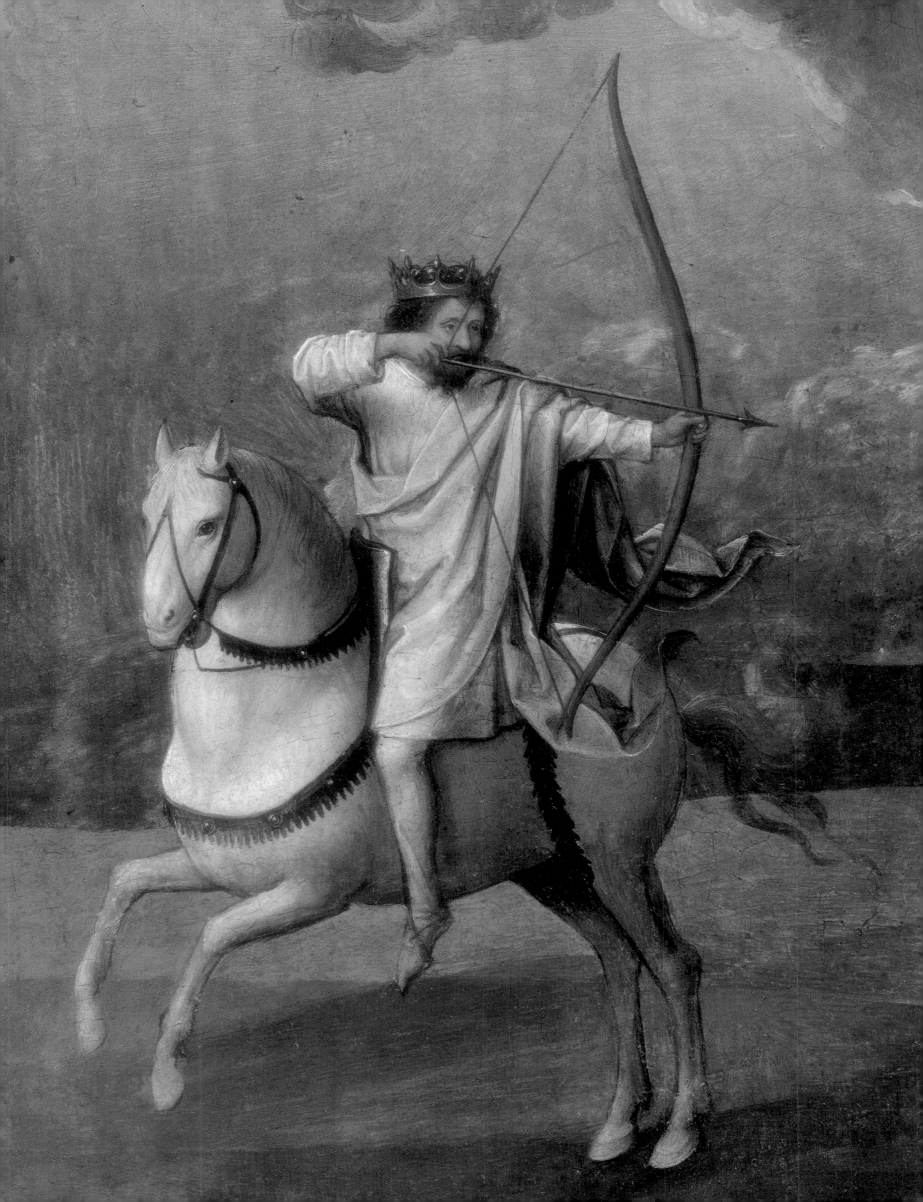

At the bottom of the vision, an angel is calling John, who hears him but does not see him, though the angel points to the Lord and holds out an inviting hand. He is a serene young deacon, in amice, alb, purple dalmatic adorned with orphreys *(clavi)* and embroidered hems, and a red stole hanging down from the right shoulder and tied on the left hip.

At his feet, on a dark cloud, an altar-table is supported by four columns; on its *mensa* coals are burning, and a fair angel, kneeling on its step, is swinging a golden censer and holding the incense-boat in his left hand. On the shield of his red cope he is seen again, in embroidery, throwing the flaming charcoals from the censer on to the earth.

On high, the Lamb has already broken a Seal, and the cataclysms are breaking loose. First of all the four Riders appear, galloping above the sea on trailing clouds. Foremost is the Lord himself, white-robed, on a white horse, already crowned. He shoots his first arrow across his left shoulder, in a Parthian shot, and passes in a flash to the left. The others are running in the opposite direction. The Rider on the red horse, armoured in black from top to toe, visor open, holds a black sword. The third, on the black horse, holding a pair of scales – symbol of Famine – is a dignified usurer wrapped in a dark fur-trimmed gown and wearing the high cap of a university doctor. The fourth, on the pale horse, Rider Death, is wielding a long dart, Pestilence. He is an elderly carcass with some hair left on his skull; the tails of his yellow shirt – which makes one think of too small a shroud – flap above a black saddle and black armour. Behind him, Hades, nothing but a monstrous head with a grimly squinting eye and flaming mane, vomits flames from an open muzzle full of screaming reprobates. The fire touches the horse's tail but does not singe it.

Fire, too, falls down on an island, together with hailstones, setting grass and shrubs aflame. A burning rock thrown into the sea is about to touch its surface, but the sea remains unruffled and quietly reflects the flaming boulder; yet a ship is in distress and another is going down with a broken mast. A column of fire – probably the Star Wormwood – is falling upon a square cistern, beside which a dead peasant lies on his back. Three men are crawling into the caves on the coast: a naked man, just out of bed, another, who has forgotten his trousers, and a king in a *houppelande*: the 'king, bondman and free man' of the text (Rev. VI: 15). A star and a key are seen above the Bottomless Pit, from which rises a column of black smoke. The swarm of Locusts is already jumping to the beach, joined by the cavalry riding on the fire-breathing horses. Armoured in black, with white wings, the four angels of the Euphrates, standing in the water, are brandishing their pikes and lances.

The Great Angel, eight times as tall as the dwarf angels at his feet, stands with one of his long red legs on the surface of the sea and with the other on the beach of a rocky island full of trees. His

268

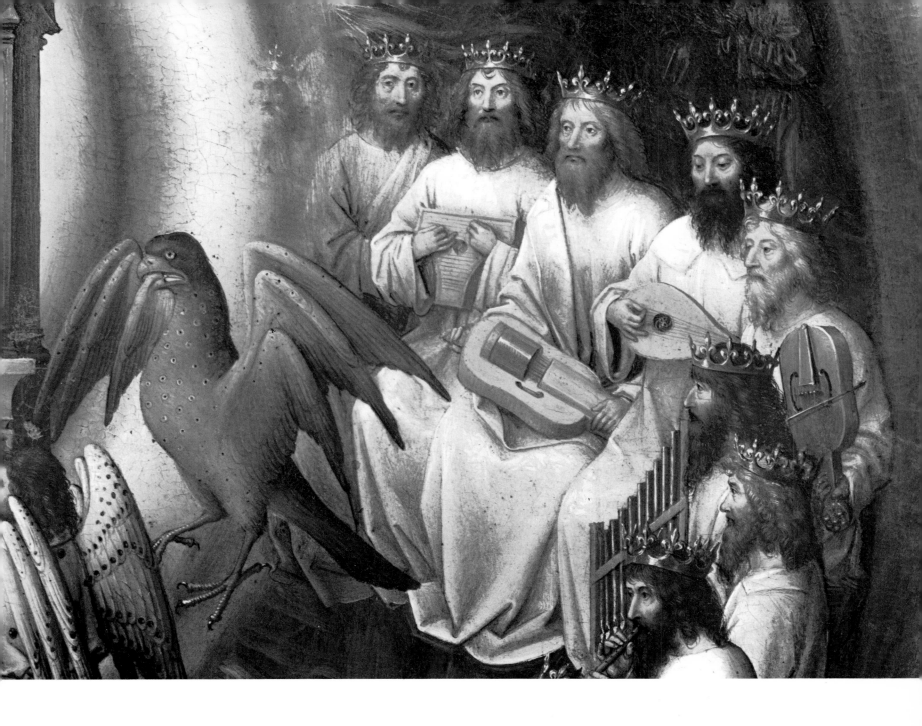

Two of the four Beings and seven of the Elders. Bruges, St John's Hospital. (174)

arms and torso are wrapped in a jacket of clouds, as in the woodcut of the contemporary *Cologne Bible*, of 1478-9. These stiff, scarlet legs, representing the 'columns of fire' of the text, are never seen in the earlier manuscripts; the angel's attitude is the same, however: raising a hand for the oath, he does not condescend to look at John, to whom he holds out the little Book. A rainbow surrounds his glowing face; above his fair head the seven thunders are growling in a dark cloud, high above the tiny, baffled John.

This thunder-cloud is violently lit up from above, where the Woman, clothed in the dark-blue of the Virgin Mary, crowned with stars, stands on the crescent of the moon, inside an oval, haloed sun. Over her shoulder she is handing her new-born Child to an angel hurriedly flying to its rescue, for the seven-headed, white-horned Dragon, erect on its short legs, almost skims the solar halo, while his tail sweeps down the stars from heaven.

In the sky, a blood-red moon hangs among cumulus clouds and the Eagle is seen screaming the threefold 'Woe!' Michael and his angels are harassing the Dragon and throwing down the rebel angels who immediately change into bat-like demons. In vain, the Dragon vomits water 'as a flood' against the Woman, who has received wings and disappears into the wilderness between the rocks of the island with the trees. On the horizon, the Dragon is handing the sceptre to the Beast from the sea: both are mirrored in the water, one standing on its surface, the other on a tiny spit of land.

Not everything has been represented. One does not see the Souls crying under the Altar nor the ascension of the two Witnesses, the Harvest, the Scarlet Woman, the downfall of Babylon, the Marriage, or the Heavenly City. Yet so much in such a small compass deserves admiration. Unable to display the totality of the visions, Memling splendidly succeeded in arranging most of the essential ones within one grandiose landscape: an endless sea full of islands, inlets, bays and creeks, under a sky full of fighting groups strangely suggesting the air battles of World War II. His weakness for picturesque episodes has not played him false. The cataclysms only enhance the glories; they can certainly evoke the ultimate spasms of a transitory world, but they do not disturb the cosmos as a whole. The sea remains calm, and continues to mirror an undisturbed azure. On the horizon, the sky is almost white, and this white is quietly reflected in the sea below, between the burning mountain, the shipwreck, and the panic-stricken people hiding in the caves.

Nothing breaks the silence of the *synaxis* before the Throne. The Riders are galloping along, stars explode, rocks are thundering down, smoke is rising from the Pit, but the sea remains unruffled, and the unapproachable Throne hangs above it in a 'more beautiful sun', *sol formosior*. Unmoved also, only attentive, and solitary, John sits on the rock of his exile, listening hard, seeing things unseen, and waiting with stylus and book ready to write it all down. In this way, that quiet man, Memling, painted his Apocalypse and the ecstasy of his patron saint.

What kind of manuscripts he might have consulted, and whether he knew the Dutch block-book or not, no one knows. After all, he only wanted the traditional series of subjects. As for the representation of the single episodes, since the Van Eyckian revolution, all pictorial figuration had been transposed from the domain of the highly-styled emblematical into the infinitely more varied realm of everyday reality, with an emphasis on direct observation and an awareness of the effects of light and dark, bright colour and deep shadow. It was characterized by an authenticity of brocades, glittering metals, soft wool, silk, flames, rocks, water, clouds and, above all, soft skins, delicate hands and quiet eyes, as seen by a great painter's eye. It still lacked an awareness of muscular strength, broad shoulders and generally of any form of visible energy.

Memling had mastered the new style. The purely visual rendering

of as many details as possible, without a trace of the learned theoretical research of his Italian contemporaries, however, did not interfere with the serenity of his inner visions. No painter either before or after him has evoked so much earthly reality with such an unearthly loftiness and in such a gentle, quiet way. It is amazing how few people have given this masterly work the attention it deserves. Fromentin, Friedländer, Claudel – they had eyes only for the central panel. But who on earth goes looking for Apocalypses?

The four Riders, the burning mountain, the shipwreck and the people hiding in the caverns. All watched by John. (175)

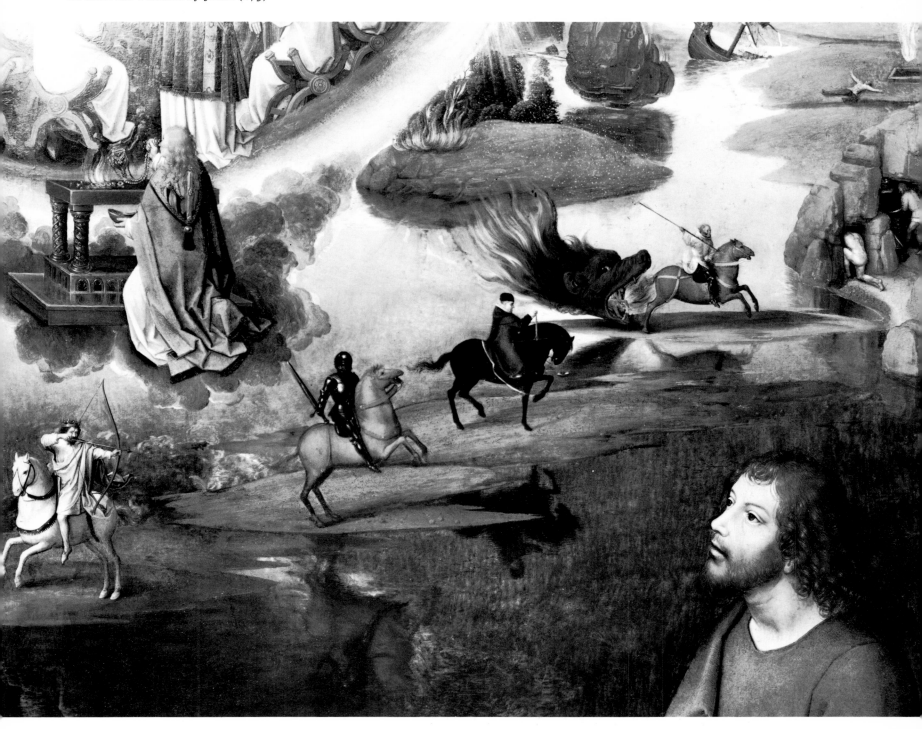

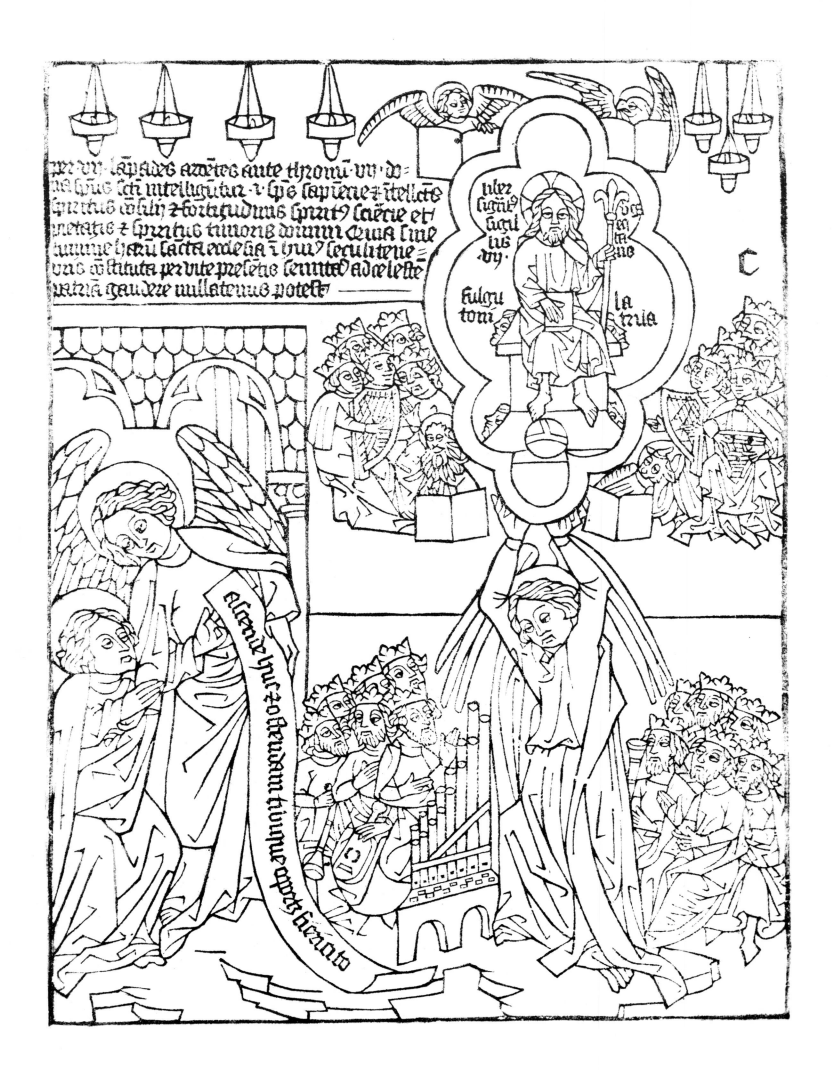

The First Block-book

Only abbeys, collegiate churches, rich convents, prelates and people of the upper class could afford the expense of an illustrated Apocalypse. Sumptuous manuscripts were made exclusively for princes and their consorts. An early fifteenth-century specimen, now preserved in the Pierpont Morgan Library (ms.133), remarkable for its originality as well as for its expressive crudity (more or less in the manner of the *Rohan Hours*), was illuminated for a member of the Berry ducal family. One of the last, now in the possession of the Escorial, begun in 1428 and finished in 1480 by no less than Jean Colombe of Bourges, was ordered by a prince of the House of Savoy.

115

From the moment the printing-press was invented, at the end of the first quarter of the fifteenth century, however, it was possible to duplicate pictures engraved on blocks of wood together with a short text. A new kind of picture-book was originated, available in many places at the same time, and not too expensive for the ordinary cleric or educated citizen. Thus, from 1420 onwards, an impressive output of xylographic products rapidly conquered the market: the *Biblia pauperum* or 'Bible for the Poor', a popular Concordance of the Old and New Testaments, each leaf presenting one mystery, surrounded by two prototypes and the images of four prophets with the relevant texts written on banderoles. Such texts were: the *Mirror of Man's Salvation;* somewhat later the *Ars moriendi,* the 'Art of Dying', including the Four Last Things; and finally the *Danse macabre,* splendidly brought out by Gyot Marchand, which, after 1500, became famous through the woodcuts of Holbein.

One of the first block-books happened to be an Apocalypse. The book has been preserved in several editions, of unequal value, as the worn blocks were copied, and the prints often hand-coloured, at the expense of the original design. The oldest copy still preserved, evidently the original model, is uncoloured. It was made in Holland, probably about 1420-35, at Haarlem, in the printing office of John Coster, or his son Laurens Janszoon Coster, once named as one of the inventors of typography. The best copy of this firstling of the xylographic species, once owned by King George III, is now in the British Museum; in 1961 it was reproduced in facsimile.

176-180

181

For anybody who likes a firm hand in drawing, it must be a pure joy to examine this typically Dutch Apocalypse. As it happens, the

From the first block-book of the Apocalypse. Holland, probably in the workshop of John or Lawrence Coster at Haarlem, about 1420-35. 'Come up hither!' and the Vision of the Throne; no. 6, block c. (176)

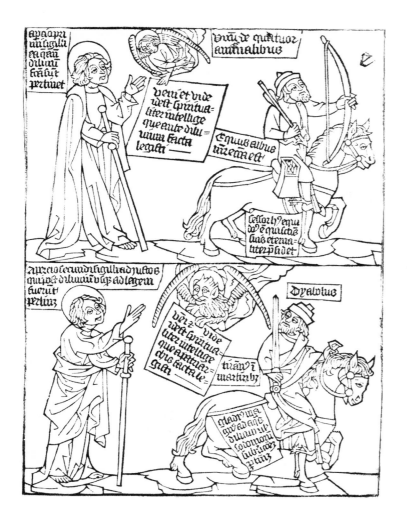
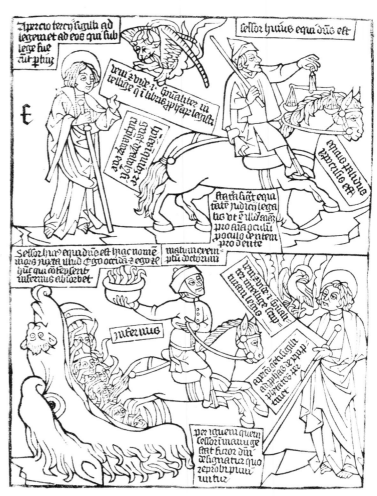

The four Riders; nos. 10-11, block f. Two
pages from the first block-book. (177, 178)

craftsman inaugurating a brand new technique at once hit the per-
fectly appropriate, though still somewhat elementary form. He did
not use any hatching. The drawing is purely and neatly linear. But
so strikingly efficient, and so expressive, and, despite the economy
of his method, so clear, that one cannot help thinking of a kind
of quintessence of the graphic arts, as when looking at a Greek vase.
Of course, the comparison is almost absurdly paradoxical: there is
no trace of gracefulness either in the proportions or the situations,
everything is angular, plain, conventional and unwieldy, but at the
same time picturesque, stalwart and extremely to the point.

Scenery and buildings are merely indicated, and always by the
same hieroglyphs. The figures, however, all of short build, with large
heads and faces drawn in six or seven strokes, and clothes enlivened
only by a multitude of triangular folds, act in such an easy and
striking way that the onlooker is likely to think that, in its elementary
way, it is unsurpassable.

Another peculiarity is the superabundance of inserted legends. In
itself, the insertion of short texts into the picture is no novelty.
85-88 Already in the twelfth-century *Liber floridus* the miniatures are
covered with explanatory texts. In the oldest and best manuscripts

274

From the *Life of John*. Top: the drinking of the poisoned cup and the death of the poisoned criminals; below: John's last Mass; the assumption of his soul and his tomb at Ephesus; no. 50, last block. (179)

The Antichrist enthroned in the Temple of God, and his assistants distributing gold and treasures. Below: the Antichrist killed 'by the breath (a Wind-head) of His mouth' (Christ holding the Wind-head); no. 19, block k. (180)

of the Anglo-Norman family, framed captions are seen inside the pictures; these necessarily brief legends often form the only text. In the block-book, however, every available space is filled up either by banderoles or by rectangular strips containing names of persons, quotations from the sacred text and the most unexpected glosses – mainly extracts from Berengaudus – crowded together, and written in that spidery, late-Gothic minuscule in which every other word is disfigured by some mark of abbreviation.

Never before were the captions so numerous. In the *Beatus* manuscripts the relatively copious legends, written in a handsome semi-uncial, are rather laconic and pertinent. In the block-books, the captioning irritates by its incoherence and arbitrary selection; the holy text itself is strangely lost among randomly inserted glosses borrowed from a spiritualistic commentary: Berengaudus sees only symbols and seldom enphasizes the literal sense, which he evidently supposes to be sufficiently known. As some visual details regularly seen in the Anglo-Norman cycle can only be accounted for by passages from his commentary, his explications must have become common property at least among clerics. A good example of these mostly tedious *177,178* explanations is furnished by the two prints showing the four Riders.

275

According to the literal sense, they symbolize the scourges of divine Wrath directed against the blasphemous Roman Empire: the Parthians (the archers par excellence, always threatening the Eastern Frontier), War, Famine (during which food is rationed and weighed on the balance in scanty measure) and Pestilence (Black Death, incessantly providing with fodder the gruesome Hades close upon its heels). Now the first Rider immediately recalls the Rider on another white horse (Rev. XIX: 11-16), who is the Word of God; because the first one 'was given a crown and went forth conquering and to conquerer' other triumphal crowns (VI: 2), and the second is already wearing those 'many crowns' (XIX: 6). The Rider with the bow, notwithstanding the Parthian cape and the Iranian trousers (as in the codex of St-Sever), was considered to be the Lord.

80

Berengaudus's exegesis confirms and complicates this identification. The legend says: 'The opening of the first Seal signifies all that happened before the Flood.' One of the four Beings, here the Man, hands to John a banderole with the inscription: 'Come and see! that is, understand spiritually, the things which happened before the Flood and about which you now read.' Next is the Rider, here a bowman in the dress of the age. 'The white horse is Mother Church. The Rider is the Lord, who from eternity leads his saints,' a quotation from Berengaudus.

In the second scene, a caption near John's head says: 'The opening of the second Seal signifies the just living after the Flood, until the Law.' The Lion says: 'Understand spiritually what you have read about the patriarchs.' Near the Rider we read: 'the Devil', and 'the tyrant turning against the martyrs.' And also: 'the big sword signifies the waters of the Flood, or the upturning of Sodom.'

In the third scene: 'the opening of the third Seal signifies the Law and those who had to live under it.' The Ox says: 'Understand what you have read in the books of the prophets.' Near the black horse we read: 'the horse is Hypocrisy, the Rider is the Lord' (although, with his pointed bonnet and pair of scales, he looks like a Jewish usurer). Behind the tail: 'the people governed by the devil, as some prelates of the Church.' Below: 'the balance signifies the justice of the Law, as, for instance, "an eye for an eye and a tooth for a tooth"' (Ex. XXI: 23-4). This a verbatim quotation from Berengaudus, who in the black Rider sees the 'dark men of the Law'; the application to avaricious prelates is probably due to the editor of the legends.

In the final scene: 'the opening of the fourth Seal signifies the prophets who foretold Christ.' The Eagle says: 'Understand spiritually what Scripture says about the Law.' Near the Rider: 'He who rides this [pale] horse is the Lord: He is called "Death", according to the text, "I shall kill, and the lowest Hell will devour whosoever has despised me."' Near the head of the Rider: 'the bad example of the doctors'; and, explaining the bowl with fire held up by the horseman: 'the fire carried by the Rider is the wrath of the Lord

Coloured woodcut of the Apocalypse. Modena, Biblioteca Estense, AD 5.22. (181)

276

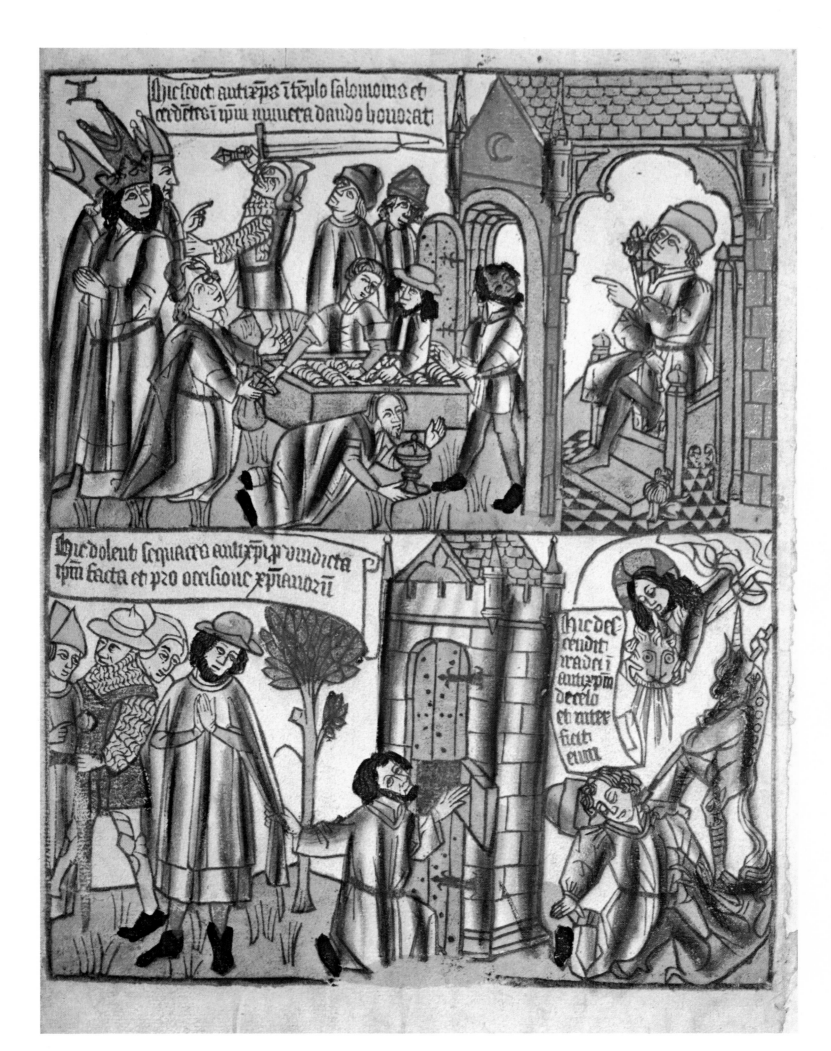

punishing the reprobate.' We have seen, above, how Berengaudus's idea of connecting Rev. VI: 8 with Deut. XXXII: 22-5 offers the only explanation of the mysterious bowl of fire.

The analysis of these two average pages makes it sufficiently clear that the captions borrowed from Berengaudus may be necessary in one or two cases, but as a rule are of little use for the understanding of the illustration. As a whole, the illustration closely follows the old Anglo-Norman cycle in its most complete form, which includes an extensive *Life of John,* and, also, in connection with the episode of the two Witnesses (Rev. XI), an interlude concerning the Antichrist, who is not mentioned in the Apocalypse but figures in St Paul's Second Letter to the Thessalonians (II: 3-12).

The block-book consists of fifty woodcuts, engraved on both sides of twenty-five blocks numbered with the letters of the alphabet and two other signs; consequently the same letter is seen twice, on subsequent pages. Nearly all pages show two scenes, one above the other; four of them form one single vertical composition absorbing one or more secondary motifs. John's *Life* occupies six and a half pages, with thirteen episodes; five scenes deal with the Antichrist. The rest, thirty-three, are dedicated to the Apocalypse.

The compositions reproduce those of the old miniatures so accurately that, notwithstanding the simplified pattern, everybody recognizes almost every figure, every group and even attitudes and accessories. Iconographically, there is nothing new; the charm of the block-book is found entirely in its clean, new technique, the skill of the draughtsman in reducing the pictures to linear simplicity and the radical popularizing of a traditional and venerable repertoire.

This adaptation to another public, another epoch and another technique is perhaps its most striking feature. The still partly symbolical,

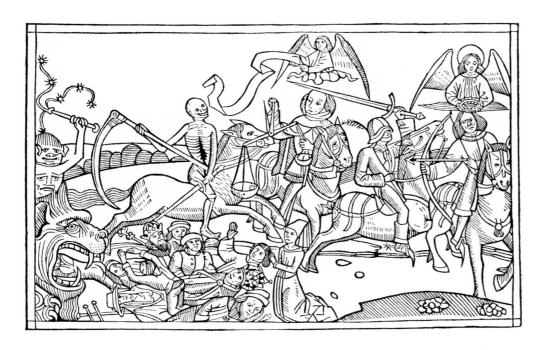

The four Riders. Woodcut from the *Cologne Bible,* 1478-9. (182)

278

distinguished, graceful miniature of old has become a cheap, severe print, in a popular book. Even though the captions are in Latin, the prints are meant to be bought not by the lords of the court and the castle, but by the ordinary cleric and the citizen of the crowded cities.

Costumes, armour and arms are modernized. And, above all, the faces have changed: they are prosaic, level-headed, quietly astonished, obtuse and uniform. Incidental scenes enliven the stately old compositions. The Ephesians harangued by John are authentic ghetto-Jews, intelligent merchants with canes, gloves and the compulsory pointed caps. A midget court-jester, squatting at the feet of the proconsul, fondles his pet dog. A ship's boy casts a tiny anchor in the harbour of Ostia. The informer denouncing John to Domitian is an ugly little rat, a bald sneaking fellow who whispers into the Emperor's ear. A cock is perched on the helm of the ship in which John, bound for Patmos, quietly reads a book.

As in the Flemish miniature (BN néerl. 3), the seven candlesticks *138* have no candles (they are already lacking in the *Liber floridus*, three centuries earlier). A tall angel holds the mandorla of the Throne *176* high above his head, but he is seen in front, and one realizes how splendidly the master of the Flemish Apocalypse has transformed *141* him. A small organ has been put before the group of Elders; the Elder consoling John is a typical schoolmaster in a don's gown. The little Souls under the Altar pull their white shirts over their heads like children changed on a Saturday evening. We are definitely in Holland. With chubby cheeks the angels are blowing their trumpets. The key of the Bottomless Pit is marked by a tassel with a small pine-cone. The Locusts have sheep's heads. One of the nicest groups is that of John and the angel prompting him and whispering: 'Do not write what the seven thunders are rumbling!'

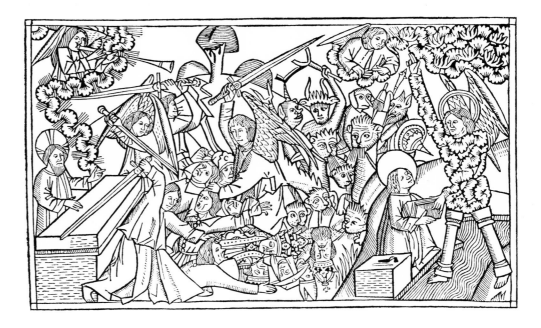

The Great Angel (with pillared legs) giving the little Book to John; the four angels of the Euphrates striking the wicked; the heavenly Altar. The *Cologne Bible*, 1478-9. (183)

The Antichrist is a princely man, alternately young and bearded, with a high cap and a judge's sword; with a tap of his cane he uproots trees. His liveried footmen distribute gold coins to grabbing worshippers, while he sits on his folding-chair, holding a sceptre and giving orders. In the final scene, the Lord Jesus, holding a Wind-head, blows the cap from his head, and the caption says: 'here divine Wrath descends from heaven upon the Antichrist and kills him' – 'with the breath of His mouth', as St Paul says. Through a peep-hole in the closed temple-door an attendant catches a glimpse of the scene, while he seizes the slip of a second who does not understand; a third is wiping his eyes. Demons are pulling the pseudo-prophet from his seat and one of them is poking his back with a stick.

For the rest, the episodes are the same as of old, in the miniatures; only the representation is jovial and often trivial. The harpers are stupid youngsters swathed in long albs, the Sea of crystal has been forgotten. At the pouring out of the fifth vial, the tormented blasphemers stick out enormous tongues. The heads of the doomed Babylonians look out vacantly from a kind of port-hole set in a cliff. The Great Prostitute, a plump middle-class lady, shows thick pigtails hanging down under a kerchief. The blessed dead 'which die in the Lord' are lying, five of them, in a bedstead, and five naked little Souls, hands joined, are escaping from the five pillows. In the scene of the Marriage, the Lamb leaps to the lap of his Bride, the Church, who looks like a morose Mother Superior.

The last page is perhaps the most moving. John is celebrating his last Mass. With uplifted hands, and a quiet face contrasting with his tousled hair, he is standing at the side of an acolyte in a long surplice who, of course, is thinking of something else. Not far from the Altar the saint is seen lying peacefully and smiling in his tomb, and the legend says:

> After John had finished his prayers such a great light caught him that nobody could see him any more. This is that John about whom the Lord said to Peter: "If I will that he tarry till I come?" Nothing was found in his tomb, save the manna that is seen flying up from it until the present day.

Far away in Hippo Regius Augustine had heard about it, and he mentions the miracle in his *City of God*. Alas, in 1430, Ephesus was lying waste in the empire of the Great Turk, and the sanctuary had been deserted. I wonder if the Dutch cleric knew about it?

There is nothing to be said about the reprints, mostly hand-coloured; for the Haarlem block-book, the prototype, is far the best of all xylographic Apocalypses.

The *Allerheiligenbild* ('All Saints') of Albrecht Dürer (see page 292), 1511, made for an Old People's Home in Nuremberg. Above: the Great Multitude (left, with palms; right, the saints of the Old Testament) before the Throne of Grace (*Gnadenstuhl*). Below: the Church Militant on earth, with Pope, Emperor, people of all walks of life, and the donor, Matthew Lanauer. At the extreme right: the small figure of Dürer himself, holding a tablet with the inscription 'Albrecht Dürer, from Nuremberg (NORICUS is the old Roman province of Noricum) made this, in the year after the Virgin Birth 1511. Vienna, Kunsthistorisches Museum. (184)

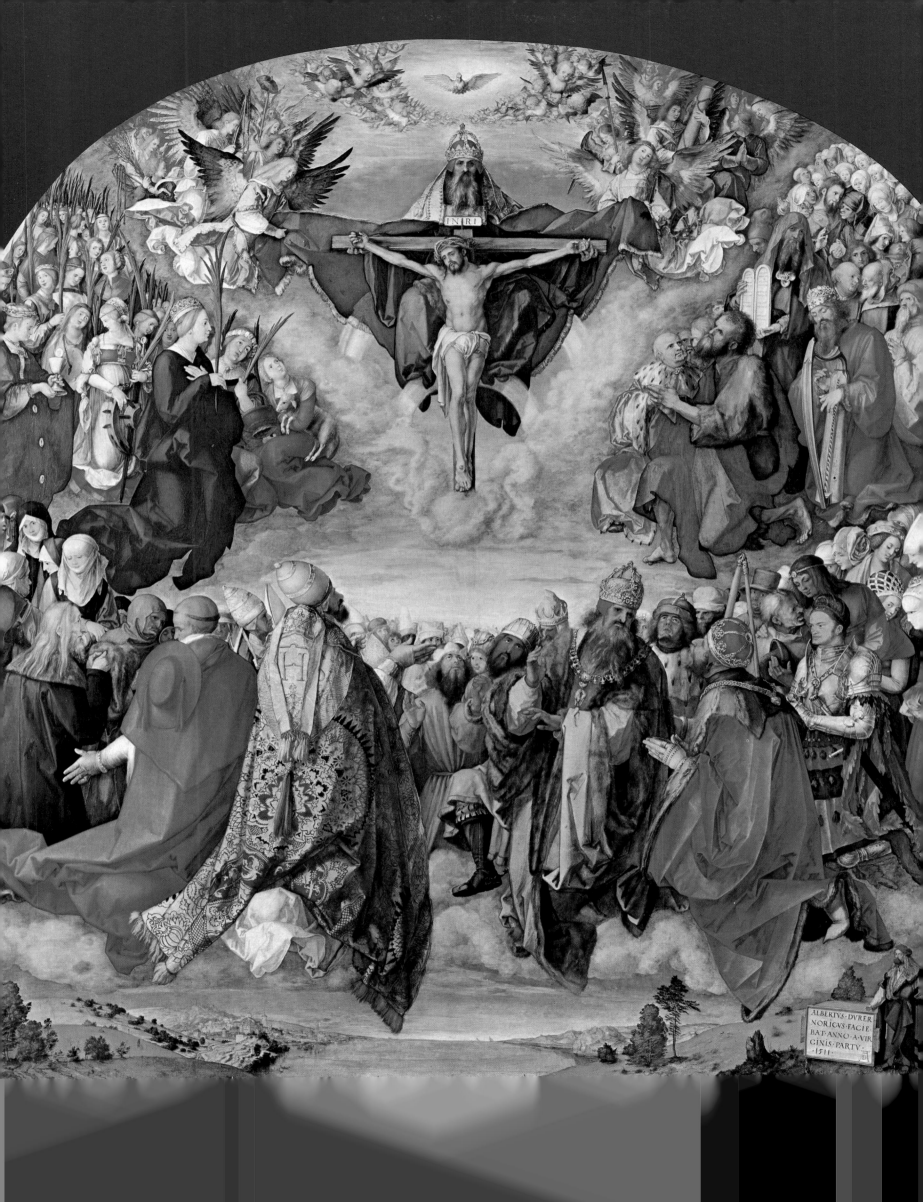

ALBERTVS·DVRER
NORICVS·FACIE
BAT·ANNO·A·VIR
GINIS·PARTV·
·1511·

Albrecht Dürer

In the spring of 1498, Albrecht Dürer, a twenty-seven-year-old goldsmith's son from Nuremberg, already much-travelled and well versed in the graphic arts, published what he himself called his 'Great Book', a series of woodcuts of the Apocalypse, which at once made him famous. Of course he did not make them entirely from nothing. After 1498, however, nobody wondered where Dürer discovered the elements of his staggering visions, so overwhelmingly original and colossal did they appear to his fellow craftsmen, as well as to the amateurs.

His work superseded everything prior to it. For some episodes, which Dürer had left out on purpose, because he had decided not to exceed the number of fifteen prints – for instance the two Witnesses and the Mariage of the Lamb – his imitators, who wanted these very scenes for a more prolix and complete illustration, would occasionally consult Tradition. But what impact could this traditional work have beside the inventions of this young man of genius?

In the printing office of his godfather, Anton Koberger, he had, of course, seen the eight woodcuts illustrating the Apocalypse in a Bible published in 1483, of which only this last book showed any illustrations. They were mediocre copies from a series of nine published in 1478-9 by Heinrich Quentell, in the so-called *Cologne Bible,* and taken over into the *Strasbourg Bible* of 1485.

The Cologne woodcuts are energetically drawn and make one think *182,183* of some fluent French model rather than of a heavy German one. They show a number of motifs lacking in the xylographic Apocalypse from about 1420-30, mentioned above, and *a fortiori* in the old cycle found in the manuscripts. We do not know whether Dürer knew the Haarlem block-book, but xylography was a young technique and the craftsmen did their best to set eyes on a many as possible of its not yet too numerous products.

Dürer knew Cologne. He might have seen the altarpiece of the 'Master of St John's Vision', ordered by the Lord Mayor, Scherfgin, *39* about 1450, representing the Heavenly Liturgy; or the curious *Coronation of the Virgin among the Elders* (conspicuous for their sweet *43* horse-faces) from about 1460, but we simply do not know. Did he visit Flanders before 1498? And did he, possibly, see Memling's side-wing at Bruges, where the apocalyptic Throne hangs above a landscape full of far-off cataclysms? It seems wise to abstain from un-

Title-page from the Latin edition, 1511, of Dürer's Apocalypse, containing fifteen engravings, which are explained on pp. 298-313. John seeing the Woman and Child, with the legend: APOCALIPSIS IN FIGURIS. The German edition, Nuremberg, dates from 1498. (185)

founded suppositions, but the fact remains that Dürer borrowed the age-old scheme for the Heavenly Liturgy, as seen in the three paintings just mentioned, and everywhere else: probably it could not be improved even by a draughtsman of his inventiveness.

He knew Martin Schongauer's copperplate showing St John on Patmos, but this subject was current and as much in demand as the Woman clothed with the sun, a favourite motif for church chandeliers. He knew, of course, the fall of the angels by that other teacher of his, Michael Wolgemut, with those hideous hermaphroditic demons, and his woodcut with the Elders cased around the Majesty, both in Koberger's *Schatzbehalter,* of 1491. Finally, in 1495, he had returned from Venice, where he had known Mantegna, Carpaccio and the Bellinis and had generally had his German's eyes wide open all about him.

That he brought out his book as an in-folio (the woodcuts measuring nearly 30.0 by 32.8 cm), containing St Jerome's *Preface,* the text and the illustrations, and with the text first in German and then in Latin, proves how seriously he set to work.

He must have been obsessed by the actuality of *Die heimlich Offenbarung Johannis.* No wonder. These were the days of Pope Alexander VI, that 'Fisher of men who saw his own murdered bastard fished out of the Tiber'; of the young emperor Maximilian, the 'last of Knights'; of King Charles VIII of France, who, after the Italian campaign, in the train of his army, brought the Renaissance and syphilis into the country of the cathedrals; of Beyazit II, filling the half-emptied town of Constantine with huge mosques. Dürer was living at the very heart of a profoundly disturbed and often desperate Christendom, hankering after a renovation of almost everything in Church and State. Much of what happened elsewhere penetrated into the beautifully pannelled mezzanine apartments of the free town of Nuremberg, a city dedicated to religion and the cult of the fine arts. It also reached the ears of Dürer, and set the guileless but intrepid soul of that young genius in an apocalyptic blaze.

THE COLOGNE BIBLE

It seems that he was particularly struck by those features in the primitive woodcuts of the *Cologne Bible* that were lacking in the traditional cycle, for he borrowed a dozen of them for his own use. Thus we find the long-handled wooden tub of boiling oil that an executioner's aide is emptying on the head of St John; the four Horsemen who ride in one oblique gallop, each overlapping the other; Death representend as a half-carcass (the scythe has been changed into a trident); the angels of the Euphrates striking a tumbling crowd with enormous swords (they are no monsters, but grim, curly-haired young men attired in amices, albs and cingulums); the Great Angel wrapped in a jacket of clouds and showing columns instead of legs – the 'pillars of fire' of the text – his toes sticking out from under the

186
189

193

194

From the *Life of John:* the saint in the cauldron of boiling oil. (186)

I *Overleaf:* the Son of Man among the candlesticks. (187)

II *Overleaf:* the Open Door, the Throne, one of the Elders talking to John. (188)

284

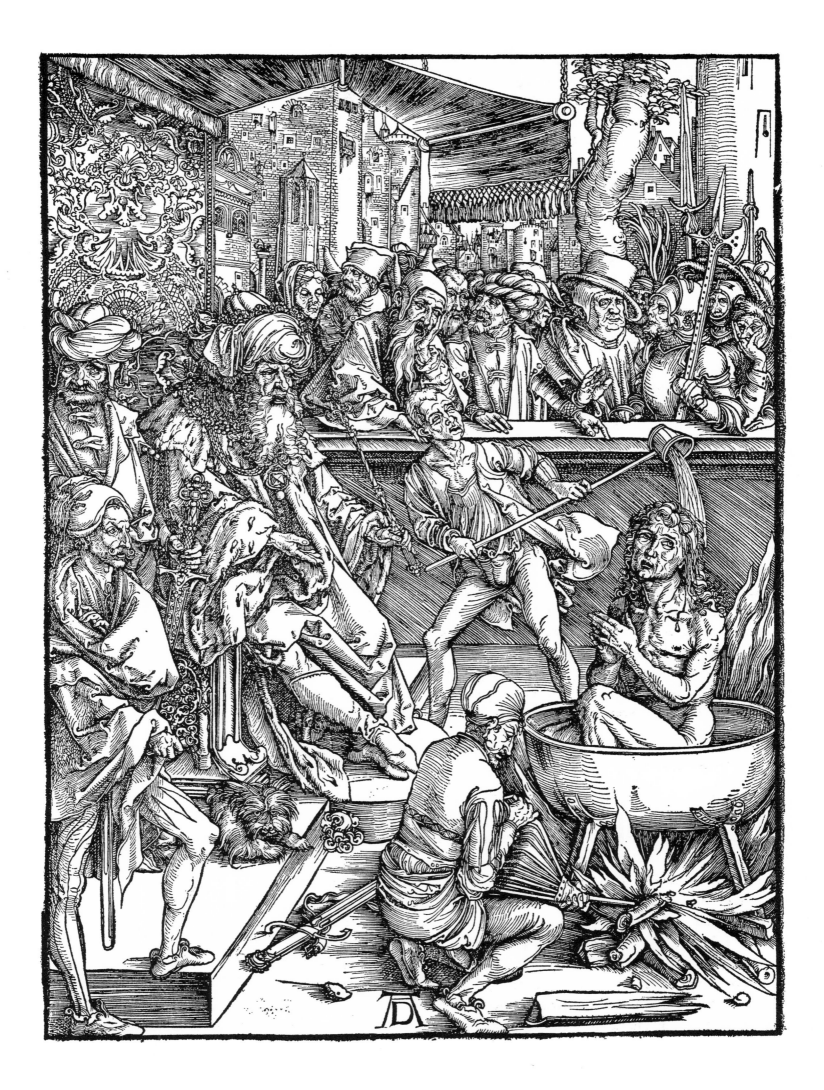

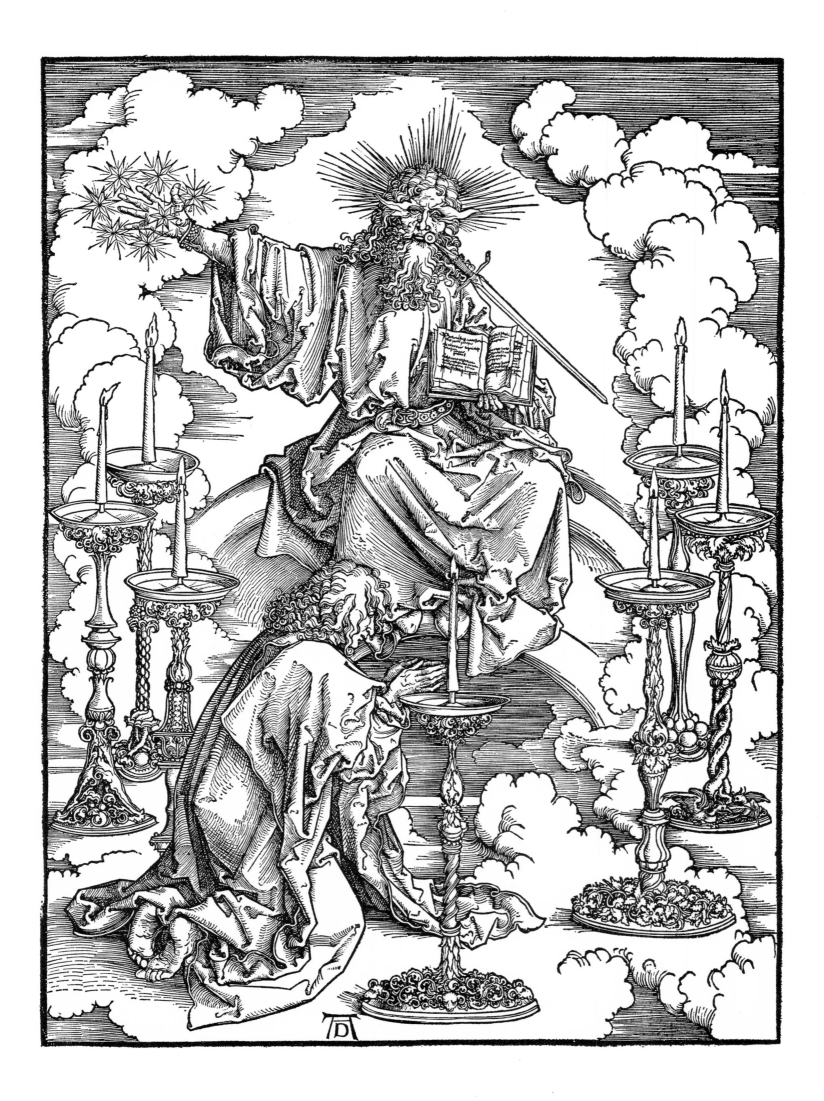

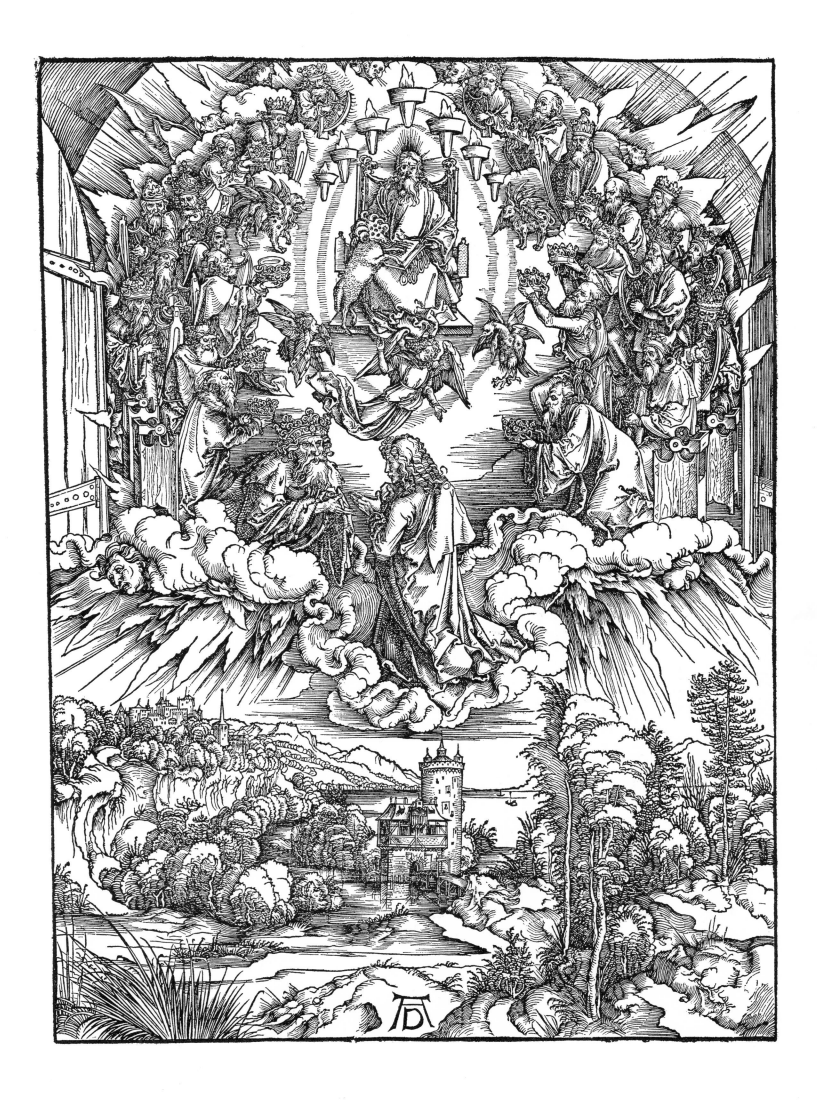

base (this hideous detail was left out by Dürer, but he retained the pillars and, alas, by doing so perpetuated for good those ungainly columns sustaining the cloud-man like the legs of an A); the four

191
angels threatening the Winds with sword and shield, and waiting; the Great Prostitute dressed up after the fashion of the day (Dürer only changed the *hennin,* the pointed coif, into a Carpaccio head-dress); the seven heads of the Beast, erect on worm-like necks run-

199
ning parallel to each other; a millstone with a swallow's-tail hole;

191
little crosses on the foreheads of the one hundred, and forty-four thousand 'sealed' Elect; Christ at the Harvest holds a sickle instead of a scythe; and while in the *Cologne Bible* the third Horseman, Famine, cheats by holding up one scale of the balance, Dürer's miser swings his balance into the air, like a sling.

Several episodes never omitted in the older cycles were consciously dropped by Dürer: the passion and the ascension of the two Wit-nesses; the Lord treading the grapes in 'the great winepress of the wrath of God' (Rev. XIV: 19); the Marriage of the Lamb; and, cur-iously enough, the pouring out of the vials of wrath. Everything he borrowed was incomparably enhanced; a great man can use almost anything. As the French say, he 'carves arrows out of all wood'.

DÜRER'S FAME

Erasmus never stopped wondering how his friend Dürer – who made his portrait – managed to evoke so much, human and divine alike, without a spot of colour, merely with thick and thin black lines. 'The things he draws that cannot be drawn!' he exclaims, in a *Dialo-gue* about something quite different; 'fire, rays, thunder, lightning, light, walls of clouds, even the affections of a man's soul, and nearly his voice.' He wrote this in 1528; by then, Dürer's woodcuts had long since conquered all Christendom, and his uncanny skill as a draughtsman was admired even by his Italian colleagues. Erasmus's opinion was shared by everyone with good eyes. In north-eastern France, the master glaziers, when designing the working sketches

203,204
for their church windows, had Dürer's prints before them. Their magnificent Apocalypses in stained glass can be admired in a dozen places but even the gorgeous colours are unable to make one forget the models: Dürer's unsurpassable groups and passionate characters strike the eye. After 1500, Dürer held the monopoly of the Apocalypse.

HIS STYLE AND TECHNIQUE

Like all born engravers, he exploits the possibilities of the métier, and especially those of his raw material: pear-wood, which does not splinter. To suggest a clear sky he uses stripes of horizontally super-imposed thin lines, set off against the outlines of flying angels and

187
bulging cumulus clouds. To give depth to a landscape, he progres-sively thins the outlines of hills and mountains, subtle coulisses vanish-

III The four Riders. (189)

IV *Overleaf:* the Souls under the Altar, the downfall of the stars, the people hiding in the caverns of the earth. (190)

V *Overleaf:* the four angels holding the Winds; the Sign of the Living God (the Cross); the Elect marked (one of them is Dürer himself). (191)

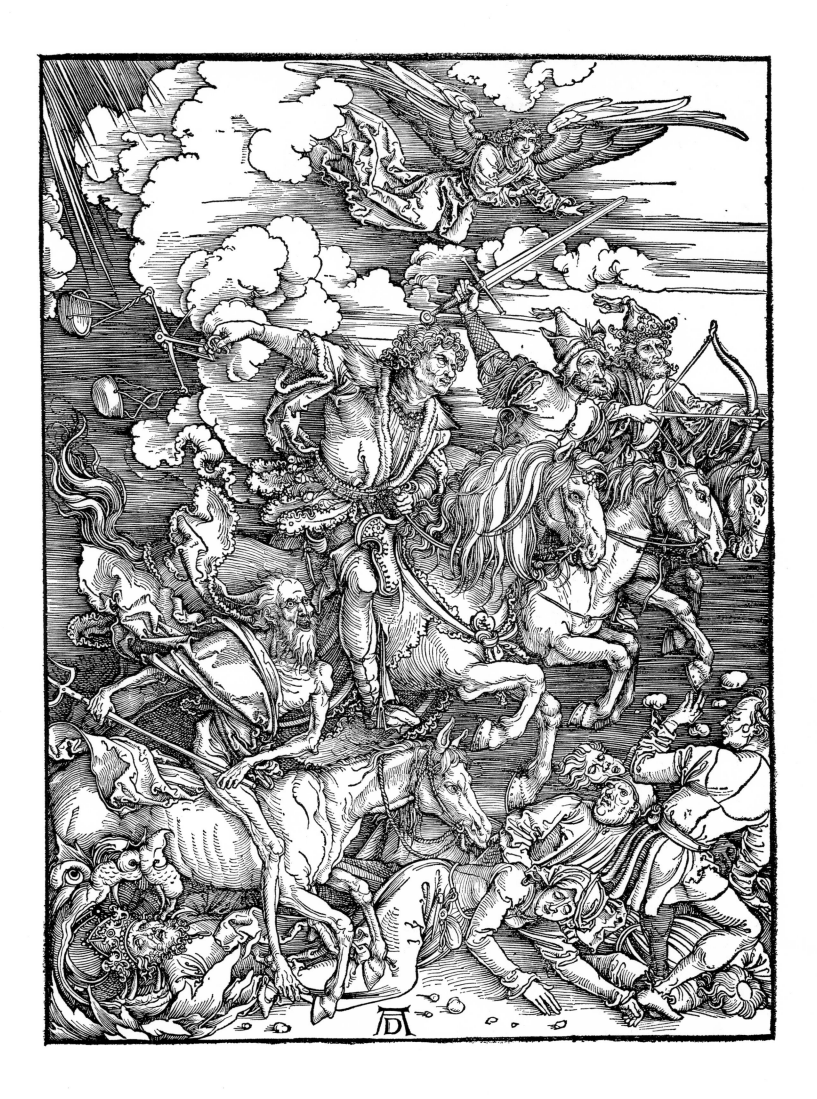

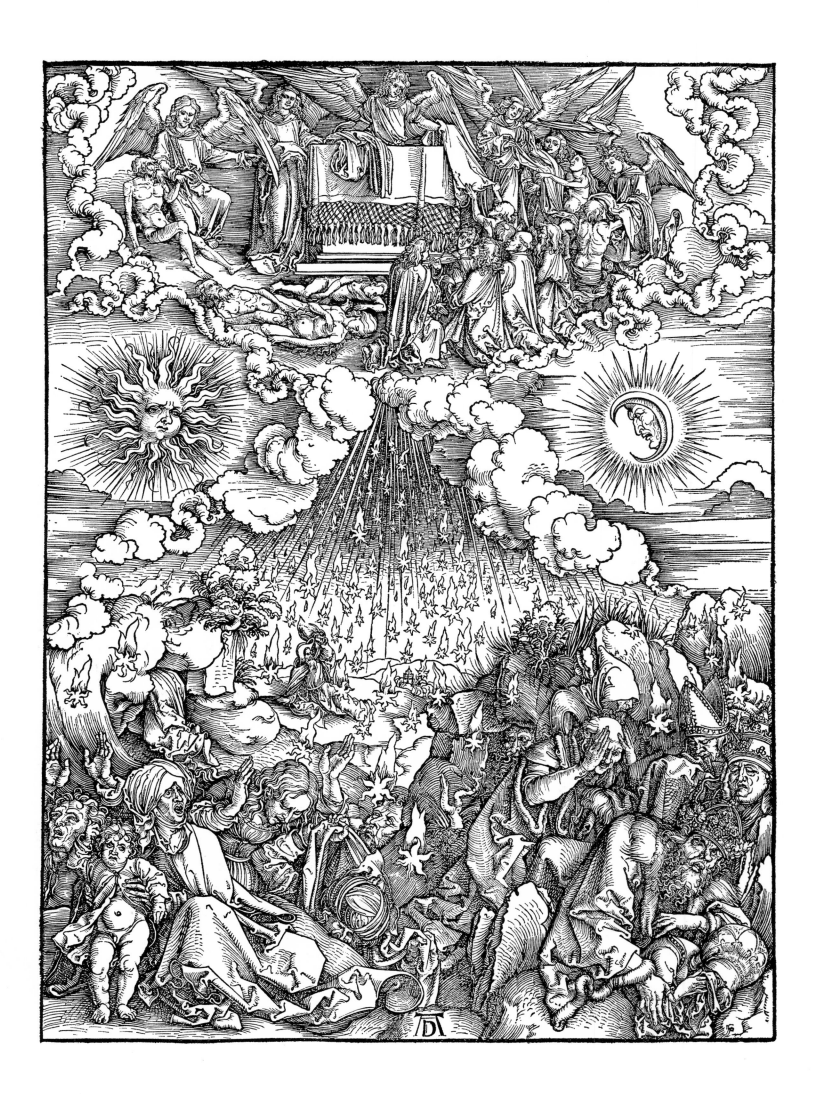

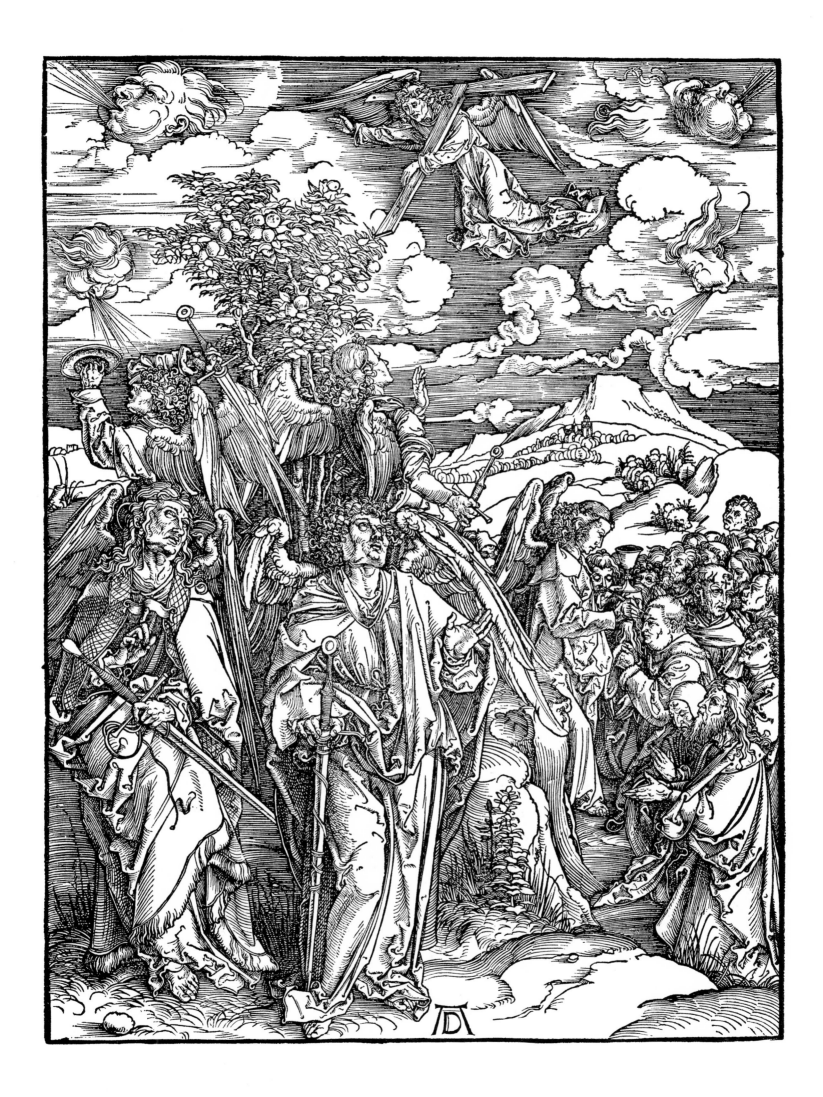

200
194

ing into an almost imperceptible horizon, far behind a more elaborate, heightened foreground. Silence is evoked by motionless branches of bare tree-tops, above which a flock of migratory birds is passing, and gnarled roots that change into high, smooth, straight trunks, towering above tufts of grass and pebbles on a sandy path.

He does not want heavily blacked parts, he can do without 'shadow', his plastic effects are obtained by innumerable varieties of bundled fibres, clustered stripes and hatches. As for his compositions, the chief figures are grouped like the sculptured groups set in the cases of wooden retables, the most important abreast, the others behind and above them, the far-off on a smaller scale. In his buildings he avoids the long lines, converging at a vanishing-point, of the *costruzione legitima,* which, of course, he had studied in Italy (and was to use copiously afterwards himself). In his background prospects he uses only empirical perspective, and always by means of gradually refining the contours of successive planes.

193
196

Looking at his Apocalypse, no one suspects that four years before he had come back to Nuremberg with a head full of Italian reminiscences – though one small Venetian palace, with quattrocento windows and scalloped tympanum, is seen among the sturdy houses of a Franconian town, in the background of the print showing the martyrdom of St John. The *Welschen,* the artists on the other side of the Alps, may have sharpened and schooled his eyes, they could not change his outlook. His people are as strong and as expressive as those of Schongauer and Wolgemut; his mastery as a draughtsman is immeasurably superior, but he is in the same tradition of emotional power. As the young Goethe said: he is 'thoroughly manly'.

186

Strictly speaking, all his faces are ugly; those of the wicked, hideous, those of the good people, plain. Some are noble. But beautiful, by the ideal standard of the southerners, they never are. One has only to compare a crowd of Raphael's *Stanze* (of slightly later date) or a turbulent scene of Poussin (a century later) with Dürer's multitudes. They are a crude humanity of fat priests, unidealized princes, brutish lansquenets and, also, solid bearded family men, housewives with bonnet, apron and bunch of keys, curly-haired angels hurrying about in their crumpled liturgical vestments and, finally, the Lord himself appears in a cope fetched from a rich vestry and the appalling crown of the German emperors on his mighty and sorrowful head.

197

The rabble from the *Borgo,* in Raphael's fresco, seem to come out of the Golden Age; Poussin's people appear to have risen from Antique sarcophagi or to have been resuscitated, in fresh colour, from forgotten Attic murals. With Dürer one feels as if one were moving in Nuremberg, or even assisting at a Diet, and yet, at the same time, witnessing the Last Days, and, sometimes, having a short view of heaven. With this triumph of the commonplace over the sublime, even in the representation of sacred reality, the waning of the Middle Ages, that strange epoch of contrasts comes to an end.

VI The trumpets distributed, four of them being blown; the angel casting the fire from the cens reupon the earth; the Eagle crying 'Woe!' (VE VE VE); two hands throwing the burning mountain into the sea; the Star Wormwood falling into the cistern. (192)

VII *Overleaf:* the sixth trumpet: the four angels of the Euphrates striking the wicked; in the sky, among clouds, the fire-breathing leopard-horses. (193)

VIII *Overleaf:* the Great Angel and John devouring the little Book. (194)

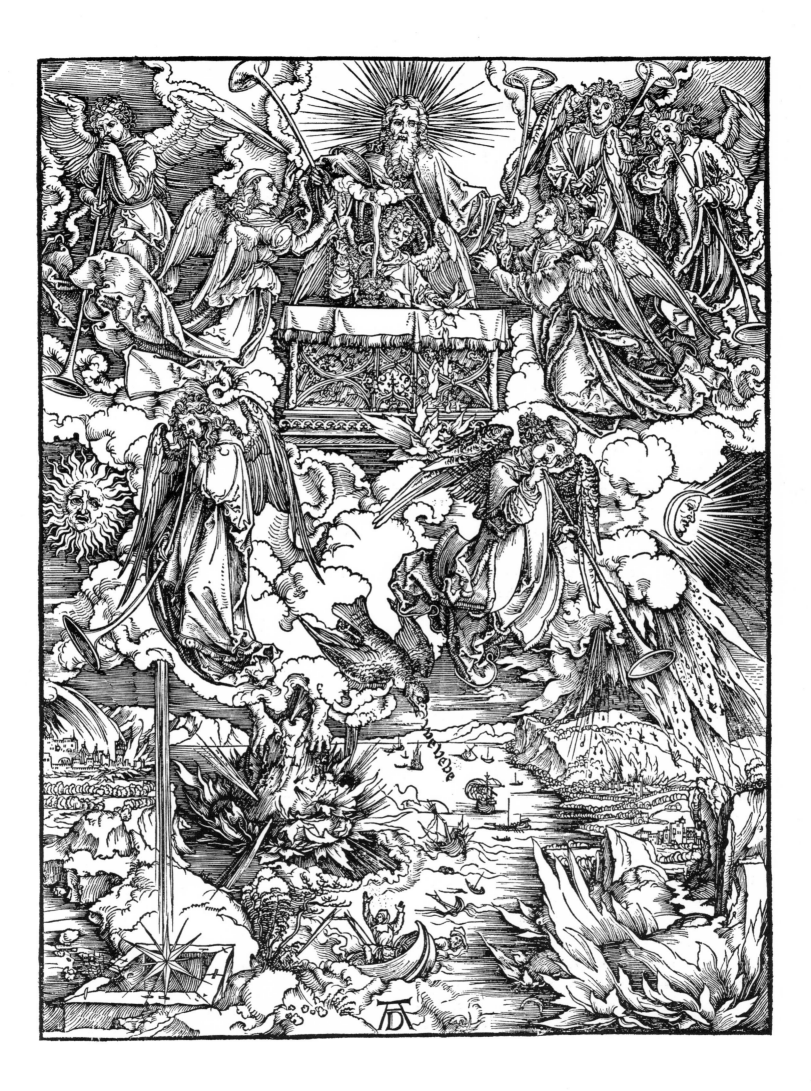

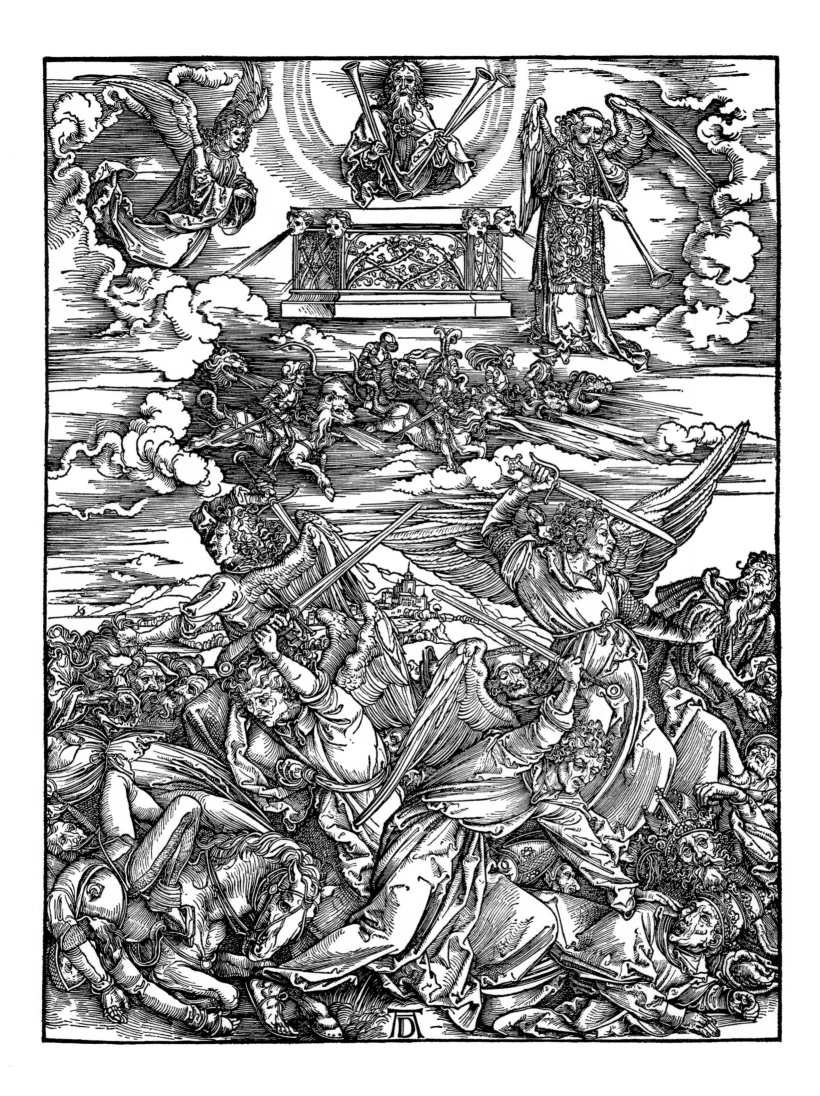

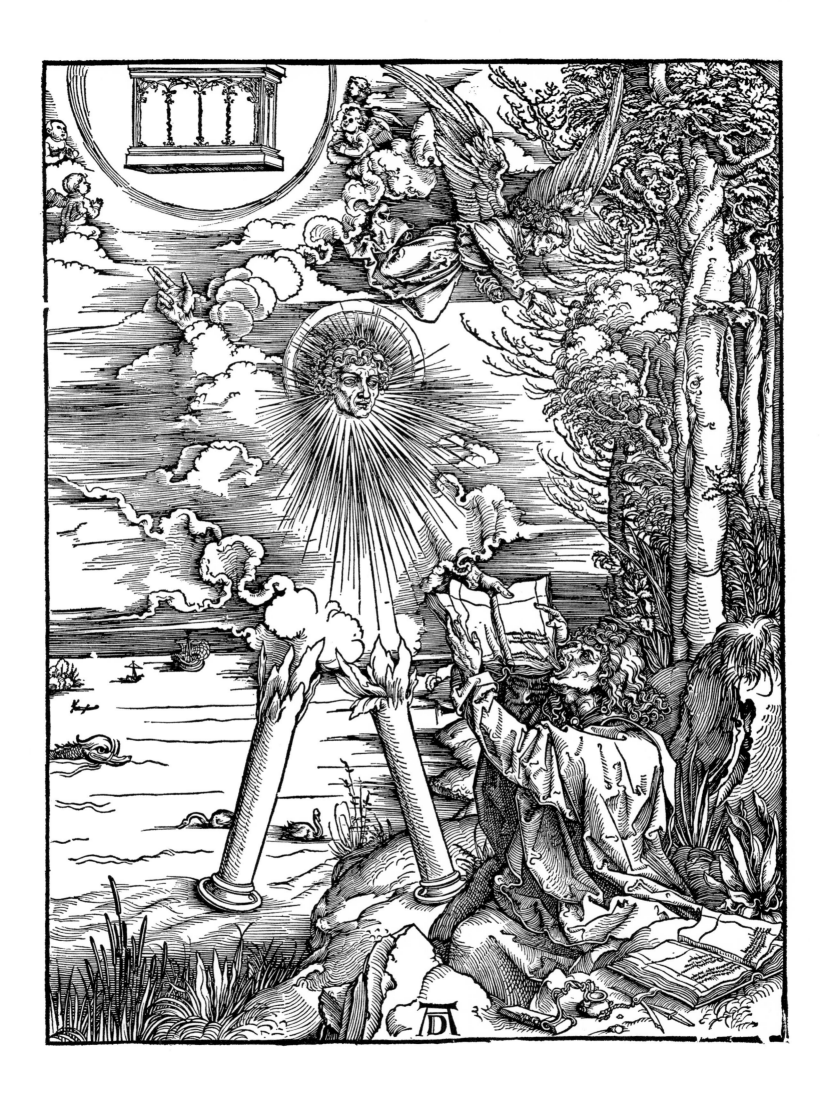

Dürer's prints should be kept in the home, where they can be enjoyed by being continually studied, for they cannot be described. However, it might be useful to examine them, initially, one at a time, and draw attention to the details, which are often overlooked simply because of the powerful and ever-changing concept of each print as a whole.

THE FRONTISPIECE

185 To the Latin edition of 1511, a title-page was added with the heading *Apocalypsis in figuris*, a masterpiece of Gothic calligraphy, and, somewhat below it, an introductory vignette. From a crescent of curling clouds, John emerges, sitting between his (very small) Eagle and his ink-well, with a book on his knees and his stylus ready. He turns his head and seems to be listening and seeing something extraordinary, for he raises his hand in rapture. His vision appears behind him: on the sickle of the moon is the Woman, half-length, in the middle of the sun, a crown of twelve stars on her long maiden's hair, holding a chubby Child nestling close to his mother. John resembles Dürer: it is almost a self-portrait.

THE MARTYRDOM OF ST JOHN

186 In both editions, the first print shows a motif from the *Life of John*: his martyrdom in Rome, already mentioned by Tertullian, and traditionally located at the Latin Gate. It is print full to the brim. Hands joined in prayer, the Apostle squats on the bottom of a shallow cauldron full of boiling oil, licked by flames crackling above splintered wood. He is a poorly built man, with too large a head, a *leptosome* torso and thin arms. Th9 resignation seen on his simple face one would expect more from a meek man like Tilman Riemenschneider than the always forceful Dürer. The torturer, who has unbuckled his sword, is comfortably seated on his heels quietly handling his pair of bellows. His aide, an ugly guttersnipe in a crumpled loose blouse and hose showing an enormous *braguette*, his wry mouth open and his eyes closed because of the heat, is mechanically emptying his long-handled pan over St John's curly locks.

Domitian, in a velvet gown, a collar of ermine, pointed boots of soft leather, a double chain with a cabbalistic stone round his neck and a high turban with a crown on his head, looks like an old asthmatic sultan, leering slyly with short-sighted eyes: clearly, a portrait of the Great Turk, the arch-enemy of Christendom. With half-open mouth, extending a small soft hand, he is watching the tortured man, who seems unmoved. The turbaned grand-vizier, standing behind him with the dress-sword, shows some embarrassment; the clerk, a skinny, spindle-legged ruffian with twisted moustache, does not even dare to look; only the Pekinese dog on the throne-step is looking at us, with its false eyes.

IX The pregnant Woman; the Dragon; the Child carried to the Lord; the earth swallowing the water; the stars swept down by the Dragon's tail. (195)

296

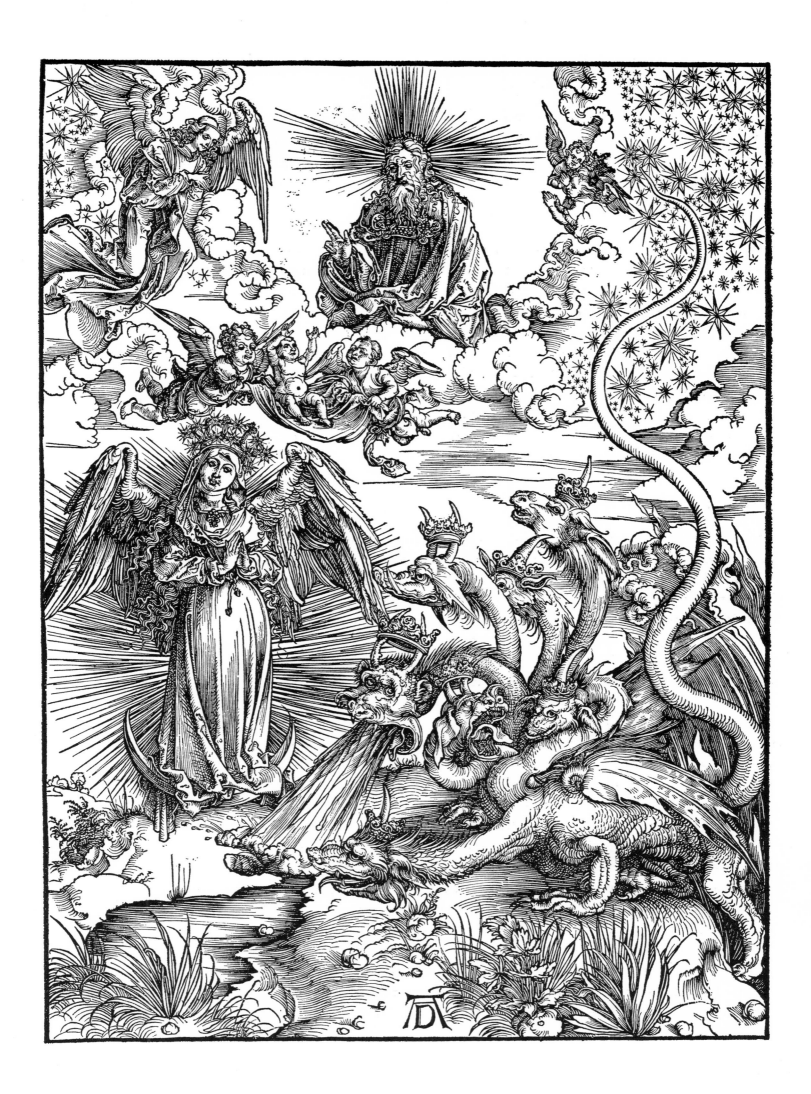

The background is more or less framed by the fringed canopy fitted on rods above the Throne. It shows an ugly Franconian street with gloomy towers and tiny windows in many-storeyed houses; an oriel window, probably a house-chapel, sticks out of a wall; the (far too small) column with St Mark's Lion, of the piazzetta, is seen next to a modest Venetian palace. Nothing recalls Rome or the Latin Gate.

In front of this scene, an eager crowd is enjoying the spectacle – ten faces, and as many head-dresses: pointed caps, low caps, a cocked top-hat, a trilby hat a turban. They hang over a wall, talking, looking elsewhere. A Turk is pointing to John, another is staring absently through his fingers; two pikemen, huge ostrich feathers standing up on their visored helmets, are absolutely uninterested.

Dürer's intention is clear. Serenely, the martyr waits for the things the Lord has in store for him, before the eyes of tyrants and imbeciles, the public ever-present at executions.

DÜRER'S APOCALYPSE

187 **I John is seen kneeling,** in the first scene, between two of the seven candlesticks. His eyes are downcast and long curls are hanging over them. His hands are joined. One immediately recognizes the young face and the famous draughtsman's hands of Dürer himself. A slip of his mantle is stretched out before him, the slightly curved bare soles of his feet stick out from the hem behind. He is the very image of a man upset by a Numinal Presence, another Samuel: 'Speak, Lord, thy servant heareth'.

The Son of Man is not walking among the candlesticks; he is sitting on a rainbow, and his feet (definitely not 'like unto fine brass, as if they burned in a furnace', but with shoes) rest on a second rainbow. Instead of being young, he rather recalls Daniel's Ancient of Days; the 'flames of fire' of his eyes flare up sideways from his brows, across his curled locks. At the corner of his mouth a long sword hangs down, the pommel of its hilt nearly touching his lips. A long beard covers his chest. A triad of rays is sent forth by this mighty Asclepiad head, mysteriously staring ahead. Out of an enormously wide sleeve, crumpled into improbable triangular folds, his right hand is raised to the sky, and around the expanded fingers the seven stars are dancing like gnats on a summer evening.

Crooked folds abound: above the golden girdle (here, not below the paps, as the text demands), in the lap, across the rainbow and in an ample slip next to the shoes. The Book is an opened missal, in which the initial and the lines are visible.

The Lord appears between billowing, towering clouds. John kneels on a floor of clouds, which are also supporting the nearly man-sized candlesticks – all of them are different, a repertoire of German and Italian chased work. It was not for nothing that Dürer was a goldsmith's son. Seven short candles are quietly burning, one flame is

X Michael and his angels fighting the Dragon and his attendants. (196)

XI *Overleaf:* The Lord holding the sickle of the Harvest; the Beasts worshipped. (197)

XII *Overleaf:* the Great Multitude holding palm branches, before the Lamb of Sion; one of the Elders explaining to John who they are. (198)

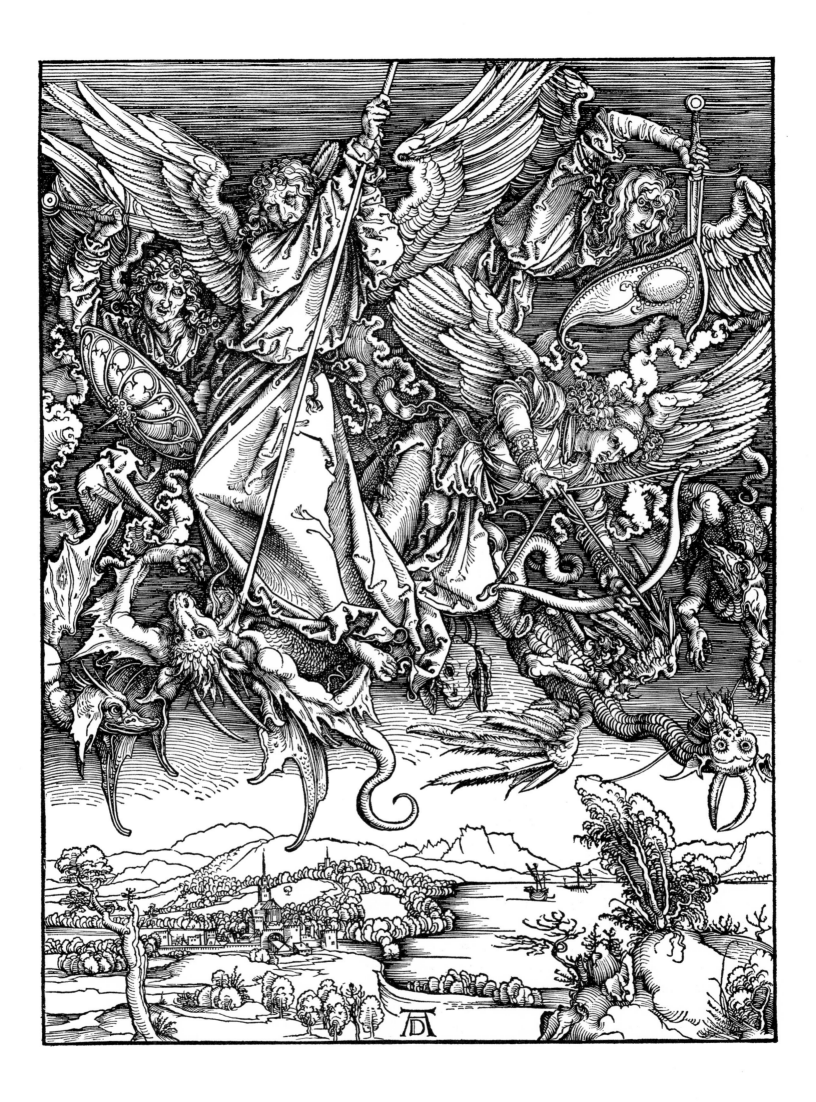

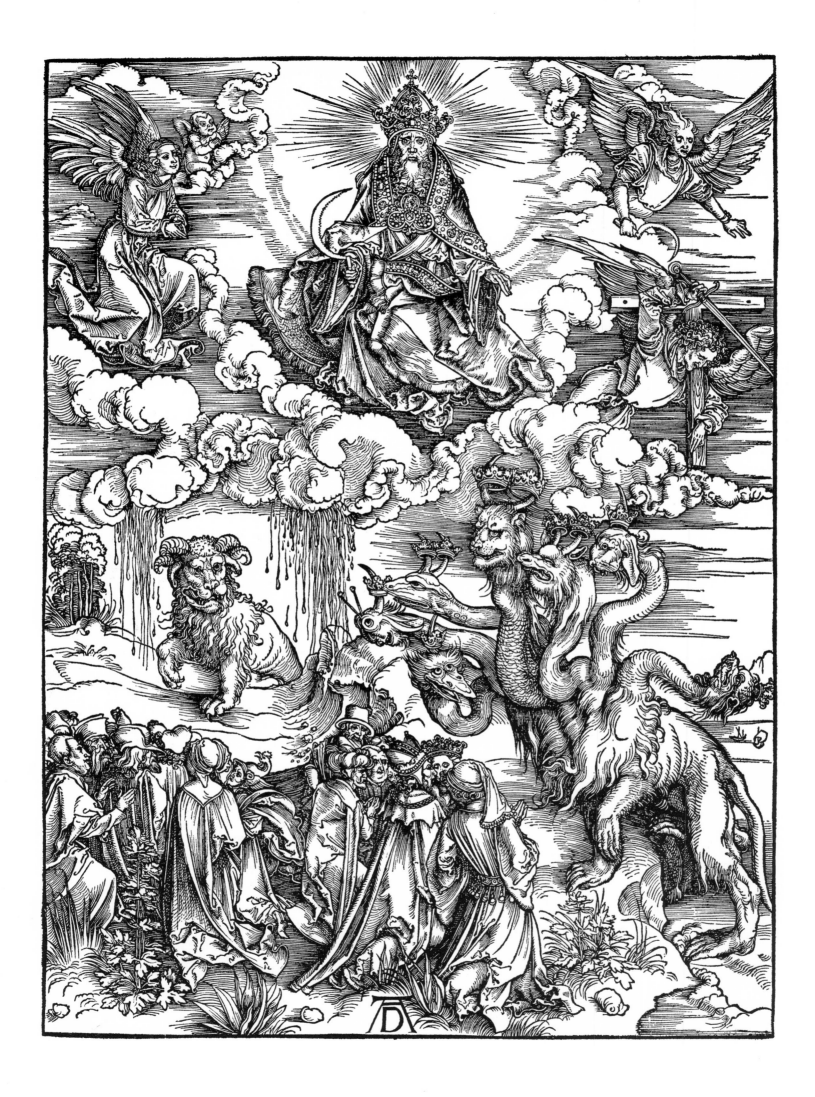

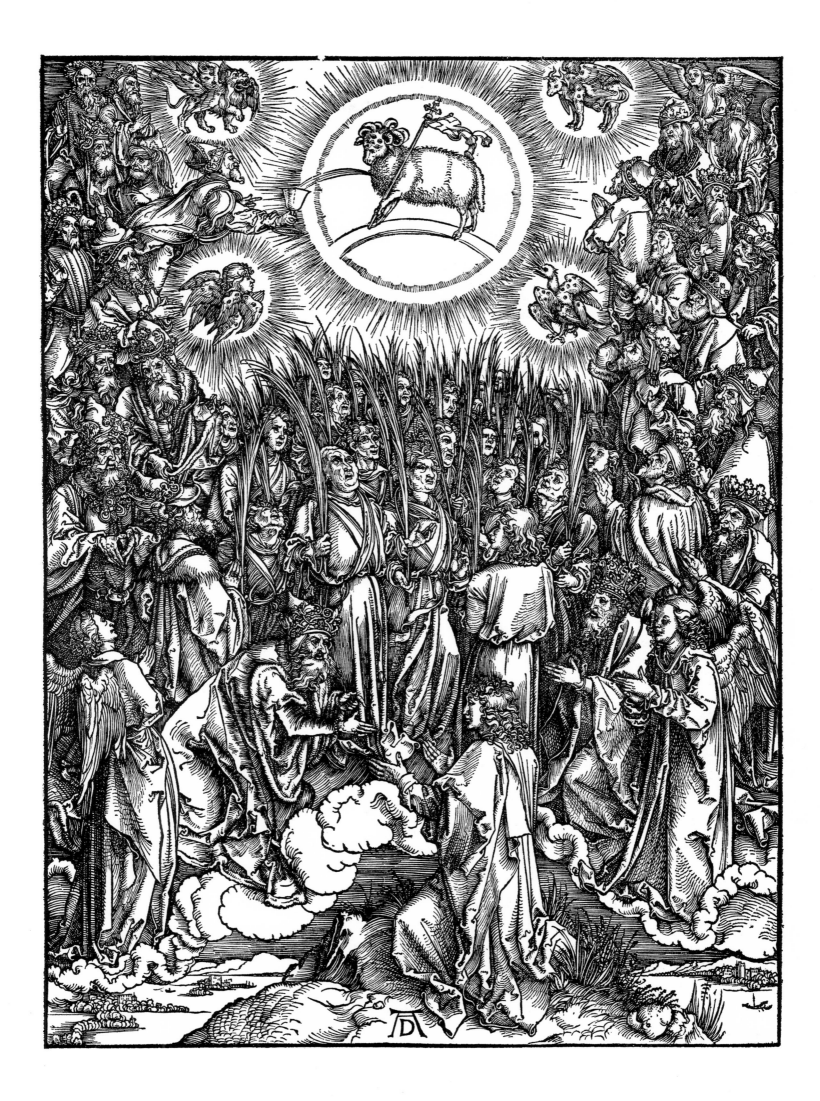

blown sideways by heaven knows what kind of superhuman draught. It was a Sunday, 'the day of the Lord' (Rev. 1: 10).

188 **II The Vision of the Throne,** borrowed from his predecessors because its composition could not be improved, bears the mark of Dürer's imagination.

He suspended it high above one of the loveliest and quietest of landscapes, of even his own invention. It is Peace itself, without a living soul – midsummer, reminiscent of a Sunday afternoon before Vespers. Smooth as a mirror, a bay glitters between low, wooded mountains studded with castles and spires; at the side of a pond, a Franconian stronghold, with draw-bridge and *Zwinger,* seems asleep; a sandy path winds through tufts of darnel grass. An idyll totally ignoring the lightning vision above.

The heavenly vision is seen through a huge arched doorway, the coarse wooden doors of which are thrown wide open; a celestial cloud already bulges across the threshold. One of the Elders is talking to John. The Lamb, with horns and eyes making its head look like a polyp, jumps to the lap of the Lord and seizes the closed Book, from which hang seven round Seals. The twenty-four Elders are all different; some are offering their crowns, no two of which are alike, others are playing the harp. Here are twenty-four masterpieces of a goldsmith's work.

The chainless lamps and the four Beasts are suspended in a halo of light. The angel, who calls John, is shouting in vain: everything is happening at the same time. And the twenty-four princely priests of heaven are sitting on low choir-stalls provided with the then usual convertible backs. To such an extent are earthly things at home in Dürer's heaven.

189 **III The four Riders rush along** together, 'as if catapulted', Emile Mâle splendidly said. They ride diagonally across the page, in one row, from bottom to top, and under the hoofs of their horses men and women topple like skittles. The angel crying 'Come and see!' looks like a small skirted bird fluttering overhead in a hole between the clouds.

The first Rider is a prince, with a crown round his tasselled, conical cap; he is about to release an arrow from a mighty bow. The second Rider, also in a pointed cap with split turned-up brim, is a warrior without armour, brandishing the sword of War above his head. The third, Famine, is seen from head to foot: a fat clean-shaven curly-haired ruffian with the face of Herman Goering, dressed like a showy usurer, with a velvet jacket, chased girdle and ostentatious necklace; the sable tails of his doublet flow behind an embroidered saddle. He is swinging his impostor's balance like a sling, high above his head. The Fourth, Death, is a hideous old carcass, thin-bearded, with fierce eyes and stumpy teeth in his half-opened mouth, grinning, staring ahead and seeing nothing. He holds a trident with both

XIII The Great Prostitute on the Beast admired by a crowd of people; the mill-stone thrown into the sea; Babylon on fire; between the clouds, the heavenly host is seen far away, led by the Rider Faithful and True. (199)

302

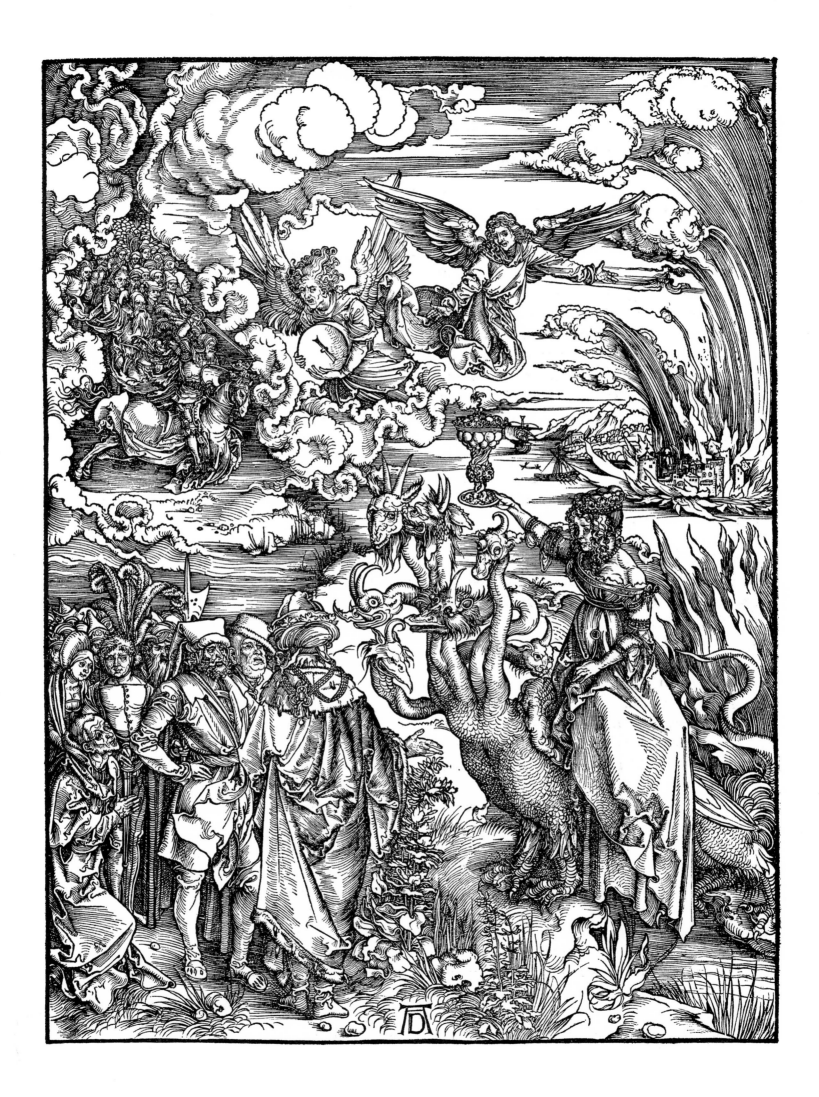

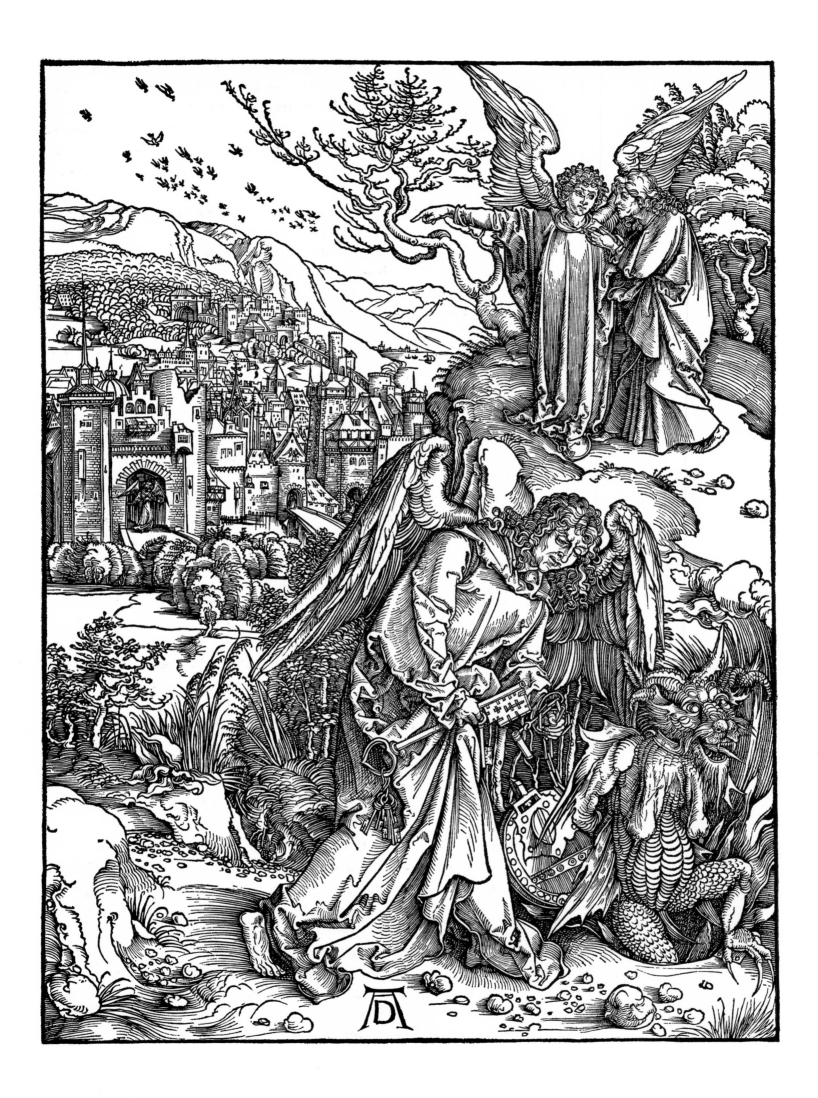

knuckly hands. His knacker's horse is so poor that its Rider's legs, mere bony sticks, are skimming the earth. Under its belly a dead emperor, crown and all, falls backwards into the mouth of hell. A housewife crawls on all fours, in agony; a surpliced canon looks up with glazed eyes; a girl screams; a tonsured cleric lies dead; only a small bald peasant is scrambling to his feet and, with a hunted look back, is trying to clear out.

Ever since the publication of this formidable print, the still half-symbolical horses of the Riders have run wild, when formerly they were so docile. Not for a moment did Dürer think about the Parthian archers or the dissolution of the Ancient World; he only wanted to satirize the scoundrels of the day, and owing to this his Riders have become eternally topical.

Everybody venturing upon the theme pillaged, or plagiarized Dürer: Lucas Cranach in Luther's *Septembertestament* of 1522 (rather poorly – his Riders are 'prince, knight, lansquenet and Death' as opposed to poor people); Hans Burgkmair, in 1522 (he made them gallop in a ring of clouds, a brilliant idea); the engraver of the Bible of Virgil Solis, in 1560 (he changed one of them into the Great Turk, and Death into a true Goodman Bones); the engraver of the *Merian Bible* omnipresent since 1630; best of all, perhaps, Peter von Cornelius in his famous cartoon for the Hohenzollern Mausoleum, after 1840; Vasnetsov, 1883 (tamely); only Jean Duvet, in 1561, and de Chirico (very poorly) went their own ways. All of them changed the carcass of Death into a skeleton, and his trident into a scythe. Vicente Blasco Ibáñez entitled his book on the war- and home-front, in 1916, *Los cuatro jinetes del Apocalipsis;* instead of a *Beatus,* I am afraid, he had in mind the inevitable print of Dürer.

IV Six tender angels take care of the naked Souls under the Altar *190* above the clouds. Three of the martyrs are lying dead before the Altar steps; a fourth, an old man, is led by an angel to the Altar, on which the white robes lie ready. Another angel distributes them, while a third puts the long shirt over a man's head. A group of already vested Souls is kneeling contentedly before the holy Table decked with a fringed and tasselled Altar-cloth.

Just below, clouds are drifting apart, and, between the sorrowful faces of sun and moon (not yet eclipsed), burning stars fall like snowflakes on a rocky landscape, where frightened people hurriedly dive into crevices and caverns. Hands raised, a peasant sinks into the earth; a shrieking mother snatching at her child tears open its smock, and the little boy, with his bare belly and thick feet, more baffled than frightened, pulls one of his locks. A Turk's turban is seen just above a hole; an old king, his crown on one side, tumbles across his queen, who is covering her eyes with a handkerchief. An inert pope, a bishop with knees pulled up, a cardinal holding his head, the red hat dangling at his back – all are sinking down. A skirted backside is sticking out of a hole; a man is trying to protect

XIV Satan thrown into the Bottomless Pit, an angel holding the key; another angel showing the Heavenly City to John. (200)

305

his head with his coat-tails against the falling fire. Far away, a Compostela pilgrim is throwing his mantle over his hat, but it is too late, he has already caught fire. The 'fall of the stars' and the 'flight into the caverns' have been copied as eagerly as the Riders.

191 **V A pleasant interlude,** the fifth scene, a pause of peace: the Elect are receiving the Sign of safeguarding. For a moment the violence has ceased. The four Winds still blow with bulging cheeks, but they are ordered to stop; the apple-tree in the middle will not be uprooted and its abundant fruit will not have to drop. The angel shouting the order appears between clouds with the 'sign of the living God', the Cross, in which the wood-fibres and the holes for three nails are visible. One of the four guardian angels threatens a Wind with sword and shield; another quietly speaks to a second Wind, from a distance; the two angels in front have dropped their huge swords and are meditating on better things. One of these angels holds his sword across his cope and lifts a finger, as if hearing or seeing something; he has closed his eyes, and ecstasy is seen on his furrowed face. Who has ever imagined an angel like this? His neighbour, too, with the sword already in the scabbard and put down on the earth, seems lost in a vision.

In the distance. standing on a high bank, a mild angel, dressed as a deacon, is marking a little cross on the foreheads of a kneeling crowd; the tiny pencil he uses is dipped in the chalice with the Blood of the Lamb, which he is holding in his hand. Not the houses, as once in Egypt, but the people are 'sealed', here with the seal of baptism. People of all sorts appear: a serious, big fellow; an old man in a cap; a curly-haired adolescent; a snub-nosed man; a Franciscan looking like St John of Capistrano; and, foremost, his fine hands joined and with long locks and flossy beard, Albrecht Dürer himself. In the tower at the foot of the distant mountain I imagine a Vesper-bell tolling peacefully.

192 **VI The cataclysms break loose** after the 'half hour of silence in heaven' Standing behind the heavenly Altar (adorned with an ultra-flamboyant Franconian frontal), the angel throws down the burning charcoal from the golden censer. The Eagle crying 'Woe, woe, woe!' is coming out of the clouds. Five angels are about to put the trumpets to their lips. Two coarse giant's hands, thrust out of a cloud, are throwing the burning mountain into the sea, the third part of which immediately becomes blood (a dark-hatched hole). A mast breaks in two, sails flap to pieces, a boatman raises both arms; far away, where the bay is still unruffled, a ship hurriedly sails to safety. Like a rocket the Star Wormwood is hurled into a primitive trough representing the 'fountains of waters'. Far away, the Locusts attack a coastal town, just below an angel in a heavy dalmatic, who is blowing the fifth trumpet. On both shores of the bay, towns are on fire; an enormous flame leaps over a city that looks like Würzburg.

The measuring of the Temple, the two Witnesses, and the Beast. The Temple is an exact replica of the Castle Church at Wittenberg, with Luther's pulpit; the Witnesses are evangelical preachers; the Beast is wearing the papal tiara. Woodcut in the *Wittenberg Bible*, 1534. (201)

VII Four heads shout from the corners of the heavenly Altar, where the Lord is holding three trumpets; an angel is blowing the sixth trumpet, and, below, the four angels of the Euphrates have been set on the wicked.

In the middle of the scene they wield broad-swords in four directions. One seizes the hilt with both hands, his long hair streaming in the wind; the second, shouting furiously, catches a whore by the hair; the third grips the shoulder of a miser with a goatee; the fourth angel raises his sword to strike at a pope lying flat on the ground screaming, with the triple crown above a syphilitic face, held by the *parura* of his amice. Only the low-necked dress and the bodice of a dead harlot are seen. A knight falls backwards from a stumbling horse and covers his eyes with an arm. Bishop, emperor, farmer, merchant – all are dead. The grim faces of the avenging angels are like images of divine Wrath itself.

Meanwhile, far away along the clouds, the cavalry with the lion-headed fire-breathing horses is storming forward: the riders, in shin-

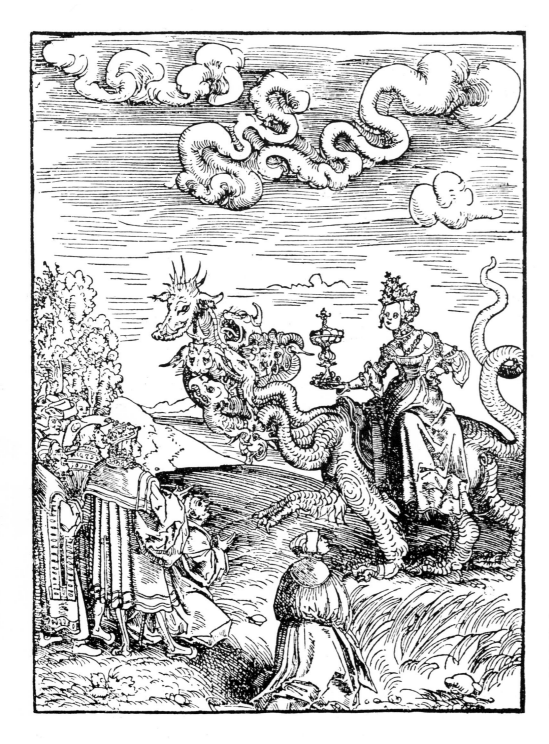

The drunken Whore on the Beast, wearing the papal tiara. Woodcut, by Lucas Cranach, in Luther's *Septembertestament*, 1522. Among the people worshipping the Whore are said to be portrayed Ferdinand I, George of Saxonia, Charles V and Johann Tetzel. (202)

ing cuirasses and with plumed helmets, look like the picked troops of Emperor Maximilian. King Abaddon is missing. They fight the good fight, though one cannot see who is fighting whom.

The group of the four warrior angels striking out in four directions is perhaps the most powerful centrifugal composition Dürer has ever invented, and one of the most unforgettable.

194 **VIII The Great Angel** is the strangest print of the series. John sits confined between boulders (he has put his book and writing-materials on one) and the border of a forest where the trees have trunks

like columns, with young leaves and the outer branches still bare. An angel, skimming their tops, is calling out to him 'not to write down what the seven thunders are shouting', but we do not see from where these voices are coming.

This narrow part of the print is heavily done in black and white; the rest is nothing but sea and sky, lightly indicated: a ship with billowing sails, a dolphin and two swans are gliding quietly over the water.

In mid-air a broad, harsh face surrounded by rays under a small rainbow stares ahead. From the cloud hiding the strange creature, a hand is raised for an oath. His legs are columns, one base of which rests on the rock, the other on the sea, the tops of which burst into flames. A left hand holds out the little open Book containing only three lines. John has already seized it with both hands and is putting his teeth into the papyrus he has to eat, grimly concentrating, his brows raised under his tousled curls.

IX The Woman representing the Church, a plump slightly 195
coquettish peasant girl in advanced pregnancy, is standing in the sun on the crescent of the moon, a brooch pinned on her neck-band, her girdle tied in a knot, her veil leaving her long hair uncovered. She has already received the wings that will carry her to the secret place. Her round head, with her tiny mouth dreamily on one side of her face, is crowned with a double row of six stars. She looks with half-closed eyes past the Monster standing before her, who gushes forth water that is changed into a quiet pool by the merciful earth. Her new-born Child is carried away upon a cloth by two small angels, across the clouds behind which the Lord, an elderly man among smiling angels, waits for the naked little boy and raises a hand as a welcome blessing.

The Dragon's upright tail sweeps down stars, symbols of the fallen angels. The Beast itself is a short-legged reptile; on seven long, twisting and turning worm-like necks it carries the horned and crowned heads of an ass, an ostrich, a wild boar, a monkey, a camel, a wolf and an indeterminate animal, all of them disfigured, while they roar, bray, snort and stick out tongues.

Dürer's monogram is seen below, next to a tuberous plant and a tuft of wild grass.

X Michael and his three brothers in arms, fighting with all 196
their might, expel the already hideous rebel angels from heaven, forming a knot of furiously battling beings that hangs heavily and darkly above an idyllic landscape.

The group is asymmetrical. Wings flapping, hand high up grasping the shaft, the archangel thrusts his javelin right into the throat of Lucifer, who is hurled backwards, with goat's horns sticking out of his ass's head. Two angels are fighting with sword and shield; a third, wearing a diadem and a stole crossed on his chest, is shooting

an arrow into the larynx of a fish-eyed demon bearded with the tentacles of a jelly-fish.

Pinions are whirring, swords clashing, clouds curling like burning paper; the angels' albs, Mâle says, seem to be made of copper, so heavy are the folds, so shining the highlights on knees and elbows. Under the knitted brows, Michael's pupils stare upwards, he does not vouchsafe a glance at the demoniacal rabble: *Mi-ka-El?* 'Who like God?'

I wonder who has ever imagined Pride's Downfall more powerfully, or concentrated such force in a single group.

197 **XI The Lord holding the sickle** of the Harvest looks like an elderly man in a heavily jewelled and fringed cope clasped with a trefoil buckle as large as his face, sorrowful beneath the imperial crown. He sits sadly on a throne of clouds, and no wonder: below, a prostrate mankind adores the Beasts.

There are two Beasts side by side. The Beast from the sea is even more hideous than the Dragon. On its seven curling necks it carries the heads of a duck, a snail with its horns out, a turtle, a lion, a camel and a leopard; its wounded head – Nero – looks like a dirty griffon's. An emperor, a queen, a scholar, a canon, a merchant and a Turk – all on their knees – are worshipping it.

The Beast from the earth – the False Prophet – is stepping out of his lair on bear-paws, two ram's horns on his head, below a rain of fire he has just caused to fall from the sky. He, too, has his worshippers, kneeling with their backs to his accomplice.

198 **XII The Great Multitude,** meanwhile, stands before the Lamb on Sion. A forest of palm branches is held by men of all ages, clothed in white albs and stoles crossed over the chest, visibly in ecstasies. The Lamb appears within a mandorla, standing on a rainbow. One of the Elders, wearing a bishop's mitre, bends forward to receive its Blood in a chalice; another Elder explains to John who the palm-bearers are and how they washed their robes white in that Blood, flowing mystically into this chalice. The Elders, the four Living Beings and two angels in albs fill the print from top to bottom; John is seen again among the Elect.

Thus Dürer interprets the epistle of All Saints' Day, in his own graceless, grandiose and almost grim way.

199 **XIII Babylon is seen** for the last time, parading and falling. Riding on the Beast from the sea (of which the ass's-head is here the most conspicuous), the Scarlet Woman appears: a Venetian harlot, hung with jewels and trinkets, a crown upon her twisted locks. She is lifting up the Cup of her Abominations, a priceless goblet in the Nuremberg style, with chased base, knop, cup, lid and top ornament. The False Prophet, now with a huge turban, is introducing her to a gaping but uncommitted crowd. A merchant, hand on his hip,

The Son of Man among the candlesticks; the Great Angel; Michael fighting the Dragon. Three panels from the top of a window containing ten panels, freely after Dürer, from about 1529. The portraits of the donors, Bertrand Darengette and Antoynette Pynot his wife, are seen, with their patron saints, in two panels (bottom right). This window is the earliest of a series of French windows inspired by Dürer's prints. St-Florentin (Yonne), parish church. (203)

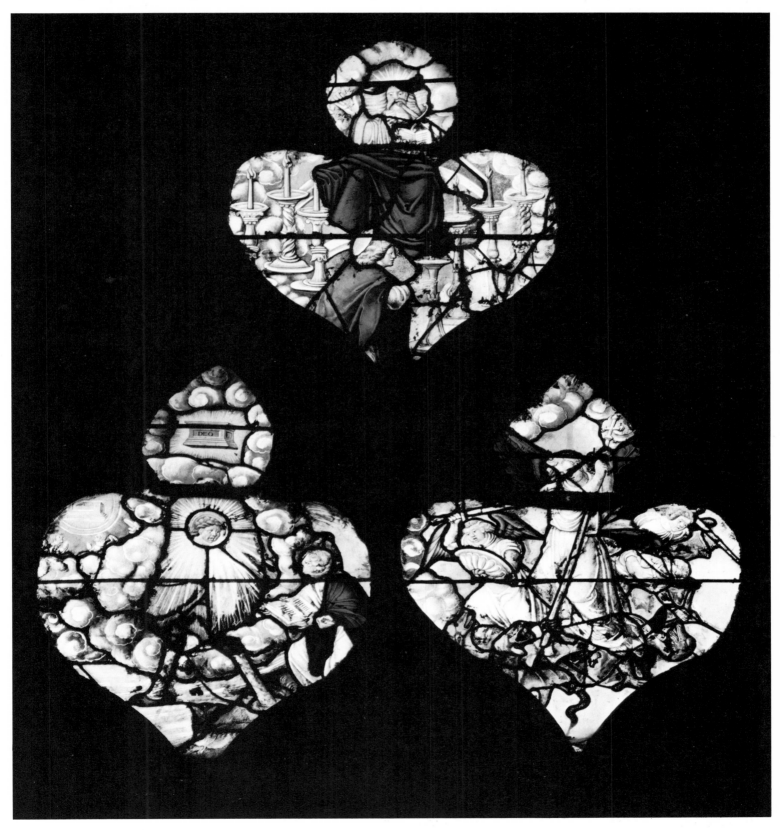

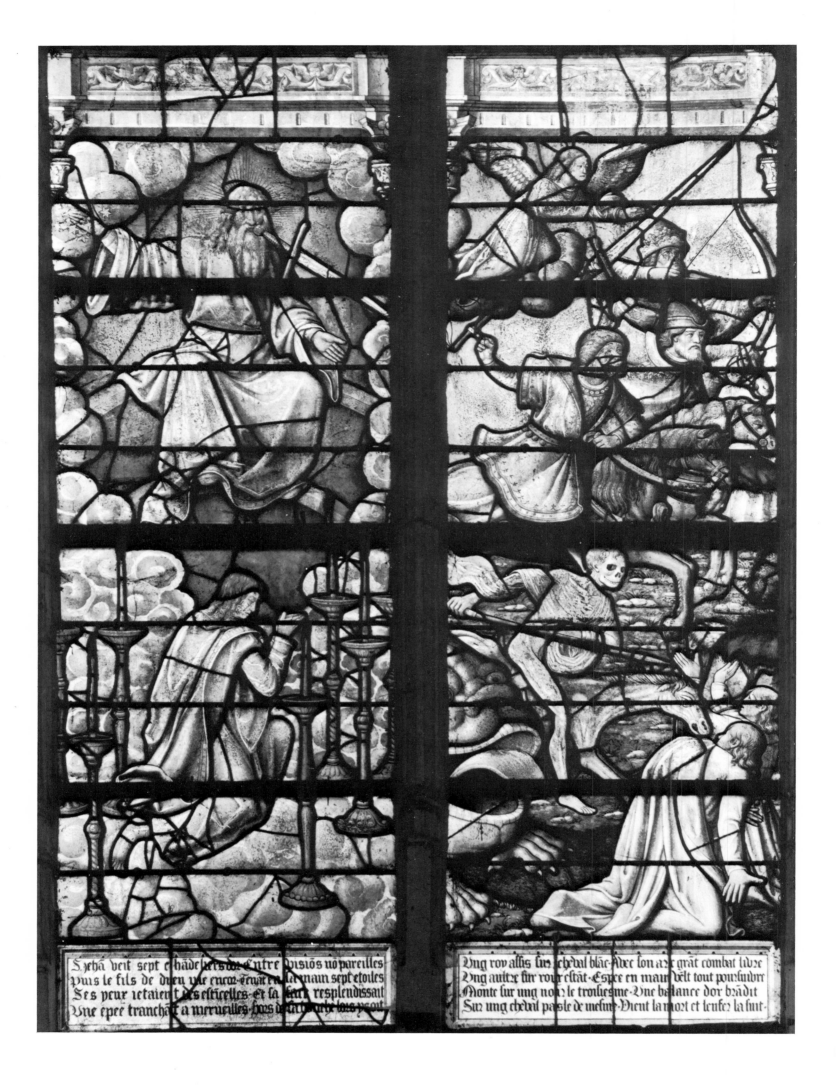

S. Jehã veit sept chādeliers dor Entre visiõs nõ pareilles
Puis le fils de dieu vne encor venāt en la main sept etoiles
Ses yeur ietaient des esticelles et sa face resplendissant
Vne epee tranchãt a merueilles hors de sa bouche tous poānt

Vng roy assis sur cheual blāc Avec son arc grāt combat liure
Vng autre sur roux estāt Espee en main velt tout poursuiure
Monte sur vng noir le troihesme Vne balance dor brādit
Sur vng cheual passle de mesme Vient la mort et lenfer la suit

looks askance at her; another, his hat on one ear, slobbers with admiration; a young lansquenet, with huge ostrich feathers on his helmet, leers at her out of the corner of an eye; a housewife in the high Nuremberg cap, and a Turk are completely under her spell; a skinny monk sinks down on his knees in ecstasy, with clasped hands.

Alas, in the background a gigantic flame already leaps up to the clouds and envelops Babylon: the entire coastline is on fire. An angel is throwing the millstone into the sea, shouting: 'Thus shall that great city Babylon be thrown down, and shall be found no more at all!' Another is pointing to the heavy cloud hanging above the burning metropolis and crying: 'Babylon the great is fallen!'

From a ravine between masses of clouds, high up in heaven, the host of heaven is approaching, the cavalry following the Rider Faithful and true, here an old armoured German prince who brandishes his sword above the mane of his white horse with the flying caparison. One cannot help thinking of a foreboding of the Reformation, and later generations have understood it as such, greatly misjudging Dürer's intentions.

XIV The strife is over, on the final page, the battle done. Satan, *200* wrapped up in a single flame, is sunk in a narrow Pit. The hinge of the lid and the lock are painstakingly drawn; the last of the avenging angels is holding the chains and a key with a huge bit, but he does not touch the Monster, which has a body like an ear of corn. With its pointed tongue, cat's whiskers, sagging breasts and scaly claws, it looks like a popular devil run away from a witches' sabbath.

On top of the mountain overhanging the Bottomless Pit a boyish angel, in a loose trailing alb, reveals the New Jerusalem to frightened John. The Heavenly City is a Franconian town, lying deep in an overgrown valley between a bay and a range of low mountains. An open-work steeple rises from the roofs; soaring spires are seen everywhere, even a cupola within a ring of towered walls, against a sort of monastic suburb.

Angels are standing in three of the twelve Gates, but there is not a soul to be welcomed. There are no precious stones, no fructifying trees, no River of Life: everything is quite commonplace.

The empty town is seen below; high up on the mountain a gnarled withered tree overhangs the ravine. The sky is cloudless, only a flight of birds is passing high above the silent City. Thus ends Dürer's Apocalypse.

The Son of Man among the candlesticks, and the four Riders, freely after Dürer, from about 1550. The four lower panels (left) of a window dedicated to the Apocalypse, in the north wall of the transept of the parish church of Chavanges (Aube). (204)

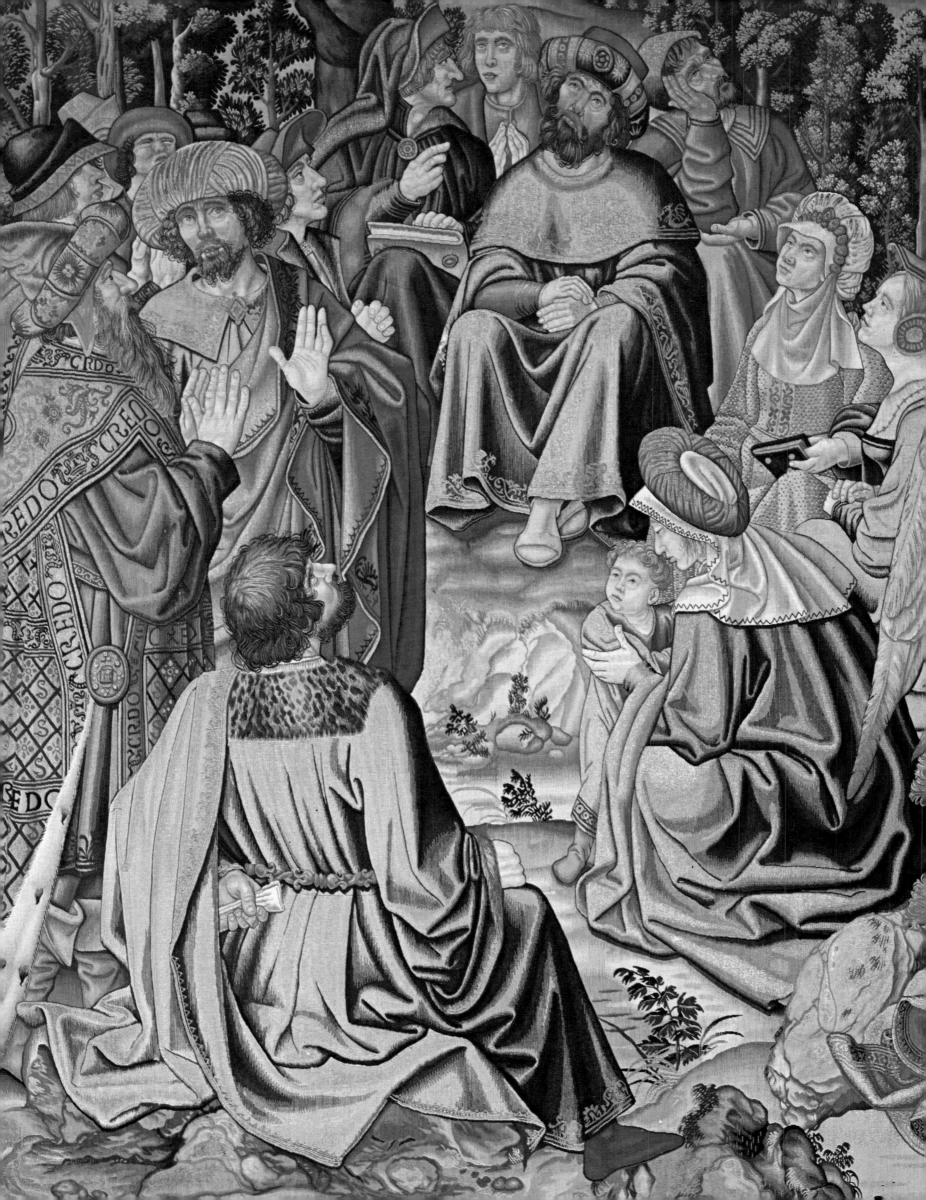

The Brussels Tapestries

206-220

'Worthy of the Emperor Charles V, and of the then unsurpassed Flemish textile arts' – such is the first impression created by the eight colossal tapestries representing the Apocalypse that hang today (temporarily in excellent copies) in the crypt of the memorial church in the Valley of the Fallen, near Madrid, the monument commemorating the victims of that other frightful apocalypse, the Spanish Civil War.

From the time that Charles retired to the monastery of Yuste (1557), where he was to die piously, and where so many Flemish tapestries followed in his wake, those tapestries formed part of the collection of the Spanish kings, the largest of their kind. The Apocalypse, woven in the workshop of Willem de Pannemaker at Brussels, between 1540 and 1553, seems to have crossed the Pyrenees somewhat earlier.

Another impression immediately springs to mind: that this is Dürer absorbed into a greater ensemble and translated into the idiom of Barend van Orley (the mannerism of the early Netherlandish Renaissance), into the technique of the *haute lisse* and into colour.

It is a very special colour: a pale greyish ochre, in which the brighter hues of red, green and blue softly blend into manifold shades, nowhere disturbing the quietness of the great decorative compositions that were intended as distinguished background for good society assembled in huge apartments.

Violent episodes alternate with peaceful scenes, but in perfect harmony: the spectator is neither shocked nor overwhelmed, only fascinated. No single motif can be said to dominate, the story is told in a vivid but purely narrative way. Only the motifs borrowed from Dürer are conspicuous. In a way, they have become less abstract, more pungent, but at the same time strangely mellowed by the much weaker style of drawing and the mild colour.

The columnar legs of the Great Angel end in flaming red; John's mantle is a dimmed vermilion; the angels are wearing liturgical vestments in subdued pastel colours, their wings show all the shades of a peacock's tail; grey horses contrast with bay and black ones; rainclouds have been set against bright ones; hailstones are flashing white disks; cuirasses lavishly decorated with arabesques. Above all, the actors of the drama have lost the elementary strength felt in

The Apocalypse, shown in eight tapestries, each measuring 5.3 m by 8.7 m (borders included), woven in Brussels in the workshop of Willem de Pannemaker, after cartoons designed in the manner of Barend van Orley. Nearly all the Dürer motifs, and many older ones, are utilized for their iconography. From 1553 onwards, the tapestries were in Spain and remained in the possession of the Spanish kings. Today they are exhibited in the crypt of the memorial church in the Valley of the Fallen, north-west of Madrid. Six of them have been replaced temporarily by copies, and two are being restored. In the top border a double Latin distich summarizes the chief subjects of the individual pieces. Here, a detail from the sixth tapestry. (205)

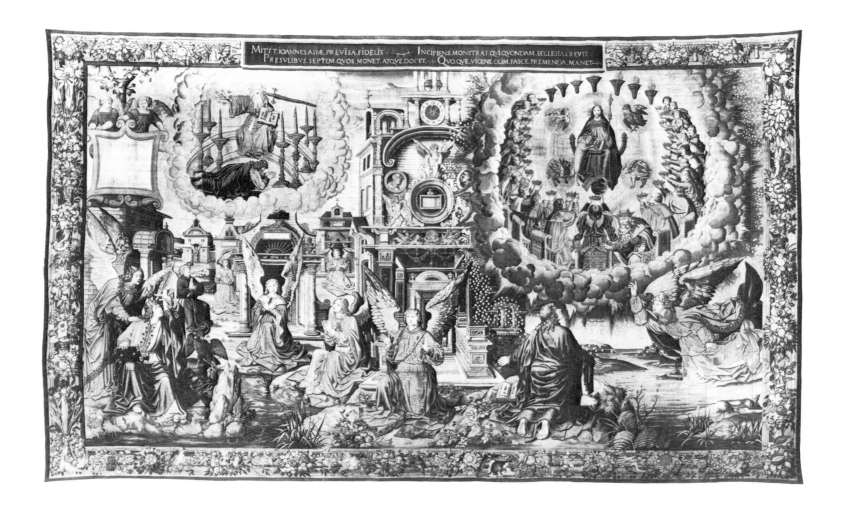

every line of Dürer's prints, and, of course, this is partly due to the different technique. Less steady on their legs, and far more ornate, they have been sweetened and tamed into insignificance. From being unique and utterly surprising they have become merely rhetorical, and less significant. Look at the four avenging angels of the Euphrates striking at the prostrate crowd: Dürer's furious Spirits have been changed into elaborately armoured parade knights. But a certain lack of fierceness is to be expected in compositions meant to serve decorative purposes and executed in the somewhat softening technique of tapestry-weaving.

206 In addition, the buildings – representing, for instance, the seven churches, Babylon or the Heavenly City – clearly show the Renaissance fashion, and the figures reveal unmistakably the characteristics of Netherlandish mannerism in its prime. Nuremberg has vanished; Lombardy and Tuscany have furnished the façades, the porticoes, the pediments and the fountains. The scanty fragments of landscape in the background recall the Flemish countryside of Brueghel and, sometimes, a Venetian vista as well. The ensemble, however, is totally un-Italian: it is a variegated display of as many motifs as possible, picturesque and yet conventional, dominated by a tamed Dürer assimilated to the exigencies of a luxury art, which only very great lords could afford.

1 The Son of Man among the candlesticks, and the seven churches, with their angels (left and centre); the Vision of the Throne (right); cf. Dürer I and II. (206)

The fallen, beneath the horse of one of the Riders; a detail from the second tapestry. (207)

316

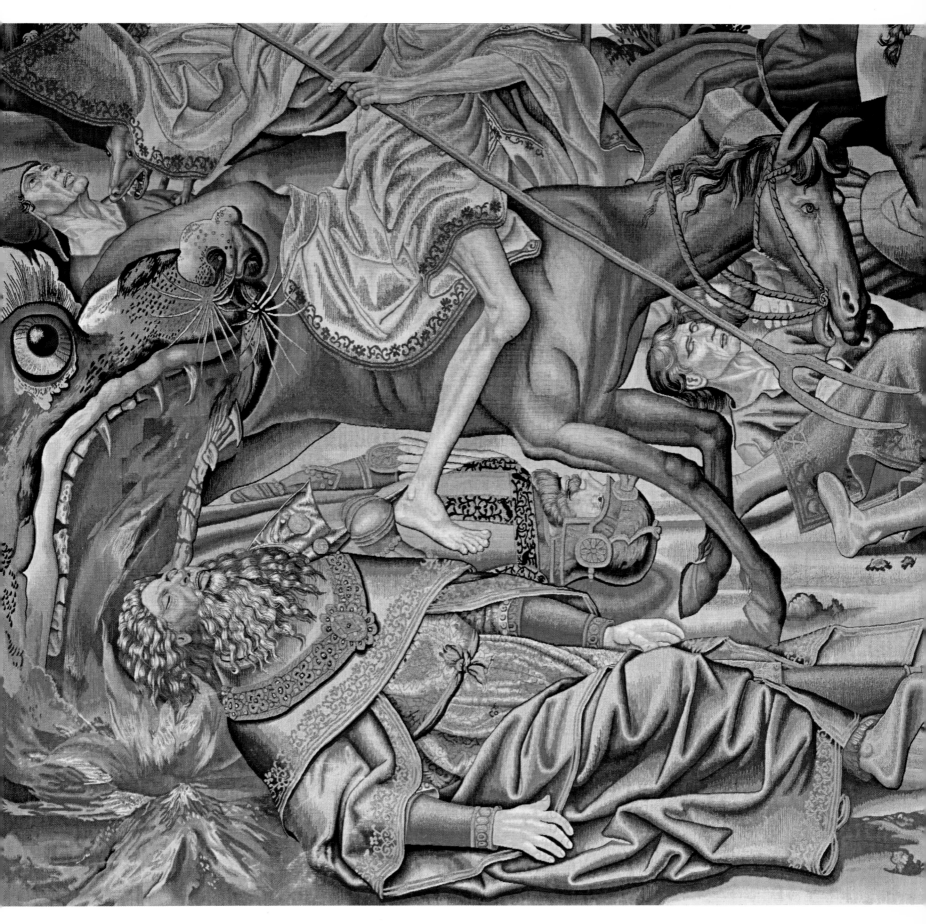

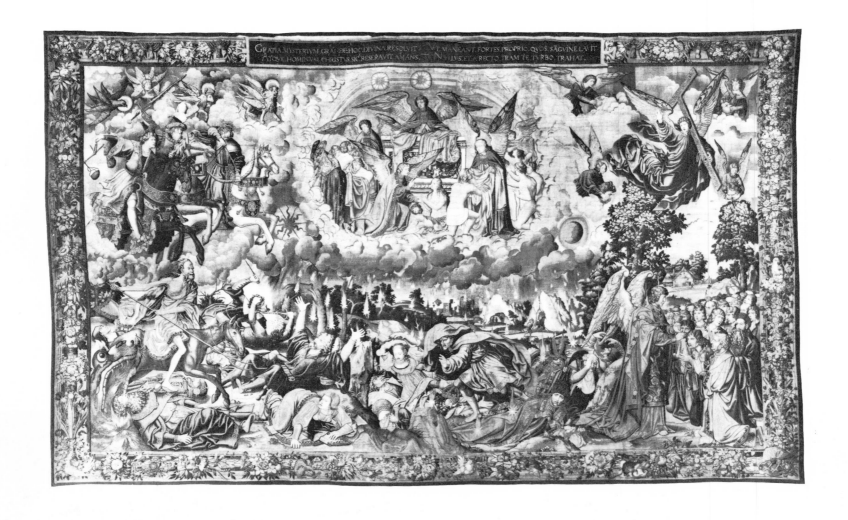

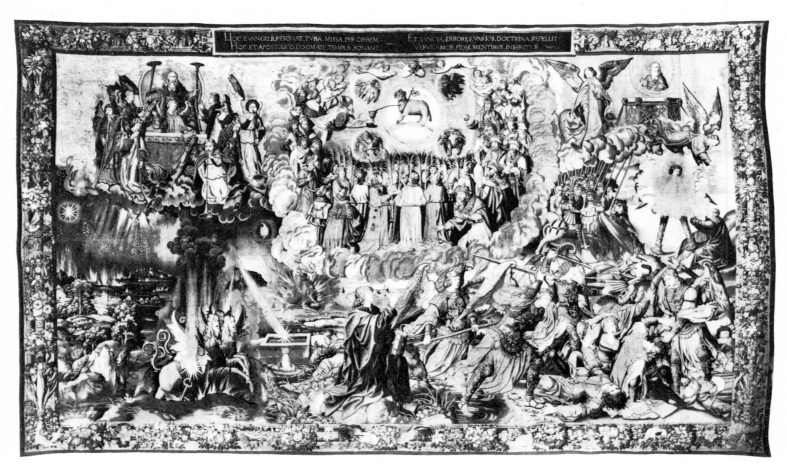

II *Opposite above*: the four Riders; the Souls under the Altar, the stars falling down and the flight into the caverns (centre); the Sign of the Living God; and the sealing of the Elect (right); cf. Dürer III, IV, and V. Here, the angels are not threatening the Winds with their swords, but covering their mouths, as seen in the older manuscripts. (208)

III *Opposite below*: the distribution of the trumpets, the angel with the censer; the rain of fire mingled with hail; the mountain cast into the sea; the Star Wormwood falling upon the cistern (left); the Locusts (bottom left); the Great Multitude with the palm branches (centre); the fire-breathing leopard-horses; the Great Angel with legs of fire giving the little Book to John; and the angels of the Euphrates (bottom right); cf. Dürer VI, VII and VIII. (209)

Nearly all Dürer's motifs can easily be traced; the rest, however, is curiously old-fashioned. The episodes Dürer left out in his condensed series are borrowed from the then three-centuries-old Anglo-Norman cycle: the seven churches with their angels; the measuring of the Temple; the interlude of the two Witnesses, the Harvest and *211* the Vintage of the earth, with the Lord himself in the wine-press (the Lord with the sickle is copied exactly from Dürer); the pouring *215,216* out of the vials of wrath and the Lion distributing them to the seven angels; the angel standing in the sun and calling the birds of prey; the Judgment; and, finally, the somewhat upper-middle-class Mar- *218* riage of the Lamb. The angels retaining the four Winds are covering

One of the victims slain by the angels of the Euphrates; a detail from the third tapestry. (210)

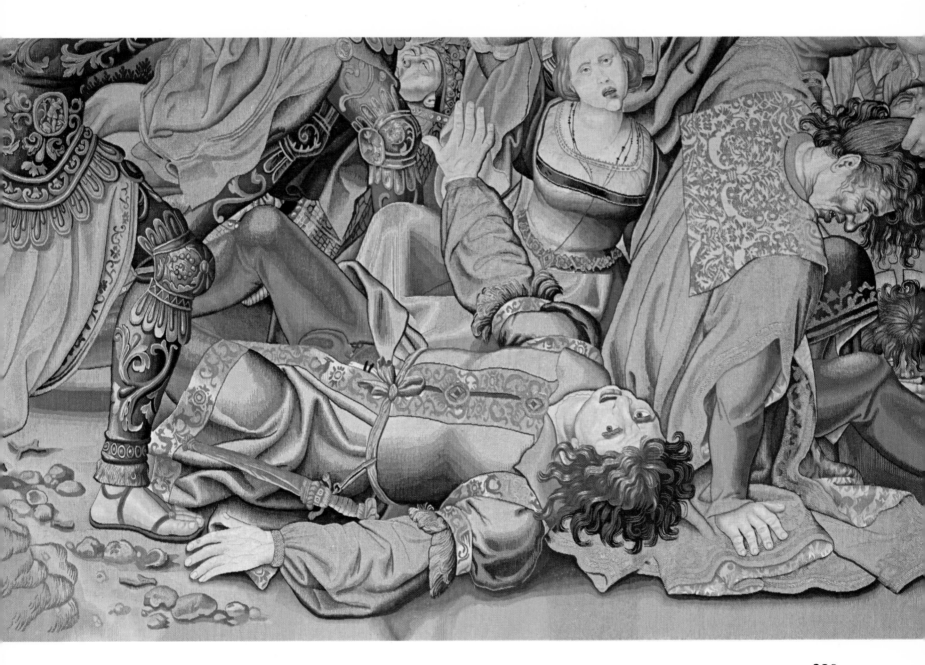

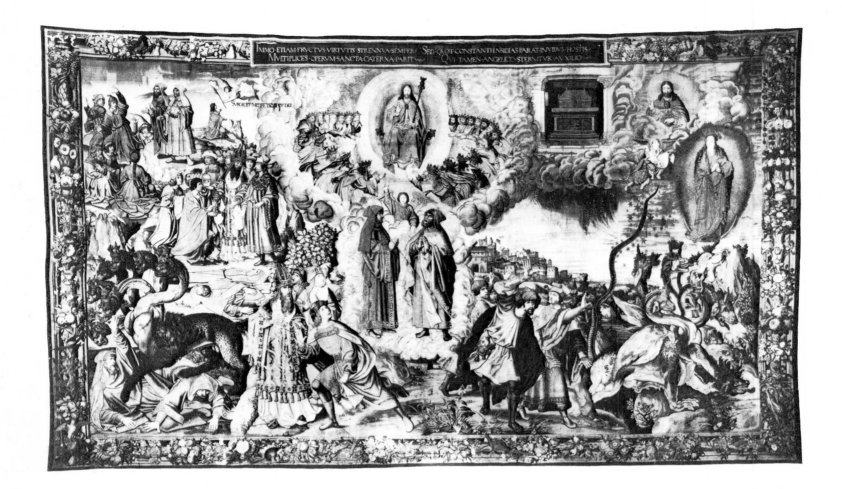

their mouth, whereas in Dürer they threaten them with sword and shield: a deliberate archaism. Exactly as in the old manuscripts, the Witnesses are ascending to heaven; the blood flows from the wine-press 'unto the horse bridles'; the Great Prostitute lies prostrate in the pool of fire and brimstone. One wonders what kind of manuscript the designer of the cartoons may have used, the block-book not being rich enough to consider. There is one motif that will presently be seen in all vignettes illustrating the last chapters of the Bible: the remarkably ugly crenellated walls and towers forming the precinct *217* of a square geometrical garden – the Heavenly City.

Each of the eight tapestries is bordered by a frame of festoons, interrupted, at the top, by a cartouche containing a double couplet, which sums up the subjects represented, in Roman capitals and correct, shallow, humanistic Latin. I failed to discover any clear allusions to the schisms afflicting the Church, which greatly worried the Emperor. This kind of secondary consideration evidently did not determine the character of the commission. As a specimen I give *206* the couplets accompanying the first tapestry:

MITTIT IOHANNES ASIAE PREVISA FIDELIS
PRESVLIBVS SEPTEM QVOS MONET ATQVE DOCET
INCIPIENS MONSTRAT QVI QVONDAM ECCLESIA CREVIT
QVOQVE VIGENS OLIM FASCE PREMENDA MANET.

IV John receiving the measuring-rod (top left); the Witnesses preaching, killed, lying dead, and taken into heaven (centre and left); the Ark in the Temple, the Woman and the Dragon (right); cf. Dürer IX. The story of the Witnesses, omitted by Dürer, has been borrowed from a traditional manuscript. (211)

One of the saints attacked by the Beast; a detail from the fifth tapestry. (212)

V *Overleaf:* Michael and his angels fighting Satan and his attendants (left); the Woman receiving wings and flying away (centre); the Beasts worshipped and, above them, the Lamb on Mount Sion (right); the Beast from the earth attacking the saints (bottom right); cf. Dürer X and XII. (213)

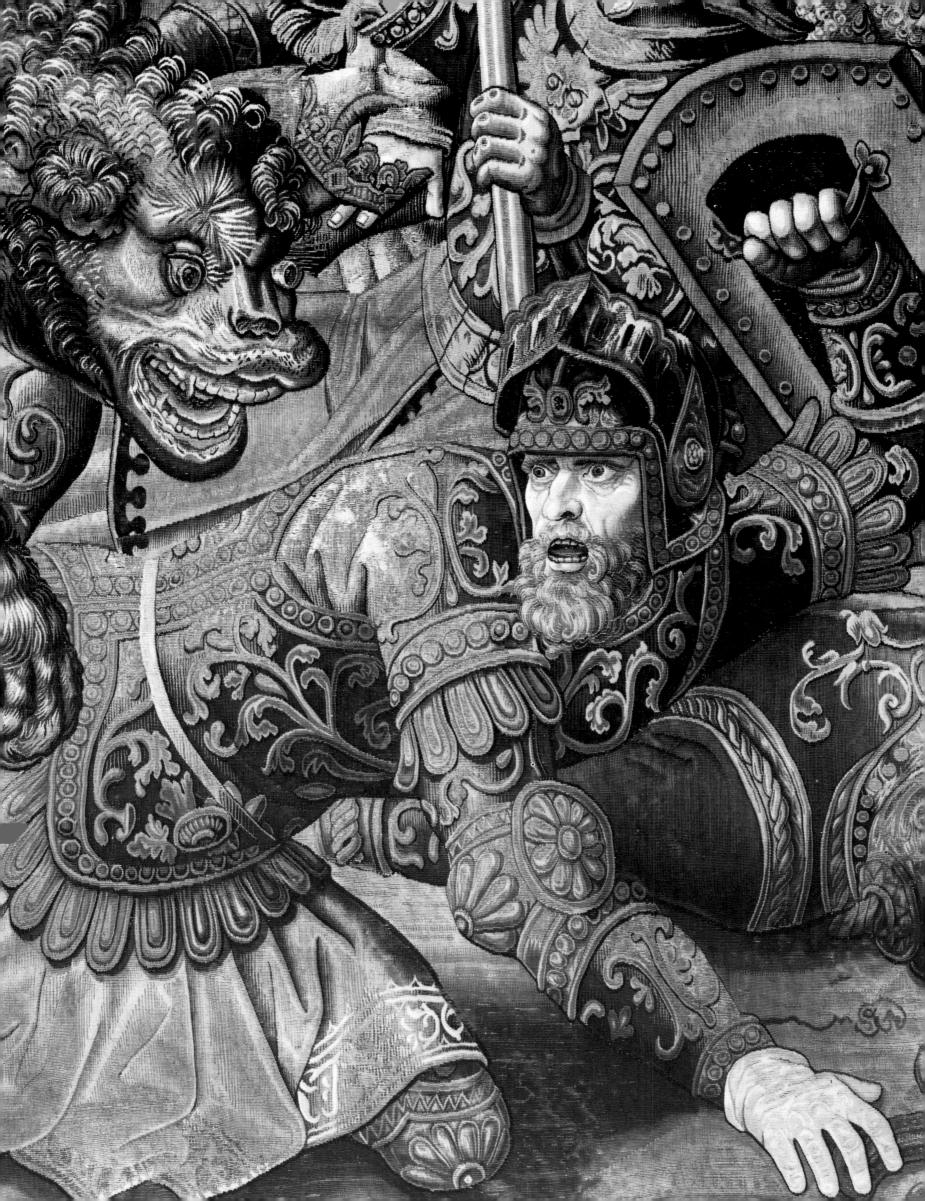

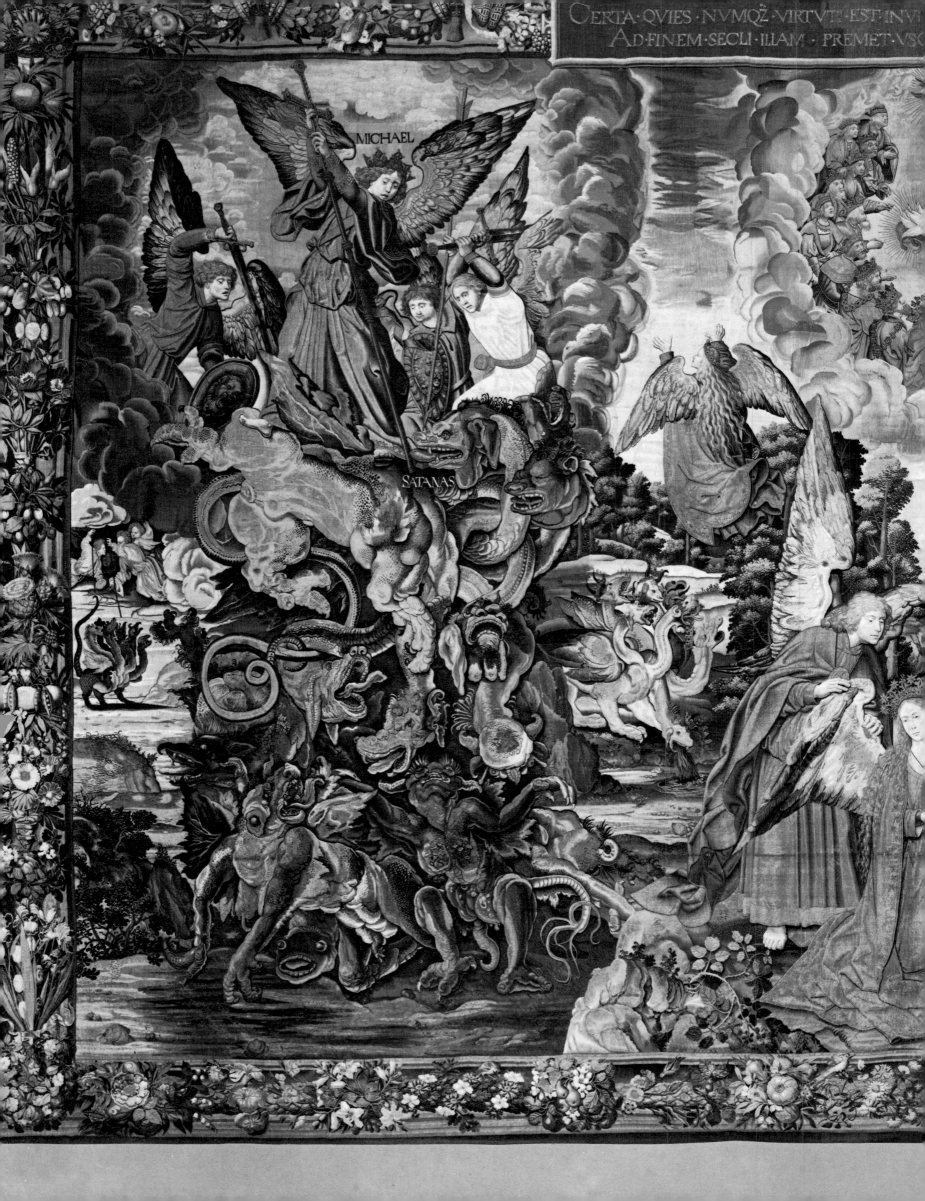

MICHAEL

SATANAS

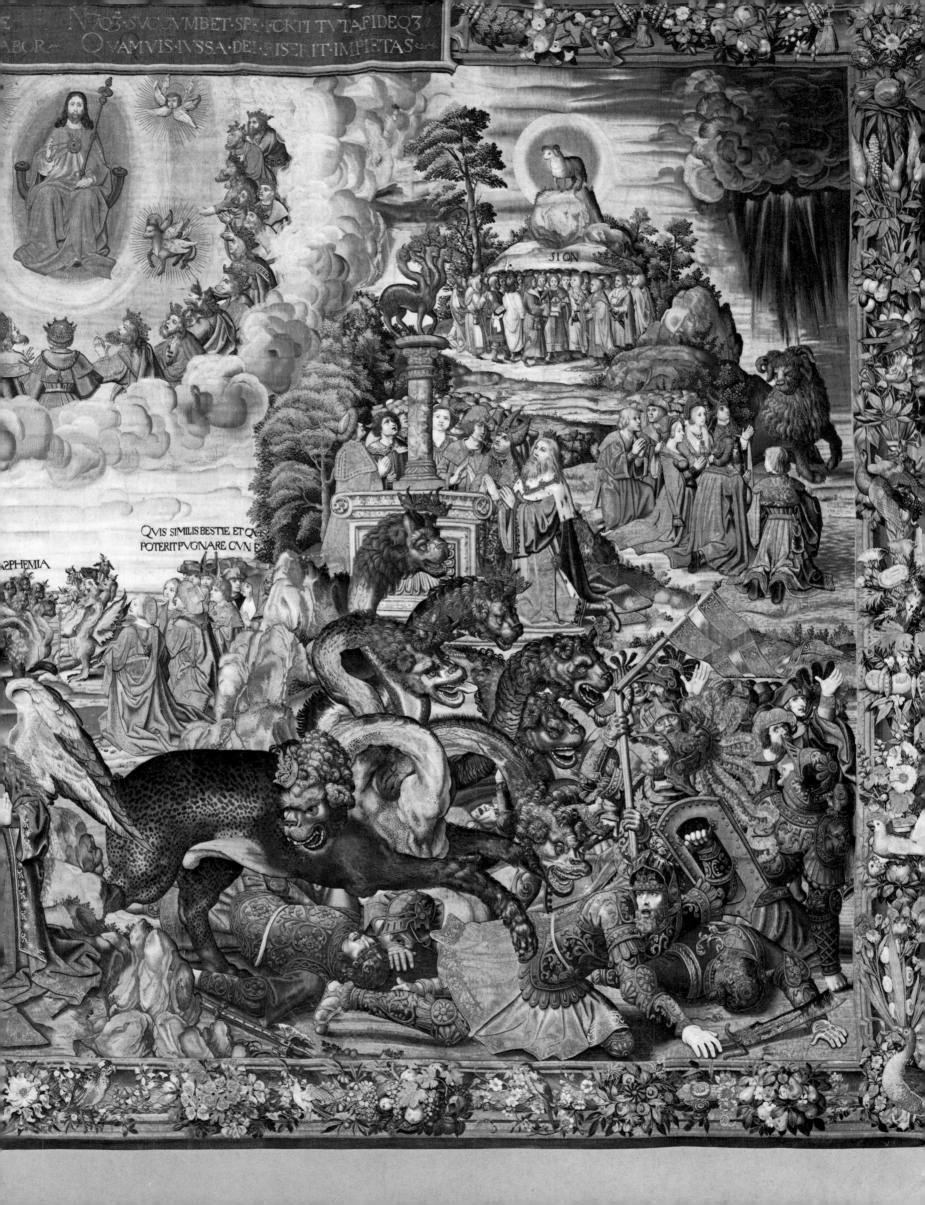

VI *Opposite above*: the angel bringing the 'everlasting Gospel' (left); the Lord with the sickle of the Harvest (centre); the Lion distributing the vials of wrath, the angels pouring them out (top right); the Lord harvesting the corn, an angel gathering the grapes of the vintage, and the blood streaming from the winepress 'unto the horse bridles' (bottom right); cf. Dürer XI. The rest, and notably the Harvest scenes, are according to the old tradition. (215)

VII *Opposite below*: vials poured out; Babylon on fire; the Scarlet Woman seated on the waters (left); under the Throne she is lying in the pool of fire. The Great Hallelujah and the Marriage of the Lamb (centre); the Rider on the white horse (right) and the heavenly host; the Lord in the winepress; the Whore on the Beast (bottom right) clearly after Dürer XIII, as is the Rider, and also the scene of the millstone thrown into the sea. (216)

The Locusts swarming out of the Pit and the Star Wormwood falling into the cistern; a detail from the third tapestry. (214)

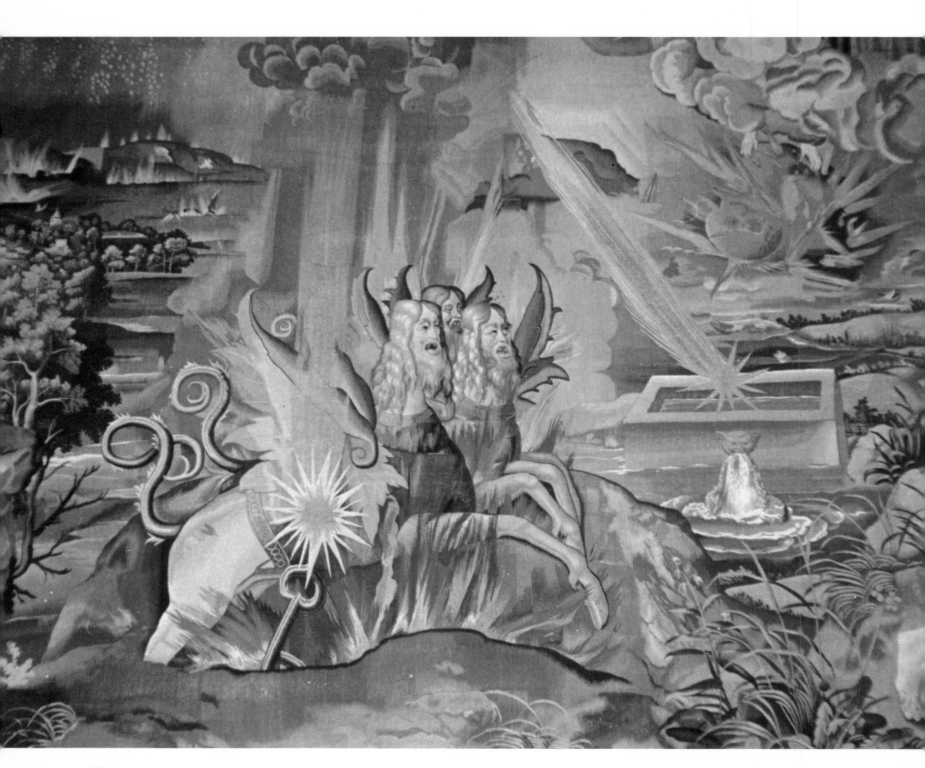

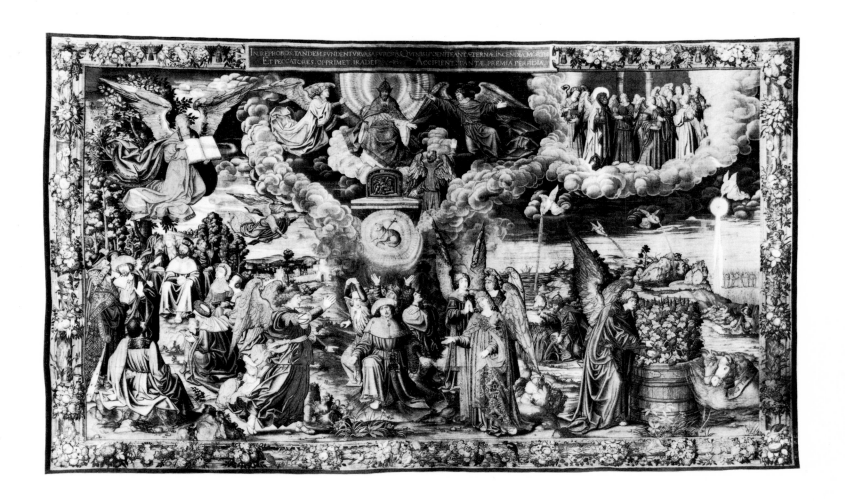

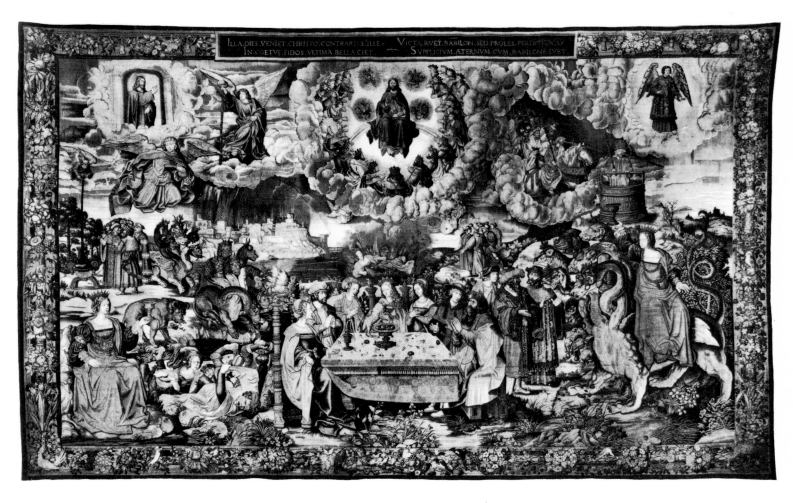

325

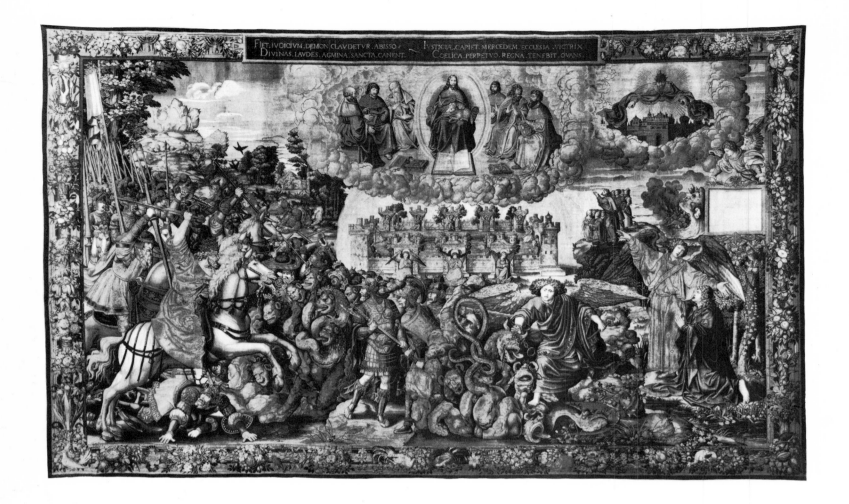

Faithfully John writes down all things he foresaw, to the seven
bishops of Asia: a solace as well as a serious call.

First he shows how the Church throve amidst unparalleled trials
and, thus strengthened, must always wait for as heavy a load.

A thought such as this can be comforting even in epochs other than
the troubled days of the Reformation.

Most people looking at the Brussels tapestries will remember those
at Angers, which are nearly 180 years older. The Angers tapestries,
measuring 5.7 m (height) by 168.0 m (original length of the whole
series put together), are divided into 84 episodes; those of the Valle
de los Caídos each measure 5.3 m by 8.7 m, and together form a
frieze of 64 m that shows about forty freely combined pictures, distri-
buted over eight pieces.

The Angers series – also designed by a Flemish artist, Jan van
Bondol – is by far the clearer, being the more primitive and the
stronger of the two. The Brussels ensemble, infinitely more sump-
tuous and more sophisticated, and, notwithstanding the somewhat
naïve Italianisms, thoroughly Netherlandish, is less distinguished. Yet
there are so many delightful combinations and the design, despite
its softness and the bizarre costumes (immediately recalling those

VIII The Rider with the 'many crowns'
(here a triple tiara) and his host fighting
the army of Gog and Magog (left); the
Judge and his assessors, the Just (top
centre); the Heavenly City (below) shown
to John; and Satan chained and cast into the
Pit; cf. Dürer XIV. (217)

326

The Marriage of the Lamb, after the traditional composition (missing in the Dürer series); here, in the setting and with the costumes of the middle of the sixteenth century. (218)

Detail of the fifth tapestry. (219)

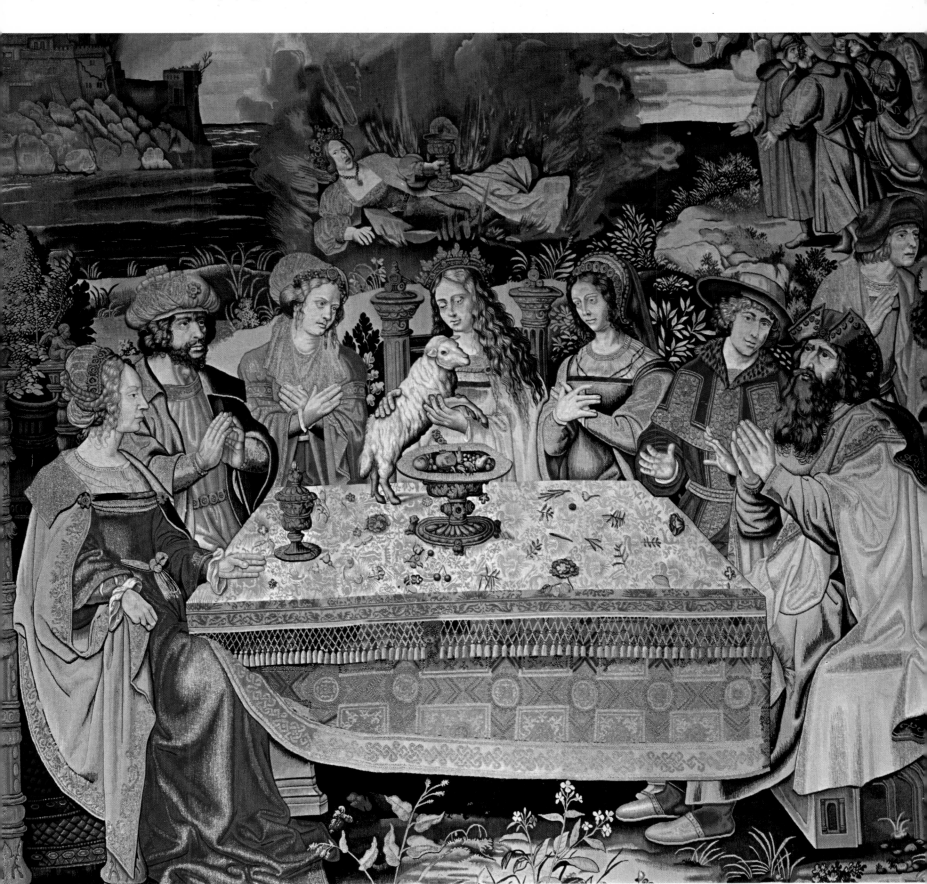

of the prophets and Sibyls of the windows in Auch Cathedral), is so strikingly clever, particularly in the groups of trampled victims, *207* and the Riders on horseback (like the Lord on the white horse – a magnificent chieftain crowned with a tiara of superimposed diadems), that a comparison of the two cycles clearly shows a difference in style – of two great works from about 1370 and 1550 – far more than a difference in quality. As for Dürer, the point of comparison should be that of inner strength, as in his Great Multitude compared *191,220* with the same crowd in the tapestry.

It is doubtful whether the Emperor Charles, or even his son, Felipe el Rey, ever took the trouble to decipher in detail this synthesis of four great creations – the English, the French, the Italian and the Nuremberg cycles. Princes are not wont to go to such pains. Philip was a true lover of art and in some way a connoisseur, even more than his pious but far from ascetic father. The fact remains, that Charles, who is said to have picked up a pencil for Tiziano when posing, and Philip, who valued the great masters of the cinque- *19* cento and disliked the apocalyptic El Greco, took this mighty woven Apocalypse with them to Spain, together with a great number of other Brussels tapestries, some of which came to adorn the austere room at San Jerónimo de Yuste, where the imperial penitent died piously.

For the *Brussels Apocalypse* was made after cartoons designed by an artist who cannot in any way be compared to Raphael, the man who drew those other Brussels tapestries, now in the Vatican. It belongs entirely to the Low Countries, and some details betray the pure Netherlandish tradition. One of the listeners to the Everlasting *205* Gospel (in the sixth tapestry) is wearing a turban studded with gems, and a mantle adorned with orphreys, on which the word CREDO has been embroidered in pearls several times, a thing Jan van Eyck could have done.

This princely Apocalypse is still an essentially medieval creation, shown in a slightly Renaissance disguise. With it, the long succession of medieval apocalypses comes to an end. It is an agreeably opulent, innocuous display of as many motifs as possible, taken from everywhere, in which, however, neither the Netherlandish bent towards the everyday picturesque dominates, nor the then tyrannical Italian manner of drawing. Yet the genius of Albrecht Dürer makes one forget the accidental and the supplementary accessories, and shows one how his immortal model, though somewhat popularized, is given not only colour, but also a new and unexpected lustre.

The Elect marked on their foreheads, after Dürer. The people are different, and Dürer's self-portrait has been replaced by somebody else. (220)

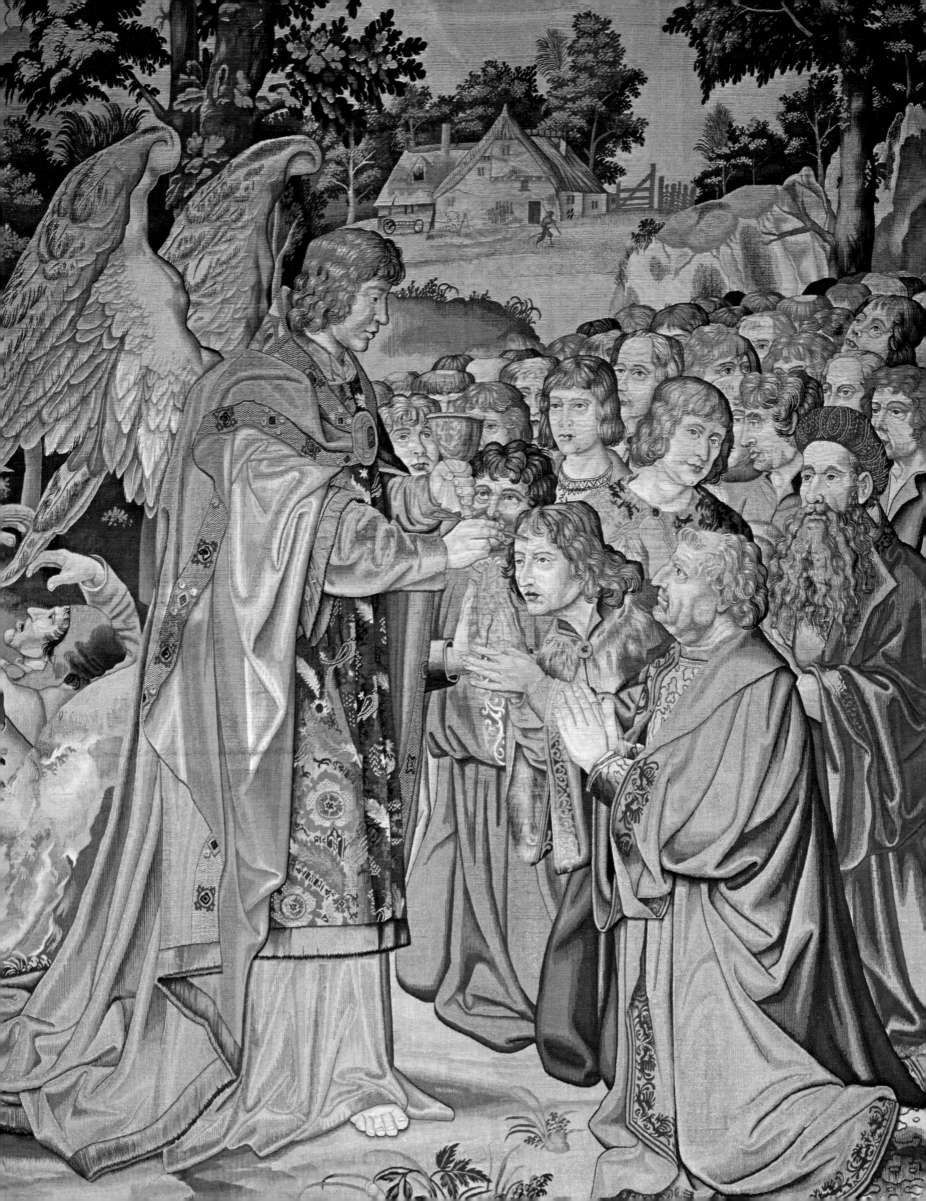

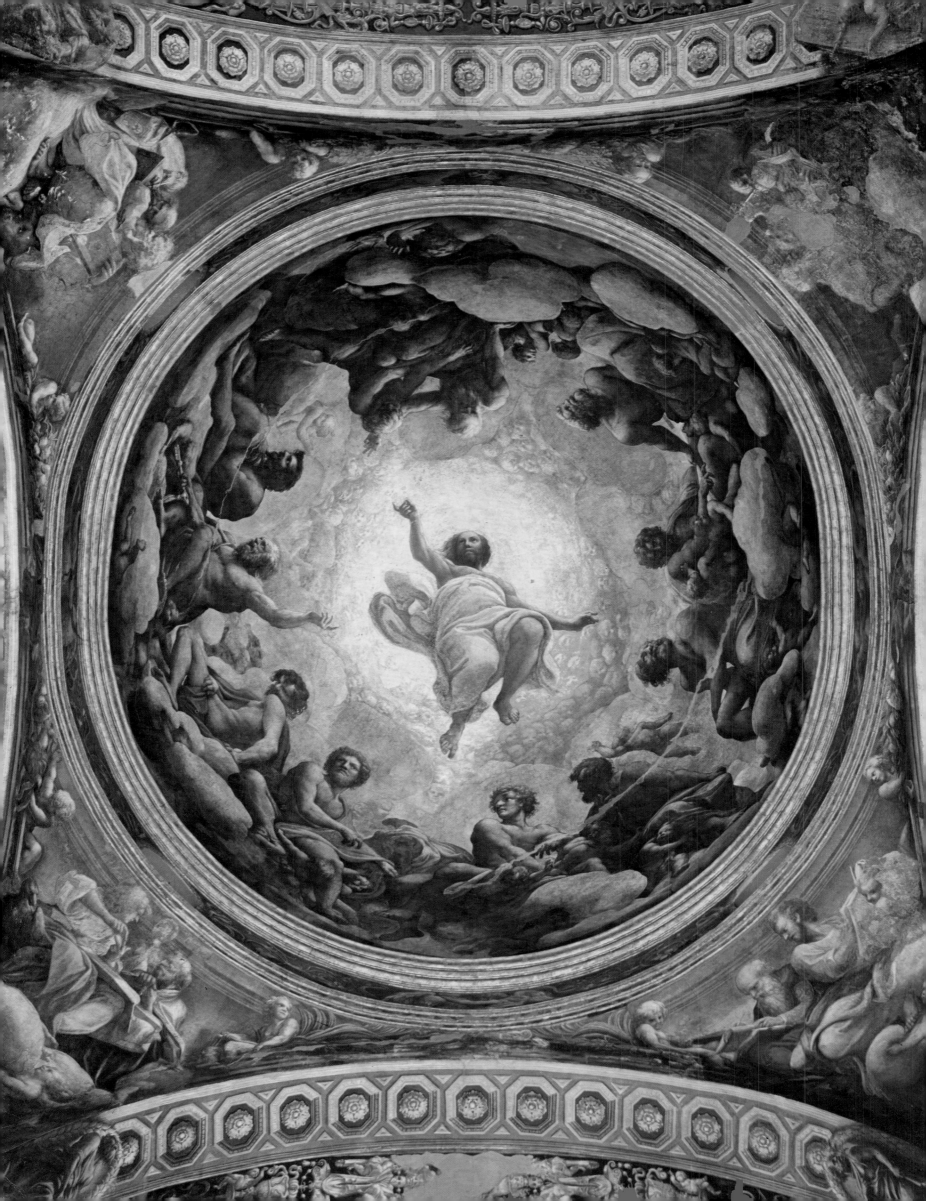

Correggio's Painted Cupola

S. GIOVANNI EVANGELISTA AT PARMA

The interior of the dome and the four pendentives of S. Giovanni Evangelista at Parma. Correggio's superb fresco shows twelve of the Elders – here the eleven Apostles and John – contemplating the Lord, soaring above in a shaft of light, the Throne. Painted during the years 1520-1, it was cleaned and restored in 1959-62.

At the centre is the Lord. Surrounding him, on the clouds, from left to right (beginning below the Lord's feet): James the Less (without a beard), Thomas, Andrew (looking up), James the Great (pointing with a finger), Simon the Zealot (looking up), Bartholomew and Matthias; below them, emerging from the border, the seer John; Paul, Peter (pointing upwards, holding the keys), Philip, Jude Thaddeus (staring ahead).

In the spandrels, bottom left: John and Augustine; right: Matthew (who is missing in the group above) with Jerome; top left: Luke and Ambrose; right: Mark and Pope Gregory the Great (badly damaged). Taken together: one Apostle, the four evangelists and their symbols, and the four great Fathers of the Latin Church.

The narrow frieze on the drum is hardly visible. On the great arches below one recognizes Elias (bottom left), Aaron (right), the sacrifice of Isaac (top left) and Samson carrying away the gates of Gaza (top right). (221)

In Parma, just behind the apse of the Romanesque Duomo, lies a Benedictine monastery that is over thousand years old. Many times rebuilt, and converted into barracks by Napoleon, it has recently been restored to its original purpose.

The church is a graceful creation of the early Renaissance. It was built in 1510-19, by Bernardo Zaccagni, the architect of that other famous Parma sanctuary, la Steccata; it did not get its tall campanile until 1614, however, together with a Baroque façade. It is dedicated to St John the Evangelist.

In 1520, according to contracts dated 1520-3, Anthony Allegri, surnamed Correggio (after his birthplace, between Parma and Carpi, in the province of Modena), was asked to paint the central cupola. Its dome, an oval, 14.5 m by 12.0 m, received little daylight: the small ox-eyes of its narrow drum are nearly screened off by a protruding cornice. Below, the four arcades are supported by the piers marking the crossing. *221*

Whose idea it was, to decorate this cupola with the Vision of the Throne as described in Rev. IV, we do not know. Correggio, then newly married, had been received as an oblate into the Congregation of Monte Cassino, on the recommendation of the prior, as appears from a document dated 1521 and issued by the General Chapter of that Order at Praglia (near Padua). His family shared the privileges of that spiritual community. Even before that, he must have been on excellent terms with the monks, and we may suppose that in the matter of iconographical planning perfect agreement existed between the principals and magister, Antonius Laetus de Corigia (as he is called in the contract). For the rest, it seems obvious, in a spacious church dedicated to the seer of Patmos, to give a place of honour to his supreme vision, a theme become familiar by an age-long tradition.

Far better than in bygone centuries, one can see today what the thirty-year-old Correggio made of it. Time and again, the fathers of the abbey as well as the visiting artists complained that this masterpiece was difficult to see and was rapidly darkened by filth and dust. The Parmesans themselves called the nearly blackened Apostles of the colossal fresco *i santi carbonari*, 'the holy charcoal-burners', with

a play of words on *I Carbonari*, the secret society of patriotic Italians before 1870. Meticulous cleaning and discreet illumination have recently restored this admirable Apocalypse to its former beauty and, above all, greatly improved its visibility.

Correggio's plan was hazardous and brand new. Four years earlier, in 1516, Raphael Sanzio had designed the cartoons for the mosaics in the small cupola of the Chigi Chapel in S. Maria del Popolo, in Rome, ordered by the banker Agostino Chigi. Covering only a side-chapel, the cupola was of modest dimensions. In a *pozzo scorciato* (a foreshortened sky-shaft seen from below), the Creator of all things is seen hovering in the air; in the compartments of a lower zone, sun, moon and planets are accompanied by the angels who, in the Neoplatonic view, govern their movements. Had Correggio seen this little masterpiece?

Vasari insinuates that Correggio never visited the Eternal City, and regrets it: 'If this man could have seen the great masters,' he writes, 'what would not have become of him!' But it seems hardly probable that he knew Raphael and Michelangelo only from engravings. However that may be, his project for the huge cupola of S. Giovanni Evangelista at Parma was little less than revolutionary: he ventured to fill the whole of the dome with a single motif, without making any compartments.

Too many people saw it as a preliminary exercise, a preamble to the audacities of the *Assunta*, the famous *Assumption of the Virgin*, which Correggio started upon some years later in the slightly larger cupola of the Duomo.

In fact, both frescoes established his fame and, in our eyes, made him the father and at the same time the morning-star of the innumerable heavens painted in the cupolas of Baroque Europe.

Moreover, the iconography of his Apocalypse is so surprising and so subtly thought-out, that the, after all, purely biblical subject somehow escaped the notice even of connoisseurs. In former studies and guides, one can read that the fresco represents the Ascension, so much is the gaze drawn to the purely formal aspects, and so little inclined to examine the content, which, in fact, should be the first aim of both artist and commissioners.

THE INSIDE OF THE DOME

'Behold,' says St John (Rev. IV: 1) 'a door was opened in heaven.' This door, opening on a sight of heaven, is here no longer the tiny window in a Gothic aedicula through which a slender John is peeping in at the vision, as in the Anglo-Norman miniatures; no longer the colossal wooden doors flung wide-open under the arch of a Franconian doorway, as in the third print of Dürer; here, the whole inside of the cupola is the 'door'.

Just above its border, and the protruding cornice, a mighty garland of dark clouds opens onto a deep golden sky. In the middle of it,

334

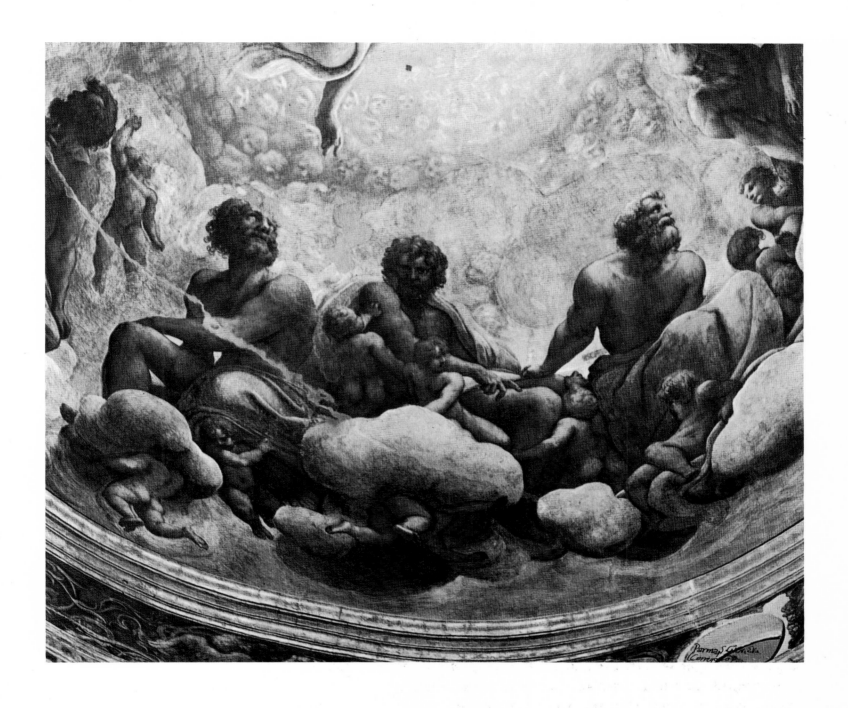

Andrew, James the Great, Simon the Zealot. (222)

on a background of dazzling light, the Son of Man is seen alone, flying in a garment of pure white fading into a shade of pink, *roseato*. Involuntarily, one recalls the words: 'Behold, He cometh with the clouds' (Rev. 1: 7). But immediately afterwards one rightly remembers the Unnamed One seated on the Throne – here the Throne, instead of the mysterious blend of precious stones suggested by the holy text, is a pit of inaccessible light.

On the bulging clouds, eleven of the twelve Apostles are sitting, in a circle that seems to turn around the Lord. They are almost naked, with scanty pieces of red and blue drapery across their loins. Muscular, heroic they are more or less recognizable. Peter brandishes a key on a string and we identify with infinite pleasure his fifteen-centuries-old portrait-head. Andrew still has his tousled hair, as of old; Paul reminds one not so much of the gastric patient one always sees

222-226

223

223

335

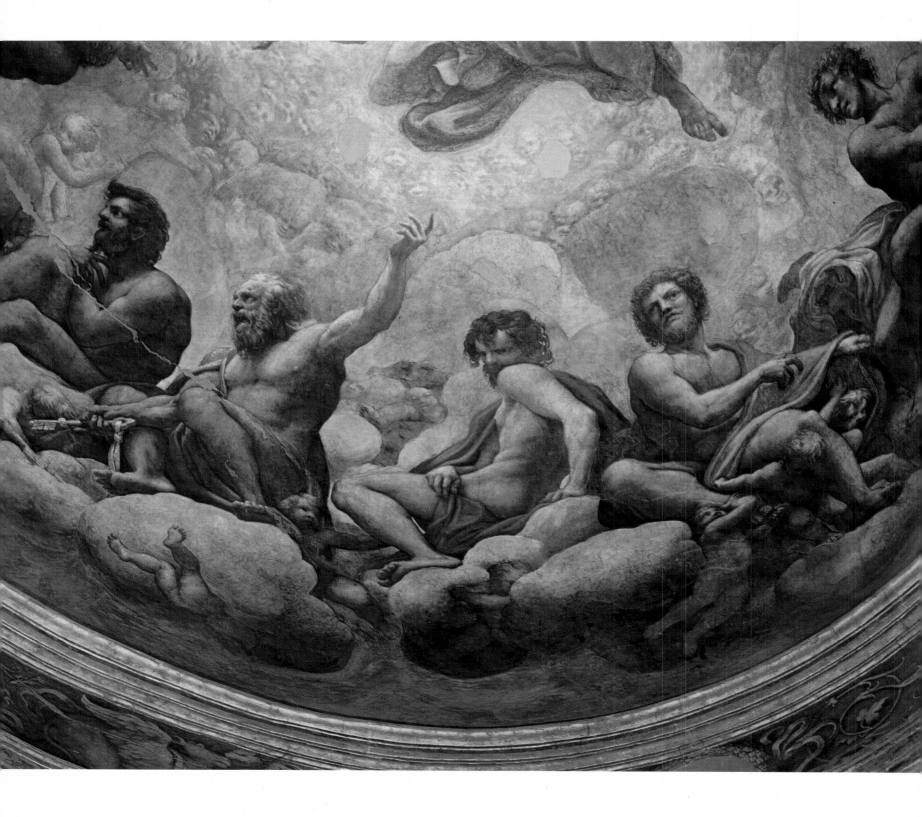

in Byzantine mosaics, as of the more vigorous type created definitively by Raphael, in the *Vision of St Cecilia* at Bologna, and in the *Disputà* of the Vatican *Stanza della Segnatura*.

Paul, Peter, Philip, Jude Thaddeus. (223)

The Apostles are riding astride the clouds, half in and half on. They are bending over to each other, gesticulating, pointing out something to a neighbour, in beautifully composed groups of two. 225 Simon is brooding alone, another is seen almost in profile. A swarm of exquisite nude children flocks around and between them: they represent the Powers Incorporeal, the 'angels', eternal Youth.

336

Several of these men and boys recall corresponding figures of the Sistine Chapel ceiling. Correggio, who modified everything he borrowed, was still young, and as much impressed as any of his colleagues by Michelangelo's unsurpassable inventions, He had not yet reached the heyday of his career, when he became famous for the mellowness of his nudes.

The Apostles are shown as middle-aged men with thick chestnut hair, or as doughty white-haired elderly men. Together they form a somewhat disorderly array of *virtù*. The children, wingless *genietti*, frolic about them – above, below and in-between – a living garland of joy. They are teasing, playing, kissing each other, discarding bits of cloud, lifting up an old foot, touching a knee, emerging, disappearing. Only the floundering legs and the buttocks are seen of one of them, the torso disappears into a cloud.

What are they doing, the august Eleven? Bartholomew, white-haired, together with a smart Matthias, look down intently, the latter putting aside his neighbour's garment for a better view. A third, Paul, his forelock standing out, a thumb at his black goatee, peers at something below, with a strong protruding black eye. Peter, who has noticed their tension, points in the same direction with his huge tasselled key, though turning his eyes to Paul. For the former three are looking at the west border of the cupola, where, just below the circle of the Eleven, in the axis of the vision, and on the side of the nave, an ecstatic old man emerges from the cornice. He looks up at the zenith where the Lord, his locks lifted up by the wind, is floating within a shaft of light. That old man is the twelfth Apostle John, the seer.

He appears in a daring foreshortening, *di sotto in su*, with coarse fisherman's hands spread apart in a gesture of admiration; his eyes are so violently raised that nearly all the white of the eyeballs is shown beneath the staring pupils. His loins are covered with pale-red drapery; a book with parchment folios is opened on the wings of his Eagle: the codex prepared for the writing down of the Apocalypse. Above his thrown-back head, the zodiac of the Apostles is turning round the Sun of Justice.

Next to the Princes of the Apostles, Peter and Paul, Philip starts up, as if remembering certain words of his Master (John XIV: 8-10?). Jude Thaddeus seems lost in thought; between his legs, set widely apart, a little boy pulls at a slip of his mantle; another has seized his right ankle, a third is playing hide-and-seek behind a piece of drapery. James the Less, an athletic Apollo, is leaning back, his legs dangling in the air. Thomas is talking to him, his sophist's profile shown against the light, as befits a sceptic. A little boy, mounted on the back of his playmate, tries to climb on to his knees. The old Andrew is the only one who looks straight into the vision. A child emerges from below the hem of his mantle, another is putting a cloud under his feet, as a footstool. Next to him, James the Greater, the first of the Twelve to die a martyr, is sadly leaning back, one

224 223 223 223 226 222

forefinger raised, his eyes flashing in the dark, his mantle billowing behind his back. Three children are assailing him: the first wants to sit on his shoulder, the second appears below his thigh, the third has seized his mighty knees upon which he evidently wants to nestle. Finally, Simon the Zealot, a handsome old man sitting quite alone, stares upwards, one hand is on James's knee while he leans on the other, his vigorous torso emerging from a brick-red mantle majestically covering his lap and legs.

THE SPANDRELS

Below the narrow drum of the cupola each of the spherical triangles of the spandrels is occupied by a different group, related to the group of the Apostles. Two of them are badly damaged, but old drawings of them are preserved in the Parma *Galleria.*

They show the four Beings of the Apocalypse, in the company of the four evangelists whom they have been thought to symbolize from the days of St Ireneus of Lyons, in the second century. Here they are writing, or conversing with the four great Latin Fathers of the Church, who sit beside them listening, or are absorbed in the drafting of their prolix and still authoritative commentaries.

In the north-east spandrel, John, a red-haired youth, counts the arguments on his fingers while discussing with Augustine, presumably about the latter's famous *Treatises on John.* His Eagle guards Augustine's crozier. Matthew – in the south-east spandrel – turns over the leaves of his Gospel, held by a boy, just as during Mass. Over his shoulder he dicatates to Jerome, the exegete, who, a scratch-pad on the text-book lying in his lap, evidently prepares the *Vulgata* version, ordered by Pope Damasus. The child is Matthew's symbol, Man. Jerome, who is wearing a red cardinal's robe, is not accompanied by his inevitable Lion (from the paw of which he once extracted a thorn). Little remains of Mark and Pope Gregory the Great. The Lion has vanished; a child holds the papal tiara.

Luke, a jovial peasant grandfather with a shock of thick grey hair, is talking to Ambrose, who takes notes in his codex. The evangelist, who does not in the least recall the distinguished Antiochene doctor that he was, is sitting on his Ox, which rests his tame head between his forelegs. The bishop of Milan is robed in a rich cope adorned with the portraits of other Milanese saints; a child hides behind his mitre, two others crawl out of the cloud that serves as a pedestal.

THE FOUR ARCADES

On top of the piers from which the four arches spring, eight medallions contain as many figures, in grisaille. So well designed are they that one can hardly fail to recognize the hand of Correggio himself. They represent the heroes of the Old Testament.

Cain stands on the back of Abel, who lies flat on the ground;

227

Bartholomew and Matthias; below: John. (224)

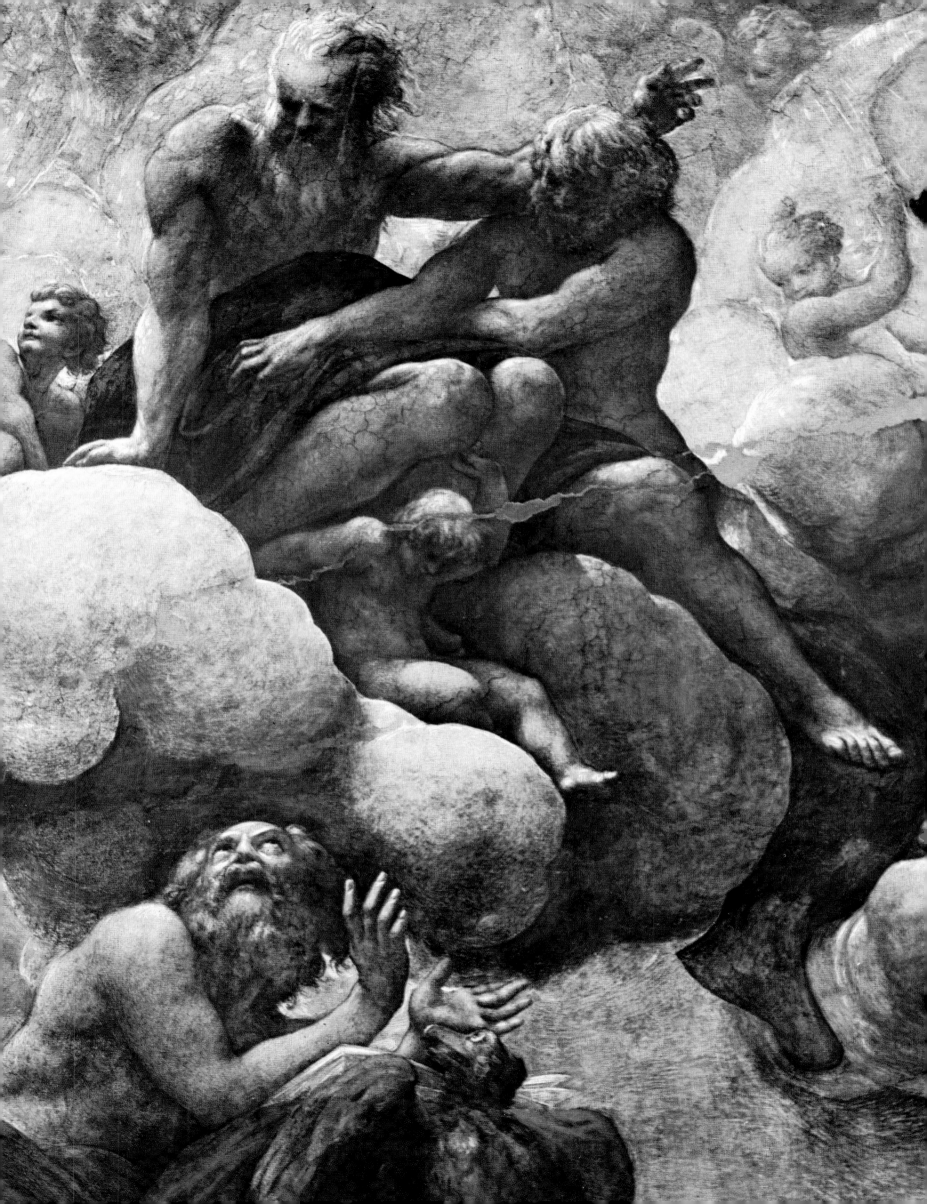

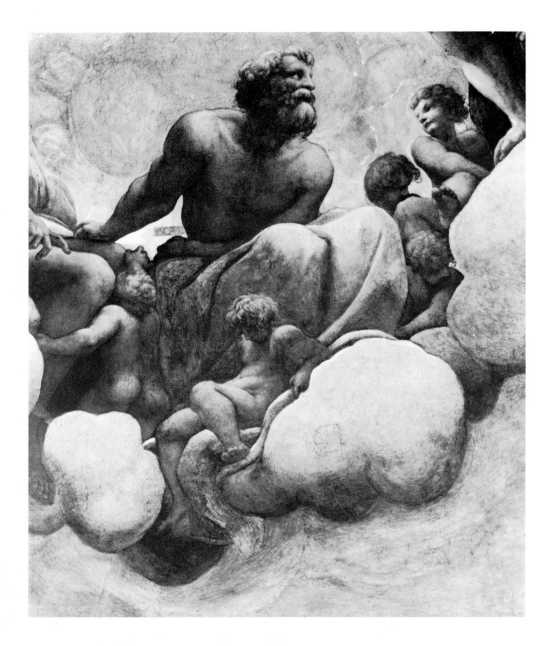

Simon the Zealot. (225)

he is raising his club for a second blow, but his hair is standing on end and he realizes what he has done. Abraham, who has already seized the hair of Isaac, squatting on the wood of the sacrifice, is listening to the angel who has grasped his wrist. His knife has fallen from his hand. Samson, seen from the back, is carrying away the splintered doors he has torn from the gates of Gaza. Jonah, old, naked and tired, is stepping from the jaws of the great Fish, a kind of squinting whale flapping its forked tail. Moses, with horns on his forehead, extends his hands in prayer before the Burning Bush; he has taken off his shoes. Aaron is holding his flowering staff. Elijah, open-mouthed, his head thrown back, is carried to heaven in the fiery chariot, his mantle slipping down to the ground (where Elisha is going to take it). Daniel is raising hopeful eyes in the lions' den. Added to the four Beings respresented in the spandrels, these eight figures make another twelve. This can hardly be mere chance: the

340

painter or his principal must have had in mind the twenty-four Elders of the Apocalypse. For a thousand years these Elders had been traditionally recognized as the heroes of the Old and New Testaments, and were interpreted as symbols of the concordance of the Ancient Law and the Gospel. The idea goes back to Victorinus, Bishop of Poetovio, in the first years of the fourth century. It did not seem incompatible with Ireneus's idea, that the four Beings symbolized the four Gospels, that two of the evangelists were Apostles. Popularized for centuries, these ideas were still commonly held after 1500, though more and more professional divines insisted on the literal sense of the relevant passages in Holy Scripture.

There must have been learned monks among the Benedictines of S. Giovanni at Parma. One has only to read the subtle legends, in Greek, of the frescoes Correggio painted on the walls between the arcades and the clerestory of the nave. The monk who made the iconographical programme for the crossing and the cupola hardly left anything to chance. He must have remembered the ancient interpretation of the mysterious Elders, though the Apostles (and John with them) have obtained the place of honour, and the great men of Israel, somewhat arbitrarily chosen, have been relegated to secondary places.

THE DRUM

Neither did he forget the four Beings: they are seen in the spandrels, and are supremely conspicuous. They are painted a second time in the narrow frieze of the drum between the round windows. Two by two, the Animals are shown romping with each others, between vine-leaves, ribbons and arabesques: the Man with the Eagle, The Lion with the Ox, The Man with the Lion, the Ox with the Eagle. It is a playful decoration in the style of the *grottesche*, very charming and not at all unbecoming, for the symbol 'Man', who leads the game, is but a graceful child.

Correggio was the first to isolate the Apostolic College from the rest of the Elders, and to show them not enthroned on lofty seats but freely swinging in a carousel of clouds round the Fathomless Light – indeed a strangely original evocation of the Beatific Vision. He was the first to omit entirely the symbols of the Heavenly Liturgy: the crowns, the citharas and the vials of perfume, the first, too, to show the Elders in heroic and slightly Michelangelesque nudity, modestly veiled with unobtrusive slips of drapery and trailing billowing clouds – a playground of the romping children who represent the eternal youth of the Powers Incorporeal.

There is nothing unwholesome in the nudity of these vigorous men; nothing of the tortuous elegance of the later Mannerists either. It rather anticipates the healthy naturalness of Annibale Carracci. The Apostles are duly styled, but, for the rest, they are exactly like the robust Emilian peasants the countryman Correggio could see

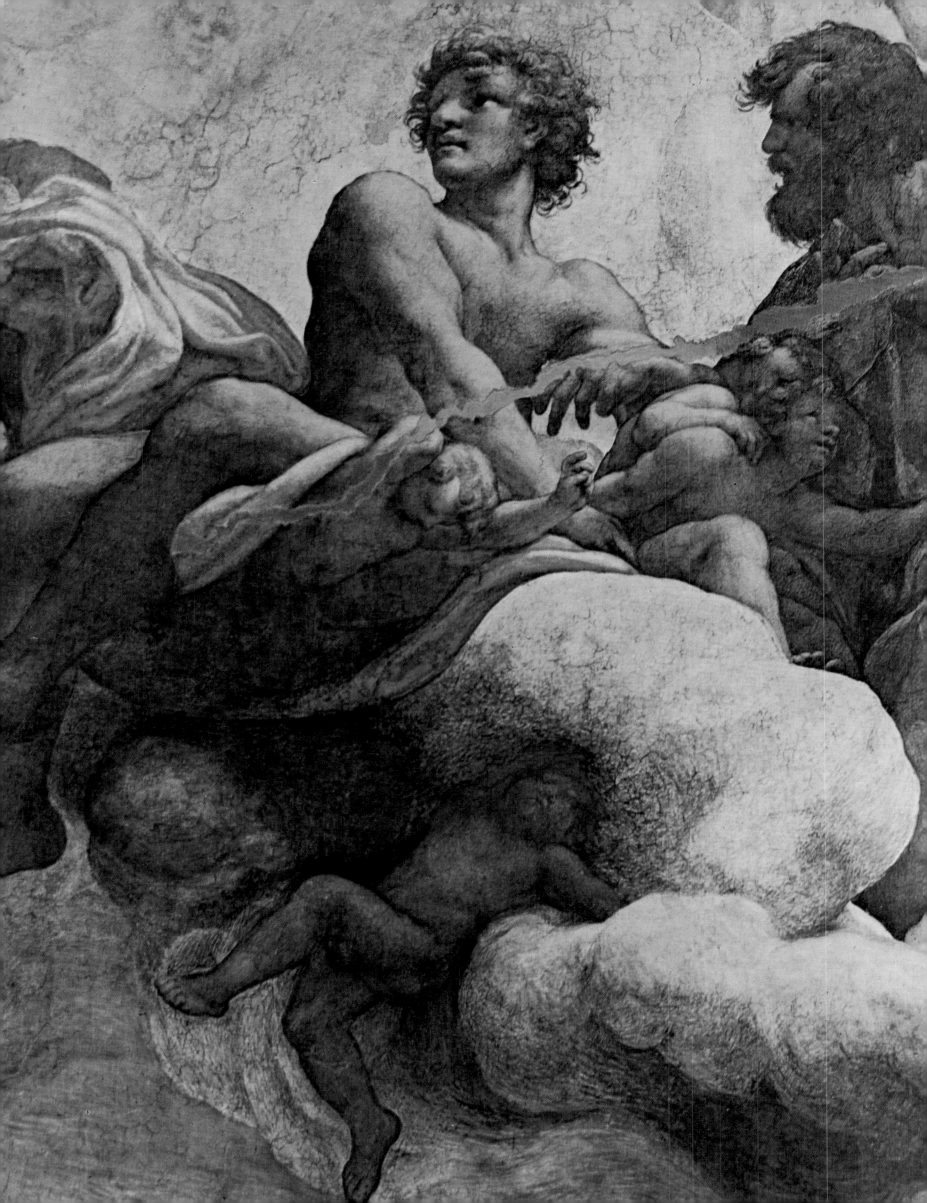

about him. For his splendid children, he had only to look out the window – he was living among a sober, sturdy, earthy people.

Arranging the Twelve on a carousel of clouds revolving round a vision of glory was a stroke of genius, a sequel to the half-circle round the Throne in Raphael's *Disputà*, and a triumphant counterpart of the group of the alarmed Apostles in Leonardo's *Cena* in S. Maria della Grazie at Milan.

It is not remarkable in itself that Correggio divided the twenty-four into very unequal groups, giving precedence to the Apostles and relegating the patriarchs and prophets to the arcades, and the four Beings to the spandrels. A curious (and somewhat pedantic) spectator, reflecting on this unusual disposition, might recollect that, just as here at Parma, in a transept window of Chartres and in a contemporary cathedral doorway at Bamberg, the authors of the New Testament are carried on the shoulders of those of the Old.

THE LUNETTE IN THE NORTH TRANSEPT

One may ask if the painter really meant to represent the Vision of the Throne. The documents, which indicate exactly in how many instalments Correggio received his 130 gold ducats, do not mention it. Yet there can be no doubt. In the lunette above the door giving entry into the cloisters, in the north transept, Correggio has again represented John: this this time sitting, the sole of a foot just visible on the lower cornice.

Here he is a young man with wavy chestnut hair, his head, without a halo, held upright on a firm and full Italian neck. His right hand, holding the quill, is resting on a folded parchment curling over the border of the writing-board: the first leaf of the Apocalypse. Behind his back, two books are on a desk decorated with a cherub's head. One may think, gratuitously, of Ezekiel and the Fourth Gospel. At his feet his Eagle, head between its wings, seems to have fallen asleep.

John himself is wide awake. With half-opened lips he stares intently at the top of the cupola, which he can see far away high in the air (29 m above the floor of the crossing). There his beloved Master, on whose breast he once rested, appears in glory, among the Eleven. Why has John suddenly become young? He was over eighty when on Patmos. But in the West he was always represented as the youngest of the Apostles, even on Patmos. The old man required by history can be seen in the East: on Mount Athos, in the Balkan frescoes, in Russia, on Cyprus and, until the present day, on all icons showing 'John the Theologian' dictating his works to his young secretary, Prochorus. In the West, the old John appears only in a few Ottonian miniatures and in Correggio's fresco, emerging naked from the cornice of the cupola, visibly in ecstasy.

In the lunette he is young again. But on the arch surrounding it, a legend in Roman capitals, says:

James the Less and Thomas. (226)

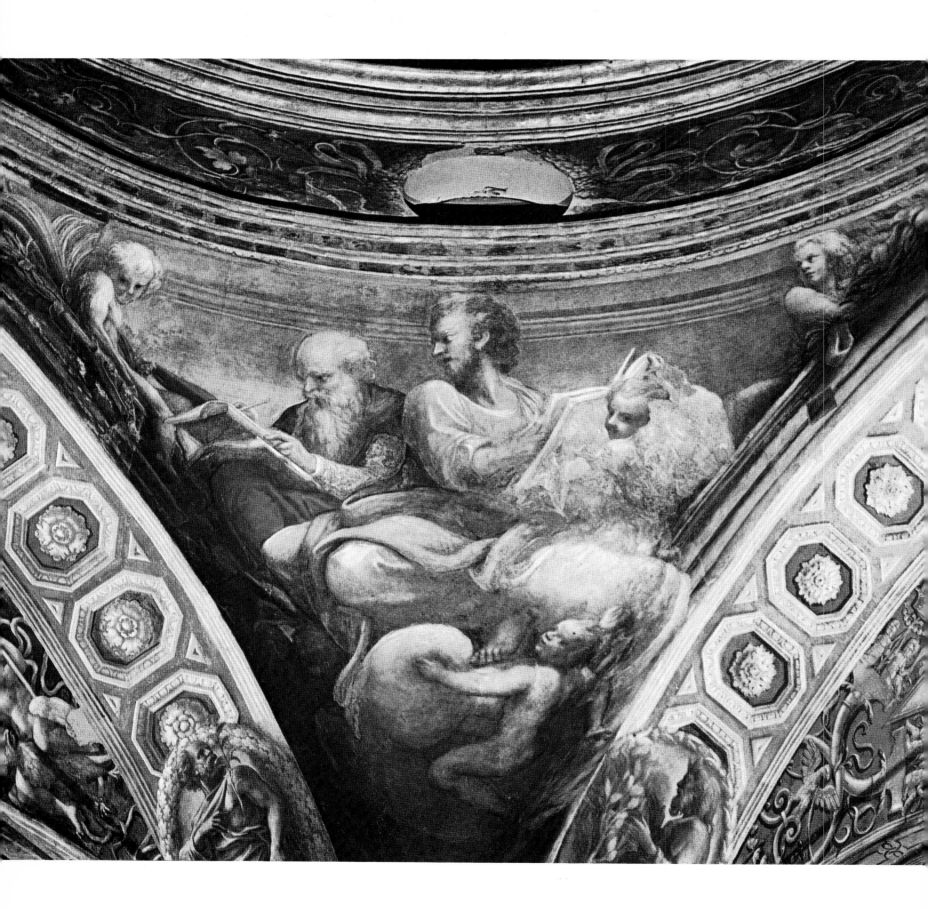

ALTIVS. CAETERIS. DEI. PATEFECTI. ARCCANA.
More profoundly than others this man revealed God's secrets.

And this laconic inscription gives the key to the whole of Correggio's conception. In the cupola we see 'him' as opposed to the Eleven, the 'others' – *caeteri*, the other authors of inspired books. And *patefecit* is an almost etymological explication of the word *Apocalypsis*, 'Revelation'.

All that remains of the preparatory work are five preliminary drawings of a few details of the cupola, some others of the groups in the spandrels and two beautiful sketches for the frieze of the drum. Above all, they show how freely Correggio obeyed the inspiration of the moment, for he changed almost everything when executing his frescoes.

We do not know what he thought about the subject proposed by his commissioners. The austere climate of the years following the Sack of Rome, in 1527, was still in the future, as were the reservations the Fathers of the Council of Trent would make concerning Church art. The carefree somatism of the cinquecento was at its height. The joy in and admiration for the beauty of the human body and natural emotions were still beyond suspicion, and were alive in the hearts of the artists as well as in those of their intelligent commissioners, who for the greater part were pious believers addicted to the then fashionable Neoplatonic idealism.

With typically Italian candidness, Correggio, full of this healthy sensuous vitality, wrote the dazzling epilogue to the millennial history of the illustration of a Book so full of ascetic visions as the Apocalypse: his illustration is the most sensuous of them all. But it does not matter, for the body serves the glorification of the Lord. It is at home in a celestial dome. Even in imagining a celestial Liturgy, this son of a refined and marvellously gifted race is no longer a child or a novice, but, also, in a spiritual sense, an adult.

And here one might well remember that the painter of the manifold 'graces', the creator of the *morbidezza* that made his altarpieces famous, the author of the Dresden *La Notte* and the many *Sacre Conversazioni*, but also of the *Ganymede*, the *Danaë*, the *Io* and the *Leda*, had been received as an oblate into the Cassinese Congregation and was one of the family in the Benedictine monastery of Parma. Vasari, who admires Correggio (but confuses the subjects of his two Parma cupolas), tells us that he was reputedly a tender, over-sensitive man, given to melancholy, mistrusting his genius and never satisfied with his work. He was very concerned about his growing family, and was contented with very little, living *da bonissimo cristiano*.

Yet with his divine athletes and his dual image of St John – at once a Ganymede with sleeping Eagle, and an ugly ecstatic old man – Correggio was able to achieve a synthesis between the tremendous Renaissance delight in the body and the final chapter in the Book of God – the Apocalypse.

A pendentive: Matthew (the 'Man' holding his Gospel-book) and Jerome; on the arches: Aaron with the flowering Rod (left) and the horned Moses standing before the Burning Bush (right). (227)

345

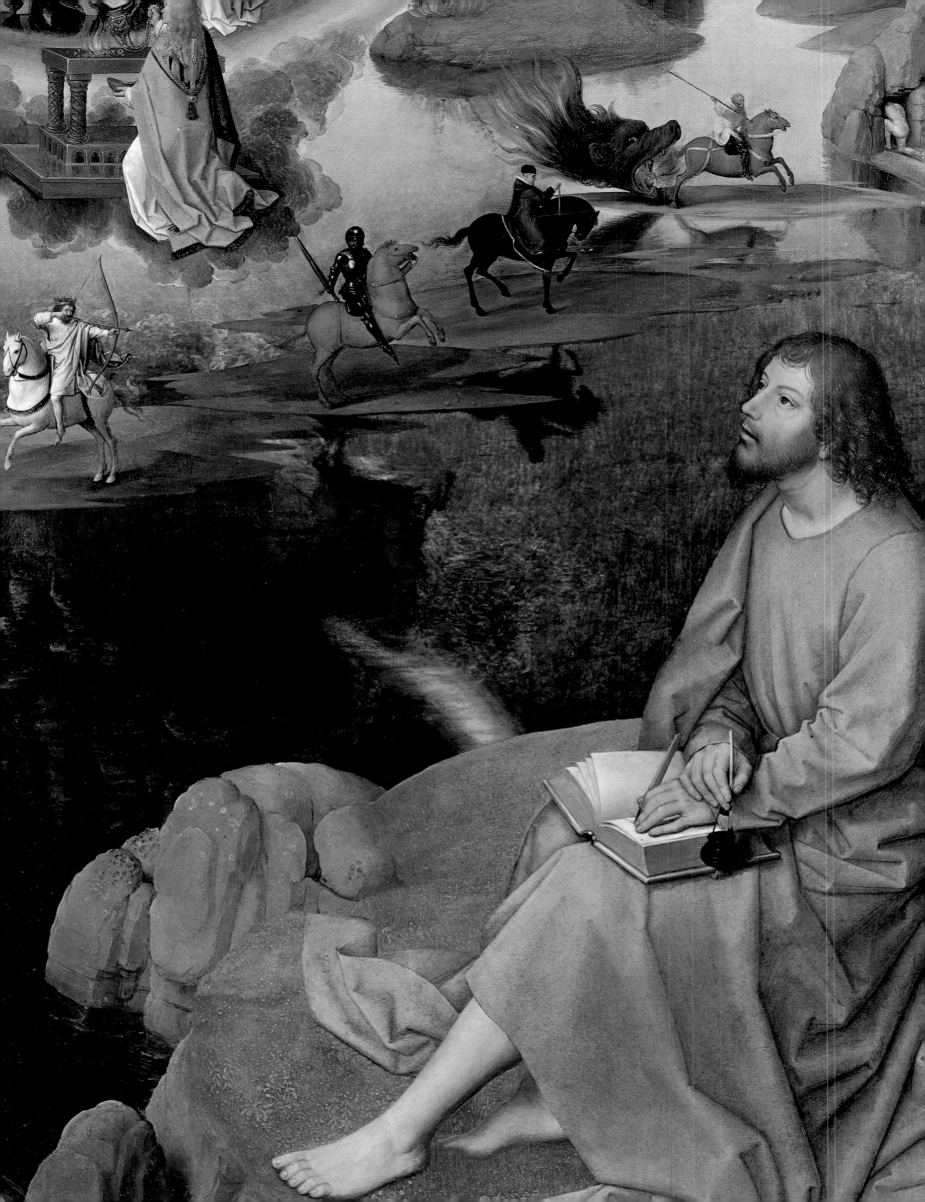

Glossary

List of terms from art historical and religious usage; explanations are as concise as possible; *italic* words refer to synonyms and related terms.

St John and the vision of the Apocalypse. Detail of pl. 168. (228)

ACANTHUS 1. herbaceous plant with prickly leaves, in Mediterrenean countries; 2. ornament carved on Corinthian *capitals*, or decorating a *frieze*.

ACOLYTE 1. cleric of lower rank; 2. boy serving at mass.

ACROTERION ornament at top of *pediment* or roof.

ACTA, ACTS (L) historical or *apocryphal* biography.

AEDICULE (L) shrine flanked by columns or pilasters and crowned with a pediment, sheltering a statue; Chr.: *memoria* of a martyr, mostly without statue or images.

AGATE banded chalcedon, a gem.

ALB (liturg.) white garment for clerics, reaching to feet.

AMARANTH (Gr. 'unfading') imaginary plant, symbol of immortality.

AMETHYST purple or violet quartz, a precious stone.

AMICE (L) linen garment worn on neck and shoulders, during Liturgy, beneath the alb.

AMPULLA (liturg.) vessel for wine and water, at mass.

ANCHORITE (Gr. 'who withdraws from the world') a Chr. hermit, since 4th C.

ANAGRAM (Gr.) transposition of letters to form a new word.

ANGEL (Gr. 'messenger, herald') 1. in HS: messenger of God, appearing in human shape; 2. (HA) figure derived from antique *Victoria*, goddess of Victory, winged, but in Chr. art nobly draped, with staff and nimbus; in later MA dressed in liturg. vestments, mostly as a deacon.

ANGLO-NORMAN 1. Romanesque in Britain, after 1066; 2. family of mss. of the Rev., after c. 1240, in England and Northern France; ch. X.

ANONYMOUS ONE, THE He who sits on the Throne, Rev. IV.

ANTEPENDIUM altar frontal.

ANTICHRIST (Gr.) enemy of Christ, symbolically representing the Evil Powers, or, sometimes conceived as a Person; the word occurs in the NT in I Jo. II, 18-22 and IV, 3; II Jo. VII; cf. II Thess. III, 8.

APOCALYPSE (Gr. 'uncovering, revelation') literary genre, dealing with *eschatological* visions in late Judaism and Early Christianity; 2. esp. the Rev. of St John. See *Introduction, the Book and its commentaries*.

APOCRYPHAL (Gr. 'what is hidden') a text of doubtful authenticity.

APSE (Gr.) semicircular recess in wall, mostly at end of building, in Chr. churches always at the east.

APSICAL COMPOSITION mosaic or fresco in the conch of the apse.

APOTHEOSIS (Gr. 'deification') HA: composition symbolizing the divine majesty of a prince or a hero; Chr. only of the Lord, the *chrismon* and the Cross.

ARABESQUE linear ornament made of plants, fiowers, leaves, or scrollwork; in Arab. art also of texts of Quran.

ARAMAIC semitic language spoken in Palestine in time of Christ.

ASCLEPIADIC (Gr.) AH of the god Asclepius, e.g. a head.

ARCHETYPE (Gr. prototype) of related works of art; in mss. of a group or family of mss.

ARCHITRAVE (archit. 'main beam') horizontal beam resting on pillars or columns supporting the superstructure, esp. the entablature.

ATLANTES (sc.) supports in form of a human figure; after Atlas (myth.) the giant supporting the celestial globe.

ATRIUM (L) 1. central court of a Rom. house; 2. forecourt of a Chr. *basilica*, mostly surrounded by three or four galleries.

ATTIC (archit.) 1. top piece of façade, above the cornice; 2. top story, item.

BABYLON in Rev. the City of Evil (lit. pagan Rome persecuting the Church).

BARREL-VAULT half-cylindrical vault, in Rom., Byzantine and Western archit. till Gothic period.

BALDACHIN, -QUIN (It. baldacchino) canopy above throne or altar; small dome on columns over pulpit, bishop's throne or altar; cf. *Bernini*'s altar.

BAPTISTRY (Gr.) square, or mostly round or octogonal separate building near an episcopal church in Chr. Antiquity, with a piscina (water basin, to be reached by steps downwards) and water supply, for baptism on Easter night.

BASILIAN monk in the Orthodox Church, following the Rule of St Basil the Great, metropolitan of Caesarea, Cappaodicia.

BASILICA (archit.) 1. public building for meetings and the administration of justice in imperial Rome; 2. Chr. church; 3. (techn.) aisled church, where the clerestory rises above the aisles.

BEHEMOTH (bibl., Book of Job) enormous creature, prob. Egyptian.

BERNINI'S ALTAR above the tomb of St Peter, Rome, by Gianlorenzo Bernini (1598-1680): with a baldachin on twisted columns.

BLACHERNIOTISSA or THE BLESSED VIRGIN OF THE BLACHERNAI type of the Virgin, praying with outstretched hand; after a famous icon in Constantinople.

BREVIARY (L breviarium, 'summary') book of Hours for priests in the later MA.

BURR rough edge of a graved line in woodcuts.

CABBALA (Hebr. 'tradition'), Jewish oral tradition, partly esoteric and mystical.

CALAMUS (Gr. 'reed') writing-pen of reed.

CALLIGRAPHY beautifully stylized handwriting.

CAMEO engraved stone.

CANON (L canonicus, 'who lives according to a rule') member of a cathedral or collegiate chapter, in the MA.

CANON (Gr. 'rule') 1. list of authentic books in HS; 2. central prayer of mass, in all rites; 3. list of parallel passages of the Gospels, compiled by Bishop Eusebius of Caesarea, 4th C., in his *canones* or *Tables of Concordance*; 4. member of a cathedral or collegiate chapter.

CANTABRIGENSIS (E 'Cantabrigian') of Cambridge.

CAPANNAE (L) straw huts in bucolic genre pieces.

CAPITAL (archit.) crowning feature of a column, between shaft and architrave and, after 300 and during the MA, between column and archivolt; figured capitals only occur in Romanesque sculpture.

CAPARISON (F caparasson, MA) luxurious trappings of a horse.

CAROLINGIAN (HA) from 770 until *c.* 900.

CARPACCIO Venetian painter of the quattrocento.

CATENA (L 'chain') series of chosen texts from commentaries on HS.

CATHEDRAL (from Gr. kathedra, L cathedra, 'bishop's seat') episcopal church.

CHALDEAN 1. Mesopotamian; 2. in time of Rom. Empire general term for dress, way of life and science of countries east of Anatolia.

CHANCEL see CHOIR, 3; = F chœur, G Chor, Sp. capilla mayor containing the 'coro' = choir stalls.

CHASUBLE (L casula) ample upper garment, with opening for head, and sleeveless; liturg. vestment for priests and bishops.

CHERUBIM (Hebr.) the four-winged creatures carrying the Throne, in vision of Ez., each with four faces (*tetramorph*, Gr. 'fourfold in figure'); in Rev. the Living Beings each have one face; in Chr. iconography they have become symbols of the four Gospels, after an idea of Irenaeus of Lyons, 2nd C.

CHLAMYS (Gr.) cloak fastened on one shoulder with clasp; 1. short military cloak; 2. in post-classical times official dress for court people, high officers of army, and Greek emperor, reaching to feet.

CHOIR (Gr. choros: 1. round dance; 2. chorus, in tragedy); Chr.: 1. the nine orders of the incorporeal spirits, after Dionysius Areopagita); 2. liturg. group of singers, in Rome named *schola cantorum*; 3. (archit.) chancel, = part of church reserved for clergy; also = presbytery: always east of nave and transept.

CHRISMON XP, = Christós, name of Christ.

CINGULUM (L 'girdle') plaited linen girdle keeping up the *alb*.

CISTERCIAN monk of strictly centralized Order of Reformed Benedictines, founded 1098 at Cîteaux (near Beaune, Côte-d'Or), following the original Rule of St Benedict, with the obligation to keep silent and to work, esp. in the fields; flourished 11th-13th C.; the old discipline was restored by the Abbé de Rancé, 1664, in his abbey of La Trappe (Orne, Normandy), cradle of our Trappists.

CITHARA wire-stringed instrument played with *plectrum*.

CLAIR-OBSCUR, It. CHIAROSCURO (HA) effects of light and dark.

CLASSICISM (HA) 1. every period that takes the strict models of Gr. Antiquity as its standard, e.g. sc. under Hadrian; 2. the period of 1750-1830.

CLAVUS (L) ornamental band on tunic, from shoulder to hem, mostly of purple colour.

CLERESTORY upper stage of main walls of central nave of basilica, containing the upper windows.

CLIPEUS (L 'shield') 1. buckler, round shield; 2. HA medallion of that form.

CLIVIA bulbous plant with stiff ligulate leaves and a cluster of flowers.

CLOISTERS (archit.) the four galleries round the small garden alongside the monastic church; L claustrum, F cloître, It. chiostro.

CLUNIAC of the monastic family of Cluny (Saône-et-Loire, Burgundy), dominating the arts of the 11th-12th C., with their famous *Romanesque* works of art; final crisis caused by the asceticism of Bernard of Clairvaux, mid 12th C.

CODEX 1. ms. in form of book (as against 'roll'); 2. book of law, esp. canon law.

CAENOBITE (Gr. koinos bios, 'community life') monk living in community, as against hermit or recluse.

CONCH half-dome of an apse.

CONCORDANCE alphabetical list of chief words from HS, and where to find them.

CONFESSIO (L 'confession') HA in the West: funeral monument *(memoria)* of a martyr or saint, originally with a window-like opening *(fenestella)* so that relics could be touched but not always seen.

COPE (late L cappa) wide cloak, opening at the front, held together by a clasp below the neck; with a shield-like ornament on the back; liturg. in MA; also: *pluvial*.

COPTS native Egyptian Christians (from Gypt = Copt), at present numbering four million.

CORONA (L 'wreath') wreath of laurel, a sign of triumph; later = crown.

CORNICE (archit.) projecting top section of an entablature.

COSMOS (Gr.) universe as an ordered whole.

CROCKET (goth. archit.) ornament in the form of curled leaves on sides of gables, pinnacles and spires.

CROSSED NIMBUS nimbus with an inside cross, attribute of the three divine Persons, esp. of Christ.

CROSSING central bay of a cross-shaped church.

CUPPA (liturg.) bowl of chalice.

DALMATIC (Gr.) 1. long women's dress, worn above tunic; 2. (liturg.) vestment worn by deacons, with short sleeves and open sides.

DEACON (HA) in the MA to be recognized by *dalmatic* and Gospel-book.

DEESIS (Gr. 'intercession') HA the group of Christ between Mary and John the Baptist, of Gr. origin, central motif of the great composition of the Last Judgment.

DEMETER (Gr.) goddess of the fertility of the earth, esp. honoured at Eleusis; represented as a veiled matron.

DIPTYCH double writing-tablet, with inner sides waxed, often of ivory; 2. (paint.) double panel.

DI SOTTO IN SÙ (It.) seen from below, foreshortened.

DISTICH pair of verse lines, couplet; = *hexameter* and pentameter.

DOCETISM heresy denying Christ's corporality; since the 2nd C.

DONATISM heresy emphasizing invalidity of sacraments administered by sinners or apostates, in N. Africa, esp. before and after the great persecution of 304-311; partly a native rebellion of Berbers against the official religion of the L. speaking cities.

DRAGON (Gr. drakoon) myth. monster, winged serpent with horns, often with many heads; L hydra, 'water-snake'.

DRUM cylindrical or octagonal wall supporting dome; mostly with windows; = F tambour.

DULCIMER musical instrument with strings of different lengths, struck with hammers.

DUOMO (It.) episcopal church, in Italy.

EDERA (L) ivy leaf.

ELDERS, THE TWENTY-FOUR (Gr. presbúteroi, Rev. IV) adoring the Lamb, see ch. II.

ELYSIUM (myth.) abode of the blessed after death.

EMAIL CHAMPLEVE enamel with figures in relief.

EMAIL CLOISONNE enamel with colour paste embedded between edges of gold forming the design.

EMBLEMS allegorical motifs with explanations.

EMERALD bright-green precious stone.

EMPYREAN (Gr. 'sphere of fire') highest heaven, in Neoplatonism symbol of nearness to deity.

ENCRATISM sectarian movement, 2nd C., condemning wine, meat and matrimony.

EPINAL, IMAGE D' hand-coloured prints, with many scenes in superimposed horizontal bands, since 18th C. made in Epinal (Vosges).

EPIPHANY (Gr. 'manifestation, revelation') 1. solemn appearance of a ruler in late Antiquity; 2. (Chr.) self-revelation of the Lord; 3. feast of January 6 (Ta Epiphaneia: the Lord revealing Himself to the Magi, and to John the Baptist, at Christ's baptism).

ESCHATOLOGICAL (Gr. ta eschata, 'the Last Things') related to the End of Time.

FRESCO (It. al fresco, 'in fresh plaster') wall-painting done when plaster still wet.

FRIEZE 1. in the Ionic order the (mostly figured) middle division of entablature; 2. every horizontal series of images, also in wall-paintings.

FRONTISPIECE title-page, opposite beginning of text (initium) in a ms.

FUGUE polyphonic composition, in which central theme is successively taken up in a pre-fixed order.

GABLET triangular gable surmounting Gothic portals and windows.

GABLE (F) slightly convex curve of a column or a figure.

GEHENNA (Hebr. Ge hinnom, 'valley of the (sons of) Hinnom') 1. place for burning of refuse S. of Jerusalem; 2. in NT the abode of the damned, in the realm of Death, Hades; = Hell.

GEM precious stone.

GENIETTO, plur. GENIETTI (It.) naked little boy, often winged; see *putto*.

GESÙ (It. Jesus) principal church of the Jesuits in Rome, by Vignola (± 1575), with the first great Baroque one-space domed interior.

GLOBE (L globus, 'ball') HA terrestrial globe, as symbol of world dominion; in MA often with cross put on top; also = *orbis*: 'stat crux dum volvitur orbis' = while the world turns, the Cross stands firm', device of the Carthusians.

GLOSS (Gr. gloossa, gloossema, 'marginal note') explanatory remark.

GNOSIS, GNOSTICISM esoteric doctrine for the initiated about 'true knowledge' (Gr. gnoosis, 'knowledge') is semi-Chr. milieux, since 2nd C.; condemned in all its variations by the Church.

GOBELIN (F) figured tapestry, techn. named after the Parisian family Gobelin, 17th C.; the word used since 1664 (Colbert's Manufacture des Gobelins).

GOG AND MAGOG in Rev. XX, 8 symbols of God's adversaries, after Ez. 38 (where Gog, king of Scythia, reigns in the land of Magog).

GOLD GLASS (HA) double bottom of a glass cup, with figures of gold leaf between, mostly Chr. motifs, esp. 4th C.; used at funeral meals.

GRAFFITTO (It.) incised drawing, inscription or name.

GRISAILLE (F) 1. (paint.) composition in grey monochrome; 2. (glass-paint.) the brownish paint marking outlines and shadows on stained glass.

GROINED VAULT vault resulting from inter-section of two *barrel-vaults*.

HADES (Gr. myth.) 1. Ruler of the Lower World (L: Pluto); 2. The Realm of the Dead (also Chr.); cp. *gehenna, infernus* (better: in-feri; 3. pejoratively: Hell).

HALLELUJAH (Hebr. and L 'Praise the Lord') from the Psalms, in the liturg. sung after Gradual and, during Easter time, after all anthems.

HAND-ORGAN small organ played with right hand (keys) and left hand (bellows), resting on knee.

HELL in German the name for the place of the damned, cf. *Hades*.

HEMLOCK 1. poisonous umbelliferous plant; 2. poison got from it; 3. cup with this poison (F la ciguë).

HENNIN high conical women's headdress with light veil, 15th C.

HERMIT (Gr. eremos, 'desert') originally a monk living in solitude; later: recluse, solitary monk.

HEXAMETER (Gr. & L) line of six metrical feet: esp. five dactyls (one long, two short syllables) and a spondee (two long). Hex (Gr.) = six.

HIERATIC (Gr. 'numinous', from hieros = holy) HA: rigid, majestic figures, mostly re-presented frontally, with solemn expression: typical of sacred art.

HIEROGLYPH (Gr.) figure of an object stand-ing for a word, as in Egyptian writing.

HIGH MASS (liturg.) since early MA: solemnly sung eucharist.

HORSESHOE ARCH (archit.) current in Arab. Visigothic and Mozarabic and sometimes too in early Romanesque architecture.

HOUPPELANDE (F) man's gown, wide upper part, reaching to the feet; late MA.

HOMILY (liturg.) sermon in the form of a commentary on the lessons of the day.

HUMERAL (liturg., L humerus, 'shoulder') pre-cious vestment covering shoulders and hands carrying chalice, ciborium or monstrance.

HURDY-GURDY in the later MA musical in-strument played by turning handle with right hand and playing keys with left hand.

HYDRA (Gr.) water-snake; cf. *Dragon*.

HYPERBOREANS in Antiquity the unknown peoples N. of the Caucasus and the Black Sea.

ICONOGRAPHY description and analysis of images, and their meaning.

ICON (Gr. eikoon, 'image') HA originally a portrait (often bust in *clipeus*, or medallion); later on whole figures, and also the canonical representations of chief mysteries of Faith; worship starts in 6th C., and flourishes after crisis of Iconoclasm (breaking of images, 728-843). The world of icons and its theology are creations of the Gr. Chr. genius.

INCUNABULA (L cunae, 'cradle') early phase of book printing, 15th C.

INFERNUS (L, better: INFERI) realm of the Dead; in MA also: Hell.

INITIAL (L initium, 'beginning') in mss. first letter of a text, richly ornamented.

IRIS (Gr. 'rainbow') in HS symbol of peace between God and men, Gen. IX, 13, and Rev. IV (iris round the Throne).

ITALIC (HA) typically Italian, in the early MA.

JASPER opaque variety of quartz, usually red, yellow or brown.

JERUSALEM 1. the city with the temple, in Ancient Israel; 2. symbol of God's dwelling amongst men; 3. Rev. 21-22: the Heavenly City, after the end of Time, symbol of the New Heaven and the New Earth.

JOACHIMISM movement going back to Joa-chim de Fiore (†1202) and his doctrine on the dawn of the era of the Holy Spirit, applied to themselves by the *Spiritual* Franciscans of the 13th C.; see text ch. X.

LAMB see ch. I, and passim.

LANCET slender pointed undivided window in Early Gothic.

LECTERN (liturg.) reading – or singing – desk in churches; in MA standing between the choir stalls.

LECTIONARY (liturg.) book with the lessons (lectiones) or *pericopes* taken from HS, to be read during mass.

LEVIATHAN (bibl., Job) HA: imaginary sea-monster.

LIBER PONTIFICALES chronicle of the Popes, after documents of the 4th to the 15th C. (Pius II), of great value for the HA.

LINTEL horizontal beam bridging an opening, from F linteau.

LISSIER (F) weaver of tapestries 'de haute lisse'.

LUCIFER (L 'morning star') the chief of the rebellious angels, cf. Jes. 14, 12.

LUNETTE (It. archit.) semicircular opening or surface.

MAGNIFICAT (liturg.) the canticle of the Vir-gin (Lk. I, 46-55) sung during vespers.

MAJESTY (HA) Christ enthroned between the four Living Beings of Rev. IV; ch. X.

MAPHORION (HA) dark purple upper garment enveloping the whole figure of the Virgin, in classic Greek-Orthodox compositions.

MAPPULA (L) precious handkerchief.

MAUSOLEUM (Gr.) magnificent tomb; name after the tomb of Mausolus at Halicarnassus (353 BC) one of the seven wonders of the antique world.

MEDUSA (myth.) woman's head with snakes for hair and petrifying look.

MEMORIA (L 'memorial') HA and liturg.: tomb of a Chr. martyr (Gr. = martyrion).

MENDICANT ORDERS monastic orders with-out landed property, after 1220: Franciscans, Dominicans, Carmelites and Augustinian Her-mits.

MENSA (L 'table') liturg. and HA: altar stone, mostly on colonettes; in MA also on closed altar tomb.

MATINS (L matutinum, 'morning prayer') first of the seven Hours, originally sung at midnight or in the small hours of the morning.

MINORITES (L fratres minores) Franciscans.

MINUSCULE in mss. cursive script, as opposed to capitals.

MISSAL mass book, containing everything found in separate books before late MA.

MODERN DEVOTION revival of piety in the later MA, originating in the Northern Nether-lands; the great names are Geert Grote, the founders of the Windesheim Congregation, and above all Thomas à Kempis, author of the 'Imitation of Christ'.

MODI (liturg.) the various 'tones' of Gregorian chant.

MONOGRAM two or three letters interwoven as a devise, esp. for a name.

MONSTRANCE (L monstrare, 'to show') li-turg.: transparent vessel in which Host is exposed for adoration; devotion starts end 13th C.; the liturg. word = ostensorium (vessel for showing).

MOORISH of Muslim influence in Spain.

MORBIDEZZA (It.) life-like delicacy in flesh tints, sometimes overrefined.

MOZARABIC (Arab. musta'rib, 'arabicized', litt.) (Sp. mozárabe): art and liturgy of the Christians who in N. and Central Spain had lived under Muslim rule, and were gradually liberated by the Reconquista; the small churches and the mss. date from 10-12th C.

MULLION vertical bar dividing lights of Gothic window; from F meneau.

NEEDLE (archit.) very slender secondary spire on crossing of church.

NEOPHYTES (Gr. litt. 'newly-grown') the new-ly baptized.

NICOLAITANES after Rev. II: 6; also a Gnostic sect of the 2nd C.; in MA also a name for those who broke the law of celibacy.

NIMBUS bright disk or halo behind the head of a saint.

NODE (L nodus, 'knot') knob on stem of cha-lice, for grasping it. (liturg.)

NORTHUMBRIA most northern of the Anglo-Saxon kingdoms, corresp. to present counties of Yorkshire (N.R.) Durham, Northumber-land and Tyne & Wear; the outburst of mo-nastic culture of the 8th C. was mainly de-termined by the Scoti (Iro-Scottish monks).

OGIVE (F) (archit.) pointed arch.

ORANS (L 'praying') HA figure in the old Chr. attitude of prayer, with elevated hands.

ORBIS see *Globe*.

ORPHREY (from F orfroi) ornamental em-broidered stripes on dalmatic, chasuble or cope.

ORTHODOX (Gr. 'of the right Faith') 1. Or-thodox Christian; 2. what belongs to the arts and culture of Greek Orthodoxy and its derivations (e.g. on the Balkans and in Russia).

OTTONIAN HA, the arts of the 10th C., in the G. Empire, under Otto I, II and III.

PALA (It.) altarpiece.

PALATINE CHURCH palace church in early MA, e.g. the rotunda of Aachen (Aix-la-Chapelle) Cathedral.

PALIMPSEST ms. where an original text has been effaced to make room for a new one.

PALLADIUM (Gr. from 'Pallas' = Athena) 1. the wooden image of Athena, brought from Troy to Athens; 2. every sacred object be-lieved to protect a country, town or king-dom, e.g. the Cross of Oviedo, for the Spain of the Reconquista.

PALLIUM (L 'upper garment') liturg. orna-mental band thrown around shoulders, derived from the toga trabeata ('beamlike toga') of the later consuls; badge of honour for arch-bishops and esp. the pope; made of white wool, with black crosses.

PANTOCRATOR (Gr. Pantokrátoor, 'Ruler of the Universe') HA: figure of Christ as King; since high MA, in the Gr. churches: as a bust, in the chief dome.

PARURA (MA liturg.) ornamental piece sewn on amice, alb or dalmatic.

PEDIMENT (archit.) triangular top gable of door, window of façade; in Gr. archit. mostly filled with sc.; Gr. name = *tympanon*.

PENDELOQUE (F pendant) hanging from crown or necklace, mostly jewelled.

PENDENTIVE (archit.) concave spandrel at base of dome, between the arcades and the drum.

PENTATEUCH (Gr.) the first five books of HS,

in the Gr. version of the LXX (Septuagint).

PERICOPE (Gr. 'cut-out piece') fragment of HS read as a lesson during mass, chosen after the order of the Ecclesiastical Year.

PHOOTISMÓS (Gr. 'illumination', 'enlightenment') = baptism; see ch. I.

PILLAR (archit.) support of arch or wall; built of bricks or stone (as opposed to column).

PILASTER (archit.) rectangular column projecting only slightly from a wall or pillar.

PINNACLE (L pinnaculum) archit. small ornamental turret crowning gables, buttresses and the corners of towers, in Gothic buildings.

PLECTRUM small pointed piece used for plucking strings.

PLUVIAL (L pluviale, 'rain-coat') = cope.

POLYPTYCH (paint.) altarpiece consisting of more than three panels.

PONTIFICAL (liturg.) office books containing rites to be performed by bishops.

POULAINES (F) fashionable shoes with extravagantly long and narrow points, late 14th and 15th C.

PROCONSUL in late Rom. Empire governor of a senatorial province, appointed after his consulate; e.g. the proconsul of Asia, at Ephesus.

PROLEGOMENA (Gr.) preliminary chapters of a book.

PSALTER (L psalterium) 1. the Book of Psalms; HA ms., containing the psalms and, in the Gr. Church, the Odes (all bibl. canticles); 3. bibl. musical instrument.

PSYCHE (Gr. 'soul') myth. figure symbolizing the Soul; sometimes the beloved of Eros.

PUTTO (It. 'small boy') HA: naked mostly winged boy, derived from Antique genii and little Eros; since the Ren. symbolizing the eternal youth of angels.

PYX or PYXIS (Gr. 'little box') 1. in Antiquity every costly little box; 2. in Chr. Antiquity round little box for relics, pilgrim's souvenirs and also for the eucharistic Bread; 3. in MA: ciborium (chalice with consecrated hosts), and also small vessel, gilt inside, for taking the holy Viaticum to the dying.

QUATREFOIL (F) archit. lobe with four foils used in Gothic windows, at the top.

RAYONNANT, STYLE (F) HA, archit.: style of the high Gothic period, 1260-1300.

RESPONSE (L responsorium) liturg. verses alternatively sung by priest and choir, during canonical Hours.

RETABLE (L retrotabulum, 'back-piece') since high MA decorated panels above back of altar; during the 15th C. grown into huge wings to be opened and closed.

RITE (L) prescribed form on every liturg. ceremony.

ROCK CHURCHES (HA) the rupestrian churches near Ürgüp and Göreme, Cappadocia (now central Turkey) with cycles of Chr. wall-paintings, 10th-11th C., badly damaged; since 1921-1922 completely abandoned.

ROCOCO the playfully decorative style of 1700-1750.

ROLL or ROTULUS (L) roll of parchment or papyrus, with text.

ROMANESQUE (HA) style of art and archit., from c. 1050 till Gothic, that is, in France until c. 1140, elsewhere until 1200 or even later; main characteristics: perfect vaulting and Ren. monumental sculpture.

ROSETTE round ornament in form of calix, seen from above.

ROTUNDA (It.) (archit.) building on central plan, often with an inner colonnade supporting a cupola.

SACRAMENTARY (liturg.) ms. containing the collects, prefaces and canon on L. mass; in

later MA replaced by missal, containing this and all other mass texts.

SARCOPHAGUS (Gr. litt. 'flesh-consuming') costly stone coffin, mostly of marble, decorated with sc. at front, and covered with a high lid.

SARDIUS a gem, variety of chalcedon.

SATAN (Hebr.) God's adversary; cf. 'devil', from Gr. diabolos = litt. 'adversary'.

SCAENAE FRONS (L) decorated front scene in Antique theatre.

SCAPULAR (L scapulare, 'shoulder-cloth') upper garment of a monk, worn over the girt tunic, with open sides.

SCHNITZALTÄRE (G) altarpieces with rich wood carvings, c. 1500.

SCHOLASTICISM theology and philosophy of high MA, esp. its Aristotelian and Thomistic chief trend (since c. 1250 until the Ren.).

SCRIPTORIUM (L 'room for writing') HA: monastic or, later, laical workship for the writing and illumination of mss.

SEQUENCE (L sequentia) liturg. hymn sung after Gradual, preceding Gospel; in the missal of 1570 (Pius V) only five of the innumerable sequences were preserved.

SERAPHIM (Hebr.) six-winged celestial beings, singing the Trisagion (threefold 'Holy') in the vision of Jesaja.

SIBYL pagan prophetess, in MA seen as a witness of future Chr. redemption.

SION or ZION mountain in David's City, Jerusalem; in Rev. the Heavenly City of the Lamb.

SOPHIST 1. in Gr. Antiquity the philosophers emphasizing logic above all; 2. pejoratively: captious or fallacious reasoner.

SOMATISM HA tendency to stress corporality (Gr. sooma = body); characteristic of Ren. and Baroque.

SPIRITUAL FRANCISCANS (MA L = spirituales), radical Minorites following the reveries of Joachim di Fiore, see Joachimism, and esp. ch. X.

STAUROTHECA (Gr. 'shrine for Cross') reliquary with fragment of the True Cross; esp. the monumental one erected on Calvary, shortly after 335.

STOLE (Gr. and L) 1. long woman's dress; 2. (liturg.) narrow strip of silk hanging from back of neck over shoulders; worn crossed over breast by priests, hanging down from left shoulder by deacons (only in the West).

SUPPEDANEUM (L 'platform under the feet') liturg. before every altar, in MA only one step high.

SYNOD (Gr. sunodos, 'meeting') of bishops.

TABELLA (L 'cartouche') HA: in Antique mss. miniature framed in red.

TAENIA (L) fillet wrapped round a wreath, on head; hairband with loose ends; in Chr. art worn by angels.

TASSILO CHALICE HA chalice of the type of the masterpiece given by Duke Tassilo of Bavaria to the abbey of Kremsmünster (c. 778, Austria) and still preserved there.

TELLUS (L) Mother Earth, often as a bust rising from the earth, or as a sitting figure with the attributes of fertility.

TETRAMORPH (Gr. 'having four figures') each of the four Beings carrying God's Throne in Ezekiel's vision; in Rev. IV it is divided into four separate Beings.

THECA (Gr.) shrine, casket.

THEOPHANY (Gr.) appearance of God's majesty.

TIARA (Gr., from Persian) 1. Persian, conical turban of a ruler; 2. in MA mitre on the pope, unpretentious until 1300, later on

adorned with three superimposed crowns (triregnum); today out of use.

TITULUS (L 'inscription') HA 1. doorplate with a name on a house, a church or a catacomb; 2. metrical inscription accompanying sc. or paint. images, in the early MA.

TONSURE (L) shaving of crown with clerics and monks; signifying renunciation of the world; in MA, in the West, sign of being admitted to the clergy.

TORSO (It. 1. trunk, of a tree etc.; 2. trunk, of human body) HA: as It. 2; also said of an unfinished statue or building.

TRANSEPT (It. transetto) transverse nave of a cross-shaped church.

TRIAD (Gr.) HA group of three figures.

TRIUMPHAL ARCH (archit.) wall and arch enclosing apsidal recess.

TRIUMPHAL CROSS HA group of the crucified Lord with Mary and John the Evangelist, set on a decorated beam above the choir screen (in England = rood loft); 12th-16th C.

TRISAGION (Gr. 'threefold Holy') our L Sanctus, sung by Jesaja's seraphim.

TROPHY (Gr. tropaion) sign of victory, often with the enemies' spoils.

TANTUM ERGO (liturg.) first words of last strophe but one of the hymn 'Pange lingua', in honour of the Blessed Sacrament (c. 1264-70), sung at every Benediction.

TUNIC (L tunica) long under garment; liturg. = alb.

TYMPANUM (Gr.) 1. inner surface of Antique pediment, always of triangular shape; 2. in MA archit. the space between lintel and archivolts, in portals or doorways.

ULTIMA THULE Antique name for 'the ends of the earth', situated in the NW.

UNCIAL rounded type of letter, between capital and minuscule.

UNGULA (L 'nail') instrument of torture with indented clawlike fork.

VELUM (L) veil.

VENUS PUDICA (L 'chaste Venus') motif of Venus covering herself with her hands.

VESICA or MANDORLA (vesica = L 'bladder'; mandorla = It. 'almond') pointed oval used as a glory surrounding an entire figure.

VICTORY (L) personification of Victory, Rom. variety of Gr. Nikè; in Chr. art transformed into the usual cliché for angels; the (unbiblical) wings have been preserved.

VILAIN (F) common man, a 'boor'.

VISIGOTHIC HA of art in Visigothic Spain, c. 420-711.

VISIO BEATIFICA (L 'beatific vision') techn. term for celestial bliss.

VOLTO SANTO (It. 'Holy Face') icon with Head of suffering Christ, venerated in Lucca.

VOUSSOIRS wedge-shaped sculptured stones forming an arch, esp. inside the concentric arcades surrounding a Romanesque or Gothic tympanum, above a door.

VULGATE (L Vulgata, 'spread everywhere') L version of HS, partly made after the original texts by St Jerome, officially adopted by the L Church.

WOODCUT print taken from engraving made on wood; see xylography.

XYLOGRAPHY (Gr. 'writing by means of wood') printing by woodcut.

YIN AND YANG roundel divided by S-line; Chinese symbol of male and female.

ZODIAC (Gr.) 'belt of heavens', including positions of sun, moon and planets, since 2nd C. divided into twelve signs, with telling names; these signs play a role in both HA (MA calender) and astrology.

ZOOMORPHIC HA ornament chiefly consisting of animal forms.

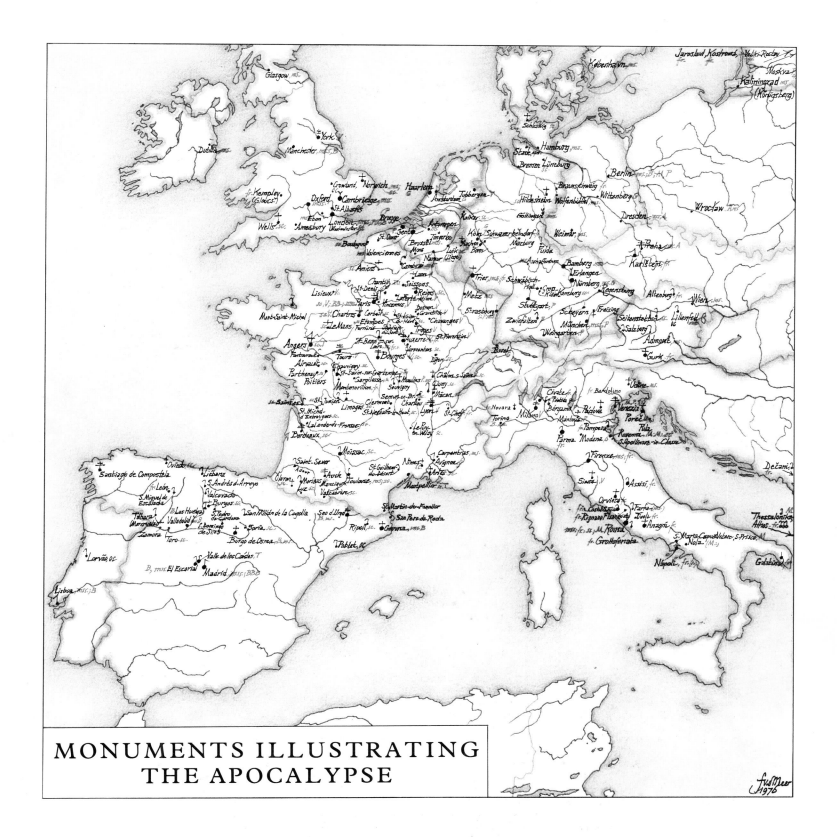

MONUMENTS ILLUSTRATING
THE APOCALYPSE

f.v.d.Meer
1976

All places where notable monuments are
to be found are indicated; also places where
well known manuscripts have been illumin-
ated.

☩ ☩	cathedrals and churches	M	mosaics
♗	abbeys and monasteries	fr	frescoes
	castles and residences	sc	sculpture
m	manuscripts	G	engravings
B	*Beatus*	P	paintings
A	commentary of Alexander	OC	Order of Cistercians
V	stained glass	OFM	Franciscans
T	tapestries	(∴)	disappeared

BRITISH ISLES
Dublin ms
Glasgow ms
York V
Manchester ms, B
Kempley (Glos.) fr
Wells sc
Crowland OC
Norwich ms, sc
Cambridge mss
Oxford mss

Eton ms
St Albans
Amesbury
London mss, P (= A), B
Westminster fr

SCANDINAVIA AND RUSSIA
Copenhagen (København) ms
Jaroslavl fr
Kostromá fr
Veliki-Rostov fr

Moscow (Moskva) P, fr
Kaliningrad (Königsberg) ms
Wroclaw ms A

EAST GERMANY
Berlin M, ms, B, P
Wittenberg G
Dresden ms A
Weimar ms

WEST GERMANY
Schleswig sc
Hamburg ms
Stade OFM
Lüneburg sc
Bremen
Brunswick (Braunschweig) fr
Wolfenbüttel ms
Hildesheim sc
Göttingen ms
Kalkar sc
Cologne (Köln) P G
Aachen M
Bonn
Schwarzrheindorf fr
Marburg
Fulda
Trier ms, fr
Aschaffenburg ms
Schwäbisch-Hall
Groß-Komburg sc
Klein-Komburg
Bamberg ms
Erlangen
Nuremberg (Nürnberg) G
Regensburg
Freising
Scheyern
Stuttgart P
Zwiefalten P
Weingarten P
Munich (München) mss, P
Basel G

AUSTRIA
Gurk fr
Salzburg
Admont ms
Seitenstetten sc
Lilienfeld ms
Altenburg fr
Vienna (Wien) ms

CZECHOSLOVAKIA
Karlštejn fr
Prague (Praha) ms A

LOW COUNTRIES
Amsterdam G
Haarlem G
Tubbergen V
Antwerp (Antwerpen) ms
Gent P
Bruges (Brugge) P
Tongerloo P
Brussels (Brussel) mss
Mons V
Namur ms
Liège (Luik) sc

FRANCE
St-Omer
Boulogne sc

Valenciennes ms
Amiens sc
Cambrai ms
Laon V
Soissons
Chantilly mss
St-Denis sc
Paris sc, V, mss, BB
Vincennes V
Reims sc
La-Ferté-Milon V
Lisieux V (.·.)
Mont-St-Michel
Chartres sc, V
Corbeil sc
Étampes sc
Le Mans sc
Angers T, sc
Fontevrault
Tours V
St-Benoît-sur-Loire sc, fr (.·.)
St-Julien-du-Sault V
St-Loup-de-Naud sc
Dosnon V
Grandville V
Chavanges V
Troyes V
St-Florentin V
Auxerre fr, V
Vermenton sc
Dijon sc
Metz ms
Strasbourg ms (.·.)
Ferrières
Châlon-sur-Saône sc, V
Cluny sc
Mâcon sc
Lyon V
St-Chef fr
Semur-en-Brionnais sc
Charlieu sc
Le Puy-en-Velay sc
St-Nectaire-le-Haut sc
Clermont
Souvigny
Moulins P, ms
Bourges sc, V
Gargilesse sc
St-Savin-sur-Gartempe fr
Montmorillon fr
Chauvigny sc
Poitiers
Parthenay sc
Airvault sc
Saintes sc
St-Michel-d'Entraygues sc
St-Junien sc
Limoges sc
Lalande-de-Fronsac sc
Bordeaux sc
Moissac sc
St-Sever-sur-l'Adour
Oloron sc
Morlaas sc
Luz sc
Auch
Mancioux
Toulouse sc, ms
Valcabrère sc
St-Martin-de-Fenollar fr
St-Guilhem-du-Désert

Nîmes sc
Montpellier sc
Arles sc
Avignon fr
Carpentras ms

SPAIN AND PORTUGAL
Lorvão OC
Lisbon (Lisboa) ms B
Santiago de Compostela sc
Oviedo sc
León fr
S. Miguel de Escalada
Tábara (Moreruela)
Zamora
Toro sc
Valladolid ms B
Las Huelgas ms B
Burgos sc
Valcovado
S. Andrés de Arroyo
Liébana
S. Pedro de Cardeña
S. Domingo de Silos
Burgo de Osma ms B
Soria
S. Millán de la Cogolla
Seo de Urgel ms B
Ripoll sc
S. Pedro de Roda
Gerona ms B
Poblet OC
Valley of the Fallen (Valle de los Caídos) T
El Escorial mss, B
Madrid mss, BBB

ITALY AND THE BALKANS
Turin ms B
Mailand V
Civate fr
Pontida sc
Bergamo P
Mantua P
Padua (Pádova) fr
Venice (Venezia) ms, M, P
Údine ms
Pomposa fr
Ravenna MM, sc
S. Apollinare in Classe M
Modena G
Parma fr
Florence (Firenze) ms, fr
Siena V
Assisi fr
Orvieto fr
Castel S. Elia fr
Rignano Flaminia fr
Farfa
Rome (Roma) MM, sc, fr, mss
Tivoli fr
Grottaferrata fr
Anagni fr
S. Maria Capua Vetere, S. Prisco M
Nola M (.·.)
Naples (Nápoli) fr (.·.)
Galatina fr
Dečani fr
Salonika (Thessalonike) M
Athos fr
Poreč M
Pula

Checklist of Works of Art Inspired by the Apocalypse

The list is incomplete for the following four themes:

1. THE 'MAJESTY': the Lord surrounded by the four Beings, symbols of the four Gospels. This motif appears as a frontispiece in nearly all *evangeliaria*, from Merovingian times up to the beginning of the fifteenth century.

2. JOHN ON PATMOS, and, behind him, in the sky, the vision of the Woman clothed with the sun (Rev. XII); a theme that was extremely popular from the end of the Middle Ages till the end of the eighteenth century.

3. THE WOMAN CLOTHED WITH THE SUN, usually holding the Child (Rev. XII); a favourite theme from the fifteenth to the eighteenth century; before and after 1500, frequently chosen as the central motif of brass church chandeliers called *Marianum*.

4. MICHAEL FIGHTING THE DRAGON, a dramatic theme, favoured by public and artists until the end of the Baroque Age.

A complete summing up of all specimens of 1–4 would make the list impracticably long; a number of famous works, however, are mentioned.

Abbreviations

VJ = scenes from the Life of John.

AXP = scenes from the Life of Antichrist, inserted into illustrated Apocalypses.

The sigla for the *Beatus* manuscripts (G = Gerona, S = St-Sever, etc.) are those used by Wilhelm Neuss, *Die Apokalypse des hl. Johannes in der altspanischen und altchristlichen Bibel-illustration*, Münster, 1931.

The Four = the four Living Beings.

The Elders = the twenty-four Elders.

Italics are used for the manuscripts and isolated miniatures; also for prints.

The 'List of Works of Art' is followed by a 'Checklist of Editors, Illustrators and Publishers'.

AACHEN (Rhineland), Cathedral, mosaic in the cupola of the octogon, tenth century, a nineteenth-century reconstruction: the Elders, see CARPENTRAS;
ibid., treasury, Mosan enamel (book cover, now a clasp of a cope): the seven lamps, the River of Life and the trees, and the Majesty, *c.* 1180;
ibid., chandelier in the form of the Heavenly City.

ADMONT (Austria), Stiftsbibliothek 1, *Admont Bible*: the Antichrist killing the Witnesses.

AIRVAULT (Deux-Sèvres), porch: the Elders in the voussoirs.

ALTENBURG (Austria), abbey church, fresco by Paul Troger, 1735: the Woman clothed with the sun.

AMIENS (Somme), Cathedral, west portal, voussoirs surrounding the Last Judgment: the Signs announcing the Last Things, among them the Riders of Rev. VI (after those of Notre-Dame, Paris), 1220-36.

ANAGNI (Lazio), Duomo, fresco in the apse: the lambs frieze with inscription, triumphal arch: the Elders; crypt: small cycle, thirteenth-century;
SS. Cosma e Damiano, marble slab: graffito of the *traditio legis* and the lambs frieze.

ANGERS (Maine-et-Loire), Cathedral, west portal: Majesty with the Elders, end twelfth century;
Castle, tapestry of the Apocalypse, 84 scenes, St John (six times), 15 scenes lost, 1373-80.

ANTWERP, Plantijn-Moretus Museum, ms. 17 (olim 134), Apocalypse, fifteenth century, 22 ff. with 45 scenes;
Musée des Beaux-Arts, Quinten Matsys, side wing of the 'Deposition', 1508-11: St John in the cauldron of boiling oil, VJ.

ARLES (Bouches-du-Rhône), Musée lapidaire chrétien, sarcophagus with the Heavenly City, the *traditio legis*, and the allegory of the lambs, end fourth century;
ibid., sarcophagus of Concordius: the thirteen Thrones, the lambs and the Heavenly City, end fourth century, Wilpert 34, 3.

ASCHAFFENBURG, Hofbibliothek, ms. 2, lectionary from Mayence, Fulda, end tenth century: All Saints.

ASSISI (Umbria), S. Francesco, upper church, north transept, cycle by Cimabue, 1280-83, 5 scenes.

ATHOS (Greece), *Hermeneia tôn zôgraphôn* (A Painter's Guide), eighteenth century: cycle of 21-22 scenes;
Dionysiou, trápeza (refectory), seventeenth century, 19 scenes, in fresco;
Dochiariou, seventeenth century, 20 scenes;
Xenophontos, sixteenth century, the earliest cycle, probably after prints by MR JP (Master Johann Franck, 1538), 13 scenes;
other cycles, seen by Didron in the nineteenth century, now lost.

AUXERRE (Yonne), Cathedral, crypt, frescoes on the vault: Christ, Rider and four angels as riders; ibid., thirteenth century: the Lord with the seven candlesticks;
clerestory, rose window at top of middle window at the end of the choir: Majesty of the Lamb, and St John;
south choir aisle, 7th bay, right lancet window, lower part of the window of the Prodigal Son, remainig 9 panels with VJ and Apocalypse, 1222-34; damaged by Huguenots in 1567 and partly restored since, lastly in 1945;
north choir aisle, 5th bay, left lancet window: panel with Rider Death (out of place);
treasury, drawing on parchment: Majesty with the Elders, twelfth century;
choir-stalls, misericord: John on Patmos, fifteenth century.

AVIGNON (Vaucluse), Papal Palace, St John's chapel, fresco by Matteo Giovanetti, 1346-8: the Son of Man and the seven candlesticks.

BALTIMORE (USA), Walter Art Gallery, ms. gr. 335, Apocalypse, with commentary by Fredericus de Venetiiis OP, 1415; Greek miniatures, Venice, *c.* 1415-20.

BAMBERG, Staatsbibliothek ms. 140 (olim A II 42), Apocalypse, 1000-2, 50 scenes;
ms. Bibl. 48, Psalter, *c.* 1201-10, f. 117: Last Judgment,

Judge with sword going out of his mouth.

BERGEN (Henegouwen), see MONS.

BERLIN, Staatsbibliothek, ms. theol. lat. fol. 561: *Beatus*, end twelfth century, probably Lombardic, 55 poor pen drawings, Old Italic iconography;

ibid., Kupferstichkabinett, *Hamilton Bible*, Italic cycle of the Apocalypse, related to that of the panels at Stuttgart, fourteenth century;

Staatliche Museen, mosaics from S. Michele-in-Affricisco, Ravenna, sixth century, heavily restored in the nineteenth century: angels with tubae in the Sea of crystal, near the Throne;

ibid., bas-relief from Deïr-Amba-Shenute, Coptic, seventh century: Rider Christ;

ibid., Rex Regum, portrait of Christ by Jan van Eyck.

BOULOGNE (Pas-de-Calais), Musée, jamb statue from St Vaast: Woman clothed with the sun.

BOURGES (Cher), Cathedral, south portal: Majesty with the Elders, twelfth century; south choir aisle, symbolic window of the Apocalypse, 5 motifs, thirteenth century.

BRUGES, St John's Hospital, right panel of St Catherine's Altar *(Mystic Marriage)* by Memling, Apocalypse, 1475-9.

BRUNSWICK, Cathedral, fresco: part of the Elders, c. 1200.

BRUSSELS, Bibliothèque Royale, ms. lat. B 282 (from the collection of Comte de Chimay), Apocalypse, fourteenth century, 73 miniatures;

ms. néerl. 10811, Apocalypse;

ms. lat. B 1020-3, t. 165, f. 134v: St John and the seven candlesticks; t. 166, f. 137: Lamb on Mount Sion, *ms. from Utrecht*, 1431;

Jubelparkmuseum, lintel from Zebed (on the Euphrates), AD 512: Aω and the oldest Arabic inscription.

BURGO DE OSMA (Soria), Archivo de la catedral, ms. 1. *Beatus*, illuminated by Martín, OC (in Fitero of Carracedo?), 1086, 71 miniatures.

BURGOS, Cathedral, Puerta del Sarmental, Majesty with the Elders, thirteenth century.

CAMBRAI (Nord), Bibl. Municipale, ms. 386 III, Apocalypse, a copy of Trier 31, second half ninth century, 44 miniatures, the rest missing, Old Italic cycle.

CAMBRIDGE, Corpus Christi College, ms. 20, Apocalypse, fourteenth century, 78 miniatures;

ms. 394, Apocalypse, fourteenth century, 69 miniatures;

Magdalen College, ms. 5, *Crowland Apocalypse*, fourteenth century, 69 miniatures;

ms. Pepys 1803, Apocalypse, fourteenth century, 89 miniatures;

Fitzwilliam Museum, ms. 62, Apocalypse, in the *Heures d'Isabelle de Bretagne*, no text, fifteenth century: 139 miniatures in the margin, illustrating the contents of the letters to the churches;

ms. Add., separate page, miniature with the first trumpet and censing angel, thirteenth century;

ms. McLean 123, *Nuneaton Apocalypse*, thirteenth century, 21 miniatures, the rest has been lost;

Trinity College, R 16 2, *Queen Eleanor's Apocalypse*, probably 1242-50, 89 miniatures, VJ; facsimile edition 1967, Eugrammia Press;

ms. B 10 6(217) Apocalypse, thirteenth century, 76 miniatures;

ms. B 10 2(213) Apocalypse, from Westminster?, c. 1400, 76 miniatures;

University Library, ms. Gg 1.1, Apocalypse, fourteenth century, 69 miniatures, poor;

ms. Mm 5.31, Apocalypse, with Alexander Commentary, fourteenth century, 71 miniatures.

CARPENTRAS (Vaucluse), Bibl. Municipale, drawing with one of the Elders, from the mosaics in the cupola of the Palatine Chapel at Aachen, made in 1607-8 for Peiresc.

CASTEL SANT' ELIA (near Nepi, Lazio), apse: *traditio legis* and the lambs frieze with inscription; on the triumphal arch

the Elders; on the north and south wall of transept parts of frescoes of an Apocalyptic cycle, eleventh century, 8 scenes can be identified.

CHALON-SUR-SAÔNE (Saône-et-Loire), Cathedral of St Vincent, portal, part of the Elders, twelfth century; window over entrance to Chapter House, sixteenth century: vision of the Woman.

CHANTILLY (Oise), Musée Condé, ms. 1378, Apocalypse, thirteenth century, 83 medallions;

Liber floridus, 1448, Franco-Flemish, Apocalypse, 31 full-page miniatures;

Limburg Brothers, *Très riches Heures* of John, Duke of Berry, beginning of the fifteenth century: miniature with John on Patmos, another of Michael fighting the Dragon, at top, Mont-St-Michel and Tombelaine.

CHARLIEU (Loire), portal, part of the Elders, twelfth century.

CHARTRES (Eure-et-Loir), Cathedral, Royal Portal: Majesty with the Elders in the voussoirs, 1137-44;

south portal: the Lamb sacrificed; pillars of porch: the Elders enthroned, thirteenth century;

south transept, rose window: four of the Elders round the Throne, c. 1250;

last window of north aisle (Delaporte no. 4), VJ: 11 scenes; beginning of thirteenth century.

CHAUVIGNY (Vienne), St-Pierre, capitals in choir: Riders, Babylon, a.o., twelfth century.

CHAVANGES (Aube), south transept, window, sixteenth century: cycle freely after Dürer.

CHICAGO (USA), collection Elisabeth Day McCormick, ms. from Greece, sixteenth century, Apocalypse, 69 miniatures (edition Willoughby-Colwell, 1939).

CIVATE, near Leccor (Lombardia), S. Pietro al Monte, small cycle in west gallery: Woman, Dragon, Michael, the trumpets, the Heavenly City, first half of twelfth century.

CLERMONT-FERRAND (Puy-de-Dome), Bibl. Municipale et Universitaire, ms. 1, *Clermont Bible*, f. 423: initial from Apocalypse: A; vision of the candlesticks.

CLUNY (Saône-et-Loire), lost tympanum of main portal inside the narthex, known from drawings, currently in the Cabinet des Estampes: Last Judgment – Majesty with the Elders, before 1135.

COLOGNE, Wallraf Richartz Museum, 112, *Meister der Inthronisation Mariens*, Lower Rhine, 1460: Majesty with Book and Lamb next to the Mother of God having been crowned, with four of the Elders; a mixture of Coronation and Rev. IV;

ibid. 113, 'Master of the Vision of St John', Cologne, before 1460: Vision of the Throne with four of the Elders and the seven candlesticks, and both founders.

COMPOSTELA, SANTIAGO DE (Galicia), Pórtico de la Gloria: Last Judgment – Majesty with the Elders by Master Matteo, the date, 1188, on the underside of lintel of tympanum.

COPENHAGEN, Kongl. Bibliothek, Thott 89, Apocalypse, fourteenth century, 32 miniatures.

CORBEIL (Essone), sculptures from Notre Dame demolished in 1819: Last Judgment with the Elders, partly preserved in Montgermont Castle and in the Louvre.

DEČANI (Yugoslavia), apocalyptic motifs (among the 365 subjects) of the fourteenth-century frescoes in interior of conventual church.

DIJON (Côte-d'Or), drawing by Dom Plancher of the lost portal of St-Bénigne: in the voussoirs the Elders; in the tympanum the Majesty; and further jamb statues of Moses, Aaron, St Peter, St Paul and the Queen of Sheba (as *la reine Pédauque*), the Church and the Synagogue, twelfth century.

DIONYSIOU, see ATHOS.

DOSNON (Aube), window next to entrance, west wall: 5 scenes, sixteenth century.

DRESDEN, Sächsische Landesbibliothek, ms. Oc 49, Apocalypse, fourteenth century (for *le Grand Bâtard d'Orléans*), 70 scenes;

ms. Oc 50, Apocalypse, probably from Lorraine, fourteenth century, 72 scenes;

ms. A 117, Apocalypse, with Alexander commentary, fourteenth century, 62 miniatures (edition by Bruck).

DUBLIN, Trinity College, K 4 31, Apocalypse, thirteenth century, 73 miniatures, Roxburghe Club.

ENTRAIGUES (Charente), tympanum with Michael and the Dragon, twelfth century.

ERLANGEN, Universitätsbibliothek, ms. 121, *Gumpertbibel*, miniature: the seven candlesticks.

ESCORIAL, EL, ms. 115, *Beatus* E, end of tenth century, poor, incomplete; Apocalypse for the House of Savoye, 49 ff., 98 miniatures: 54 by Jean Bapteur, 1428-35, and the rest, from f. 27 onwards, by Jean Colombe from Bourges, luxury codex;

codex Aemilianus, f. 457: wounded Lamb with instruments of the Passion and the four Beings, 992, San Millán de la Cogolla.

ETAMPES (Essonne), Notre-Dame-du-Port, south portal: Majesty with in the voussoirs the Elders (after those at Chartres), *c.* 1150.

ETON COLLEGE (Bucks.), ms. 125, drawing from Farfa (north of Rome), eleventh century: the Elders and the Lamb on the front of Old St Peter's in Rome, mosaic;

ms. 177, Apocalypse, thirteenth century, 98 miniatures.

FERTE-MILON, LA (Aisne), St-Nicolas, two windows with cycle after the *Wittenberg Bible*, one of them dated 1549.

FLORENCE, S. Croce, cappella Peruzzi, frescoes by Giotto, 1335 (restored from 1958 onwards): lunette with St John and the Apocalypse; below the raising of Drusiana and the assumption of St John, VJ;

S. Maria Novella, cappella Strozzi, frescoes by Filippino Lippi, 1497-1502: St John in the boiling oil and the raising of Drusiana;

Laurenziana, ms. Ashburnham 411 (415), Apocalypse with Joachim text but orthodox illustrations, incomplete, 52 scenes, Flemish, thirteenth century, Italian text and iconography;

Palazzo Pitti, Galleria Palatina 174, Raphael: Vision of Ezekiel, 1518.

GALATINA (Puglie, south of Lecce), S. Catarina, cycle on the side wall, at the back frescoes, fourteenth century, related to *Hamilton Bible*, see BERLIN.

GARGILESSE (Indre), capital with the Elders, twelfth century.

GERONA, Archivo de la catedral, ms. 1, *Beatus* G, 975, by Senior Emeritus and Ende pictrix, 144 full-page illustrations, Mozarabic.

GHENT, St Bavo's, polyptych by Jan van Eyck, before 1432: Adoration of the Lamb and the Great Multitude of All Saints; University Library, ms. 92: original manuscript of the *Liber floridus* by Lambert of St-Omer, with apocalyptic motifs (the Apocalypse itself is missing), before 1120, facsimile edition by A. Derolez, Ghent, 1968.

GLASGOW, ms. Hunter V 2 18, Apocalypse, beginning of sixteenth century, fragment probably from Poitiers, 48 miniatures.

GOTTINGEN, Universitätsbibliothek, ms. theol. 231, f. 11: *All Saints*, *c.* 975, from Fulda; the death of John and VJ.

GRANDVILLE (Aube), window to the left of the apse, cycle freely after Dürer, with inscriptions in French, sixteenth century.

GROSZKOMBURG (near Schwäbisch Hall), chandelier as Heavenly City, diameter 5 m, 1103-39.

GROTTAFERRATA (Lazio, south-east of Rome), catacomb, burial place of Biator, fresco with *traditio legis* and the lambs frieze, beginning fifth century.

GURK (Kärnten, Austria), Minster, west side, fresco cycle, 1260, with the Heavenly City.

HAMBURG, Stadtbibliothek, ms. in scrinio 87, Apocalypse, German, fourteenth century, 87 miniatures, text within the images.

HILDESHEIM, Cathedral, chandelier as Heavenly City: the oldest, by Hezilo 1054-79, hanging in the restored Cathedral since 1962;

treasury, *sacramentarium*, eleventh century: All Saints; ibid., *Bernward evangeliarium*, near 'Nativity' the Lamb on the Throne.

HOHENFURCH (Oberbayern), painted ceiling: the angel showing to John the Heavenly City with the Lamb, eighteenth century.

HORTUS DELICIARIUM, ms. in the library of Strasbourg, burnt in 1870, see HERRAD VON LANDSPERG in Checklist of Editors, Illustrators and Publishers.

KALININGRAD (Königsberg, East Prussia, now USSR), Staatsbibliothek, ms. 891, two manuscripts of the rhymed Apocalypse of Heinrich von Hessler, of the Teutonic Order, *c.* 1350.

KALKAR (Lower Rhine), St Nikolaus, upper part of the altar of the Seven Joys of Mary, fifteenth century, sculptures, wood, St John beholding the Woman.

KARLŠTEJN (south of Prague, Czechoslovakia), castle chapel S. Maria, fresco frieze with Apocalypse, before 1357, 15 scenes, edition Antonín Friedl, Prague 1950.

KEMPLEY (Glos.), fresco on barrel-vault of nave, *c.* 1200: vision of the candlesticks, with the Majesty.

KOSTROMÁ (USSR, on the Volga), cycle, seventeenth century.

LANDE-DE-FRONSAC, LA (Gironde, near Cubzac), tympanum, twelfth century: Son of Man with the seven candlesticks and the seven churches, and St John.

LANDSBERG AM LECH (Oberbayern), painted ceiling, 'Ursulines in welfare work': the seven lambs near the Throne of Trinity, eighteenth century.

LAON (Aisne), Cathedral, east rose window: the Elders round the Mother of God.

LENINGRAD (USSR), Hermitage, sardonyx of 423, with the Imperial family, Aω and PX.

LEÓN (Spain), S. Isidoro, Panteón de los Reyes, small cycle on the vault, twelfth century.

LIÈGE, St-Barthélémy, font by Reiner of Huy, 1107-18: motif from VJ: the baptism of Crato.

LIMOGES (Haute-Vienne), Cathedral, tomb of Bishop Jean de Langeac, after 1541, completed 1544: 14 alabaster reliefs freely after Dürer.

LILIENFELD, OC (Austria), Stiftsbibliothek, ms. 151, *Concordantia veritatis*, by Ulrich von Lilienfeld, with 272 partly apocalyptic motifs, facsimile edition Douteil-Vongress, 1973, after 1351; other manuscripts in Munich, Vienna and Uppsala.

LISBON, Archivo Torre do Tombo, ms. 97, *Beatus*, L, from Lorvão (OC; before 1200 OSB), *c.* 1189, 70 poor miniatures, ed. Anne de Egry, Lisbon, 1972;

Gulbenkian Foundation, ms. L A. 139 (from collection H. Yates Thompson no. 55), Apocalypse, thirteenth century, 76 miniatures;

ibid., ms. 38 (from the same collection), Apocalypse, fourteenth century, 70 miniatures.

LISIEUX (Calvados), St-Jacques, apocalyptic window (from a series of 12, sixteenth century; before the disaster of 1944).

LONDON, Westminster Abbey, Chapter House, cycle above the seats, end fifteenth century: 25 of the 91 scenes can be identified;

Victoria and Albert Museum, altar from Hamburg, workshop of Master Bertram, *c.* 1400, cycle of 45 scenes with inscriptions taken from the Alexander Commentary;

National Gallery, Room II, 4451: Wilton Diptych, end fourteenth century, French: Richard II and his patron saints kneeling before the Mother of God;

British Library, ms. Add. 1054, *Moutiers-Grandval Bible*, or *Alcuin Bible*, Tours 840, f. 449r: frontispiece to the Apocalypse;

Add. 11695, *Beatus* D, 1091-1109, late Mozarabic, poor;

Add. 17333, Apocalypse from Valdieu, Carth. Order, (near Mortagne, Orne), fourteenth century, 83 miniatures;

Add. 35166, Apocalypse, English, thirteenth century, VJ,

76 miniatures, 32 lost;

Royal 2 D, Apocalypse, fourteenth century, 102 miniatures;

Royal 15 D II, Apocalypse from Greenfield (Lincs.), fourteenth century, 64 miniatures;

Royal 19 B XV, fragments of Apocalypse, 72 miniatures, by the Master of the Queen Mary's Psalter;

Harley 152, *Bible moralisée*, French, thirteenth century, more than 150 medallions with apocalyptic motifs, edition Comte de Laborde, Paris 1912, t. IV;

Harley 4972, Apocalypse, fourteenth century, French;

Add. 42555, *Abingdon Apocalypse*, thirteenth century;

Add. 15243, Apocalypse, fifteenth century (cf. the one at Weimar), German, 14 miniatures;

Add. 17399, Apocalypse, French, fifteenth century;

Add. 18633, Apocalypse, English, fourteenth century, 106 miniatures;

Add. 18850, Apocalypse, in *Bedford Hours*, Paris, fifteenth century, by Jean Colombe, 152 medallions;

Add. 19896, Apocalypse, German, fifteenth century, AXP, 96 miniatures;

Add. 22493, 4 ff. of an Apocalypse, thirteenth century, 8 miniatures;

Add. 38118, Apocalypse, southern French, fourteenth century, 70 miniatures;

Add. 38121, Apocalypse, (from collection Huth), Flemish, *c.* 1400, VJ and AXP, 94 miniatures;

Add. 38842, 8 ff. of an Apocalypse, French, *c.* 1300, 28 miniatures;

Cotton Nero D. I, f. 156: separate page with drawing by Brother William, OFM, thirteenth century, vision of the candlesticks;

Dutch Block-book (from collection of George III), *c.* 1420-35, it is the oldest xylographic Apocalypse, probably Haarlem, Coster, 25 blocks cut on both sides, VJ and AXP, 50 scenes;

Lambeth Palace, ms. 209, Apocalypse, end thirteenth century, Canterbury, VJ and AXP, 78 miniatures;

ibid., ms. 75, Apocalypse, thirteenth century, 70 miniatures;

ibid., ms. 434, Apocalypse, from a convent of nuns, thirteenth century, 98 miniatures, and 8 lost;

Wellcome Institute of the History of Medicine, ms. 49, *Wellcome Apocalypse*, English, fifteenth century, 96 miniatures, VJ and AXP.

LUZ (Hautes-Pyrénées), north portal, tympanum, end twelfth century: Majesty without the Elders, with inscription.

LYONS (Rhône), Cathedral of St-Jean, window in choir with vision of candlesticks and Death of John, VJ, beginning of thirteenth century.

MÂCON (Saône-et-Loire), among the ruins of the old cathedral of St-Vincent (partly ruined in 1799), tympanum with the Last Judgment, with the Elders, below the Apostles, twelfth century.

MADRID, Archivo Hist. Nacional, Vit. 35, no. 257, *Beatus* T, from Tábara (near Zamora: Moriruela OC), 968-90, Mozarabic, incomplete;

Biblioteca Nacional, ms. Vit. 14-1, *Beatus* A 1, from San Millán de la Cogolla, *c.* 920-30, Mozarabic, 28 miniatures;

ibid., Vit. 14-2 (olim. B 31), *Beatus* J, from San Isidoro de León, 1047, by Facundus for Fernando I of Léon and Sancha of Castilla, 98 miniatures, edition of 28 miniatures by Ricci, Parma, 1973;

Real Academia de la Historia, ms. 33 (F 199), *Beatus* A 2, from San Millán de la Cogolla, *c.* 1000 and partly *c.* 1050, Mozarabic, incomplete;

Museo Arqueológico, Bibl. del Conde de Heredía Spínola, ms. *Beatus*, from S. Pedro de Cardeña, fragment (rest in collection Marquet de Vasselot, Paris);

Palacio Real, 8 Brussels tapestries with Apocalypse, Brussels, sixteenth century, see VALLE DE LOS CAÍDOS.

MANCHESTER, John Rylands Library, ms. lat. 8, *Beatus* R, end twelfth century, fine;

ibid., lat. 19, Apocalypse, Flemish, fourteenth century, VJ

and AXP, 96 miniatures (after an English model).

MANCIOUX (Haute-Garonne), lintel with PX and Aω, end eleventh century, see TOULOUSE, Musée des Augustins.

MANS, LE (Sarthe), Cathedral, south portal, Majesty with the Elders, twelfth century.

MANTUA, Cathedral, fresco by Gerolamo Mazzola Bedoli, freely after Correggio, end sixteenth century: vision of St John.

MARSEILLES (Bouches-du-Rhône), Musée Borély, altar-stone with doves (i.e. the Souls) and PX-Aω, fifth century;

ibid., sarcophagus with Heavenly City, *c.* 390-400 (Wilpert 34-2).

METZ (Moselle), Bibl. Municipale, ms. Salis 38, Apocalypse, thirteenth century, 66 miniatures, the rest lost.

MILAN, Cathedral, east window at the back of the choir, no. 20, apocalyptic cycle started by Stefano da Pandino in 1416 and restored in the sixteenth and nineteenth century, 55 old panels, 24 by Giovanni Battista Bertini (died 1849), in the classicist manner;

ibid., 14 panels from window just mentioned, now in window 38;

ibid., window of Buffa, 1939-60 (3rd bay in right aisle);

ibid., treasury, ivory diptych: Lamb in a ring of seasons, with two of the Living Beings and Infantia Christi; another page: triumph of the cross and two of the four Beings and the rest: Infantia, *c.* 400;

S. Ambrogio, sarcophagus under the pulpit: *traditio legis* and the thirteen Thrones in the Heavenly City, and the allegory of the Lambs, Theodosian, end fourth century (Wilpert 188, 1-2).

MODENA, Bibl. Estense, AD 5.22, hand coloured copy of Dutch block-book Apocalypse, 48 ff., 92 engravings.

MOISSAC (Tarn-et-Garonne), abbey church of St-Pierre, south portal: tympanum with Majesty and the Elders below, *c.* 1120;

ibid., cloister, on the capitals: among other things Babylon, Heavenly City, Gog and Magog, the Four (with animal heads), Christ as Rider, angel with sickle, Fight with the Dragon, also, as in *Beatus* mss., from Daniel legend: Lions' den and Nebuchadnezzar.

MONKWEARMOUTH, see WEARMOUTH.

MONS (Bergen, Henegouwen), St-Waudru, apocalyptic window in clerestory, sixteenth century.

MONTMORILLION (Vienne), chapel of Ste-Catherine, Adoration of the Lamb with the Elders, fresco, twelfth century.

MONTPELLIER (Herault), Musée archéologique, the Elders, from a portal in St-Guilhem-du-Désert, twelfth century.

MORGAN, PIERPONT collection, see NEW YORK.

MORLAAS (Basses-Pyrénées), voussoirs with the Elders, twelfth century.

MOSCOW (USSR), Kremlin, Uspenskii Sobor: icon of the Apocalypse, 1.58 m by 1.52 m, probably by Master Dionisii, *c.* 1500, complete and unique cycle;

ibid., Blagoveščenskii Sobor: small cycle in south east corner, sixteenth century, frescoes;

Troitsa v Nikitnikach, cycle, seventeenth century, inside the church.

MOULINS (Allier), Cathedral, sacristy, retable by Master of Moulins, 1498: Woman clothed with the sun, with inscription; Bibl. Municipale, *Souvigny Bible*, twelfth century: Apocalypse initial, seven candlesticks and Son of Man, St John.

MUNICH, Bayerische Nationalbibliothek, ms. lat. 14000 = Cim. 53, *Codex Aureus (Golden Codex)* of St Emmeran, 870, for Charles the Bald, f. 6: Adoration of the Lamb by the Elders, with *Tellus* and *Oceanus*, and inscription;

ibid., ms. lat. Clm 17401, *Liber matitudinalis*, by Konrad von Scheyern, 1206-25, miniature with the Woman and the Dragon.

NAMUR (Namen, Belgium), Bibl. Seminarie, ms. 8, Apocalypse, Franco-Flemish, end fourteenth century, 85 miniatures.

NAPLES, Soter baptistry (immediately to the right in S. Restitua, next to the Duomo), mosaics: *traditio legis*, shepherd and

lambs, XP-Aω in ring of seasons and stars, Lion and Angel (of the four) in corner niches, beginning of fifth century.

S. Chiara, lost cycle by Giotto, for Robert of Anjou, probably December, 1328 to 1330, mentioned by Vasari;

S. Maria Donna Regina, cappella Loffredi, part of cycle (with VJ, the Innocent Children under the Altar), anonymous, first half fourteenth century.

NEW YORK, Pierpont Morgan Library, ms. 644, *Beatus* M, *c.*926, probably from S. Miguel de Escalada, Mozarabic, more than 80 miniatures;

ibid., 429, *Beatus* H, from Las Huelgas, Cmon. Order (near Burgos), 1220, 83 miniatures, the rest lost;

ibid., 524, Apocalypse, English (from collection Vicomte Blin de Bourbon) 1240-60, VJ and AXP, 21 ff. with 42 miniatures, the remainder consisting of 56 ff. with 41 miniatures from *c.*1400;

ibid., 133, *Berry Apocalypse*, French, *c.*1400, related to the *Heures de Rohan*, normal cycle, but effectively enlivened;

The Cloisters, Apocalypse from Normandy (Coutances?), 1320-30, 38 ff. with 9 miniatures of Infantia Christi and 63 of apocalyptic cycle; facsimile edition, Metropolitan Museum 1971;

Collection Kraus, Apocalypse, (from collection C.W. Dyson Perrins, Malvern (Worcs., England), with VJ, English, 82 miniatures, facsimile edition M.R. James 1927;

Public Library de Ricci, 15, Apocalypse, German, 1430, 18 ff. with 36 full-page miniatures;

Metropolitan Museum, El Greco: El Quinto Sello *(Opening of the Fifth Seal)*, *c.*1612.

NÎMES (Gard), Cathedral, sarcophagus with Heavenly City and the thirteen Thrones, end fourth century, Wilpert 34, 5.

NOLA (Campania), lost apse, mosaic in the Felix Basilica, described by Paulinus de Nola, shortly after 400: Lamb, Cross, Mount of Paradise with four rivers, lambs.

NORWICH (Norfolk), cloister to the Cathedral, 90 keystones, in south and west walk: cycle, sculptures difficult to identify, *c.*1500;

Castle Museum, ms. Apocalypse, end thirteenth century, poor, 89 miniatures.

NUREMBERG, Germanisches Nationalmuseum, 5 ff. of an Apocalypse, copy of the one at Weimar, German, fourteenth century, Inv. Hz 1279-83, 10 miniatures.

OLORON (Basses-Pyrénées), voussoirs with the Elders, twelfth century.

ORVIETO, Cathedral, cappella S. Brizio, Signorelli's *Last Judgment*: on central wall the Antichrist, next to entrance the Signs, frescoes, 1499-1504;

S. Lodovico, gonfalone: the Innocent Children as Souls under the Altar, by Andrea di Giovanni, 1410.

OVIEDO (Cantabria), Cathedral, Cámara Santa, Cross of Covadonga (718, Pelayo, beginning of the Reconquista), the 'Cruz de la Victoria' was the Palladium of northern Spanish christendom, illustrations of it in the *Beatus* mss. with Aω.

OXFORD, Bodleian Library, ms. Auct. D 4 17, Apocalypse, English, thirteenth century, VJ and AXP, 92 miniatures, 4 missing, Roxburghe Club, 1876;

ibid., Auct. D 4 14, Apocalypse, English, fourteenth century, 99 miniatures;

Bodl. 352, *Haimo* (of Auxerre) *super Apocalipsin*, German, twelfth century, 9 ff., poor;

Bodl. 401, Apocalypse, English, fourteenth century, VJ, 106 miniatures;

Ashmol. 753, Apocalypse, English, thirteenth century: illustrations to the Letters to the Churches, 80 miniatures;

Canonici 62, Apocalypse, English, fourteenth century, 78 miniatures;

Tanner 184, Apocalypse, English, fourteenth century, 78 miniatures, ms. related to above-mentioned Canonici 62;

Selden supra 39, Apocalypse, fourteenth century, English with Infantia, 61 apocalyptic miniatures, the rest lost;

Douce 180, Apocalypse, end thirteenth century, for Edward I, luxury codex, 97 miniatures, Roxburghe Club 1922;

Lincoln College, lat. 16, Apocalypse, English, 67 miniatures, dark background;

New College, 65, Apocalypse, English, fourteenth century, 66 miniatures;

University College, 100, Apocalypse, English, fourteenth century.

PADUA, baptistry next to the cathedral, cycle on the walls, spandrels and the arch of apsidal chapel, by Giusto de' Menabuoi, completed 1378, about 50 motifs, monograph on Giusto: Longhi, 1965;

S. Benedetto, small cycle by the same artist, inside the church;

Museo Civico, host of angels, by Guariento, second half fourteenth century.

PARENZO (Istria), see POREČ.

PARIS, Notre-Dame, west middle portal: round the Last Judgment, in the voussoirs, the Riders, among them, Death, shortly after 1200;

ibid., Ste-Anne portal, sculpture fragments: Christ with the sword before his mouth, and the Lamb, now in the Louvre;

ibid., south rose window: Vision of the Throne with the Elders;

Ste-Chapelle, west rose window, 1485: cycle, 75 panels, plus 3 heraldic and 9 modern ones (together 87);

Louvre, sarcophagus from Rignieux-le-Franc, with the Heavenly City and the thirteen Thrones; Theodosian, end fourth century; Wilpert 34, 1;

Bibliothèque nationale, ms. lat. 8878, *St-Sever Apocalypse*, *Beatus* S, illuminated by Stephanus Garcia in the abbey of St-Sever-sur-l'Adour (Landes), 95 miniatures;

ibid., n. acq. lat. 1366, *Beatus* N, from Navarra of Gascogne, incomplete, 60 miniatures;

n. acq. lat. 2290, *Beatus* AR, from S. Andrés de Arroyo, Cmon. Order, *c.*1200, almost complete;

n. acq. lat. 1132, Apocalypse, *c.*900, 38 poor drawings, Old High German glossary, Old Italic cycle;

lat. 6, Bible from S. Pere de Roda (Cataluña), vol. IV, eleventh century, 20 concise drawings accompanying the Apocalypse, Italic cycle;

lat. 1, *Vivian Bible*, Tours 844-51, f. 415v: frontispice to the Apocalypse;

lat. 8850, *Evangeliarium* from St-Médard-de-Soissons, before 827, Rhine school; frontispiece to the prologue *Plures fuisse*: the four Beings, the Heavenly City, the Elders and the Liturgy of the Lamb;

fr. 403, Apocalypse, French text, French or English?, *c.*1240-50, 14 miniatures with VJ and 78 with Apocalypse (including AXP), reproduced with text by Delisle-Meyer, Paris 1901;

lat. 10474, Apocalypse, English, shortly after 1300, 90 miniatures by the Master of Douce 180 (Oxford), 4 lost;

fr. 1768, Apocalypse, French, fourteenth century, VJ, 58 miniatures;

fr. 9574, Apocalypse for Blanche de France, Longchamp, thirteenth century, 68 miniatures;

n. acq. fr. 6883, Apocalypse, thirteenth century, some of the miniatures finished, 69 not filled in;

lat. 688, Apocalypse, French, fourteenth century, VJ, 90 miniatures, many of them incomplete;

lat. 14410, Apocalypse from St-Victor, Paris, beginning fourteenth century, 83 miniatures, 2 missing, model for the Angers tapestry;

lat. 11534, f. 341: initial A of the Apocalypse, end twelfth century, St John and Christ;

lat. 1176, *Heures à l'usage de Paris*, second half fifteenth century, f. 14: vision of the candlesticks;

néerl. 3, Apocalypse, shortly after 1400, West Flemish, page 1 has VJ, 23 full-page miniatures, one to each of the 22 chapters of the Apocalypse;

Bibl. de l'Arsenal, ms. 5214, Apocalypse, English, fourteenth century, incomplete;

ibid., ms. 5091, Apocalypse, French, second half fifteenth century, grisailles.

PARMA, S. Giovanni Evangelista, frescoes by Correggio, 1520-21; in cupola: the Lord and the twelve Apostles; frieze on drum: the four Beings; on pendentives: the four evangelists and the four church Fathers; on arcades: eight figures from the Old Testament, together twenty-four, restored and cleaned 1959-62; in lunette over door to cloister: St John.

PARTHENAY (Deux-Sèvres), Notre-Dame-de-la-Couldre, voussoirs: the Elders.

POITIERS (Vienne), Musée, pulpit of Ste Radegonde: Majesty of the Lamb, Merovingian;

ibid., capital from St-Hilaire-le-Grand, with genre-piece (*Barbas conscindere*: chapter dealing with Apocalypse of St-Sever).

POMPOSA (Emilia, near Codigoro in the Romagna, north of Ravenna), west wall: Heavenly City and Last Judgment; over the arcades in the nave: small cycle; School of Bologna, *c.* 1350.

PONTIDA (Lombardy, between Lecco and Bergamo), abbey church, tomb, eleventh century: Rider with Balance, wrongly taken for Michael weighing the souls.

POREČ (Parenzo, Istria, now Yugoslavia), mosaics between windows of west wall of Euphrasiana, a sixth-century basilica: seven candlesticks, the main scene, on the gable, is lost.

PRAGUE, Bibl. of the Metropolitan Chapter, Cim. 5: Alexander Commentary on the Apocalypse, fourteenth century, 83 pen drawings, edition 1873.

PULA (Pola, Istria, now Yugoslavia), casket from Samagher, ivory, on the lid: *traditio legis* and lambs frieze, *c.* 400, disappeared after 1944 probably to Italy.

PUY, LE (Haute-Loire), St-Michel-du-Puy, portal: the Elders, twelfth century.

RAVENNA (Emilia, in the Romagna), Oratory of Laurentius (so-called Mausoleum of Galla Placidia), mosaics, *c.* 450, cupola: the cross between the four Beings and the stars, lunette: shepherd and lambs; sarcophagus with Lamb on Mount of Paradise and two lambs, fifth century;

S. Giovanni Evangelista: information by the Ravenna humanist Hieronymus Rubaeus, sixteenth century, (in: Thes. Ital. Antiq. VII, 1.98) of an *ex voto* (mosaic?) of the founder of the church, Galla Placidia, *c.* 433, after a shipwreck; he recognizes the vision of the candlesticks, the Apocalypse being handed to John, and John's help at the sea disaster, he wrongly takes the sea for the Sea of crystal of Rev. IV; not a single trace left;

S. Vitale, mosaics, *c.* 549, conch of apse: scroll in the hands of the Lord, side walls: the four Beings and the evangelists, east arcade: apotheosis of the monogram of Christ, and the two heavenly church towns, vault in bema: apotheosis of the Lamb in the stars and the wreath of the seasons – a series of discreet but clearly apocalyptic allusions;

S. Michele-in-Affricisco, drawing by Minutoli in 1842 of the lost interior with mosaics on triumphal arch and in apse, now heavily restored, in Staatliche Museen, Berlin; arch: angels with trumpets standing in the Sea of crystal, apse: Christ with crozier, as Victor, mid sixth century;

S. Apollinare in Classe, mosaics on triumphal arch, end sixth century: the four Beings on both sides of a medallon with head and shoulders of Christ, and procession of the lambs from the two twns;

ibid., sarcophagus with XP-Aω, of Bishop Theodorus, fifth century, see legend.

Museo archeologico, sarcophagus with the raising of Lazarus (side): in the nimbus of the Lord XP-Aω, beginning sixth century.

REIMS (Marne), west front, middle portal, in the voussoirs: the Elders;

ibid., right portal, cycle in the voussoirs (26 scenes unimpaired, 16 scenes badly restored in the eighteenth century;

ibid., inner side of portal, at the back of the south aisle: continuation of the cycle, in the niches: the Elders, and above them, among other things, the four Winds, the Bride and the Lord, the Woman and the Dragon, everything from the first half of the thirteenth century;

ibid., rosace in window of clerestory, with something from VJ, thirteenth century.

IGNANO FLAMINIA (on the Via Flaminia, north of Rome), SS. Abbondio e Abbondanzio, fresco on triumphal arch: the seven candlesticks, roundel with Throne, Adoration of the Lamb by the Elders, beginning of the thirteenth century.

RIPOLL (Cataluña), abbey church, west portal, twelfth century: Majesty with the Elders.

ROME, Lateran baptistry, west portal, notice in *Liber pontificalis* of a Lamb spitting water, from the Constantinian Period, beginning fourth century;

ibid., cappella di S. Giovanni Evangelista, mosaic: Lamb in wreath of seasons, below Pope Hilarius, 461-8;

ibid., oratorio di S. Venanzio, mosaic: the four Beings and the two towns (and the martyrs of Salona), seventh century.

S. Alessio-on-the-Aventine, fresco: the Lamb on the Throne, probably eleventh century.

S. Cecilia in Trastevere, mosaic in the apse: *traditio legis* and lambs frieze, with the two towns;

ibid., choir tribune, fresco of the Last Judgment by Cavallini, 1295: rest of the Innocent Children as Souls under the Altar.

S. Clemente, mosaic on triumphal arch: seven candlesticks, the four Beings, the towns, the lambs frieze, twelfth and thirteenth century;

SS. Cosma e Damiano near the Forum, triumphal arch: Lamb on the Throne, seven candlesticks, the four Beings, small remaining part, the Elders, angels standing in the crystal Sea; mosaic in the apse: lambs frieze with the towns; Felix IV, 526-30;

S. Costanza (Mausoleum of Constantia, near S. Agnese, along the Via Nomentana), mosaics, in a niche of the ambulatory: *traditio legis*, date uncertain; the Throne of the Lamb in the light shaft has been lost, a sketch from the period of the Baroque remains, *c.* 350;

S. Croce in Gerusalemme, frescoes on triumphal arch (above the eighteenth century ceiling): seven candlesticks and the four Beings;

Gesù, conch in apse, fresco by Baciccia, 1672-85: the Glory of the Lamb;

S. Giovanni a Porta Latina, triumphal arch: the four Beings, side-walls of choir: the Elders, frescoes of 1191-8;

SS. Giovanni e Paolo, crypt, fragment of a fresco: Adoration of the Lamb;

S. Lorenzo fuori le mura, mosaics on triumphal arch: the two towns, Pelagius II, 579-90;

S. Marco, mosaic in the apse: lambs frieze and towns, Gregorius IV, 827-44;

S. Maria Maggiore, mosaics, triumphal arch: Throne with insignia Christi and Book Roll and the four Beings, below the lambs near the towns, Xystus III, after 431;

S. Maria in Pallara (S. Sebastianello sul Palatino), fresco in apse: *traditio legis* and lambs frieze, triumphal arch: Adoration of the Lamb with the Elders, Silvester II, 999-1003.

S. Maria in Trastevere, mosaics, conch of apse: lambs frieze, triumphal arch: Throne and seven candlesticks, the four Beings, the two towns (and two prophets, with inscriptions), twelfth century;

S. Paolo fuori le mura, mosaics, conch of apse, in frieze below: the Innocent Children as Souls under the Altar (here the Throne of the *Etimaria*), thirteenth century, triumphal arch: badly restored remains of the Adoration by the Elders and the four Beings, Leo I, 440-60;

ibid., abbey OSB, *S. Paolo Bible*, f. 328v: frontispiece to the Apocalypse, St-Denis, 869;

St Peter's, Old, lost mosaic from the apse with the original, later altered, composition of the *traditio legis*, drawings dating from before the demolition;

ibid., lost mosaic of the façade: Adoration of the Lamb by the Elders, known through a drawing from Farfa, eleventh century, now at ETON;

S. Prassede, mosaics, apse: lambs frieze and towns, triumphal arch: Adoration of the Lamb by the Elders (copy in S. Paolo), anterior triumphal arch: the Select being received into the Heavenly City, Paschalis I, 817-24;

S. Pudenziana (*titulis Pudentis*, parish church of Pudens, mosaic in the apse: the thirteen Thrones, the City (Jerusalem of *c.* 400, with Staurothek and the Sanctuaries), the four Beings in the air, both churches (as noble ladies);

the Throne of the Lamb below has been lost, all borders heavily cut down, probably Innocentius I, 401-17;

S. Sabina sul Aventino, mosaics, west wall: the two churches (as noble ladies); triumphal arch: the towns (now lost), Caelestinus I, 422-32;

S. Sebastianello, see S. Maria in Pallara, above;

S. Sebastiano sull' Appia, museo, sarcophagus with *traditio legis* and Heavenly City, end fourth century;

Triclinium lateranense, lost mosaic of the Throne, the Elders and Leo III, 795-816, known through drawings by Onofrio and Ugonio;

Vatican Palace, Museo cristiano, gold-leaf in glass, with *traditio legis* and lambs frieze and towns, probably *c.* 400;

ibid. (formerly Lateran Museum), sarcophagi with motifs of Lamb and *traditio legis*, no apocalyptica;

Vatican Library (Bibl. apostolica), ms. lat. 3919, Apocalypse, with Alexander Commentary, some drawings;

ibid., Urb. lat. 11, 24, miniature by Nérida da Rimini, fourteenth century, Majesty with the Elders and seven hanging-lamps;

ibid., Barb. lat. 27333, f. 132v, drawing by Grimaldi of the front of Old St Peter's, with the Elders (but the Lamb has been replaced by the Lord).

ROSTOV (on Lake Nero, USSR, north of Moscow), apocalyptic motifs in the churches of the Kremlin, seventeenth century.

SAINT-BENOÎT-SUR-LOIRE (Loire), Fleury OSB, sculpture, 3 capitals in porch, eleventh century: candlesticks, Riders and Lamb, Michael and the Dragon, in transept: 2 *Beatus* motifs, Daniel and Nebuchadnezzar eating grass;

ibid., lost apocalyptic cycle *in facie ecclesiae* (west inner wall?), 1004-30, under Abbot Gauzlin, known through the inscriptions *(tituli)*, see Julius von Schlosser, *Quellenbuch*, Stuttgart, 1895, 184.

SAINT-CHEF (Isère), fresco of the Heavenly City, third quarter eleventh century.

SAINT-DENIS (Seine-St-Denis), abbey church, west portal, in the voussoirs the Elders, *c.* 1137-40.

SAINT-FLORENTIN (Yonne), St-Jean, north aisle, window: 10 scenes after Dürer, 1529, the oldest French imitation.

SAINT-GUILHEM-DU-DESERT (Hérault), the Elders, from the portal, now in Musée archéologique at Montpellier, twelfth century.

SAINT-JULIEN-DU-SAULT (Yonne), VJ in window, thirteenth century.

SAINT-JUNIEN (Haute-Vienne), shrine of the saint: the Elders round the Majesty of the Lord and His Mother, twelfth century.

SAINT-LOUP-DE-NAUD (Seine-et-Marne), west portal, rest of the Elders in the voussoirs, twelfth century.

SAINT-NECTAIRE-LE-HAUT (Puy-de-Dôme), capital with the Riders, twelfth century.

SAINT-SAVIN-SUR-GARTEMPE (Vienne), abbey church, cycle in the western porch, 7 scenes: Majesty, the four Winds, the trumpets and the Locusts, the Woman and the Dragon, angels fighting the Dragon, Apostles enthroned (on globes) and bowing angels, end eleventh century.

SAINTES (Charente-Maritime), Abbaye-aux-Dames, portal, in the voussoirs the Elders.

SALONIKA (Greece), St David, mosaic in the apse: theophany of the Trisagion (vision of Ezekiel, with the four Beings, the prophets and Habakkuk), fifth century.

SAN MARTÍ DE FENOLLAR, in the Roussillon (Pyrénées Orientales), fresco of apse: the Elders, end eleventh century, Catalan manner.

SAN PRISCO, near S. Maria Capua Vetere (Campania), cappella di S. Matrona, mosaics: Scroll and Dove on Throne, Ox and Eagle, head and shoulders of Christ with A and ω, fifth century.

SANTIAGO, see COMPOSTELA.

SCHLESWIG (Schleswig-Holstein), Cathedral, chandelier with Woman clothed with the sun, end fifteenth century.

SCHWARZRHEINDORF, opposite Bonn (Rhineland), upper church, fresco with Marriage of the Lamb and vision of All Saints, beginning thirteenth century.

SEITENSTETTEN (Austria), abbey church, censer as 'Heavenly City', beginning thirteenth century.

SEMUR-EN-BRIONNAIS (Saône-et-Loire), portal: Majesty with Lamb, and rest of the Elders.

SIENA (Toscana), Cathedral, east rose window: 12 stars near the Mother of God, 1288; a window probably designed by Duccio di Buoninsegna.

SINDELSDORF (Oberbayern), St Georg, fresco on vault of choir: Lamb, Book, Blood in chalice, and some of the Elders; eighteenth century.

SORIA, S. Tomé, portal: the Elders in the voussoirs, angels carrying the four Wind-heads, twelfth century.

STRASBOURG, Bibl. de la Ville, copies of the miniatures of the *Hortus deliciarum* by Herrad von Landsperg, second half twelfth century, burnt in 1870; 7 apocalyptic scenes, and many allusions, in the drawings; the copies are of the seventeenth century: the Woman and the Dragon, the Great Whore on the Beast, and her downfall, Complaint of the merchants, Wiping away the tears.

STUTTGART, Staatsgalerie, 2 Italian, probably Neapolitan, panels, complete cycle of 1330-40;

Landesbibliothek, Brev. 128, *Zwiefaltener Kommentar*: Majesty with the Elders;

ibid., ms. 116, the rhymed Apocalypse of Heinrich von Hesseler, Ord. Teut., fourteenth century.

TIVOLI (Lazio), S. Silvestro, fresco in apse: lambs frieze and *traditio legis*, 1175.

TONGERLOO (Belgium), abbey, Praem. Order, museum: Adoration of the Lamb, by Keerickx, seventeenth century.

TORO (Province of Zamora), Colegiata, portal, the Elders in the voussoirs, twelfth century.

TOULOUSE (Haute-Garonne), St-Sernin, remains of marble antependium, end eleventh century: the Majesty;

ibid., fresco in apse: Throne and the Four, seventeenth century;

Jacobins, Mother-Church of the Dominican Order, chapel of St Anthony, vaulting, fresco: vision of the Apocalypse, fourteenth century;

Musée des Augustins, no. 253, lintel from Mancioux (Haute-Garonne), with the apotheosis of XP-Aω, eleventh century;

Bibl. Municipale, ms. 815, Apocalypse, English, fourteenth century; the Letters to the Churches illustrated; 106 miniatures.

TOURS (Indre-et-Loire), Cathedral of St-Gatien, window in clerestory, with VJ, thirteenth century.

TRIER (Rhineland), Stadtbibliothek 31, Apocalypse, ninth century (Tours?), after a model of *c.* 500, earliest cycle, with 106 miniatures (and 2 others) on 76 ff.;

ibid., *Evangeliarium*, eleventh century, miniature with St John and vision of the candlesticks;

St Paulinus, apocalyptic motifs in the *Gloria martyrum* of the painted ceiling, 1743.

TROYES (Aube), Cathedral of St-Pierre, first window to the right of the centre of the apse clerestory: 6 scenes with

VJ, second half thirteenth century;

ibid., window (in a chapel off right aisle): Woman in the sun, with symbols of Litany, sixteenth century;

St-Martin-ès-Vignes, big window in south transept, cycle after Dürer, 1580-90, moved to new church in 1611, 9 panels, with French inscriptions;

St-Nizier, window after Dürer, sixteenth century.

TUBBERGEN (Province of Overijsel, Netherlands), parish church of St Pancras, cycle of 8 windows by Joep Nicolas, 1954-72.

TURIN (Piemonte), Bibl. Nazionale, ms. lat. 93, *Beatus* Tu, Catalan, *c.* 1100.

URGELL, LA SEU D' (Seo de Urgel), Archivo de la catedral, *Beatus* U, end tenth century, Mozarabic.

ÚDINE (Friuli), Archivio Capitulare, L 76, f. 66v: All Saints, Fulda, end tenth century.

VALCABRÈRE (Haute-Garonne, near St-Bertrand-de-Comminges), portal: the Elders, twelfth century.

VALENCIENNES (Nord), Bibl. Municipale, 99, Apocalypse, Italic cycle, ninth-tenth century, German? (scribe = Otholt), 37 poor miniatures.

VALLADOLID, Bibl. de S. Cruz, *Beatus* V, from Valcovado, *c.* 970, almost complete.

VALLE DE LOS CAÍDOS (VALLEY OF THE FAUEN), northwest of Madrid, memorial church, 8 tapestries from Palacio Real, woven at Brussels 1540-53 by Willem de Pannemaker; cycle, with 16 Latin distychs, design in the manner of Barend van Orley.

VENICE, S. Marco, mosaics in archivolt of western entrance to the nave, small cycle on gold ground, sixteenth and nineteenth-twentieth centuries: candlesticks, angels fighting, the Woman and the Dragon, Marriage of the Lamb;

ibid., *cathedra* from Grado, with apocalyptic motifs; Egypt?, date uncertain;

Museo Correr, *pala*, attributed to Jacobello Alberegno, with apocalyptic scenes: Throne and the Elders, the King with the many crowns, the Woman on the Beast, fourteenth century;

Marciana, ms. gr. 540: Emmanuel with the four Living Beings, Ezekiel and Isaiah, Theophany of the Trisagion, Constantinople, tenth century.

VERMENTON (Yonne), portal, the Elders, twelfth century.

VIENNA (Austria), Österr. Nationalbibliothek, Vind. 632, f. 20: Lamb and the Living Beings (in Hrabanus Maurus' *De laudibus s. crucis*), 831-40;

ibid., *Antiphonarium* from St Peter's, Salzburg, twelfth century: Lamb on Mount Sion, Michael and the Dragon;

ibid., ms. 1191, Bible from Naples, cycle related to that of the panels from Stuttgart, fourteenth century.

VINCENNES (Val-de-Marne; Grand Paris), castle chapel, 7 windows, 1560-80, for Henry II, by Nicolas Beauvrais, under the guidance of Philibert de l'Orme, three-quarters of the cycle survives, 12 subjects.

VREELAND (Province of Utrecht, Netherlands), Dutch Reformed Church, left transept, window: Heavenly City, by Joep Nicolas, 1968.

WEARMOUTH, St Peter's lost cycle brought from Rome by Benedict Biscop about 684 (Bede, *Vitae Abbatum*, 5, PL74, 718).

WEIMAR (DDR, Thüringen), Thüring. Landesbibliothek, Max. 4. Perg. 35, Apocalypse, together with a *Biblia pauperum*, German, 1330-40, 25 full-page miniatures, lightly tinted, poor, drawings, edition H. von der Gabelentz, Strasbourg, 1912, from St Peter's Erfurt, related to Br. Lib. Add. 15243.

WEINGARTEN, abbey church, frescoes by Kosmas and Damian Asam: Adoration of the Lamb, in the choir, first half eighteenth century.

WELLS (Som.), Cathedral, west front, 400 statues: inhabitants of the Heavenly City, 1206-42.

WESSOBRUNN (Oberbayern), parish church (St Johannes Täufer), painted ceiling in choir: St John, the Woman, the Child and the Dragon, with the four church Fathers round the cartouche, eighteenth century.

WOLFENBÜTTEL, Herzog August Bibl., Gudoh. 1-2, in 2: *Liber floridus*, German copy, twelfth century, of original ms., cycle of 25 motifs on 12 ff.;

ibid., ms. 1617, Apocalypse, German, fourteenth century, 57 miniatures in the margin, some full-page miniatures.

WROCLAW, Breslau (Poland), University Library, I, l.o. 19, Alexander Commentary on the Apocalypse, fourteenth century, 84 miniatures.

XENOPHONTOS, see ATHOS.

YAROSLAVL (USSR, on the Volga), cycle in church of St Elias, 1680; cycle in the church of John the Baptist, 1695, after engravings from the *Theatrum biblicum* by Jan Visser (Piscator), Amsterdam, 1650, edition Boeslajev, 1884.

YORK, Minster, the great East Window, 1405-8, by John Thornton from Coventry; as well as scenes from the Old Testament, and Saints and English Kings, there are 81 scenes from the Apocalypse, after the Anglo-Norman cycle; this window is the biggest in the world.

ZWIEFALTEN, abbey church, altarpiece by Spiegler: Woman clothed with the sun and the fight against the Dragon, eighteenth century.

List of Editors, Illustrators and Publishers

Note: Only the most important names have been listed; not all the engravers who have supplied prints for the Apocalypse in countless editions of Bibles since the sixteenth century; nor the numerous engravers who have illustrated the Apocalypse in the last century, and in this century.
A = Apocalypse; NT = New Testament.

ALEXANDER OF STADE, or OF BREMEN, Franciscan, author of *Scriptum super Apocalyptam*, 1230-40, orthodox commentary, but somewhat in the spirit of the Spiritual Franciscans; the mss. are sometimes illustrated.

ANSELM OF LAON, *Enarrationes in Apocalypta*, twelfth century, abstracts, under the name of Walafried Strabo, in the *Glossa ordinaria*, text in PL 162, 1187-1227.

APRINGIUS OF BEJA, Pax, Lusitiana, (Portugal), commentary, sixth century.

AUGUSTINE OF HIPPO, in *De Civitate dei*, 20 passages from the A are interpreted: Antichrist is a person; Elijah is coming back; the Beasts are the symbols of the paganism of the State; the '1000 years' refer to the 'time of the Church'.

BEATUS OF LIÉBANA (a monastery in Asturias, near Santander), died, 798; author of *In Apocalypta libri XII*, about 785; ed. H.A. Sanders, Rome. He thought the end of the world was at hand. The illustrated *Beatus* mss., more than 20, date from the tenth to the thirteenth century.

BECKMANN, MAX, German expressionist, 1884-1950; the A in 27 lithographs (1937, Amsterdam), published at Frankfurt.

BEHAM, HANS SEBALD, pupil of Dürer, 1500-50; two series of engravings of the A, after the *Wittenberg Bible*.

BERENGAUDUS, commentator, ninth or eleventh century; under the name of Ambrosius in PL 17, 841-1058; abstracts as glosses in many Anglo-Norman mss., from the thirteenth to the fifteenth century; he especially stresses the spiritual meaning.

BLAKE, WILLIAM, poet, painter, engraver, 1757-1827; watercolour with the Elders, after 1800, Tate Gallery, London; *Description of a vision of the Last Judgment*, 1808, with motifs from the A, 12 watercolours of the A made for Thomas Butts, 1799-1810, with strong stress on the demoniac aspect.

BONDOL, JAN (Hennequin de Bruges), illuminator and painter from Bruges in the service of Charles V of France, drew the cartoons for the tapestries of Angers, 1377.

BOSCH, JEROEN, *John on Patmos*, Staatliche Museen, Berlin.

BROSAMER, HANS, engravings for the A in Luther's *Volkbibel*, published by Hans Lufft, Wittenberg, 1548 *(Wittenberg Bible)*, anti-Roman motifs.

BURGKMAIR THE ELDER, HANS, *John on Patmos*, 1518, Alte Pinakothek; engravings for the A in the NT of Luther, published by Silvan Othmar, Augsburg 1523 (the 'Eagle' of the thrice Woe! is Luther's 'Angel').

CABRERA, MIGUEL, Mexican painter; *The Woman in the Sun*, Academia de San Carlos, Mexico.

CASSEL, JOHN, publisher, London, A in the *Family Bible*, very popular in the last century.

CHIRICO, GIORGIO DE, 20 lithographs of the A, 1941; instead of the phials the seven angels have bodies full of wounds (piaghe = plagues, as well as wounds).

CHODOWIECKI, DANIEL, 1726-1802; drawings for the A.

COLOGNE BIBLE, published by Heinrich Quentell (died, 1501), Cologne, 1478-9; 9 woodcuts with 25 scenes for the A, see Chapter XVII.

CORNELIUS, PETER VON, A, 17 cartoons for the Camposanto of the Hohenzollerns, 1843-7, never executed, lost in 1944.

CORREGGIO (Antonio Allegri da Correggio), 1489-1534; A in the cupola of S. Giovanni Evangelista, Parma, 1520-1.

COSYNS, ANTOINE-FRANÇOIS, 18 woodcuts for Couchoud's edition of the A, Paris, 1922.

CRANACH THE ELDER, LUCAS, 21 woodcuts (partly after Dürer) for the A in Luther's *Septembertestament* (NT), published by Melchior Lotther, Wittenberg, September 1522; expurgated edition published by the Catholic Hieronymus Emser, 1524; 26 woodcuts, very anti-Roman, in Luther's first *Vollbibel*, published by Hans Lufft, Wittenberg, 1534, imitated everywhere.

DANTE ALIGHIERI, *Purgatorio* XXIX, 82 ff.; dealing with the Elders and the four Beings.

DIEPENBEEK, ABRAHAM VAN, engraving with the Death of the Witnesses (among them Elias, founder of the Carmelites) in the *Speculum Carmelitanum* of 1680.

DIONISII, MASTER, Moscow, c.1500; icon of the A, in Oespenskii Sobor, Kremlin.

DORÉ, GUSTAVE, series of illustrations to the A, in the Bible of 1862.

DÜRER, ALBRECHT, Nuremberg, woodcuts (1 VJ, 14 A), German, 1498, Latin, 1511; imitated in Germanic countries, the Low Countries and France.

DUVET, JEAN, of Langres, 25 copper-engravings, 1546-55; Lyons, 1561; facsimile edition, London, 1965.

ENGELBRECHTSZ, CORNELIS, retable with the Adoration of the Lamb, lost in the Iconoclasm of 1566, described by Karel van Mander.

EYCK, JAN VAN, polyptych of the Lamb, St Bavo's, Ghent, inaugurated, according to tradition, May 6th, 1432, feast-day of St John, in front of the Latin Gate.

FARRAR, AUSTIN, *A Rebirth of Images, The Making of St John's Apocalypse*, Westminster, 1949, the most original of the later commentaries, especially for the astrological background and the meaning of the cosmic numbers.

FLANDIN, HIPPOLYTE, 1809-64, pupil of Ingres, paintings in the 7th chapel off the right choir aisle in St-Séverin, Paris: *John on Patmos*, his calling and his martyrdom; in the nave of St-Germain-des-Prés, Paris: *Signs of the End of the World* (completed by Paul Flandin).

FOUQUET, JEAN, miniatures (John on Patmos, Michael), see CHANTILLY.

FRANCK, JOHANN (Master JF), his engravings of the A were eventually found on Athos, see ATHOS.

FÜHRICH, JOSEPH RITTER VON, 1800-76, woodcuts, in the style of the Nazarenes.

GALLE, JOHANNES, 24 vignettes, with Latin distychs, on

6 pages for the *Biblia sacra* of J.B. Verdussen, Antwerp, 1715 and 1725.

GIOTTO, *see* FLORENCE, S. Croce, and NAPLES, S. Chiara.

GRECO, EL, Domenikos Theotokopoulos, *Opening of the Fifth Seal*, 1612 (from the Zuloaga collection), Metropolitan Museum, New York.

HAIMO OF AUXERRE, commentary, *c*. 843, text PL 117, illustrations in mss. at Oxford, Bodl. 352 and 2431, see OXFORD.

HERMENEÍA TÔN ZÔGRAPHÔN, eighteenth-century *Painter's Guide to Mount Athos*, 22 scenes for the A.

HERRAD VON LANDSPERG, abbess of the Hohenburg on St Odilia's Mountain, Alsace, 1125/30-1195, authoress of the *Hortus deliciarum*; among the 344 pen drawings there are 9 of the A; the ms. was lost by fire in Strasbourg in 1870; seventeenth-century copies pub. by Walter, Strasbourg, 1952.

HOLBEIN THE YOUNGER, HANS, woodcuts for Luther's NT, published by Thomas Wolff, Basel, 1528, freely after Cranach, imitated in Switzerland.

HUNT, WILLIAM HOLMAN, 1827-1910; *The Light of the World* (the Lord with a lantern, knock at the door, Rev. III:20), retable in Liddon Chapel, Keble College, Oxford, in the style of the Pre-Raphaelites, popular in all Anglo-Saxon countries.

IRENAEUS OF LYONS, end second century; in *Adversus haereses* V he proposes the famous identification of the four Living Beings with the Gospels; he was a millenarian; the '1000 years' is interpreted by him as the 'sabbath of the world'.

JACOBELLO ALBEREGNO, parts of a retable, formerly at Torcello, now in Museo Correr, Venice, see VENICE.

JOACHIM OF FIORE, abbot of Floris, east of Cosenza, in Calabria (the Floriacenses are a branch of the Cistercians), author of an *Expositio in Apocalypta*, in which he gives a historicist explanation, that the millennium of the spirit starts in 1260. Following him, the Spiritual Franciscans, who hailed him as a prophet, interpreted the Eternal Gospel of Rev. XIV: 6-7 as a prophecy of the appearance of St Francis, the herald of the last era, the era of the Holy Ghost (after that of the Father and the Son).

KEERICKX, retable, see TONGERLOO, in the 'List of Works of Art'.

KOBERGER, ANTON, printer of books at Nuremberg, godfather of Dürer, publisher of the *Koberger Bible*, German text, 1483 (with 8 woodcuts for the A, copies of those of the *Cologne Bible*, 1478-9; reprinted in the 3rd edition of Luther's NT, published by Adam Petri, Basel); publisher of the *Schatzbehalter*, 1491, with Wolgemut's print of the Throne with the four Beings and the Elders, no. 71.

KONRAD VAN SCHEYERN, author and illuminator of the *Liber matitudinalis*, 1206-25, miniature with the Woman and the Dragon, see MUNICH.

LEMBERGER, GEORG, 26 woodcuts for the A in Luther's Bible of 1524 published by Melchior Lotther; they temporarily replaced those by Cranach in popularity, but fell into oblivion later on (no anti-Roman allusions).

LIBER FLORIDUS, by Lambert of St-Omer, before 1120, 25 scenes for the A and many related ones, see Chapter IX.

LUTHER, MARTIN, in his preface to the NT of September 1522 (*Septembertestament*, published by Melchior Lotther, Wittenberg) he says of the A: 'Mein Geist kann sich in das Buch nicht schicken, und ist mir die Ursach gnug, dasz ich sein nicht hoch achte' ('My mind cannot suit itself to the book, and that is cause enough for me not to think highly of it'), a view he reconsidered in December of the same year (*Dezembertestament*). His exegesis, partly in the historicist spirit, goes back to that of Nicholas of Lyra (see below), but he gives it a violent anti-Roman twist; in this, later Protestant commentators have followed him, and the illustrations of the A show traces of it; because he read 'angel' instead of 'eagle' (Rev. VIII:13), some engravers

have replaced the eagle of the thrice Woe! by an angel.

LUYKEN, JAN, vignettes for the A in the Bible of Pierre Mortier, Amsterdam, 1700, published separately as an album in 1729.

MARTIN, JOHN, 1789-1854; illustrations for the A in a family Bible widely distributed, monotonous and grotesque.

MASTER OF THE LYVERSBERGER PASSION: St John seeing the Woman, at the death-bed of Mary, 1460, Nuremberg, Germanisches Museum.

MASTER OF THE VISION OF ST JOHN and MASTER OF THE ENTHRONEMENT OF THE VIRGIN, see COLOGNE in 'List of Works of Art'.

MATSYS, QUINTEN, Martyrdom of St John, VJ, left wing of the *Entombment*, 1508-11, Antwerp, Musée des Beaux-Arts; the Latin Gate is represented as Het Steen in Antwerp.

MAZZOLA BEDOLI, GEROLAMO, died, 1569, Parma; fresco after Correggio's cupola in S. Giovanni Evangelista, Parma, on left wall in choir of Mantua Cathedral.

MEMLING, HANS, St John and the visions of the A, right wing of the *Mystic Marriage of St Catherine*, St John's Hospital, Bruges, 1479; in background of middle panel: VJ.

MENABUOI, GIUSTO DE', frescoes of the A in baptistry and in S. Benedetto at Padua.

MERIAN BIBLE, THE, series of engravings for the A, by Matthäus Merian the Elder, 1627, in the Bible of 1630 published by Lazarus Zentner in Strasbourg, and later in Frankfurt *(Merianische Kupferbibel)*; 12 scenes (instead of the 26 by Cranach) in the *Wittenberg Bible*, very popular for a century; also copied in the Low Countries.

NERIDA DA RIMINI, miniature with the Vision of the Throne, ms. Vat. Urb. lat. 11, fourteenth century.

NERI DE' BICCI, *The Fall of the Angels*, Rotterdam, Museum Boymans-van Beuningen, 2450, end fifteenth century.

NICHOLAS OF LYRA, *Postillae perpetuae in Apocalypta*, 1329; the father of the historicist theory giving a purely arbitrary exegesis; he sees the beginning of the 1000 years in the appearance of the Mendicant Orders (he himself was a Franciscan); but for the rest of the Holy Bible he always stresses the literal meaning; Luther was influenced by his explanation (piously meant) of the A and gave it an anti-Roman twist.

NICOLAS, JOEP, Dutch glass-painter: 8 windows with A, at Tubbergen (Province of Overijssel), before 1972; window with A at Vreeland (Province of Utrecht), Dutch Reformed Church, see VREELAND.

ORLEY, BAREND VAN, 1488-1542, Brussels; from 1518 he was in the service of the Governess Margareta of Austria residing at Mechelen; from 1525 he designed cartoons for tapestries, among them those with the A, see PANNEMAKER, DE.

PAGANINI, ALESSANDRO, series of engravings of the A, 1515.

PANNEMAKER, WILLEM DE, weaver at Brussels, where, before 1553, the tapestries of the A for the Spanish Court were woven (now in the VALLE DE LOS CAÍDOS); the cartoons are in the style of Van Orley.

POGEDAÏEV, GEORGES DE, series for an A, Paris, 1947-50.

PRIMASIUS OF HADRUMETUM (now Sousse, Tunisia), commentator on the A, *c*. 540, text PL 68, 914 ff.

PRUDENTIUS, Christian poet, *c*. 400; in his *Dittochaeum* the last *titulus* (inscription for an image), 49, deals with the Lamb and the Elders (CSEL 61, 449).

RAPHAEL (Raphaello Sanzio), *Vision of Ezekiel*, with the Lord above the tetramorph, 1518, Palazzo Pitti, Galleria Palatina 174, Florence.

REDON, ODILON, *L'Apocalypse de Saint Jean*, 12 lithographs, pub. in an edition of 100 by Vollard, Paris, 1899.

RENI, GUIDO, *Michael and Satan*, altarpiece, 1st chapel to the right in S. M. della Concezione (I Cappuccini), Rome, after 1626.

RUBENS, PETER PAUL, *The Woman, the Dragon and St Michael*, altarpiece for the Freising Cathedral, 1608-11;

Munich, Alte Pinakothek, 739; drawing in collection of M. v. Nemerz.

SCHÄUFFELIN, HANS, A engraved for Luther's *September-testament*, published by H. Schoensperger, 1523, some fine variants of Cranach.

SCHNORR VON CAROLSFELD, JULIUS, 1794-1872, one of the Nazarenes; A in the *Bibel in Bibern* of 1860, 1866 (with 240 woodcuts).

SCHUT, PIETER, A, nos. 137-43 of *Toneel ofte Vertoon der bybelse Historiën*, pub. Nikolaas Visscher, Amsterdam, 1659 (recent ed. 1963), after the *Merian Bible*.

SOLIS, VIRGIL, A in the Bible of Feyeraband, Frankfurt, 1560, and Lechler, 1588.

STRASBOURG, BIBLE OF, published by Johann Grüninger, 1485, A with 8 of the 9 woodcuts of the *Cologne Bible*, with little variants, known by Dürer.

TRUTENBUL BIBLE, Halberstadt, 1520, A after the one in the *Cologne Bible*.

THORNTON, JOHN, glass-painter from Coventry, creator of the great East Window in York Minster, 1450 ff., see YORK.

TYCHONIUS, African Donatist, *c.* 380, author of the best Antique commentary, who broke with traditional theories on the millennium. Fragments of his work, cleared of Donatist smears by Jerome, were preserved by Primasius and Bede (and to some extent by Cesarius of Arles), and pub. in *Spicilegium Cassinense*, III. He thought the end of the world was at hand, but he kept aloof from historicist applications.

VASARI, GIORGIO, author of the famous *Lives* of artists, 1550 and 1568; he mentions Giotto's cycle of the A in S. Chiara of Naples and that of Giusto de' Menabuoi at Padua, see Chapter XII.

VASANETSOV, VIKTOR MICHAILOVIČ, 1848-1926, *The Four Riders*, 1887, crypt of the Kazan Cathedral (now Museum of the History of Religion), Leningrad.

VAVASSORE, GIOVANNI ANDREA, engraver and publisher in Venice, A, 15 woodcuts, freely after Dürer.

VELLERT, DIRCK, painter from Antwerp, mid sixteenth century; A, series of 17 drawings, freely after Dürer (angel instead of eagle, Rev. VIII: 13), Paris, Cabinet des Estampes.

VICTORINUS OF PETTAU (Poetovio, now Ptuj, Yugoslavia) died, 304, author of the principal orthodox commentary of Antiquity, expurgated by Jerome (who expunged the passages dealing with the theories of the millennarians), from whom it took its name; pub. in CSEL, 1961 ff. His explanation is based on the *recapitulatio*: all principal motifs of the A are repeated in series leading, in crescendo, to the repose of eternity.

XYLOGRAPHICA, see Chapter XVI; the oldest block-book of the A was probably made at Haarlem by Coster, *c.* 1420-35; VJ; 50 scenes on 25 blocks (cut on both sides); facsimile ed. by Musper, Munich 1961.

ZURBARÁN, FRANCISCO DE, 1598-1664; *The Angel Showing the Heavenly City to St Peter Nolasco*; after 1628, for the Mercedarios Descalzos of Seville; Madrid, Prado.

List of Illustrations

24 The New Law given to Peter.
Mosaic in the cupola of the Soter baptistry, *c.* 400.
Naples, S. Restituta.

25 The Throne in the Heavenly City.
Mosaic in the apse, probably 401-17.
Rome, S. Pudenziana.

26 The New Law given to Peter.
Lid of the ivory 'Pola Casket', *c.* 400, from Samagher, in Istria (Yugoslavia).
Formerly in Museo Civico of Pula.
Location unknown (since 1945).

27 The Law given to Peter.
Gold glass, about 400.
Rome, the Vatican, Museo Cristiano.

28 The Throne with the Lamb.
Mosaic on the triumphal arch.
Rome, SS. Cosma e Damiano.

29 The Adoration of the Lamb by the Elders.
Drawing from the abbey of Farfa (Lazio), eleventh century.
Eton College.

30 The seven candlesticks.
Mosaics, sixth century.
Poreč.

31 The saints received into the Heavenly City.
Mosaics of the two triumphal arches.
Rome, S. Prassede.

32 The Lion, the Man, the Sea of crystal.
Rome, S. Prassede.

33 The twenty-four Elders.
The actual mosaic is a reconstruction, by Salviati, from Venice, nineteenth century.
Aachen, Cathedral.

34 The Elders, holding up the vials of perfume to the Lamb.
Triumphal arch of the abbey church, eleventh century.
Castel S. Elia, near Nepi (Lazio).

35 The Heavenly Liturgy.
Remnants of the mosaic on the triumphal arch.
Rome, St Paul's Outside the Walls.

36 The theophany of the *Trisagion*.
Frescoed apsidiole in a chapel at Bawît.
Cairo, Coptic Museum.

37 The Throne and the four Beings.
Tympanum of the abbey church, *c.* 1110.
Moissac (Tarn-et-Garonne).

38 Six Elders.
Tympanum.
Moissac.

39 The Vision of the Throne.
By the 'Master of St John's Vision', *c.* 1450; panel.
Cologne, Wallraf-Richartz Museum.

40 The Elders.
Tympanum of the doorway inside the porch, called Portico de la Gloria.
Santiago de Compostela (Galicia), Cathedral.

41 The Lord and the four Beings.
Portail Royal, *c.* 1144-55.
Chartres (Eure-et-Loire), Cathedral.

42 John seeing the Son of Man.
Tympanum of the church, twelfth century.
Lalande-de-Fronsac (Gironde).

43 The four Beings and the Elders surrounding the Coronation of the Virgin.
By the 'Master of the Enthronement of the Virgin', *c.* 1460.
Cologne, Wallraf-Richartz Museum.

44 Frontispiece to the Apocalypse, in the Bible from Moutiers-Grandval; Tours, *c.* 840.
London, British Library.

45 The Lamb adored by the Elders and the four Beings in the Heavenly City.
Miniature illustrating Jerome's Prologue, *Plures fuisse*, in the Gospels from St-Médard de Soissons, probably illuminated in Rhineland before 827.
Paris, Bibliothèque Nationale.

46 Frontispiece to the Apocalypse, in the Bible of St Paul's Outside the Walls; produced in St-Denis, 869.
Rome, St Paul's Outside the Walls.

47 The Lamb adored by the Elders.
Miniature in the Golden Codex of St Emmeran, at Ratisbon, written for Charles the Bald, about 870.
Munich, Bayerische Staatsbibliothek.

48 The Lamb, the Church, and the Great Multitude.
Miniature in a *Liber sacramentorum*, probably for the diocese of Bremen-Hamburg; written at Fulda, at the end of the tenth century.
Udine (Friuli), Archivo Capitolare.

49 The Woman threatened by the Dragon.
Frescoed lunette, twelfth century.
Civate (Lombardy), S. Pietro al Monte.

50 The Son of Man and the candlesticks, the seven churches and their angels.
Frescoed vault.
Anagni (Lazio), crypt of the Duomo.

51 The Locusts swarming out of the Bottomless Pit.
Frescoed vault of the gallery, in the porch of the abbey church, eleventh century.
St-Savin-sur-Gartempe (Vienne).

52 The Rider with the iron rod, on the white horse.
Fresco on the vault of the crypt; *c.* 1100.
Auxerre (Yonne), Cathedral.

53-61 Miniatures taken from the oldest cycle illustrating the whole of the Apocalypse, a Carolingian copy of an Early Christian prototype, dating from the end of the fifth or the beginning of the sixth century.
Trier, Stadtbibliothek.

62 The four angels holding back the four Winds.
Frescoes in the transept of the abbey church, eleventh century.
Castel S. Elia, near Nepi (Lazio).

128-129 Two panels of a polyptych dedicated to the Apocalypse and attributed to Jacobello Alberegno, end fourteenth century.
Venice, Museo Correr.

130-135 Double panel, with a complete cycle of the Apocalypse, of Italian origin, possibly from Naples, 1330-40.
Stuttgart, Staatsgalerie.

136 Part of the cycle painted above the arches of the nave, in the abbey church of Pomposa, *c*. 1350, near Codigoro, in the Romagna (Prov. Emilia, north of Ravenna).

137-159 The twenty-three full-page miniatures of a Flemish Apocalypse, written about 1400.
Paris, Bibliothèque Nationale.

160-167 The polyptych of the Lamb by Jan van Eyck, before 1432.
Ghent, St Bavo's Cathedral.

168-175 *The Mystic Marriage of St Catherine.*
Altarpiece by Hans Memling.
Bruges, St John's Hospital.

176-180 Six pages from the first block-book of the Apocalypse.
Probably in the workshop of John or Lawrence Coster, about 1420-35.
Holland, Haarlem.

181 Coloured woodcut of the Apocalypse.
Modena, Biblioteca Estense.

182 The four Riders.
Woodcut from the *Cologne Bible*, 1478-9.

183 The Great Angel.
The *Cologne Bible*, 1478-9.

184 The *Allerheiligenbild* of Albrecht Dürer, 1511, made in Nuremberg.
Vienna, Kunsthistorisches Museum.

185-200 The Latin edition, 1511, of Dürer's Apocalypse, containing fifteen engravings: *Apocalipsis in figuris*.
The German edition, Nuremberg, dates from 1498.

201 The measuring of the Temple, the two Witnesses, and the Beast.
Woodcut in the *Wittenberg Bible*, 1534.

202 The drunken Whore on the Beast, wearing the papal tiara.
Woodcut, by Lucas Cranach, in Luther's *September-testament*, 1522.

203 Three panels from the top of a window containing ten panels, freely after Dürer, from about 1529.
This window is the earliest of a series of French windows inspired by Dürer's prints.
St-Florentin (Yonne), parish church.

204 The Son of Man among the candlesticks, and the four Riders, freely after Dürer, from about 1550.
The four lower panels of a window dedicated to the Apocalypse.
Chavanges (Aube), parish church.

205-220 The Apocalypse, shown in eight tapestries, woven in Brussels in the workshop of Willem de Pannemaker, after cartoons designed in the manner of Barend van Orley. Nearly all the Dürer motifs, and many older ones, are utilized for their iconography.
Valley of the Fallen, north-west of Madrid.

221-227 Correggio's frescoes from the interior of the dome and the four pendentives.
Parma, S. Giovanni Evangelista.

228 St John and the vision of the Apocalypse.
Detail of the altarpiece by Memling.
Bruges, St John's Hospital.

PHOTOGRAPHIC ACKNOWLEDGMENTS

Abrams, New York; A.C.L., Brussels; Alinari, Firenze; Amsterdam, Rijksmuseum; Braziller, New York; Dean and Chapter of York Minster; The Eugrammia Press, London; Groten, B., Tilburg; Insel Verlag, München; Marburg, Photo-Archiv; Mourlet, Munich, Bayerische Staatsbibliothek; New York, Metropolitan Museum; Padua, Museo Civico; Paris, Bibliothèque Nationale; Pierpont Morgan Library, New York; Prestel Verlag, Munich; Ricci, Parma; Rizzoli, Milan; Roux, Le, Strasbourg; Sibbelee, Maartensdijk; Stuttgart, Staatsgalerie; Stuttgart, Verlag katholisches Bibelwerk; Tórtoli, Gianni, Tavarnuzze; Trier, Stadtbibliothek; Service Commercial des Monuments Historiques, Paris; Toulouse, Musée des Augustins; Urs Graf Verlag, Olten-Lausanne; Venice, Museo Correr; Wehmeyer, Hildesheim; Wolfenbüttel, Herzog August Bibliothek; *Corpus vitrearum*, France, I, Paris, 1959; Delisle-Meyer, *L'Apocalypse en français au XIII*ᵉ *siècle*, Paris, 1901; Friedl, Antonín, *Mistr Karlštejnské Apokalypsy*, Prague, 1950; Köhler, W., *Die Karolingischen Miniaturen*, I, Berlin, 1930, 1962; Musper, H.Th., *Die Urausgabe der holländischen Apokalypse*, Munich, 1961; Schmidt, Ph., *Die Illustration der Lutherbibel*, Basel, 1962; Sergio Bettini, *Giusto de' Menabuoi*, Le Tre Venezie, Padua, 1944; Unesco, *Russian Icons*, 1966; Worringer, W., *Die Kölner Bibel*, Munich, 1923.

THIS BOOK, PRODUCED BY MERCATORFONDS, ANTWERP
IS THE FORTY-FIRST PUBLICATION BROUGHT ABOUT UPON
THE INITIATIVE OF THE BANQUE DE PARIS ET DES PAYS-BAS
AND OF THE PARIBAS GROUP
DESIGNED BY LOUIS VAN DEN EEDE
THE TEXT IS SET IN PLANTIN BY BRUFIZET S.A., BRUGES
ILLUSTRATIONS REPRODUCED BY DE SCHUTTER, ANTWERP
FIRST PRINTED AUTUMN NINETEEN SEVENTY EIGHT ON CONDAT ART PAPER
BY BREPOLS, TURNHOUT
THIS BOOK IS BEING PUBLISHED SIMULTANEOUSLY
IN DUTCH, FRENCH, ENGLISH AND GERMAN EDITIONS

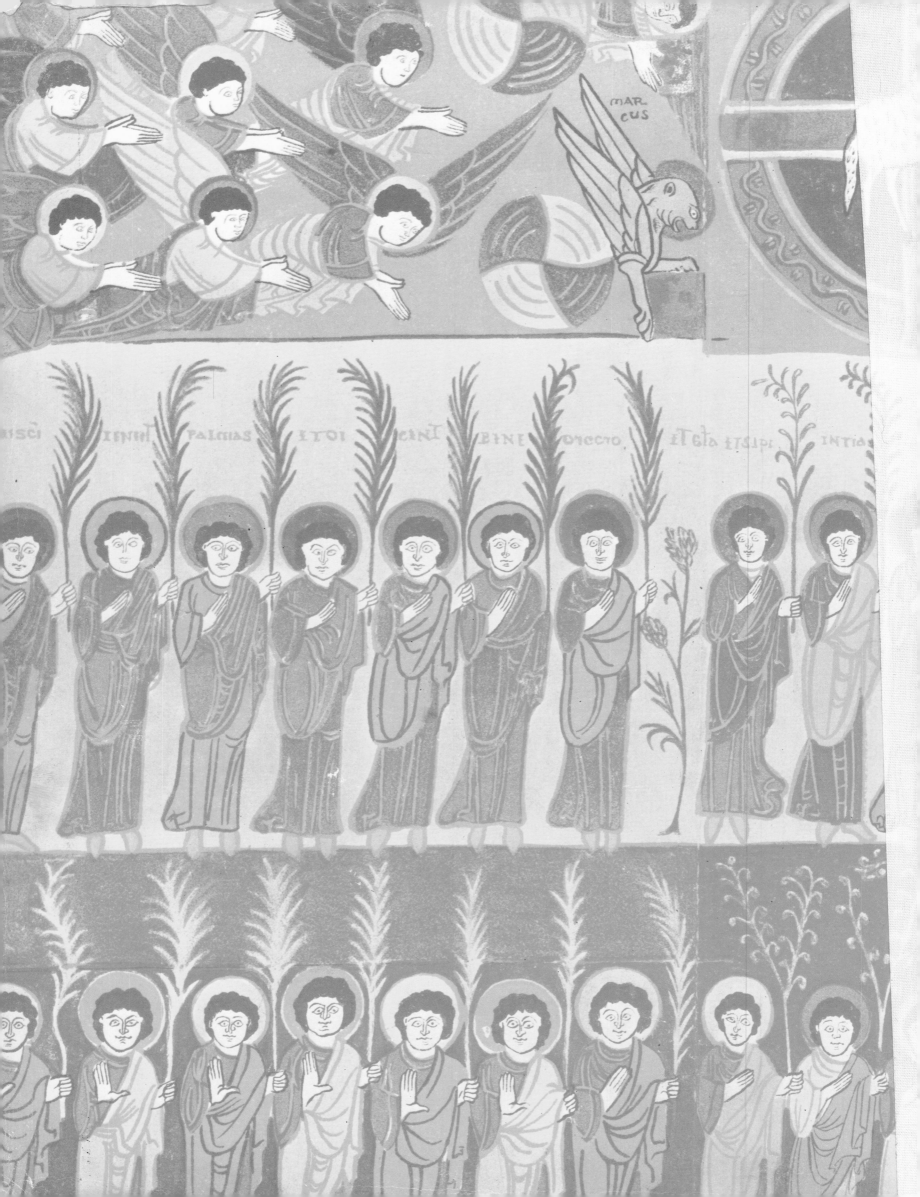